mark galer philip andrews

First published 2014 by Focal Press 70 Blanchard Road, Suite 402, Burlington, MA 01803

Simultaneously published in the UK by Focal Press 2 Park Square, Milton Park, Abingdon, Oxon OX14 4RN

Focal Press is an imprint of the Taylor & Francis Group, an informa business

© 2014 Mark Galer and Philip Andrews

The right of Mark Galer and Philip Andrews to be identified as authors of this work has been asserted by them in accordance with sections 77 and 78 of the Copyright, Designs and Patents Act 1988.

All rights reserved. No part of this book may be reprinted or reproduced or utilised in any form or by any electronic, mechanical, or other means, now known or hereafter invented, including photocopying and recording, or in any information storage or retrieval system, without permission in writing from the publishers.

Notices

Knowledge and best practice in this field are constantly changing. As new research and experience broaden our understanding, changes in research methods, professional practices, or medical treatment may become necessary.

Practitioners and researchers must always rely on their own experience and knowledge in evaluating and using any information, methods, compounds, or experiments described herein. In using such information or methods they should be mindful of their own safety and the safety of others, including parties for whom they have a professional responsibility.

Product or corporate names may be trademarks or registered trademarks, and are used only for identification and explanation without intent to infringe.

Any unauthorized manner of exhibition and any broadcast, public performance, diffusion, editing, copying, re-editing and hiring in whole or in part of this DVD or the content contained on it is strictly prohibited. Taylor & Francis reserve all rights in relation to any action it may take to enforce this prohibition.

Library of Congress Cataloging in Publication Data A catalog record for this book has been requested

Publisher's Note This book has been prepared from camera-ready copy provided by the authors.

Printed In The United States Of America By Courier, Kendallville, Indiana

Acknowledgements

To our families:

Dorothy, Matthew and Teagan and Karen, Adrian and Ellena

for their love, support and understanding.

We would like to pay special thanks to Mark Lewis for his advice and editorial input.

Picture credits

Paul Allister; Craig Banks; Magdalena Bors; Andrew Boyle; Haydn Cattach; Abhijit Chattaraj; Dorothy Connop; Giles Crook; Samantha Everton; Serena Galante; Rory Gardiner; Morten Haugen; Eeyong Heng; Jeff Ko; Michelle Lee; Seok-Jin Lee; Chris Mollison; Shane Monopoli; Chris Neylon; Serap Osman; Ed Purnomo; Jennifer Stephens; Rahel Weiss.

Also our thanks go to www.iStockphoto.com for supporting this venture by supplying various images.

All other images and illustrations by the authors.

foundation module

Introduction	xiv
A structured learning approach	XV
Online resources	XV
Research	XV
Essential information	xvi
I What's new for CC	
A new look and a new direction	2
2 Bridge	23
Introduction	24
The CC version of Bridge	25
Setting up Bridge	26
Using Bridge	32
3 Workflow	47
Introduction	48
A few key concepts before we start	50
Foundation Project 1	55
Image capture – Step 1	55
Downloading files – Step 2	60
Image management – Step 3	62
Image processing steps	63
Rotating and cropping an image – Step 4	63
Color adjustments – Step 5	65
Tonal adjustments – Step 6	67
Cleaning an image – Step 7	75
Sharpening an image – Step 8	77
Setting Workflow Options – Step 9	78
Applying changes to multiple files – Step 10	79
Outputting processed files – Step 11	81
Saving, duplicating and resizing for web – Step 12	83

4 Raw Processing	8/
Introduction	88
Processing Raw data	89
Foundation Project 2	90
Lens corrections – Step 1	90
Straighten, crop and size – Step 2	92
Color space – Step 3	93
Choosing a bit depth – Step 4	94
White balance – Step 5	95
Global tonal adjustments – Step 6	99
Controlling saturation and vibrance – Step 7	100
Localized correction – Step 8	101
Grayscale conversion and toning – Step 9	106
Adding special effects – Step 10	111
Noise reduction and sharpening – Step 11	113
Output options – Step 12	115
Foundation Project 3	118
Preliminary enhancements – Step 1	118
Add Graduated Filter effect – Step 2	119
Adjust the Graduated Filter effect – Step 3	119
Reclaim some of the filtered detail – Step 4	120
Add a film-like Grain effect – Step 5	120
Digital exposure	121
Adjusting exposure in ACR	122
Foundation Project 4	122
Dust on the sensor – batch removal	126
Archiving Raw files as digital negatives	127

5 Fine Print	129
Introduction	130
The problem and the solution	131
Prepare your print workshop	132
Prepare your monitor	133
Prepare your inkjet printer	134
Select appropriate color setting	135
Obtain a profile target	136
Print the target using Adobe® Color Print Utility	136
Alternative: Printing a target from Photoshop	137
Adjust the printer settings	138
Create and install custom profile	139
Tag images with the Adobe RGB profile	139
Test your color managed workflow	140
Make printer presets	140
Assessing the test print for accuracy	141
Preserving shadow detail	142
Soft proofing	143
Printing using a professional lab	144

Digital Basics – Online Chapter I	
Introduction	3
Channels and modes	4
Levels	5
Hue, Saturation and Brightness	6
Color and light overview	8
Bit depth	10
File size	11
File formats	12
Image compression	15
Resolution	17
Image size	21
Interpolation	24
Digital Darkroom – Online Chapter 2	27
Digital setup	28
Monitor settings	29
Choosing a workspace	30
Getting started with Photoshop	30
Settings and preferences	33
Navigation and viewing modes	35

digital darkroom - online chapter

Rulers and guides

Contents

- IntroductionChannels and modes
- Levels
- Hue, Saturation and BrightnessColor and light overview
- Bit depth File size
- File formats
- Image compression
- Resolution
- Image size

Note > Click on a heading from the contents to go straight to that topic, or use the navigation arrows at the bottom of each page to move forward or back through the document. - 38

advanced skills module

6 Layers and Channels	147
Introduction	148
Layers overview	149
Layer types	152
Channels	156
Adjustment and filter layers and editing quality	158
Layer masks and editing adjustments	159
7 Selections	161
Introduction	162
Selection tools overview	162
Shape-based selections with the Marquee tools	162
Drawn selections using the Lasso tools	163
Customizing your selections	165
Refining selections	167
Refine Edge in action	168
Saving and loading selections	170
Feather and anti-alias	171
Defringe and Matting	172
Quick Mask or Refine Edge	173
Color Range	174
Channel masking	175
Tone-based selections and masks	177
Selections from paths	181

8 Filters	187
Filtering in Photoshop	188
The 'Smart' way to filter	189
The Filter Gallery	191
Fade Filter command	192
Improving filter performance	192
Installing and using third party filters	192
Filtering a shape, text, or vector layer	193
The great filter roundup	193
Liquify filter	194
Vanishing Point	196
Adaptive Wide Angle	198
Lighting Effects Gallery	199
Blur Gallery	200
Correcting lens distortion with filters	202
Noise filters	206
Sharpen filters	208
Texture filters	210
Other filters	210
Filter DIY	211
9 Layer Blends	213
Introduction	214
The 'Darken' group	216
The 'Lighten' group	219
The 'Overlay' group	222
Difference and Exclusion	224
Hue, Saturation and Color	225
Luminosity	227

imaging projects module

10 Retouching Projects	229
Standard edit in ACR – Project 1	230
Extreme contrast edits in ACR – Project 2	255
Lens corrections – Project 3	261
Raw expression – Project 4	268
Editing for drama – Project 5	274
Black and White in ACR – Project 6	283
Working spaces – Project 7	289
Double processing – Project 8	301
11 Composite Projects	311
Refine Edge – Project 1	312
Refine Edge (Take Two) – Project 2	317
Paths, masks and blend modes – Project 3	328
Replacing a sky – Project 4	342
Composite studio lighting and action – Project 5	349
Smart fixed position composite – Project 6	356
Preserving shadows – Project 7	363
Replacing a studio background – Project 8	374
High Dynamic Range (HDR) – Project 9	382
HDR problems and solutions – Project 10	392
Photomerge – Project 11	400
Vertical panoramas – Project 12	418

12 Special Effects		427
Smooth Tone technique – Project 1		428
High Impact – Project 2		434
Color Grading – Project 3		444
Reduced Depth of Field – Project 4		453
Tilt-Shift effect – Project 5		464
Faux Holga – Project 6		468
Toy camera effect in ACR – Project 7		478
Lens Flare effect – Project 8		485
Borders and textures – Project 9		490
		407
Glossary		497
Keyboard Shortcuts	$S_1 = S_2$	507
Web Links		509
Index		510
Index		210

Online Contents

The online resources are a veritable treasure trove of supporting files for the projects in this book as well as a resource for your own creative projects. The images and movies online are divided into their respective chapters and, after downloading, can be accessed via Bridge. The movies are an invaluable resource, allowing you to start, stop and rewind so that the skills can be quickly and easily acquired at your own pace.

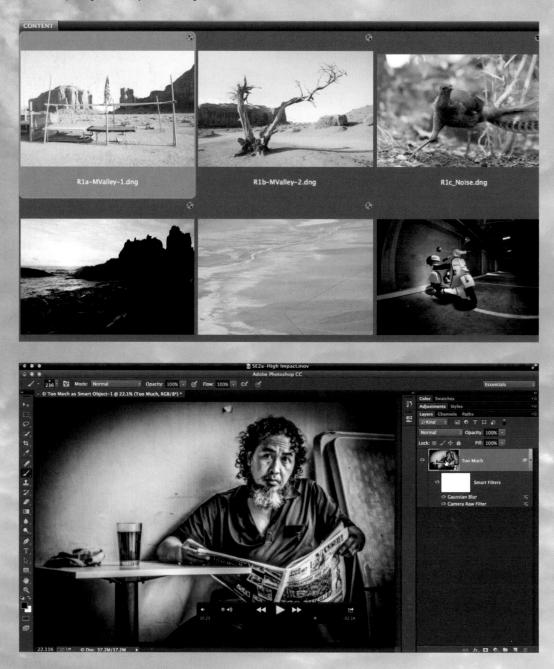

Online Contents

http://www.focalpress.com/cw/Galer To access the online resources, please see the instructions on the Web Links page in the appendices.

ONLINE RESOURCES PROVIDE EXTENSIVE SUPPORT IN THE FORM OF:

- Over ten hours of movie tutorials to guide you through all of the projects in this book.
- Digital Basics and Digital Darkroom chapters in PDF file format (learn about channels, modes, levels, file format, bit depth, resolution and more in one handy portable guide for screen viewing).
- High-resolution, high-quality JPEG images to support all of the imaging projects.
- Full-resolution images with 'saved selections' for users interested in completing the projects in the least amount of time whilst achieving maximum quality.
- Camera Raw files.
- Printable PDF file of keyboard shortcuts to act as a quick and handy reference guide to speed up your image-editing tasks.

Introduction

Photoshop has helped revolutionize how photographers capture, edit and prepare their images for viewing. Most of what we now see in print has been edited and prepared using the Adobe software. The image-editing process extends from basic retouching and sizing of images, to the highly manipulated and preconceived photographic montages that are commonly used by the advertising industry. This book is intended for photographers and designers who wish to use the 'digital darkroom' rather than the traditional darkroom for creative photographic illustration. The information, activities and assignments contained in this book provide the essential skills necessary for competent and creative image editing. The subject guides offer a comprehensive and highly structured learning approach, giving comprehensive support to guide Photoshop users through each editing process. An emphasis on useful (essential) practical advice and activities maximizes the opportunities for creative image production.

Acquisition of skills

The first section of this book is a foundation module designed to help the user establish an effective working environment and acts as a guide for successful navigation through the image-editing process from capture to print. Emphasis is placed on the essential techniques and skills whilst the terminology is kept as simple as possible, using only those terms in common usage.

Application of skills

The subsequent modules extend and build on the basic skills to provide the user with the essential techniques to enable creative and skilful image editing. The guides explore creative applications including advanced retouching, photomontage, vector graphics, special effects and preparing images for the web. Creative practical tasks, using a fully illustrated and simple step-by-step approach, are undertaken in each of the guides to allow the user to explore the creative possibilities and potential for each of the skills being offered.

A structured learning approach

The study guides contained in this book offer a structured learning approach and an independent learning resource that will give the user a framework for the techniques of digital imaging as well as the essential skills for personal creativity and communication.

The skills

To acquire the essential skills to communicate effectively and creatively takes time and motivation. Those skills should be practiced repeatedly so that they become practical working knowledge rather than just basic understanding. Become familiar with the skills introduced in one study guide and apply them to each of the following guides wherever appropriate.

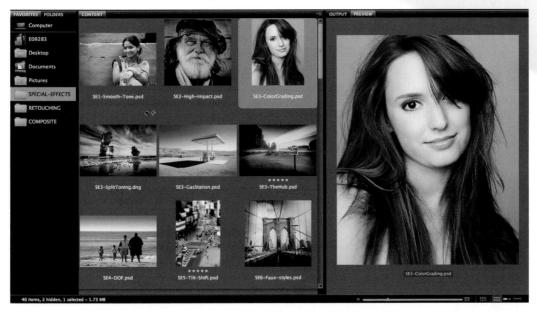

The website has images and movies available to support and guide the learning process - download them and use Bridge to manage and access the support materials quickly.

Online resources

A supporting website has been set up to enable users to access the images, movies and online chapters The address for the site is: **www.focalpress.com/cw/Galer** Mark Galer's website also has supporting information, Photoshop actions and additional tutorials. Go to **www.markgaler.com** for more information.

Research

You will only realize your full creative potential by looking at a variety of images from different sources. Artists and designers find inspiration in many different ways, but most find that they are influenced by other work they have seen and admired.

Essential information

The basic equipment required to complete this course is access to a computer with Adobe Photoshop CC (CS6 would suffice for many of the projects contained in the book). The photographic and design industries have traditionally used Apple Macintosh computers but many people now choose Windows-based PCs as a more cost-effective alternative. When Photoshop is open there are minor differences in the interface, but all of the features and tools are identical. It is possible to use this book with either Windows-based or Apple Macintosh computers.

Storage

Due to the large file sizes involved with digital imaging it is advisable that you have a highcapacity, removable storage device attached to the computer or use a DVD writer to archive your images.

Commands

Computer commands which allow the user to modify digital files can be accessed via menus and submenus. The commands used in the study guides are listed as a hierarchy, with the main menu indicated first and the submenu or command second, e.g. Main menu > Command or Submenu > Command. For example, the command for opening the Image Size dialog box would be indicated as follows: Edit > Image Adjustments > Image Size.

Keyboard shortcuts

Many commands that can be accessed via the menus and submenus can also be accessed via keyboard '**shortcuts**'. A shortcut is the action of pressing two or more keys on the keyboard to carry out a command (rather than clicking a command or option in a menu). Shortcuts speed up digital image processing enormously and it is worth learning the examples given in the study guides. If in doubt use the menu (the shortcut will be indicated next to the command) until you become more familiar with the key combinations.

Note > The keyboard shortcuts indicate both the Mac and PC equivalents.

Example: The shortcut for pasting objects and text in most applications uses the key combination Command/Ctrl + V. The Macintosh requires the Command key (next to the spacebar) and the V key to be pressed in sequence whilst a PC requires the Control key (Ctrl) and the V key to be pressed.

what's new for CC

nop photoshop photoshop photoshop photoshop phot

top photoshop photoshop photoshop photoshop phot

essentíal skílls

• Overview of the new and changed features in Photoshop CC.

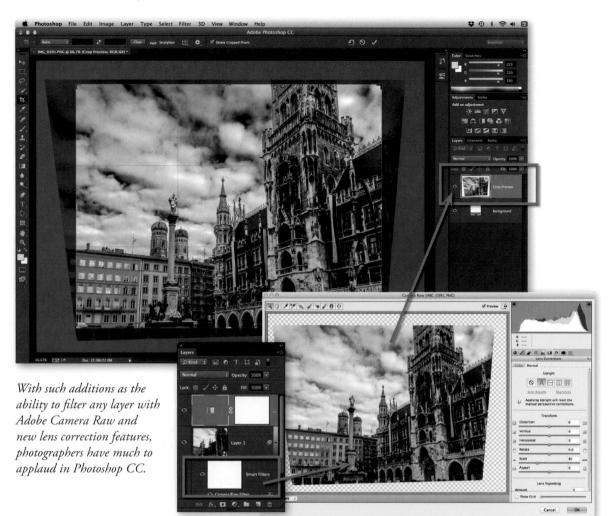

Introducing Photoshop CC

In many ways, the new version of Photoshop is the most radically different of all releases we have seen in the last few years. This is not because of the changes to the feature set, good they might be, nor because the program is now titled Photoshop CC or 'Creative Cloud', but rather because of the way the program is being sold. Now, instead of buying the program outright, or paying for an update, you will need to purchase a monthly subscription to access Photoshop CC.

Subscriptions come in several varieties, including an option to subscribe to Photoshop only, a more substantial offering which includes access to all the different programs in the Creative Suite family, and a team-based subscription for small studios or agencies.

Irrespective of if you are in favour of the change to monthly subscription payments or not the changes are here to stay so let's look at what else is new and improved with Photoshop CC.

What's new for Photoshop CC

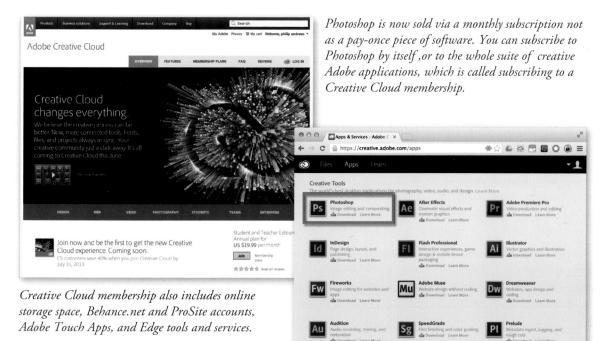

Creative Cloud integration

One of the big ticket items you get with this upgrade is better and tighter cloud-integration. No, I am not now saying that Adobe has taken Photoshop to the cloud. You can rest assured that things move a little more slowly than that. Photoshop is still anchored firmly to your desktop, or laptop, but Adobe has build more cloud based features into their frontline products than ever before.

This has some very real benefits for the digital worker. In fact the key benefits as I see them are:

Immediate Updates

Moving to a subscription service means that we shouldn't have to wait around until the next big launch date before we see new features. With an active Creative Cloud membership you should get access to features as they are rolled out. This should mean that the feature set in Photoshop will evolve in a more fluid fashion rather than the big release jumps we have seen in the past.

0.0.0	Adobe Application Manager
Updates	
Your applications are	all up-to-date as checked: less than a minute ago. O

Synchronise your settings

With the new Sync Settings options, Creative Cloud users can save their settings (shortcuts, layer styles, presets, etc) to the cloud and have them synchronised to other machines logged in under the same account. This is a much needed improvement for those users who have multiple machines and regularly optimise the 'look and feel' of their Photoshop installation.

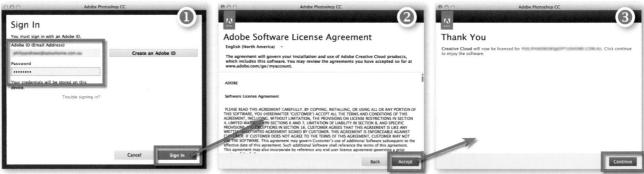

The subscription nature of Photoshop now means that when first starting the program you will need to login with the details you used to subscribe to Creative Cloud. The initial signing in process has three steps:

- 1. Type in your account email address and password, or create a new Adobe ID, and click Sign In.
- 2. Read and agree to the license agreement on the next screen and then click Accept.
- 3. The final step is to click Continue at the next Thank You screen.

You can check to see that you are signed into Creative Cloud from within Photoshop by going to the Help menu and checking the Sign In/Sign Out entry (see aside).

P	
Search	
Photoshop Online Help	% /
Photoshop Support Center	
Legal Notices	
Manage Extensions	
System Info	
Complete/ opuate Adobe to Frome	
Sign Out ()
Updates	
Photoshop Online	
Photoshop Resources Online	
Adobe Product Improvement Program	

For me, it is now a very simple task to have the same set of custom actions, patterns, shapes, and styles on both my desktop production machine and the laptop I use when travelling. And as an added bonus, I can see that setting up a new install of Photoshop will be easier than ever as I can just synchronise all my settings from those stored in Creative Cloud to the new machine.

About Photoshop About Plug-In			- m			
Preferences	*	ieg Straighten	典	•.	✓ Delete	Cropped Pic
		Sync Set			a constant	
Services		Last syn	c: 6/5/	2013	at 8:45	PM
Hide Photoshop Hide Others	нж^ нж7	Manage Manage				
Show All					kinet-42423909993454554	hereen
Quit Photoshop	¥Q.					

After logging into your Creative Cloud account you can synchronize settings to and from Photoshop by selecting the Photoshop > YourLoginName > Sync Settings Now on Mac or Edit > YourLoginName > Sync Settings Now on Windows.

Alternatively, you can synchronise your settings using the special button located at the bottom left of the Photoshop workspace.

SYNCING MY SETTINGS

First install

When you first launch Photoshop you will see the Presets Migration dialog. This was a feature that was first introduced in the last version of Photoshop. You will be asked if you want to migrate your presets from a previous install of the program.

In this release some preferences are also migrated, but not all. See the table on the next page for details of which settings are migrated versus which settings are synchronized via Creative Cloud.

Ps	Cloud.	syncs your preferences and Now to sync settings.	settings with Creative
	Advanced	Don't Sync Settings	Sync Settings Now

Next the Creative Cloud Sync dialog box appears. Clicking on the 'Sync Settings Now' button will start the sync process. Any existing settings will be synced to the cloud, but as this is the first install, only those settings you have migrated from previous versions of Photoshop will be stored in the cloud.

Synchronizing settings from an existing install

Let's now look at a different syncing scenario. You have a desktop computer already setup just the way you like it and you buy a laptop to use while you travel. You want to replicate the settings from your desktop machine to the version of Photoshop you have on your laptop.

Note > Keep in mind that with a single Creative Cloud subscription you are allowed to install the software on two separate machines so this is a scenario many of you could face.

1. Login to the Creative Cloud utility, download and install Photoshop.

Note > If you don't have the utility installed then browse to the *creative.adobe.com* login and follow the screens to download Photoshop. This will download the Creative Cloud utility.

- 2. Launch Photoshop and sign in with your Creative Cloud account.
- Photoshop opens and you are presented with an alert dialog saying, Migrate Presets From Previous Versions of Adobe Photoshop. This option loads presets from an existing, but previous version of Photoshop.
- Once Photoshop opens you can sync the settings you have stored in the cloud by go to Edit
 > YourLoginName > Sync Settings Now (Windows) or Photoshop > YourLoginName > Sync Settings Now.

		Benguard Stevensor	CONTRACTOR OF THE
In	stalling Bridge C	C (7%).	
	Home Apps	Files Fonts	Behance
	More incompation		
Lr	Lightroom 5 More information		Up to date
Ps	Photoshop CC More Information		Up to date
Ps	Photoshop CS6 More information		Up to date
FIND NEW	APPS		All Apps -
Au	Adobe Audition	сс	Install
Mu	Adobe Muse CC More information		Install
Pr	Adobe Premiere Pro CC		Install
Sc	Adobe Scout CC More Information		Install
Ae	After Effects CC More Information		Install
Br	Bridge CC		7% •
5	Dreamweaver C	c	Install

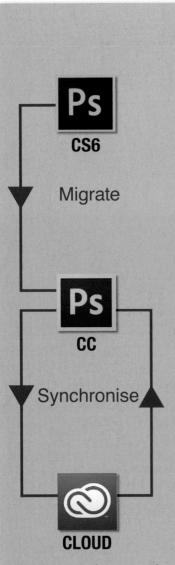

Preferences and presets can be both Migrated from previous versions of the program and Synced between installs of Photoshop CC. See the table aside for details about how each item is handled.

	MIGRATED	SYNCED
Adobe Photoshop CC Prefs.psp		
(General, Interface, File Handling, Performance, Cursors,		
Transparency & Gamut, Units & Rulers,		
GuidesGrids&Slices, Plug-Ins, Type, 3D)	NO	YES
		125
UIPrefs.psp (ex: UI color)		
	NO	YES
File Save Options	NO	YES
Keyboard shortcuts	YES	NO
Menu customization	YES	NO
Adjustment presets	YES	NO
Machine specific prefs	NO	NO
TIVE PRESETS	NO	NO
Actions Palette.psp	YES	YES
Adobe Photoshop CS(version) Prefs.psp	YES	YES
Adobe Photoshop x86 CS(version) Prefs.psp (win 32)	YES	YES
Brushes.psp	YES	YES
	123	125
Color Settings.csf	YES	YES
Contours.psp	YES	YES
CustomShapes.psp	YES	YES
Default Type Styles.psp	NO	NO
Favorites.psp	YES	YES
	YES	YES
Gradients.psp	YES	YES
Keyboard Shortcuts Primary.psp	YES	YES
Keyboard Shortcuts.psp	YES	YES
LaunchEndFlag.psp		
MachinePrefs.psp	NO	NO YES
Materials.psp	YES	
Menu Customization Primary.psp	YES	YES
Menu Customization.psp	YES	YES
New Doc Sizes.psp	YES	YES
Patterns.psp	YES	YES
Recently Used Optimizations.irs	YES	YES
RepoussePresets.psp	YES	YES
Styles.psp	YES	YES
Swatches.psp	YES	YES
SyncCollection.psp	YES	YES
ToolPresets.psp	YES	YES
UIPrefs.psp	YES	YES
Workspace Prefs.psp	YES	YES
optimized Settings folder and children files (Save for Web)	YES	YES
Optimized Colors folder and children files (Save for Web)	YES	YES
Workspaces.psp (Palette Sizes: e.g. Gradient Editor:		
Resizable and Moveable, remembers its position and size)	YES	NO
Workspaces.psp (Palette Locations e.g. Gradient Editor:		
Resizable and Moveable, remembers its position and size)	YES	NO
Keyboard shortcuts	YES	NO
3D presets	YES	NO
DSA dialogs	NO	YES
Prefs files (> 2 gig)	YES	NO
Last used settings on Filters	NO	YES
Last used settings on Adjustments	NO	YES

6

Setting up how your settings sync

So how do you choose what settings are synced and how conflicts between settings saved to a machine and those stored in the cloud are handled? The answer is via the new Sync Settings section of the Preferences dialog.

	Preferences	
General Interface Sync Settings File Handling Performance Cursors Transparency & Gamut Units & Rulers Guides, Grid & Slices Plug-Ins Type 3D	Adobe ID Signed in as: Last sync: Today at 12:32 AM	OK Cancel Prev
	Sync Settings Sync Settings Custom Shapes Tool Presets Styles Styles Custom Shapes Contours Contours Contours Contours Custom Styles Custom Shapes Custom Sha	Next
	When Conflicts Occur Veep Remote Settings Keep Local Settings Always Ask	

Sync Settings (above) is available from the Preferences menu option under Edit in Windows, or Photoshop on Mac. The dialog contains login details, time of last sync, a series of preferences to be synced and a drop-down menu with three options for handling syncing conflicts. Use the options here to determine the way that syncing works on your Photoshop CC installs.

Save files to Creative Cloud

Imaging files can now be saved directly to a special Creative Cloud Files folder on your desktop. This folder then automatically syncs to your Creative Cloud space on the internet providing you with not only a backup of your images, but also a means to synchronize them between machines, or even share them with colleagues or friends.

Files saved to Adobe's Creative Cloud can be accessed via the synchronised folder on your desktop, the Files panels in the Creative Cloud utility, or the Files section at *creative.adobe.com*. Access via the Creative Cloud utility was not made available at the time that Photoshop CC was first released but web and synchronised desktop-folder options were.

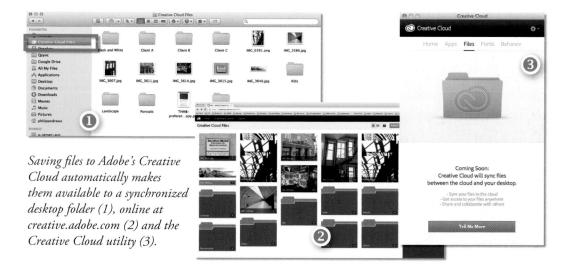

As well as providing a common cloud space where documents can be easily accessed (as long as you have a good internet connection) the file storage option of Creative Cloud also provides options to share links to individual files as well as publish pictures directly to Behance.com. In addition there are general file/folder management options such as renaming, moving, and archiving.

Clicking the downward facing arrow at the bottom right of folders (1) and files (2) in the Creative Cloud window displays a drop down menu of actions. This includes posting images to Behance.net (3) and sharing via a weblink (4).

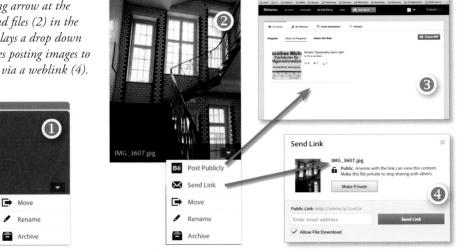

.......

You get 20Gb of storage space with individual monthly membership or 100Gb with a team subscription.

Share your work

Cloud-based files have other benefits as well. Especially when it comes to sharing those files. There are options for versioning your images, keeping them private, inviting others to comment and provide feedback. This is one of the most enabling aspects of storing your images in the cloud for teams or co-workers.

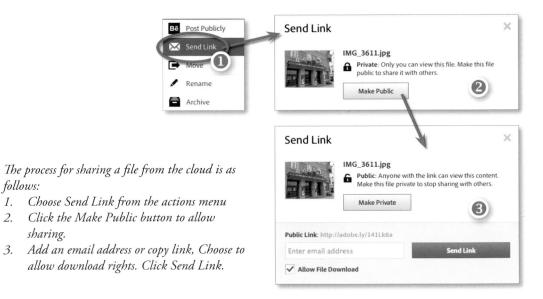

8

Unfortunately, not all cloud-based sharing options were available when Photoshop CC was released, but Adobe assures us that they will be rolled out to all Creative Cloud members in the ensuing months.

Showcase your images on Behance.net

After Adobe's recent purchase of Behance.net you would expect a degree of integration between the site and the Adobe echo system. And that's what you get. Creative Cloud membership includes access to all the pro level features of Behance.net. This includes the ability to showcase your images, get feedback from friends, co-workers and clients, and to find and follow the work of others.

A simple Post Publicly menu option exports your images to the website.

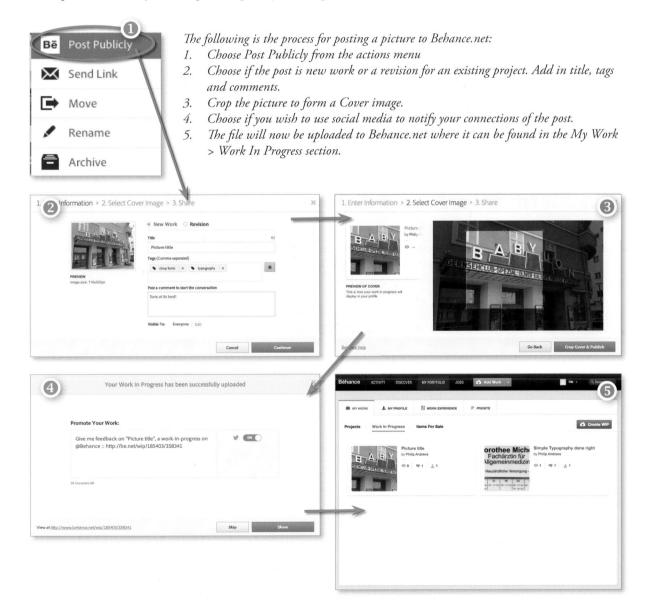

New and improved features

Despite the fact that the new cloud-based nature of Photoshop CC has dominated much of the press, there are plenty of other great features to get image-makers excited. Here are the top new and improved features that will change the way photographers work.

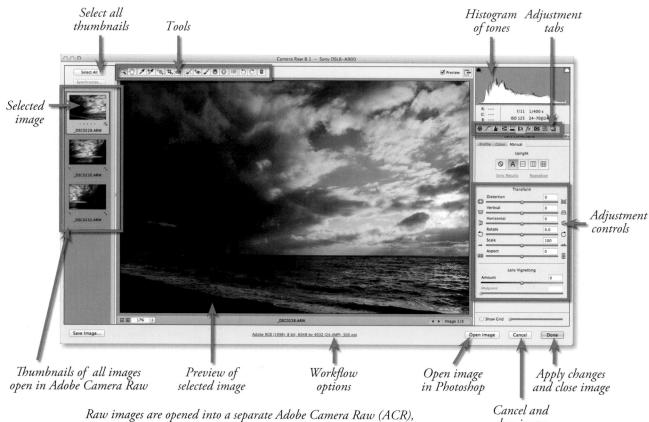

see above, window which is separate to the main Photoshop workspace. Editing and enhancement adjustments are made to the raw images here before proceeding to Photoshop or simply saving the changes back to the files.

close image

Adobe Camera Raw 8

The pivot point for all raw processing in Photoshop is Adobe Camera Raw. Each version of the program sees new features added to the utility and this release is no different.

For those new to the utility or raw files in general, first a little background. Raw files are those pictures saved in your camera's own proprietary format, such as .nef (Nikon), .crw (Canon), or .arw (Sony), which have very little processing applied to them. Because these photos are in a semi-processed state, they have to be handled differently to images stored in standard image formats such as .psd(Photoshop), .jpeg, or .tiff. Adobe Camera Raw (ACR) ships with Photoshop and is the key way raw files are processed and, if need be, converted to more standard imaging formats.

What's new for Photoshop CC

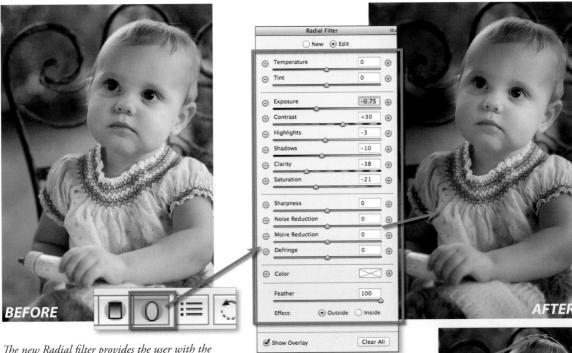

The new Radial filter provides the user with the ability to add feathered elliptical enhancements to any image. In this example it is used to add a darkening vignette around the girl's head.

Positioning handle The size and shape of the gradient marquee is controlled by the handless located at the top and bottom of the ellipse.

The handle in the center is used to reposition

the marquee on the image surface.

Size handles

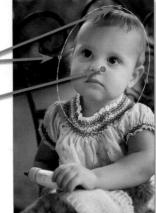

Add non-centered vignettes with the Radial Gradient filter

There is also a new Radial filter providing you with the ability to apply graded adjustments in brightness, color, sharpness and other image characteristics in an off-center position.

This new feature works like the existing Gradient Filter in that thirteen of the image's key characteristics can be altered using the tool. The adjustments include controls for color temperature and tint, as well as tonal tweaks such as exposure, contrast, highlights and shadows.

The Radial Filter differs from the Gradient Filter because the adjustments are applied either inside or outside an elliptical shape drawn onto the image surface. The feather slider controls the transition between areas where the adjustments have been applied and those parts of the image left unchanged. Higher values make this transition smoother, smaller values make the transition more abrupt.

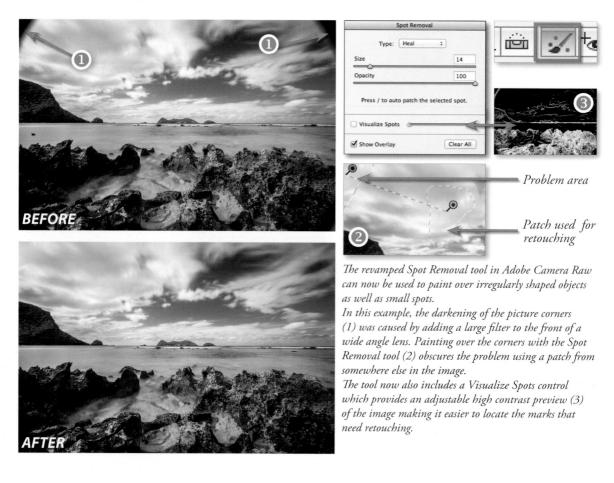

Paint-on retouching for more problem areas

Adobe Camera Raw has had a very useful spot removal tool for several versions now. Using the tool, retouching is simple: just click on a spot and ACR covers the areas with a patch taken from another part of the image. The problem area is marked with a red pin and the patch with a green one, allowing you to reposition either to fine-tune your results.

This version of Adobe Camera Raw sees this basic functionality extended so that now it is possible to retouch larger and more irregularly shaped objects. The same workflow is used. Select the tool, paint over the problem area, and then drag the problem and patch areas to customise the results.

A further useful addition to the Spot Removal tool is the Visualize Spots control which has been added to the tool's panel on the right side of the workspace. When this feature is selected, the preview changes to a high contrast, edge detection, black and white image. Viewing your photo in this way makes it easier to locate small spots and marks which may need retouching. The tool can be applied in this mode, which does speed up the retouching process for problems such as sensor dust, but it is important to review any changes you make when the preview is returned to normal to ensure accuracy.

What's new for Photoshop CC

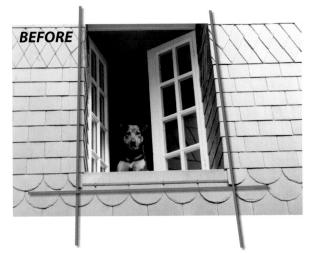

The new Upright feature is part of a growing collection of very useful Lens Correction tools that can be used to straighten photos taken on an angle. In this example the window was photographed from the side and below. Using Upright the image is now straight and the frame of the window is rectangular.

Correct your crooked pictures

The popular lens correction tool gets a new Upright feature, which enables easy straightening of horizons and buildings as well as other perspective corrections.

Controls for the new inclusion are located in the Manual tab of the Lens Corrections panel. The suggested workflow is to click one of the button presets at the top of the panel and then finetune the results with the various sliders located beneath.

The button options are:

Auto - Adobe says this option applies a 'balanced' adjustment. In practice, this results in a corrected image which has been partially but not fully corrected. Sometimes a strict correction of both vertical and horizontal elements looks a little strange.

Level - Reorientates the image horizontally only. Vertical elements are left untouched.

Vertical - Adjusts the image for vertical elements only.

Full - Makes changes to the photo to account for horizontal as well as vertical perspective issues.

Note > Raw files processed in a earlier versions of ACR will need to be updated to the most recent Raw engine (2012) before you are able to take advantage of many of the new, or recent, features.

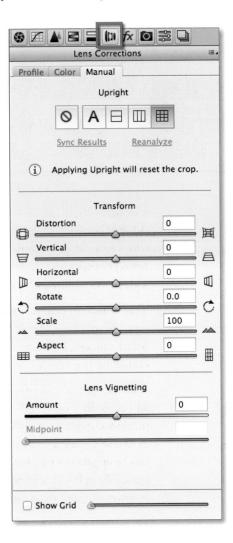

Any Smart Object layer can now be 'filtered' with Adobe Camera Raw. This provides easy access to the ACR features for non-raw file types and multiple layers. After creating the Smart Object layer simply select Filter > Camera Raw Filter (1).

With easier ways of using the features of ACR to enhance Smart Object content, the prospect of techniques such as processing the same raw file twice within a single document becomes a much more realistic prospect.

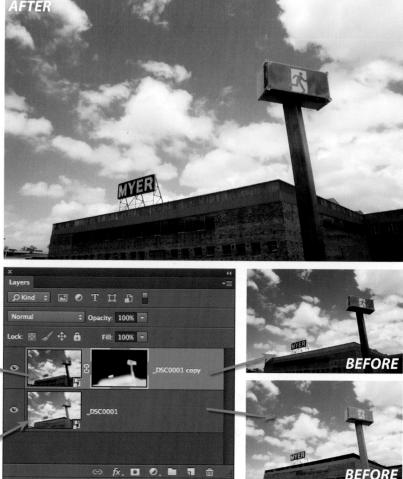

Adobe Camera Raw as a filter

This release also brings the ability to process any layer with Adobe Camera Raw(ACR). Simply convert the layer to a Smart Object first and then, by selecting Filter > Camera Raw Filter, you can use all the power of ACR to non-destructively enhance the layer content. This new development makes it much easier to combine raw files into a standard Photoshop workflow without the need to convert them from the raw file format, as well as allowing you to use the ACR enhancement feature-set with non-raw files.

Once the raw photo is stored in a smart object layer, double-clicking the layer thumbnail will open the Adobe Camera Raw workspace allowing you to change your enhancement settings before re-saving the photo back to the Photoshop document.

With raw files now so easy to integrate, this change will no doubt give rise to a range of new enhancement techniques based upon this new ability. For example, it is possible to have the same file copied to multiple smart object layers within the one document. This gives you the opportunity to process each 'copy' in a different way and then to combine the layer contents together using masks. See Project 2 in the Special Effects chapter for more techniques.

Original size of this low resolution image was 1280 x 960 pixels or 3.52Mb

Upscaling the image by 300% using the Preserve Details option in Image > Image Size dialog, enlarges the picture to 3840 x 2880 pixels or 31.6Mb, while keeping much of the sharpness and detail of the original.

Smarter upscaling

There is no getting around the fact that changing the size of your images affects their quality as you are either removing pixels, to downsize, or adding pixels, to upsize them. That said, there are always circumstances that require just such a step and this is when the new Preserve Details option in the Image Size dialog box is extremely useful. The option provides you with better upscaling results when

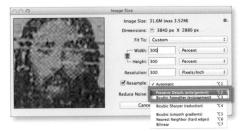

enlarging a low-res image for print, or when blowing up a larger image to poster or billboard size.

Preserve Details produces noticeable differences in sharpness as well less noise than with previous workflows such as Nearest Neighbor, Bicubic, or Bilinear.

Upscaling examples comparing the new Preserve Details option and other interpolation methods in Photoshop. All images upscaled by 300% from the original file.

Preserve Details

Nearest Neighbor

Bilinear

Bicubic

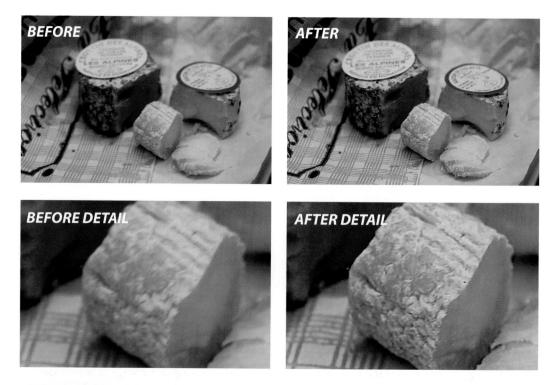

Detection Processing Center area marquee progress point

> Switching on the Advanced Mode shows the detection area marquee on the preview image. Photoshop uses the content in this area to analyze the blur in the image. The first detection marquee is drawn automatically, but you can add others to help refine the Camera Shake Reduction results.

Shooting in low light without a tripod can mean that you end up with images that are less than sharp. You can reduce the blur with the new Shake Reduction filter (Filter > Sharpen > Shake Reduction).

Camera Shake Reduction

Now you can revitalise those blurry images you have saved but never used. The new Shake Reduction filter helps restore sharpness to images blurred by camera shake. It has automatic as well as manual options and works by analyzing the trajectory of blurs resulting from movement of your camera in an effort to restore those images you may have otherwise lost. Be warned though this is not a 'fix all' solution for out-offocus images.

The feature always starts in the automatic mode, with Photoshop analyzing the image and reducing the blur accordingly. You can fine-tune the results by clicking on the Advanced Option in the feature's dialog box. This action will add a detection marquee to the preview image. This marquee can be moved around the picture to locate an area that is more indicative of the blur for the whole image, or you can refine the effect by click-dragging extra marquees in other areas of the photo. For best results, filter via a Smart Object so you can paint on the effect where it is needed and avoid the filter's effects in areas where it is not wanted.

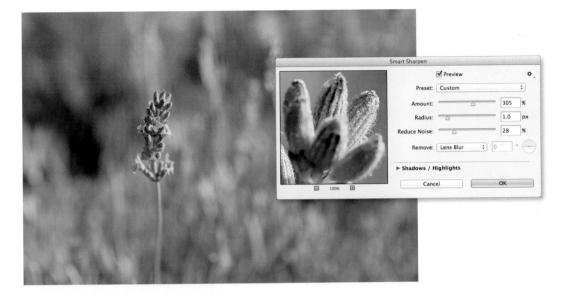

All-new Smart Sharpen

The sharpening options in Photoshop have been ramped up with the revamped Smart Sharpen filter. The big change is that the filter now uses adaptive sharpening technology to minimize noise and halo effects while producing high-quality results. These changes mean higher levels of sharpening can be applied to images with less noise present in the results.

The addition of the new Reduce Noise slider to the existing individual controls for sharpening of both shadows and highlights, means you are able to apply changes more selectively than before. Applying sharpening to broad areas of tone such as sky, or defocused areas in the background of photos, can produce very grainy or textured results in areas that should remain smooth. The Reduce Noise control restricts sharpening to hard-edged elements in the photo while protecting the smoother areas from unwanted adjustment.

Improved Minimum and Maximum filters

With new options to preserve squareness or roundness, you have better control over the masks and selections you create using the updated Minimum and Maximum filters.

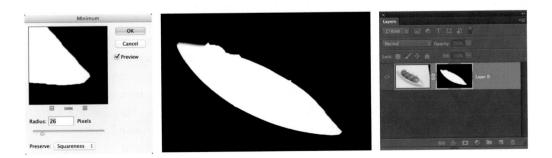

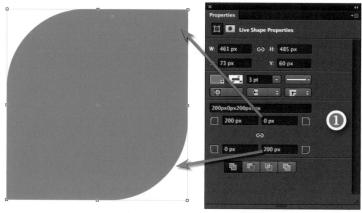

The power of vector shapes created in Photoshop has been increased substantially in this version of the program. Key among the changes is the ability to adjust a variety of shape characteristics, including corner radius, via a new Live Shape Properties panel (1). Also included is access to a CSS-based description of the shapes you create. Right-clicking the shape entry in the Layers panel provides a Copy CSS option (2) for copy/pasting the code.

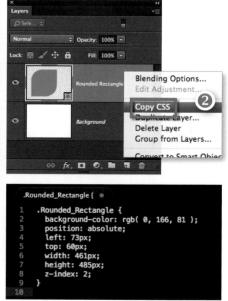

Editable rounded rectangles and other shapes

Easily resize and re-edit rounded rectangles—including corner radius rectangles and other shapes. Even after you've created a shape, you can use the improved options in the Property panel to easily change your designs, and you can also export rounded rectangles as CSS for use on the web

Improved 3D painting

With more and more image-makers trying their hand at mixing 3D content with their photos, the performance boost when painting on 3D objects will be most welcome.

Improved 3D Scene panel

The 3D Scene panel has been improved and now features options such as Duplicate, Instance, Groups, and Delete. These changes make creating and editing 3D images and artwork more similar to other workflows in Photoshop such as options available when working with the Layers panel.

System-wide type anti-aliasing

Type previews are rendered with better quality using technologies more similar to those found in web browsers.

Performance upgrade for Blur Gallery and Liquify

Adobe introduced the Mercury Graphics Engine in the last version of Photoshop and is now rolling out updates to key technologies so they are optimized for use with this engine. In Photoshop CC both Blur Gallery and Liquify get the Mercury Graphics treatment with a resultant performance gain of up to 24x.

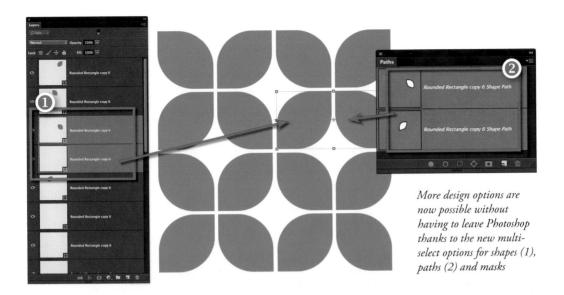

Multiple shape and path selection

For those photographers who add graphical components to their images, or who regularly use multiple masks, it is now possible to select multiple paths, shapes, and vector masks from the Paths panel or directly on canvas.

Other features updated since Photoshop CS6

In preparation for this version, Adobe released a Creative Cloud version of Photoshop a few months ago. Officially titled Photoshop 13.1, the following features were new or updated for this interim release.

Improved Type Styles

With the ability to define and save type styles you are now able to ensure consistency across multiple documents. Commonly used character and paragraph styles can be saved from one document and loaded to another, with default styles being synced from your Creative Cloud account across all your Photoshop installs.

Copy CSS attributes from layers Right-click any layer in the Layers panel and select Copy CSS from the pop-up menu to quickly export CSS code directly from layers or groups to clipboard where it can be pasted into a web editor.

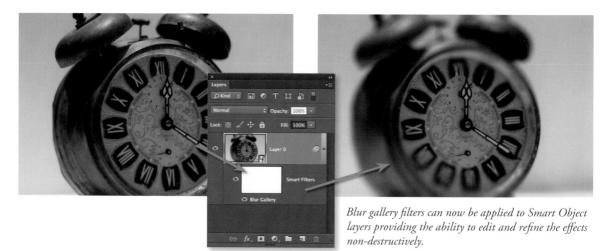

Smart Object support for more filters

With added smart object support for Blur Gallery and Liquify filters, you can non-destructively edit your images and videos. Filtering via a smart object layer provides greater control and fine-tuning ability over these effects.

Conditional Actions

A much needed addition to actions is the ability to change the flow of the recorded processing depending on specific image characteristics. Conditional actions use if/then statements to automatically choose between different Actions based on rules that you establish. So in practice this means when recording actions you can now account for more variations in images you are applying the actions to.

A good example is the seemingly simple task of applying a water mark to images you will display on your website. Previously I have used two different actions for this job, one for vertical photos and one for images in landscape orientation. Now it is possible to add a conditional statement to the action so that one action is applied for vertical images and a different one for horizontal ones.

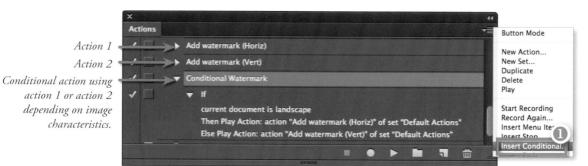

The easiest way to build conditional actions in Photoshop is to record the individual actions needed for different circumstances separately and then create another action which includes the If, Then, Else statements using the Insert Conditional option in the Actions panel menu (1).

The e circu Cono

What's new for Photoshop CC

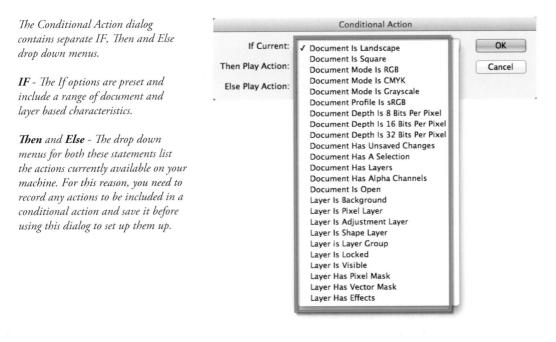

Improved 3D effects

The incorporation of OpenGL provides live previews of shadow effects as well as reflection, surface roughness, and refraction. Get more control over illumination with the inclusion of a 32-bit color picker and the ability to illuminate your scenes using 32-bit HDR images as light sources.

New workflow time savers

Small changes to workflow to save time include the ability to drag a layer to a tabbed document, the inclusion of ICC profiles in PNG formats, Crop tool refinements, and the option to see up to 100 items in your list of recently opened files.

Color-swatch import from HTML, CSS, and SVG files Import color swatches from your HTML, CSS, and SVG files.

Retina display support (high resolution Mac only)

See more of the details in your images in the Photoshop user interface when viewing on high-resolution display Mac computers.

Support for read/write of larger JPEGs

Create large images for signage, panoramas, and other large outputs. Save JPEGs of up to 65,000 x 65,000 pixels; this is more than twice the size previously supported in Photoshop.

photoshop photos

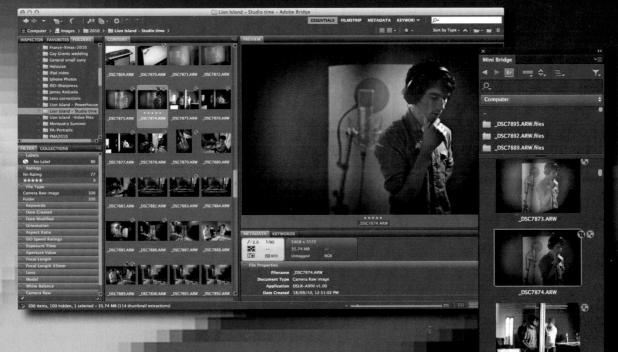

photoshop photoshop photoshop

hoto

essential skills

toshop

10p

- Gain a working knowledge of Bridge.
- Understand how to change the contents and appearance of the workspace.
- Learn how to use Mini Bridge to access assets inside Photoshop.
- Download, sort, add keywords and process files from Bridge.

Introduction

For most photographers the world of digital has heralded a new era in picture-taking. The apparent lack of cost (no film or processing charges) involved in the recording of each frame means that most of us are shooting more freely and more often than ever before. More pictures not only means more time processing, enhancing and printing them but also more time sorting, searching, naming, tagging and storing. In fact, recent studies of how photographers spend their time have shown that many spend 10–15 percent of their working day involved in just these types of management activities. For this reason many use specialized Digital Asset Management (DAM) systems or software to aid with this work. Though, for many image workers, asset management is the least stimulating part of their job, it is a key area where building skills will free up more time for those parts of the process that you enjoy the most – taking and processing pictures.

Bridge - the center for asset management

Over the last few revisions of Photoshop, Adobe has become increasingly more involved with including image management tools for the working photographer as part of the editing program. Initially this meant the inclusion of a File Browser which could be opened from inside Photoshop, but more recently a totally separate program called Bridge has replaced the standard file browser option. The application can be opened by itself via the program menu, or from within Photoshop with the File > Browse in Bridge command. With the inclusion of Mini Bridge you have a panelized version of Bridge that sits inside Photoshop and gives you access to your assets from inside the editing space.

Note> For Mini Bridge to function, Bridge itself must be running.

The fastest way to open a file from your picture library is to search for, and select, the file from within Bridge and then press Ctrl/Cmd + O or, if Photoshop is not the default program used for opening the file, select File > Open With > Photoshop. If you are opening a photo captured in a Raw file format, then the file will be displayed in Adobe Camera Raw (ACR) first and then transferred into Photoshop. If you select the File > Open With Camera Raw option then the picture will be displayed in the ACR workspace only and will be transferred to Photoshop only if you decide that this is the next step in your processing. Multi-selected files in the browser can also be opened in this way.

Keep in mind that Bridge is a separate stand-alone application from Photoshop, has its own memory management system and can be opened and used to organize and manage your photo files without needing to have Photoshop running at the same time.

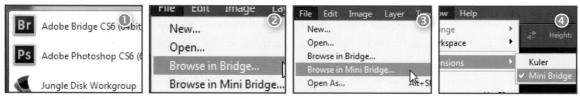

Bridge can be opened in a variety of different ways: individually via the Start menu (1) or from inside Photoshop using the File > Browse in Bridge command (2). Mini Bridge can also be opened with the Browse In Bridge entry (3) in the File menu or by selecting the Mini Bridge option in the Window > Extensions menu (4).

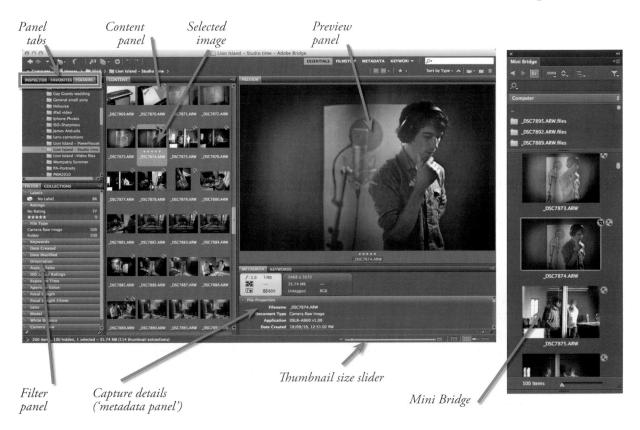

Bridge CC retains much of the interface first introduced in CS4, three panel areas, side-by-side preview options, the Filter panel and Mini Bridge (right). The view shown above is a customized version of the 'Essentials' workspace options. Many different variations are possible, and can be saved, and selected from the Workspace Switcher in the options bar.

Note > The Export panel found in the previous version of Bridge is no longer included.

The CC version of Bridge

Bridge was first introduced a couple of versions ago; it has quickly become an important part of most photographers' daily workflow. Rather than just being a file browser, Bridge also enables photographers to organize, navigate image assets, add metadata and labels, process Raw files, and access your photos inside Photoshop with Mini Bridge, a panelized version of Bridge.

The interface has remained relatively the same as the previous release of the program. Bridge CC retains the customizable layout options, most of which revolve around a three-panel setup (see above). The interface design, and its many variants, make the most of the wide-screen displays that many image makers are now using. A variety of panels can be displayed in any of the areas and the Live Workspaces feature auto-saves any changes you make to a task-specific workspace, so that if you switch to a different workspace and then back again during an editing session, your panels remain exactly where you left them.

Displayable panels in Bridge include:

- Folders panel displays a folder-based view of your computer.
- **Favorites panel** provides quick access to regularly used folders you select.
- Metadata panel shows metadata information for the selected file.
- **Keywords panel** use for adding new or existing keywords to single or multiple photos.
- **Filter panel** provides sorting options for the files displayed in the Content panel.
- **Preview panel** shows a preview of selected files or file. Includes the Loupe option.
- **Inspector panel** displays a variety of custom details controlled by options in the preferences.
- **Collections panel** this panel displays all available saved and Smart collections.

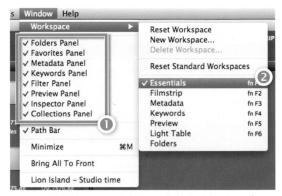

The layout and design of the Bridge interface is customizable by the user. You get to decide what information panels (1) are displayed and where they are placed. The final layout design can be saved and reused and is called a workspace. Several presaved workspaces (2) are supplied with Bridge so that you can quickly flick between screen layouts that suit different image management and editing tasks.

Setting up Bridge

Viewing options

As you can see, one of the real bonuses of Bridge is the multitude of ways that the interface can be displayed. So let's look a little closer at the two different controls that alter the way that Bridge appears – Workspace and View.

Workspace controls the overall look of the Bridge window and is centered around the Window > Workspace menu. Panels can be opened, resized, swap positions, be grouped together and pushed and pulled around so that you create a work environment that really suits your needs and specific screen arrangements. It is even possible to stretch Bridge over two screens so that you can use one screen for previewing and the other for displaying metadata, favorites or content. You also have the option to run a synchronized second version of Bridge that displays an alternate view of the photos currently selected. This means that you can display thumbnails and metadata on one screen and a larger preview on another. To activate a second Bridge view go to Window > New Synchronized Window.

Once you are happy with the layout of the workspace use the Window > Workspace > New Workspace option to store your design. Alternatively you can select from a number of preset workspace designs located in the Window > Workspace menu.

Bridge

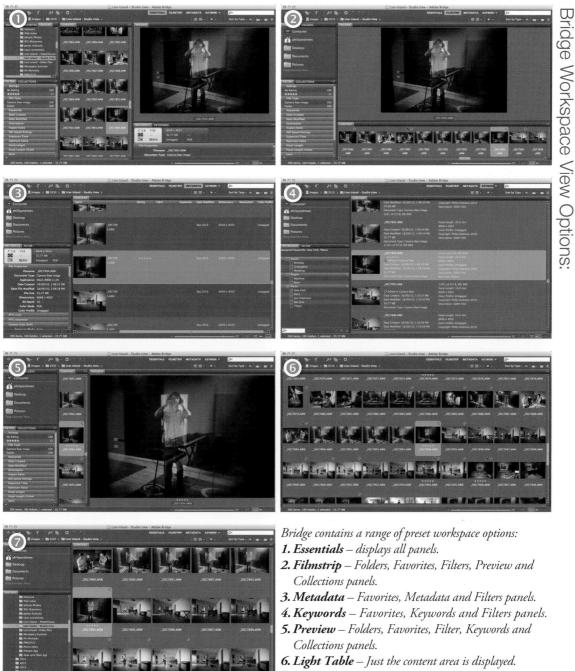

7. Folders – Folders and Favorites panels.

PHIL'S TWIN MONITOR ESSENTIALS FILMSTRIP METADATA KEYWORDS PREVIEW LIGHT TABLE FOLDERS

The Workspace Switcher located on the Options bar stores the preset workspaces and any custom entries you have saved. You can change the position of any entry by dragging it to a new location on the bar.

Bridge includes a concept of **Live Workspaces** which auto-saves any changes you make to the workspace layout as you make them. This allows switching between workspaces and having them appear just as you left them. You can return a workspace to its original layout by selecting the Rest option from the Window > Workspace menu. The number of entries displayed in the collapsible **Workspace Switcher** (located in the Options bar) can be altered, and the position of each workspace can be rearranged. Just click-drag the entry to a new position.

Most **View** options are grouped under the View menu and essentially alter the way that Content area data or thumbnails are presented. Here you can choose to show the thumbnails by themselves with no other data (View > Show Thumbnail only) or with metadata details included (View > As Details).

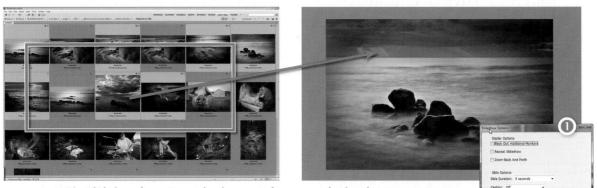

The Slideshow feature provides the option for users to display their images in an automated presentation. After selecting the photos to include, it is a simple matter of choosing View > Slideshow to start the presentation. Options for customizing the style of presentation can be found in the Slideshow Options dialog displayed by selecting the entry in the View menu (1).

Other ways to display your photos in Bridge

Slideshow – There is also an option to display the content thumbnails as an impromptu slideshow. With no images selected choose View > Slideshow to include all pictures in the content panel in the show. To display a few photos, multi-select the pictures first (hold down the Cmd/Ctrl key as you click on thumbnails), and then pick the Slideshow command. The overall slideshow options such as duration, transitions and caption content can be altered via the option settings (View > Slideshow Options).

Done

In a variation of this type of slideshow display, there is the ability to switch to a full screen view of the current selected image. By selecting View > Full Screen Preview or hitting the Spacebar, the Bridge workspace is replaced with a large preview of the selected image. While in the Full Screen Preview mode, a single click of the mouse will display a 100% view of the file. Click-dragging will move the magnified view around the picture. Pressing the Spacebar a second time reverts the display back to the Bridge workspace.

Bridge

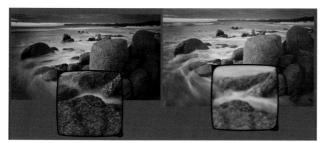

Multi-selecting images in the content space displays the photos in the Preview pane. Clicking onto the preview image displays a loupe designed to magnify a portion of the photo. Holding down the Ctrl/Cmd key allows the user to synchronize the loupe views of multiple photos as the device is dragged around the images.

Multi-image preview – In addition, Bridge also contains a couple of other view options. The first is the ability to display multiple pictures in the preview panel in a side-by-side manner. Simply multi-select several items in the content area to display them in the preview panel in this compare mode.

Loupe tool – The second feature is the Loupe tool, which acts like an interactive magnifier. The loupe size changes with the size of the displayed preview image and works best with a large preview image. To use, click the cursor on an area in the preview picture. By default a 100% preview of this picture part is then displayed, but you can change the degree of magnification of the loupe by clicking the + and – keys on the keypad. Click and drag the cursor to move the loupe around the photo. When multiple photos are displayed in the Preview pane you can display extra loupe views by clicking onto each photo in turn. The loupes can then be dragged around each photo to check sharpness and subject details like 'someone blinking' in portrait images. Holding down the Ctrl/ Cmd key while dragging a loupe will cause both loupes to move together (like the Clone Stamp Aligned setting). This technique is great for checking the same area of similar photos when trying to choose which images to keep and which to discard.

Bridge also contains a Review mode that displays images selected in the content panel in a 3D circle. Left and right arrow keys are used for navigating through the group.

> Close and revert to Bridge

Forward and back buttons Drop image from review group button

File name and current rating

Loupe Create new Collection from images

Review Mode – The Review Mode (View > Review Mode) displays a set of images in a rotating web gallery-like display. The user can move from one image to another by clicking sideways arrow keys or by clicking the mouse on the forward and back arrows; unwanted pictures can be dropped from the display set using the down arrow key and the photos left after reviewing are automatically added to a new collection when returning to Bridge. Dropping images does not delete the photo, it does not remove it from content view; it does remove it from the multi-photo view that shows up in preview after you 'Esc' out of the review mode. While in Review Mode you can add or change photo Labels and/or Ratings, and examine pictures closer using the Loupe tool. This option was added to Bridge to help photographers quickly review their images, make choices about suitable photos that deserve more attention and then save these candidate images in the easily retrievable form of a Collection. When used in combination with the Collections pane, the photographer can drop the 'rejects' from view and then create a collection of all the 'picked' photos.

The content of some panels and the way that this information is displayed can be adjusted using either the flyout menus at the top right of the panels, right-click menu options for panel items or Bridge preference settings. Fly-out menu for the Metadata panel (left) and right-click menu for Favorite panel entries (right) are shown.

Custom panel display

Some panels also contain custom options that govern the type of information displayed and the way that it is presented in the panel. For both the Keyword and Metadata panels, these options are located in the fly-out menu accessed at the top right of the panel. You can add folders to the Favorites panel by right-clicking on them in the Folder panel and then choosing the Add

to Favorites entry from the menu that appears. To remove listed folders rightclick the entry and choose the Remove from Favorites option.

The Inspector panel display and the types of data shown with thumbnails in the Content panel are controlled by settings in Preferences (Edit > Preferences).

Images with low quality, but fast to display, thumbnails are displayed with a black border (1). Create a higher quality thumbnail by selecting the option from the right-click menu.

30

Speedy thumbnail and preview generation

The images that you see in the Content and Preview panels are both based on thumbnails generated by Bridge. By default Bridge initially uses the thumbnails generated by your camera at the time of capture and then creates higher resolution images that will be used in the preview pane. Via the settings in Preferences the user has control over whether the thumbnails are built to a standard size or optimized specifically for your screen or monitor. Choose the Generate Monitor-Size previews option in the Advanced section of Bridge's Preferences (Edit > Preferences). You can force the generation of high quality thumbnails manually for an individual image or groups of multi-selected photos by selecting the pictures in the Content pane and then choosing the Generate High Quality Thumbnail entry from the right-click menu. Images with low quality thumbnails are displayed in the content area with a black line border.

You can speed up the display of images by precaching the folders they are saved in using the Build and Export Cache option in the Edit > Preference > Cache menu. After selecting the entry you can then choose to build 100% previews for faster display and to export the cache, which helps with display on other machines.

Caching decisions

The cache is an allocated space on your hard drive that is used to store thumbnail and metadata information (Labels and Ratings) for the images displayed in the Content panel. Bridge uses this cache to speed up the display of thumbnails. The information in the cache is generally built the first time the contents of a specific folder are displayed. This process can take some time, especially if the folder contains many pictures. For this reason, there is also an option to build the cache of a selected folder in the background while you continue other work. Select the directory to be cached in the Folder panel and then choose Tools > Cache > Build and Export Cache. If for any reason you want to remove a previously created cache from a specific directory, then select the folder and choose the Tools > Cache > Purge Cache for Folder option.

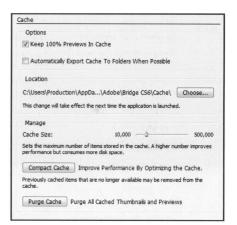

The location of centralized cache files as well as the ability to store the cache in the same folder as the images is controlled by settings in the Cache section of the Preferences dialog.

The location of the cache impacts indirectly on performance for two reasons:

- 1. Cache files can become quite large and it is important to ensure that the drive selected to house the cache has enough space to be able to store the file adequately.
- 2. When image files are copied to another drive or location, a new cache has to be constructed when the folder is first viewed unless the cache is copied along with the picture files.

The settings contained in the Cache section of the Preferences dialog provide the option to select the place where the central cache is stored. Use this setting to ensure that the cache file is located

on a drive with sufficient space. Also included here is an option for exporting cache files to folders whenever possible. Use this setting to employ a distributed cache system (rather than a centralized one), which enables image and cache files to be stored together in the same folder. If this folder is then moved, copied or written to a new location the cache will not have to be rebuilt for the photos to be displayed in Bridge. The cache should also be copied to removable drive. New changes to images will be written to the central location but, overall, the browsing will be speeded up by using the exported cache.

The preferences also contain additional controls for the number of items stored in the cache. More items means faster display but more disk space is required for cache storage. The dialog also includes a button for compacting the cache, which helps improve performance, and another for purging or deleting all cached thumbnails and previews. This option is useful if you are having problems with the consistency of quality of thumbnail and preview images.

Using Bridge

It is important to view Bridge as a key component in the photographer's workflow. From the time that the photos are downloaded from the camera, through the selection, editing and processing stages and then onto archiving and, later, locating specific pictures, the application plays a pivotal role in all image management activities. Let's look a little closer at each of these areas.

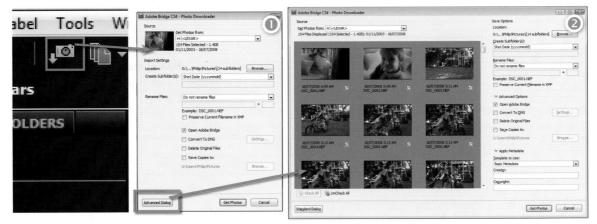

Bridge ships with the Adobe Photo Downloader utility designed to simplify the transfer of image files from camera or card reader to computer. When working with the Downloader you have a choice of two modes – Standard (1) and Advanced (2).

Transferring with the Adobe Photo Downloader

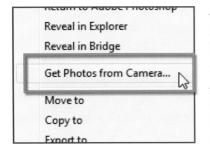

Step 1 Select the Get Photos from Camera option from the File menu inside Bridge or click the new Get Photos button in the Applications bar. Next you will see the new Adobe Photo Downloader dialog. The utility contains the option of either Standard or Advanced modes. The Advanced option not only provides thumbnail previews of the images stored on the camera or card, but the dialog also contains several features for sorting and managing files as they are downloaded. But let's start simply, with the options in the Standard dialog.

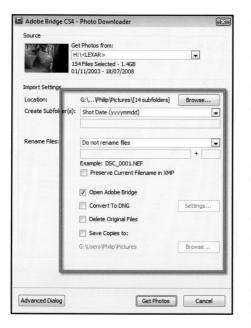

Step 2 Standard mode: To start you need to select the source of the pictures (the location of the card reader or camera). In the Standard mode all pictures on the card will be selected ready for downloading. Next set the Import Settings. Browse for the folder where you want the photographs to be stored and if you want to use a subfolder select the way that this folder will be named from the Create Subfolder drop-down menu.

To help with finding your pictures later it may be helpful to add a meaningful name, not the labels that are attached by the camera, to the beginning of each of the images. You can do this by selecting an option from the Rename File drop-down menu and adding any custom text needed. At the same time, selecting the Preserve Current Filename in XMP option will ensure the image can be found at a later date using the original file name. There are

also options to open Bridge after the transfer is complete and convert to DNG or save copies of the photos on the fly (great for backing up images). Clicking the Get Photos button will transfer your pictures to your hard drive – you can then organize the pictures in the Bridge workspace. For more choices during the download process you will need to switch to the Advanced mode.

Photos from: H:\ <lexar></lexar>	F		Save Options Location:	
	1.4GB); 01/11/2003 - 18/07/2008		G:\\Philip\Pictures\[14 subfolders]	Browse
			Create Subfolder(s):	-
	-	MARK BOARD	Shot Date (yyyymmdd)	
		C. C. LAND	Rename Files:	
		States and the second sec	Do not rename files	
4 T 4 1			Do not rename nes	-1.
		and the second states a	Example: DSC_0001.NEF	
8/07/2008 3:09 AM	18/07/2008 3:09 AM	18/07/2008 3:11 AM	Preserve Current Elename in XMP	
		C.C. COSTIC		
STATE OF STATE			Open Adobe Bridge	
			Convert To DNG	Settings
CARE SOLD BY		- 1 2	Delete Original Fijes	
02			Save Copies to:	
8/07/2008 3:12 AM	18/07/2008 3:13 AM	18/07/2008 3:13 AM	G:\Users\Philip\Pictures	Browse
SC_0004.NEF	DSC_0005,NEF	18/07/2008 3:13 AM SC_0006.NEF	I Apply Metadata	
			Template to Use:	
VIII STREET	No. of the second s	State of the second second	Basic Metadata	5
144		一個情報目	Creatgr:	
	「「「」		Cogyright:	
Check All				

Step 3 Advanced mode: Selecting the Advanced Dialog button at the bottom left of the Standard mode window will display a larger Photo Downloader dialog with more options and a preview area showing a complete set of thumbnails of the photos stored on the camera or memory card. If for some reason you do not want to download all the images,

then you will need to deselect the files to remain, by unchecking the tick box at the bottom righthand corner of the thumbnail. This version of the Photo Downloader has the same location for saving transferred files, rename, convert to DNG and copy files options that are in the Standard dialog. In addition, this mode also contains the ability to add metadata to the photos during the downloading process. You can also select a predefined metadata template (created with the File Info dialog in Bridge or Photoshop) from the drop-down menu or manually add in author and copyright details. Pressing the Get Photos button will start the download process.

Locating files

Files can be located by selecting the folder in which they are contained using either the Favorites or Folders panel or the Look In menu (top of the dialog). Alternatively, the Edit > Find command can be used to search for pictures based on file name, file size, keywords, date, rating, label, metadata or comment.

Filtering the files displayed

The options in the Filter panel provide an interactive way to find specific photos among the thousands of files that sit on photographers' hard drives. The feature is housed in a panel of its own which displays a list of attributes such as file type, orientation, date of creation or capture, rating, labels, keywords and even aspect ratio. Clicking on a heading activates the filter and alters the Content display to show only those files that possess the selected attribute. Selecting a second Filter entry reduces the displayed content further. Using this approach, it is possible to reduce thousands of photos to a select few with several wellplaced clicks in the Filter panel. To remove all filters and view all items in a folder click the stop icon in the bottom right of the panel or Ctrl/Cmd Alt/Opt A. To continue using the filtration settings when navigating to other folders or directories press the Map Pin icon in the bottom left of the pane.

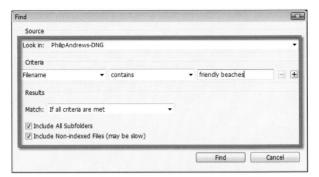

Locate specific pictures or create collections of photos using the sophisticated Find options in Bridge.

FILTER	F
Ratings	0-
Tile Type	
✓ DNG image	26
XML document	1
Keywords	
Date Created	
Date Modified	
Orientation	
Aspect Ratio	
ISO Speed Ratings	
Exposure Time	
Aperture Value	
Focal Length	
Model	
White Balance	
Camera Raw	
Opyright Notice	
	0

The Filter panel contains a selection of file attributes that can be selected as ready-made search criteria in order to quickly create a subset of photos. (1) Menu of Sort choices. (2) Remove or clear all filters. (3) Lock current filtration settings while browsing.

Stacking alike photos

One way to help organize pictures in your collection is to group photos of similar content together. Bridge contains a stacking option designed just for this purpose. After multi-selecting the pictures to include from those displayed in the content area, select Stacks > Group as Stack. All images will be collated under a single front photo like a stack of cards. The number of images included in the stack is indicated in the top left of the stack thumbnail. Stacks can be expanded or collapsed by clicking on this number (stacks expand downwards in workspaces where the thumbnails are arranged vertically).

Collapsed stack

Expanded stack

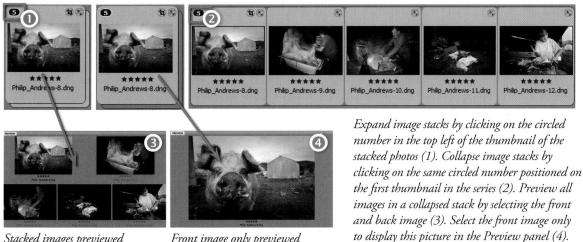

Stacked images previewed

Front image only previewed

Selecting the top of the front image of a collapsed stack displays this picture only in the Preview panel. Clicking onto the frame of the bottom image in the collapsed stack (it will change color when selected) will display all stacked photos in the Preview panel. Options for ungrouping the photos in a stack or changing the picture used as the front image are located in the Stacks menu.

Auto stacking options

Added to this manual stacking functionality is the ability for Bridge to automatically collect High Dynamic Range (HDR) sets and panoramas and collate the files as stacks and then process them in Photoshop. This functionality can be accessed in two ways, via an option in the Stacks menu (Stacks > Auto Stack Panorama/HDR) or by choosing Tools > Photoshop > Process Collections in Photoshop.

When building stacks Bridge uses the EXIF information stored with each picture to search groups of photos looking for images taken with less than an

18-second gap. Once located these images are grouped into those that have exposure differences of more than one stop; these are earmarked for processing as HDR source files, and those with similar exposure settings are marked as candidates for Photomerge processing. Next Bridge searches through the images a second time, but this time the program looks at the images themselves with Photoshop's Auto Align feature. Sequential images that are assessed to overlap by at least 80% are assumed to be HDR candidates. Photos that overlap by no more than 80% are considered to be panorama source images and are stacked as such. Finally the stacked photos are transferred to Photoshop and either processed using the Merge to HDR or Photomerge features.

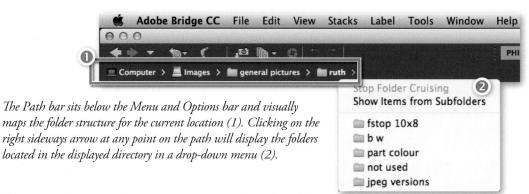

Always know where you are with the Path bar

Also new for the latest version of Bridge is the Path bar. Located just below the menu and shortcuts bar at the top of the Bridge workspace the bar provides a folder trail, working from parent directories on the left to child or subdirectories on the right. In its simplest form this bar visually displays the name and location of the folder currently selected, but this is not the end of the feature's functionality. By clicking the sideways arrow after a folder entry a drop-down menu of all the subfolders for this directory will be displayed. Navigating to a different directory option is then just a matter of selecting the folder from the menu. Just like the other interface components in Bridge, the Path bar can be displayed or hidden by selecting its entry on the Window menu.

Using Bridge's Collections

Collections are a way for photographers to group together images that relate to each other in some way. You might want to group all the photos of a particular subject, those taken for a single client or pictures captured with a specific camera and lens combination. Once created, selecting the collection entry will then display all the photos contained within the group. The collections features in Bridge are now centered around the new Collections panel. Here you can view and manage existing collections and create new ones. If not displayed it can be selected from the Window menu.

Bridge uses two different collection types - Standard Collections and Smart Collections.

Standard Collections

Standard Collections contain a selected group of images which represent a subset of all the photos in your collection and are related in some way – content, event, subject, photo, style, etc. The pictures contained in a collection are displayed when the collection entry is selected in the Collections panel. New collections can be created in two ways:

• From the Collections panel – When the Collections panel is

displayed, simply right-click on the panel area and choose the New Collection option from the pop-up menu. This will create a new entry in the panel that you can then name. To add images to the collection, select the photo or photos in the content area of Bridge and drag them over the collection entry in the panel. Selecting images before creating a new collection provides an option to add the photos to the collection in the process. • From Review Mode – A new collection can also be created from the results of selection editing using the new Review Mode. Start by selecting some images in the Content panel.

Next choose the Review Mode option from the View menu or click Ctrl/Cmd + B. Flick between the images using the sideways arrows. When you come across a photo that you want to remove from the group press the down arrow key. Once you have only the images that you want in the group displayed, click the Create New Collection

button at the bottom right of the Review Mode screen. You will be returned to the Bridge interface and a new entry will have been added to the Collections panel.

Smart Collections

Smart Collections are created by establishing a set of search criteria. The photos that meet the criteria are automatically added to the collection. These collections are dynamic in that each time the collection entry is selected a new search is conducted and any photos that match the criteria are added to the collection. In this way the contents of Smart Collections are always kept up to date automatically. Smart Collection entries are colored blue.

- From the Collections panel Smart Collections can also be created by right-clicking on the Collections panel and choosing the New Smart Collection entry. A Find dialog will then be displayed in which you can set your search criteria. Clicking the Find button will execute the search and create a new Smart Collection entry.
- As the result of a search Another way to create a Smart Collection is to locate the images to include via a search. Select the Find option from the Edit menu. Using the settings

in the Find dialog, establish a set of search criteria to help locate the required files. Click the Find button to execute the search. All images that match the search criteria will be

displayed in the Content panel. To add these photos to a new collection press the Save as a Smart Collection button at the top right of the panel.

• Via a set of filters – The same functionality is available when you use the settings in the Filter panel to display a selection of images in the Content panel. When filters are being applied the Save as a Smart Collection button is displayed in the top right of the Content panel. Clicking the button will create a Smart Collection based on the current filter settings.

Collections can also be added as an entry in the Favorites panel. Simply right-click on the collection entry in the Collections panel and choose the Add to Favorites option from the menu. Collection entries can be removed from the panel by right-clicking on the entry and choosing the Delete option from the menu. Existing collections can also be renamed in the same way. The search criteria used in a Smart Collection can be adjusted by selecting the entry and then either clicking on the Edit button at the bottom left of the panel or by selecting the Edit entry from the right-click menu.

;	2	New Smart Collect on	collect collect
	a	New Collection	right-c Collec
		Rename Delete	buttor
		Add to Favorites	
			-

The Collections panel displays both Smart Collection (1) and Standard Collection (2) entries. There are options for creating new collections, renaming, deleting and adding collections to the Favorites panel in the right-click menu (3). Edit button (4). New Collections buttons (5). Delete Collection button (6).

Downloading pictures

For the last couple of releases Bridge has included the Adobe Photo Downloader (APD) utility. The downloader manages the transfer of files from a camera or a card reader to your computer. In doing so the transfer utility can also change file names, convert to Adobe's Digital Negative format (DNG) on the fly, apply pre-saved metadata templates and even save copies of the files to a backup drive. This feature alone saves loads of time and effort for the working photographer over performing these tasks manually and for this reason should be your first point of call when downloading from your camera.

Labeling pictures

As you are probably realizing, Bridge is more than just a file browser: it is also a utility that can be used for sorting and categorizing your photos. Using the options listed under the Label menu, individual or groups of photos can be rated (with a star rating) or labeled (with a colored label).

These tags can be used as a way to sort and display the best images from those taken at a large photoshoot or grouped together in a folder. Labels and ratings are applied by selecting (or multi-selecting) the thumbnail in the Bridge workspace and then choosing the tag from the Label menu. Shortcut keys can also be used to quickly attach tags to individually selected files one at a time.

In addition to adding the star ratings and the colored labels you can also mark photos as a reject (Label > Reject) and then have these photos hidden from view (View > Show Reject Files).

File Edit View	Stacks Label] Tools Window Help
Rating		D • S D • •
No Rating	Ctrl+0	NDREWS-SERVER > _ Server-Data > _ Images
Reject	Alt+Del	
	Ctrl+1	发 (14) (1)
**	Ctrl+2	
***	Ctrl+3	
****	Ctrl+4	
*****	Ctrl+5	
Decrease Rating	Ctrl+,	
Increase Rating	Ctrl+.	
Label		
No Label		
Select	Ctd+6	****
Second	Ctrl+7	friendly beaches.dng
Approved	Ctrl+8	÷ 14.5
Review	Ctrl+9	
To Do		
I then the second		The second se

Labels or ratings are often used as a way of indicating the best images in a group of pictures taken in a single session. The photos displayed in the Content panel can be sorted according to their label or rating using the settings in the Filter panel.

KEYWORDS FILTER -= sisgned Keywords: adventure; Coles Bay; phtroom; Lightroom adventure; Tasmania @ adventure ::::::::::::::::::::::::::::::::::::	filendly beaches2.dng ***** Edited in Camera Raw Gropped Date Created: 8/04/2008, 6:33:12 AM Date Modified: 25/06/2008, 12:31:39 PM 10:38 MB	Document Type: DNG image 1/4 s at f/11.0, ISO 100 Focal Length: 16.0 mm 4163 x 2705 Color Profile: Untagged Author: Philip Andrews Copyright: Philip Andrews	Description: Lightroom Adventure Keywords: Coles Bay, Lightroom adventure, Tasmania, adventure, lightroom
D• Crayfish 2 * □ crayfish 2 * 0• 4 ▷ 40 40 60 40 60 60 60 60 60 60 60 60 60 60 60 60 60	Philip_Andrews-2.dng * * * * *	Document Type: DNG image 1/4 s at f/11.0. ISO 100	Description: Lightroom Adventure Keywords: Coles Bav. Lightroom adventure.

Keywords are words that summarize the content of the photo. They are used extensively by photo libraries for cataloging multiple photos. Keywords can be created and applied in Bridge using the Keywords panel (1). Also in Bridge CS5 the keywords and metadata associated with individual images can be displayed using the new Keywords workspace (2).

Adding keywords

Along with labeling and rating photos for easy editing and display options, it is also possible to assign specific keywords that help describe the content of your images. The keywords are stored in the metadata of the photo and are used extensively not only by Bridge as a way of locating specific photos but also by photo libraries worldwide for cataloging.

Most keyword activity is centered around the Keywords panel in Bridge. Here you can create and apply keywords to images or groups of images. To help manage an ever growing list, keywords can also be grouped into keyword sets. To apply a keyword to a photo, select the image first and then click on the check box next to the keyword or keyword set to add. Click on the check box again to remove a keyword. Buttons for creating keywords and sub-keywords as well as for deleting existing keywords can be found at the bottom of the panel. A search pane is also located here making the task of finding specific keywords a simple job. Use the Find feature to locate images that have a specific associated keyword.

A summary of all the Assigned Keywords for a specific photo

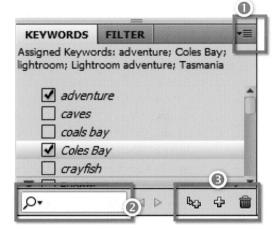

The settings menu for the Keywords panel (1) contains options for adding and removing keywords as well as the ability to import and export keyword sets. The bottom left of the panel contains a search field (2) and the three buttons on the right are for creating keywords, sub-keywords and deleting keywords (3).

is displayed at the top of the panel. New keywords or keyword sets are created, and existing ones deleted, using the buttons at the bottom right of the panel. Keep in mind that the CS4 version of Bridge also has a special Keywords workspace (Window > Workspace > Keywords), that can also be used to display metadata and associated keywords for individual files in the Content panel.

Keywords are often used as the primary method for locating appropriate images in stock libraries. For this reason accurate allocation of keywords is an important task for photographers wanting to ensure that their images feature prominently in search results. Some libraries should supply a list of pre-compiled keywords that are used by photographers to categorize their photos. Working this way helps ensure consistency in approach. To add saved keyword lists to Bridge select the Import option from the Settings menu (top right of the Keywords panel) and choose the file in the browser dialog that is displayed. Similarly the keywords lists that you create can be exported and reused using the Export option in the Settings menu.

Mini Bridge in action

Mini Bridge is a panelized version of Bridge you can access from inside Photoshop. Mini Bridge makes use of the Flash-based interface which also underpins many of the third-party panels that are available to install in Photoshop.

To launch Mini Bridge select Mini Bridge from the Windows > Extensions menu. When the panel first opens you might see a warning that Bridge is disconnected: just click the Reconnect button to connect the panel by opening Bridge in the background.

Though the key features and layout have remained the same for Mini-Bridge since the last version, you can still resize the Mini Bridge display by dragging the panel's edges, but the ability to arrange the various display areas (pods) has been removed. Images can be opened into Photoshop by double-clicking their thumbnail in the Content area or dragging them directly to the Photoshop workspace. Pressing the spacebar will display a selected image or video in Full Screen Preview mode, or hide an image or video if it is already being displayed. The slider at the bottom right of the panel adjusts the size of the Thumbnails.

The options bar at the top of the panel contains:

- · forward and back buttons to help navigate locations you have already visited,
- a quick link to Bridge that displays the currently selected image in Bridge,
- the View menu containing options for adjusting which files and details are displayed,
- the Sort menu which is used to change the sequence of the content thumbnails,
- a breadcrumb representation of the path of the current directory or folder,
- the Filter menu for displaying items by rating, label or status, and
- a Search feature for locating specific items based on the criteria entered.

My way of working with Mini Bridge is to create collections of working images in Bridge proper, which can then be accessed quickly and easily with Mini Bridge.

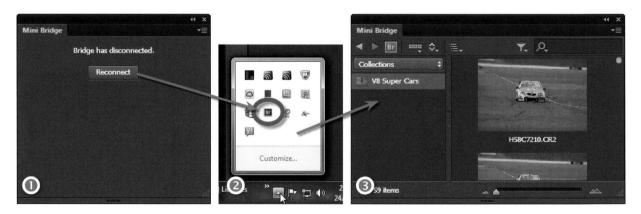

Mini Bridge can only function in Photoshop when the full version of Bridge is running in the background. If Bridge is not active then the Mini Bridge panel will display a Reconnect button (1). When pressed Bridge will open (2) and after a few moments the Mini-Bridge panel will display content (3).

Bridge

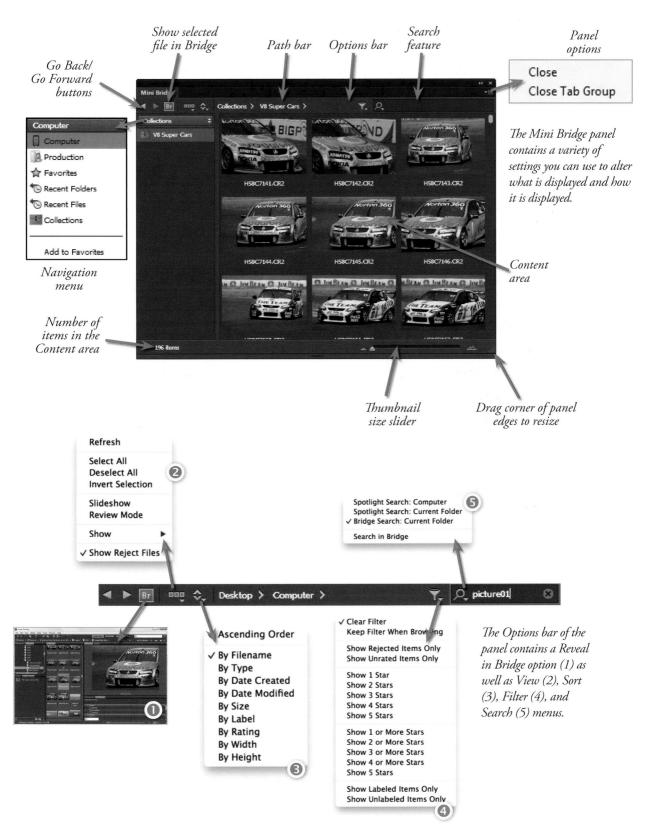

Using Mini Bridge

- 1. Launch Bridge CC first. Remember Bridge needs to be running in the background before you can launch and use Mini Bridge.
- 2. Open Photoshop and then launch Mini Bridge by selecting the Browse in Mini Bridge entry from the File menu.
- When Mini Bridge opens, select the Show Navigation Pod entry from the Panel Settings menu, to display the area in the panel where you can navigate around your computer.

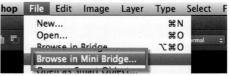

🕁 Favorites

Recent Folders

Recent Files

Collections

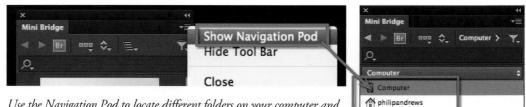

Use the Navigation Pod to locate different folders on your computer and then to find the files within them. If the Navigation Pod isn't visible then choose the Show Navigation Pod entry from the Settings menu at the top right of the panel.

- 4. Locate your files within the folder structure by double-clicking your way through the entries in the Navigation pod.
- 5. Open images into Photoshop by double-clicking them in the Content Pod (below the Navigation Pod) or dragging the thumbnail directly to the Photoshop window.
- 6. Press the spacebar with an image selected in Mini Bridge to display the image or video in Full Screen Preview mode. Press ESC to dismiss the preview.
- 7. Right-clicking a selected thumbnail (or group of thumbnails) displays an action menu with options for adding the selection to Favorites, renaming, revealing the item(s) in Bridge, displaying them as a slideshow, or in Review mode. There are also three sub-menus, Place, Open With, and Photoshop with entries of their own.

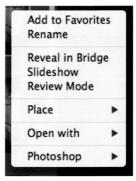

Right-click contextual menu contents as seen when selecting thumbnails in Mini Bridge

8. The Place menu allows you to open images into Photoshop as Smart objects within a Photoshop document whereas the Open option simply opens the picture in the program

associated with the file type of the selected thumbnail.

 Use Photoshop tools like Batch, Image Processor, Load files Into Photoshop Layers, Merge To HDR Pro, and Photomerge by first selecting the images in

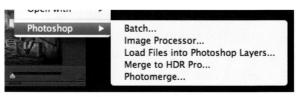

The Photoshop sub-menu contains a range of actions which can be started from Mini Bridge.

the Content Pod, then right-clicking to display the contextual menu and choosing the appropriate entry from the Photoshop menu.

Tools used in Bridge

Although no real editing or enhancement options are available in Bridge, apart from the Raw available via ACR, it is possible to use the browser as a starting point for many of the operations normally carried out in Photoshop.

For instance, photos selected in the workspace can be batch renamed, printed, used to create a Photomerge panorama, compiled into a contact sheet or combined into a PDF-based presentation, all via options under the Tools menu or the Output workspace.

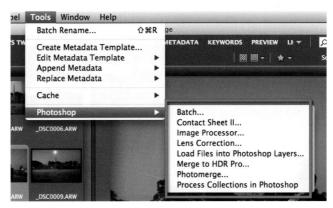

Bridge is a great starting place for many of the tools contained in the File > Automate menu in Photoshop as you can select the images to include before starting the editing feature from the Tools > Photoshop menu.

Some of these choices will open Photoshop before completing the requested task whereas others are completed without leaving the browser workspace. The Lens Correction entry facilitates batch correction of images using the new correction technology in Photoshop and Merge to HDR Pro which uses the HDR system to create a composite image from several source photos.

Tool > Photoshop options

The following options can be found listed in the Tools > Photoshop menu in Bridge:

Batch - The Batch command provides the user with the ability to apply a Photoshop Action to a series of images selected in Bridge. This utility allows for automation of repetitive actions across a series of files. When used in conjunction with the new 'conditional' actions found in Photoshop CC this option becomes even more useful.

Note > Obviously the actions used with the Batch command must already be created before using this utility.

Contact Sheet II - The Contact Sheet option creates a series of Photoshop documents with small thumbnail versions of images laid out in a grid fashion. Filenames of each image can be

Play	÷		
Action: Conditional Watermark			
	•		
Source: Bridge			
Choose			
Override Action "Open" Commands			
Include All Subfolders			
Suppress File Open Options Dialogs			
Suppress Color Profile Warnings			
Choose Override Action "Save As" Commands File Naming Example: MyFile.gif			
Document Name			extension
bocument Hune			[CATCHING)
pression of the second			
	÷	+	L
		++	l

displayed under the thumbnail which helps when you need to locate a specific image.

Image Processor - This tool processes the selected files into three different files formats - JPEG, TIFF and PSD (Photoshop). Options for resizing the images and applying a selected Photoshop Action during the file conversion process are also available. This is a very handy utility for creating multiple versions of the same photo.

Lens Correction - The Lens Correction option allows for the correction of multiple images at a same time. The utility uses the underlying technology found in the Lens Correction filter in Photoshop to correct Chromatic Aberration, Vignette and Geometric Distortion errors. The corrections are applied using custom Lens Correction profiles matched to the camera system and lens used to capture the photo. The profiles can be selected manually or you can let Photoshop find the 'best fit' for the images you are processing.

					Lens Cor	rection
Sour	e Files					
Choo	se files for ba	atch len	s corre	ction		
Use:	Files			-		
	DSC0008.4	011/				
	_DSC0008./					
	_DSC0009.4					
	_DSC0010.4					
	_DSC0011.4					
	_DSC0012./					
	DSC0013.4					
	_D3C0014.7	11.11				
File T	··· []					
File T	ype: PSD - oose ∕Vo	lumes/	Images	/2009/	millmera	an-rode
File T Ch	ype: PSD - pose /Vo Correction Pr	lumes/	Images	/2009/	'millmera	an-rode
File T Chi Lens	ype: PSD - pose /Vo Correction Pr ttch Best Profi	lumes/	Images	/2009/	millmera	an-rode
File T Chi Lens	ype: PSD - pose /Vo Correction Pr	lumes/	Images	/2009/	'millmera	an-rod
File T Chi Lens Ma Cho	ype: PSD - pose /Vo Correction Pr ttch Best Profi	lumes/ ofile — ile	Images	/2009/	'millmera	an-rod
File T Cho Lens Ma Cho Corre	ype: PSD v oose /Vo Correction Pr ttch Best Profi	ofile		/2009/		an-rod
File T Chu Lens Ma Chu Corre	ype: PSD v oose /Vo Correction Pr thch Best Profi	lumes/ ofile		o Scale		an-rode
File T Cho Ma Cho Corre Ge Corre	ype: PSD v pose /Vo Correction Pr tich Best Profi pose ection Options ometric Disto	lumes/ ofile	Aut	o Scale	Image	an-rode

Load File Into Photoshop Layers - With this tool the selected images are all opened into Photoshop and added to a single document as individual layers. The resultant layered document can then be used for further enhancement.

Merge To HDR Pro - Multiple source photos taken of the same subject but with differing exposures are merged with this tool to produce a High Dynamic Range picture.

Photomerge - Photomerge is used to stitch together a series of overlapping images to form a single panoramic photograph. Having this option available in Bridge means you can select the source files there and then use the tool to execute the stitching in Photoshop.

Process Collections In Photoshop - This tool is meant to help facilitate the creation of HDR and panoramic photos by auto-collecting groups of images into stacks which can then be processed using the Photomerge or Merge to HDR Pro tools. The tool works by assembling images into groups based on capture time, exposure settings, and image alignment. If exposures vary but content doesn't then these images are considered to be an HDR set. If exposure is constant and content differs, but overlaps slightly, then the images are considered to be part of a panoramic set.

Processing Raw inside Bridge

One of the real bonuses of Bridge is the ability to open, edit and save Raw files from inside the browser workspace. There is now no need to open the files to process via Photoshop. All key enhancement steps can be handled directly from the browsing workspace by selecting (or multi-selecting) the files and then choosing File > Open in Camera Raw. All Raw processing is undertaken by the latest version of Adobe Camera Raw (ACR) which ships with Photoshop and both TIFF and JPEG files can also be processed with the feature as well. Previous versions of Adobe Camera Raw were only able to enhance globally. That is, the changes they made to the picture were made to the whole of the image. Enhancing specific picture parts was strictly a task for Photoshop. Now ACR is capable of local correction or applying changes to just some of the picture, so more of the image enhancement tasks can occur in ACR and via Bridge. More details on localized correction can be found in the Raw Processing chapter.

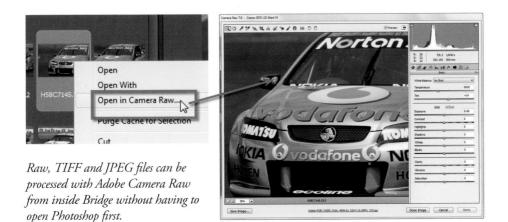

Processing in Photoshop

It is a simple matter to transfer photos from the Bridge workspace into Photoshop. You can either double-click a thumbnail or select the image and then choose Open With > Photoshop from the right-click menu. By default, double-clicking Raw images will open them into the Adobe Camera Raw utility inside Photoshop, but this behavior can be changed to process the file inside Bridge by selecting the Automatically Open option in the JPEG and TIFF Handling section of the Camera Raw Settings (Edit > Camera Raw Settings) in Bridge.

To open a file directly into Photoshop you can right-click the thumbnail and choose Open With > Photoshop or, as long as the file type is associated with Photoshop, you can also doubleclick the photo inside the Content panel.

workflow

op photoshop photoshop photoshop photoshop photoshop photo

essentíal skílls

- Examine different professional workflows.
- Capture high-quality digital images for image editing.
- Gain control over the color, tonality and sharpness of a digital image.
- Duplicate, optimize and save image files for print, presentation and for web.

Introduction

Over the last few years the way that photographers manage, edit and present their images has changed. Now we have more choices about the workflow that we use when optimizing our images for specific outcomes. In recognition of these changes this chapter will look at current professional workflow practice and the capture, editing and enhancing steps it involves.

Options for capture

When it comes to decisions about capture, if camera equipment considerations are put to one side, it boils down to a choice of shooting format. Do we shoot in JPEG or Raw?

This decision not only impacts on issues such as how many shots will fit on a memory card, but more importantly, it determines the nature of the photographer's workflow as well as the degree of control that he or she has over the adjustments made to the image.

In this book we unashamedly promote a Smart Raw workflow which is based firmly on the idea that there is a direct relationship between the quality of the final image produced and being able to perform as much editing/enhancing as possible on the virgin pixels that exit the camera as a Raw file.

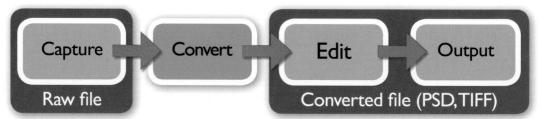

The **'Convert then Edit'** approach is the most popular workflow currently used by Raw shooting photographers. The Raw file is downloaded from the camera and the first task in the process is to convert the file to a type that is more readily supported by Photoshop, such as TIFF or PSD.

Processing your photos

Photos captured in JPEG do not require any intermediate processing before the images can be edited in programs like Photoshop. Raw images, on the other hand, need initially to be processed using a special Raw enabled utility such as Adobe Camera Raw (ACR) before further Photoshop based editing is possible. In the process often the file is converted from its Raw state to a file format that can be easily edited and enhanced in Photoshop. Despite the fact that programs designed specifically for working with Raw files such as ACR are becoming more and more sophisticated and feature-rich, most photographers still convert their Raw photos and move them to Photoshop for further processing.

Gradually this approach of 'convert and then edit' for Raw files is changing. With the increasing abilities of ACR, the Smart Object technology found in Photoshop, and now the ability to use ACR as a filter, Raw shooters no longer need to convert their files from the Raw format before being able to take advantage of the majority of the feature set of Photoshop. Keeping your photos in a Raw state maintains the flexibility of the format and is the basis of many non-destructive editing techniques designed for high-quality production. See Chapter 4 for more specific details on Raw processing.

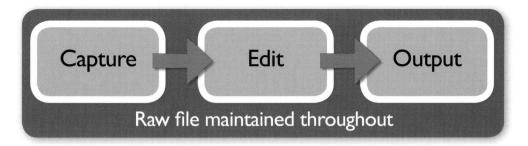

In contrast to the previous way of working, a '**Full Raw Workflow**' approach maintains the Raw file throughout the whole digital imaging process. This completely non-destructive workflow is the way of the future for Raw shooters and it is growing in support, with special editing and enhancement techniques for Photoshop and Bridge users now being promoted.

Editing and enhancing

Once the captured image is in a usable form the next step is to edit or enhance the photo. Digital shooters have much more control over their images in this editing and enhancement phase than was ever possible when working with historical darkroom methods. This is largely thanks to the host of tools, features and commands available in programs such as Photoshop, Bridge and Adobe Camera Raw.

In this phase of the workflow the digital photograph can be enhanced and edited in many ways, including changes to color, brightness, contrast and sharpness (see Foundation Project 1). In addition it is also possible to make more substantial changes such as retouching marks and dust spots, montaging several photos together, and adding text and special effects to the photo.

Producing your pictures

Even these days, many precious pictures end up as prints. Sometimes the prints are kept in an album, on other occasions they are hung on a wall, or they may simply be passed from friend to friend or photographer to client, but gradually other production outcomes are becoming easier to use and therefore more popular.

Now you can just as easily produce a web gallery, photo book or multimedia slideshow as output a bunch of 6×4 inch prints. On the whole, the same software that is used for editing and enhancing digital photos also contains the ability to output pictures in a range of different forms. The latest version of Bridge, for instance, is able to produce high-quality PDF slideshows as well as polished Flash-based websites directly from inside the program.

Sharing your imagery

For many photographers having their images seen is one of the key reasons they capture pictures in the first place. With so many ways of producing your photos there are now a host of different ways of sharing your images. Modern image makers are no longer limited by distance or geographic borders. With the ability to easily produce web galleries, attach photos to emails or create High Definition slideshows, the whole world is truly a smaller place.

A few key concepts before we start...

Raw – the ultimate 'capture' and 'processing' format

Until recently, Raw files were viewed as a capture-only format, with the first step in any workflow being the conversion of the picture to another file type so that editing, enhancing and output tasks could be performed. I say recently because with the latest release of products such as Adobe Camera Raw, Photoshop and Bridge it is no longer necessary to change file formats to move your pictures further through the production workflow.

Photoshop and Bridge are now sufficiently Raw-aware to allow the user to edit, enhance, print and even produce contact sheets, PDF presentations and web galleries all from Raw originals. Yes, sometimes the files are converted as part of the production process for these outcomes, but I can live with the intermediary step of conversion if it means that my precious pictures stay in the Raw format for more of the production workflow. With a little trickery associated with Photoshop's Smart Object technology it is now even possible to edit individual pictures inside a standard Photoshop document without having to convert the file first, thus maintaining the untouched capture pixels throughout the editing process.

Differences between Raw and other formats

Raw files differ from other file types in that some of the options that are fixed during the processing of formats such as TIFF or JPEG can be adjusted and changed losslessly with a Raw format. In this way you can think of Raw files as having three distinct sections:

- **Camera data**, usually called the EXIF or metadata, including things such as camera model, shutter speed and aperture details, most of which cannot be changed.
- **Image data** which, though recorded by the camera, can be changed in a Raw editor and the settings chosen here directly affect how the picture will be processed. Changeable options include color space, white balance, saturation, distribution of image tones (contrast) and application of sharpness.
- The image itself. This is the data drawn directly from the sensor sites in your camera in a non-interpolated form (Bayer pattern form). For most Raw cameras, this image data is captured in either 12- or 14-bit per pixel color depth. This color depth provides substantially more colors and tones to work with when editing and enhancing than the standard 8-bit JPEG or TIFF camera file.

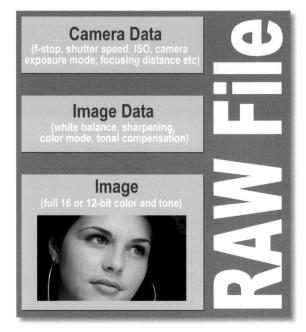

Workflow

The importance of DNG

No discussion about Raw files is complete without mentioning the importance of Adobe's Digital Negative format or DNG. As we have mentioned (and will see throughout the book) capturing in Raw has many advantages for photographers, offering them greater control over the tone and color in their files, but there is only one standard available for the Raw files. One problem is that each camera manufacturer has their own flavor of the file format.

Adobe developed the DNG or Digital Negative format to help promote a common Raw format that can be used for archival as well as editing and enhancement purposes. This includes output to DNG options in Photoshop, Lightroom

Dogurra	umbering:	L		
File E	xtension:	.dng	~	
	Distal No.	antino		~
Format:	Ulgital Neg	Jauve		
	Digital Neg			
	Digital Neg	ative		
	Digital Neg	ative		

Raw files can be converted to the DNG format either at time of import via the Photo Downloader, when saving from Adobe Camera Raw, or batches of images can be converted via the free DNG converter utility.

and Photoshop Elements, and Adobe provides a free DNG converter that can change proprietary Camera Raw formats to DNG. The converter can be downloaded from www.adobe.com. Also files imported into Bridge with the Adobe Photo Downloader can be automatically converted to DNG on the fly (during the transfer process).

In addition to providing a common Raw file format, the DNG specification also includes lossless and lossy compression options which, when considering the size of some Raw files, helps to reduce the space taken up by the thousands of images that photographers accumulate. The specification includes the ability to embed the original proprietary capture file (e.g. .nef, .crw, .arw etc.) if required. Also all development settings applied to the photo are self-contained within the DNG file instead of being stored in an extra file (called a sidecar file) that is linked with the original Raw file.

Synchronizing development settings

Archiving is one reason to switch to using the DNG format but by far the most important reason to use DNG is that it makes the synchronizing of development settings between Raw-enabled editing programs such as Adobe Camera Raw and Photoshop Lightroom easier.

Preparing your system to use Raw files

One of the difficulties when working with Raw files is that sometimes the computer's operating system is unable to display thumbnails of the images when viewing the contents of folders or directories. When using Windows XP it was necessary to install Microsoft's Raw Image Thumbnailer and Viewer utility before the operating system was able to recognize, and display, Raw files. The system was slow and most users reverted to employing Bridge as the main way they viewed their files.

For Windows users with the Windows 7 or Vista operating system, Microsoft took a different approach to the problem. They made use of a structure where the various camera manufacturers need to supply their own CODECs (Compression Decompression drivers) to be used with their particular type of Raw files inside Windows 7 or Vista. See your camera manuafactor's website for these drivers. In contrast, Windows 8 has most raw drivers built in, but this wasn't the case when it was first released.

So if you are using Windows 7 or Vista you have to install the CODEC for the camera that you use before you are able to view your images in the system folders or directories. This process is also needed to view thumbnails of your DNG files as well. You can find these at the website of your camera manufacturer or, if your specific camera is supported, make use of the combined CODEC that Mocrosoft has made available recently. Access the Microsoft CODEC here: www.microsoft. com/en-us/download/details.aspx?id=26829 and then use the following steps as a guide for Raw-enabling your own Windows 7 or Vista machine.

Note > Windows 8 users with the latest updates installed should have full raw support natively.

Locate the CODEC - Step A

Start by searching the internet, or your camera manufacturer's support site, for the specific Windows 7 or Vista CODEC that supports your Raw files. Once located, download, and in some cases extract or decompress, the files to your desktop ready for installation.

Follow the instructions - Step B

Next follow the install instructions. Here I am installing the Nikon Raw CODEC for Vista. As part of the process, the user is required to input location and language selections.

Reboot the computer - Step C

As the CODEC forms part of the file processing functions of the operating system it may be necessary to reboot (turn off and turn back on again) your computer after installing the software.

Test the install - Step D

After rebooting check to see that the CODEC is functioning correctly by displaying an Icon View of an image folder that you know contains Raw files. You should see a series of thumbnails representing your image files.

What about Mac machines?

The ability to display thumbnails of Raw files in the Macintosh operating system is driven mainly by the Preview and iPhoto utilities. Ensuring that these programs are always up to date will help guarantee that the latest camera formats are supported by the system and thumbnails and previews are displayed in the computer's browser windows.

area in http://nhoninglb.coninefcodec/	¥ 🖥 %
Nikon At the heart of the image	Nikon Imaging (Global % Nikon Imaging global site
Nikon RAW Codec	Select Language English Y Select
The Nikon RAW Codec is a software module th under Microsoft® Windows Vista® with the sam	al enables you to handle RAW image files ("NEF: Nikon Electronic Format) is ease as JPEG or TIFF images.
File Description	Supported Cameras
Product Name Nikon RAW Codec	Digital SLR Cameras
Version 1.0.2 Separated Microsofti	D1, D1H, D1X, D100, D2H, D2Hs, D2K, D2Ks, D200, D40, D40x, D50, D70, D70s, D90
Select Language	X
	kon Digital photography. Please select a language
Welcome to the world of N	
Welcome to the world of N from the choices below.	
Welcome to the world of N from the choices below.	ikon Digital photography. Please select a language
Welcome to the world of N from the choices below.	ikon Digital photography. Please select a language

Nikon RAW Codec Setup has successfully installed Nikon RAW Codec. Before you can use the program, you must restart your computer.

The need for enhancement

Every digital capture or scanned image should be enhanced further so that it may be viewed in its optimum state for the intended output device. Whether images are destined to be viewed in print or via a monitor screen, the image usually needs to be resized, cropped, retouched, color-corrected, sharpened and saved in an appropriate file format. The original capture will usually possess pixel dimensions that do not exactly match the requirements of the output device. In order for this to be corrected the user must address the issues of 'Image Size', 'Resampling' and 'Cropping'.

To end up with high-quality output you must start with the optimum levels of information that the capture device is capable of providing. The factors that greatly enhance final quality are:

- A 'subject brightness range' that does not exceed the exposure latitude of the capture device (the contrast is not too high for the image sensor).
- Using a low ISO setting to capture the original subject.
- The availability of 16 bits per channel scanning or the Camera Raw file format.

Optimizing image quality

In the next section of this chapter we will step our way through a typical digital capture workflow using Raw files. We will focus on the standard adjustments made to all images when optimum quality is required without using any advanced techniques. Standard image adjustments usually include the process of optimizing the color, tonality and sharpness of the image. With the exception of dust or blemish removal, these adjustments are applied globally (to all the pixels). Most of the adjustments in this chapter are 'objective' rather than 'subjective' adjustments and are tackled as a logical progression of tasks. Automated features are available for some of these tasks but these do not ensure optimum quality is achieved for all images. The chapter uses a 'hands-on' project to guide you through the steps required to achieve optimum quality.

Save, save and save

First, good working habits will prevent the frustration and the heartache that are often associated with the inevitable 'crash' (all computers crash or 'freeze' periodically). As you work on an image file you should get into the habit of saving the work in progress and not wait until the image editing is complete. It is recommended that you use the 'Save As' command and continually rename the file as an updated version. The Photoshop (PSD) file format should be used for all work-in-progress. Before the computer is shut down, the files should be saved to a removable storage device or burnt to a CD/DVD. In short, save often, save different versions and save backups. Also, when working with programs that make use of Library or Catalog structure, such as the system used in Lightroom, be sure to back up this database as well.

Stepping back

Digital image editing allows the user to make mistakes. There are several ways of undoing a mistake before resorting to the 'Revert' command from the File menu or opening a previously saved version. Photoshop allows the user to jump to the previous state via the Edit > Undo command (Command/ Ctrl + Z). The user can 'Step Backward' through several changes by using the keyboard shortcut Ctrl + Alt + Z (PC) or Command + Option + Z (Mac). Alternatively, 'Histories' allows access to any previous state in the History palette without going through a linear sequence of undos. The total of saved undo states stored in History is set in the Performance section of the Edit > Preferences panel.

53

Advantages and disadvantages of 16-bit editing

When the highest quality images are required there are major advantages to be gained by starting off the editing process in '16 Bits/Channel' mode. In 16 bits per channel there are trillions, instead of millions, of possible values for each pixel. Spikes or comb lines that are quick to occur while editing in 8 bits per channel, rarely occur when editing in 16 bits per channel mode. Thankfully, cameras capable of Raw capture record their images in either 12 or 14 bits per channel (which are then saved in a 16 bits per channel file) which means that Raw shooters get the advantages of high-bit capture inherently.

The disadvantages of editing in 16 bits per channel are:

- Not all digital cameras are capable of saving in the Raw format.
- The size of the file is doubled when compared to an 8 bits per channel image of the same output size and resolution.
- Some editing features (including many filters) do not work in 16 bits per channel mode.
- Only a small selection of file formats support the use of 16 bits per channel.

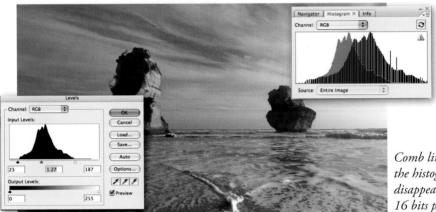

Comb lines that appear in the histogram will usually disappear if editing in a 16 bits per channel file.

Choosing your bit depth

It is preferable to make all major changes in tonality or color to the Raw file in Adobe Camera Raw (ACR). This ensures that the enhancement steps are performed on high-bit data. Using a Smart workflow involving embedded Raw files the decisions about depth and space can be further delayed as we have the option of re-opening the file in ACR and adjusting the color and tone at 12 or 14 bits and changing the gamut to accommodate a larger or smaller gamut output device. Non-Raw images can be converted from 8-bit (Image > Mode > 16 Bits/Channel) or captured in 16-bit (the preferred choice). Most scanners now support 16 bits per channel image capture with many referring to the mode as 48-bit RGB scanning. Some offer 14 bits per channel scanning but deliver a 48-bit image to Photoshop. Remember, you need twice as many megabytes as the equivalent 8-bit image, e.g. if you typically capture 13.2 megabytes for an 8×10 @ 240 ppi you will require 26.4 megabytes when scanning in 16 bits per channel.

Note > Photoshop also supports 32 Bits/Channel editing which is primarily used for editing images with a high dynamic range (see Composite Projects – High Dynamic Range).

Foundation Project 1

Follow the 11 steps over the following pages in order to learn how to create one image optimized for print and one image optimized for web viewing from the same image file.

Image capture - Step 1

Capture a vertical portrait image using soft lighting (low-contrast diffused sunlight or window lighting would be ideal). The image selected should have detail in both the highlights and shadows and should have a range of colors and tones. An image with high contrast and missing detail in the highlights or shadows is not suitable for testing the effectiveness of the capture or output device. An example file for this project is located on the book's supporting website.

Pro's tips for best capture

To achieve optimum image quality ensure as any of the following steps as possible are carried out.

- 1 Set the camera's ISO setting to no more than double the base level ISO of the sensor (typically 100 or 200 ISO for most digital cameras). Alternatively use a low ISO film, e.g. 100 ISO.
- 2 Avoid using either the minimum or maximum apertures on the camera lens.
- 3 Mount the camera on a sturdy tripod and switch off any image stabilization, steady-shot or vibration reduction settings.
- 4 Use a remote shutter release or self-timer to release the shutter.
- 5 Ensure accurate exposure metering and setting of the camera's shutter speed and aperture.
- 6 Match the camera's white balance setting for the light source that is illuminating the subject. If need be, use a custom white balance setting in mixed lighting to ensure cast-free capture. For best results though, you should create a custom white balance setting for your location and lighting setup using a photographer's gray card, or a white balance reference card, such as WhiBal or X-rite's ColorChecker Passport. Consult the camera manual to see how you can create a custom white balance. Then capture a 'reference' image using this custom white balance setting (hold the photographer's gray card or a white balance reference card just below the face and angled towards the dominant light source). Important > Do not photograph in a location where vibrant or bright colors are close to your subject (this could result in a strong color cast).
- 7 Check the lens aperture is stopped down (but not to f/22) and the ISO is low (no more than double the base ISO of the sensor the base ISO of a DSLR camera is usually 100 or 200 ISO).

8 Check the image is sharp and shutter speed is 1/60 second or faster (mount your camera on a tripod and use a remote release, timed release or 'tethered capture' – see below for details).

Note > If your shutter speed is slower than 1/60 second, check your aperture is not stopped down excessively. Your aperture must, however, be stopped down at least one full stop from maximum aperture. Note that most cameras adjust aperture settings in half or one-third stop increments. One adjustment of the command/control dial is therefore not one full stop. Choose a brighter location if required. Using shutter speeds slower than 1/60 second can result in subject blur.

- 9 Check for overexposure (clipping) or underexposure on the camera's LCD panel (using the histogram). If shadows are pressed against the left-hand wall of the histogram use a reflector, or diffuse the light source to reduce subject brightness range or choose an alternative location or time of day.
- 10 Create an additional portrait image that does not contain the gray card or white balance reference but uses the same custom white balance setting as the reference image.

Digital capture via a digital camera

Images can be transferred directly to the computer from a digital camera or from a card reader if the card has been removed from the camera. Images are usually saved on the camera's storage media as JPEG or Raw files. If using the JPEG file format to capture images you should choose the high or maximum quality setting whenever possible to select low levels of image sharpening, saturation and contrast in the camera's settings, to ensure optimum quality and editing flexibility in the image-editing software. If the camera has the option to choose Adobe RGB instead of sRGB as the color space this should also be selected if one of the final images is destined for print. For best results we suggest to always capture in Raw.

Tethered image capture Many DSLR cameras now offer the option of capturing Raw photos while the camera is connected to a computer. Some photographers would never need to shoot, nor see the benefits of shooting in this fashion; for their chosen area of speciality the added burden of dragging around a laptop computer as well as all their camera gear is a complication that they can well do without. However, for studio, product, architectural, commercial and even some landscape

A 1/4 F1.7 E ±0.0 2 ±0.0 iso 100 Contractor Adv., High White balance: Auto Wa Color fame: SSOX Contractor Date modified Date modified Default Color fame: SSOX Contractor Date modified Default Color fame: SSOX Contractor Date modified Default Color fame: SSOX Contractor Default Color fame: SSOX Contractor Default Contractor Default Color fame: SSOX Contractor Default Contractor Default Contractor Default Contractor Default Contractor Color fame: SSOX Contractor Default Contractor Color fame: SSOX Contractor Color fame: SSOX Contractor Color fame: SSOX Contractor Color fame: SSOX Contractor Color fame: SSOX Contractor Contractor Color fame: SSOX Contractor Color fame: S		🦚 Remote Camera Contro	1
Name Date modified >> Color temperature : \$500 K \$200 Default Qolor filter : 0 -> -> URWU DSC0001 Standard ->	Downlord	■ ±0.0 52 ■ 22% AFL — 4	±0.0 iso 100
DSC0001	File Ed.: View Tools Help	Continuous Adv., High White balance :	`
	File Ed. View Tools Help	Continuous Adv., High White balance : Auto WB Color temperature : Color filter : D-Range Optimizer :	
	File Ed: View Tools Help Oronize + RE Views + > (2) Name Date modified >> ARW	Continuous Adv., High White balance : Auto WB Color temperature : Color filter : D-Range Optimizer :	

photography the ability to preview, and even process, the photos captured almost immediately on a large screen ensures better results.

The utility software that comes bundled with most mid- to high-end DSLR cameras and medium format camera backs does an admirable job of providing the required software link between camera and computer. The physical connection is generally provided via a USB or Firewire connection, although some models can now connect wirelessly using a pretty standard setup. The 'remote capture' software supplied by the camera companies ranges from something as simple as a dialog containing a shutter release button right up to a full control panel that allows focus, metering, drive and exposure control right from your desktop. Once on the desktop the files can be imported into Bridge and even displayed in Adobe Camera Raw.

Lightroom provides a tethered solution

The latest couple of versions of Lightroom also provide a tethered shooting solution and support recent Canon, Nikon and some Leica models. So if you are using a combined workflow that brings together the management, processing and presentation abilities with the editing power of Photoshop then you can take advantage of this new feature.

Tethered shooting advantages

There are several advantages for viewing pictures in this type of setup:

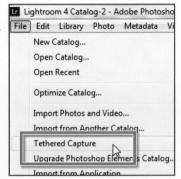

- You can review images on a larger, higher-resolution, color-calibrated monitor at the time of shooting either via the remote capture software or after downloading into Bridge.
- Critical exposures can be checked closely using histograms derived from the full high-bit Raw image data rather than a processed JPEG, as is the case with most back of camera histograms.
- It is possible to quickly apply some post-capture processing to the images when in Bridge to display the style of the treatment that will be applied to the final photos. This is a great way to show a client how the images will look seconds after they are shot.

Use the following steps to set up for tethered shooting:

Install camera drivers - Step A

Before connecting the camera ensure that you have installed any camera drivers that were supplied with the unit. These small pieces of software ensure clear communication between the camera and computer and are usually installed along with other utility programs such as a dedicated browser (e.g. Nikon View, Canon's ZoomBrowser/ImageBrowser or Sony's Image Data Suite) and camerabased Raw conversion software (e.g. Nikon Capture, Canon's Digital Photo Professional or Sony's Remote Camera Control). Follow any on-screen installation instructions and, if necessary, reboot the computer to initialize the new drivers.

Connect the camera - Step B

The next step is to connect the camera to the computer via the USB/Firewire cable or wireless network. Make sure that your camera is switched off, and the computer is on, when plugging in the cables. For the best connection and the least chance of trouble it is a good idea to connect the camera directly to a computer USB/Firewire port rather than a hub.

Check the connection – Step C With the cables securely fastened, switch the camera on and, if needed, change to the PC connection mode. Most cameras have two connection modes – one that uses the camera as a card reader (often called 'Mass Storage' mode) and another that connects the device as a camera (generally referred to as 'PTP' mode but sometimes also called Remote PC mode). The remote capture software or tethering utility will work with one of these modes only.

Most cameras no longer require a change from whatever mode is selected by default, but check with your camera manual just in case. If the drivers are installed correctly the computer should report that the camera has been found and the connection is now active and a connection symbol (such as PC) will be displayed on the camera. If the computer can't find the camera try reinstalling the drivers and, if all else fails, consult the troubleshooting section in the manual. To ensure a continuous connection use fully charged batteries or an AC adaptor.

Start the remote shooting software - Step D

For camera-based software: With the connection established you can now start the remote capture software (e.g. Nikon Capture, Canon's Digital Photo Professional or Sony's Remote Camera Control). With some models the action of connecting the camera will automatically activate the software. In other cases it will be necessary to start the software and wait for the program to locate the attached camera. Most versions of these utilities provide more than just a means of releasing the shutter from the computer and instantly (well nearly, it does take a couple of seconds

to transfer big capture files) viewing captured photos. The utilities contain options to set most camera functions including items such as shutter speed, ISO, aperture, capture format, contrast, saturation and white balance controls.

For Lightroom users: With the connection between camera and computer established, Lightroom users need to adjust some basic settings before starting to shoot. To do this you need to launch Lightroom and choose File > Tethered Capture > Start Tethered Capture. This will display the Tethered Capture Settings dialog box. Add a name for the shooting session and then choose a naming scheme for individual photos from the options in the drop-down list. Next click the Choose button in the Destination section to navigate to the folder that you want to use to save the captured files. Select the metadata to be recorded with each photo from the entries in the dropdown menu. You can easily create a custom entry by clicking the New option and adding the required details before saving this set of values as a new preset. Finally, type any keywords that you want added to the photos (separated by a comma) in the box at the bottom of the dialog. Click OK to save the settings and display the Tethered Capture widget.

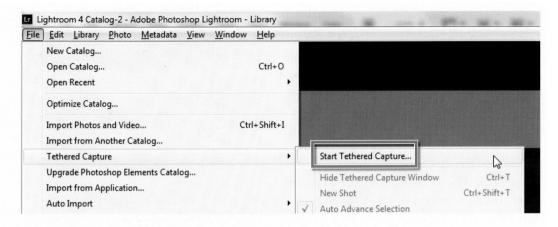

Guidelines for setting download options

With all these settings to play with, where do you start? Start by adjusting the download options found in the remote capture software. The four big settings are:

- Where the files are to be transferred to
- How they are to be labeled
- What metadata is to be added to the files during this process
- What happens to the file once it is transferred.

It is a good idea to create a new folder or directory for each shooting session and to select this folder as the place to download the captured files. Now choose a naming scheme that provides enough information to allow easy searching later. This may mean a title that includes date and name of shoot, a shooting session or subject, as well as a sequence number. In terms of additional metadata, at the very least you should always attach a copyright statement as well as any pertinent keywords that describe the subject. If these last options aren't available with your software then keywords can be added, and filenames changed, using the

Session		
Session Nam	e: Studio Session	
	Segment Photos By Shots	
Naming		
방송 같은 것이 같은 것이 없다.	e: Studio Session-001.DNG	
Templat	e: Session Name - Sequence	-
Custom Tex	t: Start Numbe	1
Destination		1000 e
Locatio	n: C:\Users\PHILIP\Pictures	oose
Information		
	a: Phill's Basic Copyright	
Keyword	is: portraits, studio, contrast lighting,	
	ОК	Cancel
		100
Save in :		
	\Philip\Desktop\Tethered Download	-
Open i	n Image Data Lightbox SR	
ansferre	d image: (_DSC0001.ARW). 0 files remaining	
	· · · · · · · · · · · · · · · · · · ·	

features in Bridge. Finally, you need to choose what happens to the captured files. Most users will want to transfer the pictures directly to a preview utility such as one of the browser programs, or alternatively, if you want to process the photo on the spot, you could pass the file directly to a Raw converter. One way of achieving this automatically is to set the download folder you have nominated to the Hot or Watched folder for Lightroom's Auto Import function.

Note > This part of the process is handled automatically for Lightroom users who are employing the Tethered shooting option in the program.

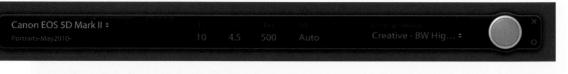

Compose, focus and release the shutter - Step E

Now to the nuts and bolts of the capture. Most remote capture systems don't offer a live preview feature so composing and framing is still a through the viewfinder and lens event. Some photographers adopt a shoot and review policy, preferring to capture a couple of test images and review these full size on their computer screens to check composition, focus and even exposure. Once you are happy with all your settings, release the shutter and automatically the file is captured and transferred from camera to computer.

Disconnecting the camera – Step F

Before turning the camera off or disconnecting the cable make sure that any transfer of information or images is complete. Interrupting the transfer at this point will mean that you lose files. Mac users can drag the camera volume from the desktop to the trash. It may be necessary to choose a menu option in the remote capture software to stop the tethering process. In Lightroom, you simply close the Tethered Capture widget or choose the Stop Tethered Capture option from the File > Tethered menu. Next, Windows users should click the Safely Remove Hardware icon in the system tray (bottom right of the screen) and select Safely Remove Mass Storage Device from the pop-up menu that appears.

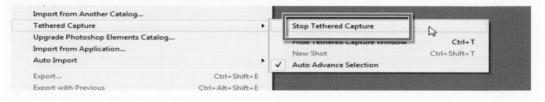

Downloading files - Step 2

For all photographers apart from those using a tethered shooting setup the very next step after capture is transferring the photos to your desktop machine. For this workflow we will assume that Bridge will be the center of all image management and that the Adobe Photo Downloader (APD) will be used for transferring files. You could just as easily use a system-based 'copy' or 'move' function, but APD contains inbuilt features that make the process easier and relieve you of some tasks such as renaming that you would normally have to undertake manually.

In the last chapter we looked at the basic steps involved in using APD to transfer your images so we won't repeat them here, but instead we'll concentrate on the other options that you may want to use to fine-tune your downloads. Most are accessed by clicking on the Advanced Dialog button in the APD dialog (see opposite for details).

Note > For Lightroom users many of these options are covered when initially setting up the Tethered Capture session.

Storage location – A good workflow starts with the transfer of images to your computer. Choosing an appropriate storage location and folder hierarchy for saving your pictures is a key decision. Some photographers use data-based storage, others create a folder structure based on client or job type. Once you have decided on a system, stick to it as this will help with locating your images later.

Save Options	
Location:	
G: \Users\Philip\Pictures\2008073	30 Browse
Create Subfolder(s):	
Today's Date (yyyymmdd)	
Rename Files:	
Custom Name + Shot Date (yy)	/ymmdd)
PHILIPANDREWS	+ 1
Example: PHILIPANDREWS_200	70427_0001.inf
V Preserve Current Filename i	n XMP
Advanced Options	
* Advanced Options	
 Øpen Adobe Bridge 	
Open Adobe Bridge	Settings
 Open Adobe Bridge Convert To DNG 	Settings
Open Adobe Bridge	Settings
 Open Adobe Bridge Convert To DNG 	Settings
 Øpen Adobe Bridge Convert To DNG Delete Original Files Save Copies to: 	Settings
 Øpen Adobe Bridge Convert To DNG Delete Original Files 	-
 Øpen Adobe Bridge Convert To DNG Delete Original Files Save Copies to: 	-
 Open Adobe Bridge Convert To DNG Delete Original Files Save Copies to: G: \Users \Philip \Pictures Apply Metadata 	-
 Open Adobe Bridge Convert To DNG Delete Original Files Save Copies to: G: \Users \Philip \Pictures 	-
 Open Adobe Bridge Convert To DNG Delete Original Files Save Copies to: G:\Users\Philip\Pictures Apply Metadata Template to Use: 	-
 Open Adobe Bridge Convert To DNG Delete Original Files Save Copies to: G: \Users \Philip \Pictures Apply Metadata Template to Use: Basic Metadata 	-

Convert to DNG – Adobe's Digital Negative format or DNG is an open source Raw file format designed to be used as the primary file type for archiving. To help reduce the steps involved in managing the thousands of photos that are transferred each year, the Adobe team has included an automatic conversion option in APD. When selected, the picture files are converted from their native Raw format (i.e. .NEF. .CRW) to the DNG automatically. From this point onwards they can still be processed as standard Raw files.

Delete Original Files – Deletes the photos from the camera card after transfer is complete. Only select this option if you have a way of verifying the accuracy of the copying or downloading process.

Apply Metadata – The Apply Metadata section contains an option for inserting author and copyright information quickly and easily. To display these input fields you will need to select the Basic Metadata option in the Template to Use dropdown menu. Also listed on this menu are any other metadata templates you have created and saved, either in Bridge (via the Metadata panel) or in Photoshop (with the File Info dialog). Automated backup – The 'Save Copies to' option provides the ability to automatically store a separate copy of each downloaded file as a primary backup. This saves having to manually back up photos at a later date or transfer the files twice from the camera or memory card – once to the drive used for processing and a second time to the backup device. It is important to note that even when the Convert to DNG setting is selected, the backup files are stored in their capture format – not DNG.

renaming options revolve around three key pieces of date – the current date, the shot date and custom name. Each menu entry uses a different combination or sequence of these details. There are 21 different naming formats and when dates are part of the renaming process both USand UK-based date formats are included.

Rename photos – The

Preserved file name –

It is handy to have the option to include the original file name stored in the XMP data associated with the photo as XMP data is searchable via the Find option in Bridge's Edit menu.

Open Adobe Bridge -

When APD starts automatically because you have attached a camera or card reader to the computer you then have the option of opening Bridge and displaying the transferred files in a new window.

Image management - Step 3

Now I know that you are eager to get editing but a largely overlooked step in any good professional workflow is image management, sometimes called DAM (Digital Asset Management). Directly after downloading is a good time to start to manage your files. A little discipline shown at this point will save time later. As we saw in the last chapter Bridge is not just a tool for viewing your photos, it is a key technology in the managing, sorting and enhancing of those files. And this pivotal role is never more evident than when one is managing Raw files. So the next step is to add keywords to your images and then select the best photos from the group and label these with ratings.

Add keywords

Keywords are single-word descriptions of the content of image files. Most photo libraries use keywords as part of the way they locate images with specific content. The words are stored in the metadata associated with the picture. Users can allocate, edit and create new keywords (and keyword categories) using the Keywords panel in the Bridge browser and File Info dialog box in Photoshop.

New keywords (categories or sets of keywords) and sub-keywords can be added to the Keywords panel by clicking the New Sub-Keyword and New Keyword buttons at the bottom of the panel. Unwanted sets or keywords can be removed by selecting first and then clicking the Delete button. Unknown keywords imported with newly downloaded or edited pictures are stored in the panel under the Other Keywords set.

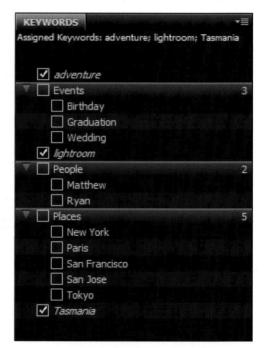

Rate and label files

One of the many ways you can organize the Raw files displayed in the Bridge workspace is by attributing a label to the picture. The labels option is supplied in two forms – a color tag, called a Label, or star rating, called a Rating. Either or both label types can be applied to any picture. The Label tag can then be used to sort or locate individual pictures from groups of photos.

Image processing steps

The next steps are concerned with basic processing and optimizing of your photos. With the growing use of Raw files as the basis of professional capture these changes will be made to several Raw files using Adobe Camera Raw (ACR). Make sure that the ACR plug-in is the latest available by selecting Help > Updates in Bridge. In previous editions of this book we have used Photoshop for these steps; this is still possible, but would generally require the Raw file to be converted to a non-Raw format before any enhancements could be applied. The example files Foundations project 1.dng, Foundations project 2.dng and Foundations project 3.dng located on the book's DVD can be used to practice these steps in the absence of your own images.

Note > For readers using non-Raw formats (JPEG and TIFF) we suggest that you still use Adobe Camera Raw as there are very real advantages to adjusting your files with the utility and it is possible to display the images in ACR by selecting the Open in Camera Raw option from the right-click menu when selecting thumbnails in the Content panel in Bridge.

Rotating and cropping an image - Step 4

The easiest way to open a file, or files, into ACR is by selecting the image(s), right-clicking (Mac: Ctrl-clicking) on one of the thumbnails in Bridge and then selecting Open in Camera Raw. Working with ACR in Bridge allows for faster Raw processing as the conversions take place without the need to share computer resources with Photoshop at the same time. The selected images will be displayed on the left of the dialog as thumbnails. Click onto the thumbnail containing the reference card to select the photo for editing and display it in the main workspace.

Next, if you need to you can rotate the image using either of the two Rotate buttons at the top of the workspace. If you are the lucky owner of a recent camera model then chances are the picture will automatically rotate to its correct orientation. This is thanks to a small piece of metadata supplied by the camera and stored in the picture file that indicates which way is up.

Pro's tip>The preferences for Bridge can be adjusted so that double-clicking a thumbnail of a Raw picture will automatically open the file in Camera Raw in the Bridge workspace. If this option is not selected, then double-clicking will open the file in ACR in the Photoshop workspace.

You can fine-tune the rotation of the picture with the Straighten tool. After selecting the tool click and drag a straight line along an edge in the photo that is meant to be horizontal or vertical. Upon releasing the mouse button ACR automatically creates a crop marquee around

the photo. You will notice that the marquee is rotated so that the edges are parallel to the line that was drawn with the Straighten tool. When you exit ACR by saving or opening (into Photoshop) the picture, the rotated crop is applied.

The crop tool in ACR can be used for basic cropping tasks as well as for cropping to a specific format. The feature works just like the regular Crop tool in Photoshop proper, just select and then click and drag to draw a marquee around the picture parts that you want to retain. The side and corner handles on the marquee can be used to adjust the size and shape of the selected area. The crop is applied upon exiting the ACR dialog.

Custom Crop

Predefined crop formats are available from the menu accessed by clicking and holding the Crop tool button. Also included is a Custom option where you can design your own crops to suit specific print or other outcome requirements.

In this instance, we will crop the picture to fit a standard 2:3 format, so select choose the Custom option from the Crop menu and input the 2:3 ratio. This action will remove the previous crop so drag a new vertical crop marquee around the image. Select any other tool from the ACR toolbar to apply the crop.

Note > Keep in mind that any crops you make with ACR are reversible. Just open the file back into ACR and select the Crop tool and then hit the Esc key to remove the current crop.

Perfecting the crop

Once you have a cropping marquee located on

your image you can resize the marquee with the corner handles. The marquee can be click-dragged to reposition and if the image is still a little crooked you can rotate the cropping marquee by moving the mouse cursor to a position just outside a corner handle of the cropping marquee. A curved arrow should appear, allowing you to drag the image straight. In ACR you just need to move the cursor outside the crop marquee to see the curved arrow.

Before completing the crop, you should check the entire image edge to see if there are any remaining border pixels that are not part of the image. Press Ctrl/Cmd + 0 to see all the image in the workspace and Ctrl/Cmd + to zoom in, or Ctrl/Cmd – to zoom out. Holding down the Spacebar activates the Hand tool so that you can quickly move the window if the image is larger than the workspace. Press the Return/Enter key on the keyboard or select another tool to complete the cropping action. Alternatively press the Esc key on the keyboard to cancel the crop.

Color adjustments - Step 5

Unlike other capture formats (TIFF, JPEG) the white balance settings are not fixed in a Raw file. This fact provides much greater control over the colors in the photo than when such settings are fixed. ACR contains three different ways to balance the hues in your photo. Here we look at each in turn.

Note > As the version of Adobe Camera Raw that ships with Photoshop CS6 and CC changed the way that it adjusts tones and colors be sure to update previously processed images to the new Raw processing engine by clicking the ! button 1 at the bottom right of the workspace. Unprocessed images will be automatically adjusted with the new engine.

Preset changes

You can opt to stay with the settings used at the time of shooting ('As Shot') or select from a range of light source-specific values in the White Balance drop-down menu of ACR. For best results, try to match the setting used with the type of lighting that was present in the scene at the time of

White Balance:	As Shot
	As Shot
Temperature	Auto
Tint	Daylight

capture. Or choose the Auto option to get ACR to determine a setting based on the individual image currently displayed.

Manual adjustments

If none of the preset White Balance options perfectly matches the lighting in your photo then you will need to fine-tune your results with the Temperature and Tint sliders (located just below the Presets drop-down menu). The Temperature slider settings equate to the color of light in

mperature	4850
t ^	+3

degrees Kelvin – so daylight will be 5500 and tungsten light 2800. It is a blue to yellow scale, so moving the slider to the left will make the image cooler (more blue) and to the right warmer (more yellow). In contrast the Tint slider is a green to magenta scale. Moving the slider left will add more green to the image and to the right more magenta.

The White Balance Tool

Another quick way to balance the light in your picture is to choose the White Balance tool and then click onto a part of the picture that is supposed to be neutral gray or white. This approach

is perfect in our situation as we have included a reference card or tone in the image. When you click on the gray card (or other neutrals that are in the photo) ACR will automatically set the Temperature and Tint sliders so that the selected picture part becomes a neutral gray and in the process the rest of the image will be balanced. So in the example photo use the White Balance tool to create a custom white balance setting in ACR by clicking on the white hair of the portrait sitter. If your custom white balance created in camera was accurate you should not see a big change. If the color temperature changes more than 200° Kelvin then your custom white balance in camera is not accurate. This may require a re-shoot.

Note > For best results when not working with a reference card select lighter tones with the tool, ensure that the area contains detail, and is not a blown or a specular highlight (reflected light source with no details).

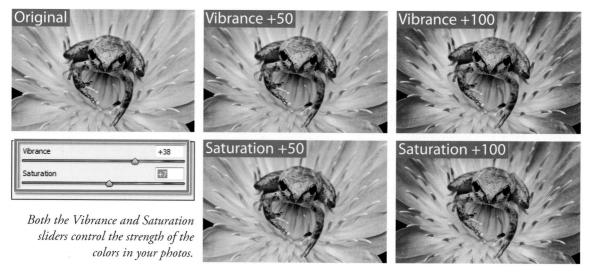

Other ACR color controls

As well as options for adjusting the white balance in a photo, Adobe Camera Raw also contains two sliders that are concerned with controlling the strength of the hues in your pictures – Vibrance and Saturation.

Vibrance

The Vibrance slider, like the Saturation control, increases the vividness of the colors in photos but applies the changes selectively to only those hues that are desaturated in the first place. This means that the slider targets the more pastel tones and doesn't boost those colors that are already rich and vibrant. In addition, the Vibrance slider tends to safeguard Caucasian skin tones when it is applied.

Saturation

In contrast the Saturation slider increases the saturation, or vividness, of all the colors in a photo irrespective of their original value. These factors make the Vibrance slider perfect when working with portraits or photos where selective adjustment is needed. The Saturation slider, on the other hand, is very useful for bumping up the color of the whole photo a few notches. Moving the slider all the way to the left creates a grayscale image devoid of color, but don't be tempted to create monochromes in this way as ACR contains more appropriate controls for this process. See the Raw Processing chapter for more details about ACR-based grayscale conversions.

Note > Adobe Camera Raw contains a variety of other color controls that are capable of adjusting specific color ranges. These and other more sophisticated ACR features are discussed in the next chapter – Raw Processing.

Tonal adjustments - Step 6

The starting point to adjust the tonal qualities of *every* image is the six slider controls (Exposure, Contrast, Highlights, Shadows, Whites, and Blacks) in the Basic pane of ACR (or the Levels dialog box in Photoshop).

Note > These controls have changed with the latest versions of the program to provide more control over highlights and shadows and experienced ACR users will need to alter their workflow slightly to take into account the new controls.

It is important to perform tonal adjustments with reference to some objective feedback about the nature of the changes you are making. For this reason the Histograms located at the top right of the ACR workspace (or inside the Levels dialog) should always be consulted when enhancing your photos. Features like Brightness/ Contrast in Photoshop, which don't include this objective feedback, should never be used.

Histograms

Essentially the histogram is a graph of the pixels in your photo. The horizontal axis of the histogram displays the brightness values from left (darkest) to right (lightest). The vertical axis of the histogram shows how much of the image is found at any particular brightness level. If

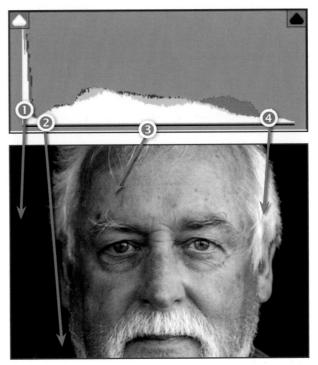

(1) Clipped Shadow Areas. (2) Shadows. (3) Midtones.
 (4) Highlights.

the subject contrast or 'brightness range' exceeds the latitude of the capture device or the exposure is either too high or too low, then tonality will be 'clipped' (shadow or highlight detail will be lost and no amount of adjustment will recover it). ACR's histogram also displays the information of each channel (red, green, blue) that makes up the photos as colored parts of the graph and includes clipping warning features in the top corners of the dialog.

During the capture stage it is often possible to check how the capture device is handling or interpreting the tonality and color of the subject. This useful information can often be displayed as a histogram on the LCD screen of high-quality digital cameras, on the screen of a tethered computer, or in the scanning software during the scanning process. The histogram displayed shows the brightness range of the subject in relation to the latitude or 'dynamic range' of your capture device's image sensor. Most digital camera sensors have a dynamic range similar to color transparency film (around five stops) when capturing in JPEG or TIFF. This may be expanded beyond seven stops when the Raw data is processed manually.

When capturing using a tethered workflow, the accuracy of the histogram is increased in that you are able to view, and base your exposure decisions on, a graph of the captured Raw file (displayed in ACR) rather than a processed JPEG as is the case for many back-of-camera LCD histograms.

Note > You should attempt to modify the brightness, contrast and color balance at the capture stage to obtain the best possible histogram before editing begins in the software.

Optimizing tonality

In a good histogram, one where a broad tonal range with full detail in the shadows and highlights is present, the information will extend all the way from the left to the right side of the histogram. The histogram on the left (below) indicates missing information in the highlights (right side of histogram) indicating overexposure. The histogram on the right indicates a small amount of 'clipping' or loss of information in the shadows (left side of histogram) or underexposure.

Brightness

If the digital file is too light a tall peak will be seen to rise on the right side (level 255) of the histogram. If the digital file is too dark a tall peak will be seen to rise on the left side (level 0) of the histogram.

Solution> Decrease or increase the exposure/brightness in the capture device.

ACR histograms indicating image is either too light (left) or too dark (right).

Levels histograms indicating image either has too little contrast or too much.

Contrast

If the contrast is too low the histogram will not extend to meet the sliders at either end. If the contrast is too high a tall peak will be evident at both extremes of the histogram.

Solution: Increase or decrease the contrast of the light source used to light the subject or the contrast setting of the capture device. Using diffused lighting rather than direct sunlight or using fill flash and/or reflectors will ensure that you start with an image with full detail.

Previewing clipping

One of the critical areas of image adjustment is ensuring that any changes to tone or color don't clip captured details in either the shadow or highlight areas of the photo. In ACR the preview image in conjunction with the histogram form a key partnership in providing this clipping feedback to the user when they are making changes to the photo. By activating the highlight and shadow clipping warnings in the histogram (click on the upwards-facing arrows in the top left, for shadows, or top right, for highlights of the histogram), areas being clipped are displayed in the preview image. Clipped shadow details are displayed in blue and clipped highlights in red. As well

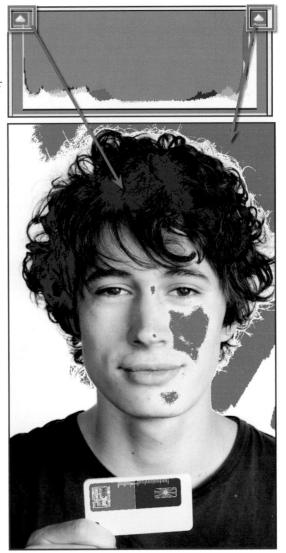

as the warning in the preview image, the actual clip warning arrows in the histogram area reflect the color of the channels (red, green, blue or combinations thereof) being clipped. If details for more than one channel are being clipped then the arrow turns white. If no details are being clipped then the arrow is black.

Optimizing a histogram after capture

The final histogram should show that pixels have been allocated to most, if not all, of the 256 levels. If the histogram indicates large gaps between the ends of the histogram and the sliders (indicating either a low-contrast scan or low-contrast subject photographed in flat lighting) the subject or original image should usually be recaptured a second time. In situations when this is not possible use the following ACR controls to adjust the look of the histogram and therefore the tones in the photo.

In ACR 7/8 start with Exposure (brightness) and contrast

Unlike previous versions of ACR where we set the white and black points first, with ACR versions 7 and 8 we usually start by using the Exposure and Contrast sliders to establish the look of the midtone areas. I say usually because in some situations such as images with high contrast you may need to deal with the shadows and highlights first and then return to work with the overall brightness of the photo.

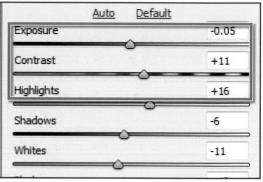

Note > The Exposure control no longer sets the white point of the image. Instead it controls the brightness of the middle values.

When changing exposure values don't be too concerned if the highlights clip a little as these will be adjusted later in the process.

Setting the white clipping point

The white point of an image is now controlled by the Whites slider. Moving the slider to the right lightens the lighter tones in the photo and to the left darkens them. Your aim, when using this control, is to lighten the highlights without clipping them (converting the pixels to pure white). To do this interactively, hold down Alt/Option while moving the slider. This action previews the photo with the pixels being clipped against a black background. Move the slider back and forth until highlights with detail start to clip; the aim is to lighten the highlights where you want to preserve detail without clipping and losing that detail.

Note > An alternative to holding down the Alt/Opt key is to keep an eye on the clipping warning triangles at the top of the histogram. When they are black no clipping is occurring, when colored the channel containing these pixels is being clipped and when white multiple channels are being clipped. Clicking the warning triangles (so that they are surrounded by a white rectangle) activates the clipping warning in the preview without the need to hold down the Alt/Opt key.

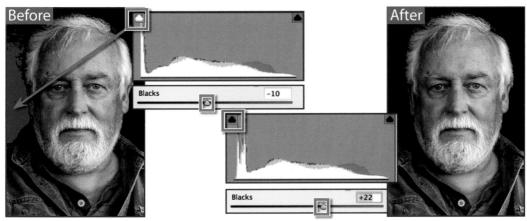

The Blacks and Shadows sliders are designed as a fine control for the darker tones in your photo.

Adjusting the black clipping point

The Blacks slider performs a similar function with the shadow areas of the image. Again the aim is to darken these tones but not to convert (or clip) delicate details to pure black. Just as with the Exposure slider, the Alt/Option key can be pressed or the clipping warning triangles consulted, while making Blacks adjustments to preview the pixels being clipped.

Tweaking problem areas

When a photograph is overexposed, one of the consequences can be that the lighter tones in the image lose detail and are converted to pure white. As we have seen, this process is called clipping. Digital images are created with details from three color channels (red, green, blue). In situations of slight overexposure, when only one channel is clipped, it is possible to recreate the lost detail with the highlight information from the other two (non-clipped) channels.

Previously we would have used the Recovery slider for this task but the slider has been removed from ACR and its functionality added into the Whites and Highlights controls. Use these sliders in combination to set white points and adjust the brightness of highlight details. For extremely overexposed images you may need set the Whites value to -100 and also drag the Highlights slider to the left to restore lost detail.

Similarly the Fill Light slider has been removed and instead we now use Blacks and Shadows controls to establish the black point and to

	<u>Auto</u>	Default	1.1.1.1.1
Exposure		^	-0.05
Contrast			+11
Highlights			+16
Shadows			-6
Whites		,	-11
Blacks	0		+18

lighten the darker tones in a picture without affecting the middle to highlight values. Use the Shadows control in particular to brighten backlit subjects or boost shadow details. The beauty of this control is that the changes it makes do not generally impact on mid to highlight values.

Brightness changes

The Brightness slider has also been removed and its functionality is handled by the Exposure slider. Moving the slider to the right lightens the overall appearance of the image and can consequently cause clipping of highlight or shadow details. This is why it is important to adjust exposure first and then to set white and black points.

More tonal control options

When the overall tonality has been optimized using either the sliders in ACR, or the Levels feature in Photoshop, the midtone contrast and appearance of the details in the shadow and highlight areas may require further work. One of the limitations of Photoshop's Levels adjustment feature is that it cannot focus its attention on only the shadows or the highlights, e.g. when the slider is moved to the left both the highlights and the shadows are made brighter. More control is available with the key tonal sliders in ACR (Exposure, Contrast, Highlights, Shadows, Whites, Blacks) where specific attention can be paid to these areas.

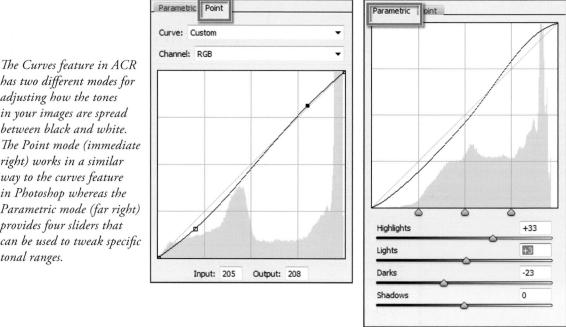

More targeted adjustments can be achieved using the Curves adjustment features found in both ACR (Tone Curve tab) and Photoshop (Image > Adjustments > Curves). Curves allows the user to target tones within the image and move them independently of other tones within the image, e.g. the user can decide to make only the darker tones lighter while preserving the value of both the midtones and the highlights. It is also possible with a powerful editing feature such as Curves to move the shadows in one direction and the highlights in another. In this way the contrast of the image could be increased without losing valuable detail in either the shadows or the highlights. Slightly different approaches are taken with the feature in ACR and Photoshop.

has two different modes for adjusting how the tones in your images are spread between black and white. The Point mode (immediate right) works in a similar way to the curves feature in Photoshop whereas the Parametric mode (far right) provides four sliders that can be used to tweak specific tonal ranges.

Adobe Camera Raw provides two different Curve modes – Parametric and Point. **Parametric:** This version of the ACR Curves feature provides four slider controls (Highlights, Lights, Darks and Shadows) as the means to adjust the shape of the curve. The slider controls tend to offer a fast way to manipulate different parts of the curve.

Point: The Point mode works in a similar way to Curves in Photoshop. Control points can be added to the different parts of the curve. These points can then be pushed and pulled to change the curve shape. Points can also be used to anchor specific tonal values so that they don't change while altering other parts of the curve. Holding down the Ctrl/Cmd key allows the user to place a control point on the curve by clicking on a specific part of the preview image.

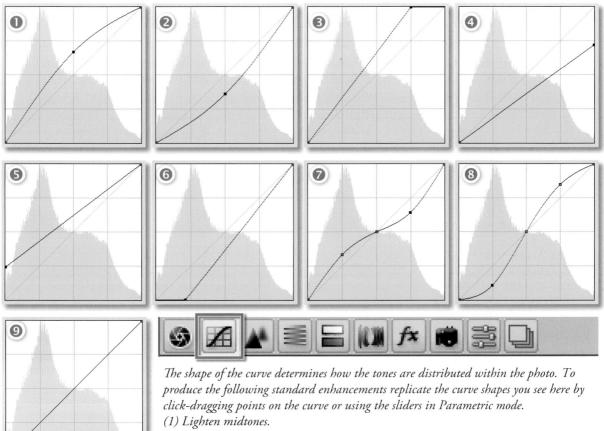

(2) Darken midtones.

- (3) Lighten highlights but watch out for possible clipping as seen here.
- (4) Darken highlights.
- (5) Lighten shadows.
- (6) Darken shadows but again be careful not to clip as is the case in this example.
- (7) Decrease contrast.

(8) Increase contrast.

(9) Default or Linear curve.

Note > In practice it is not a good idea to move the white and black points in Curves after they have been accurately established using the Blacks and Exposure sliders.

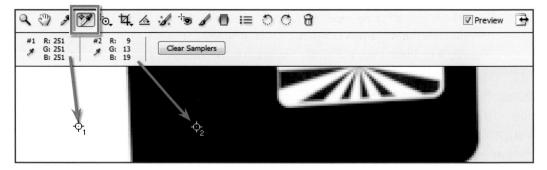

Targeting key values

To ensure highlights do not 'blow out' and the shadows do not print too dark it is possible to target, or set specific tonal values, for the highlight and shadow tones within the image using the Color Sample Tool in ACR or the eyedroppers (found in Photoshop's Levels and Curves dialog boxes). The tones that should be targeted are the lightest and darkest areas in the image with detail. The default settings of these eyedroppers are set to 0 (black) and 255 (white). These settings are only useful for targeting the white paper or black film edge. After establishing the darkest and lightest tones that will print using a step wedge (see Digital Printing) these target levels can be used as a guide with the Color Sample tool display or assigned to the Photoshop eyedroppers.

Here we will use some generic values. When using ACR look for maximum RGB values around 250 for highlights and close to 5 for shadows. Make sure that you ignore specular highlights when adjusting highlight areas. These areas are generally reflections of light sources and can have a value of 255 as they typically contain no texture. Now unless you are targeting a neutral tone, the three color values will be different; make sure that the highest, for highlights, and lowest, for shadows, are close to these targets (in Photoshop we use a Brightness setting, taken from the HSB readout, of between 4 and 8 for shadows and 92 and 99 for highlights).

Setting target values in Adobe Camera Raw

To help with keeping an eye on how changes are affecting key parts of the picture, ACR has a special Color Sample tool which can be used to display the RGB values of these picture parts. Use the following steps to use the Color Sample tool:

- 1. Start by selecting the tool from the toolbar at the top of the workspace. Now move the tool around the image until you find the darkest part of the photo. To help with this process, turn on the clipping warnings and temporarily drag the Blacks slider to the right until you start to see clipping occur in the preview. The parts of the picture where the clipping is first noticeable will be the darkest part of the image.
- 2. Click the Color Sample tool on this picture part. Notice that a small crosshairs icon has been placed on the picture and an entry area is now displayed below the toolbar and a new RGB entry is present. Now adjust the Blacks and/or Shadows sliders until the RGB display shows 5 as the lowest of the values.

3. With the highlight clipping warning selected, drag the Whites slider to the right until the preview shows a part of the photo that is being clipped. Place a second Color Sample tool on this part of the photo. Using the Whites and Highlights sliders adjust the picture part until the highest of the three values is around 250.

Note > Because the ACR Color Sample tool displays RGB values, the targeted clipping areas might not necessarily be the blackest or whitest parts of the picture.

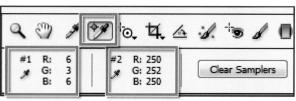

Cleaning an image - Step 7

The primary tools for removing blemishes, dust and scratches are the Spot Removal brush in Adobe Camera Raw and the Clone Stamp tool, the Healing Brush tool and the Spot Healing Brush tool in Photoshop. The process for using ACR's Spot Removal tool borrows from both the Clone Stamp and Spot Healing Brush tools in Photoshop.

The tool contains two components: a circle that indicates the target of the retouching, which is generally placed over the mark to remove, and a circle to select the source area that will be used as a reference for the color, tone and texture that will be painted over the mark. Sound familiar? It should – this is how the Clone Stamp tool works. The difference is that with ACR's Spot Removal tool, the target area is selected first by click-dragging the cursor to the size of the mark. ACR then

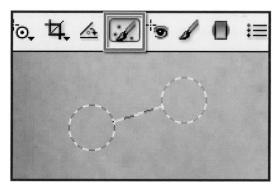

automatically searches for a suitable source point in the nearby pixels.

For ease of recognition the target circle is colored red and the source circle is a green hue. Both circles are linked with a straight line to indicate which source belongs to which target. For the majority of the time ACR does a pretty good job of selecting a source point, but there will be occasions when you may want to choose your own. This is a simple matter of click-dragging the source circle to a new location. The same technique can be used for moving the target circle. To change the target size use the Radius slider in the side bar at the right of the dialog. Holding down the Alt/Option key while clicking on the target circle deletes or cuts the retouching entry.

To Heal or Clone

The tool works in two modes – Heal and Clone. The Heal mode uses the technology found in the Spot Healing Brush to help match texture and tone of the source area to the target surrounds.

Type:	Heal	•
	Heal	1
	Clone	

The Clone option gives more weighting to the specific qualities of the source area when overpainting the mark.

- 1. Start the process by ensuring that the preview window is enlarged to at least 100%. Select the magnification level from the pop-up menu on the bottom left of the dialog. Viewing the image zoomed in helps guarantee accuracy when specifying both target and source areas and presents a more precise preview of the results. Switch to the Hand tool using the H keyboard shortcut, to click-drag the preview area around the photo. You can switch back to the Retouch tool by pressing the letter B key.
- 2. Now drag the preview until you locate an area to be retouched. Select the Spot Removal tool from the ACR toolbar at the top of the dialog. By default the tool draws from the center, so move the pointer over the middle of the mark and click-drag the circle until it encompasses the blemish. This action sets the red target circle or the area to be retouched.
- 3. Unlike the situation with the Clone Stamp or Healing Brush tools there is no need to select the sample area separately. Adobe Camera Raw automatically searches the surrounds of the target area for a likely source and draws a corresponding circle attached with a single straight line. The source circle is colored green to distinguish it from the red target circle. If the source circle has been positioned incorrectly or is providing less than acceptable results in the target area then simply click-drag the circle to a new location.
- 4. Once the target and source have been positioned, the retouching entry can be modified in a couple of different ways. The size of the target circle can be adjusted by clicking onto the circle and then changing the Radius setting in the tool's options contained in the right panel of the dialog (use the up and down arrows for 1 pixel changes). The mode used for retouching can be switched between Heal (the technology used by the Spot Healing Brush) and

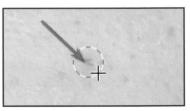

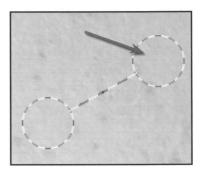

Spot Re	emoval
Type: Heal	
Radius	3
Opacity	100

Clone (which simulates the way that the Clone Stamp tool functions) using the drop-down menu also contained here. The Opacity option can be used to let more of the spot details below show through the correction.

- 5. Individual retouching entries can be removed or deleted altogether by cutting the entry. With the Spot Removal tool selected, hold down the Alt/Opt key while positioning the cursor over either the source or target circles of the retouching entry. The cursor will switch shape to a pair of scissors. Clicking the mouse button will then delete the entry.
- 6. Once you have positioned and adjusted all retouching entries for a given image you can preview the results, without the target and source circles, by deselecting the Show Overlay setting in the tool's options. To re-display the circles, reselect the option.

Workflow

7. As all retouching entries created in Adobe Camera Raw are non-destructive they can be removed at any time, even if the file has been saved and reopened. To remove all retouching entries for the current image, select the Clear All button in the Retouch tool options bar.

Sharpening an image – Step 8

Sharpening the image is the last step of the editing process. Many images benefit from some sharpening even if they were captured with sharp focus. The sliders in Adobe Camera Raw's Detail pane and Photoshop's Unsharp Mask and the Smart Sharpen filters from the Sharpen group of filters are the most sophisticated and controllable of the sharpening filters. They are used to sharpen the edges by increasing the contrast where different tones meet. The pixels along the edge on the lighter side are made lighter and the pixels along the edge on the darker side are made darker.

Before sharpening

After sharpening

In the latest versions of ACR the sharpening controls have been increased to four from a single slider a couple of versions ago. Where originally users were only able to control the amount of sharpening, now it is possible to manipulate how the effect is applied. Sharpening effects are controlled via the following sliders – Amount, Radius, Detail and Masking.

The **Amount** slider controls the strength of the sharpening effect. Move the slider to the right for stronger sharpening, to the left for more subtle effects. The **Radius** slider determines the number of pixels from an edge that will be changed in the sharpening process. The **Detail** slider is used to increase the local contrast around edge parts of the picture. An increase makes the picture's details appear sharper. The **Masking** control channels the sharpening effect through an edgelocating mask.

Both the Detail and Masking sliders are used to target the sharpening more precisely in the image. Increasing the Detail value will raise the local contrast around smaller picture parts.

Reducing the value will decrease the appearance of haloes around these areas. Moving the Masking slider to the right gradually isolates the edges until the sharpening is only being applied through the most contrasted sections of the photograph.

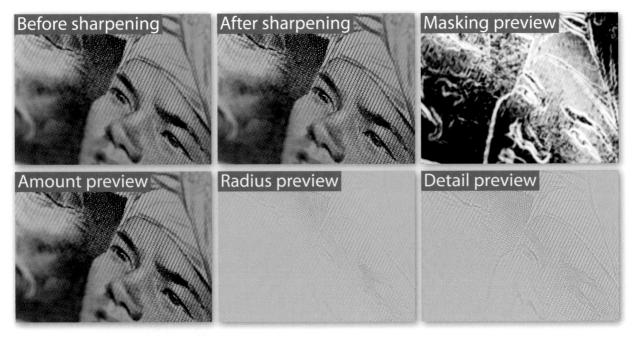

Previewing sharpening effects

With the preview at 100% magnification, holding down the Alt/Opt key will display different previews for each of the Sharpening sliders. The preview for the Amount slider shows the sharpening applied to the luminosity of the image. Both Radius and Detail sliders preview the value of the slider and the Masking option displays the mask being used for restricting where the sharpening is being applied. Remember the black areas of the mask restrict the sharpening and the light areas allow the sharpening to be applied.

Setting Workflow Options - Step 9

The section below the main preview window in ACR contains the Workflow Options settings. Here you can adjust the color depth (8 or 16 bits per channel), the color space (ICC profile), the image size (maintain capture dimensions for the picture or size up or down) and the image resolution (pixels per inch or pixels per centimeter). It is here that you adapt image

Space: Adobe I	KGB (1998)		+)	Depth:	8 Bits/Channel	•	Canc
Intent: Relative			•	🗌 Sim	ulate Paper & Ink		
Image Sizing							
Resize to Fit:	Default (13.	3 MP)		\$	🗋 Don't Enlarge		
w:	2976 H	4464	pixels	•			
Resolution:	300	oixels/inch		•			
Output Sharpening	,						
Sharpen For:	Matte Paper		\$	Amount:	Standard	•	
Photoshop							

characteristics to suit different outcomes. You can resize images to suit screen dimensions and also adjust the resolution of the file to match the dpi of the monitor. You can also upsize a photo and select an appropriate ICC profile and depth for a poster print. With these options set you can then move on to deciding how to output the file.

For the project images, set the space to Adobe RGB, Depth 16 Bits/Channel, Resolution 240 ppi and Matte Paper Standard in the 'Sharpen For' section of the Workflow Options dialog.

Applying changes to multiple files - Step 10

We now have an idea about the types of changes that are regularly applied to images in order to optimize them. Although there are not many steps, applying them to a number of images could be a time-consuming task. This is especially true when shooting Raw as there are extra processing options available with this format than if you capture in TIFF or JPEG. For this reason there are several 'batch' processing features available in Bridge and ACR that can help speed up the enhancement of groups of photos.

Multiple photos can be selected in Bridge and passed to ACR for speedier processing.

Adobt RC8 (1998): \$ bit: 6000 by 4000 (24.0MP): 300

Quality versus quantity

Now some of you might already be thinking to yourselves that any type of processing applied to a series of images rather than individual pictures will have to be less than optimal for each picture, and you would be right. But because of the nature of non-destructive editing and enhancing techniques that we are advocating here it is possible to apply some generic enhancement settings to groups of images quickly and then 'drill down' to each individual photo to apply the fine-tuning. This way of working is often used by photographers who take multiple images under the same lighting conditions or in the same environment.

While we are talking of speeding up our photo workflow don't forget that other parts of the process such as adding metadata and outputting photos to a specific format, size and ICC profile can also be handled by batch processing. Let's see how we can apply the changes made to the first image to the others photographed at the same time.

Multi-select and Open In Camera Raw

As well as being able to process files one at a time, Adobe Camera Raw is capable of queueing multiple Raw files and working on these either in sequence or in sets of pictures. After several Raw photos are selected inside Bridge and then opened into ACR (File > Open in Camera Raw), you will notice the pictures are listed on the left side of the dialog. The same scenario occurs when selecting multiple pictures in the File > Open dialog from inside Photoshop. Once loaded into ACR, the files can be worked on individually by selecting each thumbnail in turn, making the necessary changes, and then moving to the next picture in the list. But there is a more efficient way to process multiple files – synchonized processing.

Synchronized processing

Start with a group of images either taken under the same conditions with similar subject matter, or that you are wanting to process in a similar way (e.g. convert to grayscale and then sepia tone) open in Adobe Camera Raw. Now pick one of the photos that best represents the characteristics of the group (in the project files we used the image with the reference card) and proceed to make the corrections to color, tone and sharpness.

When complete, pick the Select All button at the top of the queue section of the dialog to pick all queued photos, or multi-select a subset of photos and then push the Synchronize button. The Synchronize dialog will be displayed, listing all the ACR controls that can be copied from the initial photo to the rest of the group. Select, or deselect, the controls as desired, and then click OK. Automatically the settings are synchronized across all the selected photos. To synchronize all the settings choose the Everything option from the drop-down menu.

For the project images, this technique allows us to apply the enhancement changes made to the first photo across the other photos taken in that same studio session.

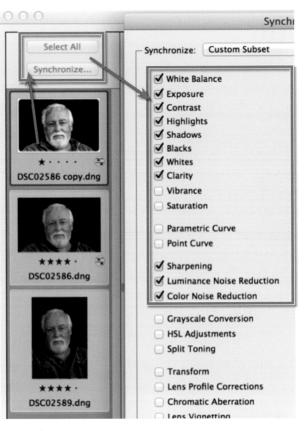

80

Note > Another way to select a subset of images from those displayed on the left of the workspace in ACR is to rate the pictures you want to apply common settings to and then select these photos with the Select Rated button (hold down the Alt/Opt key). With the Alt/Opt key still depressed, clicking the Synchronize button will synchronize using the last settings without displaying the Synchronize dialog.

Don't forget to fine-tune

The synchronization of development settings provides a good starting point for the enhancement process; all that now remains is to flick through each individual image and doublecheck that the settings are working for that specific photo. If need be, the settings can be fine-tuned to better suit any image.

In the case of the example images, the crop should be applied manually for each photo and slight changes made to highlight areas to account for small changes in lighting.

Outputting processed files - Step 11

Now to the business end of the optimization task – outputting the file. When working with Raw files in Adobe Camera Raw you have more options at this point than if you were enhancing the photos in Photoshop. There is no longer a need to convert the picture from its Raw state in order to save the changes you have made. These alterations can be either

- Stored with the Raw file.
- Applied to the file and the photo then saved as a non-Raw format such as TIF or PSD.
- Applied to the photo which is then passed to Photoshop.
- The Raw file can be embedded as a Smart Object in a new Photoshop document.

Opening into Photoshop

The most basic option is to process the Raw file according to the settings and adjustments selected and then open the picture into the editing workspace of Photoshop. To do this click the Open Image button at the bottom right of the dialog. Select this route if you intend to edit or enhance the image beyond the changes made during the conversion.

This option will maintain the Raw file in Bridge and create a new Photoshop document of the converted (no longer Raw-based) photo.

Saving the processed Raw file

There is also the ability to save converted Raw files from inside the ACR dialog via the Save button (located at the bottom left). This action opens the Save Options dialog which contains settings for inputting file names, choosing file types and extensions as well as file type-specific characteristics

Savo	Imago	N
Save	Image	

such as compression. Opt for this approach for fast processing of multiple files without the need to open them in Photoshop.

Applying the Raw conversion settings

ACR also allows the user to apply the current settings to the Raw photo without opening the picture into Photoshop. Just click the Done button. The great thing about working this way is that the settings are applied to the file losslessly. The photo remains in the Raw format. No changes are made to the underlying pixels, only to the instructions that are used to

process the Raw file. When next the file is opened, the applied settings will show up in the ACR dialog ready for fine-tuning, or even changing completely.

When the ACR dialog is closed the thumbnail for the photo is updated in Bridge to reflect the changes. If adjustment settings have been applied to the photo, then a small settings icon is placed in the top right-hand corner of the thumbnail. When a picture has been cropped, a crop icon is displayed as well.

Creating a Smart Object

If you are wanting to continue working with your unconverted Raw file inside Photoshop then you will need to embed the file in a Smart Object layer within a Photoshop document. Unlike the earlier versions of ACR where this process had to be accomplished manually, it is now possible to embed the file using a single button inside ACR. While holding down the Shift key, press the Open Object button. This action automatically creates a new Photoshop document and embeds the Raw file in a Smart Object layer. Alternatively you can set this as a default option in the workflow options dialog box.

For the purposes of the project, select the portrait file without the reference card and open the file into Photoshop as a Smart Object.

Outputting more than one enhanced file

The same output options apply when working with multiple photos in ACR. Once all the settings have been applied, the images can be saved, opened, copied or opened as objects just

like any other files. When more than one picture is selected from the queue grouping, the output button titles automatically change to plural to account for the fact that multiple photos will be saved, opened, copied, etc.

DSC02589 1 1 copy

0. 1

0

1	Layers	≥twork File name: Format:	Project 1 psd Photoshop (*,PSD,*,PDD)
6	Lock: 🛛 🖌 🕂 🔒 Fill: 100% =	Save Options Save:	As a Copy Notes Alpha Channels Spot Colors Layers
	OSC02589 1 1 copy	Color:	Use Proof Setup: Working CMYK VICC Profile: Adobe RGB (1998)
	⇔ fx. □ 0, ■ ¶ 🚔 🤞	I Thumbnail	Use Lower Case Extension

Saving, duplicating and resizing for web - Step 12

With the newly created Photoshop document open, go to the File menu and select Save As. Name the file, select 'Photoshop' as the file format and select the destination where the file is being saved. Check the Embed Color Profile box and click Save.

Keep the file name short, using only the standard characters from the alphabet. Use a dash or underscore to separate words rather than leaving a space and always add or 'append' your file name after a full stop with the appropriate three- or four-letter file extension (.psd). This will ensure your files can be read by all and can be safely uploaded to web servers if required. Always keep a backup of your work on a remote storage device if possible.

Resize for web page viewing Duplicate your file by going to Image > Duplicate. Rename the file and select OK. Go to Image > Image Size. Check the Constrain Proportions and Resample Image boxes. Type in 900 pixels in the Height box (anything larger may not fully display in a browser window of a monitor set to 1024 × 768 pixels without the viewer having to use the scroll or navigation bars). Use the Bicubic Sharper

000	Image Size			
AMP N	Image Size: Dimensions:			o.
1-51	Width:	600	Pixels	
	Height:	400	Pixels	
1-4-1	Resolution:		Pixels/Inch	
	Resample:	Automat	tic	Ð
	Cance	el	ОК	

or the new Automatic option when reducing the file size for optimum quality.

Note > Internet browsers do not respect the resolution and document size assigned to the image by image-editing software – image size is dictated by the resolution of the individual viewer's monitor. Two images that have the same pixel dimensions but different resolutions will appear the same size when displayed in a web browser. A typical screen resolution is often stated as being 72 ppi but actual monitor resolutions vary enormously.

JPEG format options

After resizing you should set the image size on screen to 100% or Actual Pixels from the View menu (this is the size of the image as it will appear in a web browser on a monitor of the same resolution). Go to File menu and select Save As. Select JPEG from the Format menu. Label the

file with a short name with no gaps or punctuation marks (use an underscore if you have to separate two words) and finally ensure the file carries the extension .jpg (e.g. portrait_one.jpg). Click OK and select a compression/quality setting from the JPEG Options dialog box. With the Preview box checked you can check to see if there is excessive or minimal loss of quality at different compression/quality settings in the main image window.

Choose a compression setting that will balance quality with file size (download time). High compression (low quality)

Matte: None 🗸		ОК
Image Options		Cancel
		curret
Quality: 10 Maximum -		Preview
small file	large file	114.1K
Format Options]	
Baseline ("Standard")		
🔘 Baseline Optimized		
Progressive		
Scans: 3		

leads to image artifacts, lowering the overall quality of the image. There is usually no need to zoom in to see the image artifacts as most browsers and screen presentation software do not allow this option.

Note > Double-clicking the Zoom tool in the Tools palette will set the image to actual pixels or 100% magnification.

Image Options: The quality difference on screen at 100% between the High and Maximum quality settings may not be easily discernible. The savings in file size can, however, be enormous, thereby enabling much faster uploading and downloading via the internet.

Format Options: Selecting the Progressive option from the Format Options enables the image to be displayed in increasing degrees of sharpness as it is downloading to a web page, rather than waiting to be fully downloaded before being displayed by the web browser.

Size: The open file size is not changed by saving the file in the JPEG file format as this is dictated by the total number of pixels in the file. The closed file size is of interest when using the JPEG Options dialog box as it is this size that dictates the speed at which the file can be uploaded and downloaded via the internet. The quality and size of the file is a balancing act if speed is an issue due to slow modem speeds.

Save for Web

The Save for Web command from the File menu offers the user an alternative, all-in-one option for resizing, optimizing and previewing the image prior to saving the file in the JPEG format. Access the Save for Web feature from the File menu. Click on the 2-Up tab to see a before and after version of your image. Click on the second image and, from the Preview menu, choose Internet Standard sRGB from the listed options: Monitor Color, Legacy Macintosh (No Color Management), Internet Standard sRGB (No Color Management) or Use Document Profile. This will enable you to anticipate how your image may be viewed in software that cannot read the ICC profile that Photoshop normally embeds as part of the color management process, e.g. most web browsers.

Workflow

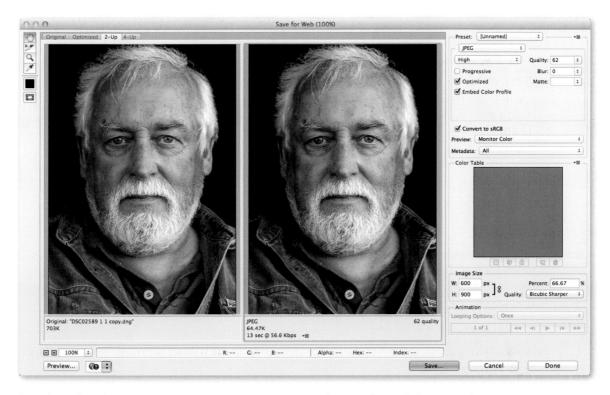

To adjust the color or tone prior to saving as a JPEG exit the Save for Web feature and go to View > Proof Setup and then choose Internet Standard sRGB option. With the Proof Setup switched on, adjustments may be required to both image brightness and saturation in order to return the appearance of the image to 'normal'. Brightness should be controlled via the Gamma slider in the Levels adjustment feature and color saturation via the Hue/Saturation adjustment feature.

Capture and enhance workflow overview

- 1. Capture an image with sufficient pixels for the intended output device.
- 2. Download or transfer files.
- 3. Rate and add keywords to files.
- 4. Resize and crop the image.
- 5. Adjust the color.
- 6. Tweak the tonality.
- 7. Clean the image.
- 8. Sharpen the photo.
- 9. Apply the processing and output the picture.

nop photoshop ph

hotos

essentíal skílls

- Take Raw processing beyond the basics outlined in the last chapter.
- Apply localized corrections to images inside Adobe Camera Raw. C
- Convert Raw files to digital negatives for archival storage.

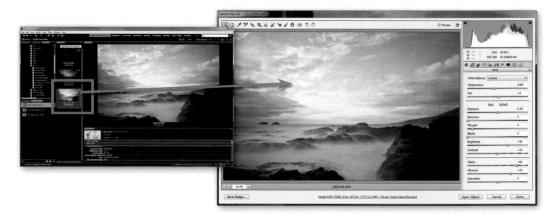

Introduction

One of the big topics of conversation over the last few years has been the subject of Raw files and digital negatives. During this time the capture format has gone from being an option for high-end work only to a key part of most professionals' workflow. For this reason we have reworked much of the content of the book to take into account Raw enabled workflows. In the last chapter we looked at the first few steps involved in optimizing a digital capture, be it Raw

based or TIFF or JPEG. And you will have noticed that we suggest that these basic steps should be undertaken in Adobe Camera Raw, irrespective of how you shoot. Here we will delve further into Raw processing and pay particular attention to the other editing and enhancement options that are possible when altering your photos directly in Adobe Camera Raw or as an embedded Raw file within Photoshop.

Note > Keep in mind that for many of the techniques there is no longer the need to convert your file from its native Raw format in order to continue editing the picture in Photoshop. This way of working ensures that not only are your images always derived from the primary capture data and not a second generation derivative, but that you maintain the flexibility of the Raw format for altering characteristics such as white balance, tonality, color space and sharpness non-destructively.

All digital cameras capture in Raw but only digital SLRs and the medium- to high-end 'prosumer' cameras offer the user the option of saving the images in this Raw format. Selecting the Raw format in the camera instead of JPEG or TIFF stops the camera from processing the color data collected from the sensor. Digital cameras typically process the data collected by the sensor by applying the white balance, sharpening and contrast settings set by the user in the camera's menus. The camera then compresses the bit depth of the color data from 12, 14 or 16 to 8 bits per channel before saving the file as a JPEG or TIFF file. Selecting the Raw format prevents this image processing taking place. The Raw data is what the sensor 'saw' before the camera processed the image, and many photographers have started to refer to this file as the 'digital negative'. The term 'digital negative' is also used by Adobe for their archival format (.dng) for Raw files.

Processing Raw data

In the last chapter we saw that unprocessed Raw data is edited and enhanced in Adobe Camera Raw (ACR) and the resultant file can be opened in Photoshop or Bridge. Variables such as bit depth, white balance, exposure, brightness, contrast, saturation, sharpness, noise reduction and even the crop can all be assigned as part of this process. There are also tools for performing localized corrections. Think 'dodge and burn' but with the power to paint on changes of saturation, contrast, exposure, clarity and sharpness in portions of the photo.

In the version of Adobe Camera Raw that ships with CC and CS6, the Raw processing engine has been rewritten to provide better processing of tones, and to coincide with this change, the tonal slider controls in the Detail pane have been reworked also. Fill-Light and Recovery sliders have been replaced with Shadows and Highlights. Exposure and Contrast sliders now predominantly target changes to midtones and Whites and Blacks controls are used for altering the white and black clip points of the image. Seven new adjustments have been added to those already possible with the Adjustment Brush and Graduated Filter. And the Point mode of the Tone Curve now includes the ability to apply curve adjustments to individual color channels. When these improvements are added to the existing spread of tools in the utility you can see why more and more key editing activities should be undertaken in ACR before moving to Photoshop.

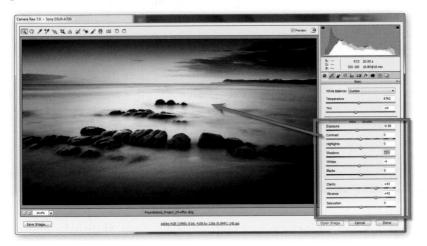

In addition, performing these image-editing tasks on the full high-bit Raw data (rather than making the changes after the file has been processed by the camera) enables the user to achieve a higher quality end-result. Double-clicking a Raw file, or selecting 'Open in Camera Raw' in Bridge, opens the Adobe Camera Raw (ACR) dialog box, where the user can prepare and optimize the file which can then be passed to Photoshop for further processing. If the user selects 16 Bits/Channel in the Workflow Options, the 12 bits per channel data from the image sensor is rounded up – each channel is now capable of supporting 32,769 levels instead of the 256 levels we are used to working with in the 8 bits per channel option. Choosing the 16 Bits/Channel option enables even more manipulation in the main Photoshop editing space without the risk of degrading the image quality.

When the optimized Raw file is passed to Photoshop from ACR we have the option of converting a copy of the photo from Raw to a Photoshop document (.psd) or embedding the picture in a Smart Object, which in turn is stored in a new Photoshop document. The advantage of the second approach is that as an embedded Smart Object the Raw file format of the original capture is maintained (and protected). In both pathways any changes you make to the appearance of the image in the ACR will be applied to the image that is opened in Photoshop's main editing space but won't alter the original image data of the Raw file. The adjustments you make in the ACR dialog box are instead saved as either a sidecar file (.xmp) or in the computer's Camera Raw database.

Foundation Project 2

In the last chapter we looked at the basic adjustments that you would make to a Raw file in order to optimize the photo; here we will employ some of the additional features to take our ACR-based editing even further. If you don't have your own Raw files to work on, the example file, named Foundation_Project_02, is located on the book's accompanying supporting website. The reader should not see this as a rigid step-by-step guide but instead use the project file to get a feel for the techniques discussed here.

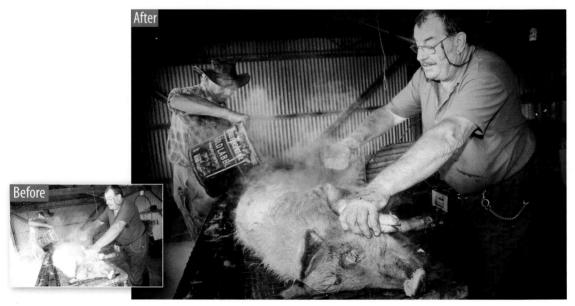

One of the strengths of working with Raw files is their ability to capture and use large amounts of data. This project uses the power of the new local correction tools in ACR together with the extra detail contained in high-bit Raw capture to reveal hidden detail in the blown highlight area of this photojournalism photo.

Lens corrections - Step 1

Over the last couple of versions of Adobe Camera Raw the features in the Lens Corrections pane have been dramatically improved to include both automatic (Profile tab) and manual (Manual tab) controls for the removal or correction of the three most common lens-based errors: geometric distortion, chromatic aberration, and vignetting. The Automatic corrections are lens and camera specific and are applied to the whole of the image, making this a good first step for your processing.

Profile-based corrections

After selecting Enable Lens Profile Corrections under the Profile tab of the Lens Corrections panel, an installed profile that matches your camera and lens combination are used to apply precise distortion corrections to your photos. Suitable profiles can be automatically located based on the EXIF data recorded with the image, or selected by camera make, model and profile. Individual error types can be adjusted via the Correction Amount sliders in the lower section of the pane. When set to 100 the slider applies the profile correction fully. Values of less than 100 reduce the correction effect and amounts over 100 multiply the effect.

Note > These Lens Correction features are also available as a Photoshop filter and can be used in Bridge to batch process multiple files in a single step. For more details about these applications, plus a guide for creating your own compatible lens profiles go to the Filters chapter later in the book.

Manual corrections

There are six transformation sliders grouped under the Manual tab in the Lens Correction panel. They provide an extra level of manual adjustment for tweaking your photos. It is important to note that these controls work in addition to the profile-based corrections and so can be used to fine-tune those enhancements.

Transform: The Distortion slider controls barrel and pincushion adjustments and the Vertical option is used to reduce the appearance of converging verticals which are often present in images taken with wide angle lenses when the camera is tilted upwards. The Horizontal slider pivots the image towards or away from the viewer correcting horizontal perspective issues and Rotate is used to straighten a tilted photo. Scale, can be used to adjust the magnification of the picture after the corrections have been made and the final new slider, Aspect, provides the option to change the format of the image.

Raw processing

	nable Lens Profil	e Corrections
	Custom	
	Lens Profi	le
Make:	Sony	+
Model:	Sony E 18-55m	m F3.5-5 ‡
Profile:	Adobe (Sony E	18-55mm \$
	Correction An	nount
Distortion		100
Vignetting		100

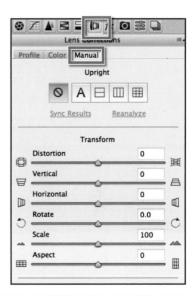

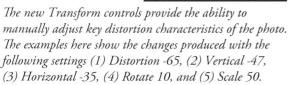

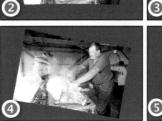

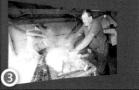

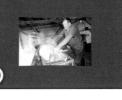

Chromatic Aberration: Gone are the two sliders that used to correct chromatic aberration. Now we have a single check box for helping with chromatic aberration, or the situation where edges recorded towards the outer parts of the frame contain slight misalignment of colors. This is caused by a lens not focusing all the visible wavelengths together on a sensor. The sliders are designed to realign the problem areas and, in so doing, remove the colored edges.

Fringing: Also included is the ability to lessen the sensor 'flooding' caused by overexposure in picture areas such as specular highlights. The Defringe controls include four sliders broken into two sections, one for controlling purple tinted fringing and a second section for green tinted fringing.

For each section there is an Amount slider to adjust the strength of the correction as well as a Hue control for finetuning the defringing color you are targeting.

Lens Vignetting: Vignetting is the slight darkening or lightening of the corners of a photo due to the inability of the lens to provide even illumination across the whole surface of the sensor. This is most prevalent in lower quality ultrawide-angle lenses when coupled with cameras with full frame sensors. Two sliders are included in the Lens Vignetting section of the Lens Corrections pane to deal with this problem. When the Amount slider is moved to the right it lightens the corners. Dragging the control to the left has the opposite effect. The Midpoint control alters the amount of

The Defringe option helps remove the purple color that can surround very bright highlights.

the frame affected by the vignetting correction. Higher settings concentrate the corrections to the corners of the frame.

Note > Post-crop vignetting controls can be found in the Fx pane. Instructions for applying this adjustment along with adding grain to your photo can be found later in the chapter.

Project application: To apply lens correction in the example image, click on the Profile tab in the Lens Corrections pane in Adobe Camera Raw. Select the Enable Lens Corrections setting and choose Sony, DT 18-200mm f3.5-6.3, Sony A-700 from the Make, Model and Profile menus.

Straighten, crop and size - Step 2

Start the process by straightening and cropping the photo. Select the Straighten tool on the top left-hand side of the ACR dialog box. Click on one end of a part of the framing in the roof structure that is meant to be horizontal, and drag the cursor to the other end and then let go of the mouse button to automatically straighten the image. Cropping in ACR does not delete pixels but merely hides them and these pixels can be recovered if necessary.

Crop the image to the correct aspect ratio or shape using the Crop tool. Select one of the existing aspect ratios or create your own using the Custom command found in the Crop menu.

The aspect ratio of the bounding box will change when a new format is selected. Click and drag on any corner handle to alter the composition or framing of the image. Use the keyboard shortcut Command/Ctrl + Z to undo any action that you are not happy with.

Note > The Crop tool setting affects the Straighten tool so make sure Crop is set to normal.

The Crop Size (pixel dimensions) and Resolution can also be set in ACR. If your target output is specified in inches or cms you will need to perform some calculations to ascertain the optimum crop size (divide the dimensions of the document needed by the optimum image resolution required by the output device). As crop sizes are only approximate in ACR you should choose a size that is slightly larger than the actual dimensions required.

Color space – Step 3

There are a range of choices of color space in the ACR dialog box and it is important to select the most appropriate one for your workflow before you start to assign color values to the image in ACR (using the controls located in the Workflow Options dialog displayed by clicking the highlighted blue text at the bottom of the screen). The main options are AdobeRGB, ColorMatch RGB, ProPhoto RGB and sRGB but you may also see printer and monitor profiles as well. ColorMatch RGB is rarely used these days so the choice is mainly between the first three options.

The wide gamut ProPhoto space (white) compared to the Adobe RGB (1998) space (color).

The main difference between these three major spaces is the size of the color gamut (the range of colors that each space supports). There is not much point in working with a color space larger than necessary as the colors outside of the monitor space will not be visible and they cannot be reproduced by an output device with a limited gamut range. The three color spaces are as follows:

sRGB – This is the smallest of the three common color spaces (with a range of colors similar to a typical monitor) and should be selected if your images are destined for screen viewing or are destined to be printed by a print service provider using the sRGB color space.

Space:	Adobe RGB (1998)		- OK
Depth:	Adobe RGB (1998) ColorMatch RGB		Canc
Crop Size:	ProPhoto RGB sRGB IEC61966-2.1		
esolution:	240 pixels/inch		-
arpen For:	Matte Paper	 Amount: Standard 	-

Adobe RGB (1998) – This space is larger than the sRGB space and is the most common color space used in the commercial industry, where the final image is to appear in print. It is a good compromise between the gamut of a color monitor and the gamut of an average CMYK printing press. It is also a space that is suitable for some print service providers and standard quality inkjet prints, e.g. a budget inkjet printer using matte or semi-gloss paper.

ProPhoto RGB – This is the largest color space and can be selected if you have access to a print output device with a broad color gamut (larger than most CMYK devices are capable of offering). When working in ProPhoto the user must stay in 16 Bits/Channel for the entire editing process. Converting to smaller color spaces in Photoshop's main editing space usually results in loss of data in the channels regardless of the rendering intent selected in the conversion process. This loss of data may not be immediately obvious if you do not check the histogram after the conversion process. The data loss is most apparent in bright saturated colors where texture and fine detail may be missing as the color information in the individual channels has become clipped in the conversion process.

Choosing a bit depth - Step 4

Select the 'Depth' in the Workflow Options (click on the blue text at the base of the ACR dialog box). If the user selects the 16 Bits/Channel option, the 14 bits per channel data from the image sensor is rounded up – each channel is now capable of supporting 32,769 levels. In order to produce the best quality digital image, it is essential to preserve as much information about the tonality and color of the subject as possible.

If the digital image has been corrected sufficiently in ACR for the requirements of the output device, the file can be opened in Photoshop's main editing space in 8 bits per channel mode. However, if the digital image has further corrections applied in the 8 bits per channel mode, the final quality will be compromised. Sixteen-bit editing is invaluable if maximum quality is required from an original image file that requires further editing of tonality and color in Photoshop after leaving the Camera Raw dialog box. If you have assigned the ProPhoto RGB color space in ACR you must use the 16 Bits/Channel color space in Photoshop to avoid color banding or posterization.

The problem with 8-bit editing

As an image file is edited extensively in 8 Bits/Channel mode (24-bit RGB) the histogram starts to 'break up', or become weaker. 'Spikes' or 'comb lines' may become evident in the resulting

Final histograms after editing the same image in 8 and 16 bits per channel modes.

histogram after the file has been flattened. This is due to the fact that there are only 256 levels or tones per channel to describe the full color range of the image. This is usually sufficient if the color space is not huge (as is the case with ProPhoto RGB) and the amount of editing required is limited. If many gaps start to appear in the histogram as a result of extensive adjustment of pixel values this can result in 'banding'. The smooth change between dark and light, or one color and another, may no longer be possible with the data supplied from a weak histogram. The result is a transition between color or tone that is visible as a series of steps in the final image.

A 'Smart' solution

By opening a Raw file as a Smart Object (Open Object – hold down the Shift key if this option is not visible or better yet set as the default opening action in the Workflow Options dialog) the user can open a Raw file in 8 Bits/Channel but keep the integrity of the histogram by returning to the ACR dialog box to make any large changes to hue, saturation or brightness (luminosity) values. Though working with 16 bits per channel is always preferable, with some filters there is only the option to apply the changes to an 8 bits per channel file.

Setting white balance - Step 5

As we saw in the last chapter, the first step in optimizing the color and tonal values for the color space we have chosen to work in is to set the white balance by choosing one of the presets from the drop-down menu. Remember that there are three approaches to setting white balance:

- Select a preset White Balance option based on specific lighting sources Daylight, Cloudy, Shade, Tungsten, etc.
- Manually adjust the Temperature and Tint sliders to remove any color cast present in the image.
- Alternatively you can simply click on the White Balance eyedropper in the small tools palette (top left-hand corner of the dialog box) and then click on any neutral tone you can find in the image.

For more details on using these features with your image, revisit the White Balance section in the previous chapter.

Control the White Balance in your image using either the drop-down presets, the Temperature and Tint sliders or the White Balance tool.

Note > Although it is a 'White Balance' you actually need to click on a tone that is not too bright. Clicking on a light or mid gray is preferable. A photographer looking to save time may introduce a 'gray card' in the first frame of a shoot to simplify the task.

Advanced WB fine-tuning

If precise white balance is extremely critical the photographer can shoot an xRite ColorChecker Chart that uses a range of color and gray patches. The user can then target the Red, Green and Blue patches and fine-tune the white balance using the Camera Calibration controls in ACR. The settings grouped here enable photographers to alter the way the colors captured by their cameras, and recorded in the Raw file, are interpreted by the software. Essentially this is a process that edits the default profile that Adobe developed for the camera. These Adobe based camera profiles are not strictly ICC profiles but they are the core technology used in Lightroom and ACR for interpreting the colors and tones captured by the camera.

Though daunting to start with, the options found under the Calibrate tab do provide an amazing amount of control and are used by many professional photographers to 'profile' the way that the color from their cameras is interpreted by the Raw converter. This is particularly useful for building a profile for neutralizing the casts that are present in images photographed under mixed artificial lighting conditions.

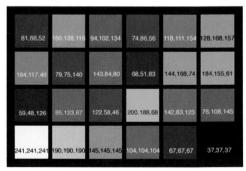

An xRite ColorChecker Chart.

Given the level of complexity involved in this process, most photographers simply do not bother, preferring to use the general profiles supplied by Adobe for their specific camera.

Custom profile creation

Now for those of you who really like to 'tinker under the hood', you can create your own custom profiles, which in turn, leads to better color capture. The process involves photographing a reference board like the xRite ColorChecker Passport under the lighting conditions that are typical for the scene. The Raw file is then opened into Adobe Camera Raw and the color and tones of the captured file are adjusted with the sliders in the Camera Calibration section of ACR to match the 'true' values of the patches. Performing this process manually is tedious and takes a lot of time; a better approach is to employ the help of the software that accompanies the ColorChecker Passport.

With pretty much drag-and-drop simplicity, the program uses the reference image to create a new profile. The original capture is converted to DNG, Adobe's digital negative format, before being imported into the ColorChecker Passport software where the swatches are analyzed and a custom profile produced. The resulting file is then saved and made available as one of the Profile options in the drop-down menu of the Camera Calibration pane/tab in ACR.

Automating profile settings

To automate the process of applying the profile simply change profiles for an example image and then select the Save Settings option from the Settings button (the button icon looks like a list) at the top right of the Presets pane. Deselect all Settings except Calibration and save the preset. To use this preset, simply select the Preset tab on the far right and select the preset of your choice from the list. It will automatically be applied to the image open in ACR.

The ColorChecker Passport reference target.

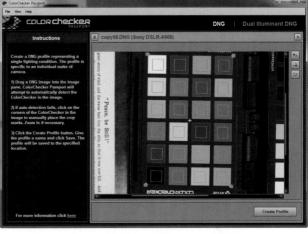

Custom Camera profiles loaded into the drop-down menu in Adobe Camera Raw.

Note > Using a custom profile with your photo won't permanently change your picture. To revert the image back to its original settings all you need to do is select one of the Adobe created profiles from the Camera Profile menu in the Camera Calibration section of ACR.

Reprocessing older Raw files As we have already mentioned, one of the biggest changes for Adobe Camera Raw in the last couple of versions is the reworking of the engine that builds the images we see from the Raw data captured by the camera. It is largely this engine update that underpins much of the improved tonal controls and changes to curves and adjustment brush features in ACR 7/8, but how does it fit in with images that have been processed in previous versions of the utility?

When opening the file, Adobe Camera Raw 8 respects the processing I have already made to the photo and dutifully displays the picture using these settings. I do, however, have the addition of a warning button displayed in the bottom right of the display. This indicates that the photo is being processed using the a previous demosaicing engine and that it is possible for me to reprocess the file with the 2012 version. When you click this button, ACR does its thing, the warning button disappears and new life is breathed into the old picture.

The warning button is displayed in the bottom right of the workspace when a Raw file that has been processed with the 2003 engine is opened in latest version of ACR. Clicking the button will rework the photo with the new 2012 engine.

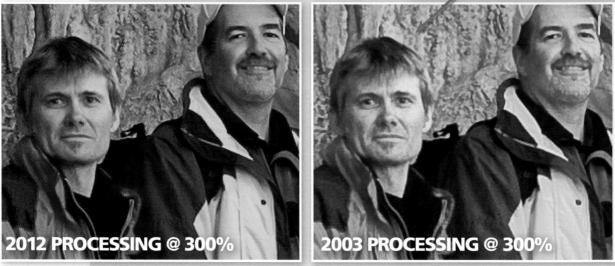

The details in the examples clearly show the difference between the two different demosaicing methods. The 2012 option displays more detail and at the same time smoother transitions than its 2003 counterpart.

What's the difference?

At first glance you mightn't see much difference between the two versions of the file but if you do a side-by-side comparison at 300% you will start to notice some distinct differences. The first thing you should see is that the somewhat plastic-looking flat areas of tone that appear with some images have disappeared. Instead, in their place is a more textured rendering of the photo. There is more detail present in the 2012 processed file and the detail is more refined. The graduation between contrasting areas is smoother and the middle values of the picture, in particular, feel sharper and cleaner. In fact, the differences are so pronounced that many photographers are now revisiting their older images and reworking them with the new version of Adobe Camera Raw (or Lightroom 4/5 – which has the same engine) to take advantage of the image improvements the new engine offers. Plus you will have access to all the new local adjustment, curves and tonal controls.

Global tonal adjustments – Step 6

In the last chapter we looked at how careful adjustment of the tonal controls listed directly beneath the White Balance sliders will allow you to get the best out of the dynamic range of your imaging sensor, thereby creating a tonally rich image with full detail. For more details on using these controls revisit the appropriate section in the last chapter.

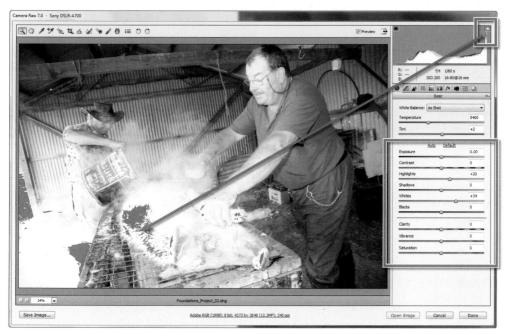

The example image has some real problems with overexposure and therefore potential clipping in the highlight areas of the photo. Careful adjustment of the Whites and Highlights sliders will help with this problem but not totally remove it.

In this example we will start by adjusting the tones and color 'globally'. That is, making changes to the whole of the image. Next, unlike in the previous chapter, we will fine-tune the results by using the new Adjustment Brush to alter specific sections of the photo. These types of changes are a fairly recent addition to ACR and are called 'local' corrections.

But we're getting ahead of ourselves. To start with the global changes you will need to set the overall brightness and contrast of the midtones using the 'Exposure' and 'Contrast' sliders. Make sure that the clipping warnings for both highlights and shadows are active when making these changes. Immediately you will notice how much of the highlight detail is displayed with the red highlight warning. Don't be too concerned about this, just concentrate on the middle tones in the image.

Now reclaim some of the clipped highlights by dragging the Whites slider all the way to the left. Most of the clipping will be gone but still there is little detail in these bright areas so also drag the Highlights slider to the left until you can see the first glimpse of detail. Use the Blacks slider set to the black point and the Shadows slider to lighten the very dark shadow tones that may not print with any texture or detail.

Next you can return to the Exposure and Contrast sliders to fine-tune the midtone values. Remember use the Highlights slider to recover lost highlight details instead of moving the Exposure slider to the left as this action will also darken the midtones.

Advanced clipping information

Remember that holding down the Alt/ Option key when adjusting either the Whites or Blacks slider will also provide an indication in the image window of the channel, or channels, where clipping is occurring. Excessive color saturation for the color space selected, as well as overly dark shadows and overly bright highlights, will also influence the amount of clipping that occurs. Clipping in a single channel (indicated by the red, green or blue warning

The channel, or mix of channels, being clipped are also displayed as a change of color of the arrow in the buttons at the top of the histogram.

colors in the arrows) will not always lead to a loss of detail in the final image. However, when the secondary colors appear (cyan, magenta and yellow), you will need to take note, as loss of information in two channels starts to get a little more serious. Loss of information in all three channels (indicated by black when adjusting the shadows and white when adjusting the exposure) should be avoided.

Note > Large adjustments to the Exposure, Contrast or Saturation sliders may necessitate further 'tweaking' of the Whites, Highlights, Shadows or Blacks sliders.

Controlling saturation and vibrance - Step 7

Increasing saturation in ACR can lead to clipping in the color channels. Clipping saturated colors can lead to a loss of fine detail and texture. Saturation clipping is especially noticeable when you have selected the smaller sRGB color space and have captured an image with highly saturated colors. As this image will end up being a split-toned monochrome we'll step away

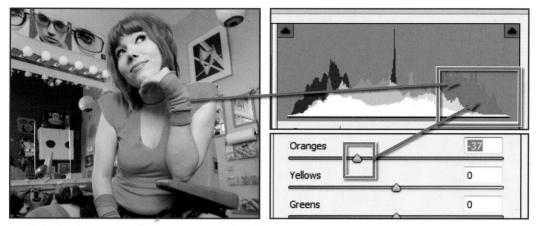

High levels of saturation clipping present in this file were corrected with the help of the Saturation controls in the HSL tab – saturation could then be increased reasonably non-destructively using the Vibrance slider.

Image of Melissa Zappa by Victoria Verdon Roe.

from the example photo for a moment in order to illustrate saturation and vibrance. Instead we will use the more colorful image to illustrate these issues. The Vibrance slider applies a non-linear increase in saturation (targeting pixels of lower saturation). It is also designed to protect skin tones in order to prevent faces from getting too red. It should create fewer clipping problems when compared to the Saturation control.

In images where some colors readily clip due to their natural vibrance (especially when using a smaller gamut such as sRGB), lowering the global saturation in order to protect the clipping of a single color can result in a lifeless image. In these instances the user can turn to the HSL tab to edit the saturation of colors independently.

Note > Choosing a larger color space such as ProPhoto RGB, where the colors rarely clip, is only a short-term solution. The color gamut must eventually be reduced to fit the gamut of the output device. ACR is currently the easiest place in Photoshop to massage these colors into the destination space.

Localized correction - Step 8

In earlier versions of ACR, all alterations were applied to all of the image, with the exception of the Spot Removal tool, which corrected dust marks on small portions of the image. This meant that for those of us who wanted to perform a seemingly simple operation, such as a little dodging or burning, we needed to transfer the file from ACR to Photoshop where the editing changes could be made. 'Okay, this is only a small inconvenience,' you may say, but it was the changes made to the file during this transfer that had Raw devotees frustrated. In moving the picture from ACR to Photoshop, the file needed to be converted from its Raw origins to a standard file format such as PSD (Photoshop), TIFF, or JPEG. All the advantages of non-destructive editing changes that constitute the very basis of enhancement steps in ACR are lost in the conversion process. This is still true for many Raw images, except those that are placed in Photoshop as Smart Objects.

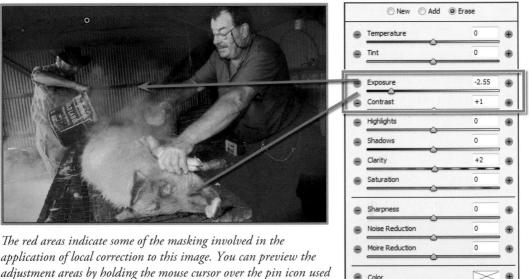

application of local correction to this image. You can preview the adjustment areas by holding the mouse cursor over the pin icon used to indicate the starting point for the adjustment or selecting the Show Mask option in the Adjustment Brush pane.

In the last couple of releases it is possible to perform localized corrections (as opposed to global ones) directly inside the program. More important is the fact that these corrections are applied in the same non-destructive manner as all other alterations in the program. In other words, the changes are made via a series of parameter settings which are stored in an associated file and are used to create a preview of how the Raw file would look with the settings applied. It is this processed preview that we see in the ACR preview and Bridge Content and Preview panes. The primary Raw file is never converted to a non-Raw format (except when exporting or opening in Photoshop) and as the enhancements are simply a series of stored settings, the file can be restored to its original appearance at any time.

Size

12

But how do local corrections work?

Most localized corrections are based around a new tool called the Adjustment Brush (shortcut key K). The tool uses a brush-type icon and is grouped together with the other tools in the toolbar that sits at the top of the workspace. Here you will also find a new Graduated Filter tool as well, but more on this later.

Applying a localized correction is essentially a two-step process. First you mark out the adjustment area (similar to making a correction) and then you fine-tune the degree and type

Two new local correction features are contained in the ACR toolbar – the Adjustment Brush (shortcut key K) and the Graduated Filter (shortcut key G).

of adjustments made to this area. It is important to understand that unlike an action such as dodging and burning, performed in Photoshop, working with local adjustments in ACR means that you can manipulate the degree of adjustment and, if need be, you can also switch the image parameter you are adjusting as well after the changes have been made. For example, after painting on the adjustment area using an Exposure value of -2.80 EV so that the effects can be clearly seen on the image, you can then change to the Edit mode for the tool and drag the Exposure value back to 0 and input a value for Saturation instead. If that isn't powerful enough you can also create a custom adjustment mix that includes settings for multiple image characteristics all applied to the same adjustment area.

Adjustment Brush workflow

Select the Adjustment Brush – The first step in the process of using localized corrections in Adobe Camera Raw involves selecting the new Adjustment Brush tool situated in the toolbar at the top of the workspace. This will open up a new pane containing a range of image characteristics that you can adjust within your image. Select the primary effect that you wish to change from the pane. Here I used Exposure with a setting of -2.74 EV.

Set brush tip characteristics – Next you need to set the brush tip characteristics. You essentially have four controls here – Size, Feather, Flow (similar to airbrush where multiple strokes build up the effect) and Density or level of effect. The brush tip is displayed with two concentric circles. The outer one represents the edge of the brush, the inner circle outlines where the brush is solid and the space between is the width of the feather.

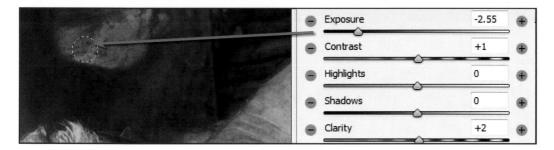

Paint in the adjustment mask – With the effect and the brush tip now set, move the cursor over the image and paint in the area to be adjusted. Notice that the adjustment is made in real time on your image. I purposely used a strong 'underexposure' setting so that I could clearly see the extent of the painted area. Don't be concerned if the effect is too strong or not the style required as these can be tweaked later. Continue to build up the mask by painting in the areas to be adjusted. Alternatively you can click the Show Mask option to display the selected areas.

On-the-fly masking – At the bottom of the Adjustment Brush pane is an Auto Mask option. Use this setting to get ACR to automatically try to restrict the mask within the boundaries of high contrast objects. When painting with this option selected, make sure to keep the inner circle within the area, or within the edges of objects, to be adjusted.

Fine-tune the adjustment – Notice that once you start to paint, the mode at the top of the pane switches from New to Add. While in the Add mode you can proceed to fine-tune the changes made to the various image characteristics using the sliders. Although I initially selected the Exposure slider, I can now include other characteristics in the mix.

Adding to, subtracting from and creating new localized corrections

Adding to – Once an adjustment area or mask has been created it is possible to add other parts of the image to this area by selecting the Pin icon for the area. This activates the Add mode for an existing painted area. Now continue to paint with the brush tip. The enhancement changes for the newly painted area will be exactly the same

style and degree as those already existing in the previously painted section. While in the Add mode it is possible to change the image's characteristics (e.g. Exposure, Brightness, Contrast, etc.) that are being changed by the adjustment. The tool is automatically placed in this mode after creating a new mask. You must select another mode (New or Erase) or choose another tool from the ACR toolbar to cease the Add function.

Subtracting from – As well as being able to add to an existing adjustment area you can also remove parts from this mask. To do so either hold down the Alt/Opt key and paint away the areas to remove or click on the Erase entry in the Adjustment Brush pane. While in this mode you

can refine the areas of the picture that are being affected by the localized adjustment.

Creating new – When first selecting the Adjustment Brush the feature is placed in the New mode in anticipation of creating a fresh or initial localized adjustment. The Adjustment Brush automatically changes from New to Add modes when you apply the first stroke of a new mask. From that time forward additional

painting strokes will continue to build the mask until a new mode is selected or you select another tool.

Note > To jump out of the Adjustment Brush mode, just click on another tool.

Adjustment Brush III Add Erase Temperature 0 Tint 0 ⊕

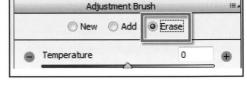

Adjustment Brush

🔿 Add 🛛 🔿 Erase

0

New

Temperature

Adjustment Brush					
	🔘 New	Add	🔘 Erase		
🖨 🖻	posure	<u></u>	-1,10		
e Br	ightness		0		
	ontrast		+36		
Sa	aturation		0		

Project application: Using the example image and the Adjustment Brush, make two separate localized corrections to the photo. First, burn in extra detail to the lower left part of the picture and the back of the pig by painting in negative Exposure. Next, use the Auto Mask to isolate the blue shirt area on the subject on the right and reduce the saturation of the shirt. Try switching between Add and Erase modes to fine-tune the areas being adjusted.

Raw versus JPEG corrections

Being able to perform localized corrections in ACR is a real improvement in tricky situations such as the example image used here. This is because the corrections are performed on the Raw file. Stated like that, this fact may seem a little underwhelming but have a look at the example images below and you will see why this is a key issue. The

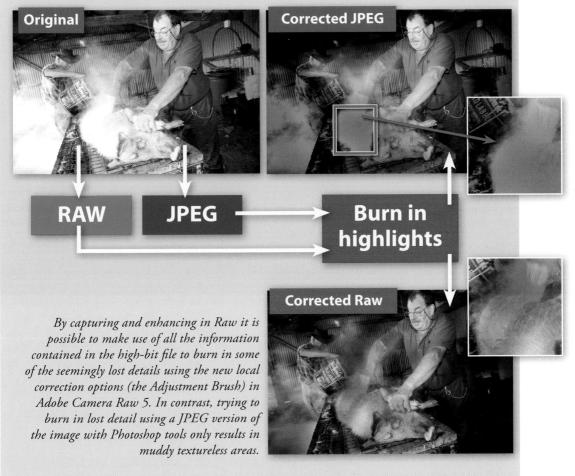

original was shot in an open barn on one of the back roads of Tasmania. The lighting was always going to be tricky so to help even out the foreground some fill flash was added to the foreground. This worked fine in that portion of the image, but further back and to the left, the extra light coming into the barn blew out the highlights. It is easy to lose detail in highlight and shadow areas with incorrect exposure settings. When a camera is set to JPEG as the capture format, often subtle details that would be held in the high-bit Raw file are lost during the conversion to the lower-bit JPEG format. If we take the process one step further and try to burn the lost detail back into the photo using the Burn Tool in Photoshop you will start to see the problem. Rather than ending up with extra visual information we end up with a muddy mess.

If, instead, the image was captured and stored in Raw and then processed in Adobe Camera Raw using the localized correction tools then the outcome would be drastically different (see above for the comparisons). Because of the extra bit depth of the Raw file, more of the original details are retained in the highlight areas of the image. When ACR is put to work on these details a substantial amount of seemingly lost information can be revealed. If you have been wavering about whether to switch from JPEG capture to Raw then this example should help you with the decision.

Grayscale conversion and toning – Step 9

At this point the example image has been adjusted both globally and locally and, if we wanted a color outcome, we would apply some sharpening and noise reduction (see Step 11) and then output the file (see Step 12), but in this instance the end result is a split-toned monochrome. So the next part of the process is to convert to gray and then we'll tint the photo with separate colors for highlights and shadows.

HSL/Grayscale

Drawing inspiration from the type of features located in Lightroom, the options in the HSL/ Grayscale pane provide control of the Hue, Saturation and Luminance of each color group (red, orange, yellow, green, aqua, blue, purple and magenta) independently.

This is a great improvement over what was available previously, when color changes were limited to red, green and blue channel-based divisions and saturation control. There are also three tabs across the top of the pane that allow color range adjustments to be made to the Hue (color), Saturation (color strength) and Luminance (brightness) independently. Clicking the Grayscale tickbox switches the pane to a monochrome conversion mode with only one tab display, where the color range sliders adjust the type of gray that the hue is being mapped to. Let's look at each section in turn.

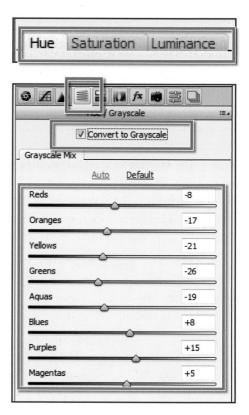

Raw processing

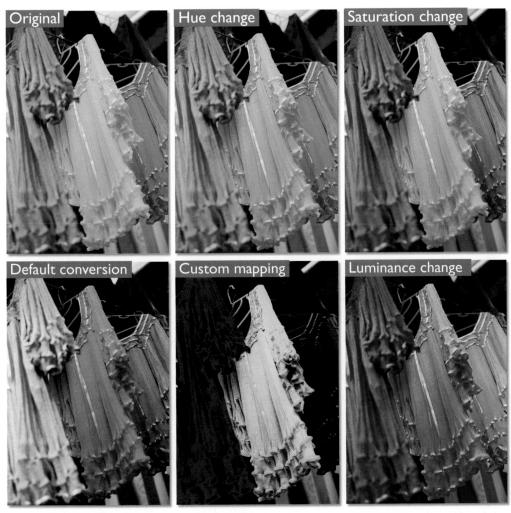

The HSL/Grayscale pane provides color range-based controls for altering the hue, saturation and luminance of the colors in your photo. In the Grayscale mode you can adjust how specific colors are mapped to gray.

Hue – The Hue tab in the HSL control provides the ability to tweak the flavor of a specific color range. Unlike the drastic changes brought about by the Hue control in Photoshop's Hue/ Saturation feature, the sliders here manipulate the color of a selected color within a given range. The Reds slider, for instance, moves from a magenta red through to a pure red to an orange red. Moving this slider would enable the fine-tuning of just the reds in a photo between these limits.

Saturation – The Saturation control provides the ability to customize the saturation of not the whole image as is provided with the Saturation slider in the Basic pane, but a specific range of colors. Try adjusting the Blues slider with the example image of the shearer and notice the change in the strength of the color of the shirt worn by the subject on the right.

Luminance – The third tab in the HSL control deals strictly with the luminance of specific colors. With the sliders grouped here it is possible to change the brightness of a color grouping, which can translate into altering the color contrast in a photo by selectively increasing and decreasing the brightness of opposite hues.

Grayscale – By clicking the Convert to Grayscale option the feature changes to provide a method for creating custom mapping of the same color groupings to gray. Using this control it is possible to restore contrast to a grayscale conversion when the different colors in the photo have translated to similar tones of gray, producing a lowcontrast monochrome.

Project application: In the example image you may need to flip back to the controls in the Basic pane and make some adjustments to Contrast, Exposure and Blacks sliders alongside the changes made with the HSL sliders in order to ensure sufficient contrast results in the conversion.

Targeted Adjustments in ACR

The majority of the image changes made with the editing features in ACR are done so via a set of controls in a panel. These generally come in the form of sliders which are dragged to alter the appearance of the image. But there is a way to adjust your photos which is much more direct. The Targeted Adjustment tool (TAT) is accessed via a button located on the utilities toolbar at the top of the workspace.

0 4. 4. 1/ 10		
✓ Parametric Curve	Ctrl+Shft+Alt+T	
Hue	Ctrl+Shft+Alt+H	
Saturation	Ctrl+Shft+Alt+S	
Luminance	Ctrl+Shft+Alt+L	
Grayscale Mix	Ctrl+Shft+Alt+G	
ALM	THEFT	

The unique characteristic of the TAT is that it is used to make changes by click-dragging on the image itself. After selecting the tool, move the cursor over the picture until it sits on an image part that you want to change. If you have the Parametric Curve option selected then this would translate into either darkening

First introduced in ACR 5.2 the Targeted Adjustment tool, or TAT, as it is unfortunately referred to, provides direct control over the tones and colors in your image.

or lightening the tones that you select. Next, click-drag the cursor upwards to lighten the area, or downwards to darken it. This is a very interactive way of adjusting your pictures and all changes made with this tool are reflected in changes to the shape of the curve and the settings of the sliders below it.

Like Lightroom, the TAT in ACR can be used to alter the values of four different image characteristics. Simply select the type of adjustments that you want to make from the drop- down menu beneath the tool's button and click-drag to make the change. The choices are revealed by holding down the mouse button on the small downwards-facing arrow located at the bottom right of the tool's icon. Alternatively, you can switch between options by taking advantage of the shortcut keys associated with each image adjustment type or choosing the entry from the right-click context menu.

Using TAT makes image adjustment a lot more intuitive and as long as you have the Highlights and Shadows clipping warnings active (in the top corners of the histogram) you can edit freely knowing that any clipping that occurs as a result of the adjustments will be displayed on the preview image.

Right: In this example the model's skin was lightened by dragging the cursor upwards with the Parametric Tone Curve selected. **Below:** With several quick mouse clickdrags the (1) Hue, (2) Saturation or (3) Luminance of the background can be altered. The TAT can also be used to adjust the mapping of particular colors to gray using the Grayscale Mix (4).

Florian Groehn (photographer), Lea Lazarescu (Dallys Models), Lily Fontana (make-up), Lucia Martinez (styling) and Tim Ashton (photographic assistant).

The controls in the Split Toning pane provide the ability to tint shadows and highlights slightly different colors. The Balance slider also allows for the adjustment of the split point between the tint used for highlights and the one used for shadows.

Split toning

When first introduced to ACR, monochrome workers rejoiced at the inclusion of the dedicated Split Toning pane as the controls provide the ability to use the included Hue and Saturation sliders to tint highlights and shadows independently. Hue controls the color of the tint, and Saturation controls its strength. Holding down the Alt/Opt key while moving either of the Hue sliders will preview the tint at 100% saturation (full strength), allowing for easier selection of the correct color. After selecting the color you need to adjust the saturation. To understand how the Hue slider works, imagine the control moving progressively through the colors of the rainbow from red, through yellow, green and blue to purple and magenta.

Also included is the Balance slider, which provides the ability to change the point at which the color changes. Movements to the right push the split point towards the highlights, whereas dragging the slider to the left means that more mid to shadow areas will be colored the selected highlight hue.

Remember that to use split toning with a monochrome image you must make the conversion to grayscale first. Do this by selecting the Convert to Grayscale option in the HSL/Grayscale pane first. Then move back to the Split Toning pane and adjust Highlight and Shadow Hue and Saturation and then the Balance point to suit.

Note > Don't restrict your split toning activities solely to the realms of monochromes. The feature can also be applied to color images as well, providing some rather striking results.

Project application: Split tone the project image so that the highlights are tinted traditional sepia brown and the shadows contain a slightly blue tinge.

Raw processing

Adding special effects - Step 10

The post-crop vignetting features that used to be in the lens vignetting options in the Camera Calibration pane in the previous releases are now in the Fx pane.You will also find a Grain feature included in the pane as well.

Remember that because both these artistic image adjustments are applied in Adobe Camera Raw they are added nondestructively to the photo. This means that not only can you return to the settings used and make changes when needed, but it is also possible to remove the effect totally without any residual changes being left in the original photo.

Grain

The Grain feature allows you to apply a grain effect to your photos. It contains three slider controls for adjusting the strength (Amount), Size and smoothness (Roughness) of the grain. You can use this feature to mimic old world photos or provide a film-like feel to your images.

S 🖍 📰 🔚 🛤 Á Effects	
Grain	
Amount	45
Size	25
Roughness	50
Post Crop Vign	etting
Amount	32
Midpoint	56
Roundness	-39
Feather	56
Highlights	23

The Fx pane contains both the updated Post Crop Vignetting controls and the new Grain setting.

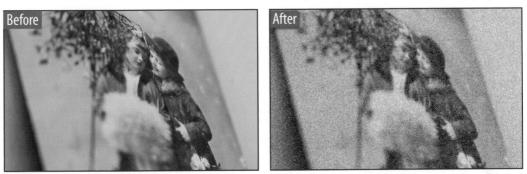

You can add grain-like texture to photos as part of your non-destructive editing workflow.

Post Crop Vignetting

The ability to apply vignetting adjustments to a cropped photo was first introduced in ACR 5 and was updated for ACR 6, and has been unchanged for the last couple of versions. This feature differs from the vignetting option found in the Lens Corrections pane where the vignetting changes are applied to the original full frame image, rather than the cropped picture. That approach is fine when used for correcting lens-based vignetting, but is not appropriate when photographers desire an artistic outcome rather than a lens correction solution. This set of vignetting tools provides the ability to apply such artistic vignetting to the cropped image and to automatically adapt to a new format if the cropping is removed or changed.

With the inclusion of different vignetting styles and a dedicated slider for highlight adjustments, the feature provides great control over the look of the vignette and how it interacts with the photo. Paint Overlay is the style found in the earlier versions of the feature and Highlight and Color Priority options give more weighting to either of these characteristics when darkening or lightening photo edges. The Amount slider controls the strength of the correction effect and the

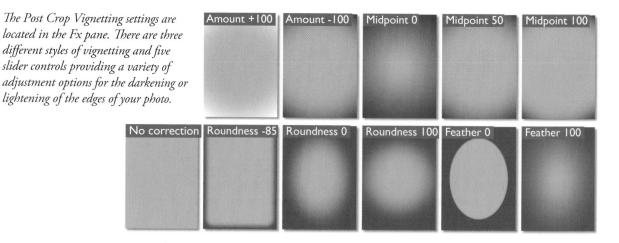

Midpoint alters how much of the image is included in the enhancement. The Roundness slider controls the shape of the vignetted area and Feather is used to adjust the softness of the edge of the vignette. The Highlights slider controls the way that the vignette blends with the lighter tones in the photo and is only available in the Highlight Priority and Color Priority styles and when the Amount is set to darken edges (negative values).

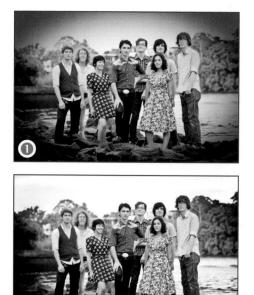

The Post Crop Vignetting (PCV) options offer creative control over the corner darkening and lightening process with the inclusion of a new Highlight Contrast slider and a choice of vignette styles.

(1) PCV without highlight control.(2) PCV with highlight control.

Project application: To get you up to speed on the Post Crop Vignetting tools, darken the edge of the project image using a vignette that has full Feather and a negative Roundness value. This will add a soft-edged darkening of the edges. The Grain feature will be used in the next project.

The new Radial Filter

New to ACR 8 is the Radial Filter. I include it here as it provides a way to apply off-center vignette-like adjustments to your images. The feature allows you to enhance your pictures using all the options of the Adjustment Brush and the Graduated Filter but apply these through an oval-shaped mask which can be positioned anywhere on the image canvas. The shape of the oval mask is control by dragging any of the four handles located on the side of marquee and the marquee

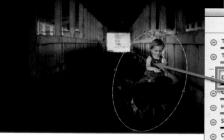

The Radial Filter is used to apply adjustments via an oval-shaped mask.

	Radial Filter		16.
	⊖ New ⊙	Edit	
Θ	Temperature	0	•
Θ	Tint	0	•
-	Exposure	-1.55	•
0	Contrast	0	Θ
Θ	Highlights	0	•
Θ	Shadows	0	•
Θ	Clarity	0	•
Θ	Saturation	0	•
9	Sharpness	n	10

is repositioned by dragging the red dot in the center. Adjustment changes can be applied either inside or outside the mask using the options in the panel on the right side of the ACR workspace. There is also a slider control here to adjust the transition between the enhanced and masked areas.

This new feature means there are now three places to apply vignette type enhancements in ACR - via Lens Corrections, Post Crop Vignetting, and now the Radial Filter.

Noise reduction and sharpening - Step 11

To access the sharpness and noise reduction controls click on the Detail tab. Set the image view to 200%. The Luminance and Color sliders (designed to tackle the camera noise that occurs when the image sensor's ISO is high) should only be raised from 0 if you notice image artifacts such as noise appearing in the image window.

Note > Zoom image to 200% to determine levels of noise present in the image.

The Noise Removal system which was updated for ACR 6 makes it possible to produce substantially smoother images from noisy originals and still maintain fine details. (1) ISO 800 image before noise reduction. (2) After noise reduction.

Noise control

In the example image above, the sensor was set to ISO 800 on a budget DSLR. Both luminance noise (left) and color noise (right) are evident when the image is set to 200%. When using more expensive DSLR cameras that are set to ISO 100, it may be possible to leave the Luminance and Color noise sliders set to 0. In the Noise Removal system revamp for ACR 6, not only were the algorithms used for reducing the appearance of noise re-engineered but three new sliders were added to the pane. Luminance Detail and Color Detail sliders reintroduce a measure of texture into areas that have been overly smoothed by the Luminance and Color sliders and the Luminance Contrast slider increases the contrast areas which have been rendered flat by the system. Used in combination, these five sliders have the ability to transform very noisy images into usable photos. From ACR 7 we were given the ability to paint Noise and Moire reduction onto specific parts of the image using the Adjustment Brush and now via the Radial Filter.

Detail	
Sharpening	
Amount	111
Radius	12
Detail	34
Masking	0
Noise Reductio	on 20
Luminance	20
Luminance	20

Warning > Though much improved, the Luminance and Color sliders can remove subtle detail and color information that may go unnoticed if the photographer is not careful to pay attention to the effects of these sliders. Use the Luminance Detail and Color Detail sliders to bring back lost texture. Zoom in to take a closer look, and unless you can see either the little white speckles or the color artifacts keep these sliders set at 0.

The three-pass sharpening workflow

Sharpening is an enhancement technique that is easily overdone and this is true even when applying the changes at the time of Raw file editing. The best approach is to remember that sharpening is applied at three points in the process – capture, locally and output.

The settings applied in Adobe Camera Raw with settings in the Detail pane are used for overall capture sharpening; local or paint-on sharpening is applied with the Adjustment Brush set to Sharpness; and the output side of things is handled as the last step of the editing process. In Adobe Camera Raw this last sharpening step is applied via the Workflow Options settings and takes into account output media, sharpening strength, size and resolution. In practice this means that all images should be sharpened to some extent in ACR first, specific areas sharpened more with the Adjustment Brush, and then specific sharpening, determined by output size and media surface, applied later in the process.

All digital photos can benefit from cleverly applied sharpening as it adds clarity to images that, if left unsharpened, appear blurry. (1) No sharpening applied. (2) After global and localized sharpening in ACR.

Capture sharpening: Adobe Camera Raw contains four sliders in the Detail pane that are designed to aid in overall or capture sharpening. The Amount slider determines the strength of the effect. The Radius slider is used to adjust the range of pixels used in the sharpness calculation. Detail and Masking both control where the sharpening effect is applied. Increasing the Detail value raises the local contrast around small picture parts, making these appear sharper. Moving the Masking slider to the right gradually restricts the sharpening to just the most contrasty edges of the picture (for visual examples of masking in action see the previous chapter).

Localized sharpening: Localized sharpening is added using the Adjustment Brush. Take a look at the example images on the opposite page. The detail on the left has no sharpening applied and represents the look of a file as it appears 'straight from the camera'. The detail on the right has had global sharpening (via the controls in the Detail pane) and local sharpening (via the Adjustment Brush) applied. In this instance,

Amount	111
Radius	0.8
Detail	23
Masking	0

the Adjustment Brush was used to paint on more clarity around the glasses and stubble area on the man's face.

Output sharpening: Different

output types require different degrees and styles of sharpening. The settings you would use when printing on matte paper for instance, will be very different to the sharpening values employed for the same photo being printed on glossy paper. The Sharpen For setting in the Workflow Options dialog gives you the choice of gloss paper, matte paper or screen and the Amount value determines the strength of the effect. You can opt

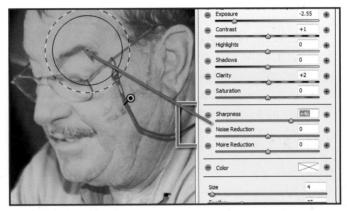

for low, standard, or high sharpening. The sharpening settings are applied to the image when opening or saving the file.

Note > Always make sure that the preview is zoomed to a value of 100% before manipulating these controls so that you can preview the effects. Holding down the Alt/Opt key when adjusting the sharpening sliders in the Detail pane provides a preview of the settings for each slider as the effect is applied. For

Space:	Adobe RGB (1998)			-	ОК
Depth:	8 Bits/Channel				Cancel
Crop Size:	6 by 4 inches	•			
Resolution:	240 pixels/inch			-	
harpen For	Matte Paper	Amoun	Standard	-	
	None Screen Glossy Paper	art Obje	Low s Standard High		

more details on these Sharpening controls refer to the Sharpening and Image section in the previous chapter.

Output options - Step 12

Apart from the Open Image button, Adobe Camera Raw provides several other options that will govern how the file is handled once all the enhancement options have been set. To this end, the lower part of the dialog contains four buttons, Save Image, Open Image, Cancel and Done, and a further three, Save Image (without the options dialog), Open Copy, and Reset when the Alt/Option button is pushed, and Open Object when the Shift key is pushed.

Cancel: This option closes the ACR dialog, not saving any of the settings to the file that was open.

Save Image: The normal Save Image button, which includes several dots (...) after the label, displays the Save Options dialog. Here you can save the Raw file, with your settings applied, in Adobe's own DNG format as well as TIFF, JPEG and PSD formats. The dialog includes options for choosing the location where the file will be saved, the ability to add in a new name, as well as format-specific settings such as compression, conversion to linear image and/or embed the original Raw file for the DNG option.

It is a good idea to select Save in Different Location in the Destination drop-down at the top to keep processed files separate from archived originals. Clearly the benefits of a compressed DNG file are going to help out with storage issues and compression is a big advantage with DNG. Embedding the original Raw file in the saved DNG file begs the question of how much room

you have in the designated storage device and whether you really want to have the original Raw file here.

Save (without save options):

Holding down the Alt/Option key when clicking the Save button skips the Save Options dialog and saves the file in DNG format using the default save settings, which are the same as those last set.

Open Image: If you click on the Open Image button ACR applies the conversion options and opens the file inside the Photoshop workspace. At this point, the file is no longer in a Raw format so when it comes to saving the photo from the Editor workspace, Photoshop automatically selects the Photoshop PSD format for saving.

Reset: The Reset option resets the ACR dialog's settings back to their defaults. This feature is useful if you want to ensure that all settings and enhancement changes made in the current session have been removed. To access the Reset button click the Cancel button while holding down the Alt/Option key. This action cannot be undone.

Save Image		
Open Image	Cancel	Done
	Standa	ard button display.
Save Image		
Open Copy	Reset	Done
		and the second

ave Image		
Open Object	Cancel	Done

Display when Shift key is pressed.

Adobe Camera Raw contains four default output buttons, Save Image (with options) Cancel, Open Image and Done, plus an extra four when the Alt/Option or Shift keys are pressed. **Done:** Clicking the Done button will update the Raw conversion settings for the open image or images. Essentially this means that the current settings are applied to the photo and the dialog is then closed. The thumbnail preview in the Bridge workspace will also be updated to reflect the changes. In effect this is also a save button.

Open Copy: Holding down the Alt key while clicking the Open button will apply the currently selected changes to a copy of the file which is opened inside the Photoshop workspace.

Open Object: The most exciting new addition to the list of ACR output options is the Open Object entry, which is displayed when the Shift key is held down. Choosing Open Object will create a new document in Photoshop and embed the Raw file in the document as a Smart Object. This route for transferring your files to Photoshop is the only one that continues to work with the picture in a lossless manner and is the core of many of the non-destructive editing techniques discussed in the next chapters.

Project application: Click the Save button (bottom left), pick DNG as the file format and input the following title – *foundations-proj-02-after*. This way you will be able to compare the before and after versions of the project files in the Bridge preview pane.

Space: Adobe F	RCB (1998)		+	Depth:	8 Bits/Channel	<u></u>	Cancel
Intent: Relative			\$)	🔘 Sim	ulate Paper & Ink		
mage Sizing							
Resize to Fit:	Default	(13.3 MP)		•	Don't Enlarge		
W :	2976	H : 4464	pixels	\$			
Resolution:	300	pixels/inch		•			
Output Sharpening	,						
Sharpen For:	Matte Pa	aper	\$	Amount:	Standard	•	
hotoshop							
		mart Objects					

By selecting the 'Open in Photoshop as Smart Objects' setting in the Workflow Options dialog of ACR, the Open button will change to Open Object. From that point on, your Raw files will always be placed into a Smart Object layer in a new Photoshop document when you click the Open Object button.

The Graduated Filter tool is another form of localized adjustment. This feature can be used to apply custom gradients across the full height or width of the photo. Once created, the size, position and rotation of the gradient remains editable along with the image characteristics that can be altered via the gradient.

Foundation Project 3

As an extension of the ability to apply localized corrections in Adobe Camera Raw, the engineering team at Adobe also added a Graduated Filter tool to the utility. Working like a combination of the Photoshop's Gradient tool and ACR's Adjustment Brush, the feature provides the user with the ability to add graduated enhancement changes to their images. This is useful for picture-wide changes such as darkening skies and can be used in conjunction with the Adjustment Brush in an 'add filtration and paint out the areas where it is not wanted' fashion. Again, application is a two-step process, just as it was with the Adjustment Brush. First, you define the size, position and direction of the gradient, then you fine-tune the filter effects using the same image parameter slider controls found in the Adjustment Brush.

In this project we'll apply the Graduated Filter tool to a landscape image and then fine-tune its placement with the Adjustment Brush before adding some film-like grain with the new Grain feature.

Preliminary enhancements - Step 1

When opening the project file you will notice that no changes have been made to the image. This is the Raw file straight from the camera. Before commencing the application of the Graduated Filter work your way through the steps laid out in the previous project to enhance the image. Once you are happy with the results then move on to the next step.

Add a Graduated Filter effect - Step 2

Start by selecting the Graduated Filter tool from the toolbar at the top left of the ACR workspace. Next select and adjust the primary enhancement change that you wish to make from those listed in the Graduated Filter pane that is displayed on the right of the workspace. Here I have chosen Exposure. Locate a starting point on the photo and then click-drag a gradient effect on the image. The starting point (displayed as a green pin) is where the effect is the strongest, gradually lessening until you release the mouse button (marked by a red pin). The longer the drag the more gradual the gradient change. Hold down the Shift key to add gradients either horizontally or vertically. A second Graduated Filter is added to the bottom of the image, dragging the effect up through the rocks.

In the project image the upper and lower portions of the photo have been adjusted with two separate Graduated Filters. The lower filter just altered exposure whereas the upper one changed the Color characteristic as well.

Adjust the Graduated Filter effect – Step 3

Once you have added a Graduated Filter to the photo you can adjust the gradient to change the enhancement characteristics. Click onto either Pin icon that represents the filter and then adjust the slider controls in the pane. When a pin is selected the feature is switched to the Edit mode. To create a different Graduated Filter click-drag in another part of the image. In addition to these changes you can also rotate, move and adjust the size of the gradient by click-dragging either pin or, once the filter is selected, by moving any of the three lines displayed on screen. Gradients may be adjusted individually using this technique. Adjust the upper graduated filter to -100 Saturation, -3.00 Exposure and then add a Color to reflect the hue of the sea below. The lower Graduated Filter should be set to -2.50 Exposure only.

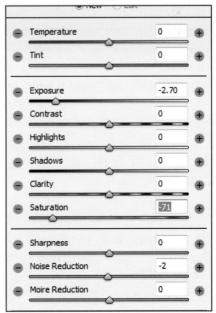

Reclaim some of the filtered detail - Step 4

Dragging the lower filter over the foreground rocks causes them to be darkened with an effect that tends to blend into the background. Restore their original visual dominance by selecting the Adjustment Brush, setting it to Auto Mask to keep the corrections to just the rocks, and painting on a change to Exposure and Contrast.

Add a film-like Grain effect - Step 5

The last step in this stylized enhancement is to add some texture to the image. Unlike the situation in the last project where our aim was to minimize noise and maintain sharpness and detail, here we will use the Grain feature to add a film-like quality to the photo. The feature contains three sliders – Amount for the density of grains in a given area, Size which controls the dimensions of the grain particles, and Roughness for how uniform the shape of the grain is. In our example I add small, tight grain to give the sense of texture to the image by using the settings – Amount 60, Size 5 and Roughness 70.

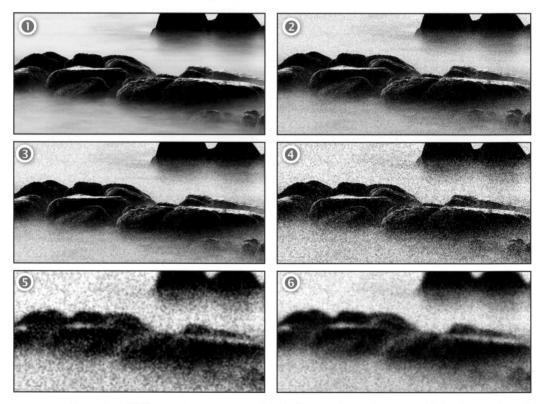

Examples of different grain types created with the new Grain feature in Adobe Camera Raw 6. (1) No grain applied. (2) Grain settings -60, 5, 70 (Amount, Size, Roughness). (3) 45, 20, 100. (4) 100, 20, 10. (5) 100, 100, 100. (6) 100, 100, 50.

Digital exposure

Most digital imaging sensors capture images using 12 bits of memory dedicated to each of the three RGB color channels, resulting in 4096 tones between black and white. Most of the imaging sensors in digital cameras record a subject brightness range of approximately five to eight stops (five to eight f-stops between the brightest highlights with detail and the deepest shadow tones with detail).

Tonal distribution in 12-bit capture

Darkest Shadows	- 4 stops	- 3 stops	- 2 stops	-1 stop	Brightest Highlights
· 25% of	f all levels =		*		75% of all levels

Distribution of levels.

One would think that with all of this extra data the problem of banding or image posterization due to insufficient levels of data (a common problem with 8-bit image editing) would be consigned to history. Although this is the case with midtones and highlights, shadows can still be subject to this problem. The reason for this is that the distribution of levels assigned to recording the range of tones in the image is far from equitable. The brightest tones of the image (the highlights) use the lion's share of the 4096 levels available while the shadows are comparatively starved of information.

Shadow management

CCD and CMOS chips are, however, linear devices. This linear process means that when the amount of light is halved, the electrical stimulation to each photoreceptor on the sensor is also halved. Each f-stop reduction in light intensity halves the amount of light that falls onto the receptors compared to the previous f-stop. Fewer levels are allocated by this linear process to recording the darker tones. Shadows are 'level starved' in comparison to the highlights which have a wealth of information dedicated to the brighter end of the tonal spectrum. So rather than an equal amount of tonal values distributed evenly across the dynamic range, we actually have the effect as shown above. The deepest shadows rendered within the scene often have fewer than 128 allocated levels, and when these tones are manipulated in post-production Photoshop editing there is still the possibility of banding or posterization.

An example of posterization or banding.

Adjusting exposure in ACR

For those digital photographers interested in the dark side, an old SLR loaded with a fine-grain black and white film is a hard act to follow. The liquid smooth transitions and black velvet-like quality of dark low-key prints of yesteryear are something that digital capture is hard pressed to match. The sad reality of digital capture is that underexposure in low light produces an abundance of noise and banding (steps rather than smooth transitions of tone). The answer, however, is surprisingly simple for those who have access to a DSLR camera and have selected the Raw format from the Quality menu settings in their camera. Simply be generous with your exposure to the point of clipping or overexposing your highlights and only attempt to lower the exposure of the shadows in Adobe Camera Raw.

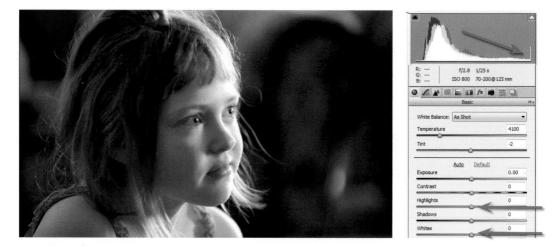

Foundation Project 4

1 In-camera: The first step is the most difficult to master for those who are used to Auto or Program camera exposure modes. Although the final outcome may require deep shadow tones, the aim in digital low-key camera exposure is to first get the shadow tones away from the left-hand wall of the histogram by increasing and **not** decreasing the exposure. It is vitally important, however, not to increase the exposure so far that you lose or clip highlight detail. The original camera exposure of the image used in this project reveals that the shadow tones (visible as the highest peaks in the histogram) have had a generous exposure in-camera so that noise and banding have been avoided (the tones have moved well to the right in the histogram). The highlights, however, look as though they have become clipped or overexposed. The feedback from the histogram on the camera's LCD should have confirmed the clipping at the time of exposure (the tall peak on the extreme right-hand side of the histogram) and if you had your camera set to warn you of overexposure, the highlights would have been merrily flashing at you to ridicule you for your sad attempts to expose this image. The typical DSLR camera is, however, misleading when it comes to clipped highlights and ignorant of what is possible in Adobe Camera Raw. Adobe Camera Raw can recover at least one stop of extra highlight information when the Whites and Highlights sliders are dragged to the left (so long as the photographer has used a DSLR camera that has a broader dynamic range than your typical fixed-lens compact digicam).

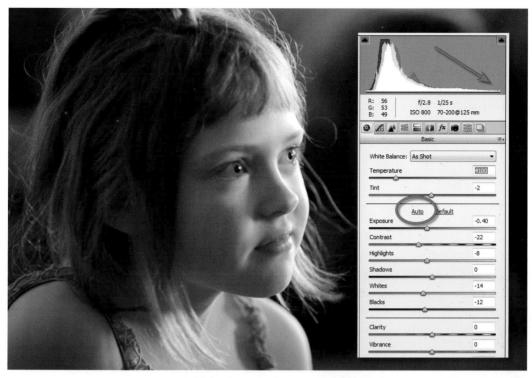

Adobe Camera Raw rescues the highlights – sometimes automatically.

'Exposing right'

In ACR when the Auto checkbox in the Exposure slider is selected, Adobe Camera Raw often attempts to rescue overexposed highlights automatically. With a little knowledge and some attention to the camera's histogram during the capture stage, you can master the art of pushing your highlights to the edge. So if your model is not in a hurry (mine is watching a half-hour TV show) you can take an initial exposure on Auto and then check your camera for overexposure. Increase the exposure using the exposure compensation dial on the camera until you see the flashing highlights. When the flashing highlights start to appear you can still add around one extra stop to the exposure before the highlights can no longer be recovered in Adobe Camera Raw. The popular term for this peculiar behavior is called 'exposing right'.

PERFORMANCE TIP

If the highlights are merrily flashing and the shadows are still banked up against the lefthand wall of the histogram, the solution is to increase the amount of fill light, i.e. reduce the difference in brightness between the main light source and the fill light. If you are using flash as the source of your fill light, it would be important to drop the power of the flash by at least two stops and choose the 'Slow-Sync' setting (a camera flash setting that balances both the ambient light exposure and flash exposure) so that the flash light does not overpower the main light source positioned behind your subject. The harsh light from the on-camera flash can also be diffused using a diffusion device.

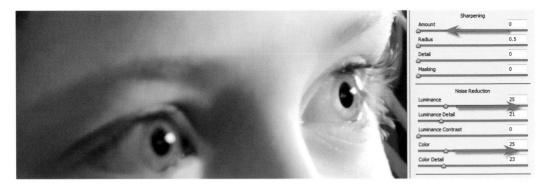

2 Before we adjust the tones to create our low-key image we must first check that our tones are smooth and free from color and luminance noise. Zoom in to 100% magnification for an accurate preview and look for any problems in the smooth dark-toned areas. Setting both the Luminance and Color reduction sliders (found in the Detail tab) to 25 removes the noise in this image. For this example, I would also recommend that the Sharpness slider be set to 0 at this point. Rather than committing to global sharpening using the Adobe Camera Raw dialog box, we can apply selective sharpening either in ACR using the Adjustment Brush or in the main Photoshop editing space. This may help to keep the tones as smooth as possible.

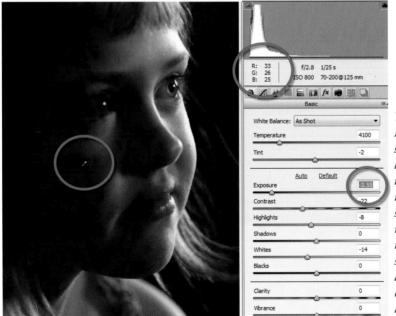

Tip: Click in the Exposure slider text box so it is selected (cursor line appears), then move the White Balance tool in place over the deeper shadows. You can now use the up/down keys on the keyboard to move the slider and monitor the actual pixel value change on the screen during adjustment.

3 Create the low-key look by moving the Exposure slider to the left in the Basic tab. You can continue to drop this slider until the highlights start to move away from the right-hand wall of the histogram. Select the White Balance tool and move your mouse cursor over the deeper shadows – this will give you an idea of the RGB values you are likely to get when this image is opened into the editing space. Once you approach an average of 30 to 40 in all three channels the low-key look should have been achieved. If any highlight clipping is still present then move the Whites and/or the Highlights slider to the left to reclaim the lost detail.

Expose right and adjust left.

'Expose right' and multiple exposures

The inequitable distribution of levels discussed earlier in this chapter (see Digital Exposure) has given rise to the idea of 'exposing right'. This work practice encourages the user seeking maximum quality to increase the camera exposure of the shadows (without clipping the highlights) so that more levels are afforded to the shadow tones. This approach to making the shadows 'information rich' involves increasing the amount of fill light (actual light rather than the adjustment possible with ACR's Shadows control) or lighting with less contrast in a studio environment. If the camera file is then opened in the Adobe Camera Raw dialog box the shadow values can then be reassigned their darker values to expand the contrast before opening the file as a 16 Bits/Channel file. When the resulting shadow tones are edited and printed, the risk of visible banding in the shadow tones is greatly reduced.

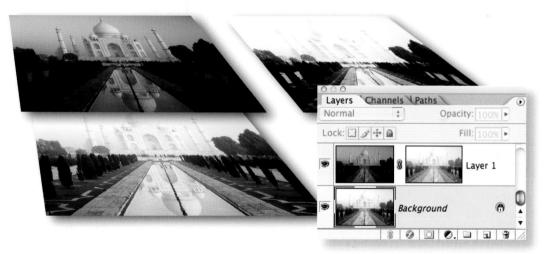

Separate exposures can be combined during the image editing process.

This approach is not possible when working with a subject with a fixed subject brightness range, e.g. a landscape, but in these instances there is often the option of bracketing the exposure and merging the highlights of one digital file with the shadows of a second. Choose 'Merge to HDR Pro' (high dynamic range) from the File > Automate menu. The example above shows the use of a layer mask to hide the darker shadows in order to access the bit-rich shadows of the underlying layer and regain the full tonal range of the scene.

Dust on the sensor – batch removal

As we saw in the last chapter a significant problem arises for many digital cameras when dust is allowed to accumulate on the sensor. This becomes most noticeable in smooth areas of light tone such as sky or white studio backdrops as dark spots. Use the Retouch tool and click on a spot in the image. Photoshop will automatically choose an area of the image to heal this spot. The radius can be changed by raising the Radius slider or dragging the red circle bigger. The source for the heal area (the green circle) can be dragged to an alternate location if required. Fortunately the dust is in the same place in each and every image and so after spotting one image you can choose Select All and Synchronize to remove the dust from all images you have open in the ACR dialog box. Be sure to check the Spot Removal option in the Synchronize dialog box before selecting OK.

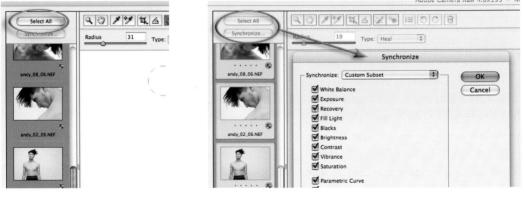

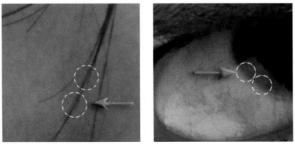

In areas of continuous tone the heal area that is selected automatically by Photoshop is usually OK. In areas of fine detail the healing area may need to be relocated to ensure lines do not appear disjointed.

Raw processing

New retouching options for ACR 8 Adobe Camera Raw 8 includes a long awaited improvement to the Spot Removal tool, namely the ability to paint on retouching in a similar way to how the process works in Photoshop. Now instead of just being able to place retouching 'dots' on the image, you can paint over long scratches or irregularly shaped marks. The retouching process remains the same: paint on the mark to establish the area to be fixed, and then ACR will try to automatically select a comparable sample area to use to paste over the problem mark. You can reposition the sample area to fine-tune the results by dragging it to a new location.

This new feature opens new avenues for retouching Raw files including the ability to remove unwanted image parts. Until now this type of activity has been an activity reserved for Photoshop.

Aside: The Spot Removal Brush has been upgraded to allow paint-on retouching. This opens the door to the removal of unwanted objects in your photos, an option that was only possible before by using overlapping circles. (1) Original image with unwanted detail. (2) The Spot Removal tool is used to paint over the problems. (3) The retouched results.

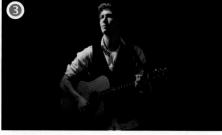

Archiving Raw files as digital negatives

Working with camera Raw files is going to create some extra strain on the storage capacity found on a typical computer's hard drive. What to do with all of the extra gigabytes of Raw data is a subject that people are divided about. You can burn them to CD or DVD disks – but are the disks truly archival? You can back them up to a remote Thunderbolt drive – but what if the hard drive fails? Some believe that digital tape offers the best track record for longevity and security. Why archive at all you may ask? Who can

really tell what the image editing software of the future will be capable of – who can say what information is locked up in the Raw data that future editions of the Raw editors will be able to access?

Adobe has now created a universal Raw file format called DNG (Digital Negative) in an attempt to ensure that all camera Raw files (whichever camera they originate from) will be accessible in the future. The Digital Negative format also includes lossless compression to reduce the size of the Raw files. The Adobe DNG converter is available from the Adobe website or from the supporting DVD. The converter will ensure that your files are archived in a format that will be understood in the future. Expect to see future models of many digital cameras using this DNG format as standard. One thing *is* for sure – Raw files are a prime source of the rich visual data that many of us value and so the format will be around for many years to come.

Image over page: Highly saturated colors carefully massaged into the Adobe RGB (1998) profile in Adobe Camera Raw.

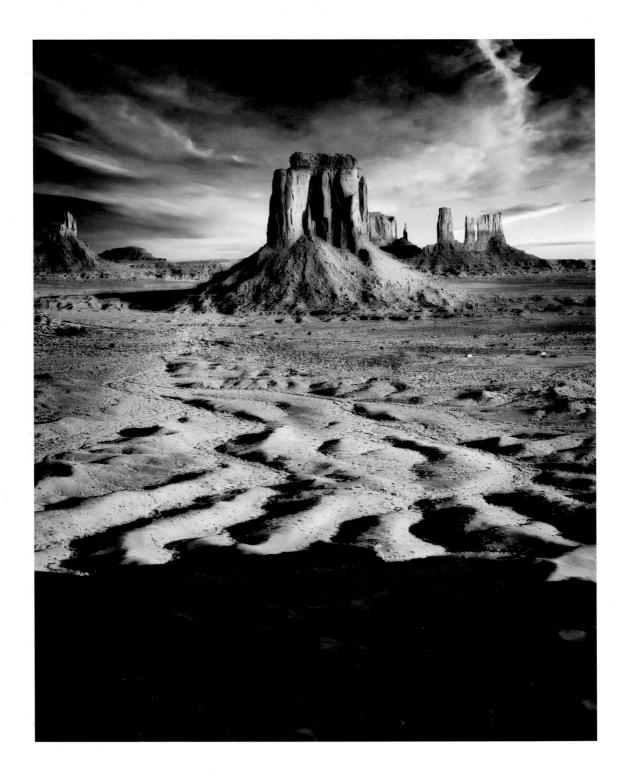

shop photoshop p

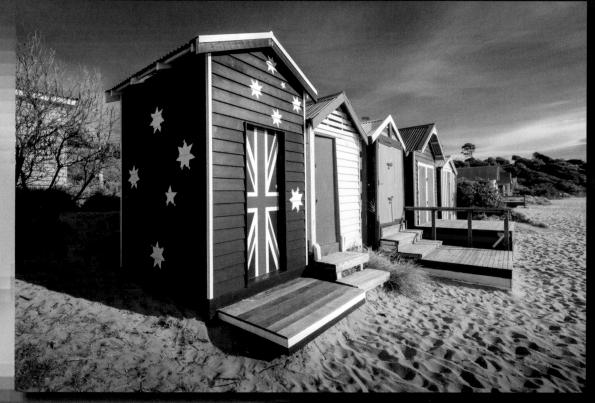

Mark Galer

photo

essentíal skílls

- Control the color accuracy between monitor preview and print.
- Understand the procedures involved with producing a digital print.
- Print a color-managed digital image using a desktop inkjet printer.
- Compensate for visual differences between the monitor preview and print.

Introduction

The secret to successful printing is to adopt a professional print workflow that takes the frustration out of seeing the colors shift as your image moves from camera to monitor, and from monitor to print. Color consistency has never been more easy and affordable to implement for the keen amateur and professional photographer. This project guides you along the path to ultimate print satisfaction, so that you will never again say those familiar words 'why do the colors of my print look different to my monitor?'

The reward for your effort (a small capital outlay and a little button pushing) is perfect pixels – color consistency from camera to screen to print. Once the initial work has been carried out predictable color is a real 'no-brainer', as all of the settings can be saved as presets. As soon as you start printing using your new color-managed workflow you will not only enjoy superior and predictable prints, but you will also quickly recover the money you outlaid to implement this workflow (no more second and third attempts).

The range or 'gamut' of colors that each output device is capable of displaying can vary enormously. The illustrations above shows two different views of the same gamut comparison. The Adobe RGB working space is able to contain the gamut of a typical inkjet printer. The Adobe RGB space is shown as a white wire frame surrounding a 3D colour shape (the printer's color space). Note how the Magenta (left) and Cyan (right) of the pinter's gamut is slightly larger than the gamut of Adobe RGB.

The problem and the solution

Have you ever walked into a TV shop or the cabin of an aircraft and noticed that all the TVs are showing exactly the same TV program but no two pictures are the same color? All of the TVs are receiving exactly the same signal but each TV has its own unique way of displaying color (its own unique 'color characteristics'). Different settings on each TV for brightness, contrast and color only make the problem worse.

One signal – different pictures (image courtesy of iStockphoto.com).

In the perfect world there would be a way of making sure that all of the TVs could synchronize their settings for brightness, contrast and color, and the unique color characteristics of each TV could be measured and taken into account when displaying a picture. If this could be achieved, we could then send ten different TVs the same picture and the image would appear nearly identical on all the TVs, irrespective of make, model or age. In the world of digital photography, Adobe has made the elusive goal of color consistency possible by implementing a concept and workflow called Color Management. Color Management, at first glance, can seem like an incredibly complex science to get your head around, but if just a few simple steps are observed, then color consistency can be yours.

Don't position your monitor so that it faces a window, and lower the room lighting so that your monitor is the brightest thing in your field of vision.

Prepare your print workshop

The first step is to optimize the room where your monitor lives. Ideally, the monitor should be brighter than the light source used to illuminate the room, and positioned so the monitor does not reflect any windows or lights in the room (the biggest problems from light will all be behind you and over your shoulders as you sit at the monitor). Professionals often build hoods around their monitors to prevent stray light falling on the surface of the monitor but if you carefully position the monitor in the room you should be able to avoid this slightly 'geeky' step. Stray light that falls on your monitor will lower the apparent contrast of the image being displayed and could lead you to add more contrast when it is not required.

The color of light in the room (warm or cool) is also a critical factor in your judgement of color on the screen. It is advisable to light the room using daylight but this should not be allowed to reflect off brightly colored surfaces in the room, e.g. brightly painted walls or even the brightly colored top you may be wearing when you are sitting in front of your monitor. If the room is your own personal space, or your partner supports your passion/obsession/addiction for digital imaging, then you could go that bit further and paint your walls a neutral gray. The lighting in the room should be entirely daylight – without the possibility of warm sunlight streaming into the room at certain times of the day. The brightness of the daylight in the room can be controlled with blinds or you can introduce artificial daylight by purchasing color-corrected lights, e.g. Solux halogen globes or daylight fluorescent lights. If the above recommendations are difficult to achieve, lower the level of the room lighting significantly.

Overview > Position your computer monitor so that it does not reflect any windows, lights or brightly colored walls in the room (when you sit at the monitor a neutral colored wall, without a window, should be behind you). Use daylight or daylight globes to light the room and make sure the room lighting is not as bright as the monitor (the monitor should be the brightest thing in your field of view).

Prepare your monitor

Purchase a monitor calibration device (available for as little as US\$100 from X-Rite or DataColor) and follow the step-by-step instructions. The calibration process only takes a few minutes once you have read through the instructions and adjusted a few settings on your monitor. It is now widely accepted that photographers should choose a D65 whitepoint (how cool or warm tones appear on your monitor) and a Gamma of 2.2 (this controls how bright your midtones are on your monitor). The next time you use your calibrated and profiled monitor, Photoshop will pick up the new profile to ensure you are seeing the real color of the image file rather than a version that has been distorted by the monitor's idiosyncrasies and inappropriate default settings.

MONITOR CALIBRATOR RECOMMENDATIONS

If you are on a budget I recommend the DataColor Spyder4 Pro. If you have a little more money and are looking for a really professional tool, then the X-Rite i1 Display Pro is my personal favorite. If you are looking for a monitor calibrator that will also create printer profiles then you may want to check out the X-Rite Color Munki Photo.

Prepare your inkjet printer

Just as the color characteristics of the monitor have to be measured and profiled in order to achieve accurate color between camera and monitor, a profile also has to be created that describes the color characteristics of the printer. This ensures color accuracy is maintained between the monitor and the final print. When an accurate profile of the printer has been created, Photoshop (rather than the printer) can then be instructed to manage the colors to maintain color consistency. Photoshop can only achieve this remarkable task because it knows (courtesy of the custom profile) how the printer reproduces the color information it is handed.

Adobe RGB (1998) Epson R2400

If you want to achieve optimum print quality at home it is recommended that you use a photo-quality printer (one with six or more inks), and that lets Photoshop manage the colors for the best results. A custom profile is only accurate so long as you continue to use the same ink and paper. Additional profiles will need to be created for every paper surface you would like to use. Printers come shipped with profiles, but these are of the 'one size fits all' variety, otherwise known as 'canned profiles'. For optimum quality, custom printer profiles need to be made for the unique characteristics of every printer (even if they are of the same brand and model number).

Note > Canned profiles for different paper stocks are also available on the web so check that you have the latest versions if you intend to proceed without making a custom profile.

PERFORMANCE TIP

To avoid the first run for your new printer being memorable, for all the wrong reasons, check that your ink cartridges are not about to run out of ink and that you have a plentiful supply of good quality paper (same surface and same make). Refilling your ink cartridges with a no-name brand and using cheap paper is not recommended if you want to achieve absolute quality and consistency. I would recommend that you stick with the same brand of inks that came shipped with your printer and use the same manufacturer's paper until you have achieved your first successful workflow.

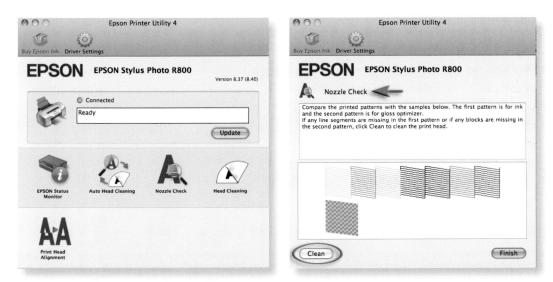

Important note > Before proceeding to create a custom profile for your printer, check that all the ink nozzles are clean. Open your printer utility software and run a Nozzle Check. This will print out a pattern on plain paper so that you can check all of the inks are running cleanly. If one or more of the inks are not printing or some of the pattern is missing then proceed to select the option to clean the heads in the Utility software.

RGB:	Adobe RGB (1998)
CMYK:	U.S. Web Coated (SWOP) v2 💠
Gray:	Dot Gain 20%
Spot:	Dot Gain 20%
Color Management	Policies
RGB:	Convert to Working RGB \$
CMYK:	Convert to Working CMYK \$
Gray:	Preserve Embedded Profiles 💠
Profile Mismatches:	Ask When Opening Ask When Pasting

Select appropriate color setting

Select a 'Working Space' for Photoshop that is compatible with the range of colors that can be achieved with your inkjet printer using good quality photo paper. The most suitable working space currently available is called Adobe RGB (1998). To implement this working space, choose Color Settings in Photoshop and set the workspace to Adobe RGB (1998) from the RGB pull-down menu. In the Color Management Policies section, select Convert to Working RGB from the RGB pull-down menu and check the Ask When Opening boxes.

Note > Selecting North America Prepress 2 from the Settings menu in the Color Settings dialog will automatically adjust the RGB working space to Adobe RGB (1998).

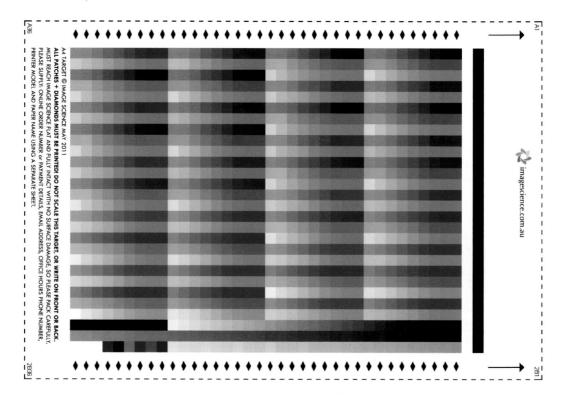

Obtain a profile target

You can profile your printer, but the equipment that is required for this step is a little expensive. You can, however, print out a test or 'target' chart and mail it to a custom printer profile company that has the equipment and will make the profile for you. There is no need to visit the company as the target can be downloaded online, mailed to the company via the postal service and the profile emailed back to you as an attachment.

Print the target using Adobe® Color Print Utility

The Adobe Color Print Utility is available as a free download from: http://kb2.adobe.com/cps/834/cpsid_83497.html

The print utility allows you to print a non-color-managed target. This non-color-managed print enables your profile service provider to create a custom profile for your specific printer and paper combination. The most important steps to ensure accuracy in this process are:

- You have selected the paper or media type in the printer driver.
- Color Management is switched off in the printer driver (this option may be hidden away in the Advanced or Custom menus of the printer driver).
- You have carried out a nozzle check and used the head cleaning function in the Printer Utility software if required prior to printing.
- You do not scale the file in the printer driver, i.e. it is printed at 100% size.
- The print is allowed to dry and delivered in good condition to the profile service provider.

20.99 cm x 29.67 cm	Printer Setup
-1 Z.I	Printer: EPSON Stylus Photo R800 \$
T imagescience com.au	Copies: 1 Print Settings
Missing Profile	Layout: 📦 🚳
The document "Image Science Custom Profile" does not have an embedded RCB profile. What would you like to do?	Color Management Please use Adobe Color Printer Utility if you need to
O Leave as is (don't color manage)	print with No Color Management.
O Assign working RGB: Adobe RGB (1998)	Document Profile: sRGB IEC61966-2.1
Assign profile: sRGB IEC61966-2.1	Color Handling: Photoshop Manages Colors
and then convert document to working RGB	
• • • • • • • • • • • • • • • • • • • •	Printer Profile: sRGB IEC61966-2.1
	Send 16-bit Data
	Normal Printing \$
	Rendering Intent: Relative Colorimetric
	Black Point Compensation
	► Description
	Description Position and Size Position
	▼ Position and Size
	Position and Size Position
AT ACT 2 PAGE SCIENCE AN 2011	▼ Position and Size Position ✓ Center Top: 0.211 Left: 0.282

Alternative: Printing a target from Photoshop

There is an alternative workflow to using the Adobe Color Print utility to print your non-color managed target. When opening the untagged profile target in Photoshop assign the Profile sRGB IEC61966-2.1. Do not convert the image to the working RGB.

When the target image is open in Photoshop proceed to 'File > Print'. In order to measure the unique characteristics of the printer colors on the test chart, Photoshop must not change the RGB numbers. Assigning Adobe RGB as the document profile and the Printer profile will ensure the color numbers remain unchanged when they are sent to the printer driver.

- Select your printer from the Printer menu.
- Rotate the paper orientation if required by clicking on the appropriate icon next to the Print Settings button.
- Make sure that the Scale is set to 100%. The patches **MUST** be output at 100%.
- In the Color Management section of the dialog box choose Photoshop Manages Color for the Color Handling option. The Source Space should read 'Adobe RGB (1998)' and there will be a reminder to switch off the color management in the Printer Preferences dialog.
- Select Adobe RGB (1998) as the Printer Profile and Relative Colorimetric as the Rendering Intent.
- Click the Printer Settings button to open the printer driver dialog.

Note > Do not attempt to print a profile target file or test chart using Photoshop Lightroom as Lightroom cannot leave a file 'as is', i.e. switch off the color management. Lightroom can use custom profiles but it cannot be used to make them. Photoshop CC: Essential Skills

	Print
Printer:	EPSON Stylus Photo R800
Presets:	Epson-Matte
Copies:	1 Collated
Paper Size:	A4 \$21.00 by 29.70 cm
	Print Settings
	Basic Advanced Color Settings
Page Se	tup: Standard
Media T	ype: Epson Archival Matte
Co	olor: Color 🗘
Color Settin	ngs: Off (No Color Adjust
Print Qua	lity: Best Photo
	High Speed
	☐ Mirror Image ✓ Finest Detail
Gloss Optimi	

The printer driver of an Epson R800 – the layout and naming of the various options will vary between different makes and models of printers.

Adjust the printer settings

Click on 'Print Settings' to open the printer driver dialog and make the following adjustments:

- Choose the size of your printing paper (large enough to print the target image at 100%).
- Choose the paper or media type and the print quality.
- Switch off the color management.
- Switch off any Auto settings and the Gloss Optimizer option if available.

Note > For owners of Canon printers, make sure the Print Type is set to 'None'. The precise wording for switching off the color management in the printer driver will vary depending on the make of the printer and the operating system you are using (you may need to select an 'Advanced' option in your printer driver to alter some or all of these settings). When using an Epson or Canon printer you may see that color management is referred to as ICM or ICC. Other manufacturers may refer to 'letting the software' (Photoshop) manage the color. This will switch off the printer's color management.

When you print this target print, the colors are effectively printed in their raw state. In this way the lab that creates your profile can measure how the colors vary from one printer to another and they can then create a unique profile that best describes what your printer does with standard 'unmanaged' color. Click Save to return to Photoshop's Print dialog and then select the Print button in the bottom right-hand corner of the dialog.

Note > If in doubt, consult your profile service provider for the precise settings you should use for your printer.

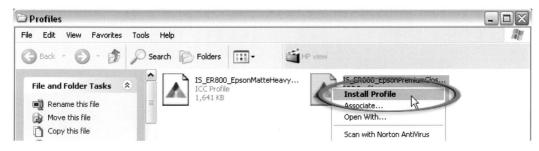

Create and install custom profile

Examine the target print to ensure that it is free from streaking (this may occur due to clogged printing heads) and if clean send this target print to the profiling company so that it can be measured using the more sophisticated and expensive profiling hardware that is required to complete this process. They will be able to send you the profile as an attachment to an email. If you are using a PC, right-click the profile and choose Install, and Windows will install it in the correct location. If using a Mac you will need to locate the ColorSync folder on your hard drive (Library > ColorSync > Profiles) and copy the ICC profile to this location.

Note > For Mac OSX 10.7 (Lion) the Library folder is hidden. To temporarily unhide the folder so you can install your ICC profile hold down the option key and use the Go menu to go to the folder. To permanently unhide the folder Open Terminal and use this command: 'chflags nohidden ~/Library/'.

Space:	Adobe RGB (1998)	+	OK
Depth:	8 Bits/Channel	\$	Cancel
Size:	3464 by 2309 (8.0 MP)	\$	
Resolution:	240 pixels/inch	\$	
Sharpen For:	None Amount: Standard	\$	
	Open in Photoshop as Smart Objects		

Tag images with the Adobe RGB profile

When you have installed your custom printer profile make sure that your images destined for print are tagged with the Adobe RGB profile. Select the Adobe RGB profile in the camera if possible when shooting in the JPEG file format (DSLR cameras and many prosumer fixed-lens digicams allow the photographer to choose this setting). When preparing images in Photoshop's Adobe Camera Raw (ACR), click on the blue writing at the base of the ACR dialog box to open the Workflow Options. Select Adobe RGB (1998) from the Space menu.

Photoshop CC: Essential Skills

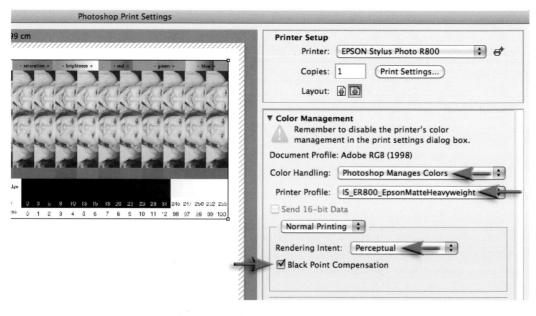

Test your color-managed workflow

It is recommended that the first print you make using your custom profile is a test image – one that has a broad range of colors and tones (such as the one on the supporting website). A test image with skin tones can be very useful for testing the accuracy of your new print workflow. When you next open the Print dialog box make sure you set the Color Handling to 'Photoshop Manages Colors'. Select your new custom profile from the Printer Profile menu and in the Rendering Intent options choose either 'Perceptual' or 'Relative Colorimetric' (these two options are the best choices for managing 'out of gamut' colors in photographic images). Select the Black Point Compensation option and then select 'Print'.

Note > All of the printer driver settings that were used to print your target print must be duplicated with every other image to be printed using your custom profile.

Make printer presets

From the Printer Preferences menu select the same settings that were used to print the profile target (don't forget to ensure the color management is turned Off). Save a 'Preset' or 'Setting' for all of the printing options so that you only choose this one setting each time you revisit this dialog box. View your first print using bright daylight and you will discover, if you have followed these directions to the letter, that you have almost certainly found a solution to one of the mysteries of digital color photography – the search for predictable color.

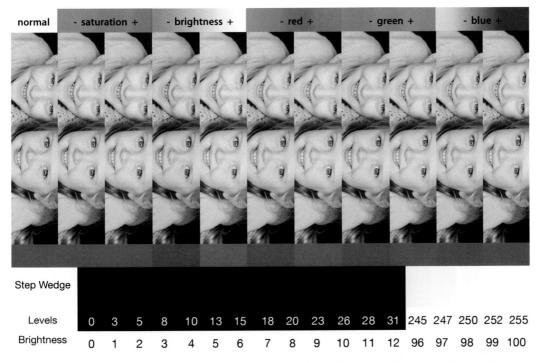

Use the test file on the supporting website to help you target the perfect color balance quickly and efficiently.

Assessing the test print for accuracy

View the print using daylight (not direct sunlight) when the print is dry, and look for differences between the print and the screen image in terms of hue (color), saturation and brightness.

- Check that the colors are saturated and printing without tracking marks or banding. If there is a problem with missing colors, tracking lines or saturation, clean the printer heads using the available option in the printer driver.
- View any skin tones to assess the appropriate level of saturation.
- View any gray tones to determine if there is a color cast present in the image. If these print as gray then no further color correction is required.

PERFORMANCE TIP

Any differences between the monitor and the print will usually now be restricted to the differences in color gamuts between RGB monitors and CMYK printers. The vast majority of colors are shared by both output devices but some of the very saturated primary colors on your monitor (red, green and blue) may appear slightly less saturated in print. Choose a printer with an inkset that uses additional primary inks if you want to achieve the maximum gamut from a printer.

Photoshop CC: Essential Skills

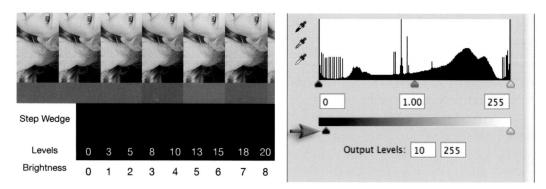

Preserving shadow detail

If the dark shadow detail that is visible on screen is printing as black without detail then you could try switching from the 'Relative Colorimetric' rendering intent to the 'Perceptual' rendering intent. If this does not resolve the problem then establish a Levels adjustment layer to resolve the problem in Photoshop. The bottom left-hand slider in the Levels dialog box should be moved to the right to reduce the amount of black ink being printed in the shadows (raise it to a value of no higher than 10 otherwise the darkest tones will start to appear gray). This should allow dark shadow detail to be visible in subsequent prints. This adjustment layer can be switched on for printing and switched off for viewing the image on screen (see the Retouching Projects chapter for additional information about adjustment layers).

Note > It is important to apply these output level adjustments to an adjustment layer only as these specific adjustments apply only to the output device and media you are currently testing. You may need to create another adjustment layer for a different output device.

PERFORMANCE TIPS

Materials

- Start by using the printer manufacturer's recommended ink and paper.
- Use premium grade 'photo paper' for maximum quality.

Monitor

- Position your monitor so that it is clear of reflections.
- Calibrate your monitor using a calibration device.

Adobe

- Set the Color Settings of the Adobe software to allow you to use the Adobe RGB profile.
- Select 'Photoshop Manages Color'.
- Use a six-ink (or more) inkjet printer or better for maximum quality.
- Select the 'Media Type' in the Printer Software dialog box.
- Select a high dpi setting (1440 dpi or greater) or 'Photo' quality setting.
- Use a profile service provider to create a custom printer profile.

Proofing

• Allow print to dry and use daylight to assess color accuracy of print.

Soft proofing

Although the image that appears on your monitor has been standardized (after the calibration process and the implementation of the Adobe RGB working space), the printed image from this standardized view would appear different if printed through a variety of different inkjet printers onto different paper surfaces or 'media types'. In Photoshop it is possible to further alter the visual appearance of the image on your monitor so that it more closely resembles how it will actually appear when printed by your specific make and model of inkjet printer on a particular paper surface. This process is called 'soft proofing'.

Proof Setup ✓ Custom ✓ Proof Colors ₩Y Gamut Warning ① ₩Y V Pixel Aspect Ratio ► Pixel Aspect Ratio Correction Working CMYK 32-bit Preview Options Working Yellow Plate		Proof Setup ► ✓ Proof Colors % Y Gamut Warning ☆ % Y Pixel Aspect Ratio ► Pixel Aspect Ratio Correction 32-bit Preview Options		Custom Working CMYK Working Cyan Plate Working Magenta Plate Working Yellow Plate	
Custom Proof Condition: R800-Matte		Zoom In Zoom Out Fit on Screen Actual Pixels Print Size	೫ + ೫ -	Working Black Plate Working CMY Plates Macintosh RGB Windows RGB Monitor RGB	
			₩0 ₩1		
		Screen Mode	•	Color Blindness - Protanopia-t	
		✓ Extras Show	жн ▶	Color Blindness - Deuteranopis	

To set up the soft proof view go to View > Proof Setup > Custom. From the Profile menu select the profile of your printer and paper or 'media type'. Choose Perceptual from the Intent menu. Check the Use Black Point Compensation and Paper White boxes if you intend to remove all other white and black tones from your display when you view your image (this would include Photoshop's panels, menu and the desktop colors). The image colors will look gray or washed out if you don't take this step. Save the soft proof settings so they can be accessed quickly the next time you need to soft proof to the same printer and media type.

When you view your image with the soft proof preview the color and tonality will be modified to more closely resemble the output characteristics of your printer and choice of media. The image can now be edited with the soft proof preview on, to achieve the desired tonality and color that you would like to see in print. It is recommended that you edit in Full Screen Mode to remove distracting colors on your desktop and use adjustment layers to modify and fine-tune the image on screen.

Photoshop CC: Essential Skills

Printing using a professional lab

Professional photographic laboratory services are now expanding into the production of large and very large prints using the latest inkjet and piezo technology. Many are also capable of printing your digital files directly onto color photographic paper. In fact, outputting to color print paper via machines like the Durst Lambda and Fuji Frontier has quickly become the 'norm' for a lot of professional photographers. Adjustment of image files that print well on desktop inkjets so that they cater for the idiosyncrasies of these RA4 and large inkjet machines is an additional output skill that is really worth learning.

With improved quality, speed and competition in the area, the big players like Epson, Durst, Fuji and Hewlett Packard are manufacturing units that are capable of producing images that are not only visually stunning, but also very, very big. Pictures up to 60 inches wide can be made on some of the latest machines, with larger images possible by splicing two or more panels together. A photographer can now walk into a bureau with a USB drive containing a

favorite image and walk out the same day with a spliced polyester poster the size of a billboard, printed with fade-resistant, all-weather inks. In addition to these dedicated bureau services, some professionals, whose day-to-day business revolves around the production of large prints, are actually investing in their own wide-format inkjet machine. The increased quality of pigment or dye based systems together with the choice of different media, or substrates as they are referred to in the business, provides them with more imaging and texture choices than are available via the RA4 route.

Before you start

Getting the setup right is even more critical with large-format printing than when you are outputting to a desktop machine. A small mistake here can cause serious problems to both your 48×36 inch masterpiece as well as your wallet, so before you even turn on your computer, talk to a few professionals. Most output bureaus are happy to help prospective customers with advice and usually supply a series of guidelines that will help you set up your images to suit their printers. These instructions may be contained in a pack available with a calibration swatch over the counter, or might be downloadable from a company's website. For example:

http://www.imagescience.com.au/pages/How-To-Prepare-Files.html http://www.imagescience.com.au/pages/How-To-Send-Us-Files.html

Some of the directions will be general and might seem a little obvious, others can be very specific and might require you to change the settings of your image editing program. Some companies will check that your image meets their requirements before printing, others will dump the unopened file directly to the printer's RIP (printer's image processor) assuming that all is well. So make sure that you are aware of the way the bureau works before making your first print.

		New	
Name:	Big Print		
Preset: Custom		•	
Size:	[\$
Width:	32	inches	\$
Height:	20	inches	\$
Resolution:	240	pixels/cm	\$
Color Mode:	RGB Color	8 bit	\$
Background Contents:	White		\$
Advanced			
Color Profile:	sRGB IEC61966-	2.1	\$
Pixel Aspect Ratio:	Square Pixels	and the second second	

	Convert to Profile
- Source	Space
Profile:	Adobe RGB (1998)
- Destin	ation Space
Profile:	FujiFlex TC918 SuperSat2_GAMUT
- Conve	rsion Options
Engine:	Adobe (ACE)
Intent:	Perceptual 🛟
Use B	lack Point Compensation
Use [Dither
Flatte	en Image to Preserve Appearance

General guidelines for professional labs

The following guidelines have been compiled from the suggestions of several output bureaus. They constitute a good overview but cannot be seen as a substitute for talking to your own lab directly.

- 1 Ensure that the image is orientated correctly. Some printers are set up to work with a portrait or vertical image by default; trying to print a landscape picture on these devices will result in areas of white space above and below the picture and the edges being cropped.
- 2 Make sure the image is the same proportion as the paper stock. This is best achieved by making an image with the canvas the exact size required and then pasting your picture into this space.
- 3 Don't use crop marks. Most printers will automatically mark where the print is to be cropped. Some bureaus will charge to remove your marks before printing.
- 4 Convert text to line or raster before submission or flatten the file (the only sensible option) and save as an RGB TIFF at the appropriate resolution this is far better than faffing about with fonts etc.
- 5 Use the resolution suggested by the lab. Most output devices work best with an optimal resolution: large-format inkjet printers are no different. The lab technician will be able to give you details of the best resolution to supply your images in. Using a higher or lower setting than this will alter the size that your file prints so stick to what is recommended. Incorrect resolutions can also result in straight line 'jaggies'.
- 6 Keep file sizes under the RIP maximum. The bigger the file the longer it takes to print. Most bureaus base their costings on a maximum file size. You will need to pay extra if your image is bigger than this value.
- 7 Use the color management system recommended by the lab. In setting up you should ensure that you use the same color settings as the bureau. ICC profiles provided from labs are useful, if only to soft proof to. However, care should be taken not to convert the image to the lab's ICC profile unless you are asked to.

photoshop phot

essentíal skílls

OÞ

- Learn the creative potential of layers, adjustment layers, channels and layer masks.
- Develop skills and experience in the control and construction of digital montages.

Introduction

The traditional photograph contains all the picture elements in a single plane. Digital images captured by a camera or sourced from a scanner are similar in that they are also 'flat files'. And for a lot of new digital photographers this is how their files remain – flat. All editing and enhancing work is conducted on the original picture but advanced techniques require things to be a little different.

Digital pictures are not always flat

Photoshop contains the ability to use layers with your pictures. This feature releases your images from having to keep all their information in a flat file. Different image parts, added text and certain enhancement tasks can all be kept on separate layers. The layers are kept in a stack and the image you see on screen in the work area is a composite of all the layers.

Sound confusing? Well, try imagining, for example, that each of the image parts of a simple portrait photograph are stored on separate plastic sheets. These are your layers. The background sits at the bottom. The portrait is laid on top of the background and the text is placed on top. When viewed from above the solid part of each layer obscures the picture beneath. While the picture parts are based on separate layers they can be moved, edited or enhanced independently of each other. If they are saved using a file format like Photoshop's PSD file (which is layer friendly) all the layers will be preserved and available next time the file is opened.

Layers and channels confusion

Another picture file feature that new users often confuse with layers is channels. The difference is best described as follows:

- Layers separate the image into picture, text, shapes and enhancement parts.
- Channels, on the other hand, separate the image into its primary base colors.

The Layers panel will display the layer stack with each part assembled on top of each other, whereas the Channels panel will show the photograph broken into its red, green and blue components (if it is an RGB image – but more on this later).

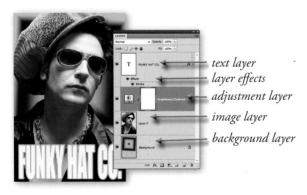

all channels red channel green channel blue channel

Example image showing the layer components (left) and channels (right).

Layers overview

Being able to separate the components of a picture means that these can be moved and edited independently. This is a big advantage compared to flat file editing, where the changes are permanently made part of the picture and can't be edited at a later date. A special file type is needed if these edit features are to be maintained after a layered image is saved and reopened. In Photoshop, the PSD (Photoshop document), Photoshop PDF and PSB (Large Document Format) file formats support all layer types and maintain their editability. It is important to note that other common file formats such as standard JPEG and TIFF do not generally support these features. They flatten the image layers while saving the file, making it impossible to edit individual image parts later (although JPEG2000 and TIFF saved via recent versions of Photoshop can support all layer types).

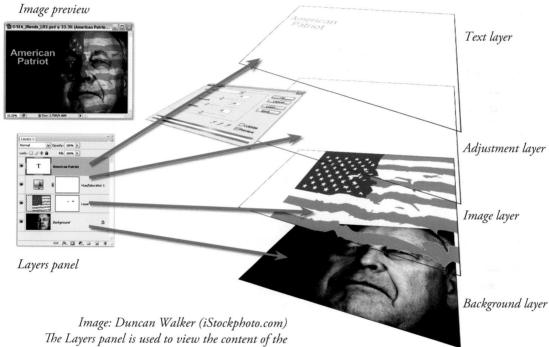

different layers that make up a picture.

Adding layers

When a picture is first downloaded from your digital camera or imported into Photoshop or Bridge it usually contains a single layer. It is a flat file. By default the program classifies the picture as a background layer. You can add extra 'empty' layers to your picture by clicking the Create New Layer button at the bottom of the Layers dialog or choosing the Layer option from the New menu in the Layer heading (Layer > New > Layer). The new layer is positioned above the currently selected layer (highlighted in the Layers panel).

Some actions such as adding text with the Type tool or drawing a shape automatically create a new layer for the content. This is also true when adding adjustment and fill layers to your image and when selecting, copying and pasting image parts.

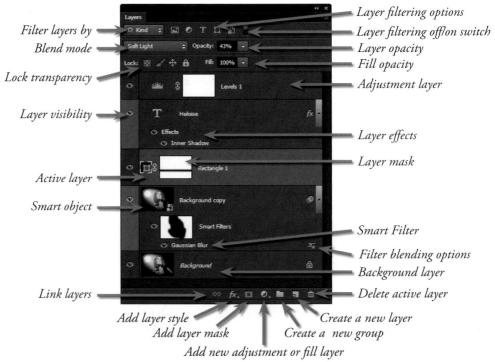

Viewing layers

Photoshop's Layers panel displays all your layers and their settings in the one dialog box. If the panel isn't already on screen when opening the program, choose the option from the Window menu (Window > Layers). The individual layers are displayed, one on top of each other, in a 'layer stack'. The image is viewed from the top down through the layers. When looking at the picture on screen we see a preview of how the image looks when all the layers are combined. Each layer is represented by a thumbnail on the left and a name on the right. The size of the thumbnail can be changed, as can the name of the layer. By default each new layer is named sequentially (layer 1, layer 2, layer 3). This is fine when your image contains a few different picture parts, but for more complex illustrations it is helpful to rename the layers with titles that help to remind you of their content (portrait, sky, tree). This is especially true when working with 3D layers as the layer name is incorporated in other characteristics of the 3D environment. Layers can be turned off by clicking the eye symbol on the far left of the layer so that it is no longer showing. This action removes the layer from view but not from the stack. By default all layers are displayed but you can filter the panel to display a subset of layers using the new filtering options at the top of the panel.

Working with layers

To select the layer that you want to change you need to click on the layer. At this point the layer will change to a different color from the rest in the stack. This layer is now the 'selected layer' or 'active layer' and can be edited in isolation from the others that make up the picture. It is common for new users to experience the problem of trying to edit pixels on a layer that has not been selected. Always check the correct layer has been selected prior to editing a multi-layered image. Each layer in the same image must have the same resolution and image mode (a selection from one image that is imported into another image will take on the host image's

resolution and image mode). Increasing the size of any selection will lead to 'interpolation', which will degrade its quality unless the layer is converted into a 'Smart Object' first.

Manipulating layers

Layers can be moved up and down the layer stack by click-hold-dragging. Moving a layer upwards will mean that its picture content may obscure some of the details in the layers below. Moving downwards progressively positions the layer's details further behind the picture parts of the layers above. In this way you can reposition the content of any layers (except *background* layers). Two or more layers can be linked together so that when the content of one layer is moved the other details follow precisely. Simply multi-select the layers to link (hold down the Shift key and click onto each layer) and click the Link Layers button (chain icon) at the bottom of the panel. A chain symbol will appear on the right of the thumbnail to indicate that these layers are now linked. To unlink selected layers click on the Link Layers button again. Unwanted layers can be deleted by dragging them to the trash icon at the bottom of the Layers panel or by selecting the layer and clicking the trash icon.

Filtering the display in the Layers panel

The layer search and filtering options give you a way to quickly isolate individual layers based on layer type, name, color, effect, mode, and attribute. Being able to display a subset of layers based on your search criteria makes working with complex files much easier.

Layer styles

Layer styles or effects can be applied to the contents of any layer. Users can add effects by clicking on the 'Add a Layer Style' button at the bottom of the Layers panel (the Fx icon), by choosing Layer Style from the Layer

menu, by clicking on the desired effect in the Styles panel or by dragging existing effects from one layer to another. The effects added are listed below the layer in the panel. You can turn effects on and off using the eye symbol and even edit effect settings by double-clicking on them in the panel. From CS6 layer styles can be applied to layer groups as well as individual layers. This provides the ability to quickly apply the same style across multiple layers or create more complex designs by mixing group applied and individually applied styles.

Opacity

As well as layer styles, or effects, the opacity (how transparent a layer is) of each layer can be altered by dragging the opacity slider down from 100% to the desired level of translucency. The lower the number, the more detail from the layers below will show through. The opacity slider is located at the top of the Layers panel and changes the selected layer only. You can adjust the opacity of multi-selected layers in one step.

Blending modes

On the left of the opacity control is a drop-down menu containing a range of blending modes. The default selection is 'Normal', which means that the detail in the upper layers obscures the layers beneath. Switching to a different blending mode will alter the way in which the layers interact. Checking the Lock Transparency box confines any painting or editing to the areas containing pixels (transparent areas remain unaffected).

Layers

 O Kind
 Image: Control of the second second

Filter the layers displayed with the options at the top of the panel.

Photoshop CC: Essential Skills

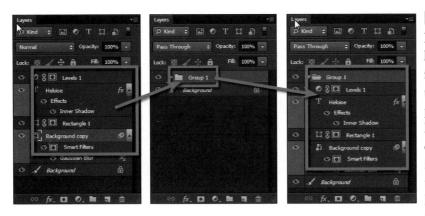

Layer groups

Layer groups are a collection of layers organized into a single folder. Placing all the layers used to create a single picture part into a group makes these layers easier to manage and organize. Layers can be moved into the group by dragging them onto the group's heading. Layers in groups can have their stacking order (within the group) adjusted without ungrouping.

Layers can be collected together into a Layer Group making it easy to manage large, complex, multi-layered documents.

To create a layer group click on the New Group button at the bottom of the panel or choose Layer > New > Group or multi-select the layers to include in the group and press Ctrl/Cmd + G. In previous versions of Photoshop this feature was referred to as Layer Sets.

Layer masks

A layer mask is attached to a layer and controls which pixels are concealed or revealed on that layer. Masks provide a way of protecting areas of a picture from enhancement or editing changes. In this way masks are the opposite to selections, which restrict the changes to the area selected. Masks are standard grayscale images and because of this they can be painted, edited and erased just like other pictures. Masks are displayed as a separate thumbnail to the right of the main layer thumbnail in the Layers panel. The black portion of the mask thumbnail is the protected or transparent area and is opaque or shows the layer image without transparency. Grays, depending on the dark or lightness of the tone, will give varying amounts of transparency from partially transparent to almost opaque. Photoshop provides a variety of ways to create masks but one of the easiest is to use the special Quick Mask mode.

Layer types

New custom stroke options for vector shapes.

Image layers: This is the most basic and common layer type containing any picture parts or image details. Background is a special type of image layer, which is positioned at the bottom of the layer stack and can't contain any transparency.

Text layers: Designed solely for text, these layers allow the user to edit and enhance the text after the layer has been made. It is possible to create 'editable text' in Photoshop. If the text needs to be modified (font, style, spelling, color, etc.) the user can simply double-click the type layer. To apply filters to the contents of a text layer, it must be rasterized (Layer > Rasterize > Type or Layer > Rasterize > Layer) first. This converts the text layer to a standard image layer

and in this process the ability to edit the text is lost, so duplicate the layer first to preserve an editable copy.

Vector layers: Previously called Shape layers, vector layers are designed to hold the vector artwork created with Photoshop's drawing tools (Rectangle, Ellipse, Polygon, Line and Custom Shape). Like text layers, the content of these layers is 'vector' based and therefore can be scaled upwards or downwards without loss of quality. Adobe has been increasing Photoshop's vector abilities over the last few releases and it now includes better arrangement, combining and pixel snapping features as well as a range of Live Shape Properties to edit and control.

Smart Object layers: Smart Object layers are special layers that encapsulate another picture (either vector or pixel based). As the original picture content is always maintained, any editing action such as transforms or filtering that is applied to a Smart Object layer is non-destructive. Pixel-based editing (painting, erasing, etc.) can't be performed on Smart Objects without first converting them to a normal image layer (Layer > Smart Object > Rasterize). You create a Smart Object layer by either converting an existing image layer (Layer > Smart Objects > Convert to Smart Objects) or by opening the

Layers and channels

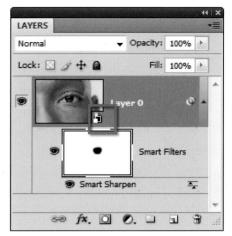

Smart Object layers are used for some non-destructive editing techniques as they contain and protect the original picture.

original file as a Smart Object (File > Open As Smart Object) when commencing initial editing. When a filter is applied to a Smart Object layer it is termed a Smart Filter and appears below the Smart Object layer. Because the effects of a Smart Filter can be altered or removed after application, this type of filtering is non-destructive.

3D Layers: The Extended edition of Photoshop also has the ability to open and work with three-dimensional architectural or design files. When Photoshop opens a 3D file it is placed on a separate layer where you can move, scale, and change lighting and rendering of the 3D model.

Adjustment layers: These layers alter the layers that are arranged below them in the stack. Adjustment layers act as a glass filter through which the lower layers are viewed. They allow image adjustments to be made without permanently modifying the original pixels (if the adjustment layer is removed, or the visibility of the layer is turned off, the pixels in the lower layers revert to their original value). You can use adjustment layers to perform many of the enhancement tasks that you would normally apply directly to an image layer and avoid changing the image itself. Adjustment layers are added automatically when clicking onto an Adjustment Type icon in the Adjustment panel. This is a big change in adjustment layer workflow from previous versions of Photoshop. Adjustment layers are always added to the stack with a linked layer mask.

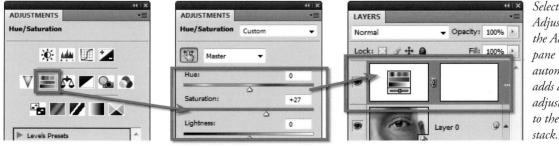

Selecting an Adjustment in the Adjustments pane automatically adds an adjustment layer to the layers stack.

Photoshop CC: Essential Skills

Background layers: All images start with a background layer (unless they are opened as a Smart Object from ACR). An image can only have one background layer. It is the bottom-most layer in the stack. No other layers can be moved beneath this layer. You cannot adjust this layer's opacity or its blending mode. You can convert background layers to standard image layers by double-clicking the layer in the Layers panel, setting your desired layer options in the dialog provided and then clicking OK.

Saving an image with layers

The file formats that support layers are Photoshop's native Photoshop document (PSD) format, Photoshop PDF, JPEG2000, PSB (Large Document Format) and Photoshop's version of TIFF. The layers in a picture must always be flattened if the file is to be saved as a standard JPEG. It is recommended that a PSD with its layers is always kept as an archived master copy – the best practice is to keep in progress archives as well as the final image. It is possible to quickly flatten a multi-layered image and save it as a JPEG or TIFF file by choosing File > Save As and then selecting the required file format from the pull-down menu.

Quick Masks, selections and alpha channels

Selections isolate parts of a picture. When first starting to use Photoshop it is easy to think of selections, masks and channels as all being completely separate program features, but in the reality of day-to-day image enhancement each of these tools is inextricably linked. As their skills develop, most image-makers will develop their own preferred ways of working. Some use a workflow that is selection based, others switch between masking and selections and a third group concentrates all their efforts on creating masks only. No one way of working is right or wrong. In fact, many of the techniques advocated by the members of each group often provide a different approach to solving the same problem.

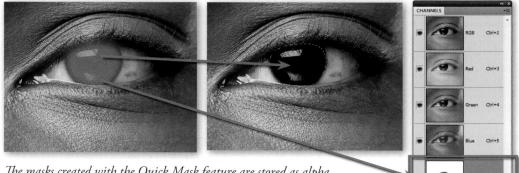

The masks created with the Quick Mask feature are stored as alpha channels which can be viewed and edited via the Channels panel. Switching from the Quick Mask mode changes the mask to a selection.

Switching between Mask and Selection modes

You can switch between Mask and Selection (also called 'Standard') modes by clicking on the mode button positioned at the bottom of the toolbox. Any 'marching ants' indicating active selections will be converted to red shaded areas when selecting the Mask mode. Similarly active masks will be outlined with 'marching ants' when switching back to Selection mode.

Layers and channels

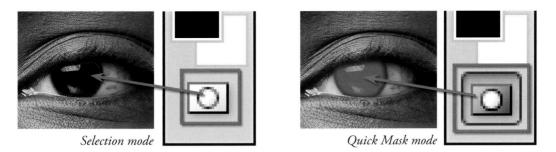

Saving selections

Photoshop provides users with the option to save their carefully created selections using the Select > Save Selection option. In this way the selection can be reloaded at a later date in the same file via the Select > Load Selection feature, or even after the document has been closed and reopened. Though not immediately obvious to the new user, the selection is actually saved with the picture as a special alpha channel. Alpha channels are essentially grayscale pictures where the black section of the image indicates the area where changes can be made, the white portion represents protected areas and gray values allow proportional levels of change. This is where the primary link between selections and masks occurs; masks (such as layer masks) too are stored as alpha channels in your picture documents. Alpha channels can be viewed, selected and edited in the Channels panel.

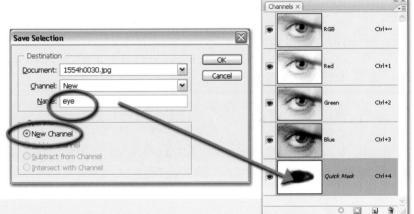

When you save a selection you create a grayscale alpha channel. You can name the selection inside the Save Selection dialog.

QUICK DEFINITIONS

Selections – A selection is an area of a picture that is isolated so that it can be edited or enhanced independently of the rest of the image. Selections are made with a range of Photoshop tools including the Marquee, Lasso and Magic Wand tools.

Masks – Masks also provide a means of restricting image changes to a section of the picture. Masks are created using standard painting tools.

Alpha channels – Alpha channels are a special channel type that are separate to those used to define the base color of a picture such as Red, Green and Blue. Selections and masks are stored as alpha channels and can be viewed in the Channels panel. You can edit a selected alpha channel using painting and editing tools as well as filters.

Channels

As we have already seen, channels represent the way in which the base color in an image is represented. Most images that are created by digital cameras are made up of Red, Green and Blue (RGB) channels. In contrast, pictures that are destined for printing are created with Cyan, Magenta, Yellow and Black (CMYK) channels to match the printing inks. Sometimes the channels in an image are also referred to as the picture's 'color mode'.

Viewing channels

Many image editing programs contain features designed for managing and viewing the color channels in your image. Photoshop uses a separate Channels panel (Window > Channels). Looking a little like the Layers panel, hence the source of much confusion, this panel breaks the full color picture into its various base color parts.

Auto Tone Shift+Ctrl+L Auto Contrast Alt+Shift+Ctrl+L Auto Color Shift+Ctrl+B Image Size Alt+Ctrl+I Canvas Size Alt+Ctrl+C Image Rotation • • • • • • • • • • • • • • • • • • •		Bitmap Grayscale Duotone	•	Mode Adjustments
Auto Color Shift+Ctrl+B CMVK Color Image Size Alt+Ctrl+I Lab Color Canvas Size Alt+Ctrl+C Multichanne Image Rotation ✓ 8 Bits/Channe 16 Bits/Channe 32 Bits/Channe Bits/Channe Statistic Color Table 	or	Indexed Color		
Image Size Alt+Ctrl+I Canvas Size Alt+Ctrl+C Image Rotation ✓ 8 Bits/Chan Crop 16 Bits/Chan Trim 32 Bits/Chan Reveal All Color Table.	5	CMVK Color		
Crop 16 Bits/Chan Trim 22 Bits/Chan Reveal All Color Table.	:I	Lab Color Multichannel		
Reveal All Color Table.		 8 Bits/Channel 16 Bits/Channel 	•	-
Color Table.	nel	32 Bits/Channe		
•		Color Table		
Apply Image				
Calculations				Calculations

The type and number of color channels used to create the color in your pictures can be changed via the Mode option in the Image menu.

Changing color mode

Though most editing and enhancement work can be performed on the RGB file, sometimes the digital photographer may need to change the color mode of his or her file. There are a range of conversion options located under the Mode menu (Image > Mode) in Photoshop. When one of these options is selected, your picture's color will be translated into the new set of channels. Changing the number of channels in an image also impacts on the file size of the picture. Four-channel CMYK images are bigger than three-channel RGB pictures, which in turn are roughly three times larger than single-channel grayscale photographs.

When do I need to change channels?

For most image editing and enhancement tasks RGB color mode is all you will ever need. Some high-quality and printing-specific techniques do require changing modes, but this is generally the field of the 'hardened' professional. A question often asked is 'Given that my inkjet printer uses CMYK inks, should I change my photograph to CMYK before printing?' Logic says yes, but practically speaking this type of conversion is best handled by your printer's driver software. Most modern desktop printers are optimized for RGB output even if their ink set is CMYK.

Channel types

RGB: This is the most common color mode. Consisting of Red, Green and Blue channels, most digital camera and scanner output is supplied in this mode.

CMYK: Designed to replicate the ink sets used to print magazines and newspapers, this mode is made from Cyan, Magenta, Yellow and Black (K – for keyline) channels.

LAB: Consisting of Lightness, A color (green–red) and B color (blue–yellow) channels, this mode is used by professional photographers when they want to enhance the details of an image without altering the color. By selecting the L channel and then performing their changes, only the image details are affected.

Grayscale: Consisting of a single black channel, this mode is used for monochrome pictures. Duo-, Tri- and Quad-tones are a special variation of grayscale images that include extra colors, creating tinted monochromes.

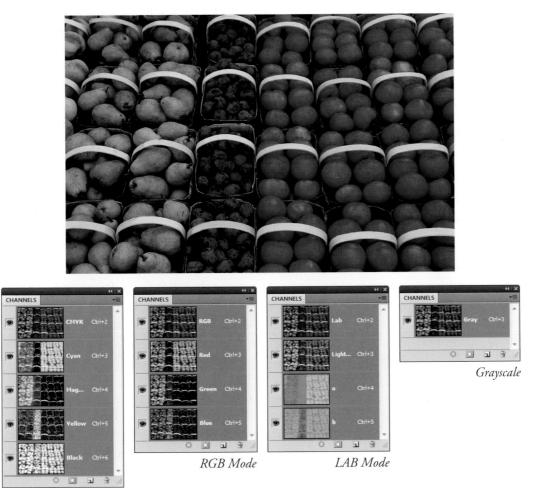

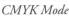

The most used color modes (channel types) are RGB, CMYK, LAB and Grayscale. Unless you are working in the publishing industry, or you want to use advanced image editing techniques, keep your picture in RGB mode.

Adjustment and filter layers and editing quality

As introduced earlier, adjustment layers act as filters that modify the hue, saturation and brightness of the pixels on the layer or layers beneath. Using an adjustment layer instead of 'Adjustments' from the Image menu allows the user to make multiple and consecutive image adjustments without permanently modifying the original pixel values.

Non-destructive image editing

The manipulation of image quality using adjustment layers and layer masks is often termed 'non-destructive'. Using adjustment layers to manipulate images is preferable to working directly and repeatedly on the pixels themselves. Using 'Adjustments' from the Image menu, or the manipulation tools from the toolbox (Dodge, Burn and Sponge tools) directly on pixel layers can eventually lead to a degradation of image quality. If adjustment layers are used together with layer masks to limit their effect, the pixel values of the image are not changed, but their effects are still displayed. This way of working retains the integrity of the original file and is essential for high-quality output. Note that the effects of adjustment do change the image pixels when the image is flattened or the layers are merged.

Note > For the last couple of versions of Photoshop it has been possible to scale or 'transform' a layer or group of layers non-destructively by turning the layer, or layers, into a Smart Object. More recently it has became possible to apply filters (called Smart Filters) non-destructively, Skew, Distort and add Perspective interactively to a Smart Object.

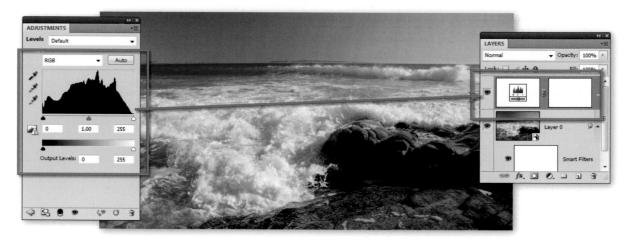

Retaining quality

The evidence of a file that has been degraded can be observed by viewing its histogram. If the resulting histogram displays excessive spikes or missing levels there is a high risk that a smooth transition between tones and color will not be possible in the resulting print. A tell-tale sign of poor scanning and image editing is the effect of 'banding' that can be clearly observed in the final print. This is where the transition between colors or tones is no longer smooth, but can be observed as a series of steps, or bands, of tone and/or color. To avoid this it is essential that you start with a good scan (a broad histogram without gaps) and limit the number of changes to the original pixel values.

Layer masks and editing adjustments

The use of layer masks is an essential skill for professional image retouching. Together with the Selection tools and adjustment layers they form the key to effective and sophisticated image editing. A 'layer mask' can control which pixels are concealed or revealed on any image layer except the background layer. If the layer mask that has been used to conceal pixels is then discarded or switched off (Shift-click the layer mask thumbnail) the original pixels reappear. This non-destructive approach to retouching and photographic montage allows the user to make frequent changes. To attach a layer mask to any layer (except the background layer) simply click on the layer and then click on the 'Add layer mask' icon at the base of the Layers panel.

Photoshop contains a special Masks pane with controls for adjusting the density and feather of a layer mask. Also included are buttons for refining the mask using Mask Edge, Color Range and Invert features. Remember that painting or adding gradients to a mask will reveal or conceal the adjustment when used with Adjustment layers.

A layer mask is automatically attached to every adjustment layer. The effects of an adjustment layer can be limited to a localized area of the image by simply clicking on the adjustment layer's associated mask thumbnail in the Layers panel and then painting out the adjustment selectively using any of the painting tools while working in the main image window. The opacity and tone of the foreground color in the toolbox will control the degree to which the adjustment is applied. Painting with a dark tone will conceal the effect while painting with a light tone will reveal the effect.

A layer mask can be filled with black to conceal the effects of the adjustment layer. Painting with white in the layer mask will then reveal the adjustment in the localized area of the painting action. Alternatively the user can select the Gradient tool and draw a gradient in the layer mask to selectively conceal a portion of the adjustment. To add additional gradients the user must select either the Multiply or Screen blend modes for the gradient in the Options bar.

LAYER MASK SHORTCUTS

Disable/enable layer mask	.Shift + click layer mask thumbnail
Preview contents of layer mask	.Opt/Alt + click layer mask thumbnail
Preview layer mask and image	.Opt/Alt + Shift + click layer mask thumbnail

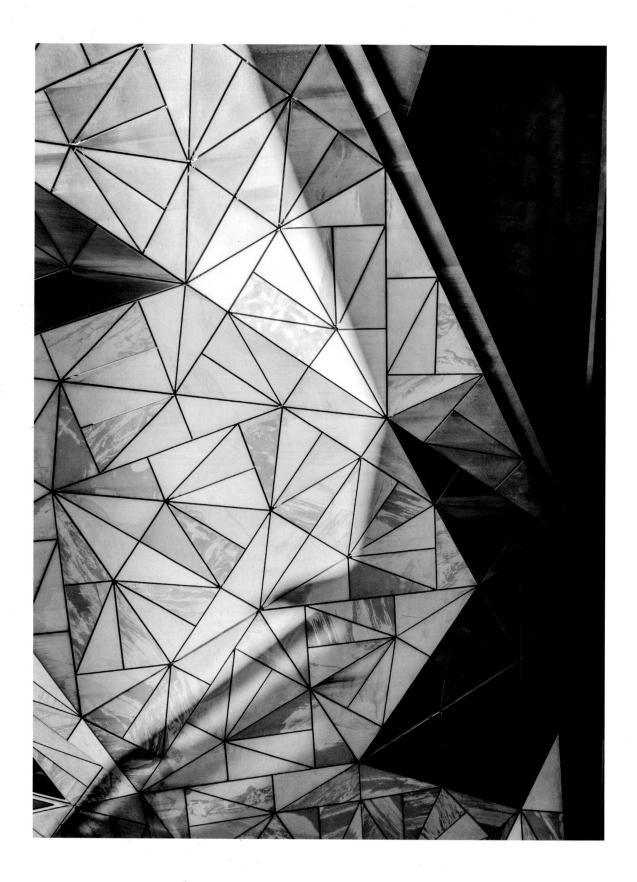

nop photoshop ph

essentíal skílls

- Develop skills in creating and modifying selections to isolate and mask image content.
- Develop skills using the following tools and features:
 - Selection Tools
 - Quick Mask, alpha channels and layer masks
 - Color Range and Refine Edge
 - Tone-based selections and masks
 - Selections from paths and the Pen tool.

Introduction

One of the most skilled areas of digital retouching and manipulation is the ability to make accurate selections of pixels for repositioning, modifying or exporting to another image. This skill allows localized retouching and image enhancement. Photoshop provides several different tools that allow the user to select the area to be changed. Called the 'Selection' tools, using these features will fast become a regular part of your editing and retouching process. Photoshop marks the boundaries of a selected area using a flashing dotted line, sometimes called 'marching ants'. Obvious distortions of photographic originals are common in the media but so are images where the retouching and manipulations are subtle and not detectable. Nearly every image in the printed media is retouched to some extent. Selections are made for a number of reasons:

- Making an adjustment or modification to a localized area, e.g. color, contrast, etc.
- Defining a subject within the overall image to mask, move or replicate.
- Defining an area where an image or group of pixels will be inserted ('paste into').

Selection tools overview

Photoshop groups the Selection tools based on how they isolate picture parts.

- The **Marquee tools** are used to draw regular-shaped selections such as rectangles or ellipses around an area within the image.
- The **Lasso tools** use a more freehand drawing approach and are used to draw a selection by defining the edge between a subject and its background.
- The **Magic Wand** and the **Quick Selection** tools both create selections based on color and tone and are used to isolate groups of pixels by evaluating the similarity of the neighboring pixel values (hue, saturation and brightness) to the pixel that is selected.

Shape-based selections with the Marquee tools

The Marquee tools select by dragging with the mouse over the area required. Holding down the Shift key as you drag the selection will 'constrain' the selection to a square or circle rather than a rectangle or oval. Using the Alt (Windows) or Option (Mac) key will draw the selections from their centers. The Marquee tools are great for isolating objects in your images that are regular in shape, but for less conventional shapes, you will need to use one of the Lasso tools.

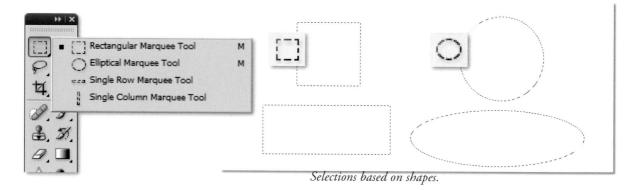

Selections

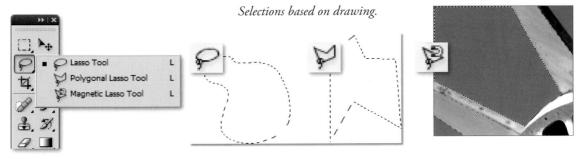

Drawn selections using the Lasso tools

Select by encircling or drawing around the area you wish to select. The standard Lasso tool works like a pencil, allowing the user to draw freehand shapes for selections. A large screen and a mouse in good condition (or a graphics tablet) are required to use the Freehand Lasso tool effectively. In contrast, the Polygonal Lasso tool draws straight-edged lines between mouse-click points. Either of these features can be used to outline and select irregular-shaped image parts. A third tool, the Magnetic Lasso, helps with the drawing process by aligning the outline with the edge of objects automatically. It uses contrast in color and tone as a basis for determining the edge of an object. The accuracy of the 'magnetic' features of this tool is determined by three settings in the tool's Options bar. **Contrast** is the value by which a pixel has to differ from its neighbor to be considered an edge, **Width** is the number of pixels either side of the pointer that are sampled in the edge determination process and **Frequency** is the distance between fastening points in the outline.

Double-clicking the Polygonal Lasso tool or Magnetic Lasso tool automatically completes the selection using a straight line between the last selected point and the first.

Note > Remember the Magnetic Lasso tool requires a tonal or color difference between the object and its background in order to work effectively.

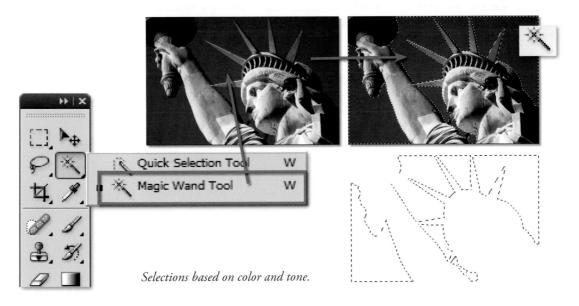

The Magic Wand

Unlike the Lasso and Marquee tools the Magic Wand makes selections based on color and tone. It selects by relative pixel values. When the user clicks on an image with the Magic Wand tool Photoshop searches the picture for pixels that have a similar color and tone. With large images this process can take a little time but the end result is a selection of all similar pixels across the whole picture.

Tolerance

How identical a pixel has to be to the original is determined by the Tolerance value in the Options bar. The higher the value, the less alike the two pixels need to be, whereas a lower setting will require a more exact match before a pixel is added to the selection. Turning on the Contiguous option will only include the pixels that are similar and adjacent to the original

Quicker selections

Right from the very early days of Photoshop most users quickly recognized that being able to apply changes to just a portion of their images via selections was a very powerful way to work. It followed that the quality of their selective editing and enhancement activities was directly related to the quality of the selections they created. This was the start of our love/hate relationship with selection creation.

Over the years Adobe has provided us with a range of tools designed to help in this quest. Some, like the Magic Wand, are based on selecting pixels that are similar in tone and color; others, such as the Lasso and Marquee tools, require you to draw around the subject to create the selection.

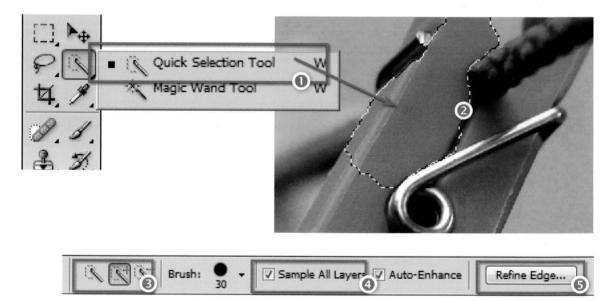

The Quick Selection tool is grouped with the Magic Wand in the toolbar (1). The feature creates intelligent selections as you paint over the picture surface (2). The tool's options bar contains settings for adding to and subtracting from existing selections (3), using the tool over multiple layers (4), as well as a button to display the Refine Edge feature (5).

The Quick Selection tool is grouped with the Magic Wand in the toolbar. The tool is used by painting over the parts of the picture that you want to select. The selection outline will grow as you continue to paint. When you release the mouse button the tool will automatically refine the selection further.

Moving a selection

If the selection is not accurate it is possible to move it without moving any pixels. With the Selection tool still active place the cursor inside your selection and drag the selection to reposition it. To move the pixels and the selection, use the Move tool from the Tools palette. You can also move selections even if the active layer is currently hidden.

To remove a selection

Go to Select > Deselect or use the shortcut Command/Ctrl + D to deselect a selection.

Customizing your selections

Basic selections of standard, or regular-shaped, picture parts can be easily made with one simple step – just click and drag. But you will quickly realize that most selection scenarios are often a little more complex. For this reason, the thoughtful people at Adobe have provided several ways of allowing you to modify your selections. The two most used methods provide the means to 'add to' or 'subtract from' existing selections. This, in conjunction with the range of selection tools offered by the program, gives the user the power to select even the most complex picture parts, often using more than one tool for the task. Skillful selecting takes practice and patience as well as the ability to choose which selection tool (or tools) will work best for a given task. Photoshop provides two different methods to customize an existing selection.

Mode buttons

Use the mode buttons located in a special portion of the tool's Options bar to start changing your selections. The default mode is 'New Selection', which means that each selection you make replaces the last. Once another option is selected the mode remains active for the duration of the selection session. This is true even when you switch selection tools.

The user can make a selection before creating the adjustment layer and then when the adjustment layer is created the selection is used to automatically create a mask.

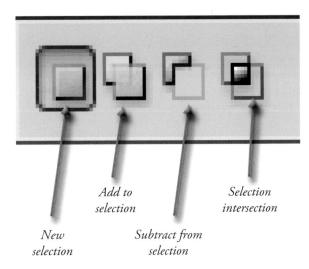

Add to a selection

To add to an existing selection hold down the Shift key while selecting a new area. Notice that when the Shift key is held down the Selection tool's cursor changes to include a '+' to indicate that you are in the 'add' mode. This addition mode works for all tools and you can change selection tools as needed to make further refinements.

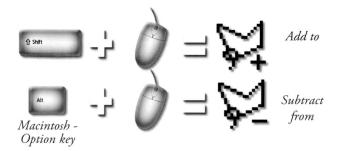

Keyboard shortcuts provide the fastest way to customize your selections.

Subtract from a selection

To remove sections from an existing selection hold down the Alt key (Option for Macintosh) while selecting the part of the picture you do not wish to include in the selection. When in the subtract mode the cursor will change to include a '-'.

Selection intersection

In Photoshop often the quickest route to selection perfection is not the most direct route. When you are trying to isolate picture parts with complex edges it is sometimes quicker and easier to make two separate selections and then form the final selection based on their intersection. The fourth mode available as a button on the Selection tool's Options bar is the Intersect mode (Opt/Alt Shift). Though not used often, this mode provides you with the ability to define a selection based on the area in common between two different selections.

Inversing a selection

In a related technique, some users find it helpful to select what they don't want in a picture and then instruct Photoshop to select everything but this area. The Select > Inverse command (Ctrl/Cmd Shift I) inverts or reverses the current selection and is perfect for this approach. In this way foreground objects can be quickly selected in pictures with a smoothly graduated background of all one color (sky, snow or a wall space) by using the Magic Wand to select the background. Then the act of inversing the selection will isolate the foreground detail.

Professionals who know that the foreground will be extracted from the picture's surrounds often shoot their subjects against an evenly lit background of a consistent color to facilitate the application of this technique.

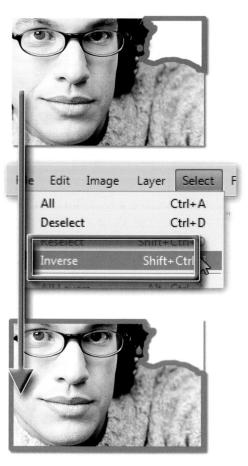

Sometimes it is quicker to select the area that you don't want and then inverse the selection to produce the required results.

Selections

Refining selections

As well as 'adding to' and 'subtracting from' existing selections, Photoshop contains several other options for refining the selections you make. Grouped under the Select menu, these features generally concentrate on adjusting the edge of the current selection. The options include:

Border – Choosing the Border option from the Modify menu displays a dialog where you can enter the width of the border in pixels (between 1 and 200). Clicking OK creates a border selection that frames the original selection.

Smooth – This option cleans up stray pixels that are left unselected after using the Magic Wand tool. These will result in holes in your selection. After choosing Modify enter a radius value to use for searching for stray pixels and then click OK.

Other options for modifying your selections can be found under the Select menu.

Expand – After selecting Expand, enter the number of pixels that you want to increase the selection by and click OK. The original selection is increased in size. You can enter a pixel value between 1 and 100.

Contract – Selecting this option will reduce the size of the selection by the number of pixels entered into the dialog. You can enter a pixel value between 1 and 100.

Feather - The Feather command softens the transition between selected and non-selected areas.

Grow – The Grow feature increases the size of an existing selection by incorporating pixels of similar color and tone to those already in the selection. For a pixel to be included in the 'grown' selection it must be adjacent to the existing selection and fall within the current tolerance settings located in the Options bar.

Similar – For a pixel to be included in the 'Similar' selection it does not have to be adjacent to the existing selection but must fall within the current tolerance settings located in the Options bar.

Refine Edge – The Refine Edge feature provides a mechanism for intelligently adapting the qualities of the selection edge to the changing characteristics of the subject. Refine Edge is accessed either via the button now present in all the Options bars of all Selection tools, or via Select > Refine Edge. The dialog brings together a range of different controls for adjusting the edges of the selection with seven selection edge preview modes and the Edge Detection ability (Smart Radius) and Output options. Smart Radius plus the Output and Preview modes make refining edges a lot easier to manage, with the ultimate result of the production of better selection edges for all.

Several other options are available only in Refine Edge:

Radius – Use this slider to increase the quality of the edge in areas of soft transition with background pixels or where the subject's edge is finely detailed.

Contrast – Increase the contrast settings to sharpen soft selection edges.

Shift Edge - Moves the selection edge, effectively expanding or contracting the selection.

Smart Radius – Applies the edge detection technology to the selection. The Radius slider changes the width of the area around the selection edge being used in the detection.

Decontaminate – Removes the remnants of background color from the selection edge in order to produce a better blend when placing the subject on a new background. The Amount slider controls the strength of the effect.

	Refine Edge	
Marching Ants (M) Overlay (V) On Black (B)	View Mode View: Show Radius (J) Show Original (P)	Refine Radius T E Erase Refinements Tool E
Dn White (W)	Smart Radius	
On Layers (L) Reveal Layer (R) Press F to cycle views. Press X to temporarily disable all views.	Adjust Edge Image: Contrast: Image: Contrast:	
The Refine Edge dialog includes View options (1), powerful Edge Detection features (2), selection refinement tools (3), Edge adjustment controls (4), and Output settings (5).	Output Decontaminate Colors Amount: Output To: New Layer with Layer Mask Remember Settings Cancel OK	Output To: New Layer with Layer Mask Selection Remember S Layer Mask New Layer With Layer Mask New Document New Document with Layer Mask

Previewing edge refinements – The View mode menu at the top of the Refine Edge dialog provides a range of different ways to view the selection on your picture. Press the F key to cycle through the view modes and the X key to temporarily display the full image view.

Output To – There is also a drop-down list of output options at the bottom of the Refine Edge dialog. Included are options to create layers, masks and even new documents from the refined selection.

Refine Edge in action

The power of the recently introduced edge detection and refinement features are put to best use when creating a seamless montage of a subject against a new background. Just as in the last release, using Refine Edge is a three-step process. First you need to make a rough selection of the subject, next you use the feature's controls to adjust the selection edge before finally extracting the subject from its existing background and layering above the new background.

Selections

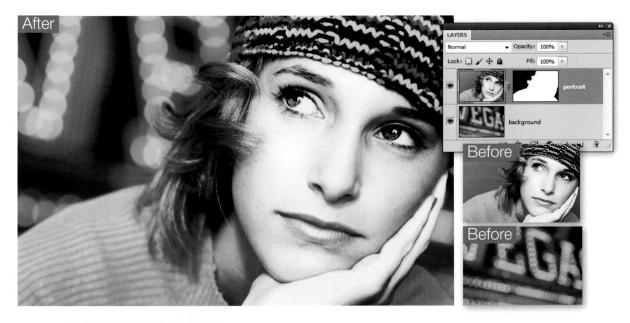

The first step is to create a selection around the subject. In the example above, the girl on the upper layer, I chose the Quick Selection Tool from the toolbar and painted a selection over the subject. The tool automatically selects the jumper, face, hat and hair as I drag the tool over the canvas.

View Mode View: Show Radius (3) Show Original (P) Edge Detection Smart Radius Radius: P px

If some of the background is included in your selection, remember you can adjust the selection further by holding down the Alt/Opt key to switch the tool to the Subtract From Select mode, and then painting over these parts to remove them.

With the newly created selection displayed, I chose Select > Refine Edge. This displays the Refine Edge dialog box. Next, I adjusted the settings so that the View was Black and White, Smart Radius was checked, Radius was 1 pixel, Decontaminate Colors was unchecked and all other settings were zero.

The Smart Radius feature automatically adapts the selection approach to the differences in edge between the subject's jumper, hat and hair. I moved the Radius slider to increase the width of the area either side of the selection's edge used by the Smart Radius. Pressing the J key displays the radius and adjusting the Shift Edge slider moves the position of the edge.

With some subjects a single Radius setting will not encompass all edge details. In these cases, you can customize the width and positioning of the edge with the Refine Radius and Erase Refinements tools. Here, I fine-tuned the mask around the subject's hair by painting with the Refine Radius tool. I then pressed the F key to cycle through the preview modes to check the quality of the edge.

Next, I switched to the Erase Refinements tool to remove any unwanted areas that had crept into the mask's edge. Here, I viewed the changes in the On Layer view so that it was possible to see the subject against the layer beneath.

If you intend to place the selected subject on a new background you can use the Decontaminate Colors setting and its associated Amount slider to remove any color remaining in the edge from the old background. These settings introduce a degree of transparency to the mask edge so that the subject is merged more seamlessly with the new background. The Output To menu contains a range of options that determine how the selected part of photo will be processed when exiting the Refine Edge dialog box. For this example I selected the New Layer With Layer Mask option.

Saving and loading selections

2

The selections you make remain active while the image is open and until a new selection is made, but what if you want to store all your hard work to use on another occasion? As we have already seen in the previous chapter, Photoshop provides the option to save your selections/ masks as part of the picture file. Simply choose Select > Save Selection and the existing selection will be stored with the picture.

To show a selection saved with a picture, open the file and choose Load Selection from the Select menu. In the Load Selection dialog click on the Channel drop-down menu and choose the selection you wish to reinstate. Choose the mode with which the selection will be added to your picture from the Operation section of the dialog. Click OK to finish.

170

Feather and anti-alias

The ability to create a composite image or '**photomontage**' that looks subtle, realistic and believable rests with whether or not the viewer is able to detect where one image starts and the other finishes. The edges of each selection can be modified so that it appears as if it belongs, or is related, to the surrounding pixels. Options are available in Photoshop to alter the appearance of the edges of a selection. Edges can appear sharp or soft (a gradual transition between the selection and the background). The options to effect these changes are:

- Feather
- Anti-aliasing.

Feather

When this option is chosen the pixels at the edges of the selection are blurred. The edges are softer and less harsh. This blurring may either create a more realistic montage or cause loss of detail at the edge of the selection. You can choose feathering for the Marquee or Lasso tools as you use them by entering a value in the tool options box, or you can add feathering to an existing selection (Select > Feather). The feathering effect only becomes apparent when you move or paste the selection to a new area.

Anti-aliasing

When this option is chosen the jagged edges of a selection are softened. A more gradual transition between the edge pixels and the background pixels is created. Only the edge pixels are changed so no detail is lost. Anti-aliasing must be chosen before the selection is made: it cannot be added afterwards. It is usual to have the anti-alias option selected for most selections. The anti-alias option also needs to be considered when using type in image editing software. The anti-alias option may be deselected to improve the appearance of small type to avoid the appearance of blurred text.

More control of pixel edges in Photoshop

The appearance of the edges of objects is also controlled by how they are aligned to the underlying pixel grid of a Photoshop document. Photoshop has two features designed especially for this purpose. **Align Edges**, found in the Options bar of all vector tools and applicable on a per-layer basis, and the **Snap Vector Tools And Transforms to Pixel Grid** setting, located in the General section of Preferences and applied to vector tools program-wide. The features work in different ways. Align Edges snaps the edge of an object to the pixel grid, whereas the Preferences option snaps all newly created and edited vector content to the grid.

Defringe and Matting

When a selection has been made using the anti-alias option, some of the pixels surrounding the selection are included. If these surrounding pixels are darker, lighter or a different color to the selection, a fringe or halo may be seen.

Your first point of call for fixing this problem should be the Decontaminate Colors option in the Refine Edge dialog. For the best blending be sure to preview the subject against the new background as you adjust the Amount slider.

Alternatively, you can choose Layers > Matting > Defringe from the Layers menu to replace the different fringe pixels with pixels of a similar hue, saturation or brightness found within the selection area.

The user may have to experiment with the most appropriate method of removing a fringe. The alternative options of Remove White Matte and Remove Black Matte may provide the user with a better result. If a noticeable fringe still persists it is possible to contract the selection prior to moving it using the Modify > Contract option from the Select

the Modify > Contract option from the Select menu.

Saving a selection as an alpha channel

Selections can be permanently stored as **alpha channels**. The saved selections can be reloaded and/or modified even after the image has been closed and reopened. To save a selection as an alpha channel simply click the 'Save selection as channel' icon at the base of the Channels palette. To load a selection either drag the alpha channel to the 'Load channel as selection' icon in the Channels palette or Command/Ctrl-click the alpha channel.

It is possible to edit an alpha channel (and the resulting selection) by using the painting and editing tools. Painting with black will add to the alpha channel whilst painting with white will remove information. Painting with shades of gray will lower or increase the opacity of the alpha channel. The user can selectively soften a channel and resulting selection by applying a Gaussian Blur filter. Choose Blur > Gaussian Blur from the Filters menu.

Note > An image with saved selections (alpha channels) cannot be saved in the standard JPEG format. Use the PSD, PDF or TIFF formats or JPEG2000 (optional plug-in) if storage space is tight.

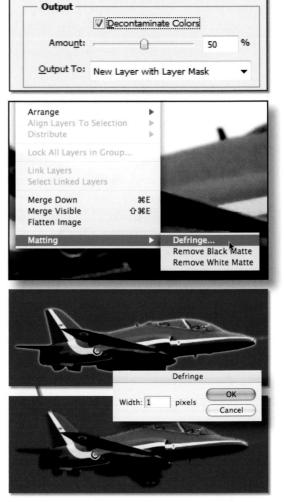

Selections

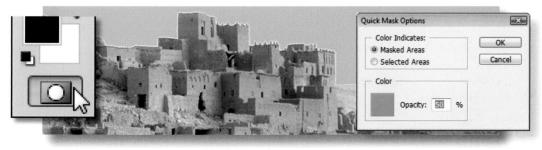

Quick Mask or Refine Edge

The problem with feathering and modifying selections using the Modify commands in the Select menu is that the ants give very poor feedback about what is actually going on at the edge. Viewing the selection against a Matte color in the Refine Edge dialog box or as a mask in Quick Mask mode allows you to view the quality and accuracy of your selection. Quick Mask allows the user to modify localized areas of the edge while Refine Edge works on the entire edge. Zoom in on an edge to take a closer look. Double-click the Quick Mask icon to change the mask color, opacity and to switch between Masked Areas and Selected Areas. If the mask is still falling short of the edge you can expand the selection by going to Filter > Other > Maximum. Choose a 1-pixel radius, select OK and the mask will shrink (expanding the selection). A 'Levels' adjustment in Quick Mask mode provides a 'one-stop shop' for editing the mask, giving you the luxury of a preview as with Refine Edge, but also the advantage of localized editing.

Using a Levels adjustment (Image > Adjustments > Levels) in Quick Mask mode allows you to modify the edge quality if it is too soft and also reposition the edge so that it aligns closely with your subject. Make a selection of the edge using the Lasso tool if you need to modify just a small portion of the Quick Mask with Levels. Dragging the shadow and highlight sliders in towards the center will reduce the softness of the mask while moving the midtone or Gamma slider will move the edge itself. Unlike the Refine Edge dialog box you can paint in Quick Mask to refine localized areas of the selection.

Note > The selection must have been feathered prior to the application of the Levels adjustment for this to be effective.

Save the selection as an alpha channel. This will ensure that your work is stored permanently in the file. If the file is closed and reopened the selection can be reloaded. Finish off the job in hand by modifying or replacing the selected pixels. If the Quick Selection tool or Magic Wand tool are not working for you, try exploring the following alternatives.

Color Range

The Quick Selection tool may be the obvious tool for making a selection of a subject with a good color or tonal contrast, but Color Range can be utilized for making selections of similar color that are not contiguous. Color Range, from the Select menu, is useful for selecting subjects that are defined by a limited color range (sufficiently different from those of the background colors). The feature contains Localized Color Clusters and Range options for better control over where the feature is put to work. Color Range is especially useful when the selection is to be used for a hue adjustment. Use a Marquee tool (from the Tools palette) to limit the selection area before you start using the Color Range option.

Note > The Color Range option can misbehave sometimes. If the selection does not seem to be restricted to your sampled color press the Alt/Option key and click on the reset option or close the dialog box and re-enter.

Use the 'Add to sample' eyedropper and drag the eyedropper over the subject area you wish to select. In the later stages you can choose a matte color to help the task of selection. Adjust the Fuzziness slider to perfect the selection.

Very dark or light pixels can be left out of the selection if it is to be used for a hue adjustment only. The dialog contains four options in the Selection Preview menu that will allow you to view the quality of the selection on the image to gain an idea of the selection's suitability for the job in hand.

Two additional options allow you to quickly target skin tones and faces in your selections. Once you choose the Skin Tone option from the Select menu it becomes possible to also choose the Detect Faces option in the dialog box. Though not perfect, these additions help concentrate the feature's selecting abilities when you are making adjustments to portraits. The resultant masks created by the Color Range feature can be 'cleaned' using the Dust & Scratches filter and softened using a Gaussian Blur filter.

A selection prepared by the Color Range command is ideal for making a hue adjustment. It is also recommended to view the individual channels to see if the subject you are trying to isolate is separated from the surrounding information. If this is the case a duplicate channel can act as a starting point for a selection.

Channel masking

An extremely quick and effective method for selecting a subject with reasonable color contrast to the surrounding pixels is to use the information from one of the channels to create a mask and then to load this mask as a selection.

Click on each individual channel to see which channel offers the best contrast and then duplicate this channel by dragging it to the New Channel icon.

Apply a Levels adjustment to the duplicate channel to increase the contrast of the mask. Slide the shadow, midtone and highlight sliders until the required mask is achieved. The mask may still not be perfect but this can be modified using the painting tools.

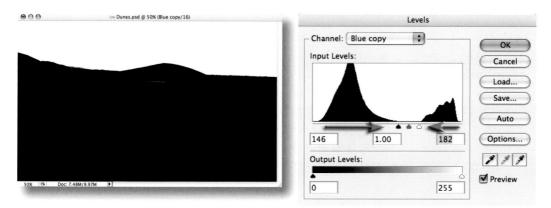

900	🖙 Dunes.psd @ 100% (Blue copy/16)	Gaussian Blur
		OK Cancel
		Preview 🗹
		⊡ 100% •
		Radius: 1.5 pixels

Select the default settings for the foreground and background colors in the Tools palette, choose a paintbrush, set the opacity to 100% in the Options bar and then paint to perfect the mask. Zoom in to make sure there are no holes in the mask before moving on. To soften the edge of the mask, apply a small amount of Gaussian Blur.

Note > Switch on the master channel visibility or Shift-click the RGB master to view the channel copy as a mask together with the RGB image. This will give you a preview so that you can see how much blur to apply and if further modifications are required.

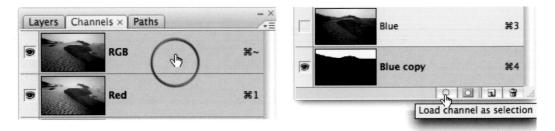

Click on the active duplicate channel or drag it to the 'Load channel as selection' icon. Click on the RGB master before returning to the Layers palette.

Channel masking may at first seem a little complex but it is surprisingly quick when the technique has been used a few times. This technique is very useful for photographers shooting products for catalogs and websites. A small amount of color contrast between the subject and background is all that is required to make a quick and effective mask.

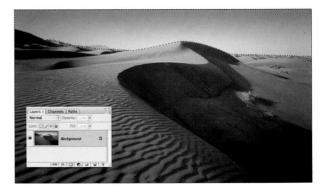

Tone-based selections and masks

So, as we can see, masks and, their alter ego, selections, are very useful for controlling how layers are blended together and also how effects are applied to images, but they can also help us alter specific tones in a photo. Once created, a mask can be used in conjunction with a Curves or Levels Adjustment layer to restrict the changes made with these features to a specific tonal range.

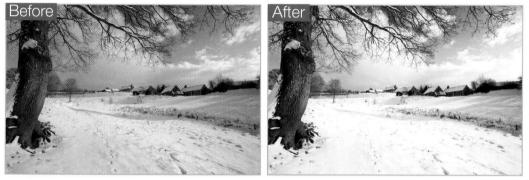

Using the abilities of a luminosity mask it is possible to control adjustments so that they are applied proportionately to highlights, then midtones and shadows.

Luminosity masking

In this example, a Luminosity mask is used to alter the highlight details of the photo to provide more apparent detail. Because the mask was created with tones of the original image the adjustment is applied proportionately to the highlights most, then midtones, and finally, to the shadow areas. This is because of the basic nature of masks where white areas 'reveal' the effect and black areas 'conceal' the effect.

Start by displaying the Channels palette and then make a selection from the image. Drag the RGB channel to the Load Selection button at the bottom of the palette. Click the Save Selection button to create a new entry called Alpha 1. Rename the entry Highlights.

The Luminosity mask is used in conjunction with the Adjustment layer to tweak the highlight tones.

Click the RGB Channel entry at the top of the palette to make it active. This restores the color preview. Now, choose Select > Deselect to remove the marching ants from the preview.

Drag the channel to the Load Selection button at the bottom of the Channels palette. With the selection active you can now add a new Curves Adjustment layer that will use the selection as a highlight mask. Make changes to the shape of the highlight end of the curve and click the OK button to apply the adjustments via the associated Highlights mask.

Using a shadow mask, it is possible to alter the tones of the dark portions of the image while leaving many of the midtones and all of the highlights untouched. Here more detail was added to the dark curtains by boosting the brightness and contrast of these tones.

Shadow masking

Shadow luminosity masking, like the highlight masking we have just looked at, is a process by which the darker tones in an image are isolated with a mask. Once this has occurred, then it is possible to adjust just those values in the photo using an Adjustment layer. In this example the shadow areas have been changed

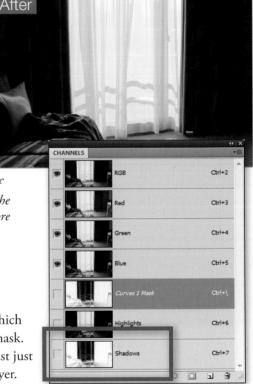

using a Curves Adjustment layer and in the process, the highlights in the image have been left unchanged.

The first step is to create a highlight mask. Do this by displaying the Channels palette and then dragging the RGB entry to the Load Channel as Selection button at the bottom of the palette. With the selection still active, click on the next button along to create a mask from the selection. Rename the new mask Highlights.

Ctrl+7 î 1

We will now use the Highlights mask to create the shadow mask. Start by deselecting any selections still active. Next, drag the Highlights mask entry to the Create New Channel button at the bottom of the palette. This will create a copy of the Highlights mask entry. Select the copied entry and type Ctrl/Cmd I to inverse the image. Rename the channel Shadows.

Inverting the Highlights mask effectively creates a mask that concentrates on the opposite end of the spectrum - the shadows. Now with the Shadows channel selected click onto the Load Channel as Selection button at the bottom of the palette. Next deselect the Shadows channel and click onto the RGB channel entry. Then select Layer > New Adjustment Layer > Curves. Make your shadow adjustment via the Curves feature.

midtone luminosity mask. This will largely restrict the changes from shadows and highlight areas.

Midtone contrast boost

We have already looked at the how to adjust middle tones using controls such as Curves and Shadows/ Highlights, but what if we want to use a masking approach for the task? In other words, to apply the Curves control through a midtone mask which, by definition, restricts the changes from being applied to shadows or highlights. This technique is based on creating highlight and shadow masks first and then using these to generate a third mask that just isolates the middle values of the image.

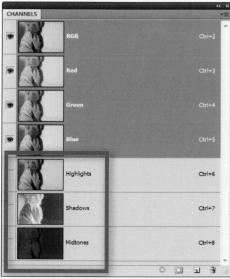

Start by creating a luminosity highlight mask. Do this by dragging the RGB entry in the Channels to the Load Channel as Selection button. Then click onto the Save Selection as Channel button. Rename the entry Highlights. Hit Ctrl/Cmd D to deselect the active selection.

Now to create the shadow luminosity mask. Start by dragging the Highlights mask to the Create New Channel button at the bottom of the Channels palette. Rename this entry Shadows. Select the new Shadows mask and inverse the tones of the mask by hitting the Ctrl/Cmd I keys.

To create the midtone mask, firstly click onto the RGB channel entry. Choose Select > All to create a selection of all the image. Now hold down the Ctrl/ Cmd Alt/Opt keys while clicking both highlight and shadow mask channel thumbnails. This subtracts highlights, and shadows from the whole image selection. During this process you may see a warning like the one on the right. Click OK to continue. Save the selection as a new mask called Midtones. Deselect. Now select the Midtones entry in the Channel palette. Click onto the Load Channel as Selection button at the bottom of the palette then select the RGB channel entry to reset the preview back to full color. You may not see the marching ants of the selection but it will be active. Now create a new Curves Adjustment layer. Automatically the midtone mask will be used in conjunction with the Curves feature. Now you can alter the curve's shape to adjust the middle values.

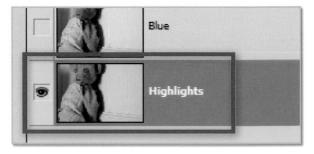

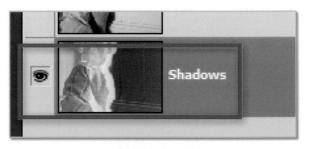

Selections from paths

The Pen tool is often used in the creation of sophisticated smooth-edged selections, but strictly speaking it is not one of the selection tools. The Pen tool creates vector paths instead of selections; these, however, can be converted into selections that in turn can be used to extract or mask groups of pixels. The Pen tool has an unfortunate reputation – neglected by most, considered an awkward tool by those who have made just a passing acquaintance, and revered by just a select few who have taken a little time to get to know 'the one who sits next to Mr Blobby' (custom shape icon) in the Tools palette. Who exactly is this little fellow with 'ye olde' ink nib icon and the awkward working persona?

The Pen tool was drafted into Photoshop from Adobe Illustrator. Although graphic designers are quite adept at using this tool, many photographers the world over have been furiously waving magic wands and magnetic lassos at the megapixel army and putting graphics tablets on their shopping lists each year in an attempt to avoid recognizing the contribution that this unique tool has to offer.

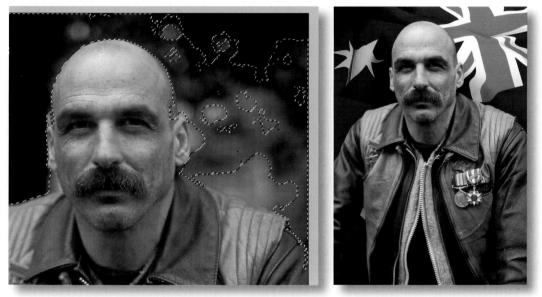

Not everything you can see with your eye can be selected easily with a technique based on color or tonal values. The resulting ragged selections can be fixed in Quick Mask mode, but sometimes not without a great deal of effort. The question then comes down to 'How much effort am I prepared to apply, and for how long?' It's about this time that many image editors decide to better acquaint themselves with the Pen tool. Mastering the Pen tool in order to harness a selection prowess known to few mortals is not something you can do in a hurry – it falls into a certain skill acquisition category, along with such things as teaching a puppy not to pee in the house, called time-based reward, i.e. investing your time over a short period will pay you dividends over a longer period. The creation of silky smooth curvaceous lines (called paths) that can then be converted into staggeringly smooth curvaceous selections makes the effort of learning the Pen tool all worthwhile.

Basic drawing skills

Vector lines and shapes are constructed from geographical markers (anchor points) connected by lines or curves. Many photographers have looked with curiosity at the vector tools in Photoshop's Tools palette for years but have dismissed them as 'not for me'. The reason for this is that for the inexperienced image editor drawing vector lines with the Pen tool is like reversing with a trailer for the inexperienced driver. It takes practice, and the practice can initially be frustrating.

The Pen can multi-task (just like most women and very few men that I know). The pen can draw a vector shape while filling it with a color and applying a layer style – all at the same time. We can also use the training wheels, otherwise known as the 'Rubber Band' option, by clicking on the menu options in the Options bar.

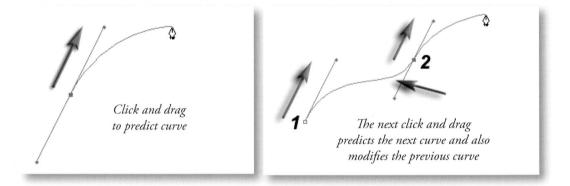

Step 1 – Go to 'File > New' and create a new blank document. Choose White as the Background Contents. Size is not really important (no, really – in this instance anything that can be zoomed to fill the screen will serve your purpose). Click on the Pen tool (double-check that the Paths option, rather than the Shape Layers option, is selected in the Options bar) and then click and drag in the direction illustrated above. The little black square in the center of the radiating lines is called an anchor point. The lines extending either side of this anchor point are called direction lines, with a direction point on either end, and that thing waving around (courtesy of the Rubber Band option) is about to become the path with your very next click of the mouse.

Step 2 – Make a second click and drag in the same direction. Notice how the dragging action modifies the shape of the previous curved line. Go to the Edit menu and select Undo. Try clicking a second time and dragging in a different direction. Undo a third time and this time drag the direction point a different distance from the anchor point. The thing you must take with you from this second step is that a curve (sometimes referred to as a Bézier curve) is both a product of the relative position of the two anchor points either side of the curve, and the direction and length of the two direction lines (the distance and direction of the dragging action).

Selections

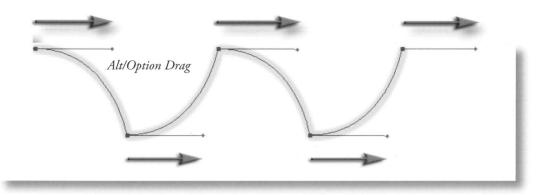

Step 3 – Let us imagine that the first click and drag action has resulted in a perfect curve; the second dragging action is not required to perfect the curve but instead upsets the shape of this perfect curve – so how do we stop this from happening? Answer: Hold down the Alt key (PC) or Option key (Mac) and then drag away from the second anchor point to predict the shape of the next curve. This use of the Alt/Option key cancels the first direction line that would otherwise influence the previous curve.

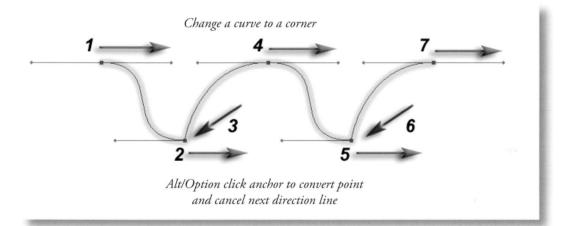

Now let us imagine that we have created the first perfect curve using two normal click and drag actions (no use of a modifier key). The direction lines that are perfecting the first curve are, however, unsuitable for the next curve – so how do we draw the next curve while preserving the appearance of the first curve? Answer: The last anchor point can be clicked while holding down the Alt/Option key. This action converts the smooth anchor point to a corner anchor point, deleting the second direction line. The next curved shape can then be created without the interference of an inappropriate direction line.

Note > The information that you need to take from this third step is that sometimes direction lines can upset adjacent curves. The technique of cancelling one of the direction lines using a modifier key makes a series of perfect curves possible. These two techniques are especially useful for converting smooth points into corner points on a path.

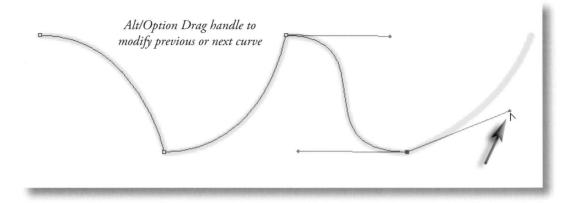

Step 4 – Just a few more steps and we can go out to play. It is possible to change direction quickly on a path without cancelling a direction line. It is possible to alter the position of a direction line by moving the direction point (at the end of the line) independently of the direction line on the other side of the anchor point. To achieve this, simply position the mouse cursor over the direction point and, again using the Alt/Option key, click and drag the direction point to a new position.

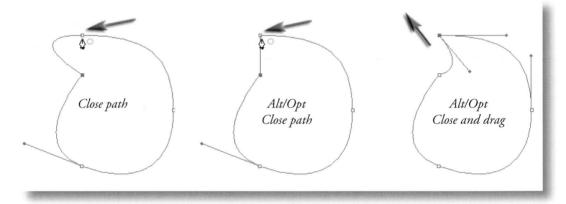

Step 5 – If this path is going to be useful as a selection, it is important to return to the start point. Clicking on the start point will close the path. As you move the cursor over the start point the Pen tool will be accompanied by a small circle to indicate that closure is about to occur. You will also notice that the final curve is influenced by the first direction line of the starting anchor point. Hold down the Alt/Option key when closing the path to cancel this first direction line. Alternatively, hold down the Alt/Option key and drag a new direction line to perfect the final curve.

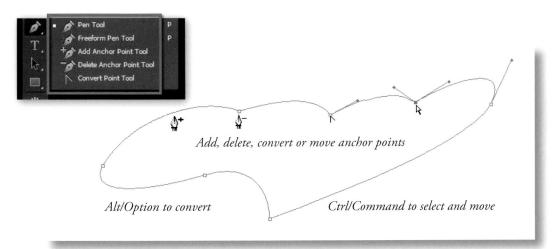

Step 6 – When a path has been closed it is possible to add, delete, convert or move any point. Although these additional tools are available in the Tools palette they can all be accessed without moving your mouse away from the path in progress. If the Auto Add/Delete box has been checked in the Options bar you simply have to move the Pen tool to a section of the path and click to add an additional point (the pen cursor sprouts a + symbol). If the Pen tool is moved over an existing anchor point you can simply click to delete it. Holding down the Ctrl key (PC) or Command key (Mac) will enable you to access the Direct Selection tool (this normally lives behind the Path Selection tool). The Direct Selection tool has a white arrow icon and can select and move a single anchor point (click and drag) or multiple points (by holding down the Shift key and clicking on subsequent points). The Path Selection tool has to be selected from the Tools palette and is able to select the entire path.

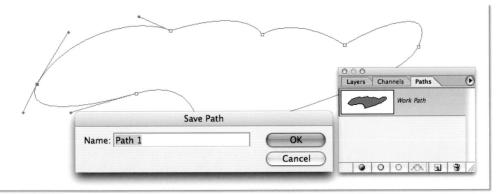

Step 7 – The final step in the creation of a Path is to save it. All Paths, even Work Paths, are saved with the image file (PSD, PDF, PSB, JPEG or TIFF). If, however, a Work Path is not active (such as when the file is closed and reopened) and then the Pen tool is inadvertently used to draw a new Path, any previous Work Path that was not saved is deleted.

Click on the Paths palette tab and then double-click the Work Path. This will bring up the option to save and name the Work Path and ensure that it cannot be deleted accidentally. To start editing an existing Path, click on the Path in the Paths palette and then choose either the Direct Selection tool or the Pen tool in the tTools palette. Click near the Path with the Direct Selection tool to view the handles and the Path.

filters

op photoshop photoshop photoshop photoshop photoshop photo

op photoshop photoshop photoshop photoshop photoshop phot

essentíal skílls

- Apply filter effects to a picture.
- Use the Filter Gallery feature to apply several filters cumulatively.
- Use filters with text and shape layers.
- The 'Smart' way to apply filters.
- Filter a section of a picture.
- Paint with a filter effect.
- Install and use third party filters.

Introduction

Traditionally the term filter, when used in a photography context, referred to a small piece of plastic or glass that was screwed onto, or clipped in front of, the camera's lens. Placing the filter in the imaging path changed the way that the picture was recorded. During the height of their popularity there were literally hundreds of different filter types available for the creative photographer to use. The options ranged from those that simply changed the color of the scene, to graduated designs used for darkening skies to multi-faceted glass filters that split the image into many fragments. Even now, when their popularity has waned, most photographers still carry a polarizing filter, maybe a couple of color conversion filters and perhaps the odd graduated filter as well. But apart from these few examples, much of the creative work undertaken by in-front-of-camera filters is now handled by the digital filters that are shipped with your imaging program. These options, like the filters of old, are designed to change the way that your picture looks, but you will find that it is possible to create much more sophisticated effects with the digital versions than was ever possible before.

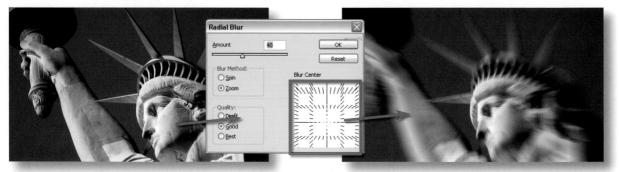

Statue of Liberty - Jeremy Edwards

Applying a filter is a simple process. After opening the image simply select the filter option from those listed under the Filter menu. This approach applies the effects of the filter to the whole of the photo, changing it forever. So be sure to keep a back-up copy of the original picture or apply the filter to a merged copy of all the visible layers, just in case you change your mind later. Better still, use the Smart Filter option to apply your filter changes losslessly.

ЖF	
X企業A	
ĉ₩A	
ΰ₩R	
ΰжх	
7.#V	
Sector 1	Field Blur
•	Iris Blur
	Tilt-Shift
× 1	
•	Average
•	Blur
•	Blur More
	Box Blur
•	Gaussian Blur
	Motion Blur
	Radial Blur
	Shape Blur
	Smart Blur
	で 分開A 分開A 分開A 分開X で 開X で 開X と ト ト ト ト ト ト ト ト ト ト ト ト ト

To get you started, I have included a variety of examples from the range that comes free with Photoshop. I have not shown Gaussian Blur or all the sharpening filters as these are covered in techniques elsewhere in the text, but I have tried to sample a variety that, to date, you might not have considered using. I have also included an overview of some of the newer offerings such as the Blur Gallery (Filter > Blur) and Adaptive Wide Angle (Filter > Adaptive > Wide-Angle) options, and the Liquify (Filter > Liquify) and Lighting Effects (Filter > Render > Lighting Effects) filters. If you are unimpressed by the results of your first digital filter foray, try changing some of the variables or mixing a filtered layer (using the layer's Blending Mode or Opacity controls) with an unfiltered version of the image. An effect that might seem outlandish at first glance could become usable after some simple adjustments of the in-built sliders contained in most filter dialog boxes or with some multiple layer variations.

The 'Smart' way to filter

The concept of non-destructive editing is the future of editing for photographers and is ever growing in popularity and acceptance. Now many dedicated amateurs are working like professionals by embracing ways of enhancing and editing that don't destroy or change the original pixels in the end result. Masking techniques, Adjustment Layers and the use of Smart Objects are the foundation technologies of many of these techniques. But try as we may, some changes have just not been possible to apply non-destructively.

Filtering is one area in particular where this is the case. For example, applying a sharpening filter to a picture irreversibly changes the pixels in the photo forever. For this reason, for many years, the smart photographer applied filters to copies of their photos in order to maintain the integrity of the original capture. A few versions ago Adobe added a filtering option called Smart Filters and yes, you guessed it, this technology allowed users to apply a filter to an image non-destructively. Cool!

Based around the Smart Object technology, applying a Smart Filter is a two-step process. First the image layer needs to be converted to a Smart Object. This can be done via the new entry in the Filter menu, Convert for Smart Filters, opening an Object from Camera Raw, or by selecting the image layer and then choosing Layer > Smart Object > Convert to Smart Object. Next pick the filter you want to apply and adjust the settings as you would normally before clicking OK.

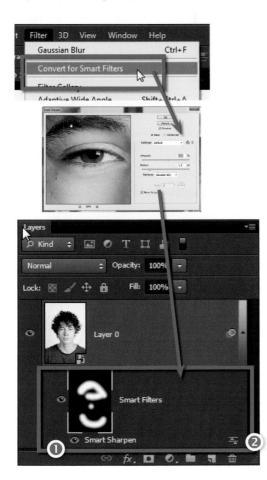

Applying Smart Filters

Applying a filter to a Smart Object layer will automatically create a Smart Filter entry in the Layers palette. Multiple filters with different settings can be added to a single Smart Object layer. The settings for any Smart Filter can be adjusted by double-clicking the filter's name (1) in the Layers palette. The blending mode of the Smart Filter can be changed by doubleclicking the settings icon (2) at the right end of the entry. This changes the way that the filter is applied to the image. To apply a filter to several layers, select multiple layers and then convert to a Smart Object first and then filter.

New for Photoshop CC

And the good news is that with each new release more and more filters can be applied to Smart Objects. So in Photoshop CC the Blur Gallery and Liquify filters can be applied directly to a smart object, plus we get the ability to apply Camera Raw as a Smart Filter as well. Also new for CC is the updating of the Smart Sharpen filter so we have more control over where and how sharpening is applied to our images, and the addition of a completely new filter in the form of Shake Reduction (Filter > Sharpen > Shake Reduction).

Smart Filters are added as an extra entry beneath the Smart Object in the Layers palette. The entry contains both a mask and a separate section for the filter entry and its associated settings. Like Adjustment Layers, you can change the setting of a Smart Filter at any time by double-clicking the filter's name in the Layers palette. The blending mode of the filter is adjusted by double-clicking the settings icon at the right end of the filter entry.

The Smart Filter mask can be edited to alter where the filter effects are applied to the photo. From CS6 it became possible for multiple Smart Filters can be added to a photo but they all must use the one, common mask.

Finally, with the Smart Filter technology we have a way to apply such things as sharpness or texture non-destructively.

Sharpness applied locally using a masked Smart Object.

Masking Smart Filters

You can easily localize the effects of a Smart Filter by painting directly onto the mask associated with the entry. Here the mask thumbnail was selected first and then inverted using the Image > Adjustments > Inverse option. Keep in mind that black sections of a mask do not apply the filter to the picture so inverting the thumbnail basically removes all filtering effects from the image. Next white was selected as the foreground color and the Brush tool chosen. The opacity of the tool was reduced and with the mask thumbnail still selected, the areas to be sharpened were painted in.

The Filter Gallery

Most Photoshop filters are applied using the Filter Gallery feature. Designed to allow the user to apply several different filters to a single image, it can also be used to apply the same filter several times. The dialog consists of a preview area, a collection of filters that can be used with the feature, a settings area with sliders to control the filter's effect and a list of filters that are currently being applied to the image. The gallery is faster and provides previews that are much larger than those contained in individual filter dialogs.

Filters are arranged in the sequence that they are applied. Filters can be moved to a different spot in the sequence by click-dragging up or down the stack. Click the 'eye' icon to hide the effect of the selected filter from preview. Filters can be deleted from the list by dragging them to the dustbin icon at the bottom of the dialog.

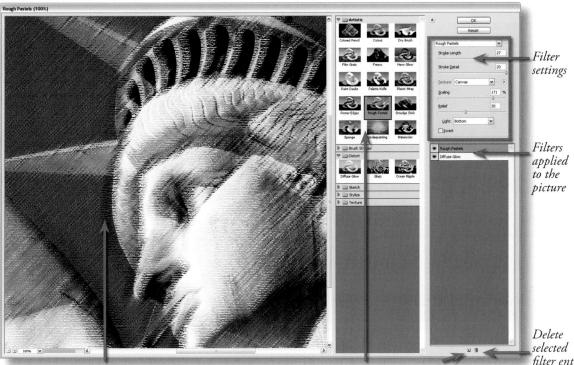

Preview area

New filter entry Gallery filters

filter entry

Filters that can't be used with the Filter Gallery feature are either applied directly to the picture with no user settings or make use of a filter preview and settings dialog specific to that particular filter, and they generally cannot be used on 16-bit images.

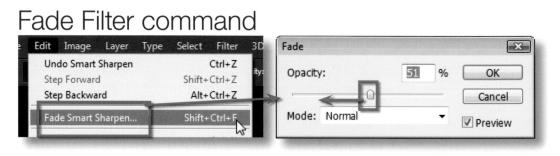

The opacity, or strength, of a filter effect applied to a regular layer can be controlled by selecting the Edit > Fade command when selected directly after the filter is applied. With a value of 0%

the filter changes are not applied at all, whereas a setting of 100% will apply the changes fully. As well as controlling opacity the Fade dialog also provides the option to select a different blend mode for the filter changes. Note that the actual entry for the Fade command will change depending on the last filter applied and this option is not available when using Smart Filters.

Note > When using Smart Filters you can change the Blend Mode and filter amount (use the Opacity slider) via the Blending Options dialog. This is displayed by double-clicking the settings icon on the right of the filter entry in the Layers palette.

Improving filter performance

A lot of filters make changes to the majority of the pixels in a picture. This level of activity can take considerable time, especially when working with high-resolution pictures or underpowered computers. Use the following tips to increase the performance of applying such filters:

- Free up memory by using the Edit > Purge > All command before filtering.
- Allocate more memory to Photoshop via the Edit > Preferences > Performance (Windows) or Photoshop > Preferences > Performance (Mac) option before filtering.
- Try out the filter effect on a small selection before applying the filter to the whole picture.
- Apply the filter to individual channels separately rather than the composite image.

Installing and using third party filters

Ever since the early versions of Photoshop, Adobe provided the opportunity for third party developers to create small pieces of specialist software that could plug into Photoshop. The modular format of the software means that Adobe and other software manufacturers can easily create extra filters that can be added to the program at any time. In fact, some of the plug-ins that have been released over the years have became so popular that Adobe themselves incorporated their functions into successive versions of Photoshop. This is how the Drop Shadow layer effect came into being.

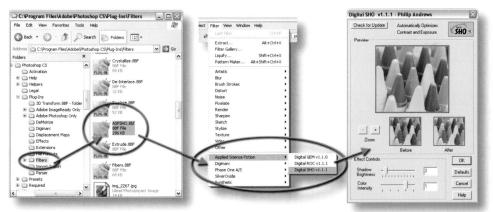

Most plug-ins register themselves as extra options in the Filter menu where they can be accessed just like any other Photoshop feature. The Digital SHO filter from Applied Science Fiction is an example of such plug-in technology. Designed to automatically balance the contrast and enhance the shadow detail in digital photographs, when installed it becomes part of a suite of filters supplied by the company that are attached to the Filter menu (see above). Other filters like those supplied by Pixel Genius Suite are automation filters and are therefore placed in the Automate folder.

Filtering a shape, text, or vector layer

Filters work with bitmap or pixel-based layers and pictures and, more recently, with Smart Object layers. As text, vector masks and shape layers are all created with vector graphics (nonpixel graphics), these layers need to be either converted to a bitmap (pixel-based picture) version or Smart Objects before a filter effect can be applied to them. Photoshop uses a Rasterize function to make this bitmap conversion. Simply select the text or shape layer and then choose the Layer > Rasterize option. Alternatively, you can now just convert the layer to a Smart Object by selecting Filter > Convert To Smart Filter.

The great filter roundup

The filter examples on the next few pages will give you an idea of how this type of technology can be used to enhance, change and alter your photos. Keep in mind that there are many more filters that ship with Photoshop or are available online. In fact, Photoshop also includes an option in the Filter menu (Filter > Browse Filters Online) that allows you to search for other Photoshop filters on the web.

Liquify filter

The Liquify filter is a very powerful tool for warping and transforming your pictures. The feature contains its own sophisticated dialog box complete with a preview area and no less than ten different tools (eight warp and two mask tools) that can be used to twist, warp, push, pull and reflect your pictures with such ease that it is almost as if they were made of silly putty. The filter has two modes, standard and advanced, and works with 8- and 16-bit images but not Smart Objects. The effects obtained with this feature can be subtle or extreme depending on how the changes are applied. Stylus and tablet users have extra options based on pen pressure. Liquify works by projecting the picture onto a grid or mesh. In an unaltered state, the grid is completely regular; when liquifying a photo the grid lines and spaces are intentionally distorted, which in turn causes the picture to distort. As the mesh used to liquify a photo can be saved and reloaded, the distortion effects created in one picture can also be applied to an entirely different image. And remember in CC you can now Liquify a smart object.

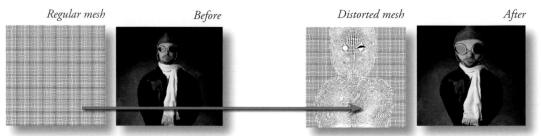

The tools contained in the filter's toolbox are used to manipulate the underlying mesh and therefore distort the picture. Areas of the picture can be isolated from changes by applying a Freeze Mask to the picture part with the Freeze Mask tool. While working inside the filter dialog, it is possible to selectively reverse any changes made to the photo by applying the Reconstruct tool. When applied to the surface of the image the distorted picture parts are gradually altered back to their original state (the mesh is returned to its regular form). Like the other tool options in the filter, the size of the area affected by the tool is based on the Brush Size setting and the strength of the change is determined by the Brush Pressure value.

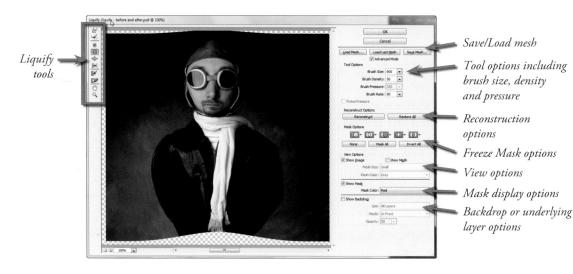

Usage summary

- 1. Open an example image, convert the layer to a Smart Object (Filter > Convert For Smart Filters) and then open the Liquify filter (Filter > Liquify). The dialog opens with a preview image in the center, tools to the left and tool options to the right. Click the Advanced mode button to reveal more options. The Size, Pressure, Rate and Jitter options control the strength and look of the changes, whereas the individual tools alter the type of distortion applied. In order to create a caricature of the example picture we will exaggerate the perspective of the figure. Select the Pucker tool and increase the size of the Brush to cover the entire bottom of the subject. Click to squeeze inwards the lower part of the subject.
- 2. Now select the Bloat tool and place it over the head; click to expand this area. If you are unhappy with any changes you can use the keyboard shortcuts for Edit > Undo (Ctrl + Z) to remove the last changes. Use a smaller brush size to bloat the goggles.

- 3. To finish the caricature, switch to the Forward Warp tool and push in the cheek areas. You can also use this tool to drag down the chin and lift the cheekbones.
- 4. The picture can be selectively restored at any point by choosing the Reconstruct tool and painting over the changed area. Click OK to apply the distortion changes.

Vanishing Point

The Vanishing Point filter has its own dialog complete with preview image, toolbox and options bar. The filter allows the user to copy and paste and even Clone Stamp portions of a picture while maintaining the perspective of the original scene. More recent versions of the filter also allow perspective planes to be linked at any angle. Vanishing Point cannot be used in conjunction with Smart Objects and from CS6 the perspective grids created in the filter can also be used as a starting point for 3D projects.

Using the filter is a two-step process:

Step 1: Define perspective planes To start, you must define the perspective planes in the photo. This is achieved by selecting the Create Plane tool and marking each of the four corners of the rectangular-shaped feature that sits in perspective on the plane. A blue grid means that it is correct perspective, yellow that it is borderline, and red that it is mathematically impossible. In the example, the four corners of a window were used to define the plane of the building's front face. Next, a second plane that is linked to the first at an edge is dragged onto the surface of the left side wall.

Step 2: Copy and paste or stamp With the planes established, the Marquee tool can be used to select image parts which can be copied, pasted and then dragged in perspective around an individual plane and even onto another linked plane. All the time the perspective of the copy will alter to suit the plane it is positioned on. The feature's Stamp tool operates like a standard

stamp tool except that the copied section is transformed to account for the perspective of the plane when it is applied to the base picture.

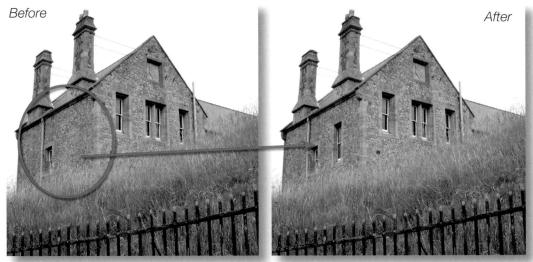

The Vanishing Point filter edits and enhances using the perspective of the picture.

Usage summary

- Create a new layer above the image layer to be edited (Layer > New > Layer) and then choose the Vanishing Point filter from the Filter menu.
- 2. Select the Create Plane tool and click on the top left corner of a rectangle that sits on the plane you wish to define. Locate and click on the top right, bottom right and bottom left corners. If the plane has been defined correctly the corner selection box will change to a perspective plane grid. In the example, the front face of the building was defined first.

Use the Vanishing Point filter to quickly and accurately establish the perspective of background images in a 3D project.

- 3. To create a second, linked, plane, Ctrl/Cmd-click the middle handle of the plane and drag away from the edge. The left side of the building was defined using the second plane.
- 4. To copy the window from the building's front face (above), select the Marquee tool first, set a small feather value to soften the edges and then outline the window to be copied. Choose Ctrl/Cmd + C (to copy) and then Ctrl/Cmd + V (to paste). This pastes a copy of the window in the same position as the original marquee selection.
- 5. Click-drag the copy from the front face around to the side plane. The window (copied selection) will automatically snap to the new perspective plane and will reduce in size as it is moved further back in the plane. Position the window on the wall surface and choose Heal > Luminance from the Marquee options bar.
- 6. Press the 'T' key to enter the Transform mode and select Flip from the option bar to reorientate the window so that the inside edge of the framework matches the other openings on the wall. Click OK to complete the process.

- DETAIL

The Camera Shake helps sharpen images that are slightly blurred from camera movement.

Reducing camera shake

The new Camera Shake filter helps restore sharpness to images blurred by camera movement at slow shutter speeds or with long focal lengths. With this feature Photoshop analyzes the direction of blurs that are the result of camera movement, producing sharper versions of images which may have otherwise been unusable.

Detection Processing area marquee progress

Switching to the Advanced Mode

shows the detection area marguee

on the preview image. Photoshop uses the content in this area to

analyze the blur in the image. The

first detection marquee is drawn

automatically, but you can add

others to help refine the Camera

Center point

Usage summary

- 1. Open a blurred image.
- Choose Filter > Sharpen > Shake Reduction. The image is displayed in the preview section of the dialog box. Photoshop automatically attempts to sharpen the photos; within a few seconds the blur will be noticeably reduced.
- To fine-tune the results, click the triangle next to the Advanced Shake Reduction results. heading in the right panel of the dialog box to display Blur Detection regions. Automatically a Blur Detection marquee is created and added to the image.
- 4. You can change the position of the Detection Area by dragging the center point of the marquee to reposition it over another portion of the photo. This will change the results.
- 5. Click and drag to create a second marquee in another part of the image to refine results.
- 6. Click the Undock Detail icon at the lower right of the Detail preview window to undock, and reposition it over a flower. To re-dock, click the X icon in the top left of the window.
- 7. To review the results of each Detection Area, select and deselect a thumbnail to include the area in the shake reduction calculations.
- 8. Click OK to apply the Camera Shake Reduction effect.

Note > Adding multiple detection areas can help Photoshop determine more accurately the type and direction of the blur. By selecting and deselecting different detection areas, you can test which combination of areas provides the best results.

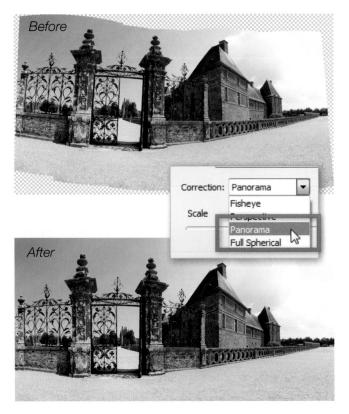

Straighten panoramas and images taken with extreme wide angle lenses with the controls in the Adaptive Wide Angle filter.

Adaptive Wide Angle

When Adobe introduced the Lens Correction system in CS5 many of us wondered where they would go next. After all, it was obvious from the amazing corrections that Photoshop was applying to our distorted photos the program now knew a lot about how the lenses were capturing pictures. Well, the Adaptive Wide Angle filter (Filter > Adaptive Wide Angle) is the logical next step. Building on the lens correction technology framework we can now straighten our extreme wide angle and panoramic images even more. By placing a series of guides on the image, curved picture parts can be straightened and wonky panoramas made rectangular. And for me the best part of this technology is the way that I can now correct the problems I have with the panoramas I shot without a tripod and stitched together in Photomerge. The blending was great but as my aim wavered so too did the horizons and verticals in the resultant panorama (see example).

Usage summary

- 1. After creating your panorama with Photomerge, select all the layers in the Layers Panel and choose Convert To Smart Object from the rightclick context menu. This groups all source layers into a single Smart Object layer.
- 2. With the Smart Object layer selected choose Filter > Adaptive Wide Angle. Select Panorama from the Adaptive mode menu. Press the C key to select the Constraint tool, hold down the Shift key and drag vertical lines on the edges of prominent buildings and structures in the image.
- Repeat the action for image parts that are meant to be horizontal (remembering to hold down the Shift key). For straightening of image parts only, drag lines without using the Shift key.
- 4. Adjust the angle of any line by selecting it first and then dragging one of the handles on the circle. Click OK to process the file and then use Copy Merge to create a single layer version of the Smart Object. Finally crop away any ragged edges or use Content-Aware Fill to insert texture.

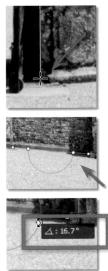

Filters

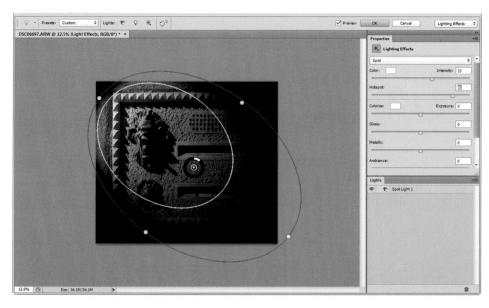

The Lighting Effects filter in the latest versions of Photoshop offers more control and accuracy thanks to a new interface and on-image adjustments.

Lighting Effects Gallery

Another filter that was revamped for Photoshop CS6 was Lighting Effects (Filter > Render > Lighting Effects). Gone is the tiny, let's face it, almost useless, preview panel, replaced with an interface that echoes that of the Blur Gallery. Now you get to make adjustments directly on the surface of the image and preview the changes instantly. As well as the familiar slider controls which are now located on the right of the workspace, Lighting Effects users also get to manipulate the position, shape and strength of the effect with the aid of some funky on-image controls. This change, along with the full size preview, makes the filter much more usable and the results much more accurate. Also, 64-bit users will notice better performance as the filter takes advantage of more resources.

Usage summary

- With an example image open in Photoshop, choose Lighting Effects from the Filter > Render menu. The workspace opens and a single Spot Light is added to the photo and positioned using the Default preset.
- 2. Drag the central pin to reposition the effect. Drag the handles on the outer boundary to rotate the projected light beam and alter the shape of the lit area. Use the Hotspot slider to change the size of the hotspot.
- 3. Dial the Intensity Ring to change the brightness of the hotspot. Move the Ambience slider to change the brightness of the rest of the image and alter the Gloss, Metallic, and Texture controls to vary the way the light interacts with the image. Click OK to process.
- 4. Add extra lights to the image by clicking one of the light icons in the filter's options bar.

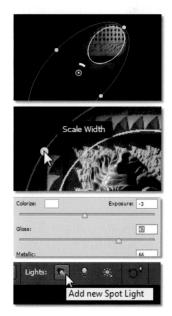

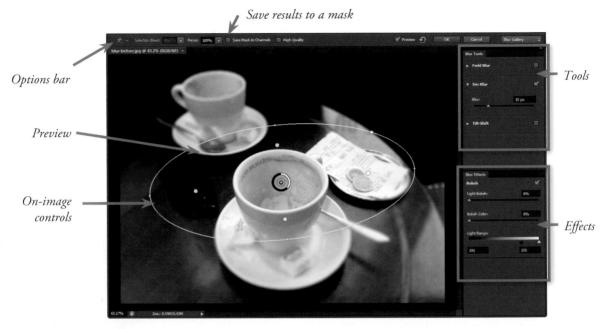

Blur Gallery

Photoshop CS6 introduced three new Blur filters in a brand new workspace called the Blur Gallery. Featuring full image preview, a bunch of on-canvas controls and lightning fast processing this feature points to the way of the future for Photoshop controls. Photographers will adore the directness of being able to alter the size and shape of the area that remains sharp, change the width of the transition from sharpness to blur and dial in the degree of blurriness all with simple mouse movements. The three different blur styles are Iris Blur, Field Blur and Tilt-Shift Blur.

Iris Blur

Iris Blur creates blur effects that radiate from a central point. The blur strength, size and shape of the area and the boundary of maximum blurriness can all be adjusted using the on-image controls. Multiple focus points can be added to a single image producing an effect where the different blur fields interact. Use this option for directing your viewer's attention to a single point in an image by making that area sharp while blurring the rest.

- 1. Choose Iris Blur from the Filter > Blur menu. Drag the central pin over the area that is to remain sharp in the photo. Dial the Blur Ring to adjust the amount of blurriness surrounding the pin. Click onto a different part of the image to add other pins.
- 2. Drag the inner dots to change the size of the sharp area. Hold down Alt/Opt as you drag to change its shape. Drag the handles on the outer ellipse to change the size of the boundary of maximum blurriness and drag the big square handle to change its shape to rounded rectangle.

Filters

Field Blur

The Field Blur option doesn't have the same approach as the other two blur options. Instead, an interwoven fabric of blurriness and sharpness is built upon the image by placing multiple pins to mark different focus points. As there are no on-image controls for controlling the shape and size of sharp/blurred areas most control is gained by altering the strength of blur of each pin individually.

This option provides the opportunity to build multiple sharpness points within an image, something that was never possible when controlling blur in-camera.

- Choose Field Blur from the Filter > Blur menu. Drag the central pin over the first area to remain sharp in the photo. Dial the Blur Ring to 15 to add some softness to the photo. Click another area of the image to add a second pin. Dial the Blur Ring to a setting of 0 for no blur or to remove the blur from this section of the image.
- 2. Continue adding pins and adjusting their blur setting to gradually build a series of blur contours across the image. Experiment with keeping some areas sharp and some blurred.

Tilt-Shift Blur

The Tilt-Shift Blur option provides a mechanism for creating a plane of sharpness that crosses the whole of the image. The on-image controls provide options for positioning and rotating the plane and for changing the size of the sharpness area and the position of the maximum blur boundary. This is great choice for images where you want to replicate the miniature world look popular with Lens Baby shooters. Alternatively, it also works wonders if you want a plane of sharpness to move from the foreground into the background of the photo.

- Choose Tilt-Shift Blur from the Filter > Blur menu. Drag the central pin over the area that is to remain sharp in the photo. Dial the Blur Ring to adjust the amount of blurriness along the boundary of the sharpness plane. Drag the handle on the inner lines to rotate the plane.
- 2. Drag the inner solid lines to alter the width of the sharpness plane. Hold down Alt/Opt to do this asymmetrically. Drag the dotted outer lines to mark the boundary of maximum blurriness. Use the Distortion slider to change the direction of the blur.

The Lens Correction filter can be found in Photoshop CS5, CS6 and CC automatically corrects three typical lens-based errors, including the extreme barrel distortion seen here.

Correcting lens distortion with filters

We have already seen that the new version of Adobe Camera Raw contains a sophisticated lens correction system. The core technology used to correct raw files in ACR can also be employed inside Photoshop with the Lens Correction filter (Filter > Lens Correction). The feature is specifically designed to correct the three key imaging problems that can occur when shooting with different lenses. Apart from correcting barrel and pincushion distortion, the filter can also fix the color fringing (color outlines around subject edges) and vignetting (darkening of the corners) problems that can also occur as a result of poor lens construction.

As is the case in ACR, the corrections can be applied automatically by matching the lens used to take the picture with a custom Lens Correction profile. This occurs in the Auto Correction section of the filter. The filter will try to locate such a profile automatically by matching the lens information recorded in the metadata of the photo with one of the profiles contained in the filter. For those times when an exact match can't be found, it is also possible to search for a suitable filter on the net using the Search Online button at the bottom of the dialog. You can choose to correct all three error types (Geometric Distortion, Chromatic Aberration and Vignette) or select only those options you wish to apply.

The controls located in the Custom section of the filter can be used to manually apply lens correction adjustments or to fine-tune those already applied with a correction profile. Extra controls located here can be used for changing the perspective of the picture (great for eliminating the issue of converging verticals) and manual handling of the vacant areas of the canvas that are created after distortion correction has been applied.

Lens Correction in action

To demonstrate the power of this feature I ran one of the images from a series of photos taken with a Nikkor DX 10.5mm f2.8 lens through the Lens Correction filter. With no manual adjustments at all the results were amazing. Yes, the final image was cropped a fair bit but the photo was completely usable. A few more seconds fine-tuning the results with the controls in the Custom panel produced an even squarer result that still retained the feeling of exaggerated perspective but had lost the barrel distortion. Use these steps to correct your images.

Filters

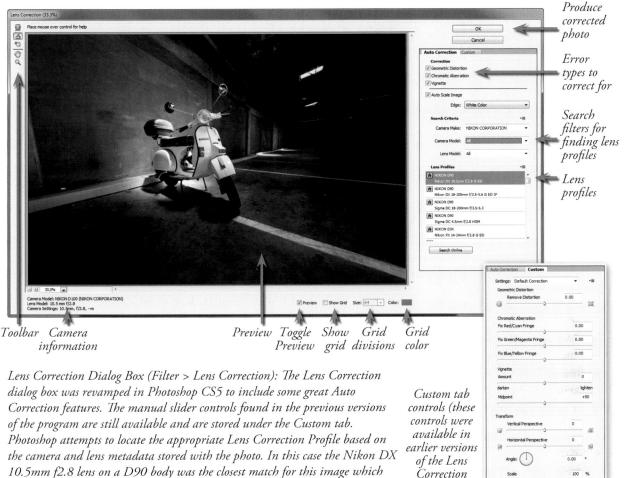

10.5mm f2.8 lens on a D90 body was the closest match for this image which was shot with a D100 and the 10.5mm lens.

	ОК
	Cancel
Auto Correction	Custom
Correction Correction Convertic Distortio Convertic Aberrat Convertient	
Auto Scale Image	
Edge:	Transparency
	Transparency
<u>E</u> dge: Search Criteria	
<u>E</u> dge: Search Criteria Camera Ma <u>k</u> e:	

Start by opening an example image in Photoshop. Next, choose Filter > Lens Correction, and click onto the Auto Correction tab.

filter)

To ensure correction of all error types select Geometric Distortion, Chromatic Aberration, and Vignette in the Correction section of the panel on the right side of the dialog box.

To straighten the photo select the Straighten tool from the left of the dialog box and drag it along an image part that is meant to be horizontal or vertical.

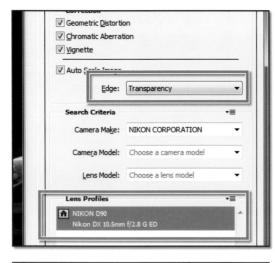

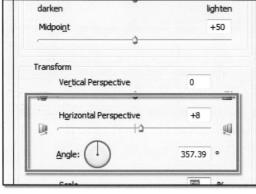

Next, choose the Transparency mode from the Edge menu. This will produce the corrected image with transparent areas around the reshaped photo.

In this case the appropriate lens-correction profile was automatically matched with the example image, and the preview updated to display the corrected photo. If this doesn't happen with your photos you can select other profiles by Camera Make, Camera Model, and Lens Model, or locate them on the web by pressing the Search Online button at the bottom of the dialog box.

To fine-tune the results click the Custom tab to switch over to the manual controls. In this example a small change to the Geometric Distortion (-2) and Horizontal Perspective (+8) controls straightened the picture further.

Switching back to the Auto Correction panel make sure that the Auto Scale Image option is checked before clicking OK to process the corrected photo. Use Photoshop's history palette to compare before and after corrections.

Batch processing your lens corrections

Correcting a single image at a time is all well and good when you have only a few files to process, but if your shooting session has amassed several hundred photos then any type of automated correction would be most welcome. Well, the Adobe guys must have read my thoughts as there is a new Lens Correction batch tool in Bridge.

The feature works like other Photoshop tools in Bridge: you multi-select the photos from the Content panel first and then choose the Lens Correction from the Tools > Photoshop menu. This action opens a new Lens Correction dialog box in Photoshop and automatically adds the selected files.

The dialog contains sections to choose the destination folder for the corrected photos, settings to either automatically locate the best profile for the images or manually choose your own, and a series of check boxes to determine correction type and scaling. After working your way through the settings all you need to do is click the OK button to process the files.

Note > You can also display this batch processing dialog box by selecting File > Automate > Lens Correction from within Photoshop. It is then possible to add files that are already open in the program or to browse for the images you want to correct.

Filters

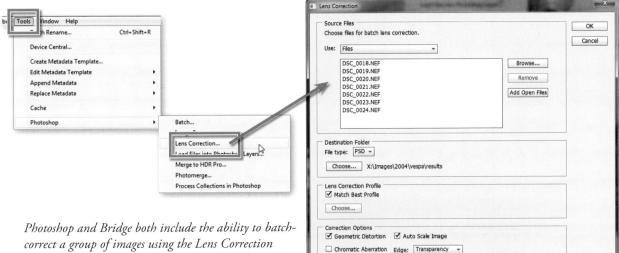

U Vignette

correct a group of images using the Lens Correction option in the Tools > Photoshop menu in Bridge and the File > Automate menu in Photoshop.

Color Profile	
ISO Speed Ratings	
Exposure Time	in the second
Aperture Value	DSC_0054.NEF
* Focal Length	
No Focal Length	2
✓ 10.5 mm	75 10101000
Focal Length 35mm	1 5 F L S
Model	No.
White Balance	and the second s
Camera Raw	DSC_0062.NEF
불법 방법이 가장에서 가장되었다. 이 가장에 가장되었다. 정도 사람이 가지 못한 것이 못 꽂았다. 이 가 많은 것이 생각하는 것이 많은 것이 같이 많이 많이 많이 많이 많이 많이 없다. 것이 같이 많이 많이 없다. 것이 같이 많이 없다. 것이 많이 많이 많이	

File Edit View Stacks Label Tools	Window Help
🔶 - 🏀 - 🧳 -	h- 0 h+-
📰 Desktop 👌 🕼 Computer 👌 🛫 Andrews	s-Data (\\andrews-server) (X:) 🗲 🔋 🏻
FAVORITES FOLDERS	CONTENT
🖻 📕 qca-10-5	6
ross-poetry-fest-2004	- marker 1
sophie jamie coffee	1 22 2 1
⊳ 🝓 still life shots 🐻 toy-lens	
wy rens	
results	DSC_0018.psd DSC_0019.psd
be 🦲 2006	Martine commendation and the second second
> 🔝 2007	mi chi salami a
i> 📕 2008	the chisalami, ci
> 📕 2009	chonce . a
2010	DSC 0050 and DSC 0051 and

Next multi-select several images by click-dragging a marquee around the thumbnails before selecting Lens Correction from the Tools > Photoshop menu. Photoshop opens and the files are listed in the batchprocess Lens Correction dialog box. You can add or remove images using the buttons listed next to the file list. Now, select a destination folder and File Type. By default Photoshop stores the process photos in a folder titled Results.

Check the Match Best Profile option to instruct Photoshop to locate the best profile for each photo and finally choose the error type to be corrected. In this case, I chose all three of the available corrections. With all the options set, click the OK button. The Lens Correction dialog box closes and one by one the photos are opened into Photoshop. Each image is then corrected and saved off to the folder in the format selected. And that's it. Job done!

Noise filters

The Noise filters group contains tools that are used for either adding noise (randomly colored pixels) to a photo, or reducing the existing noise in a photo. Dust & Scratches is designed to automatically hide picture faults such as hairs or scratches in scanned photos. Despeckle, Median and the Reduce Noise filter remove or hide the noise associated with high ISO pictures and the Add Noise filter is used to create and add noise to photos.

All the filters in this group, except Despeckle, are applied via their own filter dialog.

Note > With the substantial upgrading of the Noise Removal technology in Adobe Camera Raw it is generally better practice to remove noise at the Raw processing stage than to wait until the image is opened in Photoshop.

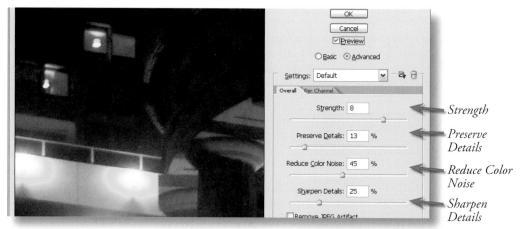

The Reduce Noise filter

The feature includes a preview window, a Strength slider, a Preserve Details control and a Reduce Color Noise slider. As with the Dust & Scratches filter you need to be careful when using this filter to ensure that you balance removing noise while also retaining detail. The best way to guarantee this is to set your Strength setting first, ensuring that you check the results in highlights, midtone and shadow areas. Next gradually increase the Preserve Details value until you reach the point where the level of noise that is being reintroduced into the picture is noticeable and then back off the control slightly (make the setting a lower number). For photographs with a high level of color noise (random speckles of color in an area that should be a smooth flat tone) you will need to adjust this slider at the same time as you are playing with the Strength control.

When the Advanced mode is selected the noise reduction effect can be applied to each channel (Red, Green, Blue) individually. This filter also works in 16-bit mode and contains saveable/loadable settings. There is also a special option for removal of JPEG artifacts. One of the side effects of saving space by compressing files using the JPEG format is the creation of box-like patterns in your pictures. These patterns or artifacts are particularly noticeable in images that have been saved with maximum compression settings. With the Remove JPEG Artifact option selected in the Reduce Noise dialog, Photoshop attempts to smooth out or camouflage the box-like pattern created by the overcompression. The feature does an admirable job but the results are never as good as if a lower compression rate was used initially.

Per Channel mode (Advanced section) The Per Channel option provides the ability to adjust the noise reduction independently for each of the Red, Green and Blue channels. This allows the user to customize the filter for the channel(s) that have the most noise. The **Strength** setting controls the amount of Luminance or noncolor noise reduction applied to each channel. The **Preserve Details** slider maintains the appearance of edge details at the cost of lowering the noise reduction effect. The best results balance both these options for each channel.

> Convert to Smart Object New Smart Object via Copy

Edit Contents

Stack Mode

Rasterize

Ctrl+G

Export Contents

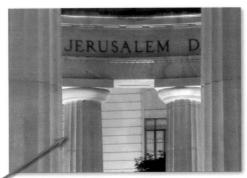

After creating an Image Stack, Smart Object in the Extended Version of Photoshop you can apply a rendering option such as Median to the stack. In this example this has the effect of reducing noise.

Reducing noise with Image Stacks

JERUSALEM

3D Layers

Dactorize

Group Lavers

ide Layers

New Layer Based Sli

Another way to reduce noise is to take a series of images of the same scene in quick succession and then use the combined information from all the photos to produce a new, less noisy, composite picture. The process of achieving this outcome became possible in Photoshop CS3 Extended as Adobe introduced the concept of Image Stacks as well as the ability to apply functions, such as the Median command, to these stacks. The process involves layering the sequential source images in a single document, applying the Auto-Align option (to ensure registration) and then converting the layers into a Smart Object. Once in this Image Stack form it is possible to select one of a range of rendering options from those listed in the Layer > Smart Objects > Stack Mode menu. These options manage how the content of each of the layers will interact with each other.

Standard Deviat

Summatic Variance

In the noise reduction technique shown here, the Median command creates the composite result by retaining only those image parts that appear (in the same spot) in more than 50% of the frames (layers). As noise tends to be pretty random, its position, color and tone change from one frame to the next and so are removed from the rendered photo, leaving just the good stuff – the picture itself.

1 1

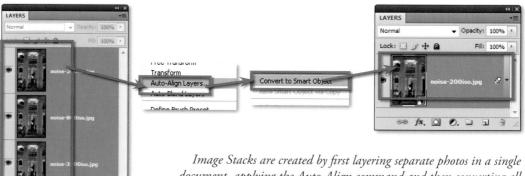

Image Stacks are created by first layering separate photos in a single document, applying the Auto-Align command and then converting all layers to a single Smart Object.

In another example of how this technology can be used, in order to remove tourists from in front of your favorite statue, there is no need to wait until they have all gone home. Instead, simply capture multiple pictures of the monument, group them together in an Image Stack and apply the Median function to the group. Hey presto, tourists be gone!

Using Image Stacks to remove noise in Photoshop Extended

- 1. Reducing noise using this technique is a multi-step affair that starts at the time of capture. If you are confronted with a scene where it is essential that you use either a long exposure or high ISO setting (or both) then you can be pretty sure that your resultant images will contain some noise. So in these circumstances shoot several photos of the same scene. For best results maintain the same camera settings and camera position throughout the whole sequence.
- 2. Next open all photos into Photoshop and drag each picture onto a single document, creating a multi-layer file containing all the photos in the sequence.
- 3. Multi-select all the layers and choose the Auto-Align option (Auto Projection) from the Edit menu. Photoshop will arrange all the layers so that the content is registered.
- 4. With the multiple layers still selected choose Layer > Smart Objects > Convert to Smart Object. This places all the layers in a single Smart Object.
- 5. The last step in the process is to select the Smart Object layer and then choose how you want to render the composite image. Do this by selecting one of the options from the Layer > Smart Objects > Stack Mode menu. To reduce noise we choose the Median entry.

Sharpen filters

Photoshop provides a variety of sharpening filters designed to increase the clarity of digital photographs. The options are listed in the Filter > Sharpen menu and include the Sharpen, Sharpen Edges, Sharpen More, Unsharp Mask filters as well as the Smart Sharpen option. Digital sharpening techniques are based on increasing the contrast between adjacent pixels in the image. When viewed from a distance, this change makes the picture appear sharper. The Sharpen and Sharpen More filters are designed to apply basic sharpening to the whole of the image and the only difference between the two is that Sharpen More increases the strength of the sharpening effect.

One of the problems with sharpening is that sometimes the effect is detrimental to the image, causing areas of subtle color or tonal change to become coarse and pixelated. These problems are most noticeable in image parts such as skin tones and smoothly graded skies. To help solve this issue, Adobe included the Sharpen Edges filter, which concentrates the sharpening effects on the edges of objects only. Use this filter when you want to stop the effect being applied to smooth image parts.

Customizing your sharpening

Out of all the sharpening options in Photoshop, the Smart Sharpen, which has been updated for CC, and Unsharp Mask filters provide the greatest control over the sharpening process by

giving the user a variety of slider controls that alter the way the effect is applied to their pictures. Both filters contain Amount and Radius controls. The Unsharp Mask filter includes a Threshold slider and the Smart filter contains controls for adjusting sharpness in Shadows and Highlights independently (in Advanced mode) as well as a Removal option for ridding images or specific blur types (Gaussian, Motion or Lens Blur). In the CC version of Smart Sharpen a special Reduce Noise slider has been added to Smart Sharpen to help reduce unwanted grittiness which is sometimes introduced to images when sharpening is applied to otherwise smooth areas of tone and color.

reset: Cust

Sharpening controls

The **Amount slider** controls the strength of the sharpening effect. Larger numbers will produce more pronounced results, whereas smaller values will create more subtle effects.

The **Radius slider** value determines the number of pixels around the edge that are affected by the sharpening. A low value only sharpens edge pixels. High settings can produce noticeable halo effects around your picture so start with a low value first.

The **Threshold slider** is used to determine how different the pixels must be before they are considered an edge and therefore sharpened.

The **Remove (Smart Sharpen)** setting locates and attempts to neutralize different blur types.

The **Shadow and Highlight (Smart Sharpen)** tabs contain options for adjusting the sharpening effects in these tonal areas.

The new **Reduce Noise slider (Smart Sharpen)** is used to mitigate emphasizing the underlying grainy or pixelated structure of an image when sharpening. Noticeable more in image areas such as sky or skin, this feature helps balance the sharpness needed to make key features stand out and the untextured appearance of smooth areas.

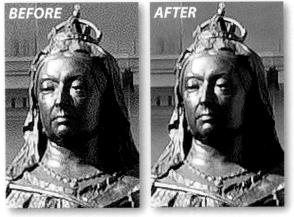

The Reduce Noise slider found in the CC version of Smart Sharpen noticeably reduces the grittiness which oversharpening can produce in smooth toned areas of an image when sharpening.

Texture filters

The Texture filter group provides a range of ways of adding texture to your photos. Most of the filters apply a single texture type and include controls for varying the strength and style of the effect, but the Texturizer filter adds to these possibilities by allowing users to add textures they create themselves to a photo.

All filters in this group are applied via the Filter Gallery dialog.

The Texturizer filter

When applying the Texturizer filter the picture is

Other filters

The filters grouped together under the Other heading include the Custom filter, which is used for creating you own filter effects (see opposite page), the edge-finding High Pass filter, the Offset filter that shifts picture pixels by a set amount, and the Maximum and Minimum filters, which are most often used for modifying masks.

Filters in this group are not applied via the Filter Gallery dialog but rather have their own specific dialog containing both controls and preview.

Sharpening with the High Pass filter The High Pass filter isolates the edges in a picture and then converts the rest of the picture to mid gray. The filter locates the edge areas by searching for areas of high contrast or color change. The filter can be used to add contrast and sharpening to a photo.

- To start, make a copy of the picture layer that 1. you want to sharpen, then filter the copied layer with the High Pass filter. Adjust the Radius so that you isolate the edges of the image only against the gray background and then click OK.
- 2. Next select the filtered layer and switch the blend mode to Hard Light.
- 3. Finally, adjust the opacity of this layer to govern the level of sharpening being applied to the picture layer.

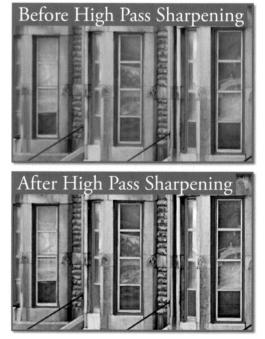

The ten commandments for filter usage

- 1. Subtlety is everything. The effect should support your image not overpower it.
- 2. Try one filter at a time. Applying multiple filters to an image can be confusing.
- 3. *View at full size.* Make sure that you view the effect at full size (100%) when deciding on filter settings.
- 4. *Filter a channel.* For a change try applying a filter to one channel only Red, Green or Blue.
- 5. *Print to check effect.* If the image is to be viewed as a print, double-check the effect when printed before making final decisions about filter variables.
- 6. *Fade strong effects.* If the effect is too strong try fading it. Use the 'Fade' selection under the 'Edit' menu.
- 7. Experiment. Try a range of settings before making your final selection.
- 8. *Mask then filter*. Apply a gradient mask to an image and then use the filter. In this way you can control what parts of the image are affected.
- 9. *Try different effects on different layers.* If you want to combine the effects of different filters try copying the base image to different layers and applying a different filter to each. Combine effects by adjusting the opacity of each layer.
- 10. Did I say that subtlety is everything?

Filter DIY

Can't find exactly what you are looking for in the hundreds of filters that are either supplied with Photoshop or are available for download from the Net? I could say that you're not really trying, but then again some people have a compulsion to 'do it for themselves'. Well, all is not lost. Photoshop provides you with the opportunity to create your own filtration effects by using its Filter > Other > Custom option.

By adding a sequence of positive/negative numbers into the 25 variable boxes provided you can construct your own filter effect. Add to this the options of playing with the 'Scale' and 'Offset' of the results and I can guarantee hours of fun. Best of all, your labors can be saved to use again when your specialist customized touch is needed.

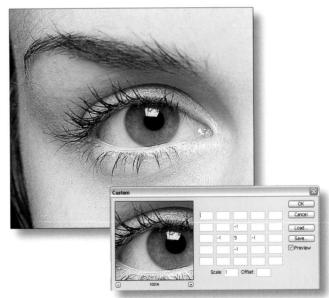

photoshop photos

shop

essential skills

- Learn the practical applications of layer blend modes for image retouching and creative compositing work.
- Develop skills using the following techniques:
 - blend modes
 - layers and channels
 - layer masks.

Introduction

When an image, or part of an image, is placed on a separate layer above the background, creative decisions can be made as to how these layers interact with each other. Reducing the opacity of the top layer allows the underlying information to show through, but Photoshop has many other ways of mixing, combining or 'blending' the pixel values on different layers to achieve different visual outcomes. The different methods used by Photoshop to compare and adjust the hue, saturation and brightness of the pixels on the different layers are called '**blend modes**'. Blend modes can be assigned to the painting tools from the Options bar but they are more commonly assigned to an entire layer when editing a multi-layered document. The blend modes are accessed from the Modes pull-down menu in the left-hand corner of the Layers panel.

The major groupings

The blend modes are arranged in family groups of related effects or variations on a theme. Many users simply sample all the different blend modes until they achieve the effect they are looking for. This, however, can be a time-consuming operation and a little more understanding of what is actually happening can ease the task of choosing an appropriate blend mode for the job in hand. A few of the blend modes are commonly used in the routine compositing tasks, while others have very limited or specialized uses only. The five main groups of blend modes after Normal and Dissolve that are more commonly used for image editing and montage work start with:

- Darken
- Lighten
- Overlay
- Difference
- Hue

More blend modes than a photographer needs

There are 27 blend modes (counting Normal as a mode) but photographers will usually only rely on less than half of these modes on a regular basis in their image retouching and composite projects. There are a few modes (such as Darker Color and Lighter Color) that offer the photographer with few if any practical uses. This chapter will focus on the 'essential' modes and skip over, or omit, the non-essential modes. Open the supporting files and experiment with the settings to fully understand these modes. The essential blend modes for image-editing are:

- Normal
- Darken
- Multiply
- Lighten
- Screen
- Overlay
- Soft Light
- Difference
- Luminosity
- Color

Opacity and Dissolve

At 100% opacity the pixels on the top layer obscure the pixels on the layers underneath. As the opacity is reduced, the pixels underneath become visible. The **Dissolve** blend mode only works when the opacity of the layer is reduced. Random pixels are made transparent on the layer rather than reducing the transparency of all the pixels. The effect is very different to the reduced opacity of the Normal blend mode. Dissolve can be used as a transition for fading one image into another, but the effect has very limited commercial value for compositing of images.

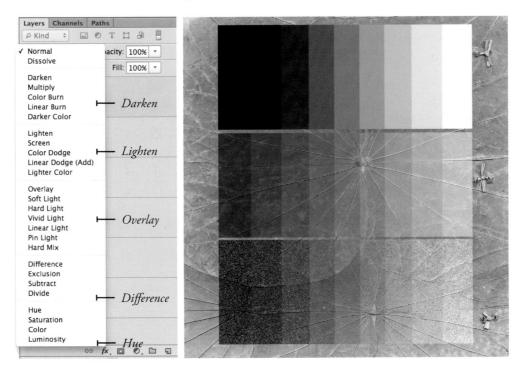

Image 02_Opacity. The groups of blend modes are listed using the name of the dominant effect. The step wedge above shows 'Normal' at 100% and 50% opacity and the 'Dissolve' blend mode at 50% opacity.

The Opacity control for each layer, although not strictly considered as a blend mode, is an important element of any composite work. Some of the blend modes are quite 'aggressive' in their resulting effect if applied at 100% opacity. Experimenting with some blend modes at a reduced opacity will often provide the required result.

KEYBOARD SHORTCUTS

The blend modes can be applied to layers using keyboard shortcuts (so long as a painting tool is not selected). Hold down the Shift key and press the + key to move down the list or the – key to move up the list. Alternatively, you can press the Alt/Option key and the Shift key and key in the letter code for a particular blend mode. If a tool in the painting group is selected (i.e. in use) the blend mode is applied to the tool rather than the layer. See the Keyboard Shortcuts section at the end of the book for more information.

The 'Darken' group

It's not too hard to figure out what this group of blend modes have in common. Although Darken leads the grouping, Multiply is perhaps the most used blend mode in the group.

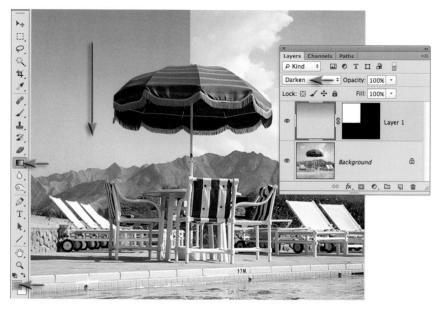

Image 03_Darken. The Darken mode can replace existing highlights while ignoring darker tones. The layer mask on Layer 1 protects the highlights of the sun loungers. Try shift-clicking on the layer mask thumbnail to temporarily disable the mask.

Darken

When the top layer is set to Darken mode Photoshop displays the darker pixels, regardless of whether they are on the layer set to the Darken mode or on the underlying layers. Pixels on the layer with the blend mode applied that are lighter than the underlying pixels in the same location will no longer be visible. This mode is invaluable when retouching portraits or removing halos from around subjects due to masking errors.

Multiply is a useful blend mode when overall darkening is required.

Multiply

The Multiply blend mode belongs to the 'Darken' family grouping. The brightness values of the pixels on the blend layer and underlying layer are multiplied to create darker tones. Only values that are multiplied with white (level 255) stay the same, i.e. do not become darker.

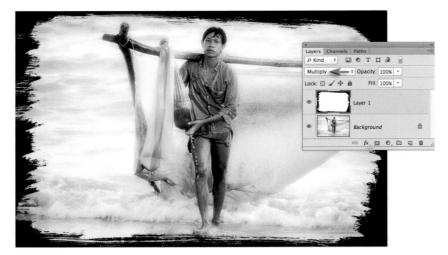

Image 04_Multiply. The Multiply mode is used to apply a dark edge to the image (white is neutral).

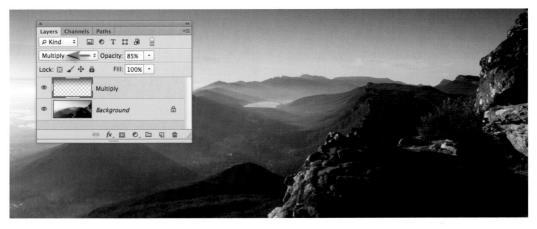

Image 05_Multiply. The Multiply blend mode is used to darken the sky in this landscape image.

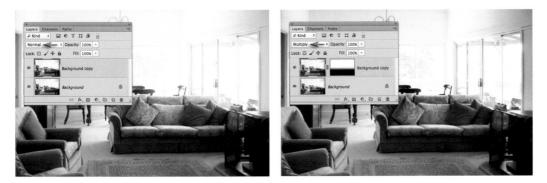

Image 06_Multiply. The Multiply blend mode is used to darken the top half of the image. The layer is first duplicated and the Multiply mode set. A layer mask is added and a linear gradient in the layer mask shields the lower portion of the image from the effects of the blend mode. Try turning off the visibility of the layer and/or the layer mask to gain a better understanding of the mode and the mask.

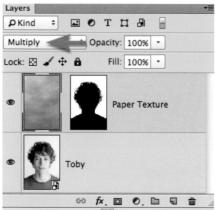

Image 07_Multiply. The Multiply blend mode is an alternative to the Refine Edge technique when masking hair that was first captured against a white background. The new background layer and layer mask are positioned above the portrait and the layer is then set to the multiply mode. Note the difference before and after the blend mode has been applied (see Montage Projects > Hair Extraction).

Color Burn, Linear Burn and Darker Color

Color Burn increases the underlying contrast, Linear Burn decreases the underlying brightness. These are difficult blend modes to find a use for at 100% opacity. Saturation can become excessive and overall brightness, now heavily influenced by the underlying color, can 'fill in' (become black). Darker Color is very similar to the Darken mode in that only the darker pixels remain visible. The difference between the two 'darkening' modes is how Photoshop assesses the brightness value – channel by channel (Darken) or combined channels (Darken Color).

The 'Lighten' group

The name of this group of blend modes is self-explanatory. If one of the modes in this group is applied to the top layer it usually results in a lighter outcome in some areas of the image. Although Lighten leads the grouping, Screen is perhaps the most used blend mode in the group.

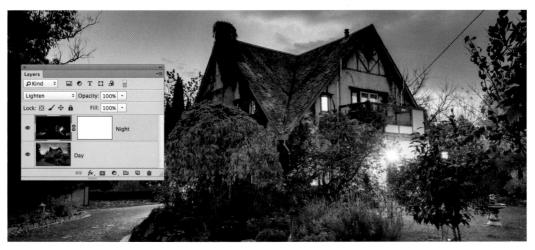

Image 08_Lighten. Two exposures are combined to balance the bright ambient light and the dim interior lighting of a building. A second image is captured at night and placed on a layer above the daylight exposure. The layer is then set to the Lighten blend mode.

Lighten

When the top layer is set to Lighten mode, Photoshop displays the lighter pixels, regardless of whether they are on the layer set to the Lighten mode or on the underlying layers. Pixels on the layer with the blend mode applied that are darker than the underlying pixels in the same location will no longer be visible. This blend mode is particularly useful for introducing highlights into the underexposed areas of an image. This technique can also be useful for replacing dark-colored dust and scratches from light areas of continuous tone.

Image 9_Screen. Screen is useful when overall lightening is required.

Screen

The Screen blend mode belongs to the 'Lighten' family grouping. The 'inverse' brightness values of the pixels on the blend layer and underlying layers are multiplied to create lighter tones (a brightness value of 80% is multiplied as if it was a value of 20%). Only the underlying values that are screened with black (level 0) on the upper layer stay the same (see Project 5 in the Advanced Retouching chapter).

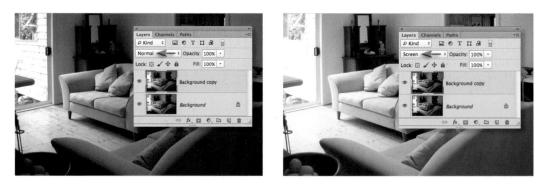

Image 10_Screen. A background layer is duplicated and a Screen blend mode is applied to lighten all levels.

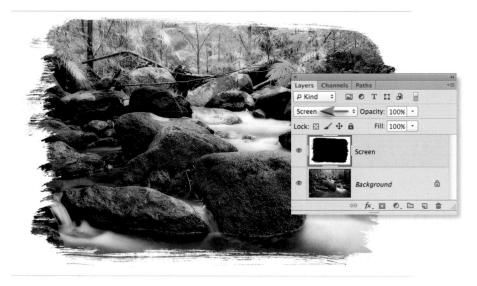

Image 11_Screen. The Screen mode can be used to apply a white border around an image.

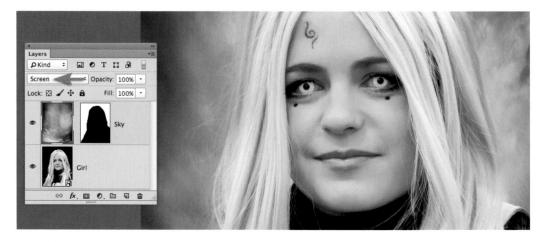

Image 12_Screen. The Screen blend mode is useful when masking hair that was first captured against a black background.

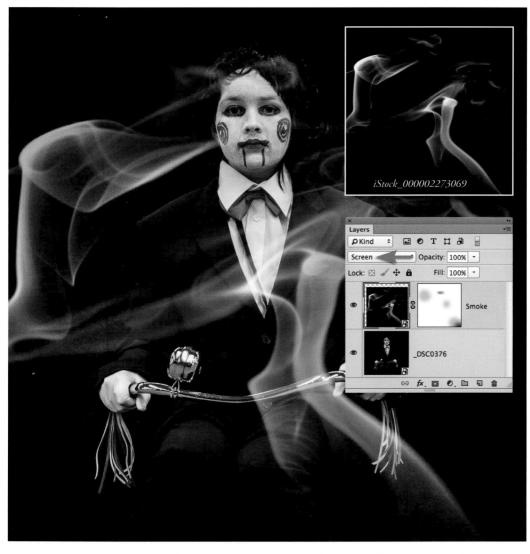

Image 13_Screen. The Screen blend mode is particularly useful for quickly dropping in elements that were photographed against a black background such as smoke, bubbles, splashing or spurting water and fireworks. For transparent elements the lighting is usually positioned to one side or behind the subject matter to create the best effect.

Color Dodge, Linear Dodge and Lighter Color

Color Dodge decreases the underlying contrast while Linear Dodge increases the underlying brightness. This again is a difficult blend mode to find a use for at 100% opacity. Saturation can become excessive and overall brightness, heavily influenced by the underlying color, can blow out (become white). Lighter Color is very similar to the Lighten mode in that only the lighter pixels remain visible. The difference between the two 'lightening' modes is how Photoshop assesses the brightness value – channel by channel (Lighten) or combined channels (Lighter Color).

The 'Overlay' group

This is perhaps the most useful group of blend modes for photomontage work.

Image 14_Overlay. Applying the blend mode Overlay to a texture or pattern layer will create an image where the form appears to be modeling the texture. Both the highlights and shadows of the underlying form are respected.

Image 15_Overlay. The Overlay blend mode is useful for overlaying textures over 3D form.

Overlay

The Overlay blend mode uses a combination of the Multiply and Screen blend modes while preserving the highlight and shadow tones of the underlying image. The Overlay mode multiplies or screens the colors, depending on whether the base color is darker or lighter than a midtone. The effect is extremely useful when overlaying a texture or color over a form modeled by light and shade. Excessive increases in saturation may become evident when overlaying white and black. The Soft and Hard Light blend modes produce variations on this overlay theme.

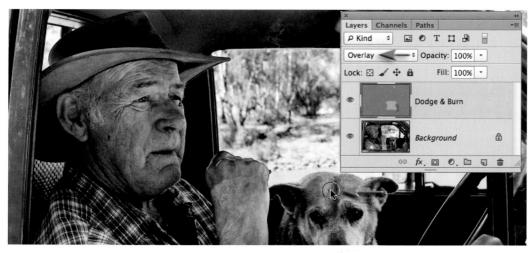

Image 16_Overlay. A 50% Gray layer set to Overlay mode can be used to dodge and burn where increased localized contrast and saturation are required (such as dodging dark shadow tones).

A layer filled with 50% Gray is invisible in Overlay and Soft Light mode and, as a result, is commonly used as a 'non-destructive' dodging and burning layer (see Project 3 in the Retouching chapter for a more in-depth look at this skill).

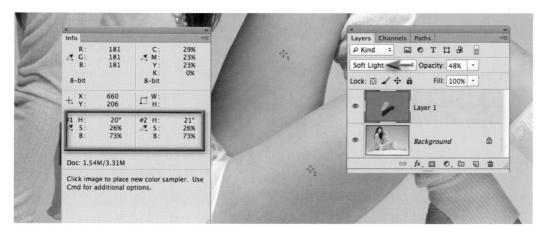

Image 17_Soft Light. A 50% Gray layer set to Soft Light mode provides the most effective way to lighten or darken tones within an image. This is a more effective way than using Levels or Curves to change the luminance values. Using Levels or Curves to change localized luminance values always results in excessive shifts in Saturation and Hue values.

Soft and Hard Light - variations on a theme

The Soft and Hard Light blend modes are variations on the Overlay theme. Photoshop describes the difference in terms of lighting (diffused or harsh spotlight). If the Overlay blend mode is causing highlights or shadows to become overly bright or dark or the increase in saturation is excessive, then the Soft Light blend mode will often resolve the problem. The Hard Light, on the other hand, increases the contrast – but care must be taken when choosing this option as blending dark or light tones can tip the underlying tones to black (level 0) or white (255).

Difference and Exclusion

The Difference blend mode subtracts either the underlying color from the blend color or vice versa, depending on which has the highest brightness value. This blend mode used to be useful for registering layers with the same content but this has now largely been replaced with the Auto-Align Layers for layers that are not Smart Objects. The Exclusion blend mode works in the same way except where the blend color is white. In this instance the underlying color is inverted.

Image 18_Difference. The Difference mode is used to align two layers.

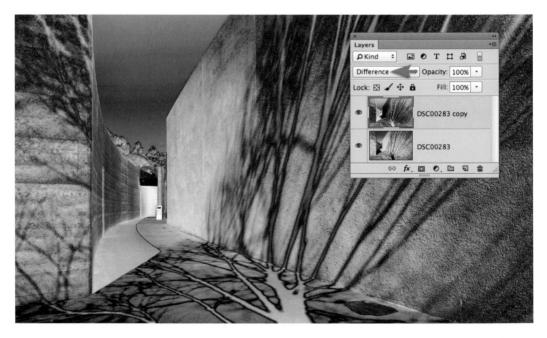

Image 19_Difference. The Difference mode can also be used to create a 'solarized' or 'sabattier' effect. Duplicate the layer and go to Image > Adjustments > Invert and then apply the Difference blend mode to the copy layer.

Hue, Saturation and Color

The Hue and Color blend modes are predominantly used for toning or tinting images while the Saturation blend mode offers more limited applications. Saturation precedes Color in the Modes menu but is discussed after Hue and Saturation in this section due to their inherent similarities. See Project 1 in the Advanced Retouching chapter to see how the Color mode is used to reintroduce some of the original color back into an image that has been converted to black and white.

Hue

The Hue blend mode modifies the image by using the hue value of the blend layer and the saturation value of the underlying layer. As a result the blend layer is invisible if you apply this blend mode to a fully desaturated image. Switch the visibility of the Gray layer on in the sample file to see the effect.

Color

The Color blend mode is useful for toning desaturated or tinting colored images. The brightness value of the base color is blended with the hue and saturation of the blend color.

Image 20_Hue-Color. Hue and Color blend modes.

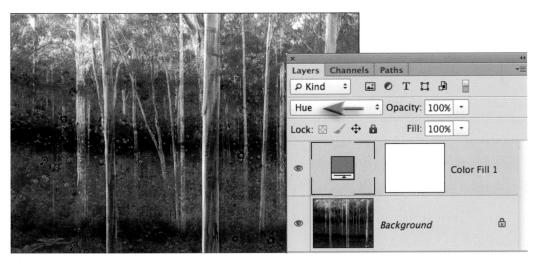

Image 21_Hue.

Note > Color fills can be used to tint or tone images by setting them to Hue or Color mode. Color variations in skin can be evened out by sampling one skin tone and using this as the fill color. Use a layer mask to shield areas you don't want to modify.

Saturation

The brightness or 'luminance' of the underlying pixels is retained but the saturation level is replaced with that of the blend layer's saturation level.

Note > This blend mode has limited uses for traditional toning effects but can be used to locally desaturate colored images. To work with this blend mode try creating a new empty layer. Then either fill a selection with any desaturated tone or paint with black or white at a reduced opacity to gradually remove the color from the underlying image. (Note the desaturation of the wall in the picture below.)

Image 22_Saturation.

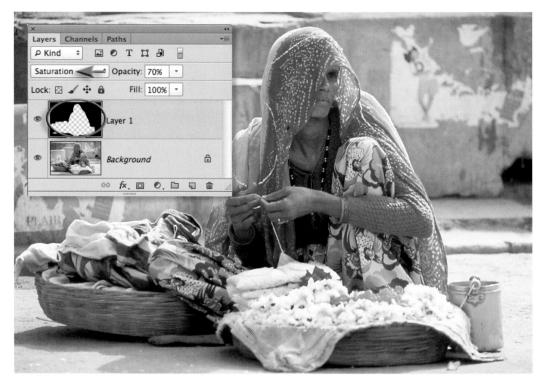

Image 23_Saturation. A Saturation layer is used to desaturate the underlying image.

Luminosity

1

Setting a layer to Luminosity mode allows the Hue and Saturation values from the underlying layers to replace these on the Luminosity layer. The luminosity values within an RGB image have a number of other very useful applications. The luminosity values can be extracted from an RGB image (from the Channels panel) and saved as an alpha channel.

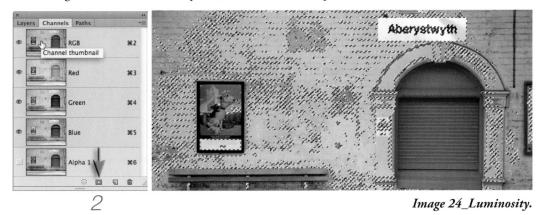

Creating a luminance channel

- 1 In the Channels panel Command/Ctrl-click the master RGB channel to select the luminance value.
- 2 Hold down the Option/Alt key and click on the 'Save selection as channel' icon to create an alpha channel. In the New Channel dialog select the Masked Areas option and OK.
- 3 Go to Select > Deselect or proceed to the Layers panel and select Paste from the Edit menu to create a new Luminosity layer or select an adjustment layer to create a Luminosity mask.

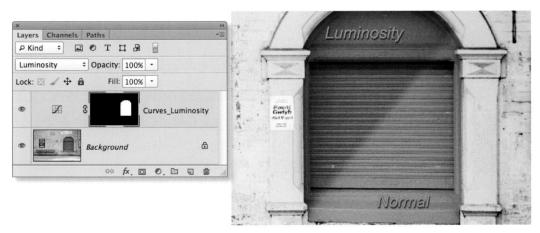

Setting adjustment layers to Luminosity

Curves and Levels adjustment layers can be switched to Luminosity mode to eliminate shifts in saturation when contrast is increased. The example above illustrates what happens when contrast is increased using a Curves layer in Luminance and Normal blend modes. Open up the file and try it!

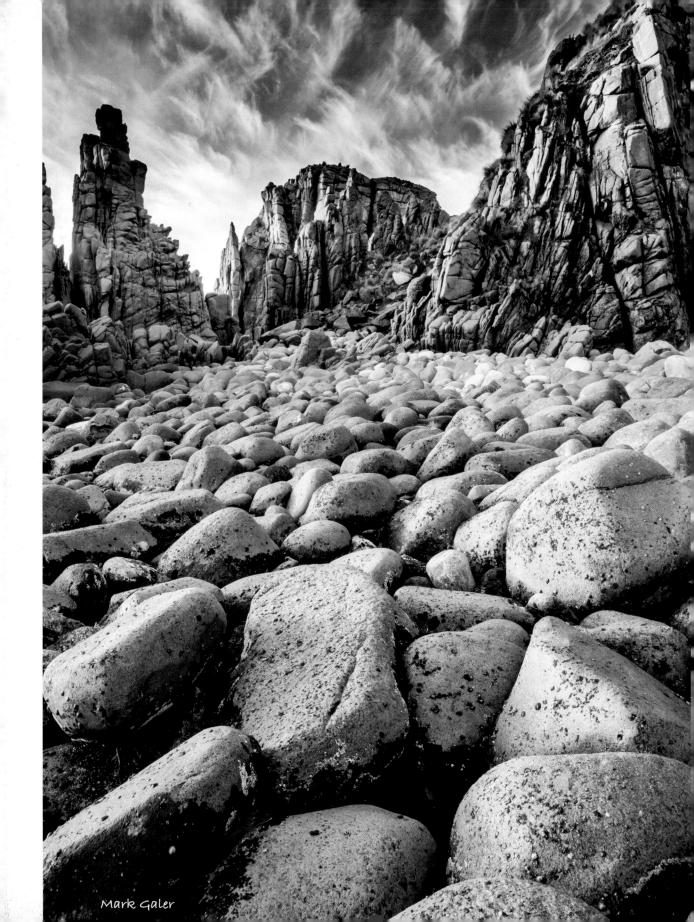

hop photoshop ph

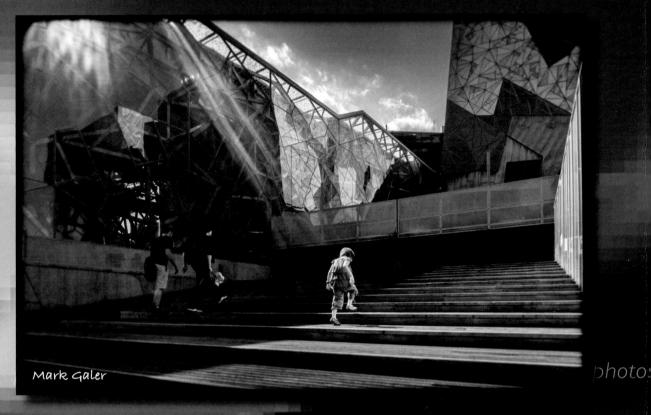

essentíal skílls

- Retouch and enhance images using the following techniques and tools:
 - Adjustments in Adobe Camera Raw
 - Adaptive Wide Angle and Warp
 - Adjustment layers and layer masks
 - Target tones

NOD

- Healing Brush, Clone Stamp tool and Stamp tool
- Shadow and Highlight adjustment
- Adjustment layers, channels and layer masks.

Monument Valley, USA

Standard edit in ACR – Project 1

Most images that have come straight off the memory card of a camera benefit from some adjustments. These adjustments optimize images for screen or print, or correct for any in-camera auto settings that were inappropriate. Traditionally, these adjustments were always carried out inside the main editing space of Photoshop. These adjustments are now faster and easier to make in Adobe Camera Raw (ACR). ACR has been around since Photoshop 7 and was created as a gateway for all Raw files so that they could be optimized before they were opened in the main editing space of Photoshop (unlike JPEGs, Raw files are saved in the camera without any processing). The new revolutionary approach (or workflow) is to use ACR for Raw and JPEGs. ACR is non-destructive, simple and fast. The editing space of Photoshop is best used for specialized tasks. In this project we will perform the basic editing tasks to a Raw image in ACR and complete the project with a single adjustment layer in the main editing space of Photoshop.

Note > If you want to follow this workflow using a JPEG image simply right-click on the JPEG in Bridge and choose Open in Camera Raw. If you are working with the project image you will notice the image is very bright when opened in ACR. The exposure for this image was set high in the camera to increase the quality of the shadows (a technique known as 'Exposing Right'). The exposure latitude available to photographers shooting in the Raw format allows for extensive exposure adjustments in ACR that are not possible when capturing in JPEG images, due to their lower bit depth and exposure latitude.

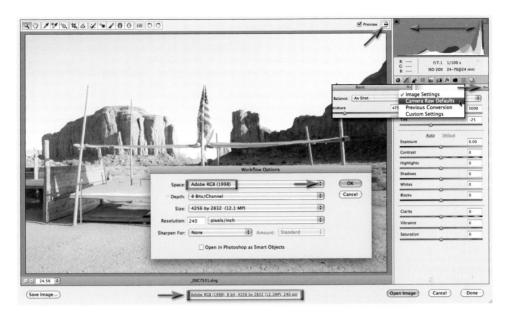

1 Open the project image in Adobe Camera Raw (ACR). Click on the Toggle Full Screen Mode icon (just to the left of the histogram in the top right-hand corner of the ACR dialog) or simply press the F key to maximize the use of your screen real-estate. Make sure the image is set to the Camera Raw Defaults by selecting the option in the flyout menu in the top right-hand corner of the Basic panel. This will establish the starting point for the image. Before optimizing the color and tone for an image it is important to establish the correct color space to suit your needs (print or web). Click on the blue writing at the base of the ACR dialog to open the Workflow Options dialog. Select Adobe RGB (1998) from the Space menu and then select OK. Selecting Adobe RGB will allow us to optimize the image for print.

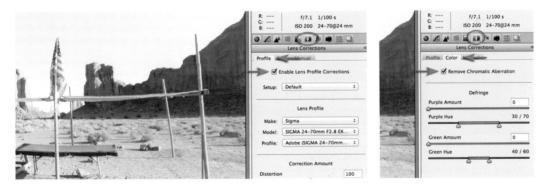

2 The second step we can take to ensure maximum quality is to select the Enable Lens Profile Corrections and Remove Chromatic Aberration options in the Lens Corrections panel (a Sigma 24-70 F2.8 EX Lens was used on a Nikon camera to capture this image). This will remove any lens distortions that were introduced into the image (if the appropriate lens profile is selected) and any possible color aberrations (common with wide-angle images). Once this has been done we can click on the Basic panel once again to start the color and tonal editing of this image.

SETTING CAMERA RAW DEFAULTS

After setting a lens profile correction, removing chromatic aberration and making Detail adjustments (see the Noise Reduction in ACR and Sharpening in ACR sections that appear later in this project) it is possible to select the Save New Camera Raw Defaults option in the flyout menu. It is important to make only those adjustments that would be suitable for all images captured by the camera at a specific ISO setting. Prior to saving new Camera Raw defaults you should select the camera serial number and camera ISO setting options in the Camera Raw Preferences dialog (the dialog can be accessed by clicking on the icon in the Tools at the top of the ACR dialog).

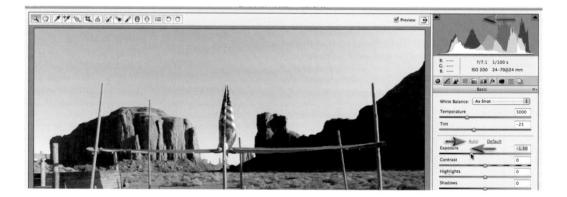

3 You can observe how ACR could automatically try to correct this image by clicking on the word 'Auto' in the Basic panel. Now click on the word 'Default' so that we can manually correct this image. We will adopt a top-down approach, in this instance, to adjust the tonality of this image (it is too difficult to start with correcting the Color Balance at the top of the basic panel when the image is so bright). Drag the Exposure slider to the left so that it has a negative value of -1.5. This action recovers a small amount of overexposure and adjusts the overall brightness of the image. Watch the histogram at the top of the ACR dialog change its shape. There is no 'correct' position for this Exposure slider and we may return to this slider at any time to fine-tune the overall brightness of the image after making additional adjustments.

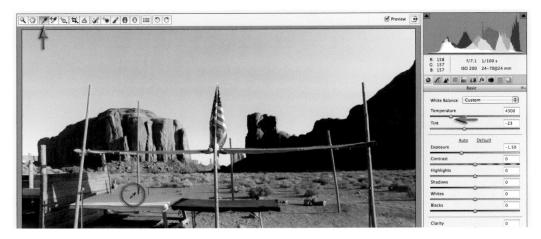

4 Now that we have adjusted the overall brightness we are able to assess the white balance for the image. The image was captured with the camera set to Auto White Balance. This, however, has created an image that feels a little too warm. It is possible to select an alternative white balance setting from the White Balance drop-down menu in the Basic panel (these are the alternative custom white balance options you could have selected in-camera at the time of capturing the image). None of these settings, however, gets the image closer to a 'neutral setting'. We can manually adjust the Temperature and Tint sliders or click on the White Balance tool in the top left-hand corner of the ACR dialog and then click on something that is neutral (gray) in the image. If we click on the tablecloth in the center of the table we should see the Temperature slider move to the left (4300) to create a slightly cooler looking image. The Tint slider should not move significantly.

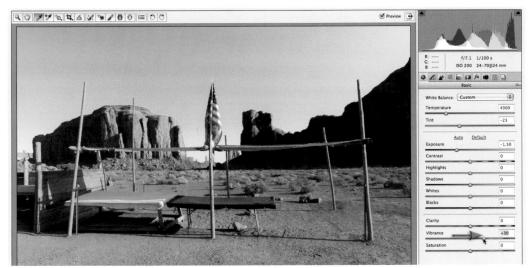

5 When the image is adjusted cooler the warm colors appear less vibrant. We can compensate for this by dragging the Vibrancy slider to a value of +30. The Vibrancy slider is used in preference to the Saturation slider in most instances, as it protects any colors that are already vibrant from becoming too saturated.

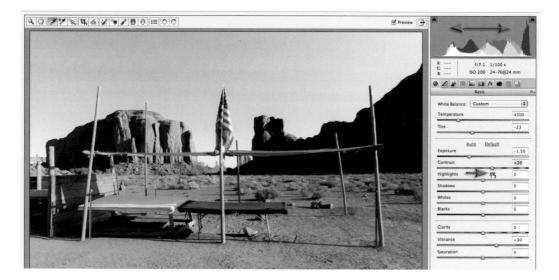

6 Now that we have set the Exposure, White Balance and Vibrancy we can set the Contrast for the file. Contrast is a subjective adjustment (no right or wrong). Before choosing a precise setting for this adjustment slider I recommend moving it in both directions in large and small amounts to see what can be achieved (good advice for all sliders). I would also take note of what is happening with the histogram as you move the slider so you can get an idea of what sections of the histogram are being adjusted. I have chosen to increase the contrast to +20. Adjusting contrast can also effect the saturation of the colors (raising contrast raises saturation) so some additional fine-tuning of the Vibrance slider may be required.

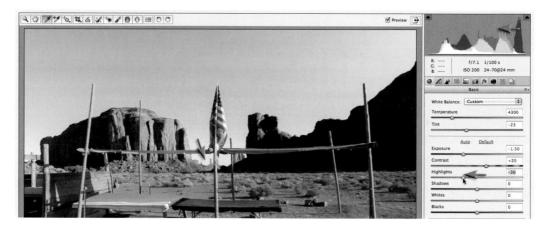

7 We can also control the image contrast using the Highlights and Shadows sliders. Using the Highlights slider we can control how bright or dark we wish to render these areas of the image. The highlights in this project image are represented by the lighter areas of the tablecloth, the white stripes on the flag and the brighter areas of the sky. If we render them too bright we will 'clip' or lose detail and the highlight warning triangle sitting above the top right-hand corner of the histogram will change from black to either white or a color. I have chosen to lower the Highlights slider to a value of -30 to protect the subtle detail in these areas.

Retouching projects

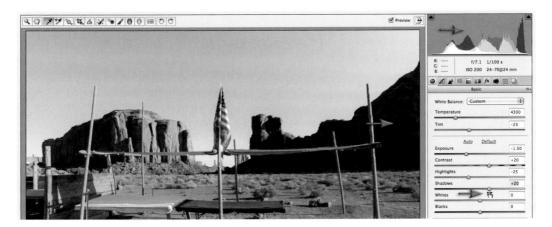

8 I have raised the Shadows slider to +20 so that the rock formations on the right side of the image do not become too dark. If we render the shadows too dark they risk being rendered black by any subsequent printing process. The original exposure in-camera was raised at the time of capture to preserve maximum detail in the rock formations so it is important not to lose this detail during the processing of this file.

. 4300 -23 -1.50 -25 +20 -20

The Whites and Blacks sliders are used to fine-tune the tonal processing of this file. Most professionally edited files are processed to have both a white and a black point. There are some exceptions where an image is processed to either clip highlights and/or shadows or where a particular mood or treatment requires subdued tones. When setting either the White Point or Black Point of the image it is advisable to hold down the Alt key (PC) or Option key (Mac) while moving these sliders. The preview window will turn mostly black (when adjusting the Whites slider) or mostly white (when adjusting the Blacks slider) while the modifier key (Alt/Option) is held down. This view is called Threshold and you will see what colors (if any) are being clipped to white or black. If you see an area of color in the preview window (rather than black or white) this indicates that one or two channels are being clipped rather than all three. This can occur when the tone is either too bright, too dark or when the color is too saturated to print with significant detail or texture. In this project image the Whites slider has been left at zero and the Blacks slider reduced to -20. At -20 there will be small dots and thin lines visible in the preview window when holding down the Alt/Option key. This does not indicate a significant loss of detail. It is only when areas, instead of lines, appear black that we need to stop lowering the Blacks slider. Even the edges we can see will mostly disappear if we zoom into 100% view.

10 With the basic edit complete we can turn our attention to some 'targeted adjustments'. Click on the Targeted Adjustment tool (TAT) at the top of the dialog and choose Luminance from the drop-down menu. Click on the blue sky in the image preview and, with the mouse button held down, drag down a short distance to darken the sky. A luminance adjustment will control the brightness of a color but maintain its hue and saturation values. Notice how, on the right side of the ACR dialog, the Luminance tab of the HSL/Grayscale panel is made visible and how the Blues and Cyan sliders move to the left as you click and drag down. Stop dragging down when the Blues slider is at a value of around -30.

Note > Use the keyboard shortcut (Ctrl/Cmd-Z) to undo any adjustment you feel is inappropriate.

11 Click on the Basic tab. In this step we will increase the vibrance of the colors and then in the next step learn how to recover one color that becomes 'out of gamut' (too vibrant for the limitations of the color space and output device). Raising the Vibrance slider to +50 will result in the Shadow clipping warning triangle turning red (indicating a gamut problem rather than luminance clipping). If we then hold down the Alt/Option key and click on our Blacks slider we will see an area of the sky being displayed with a Cyan overlay.

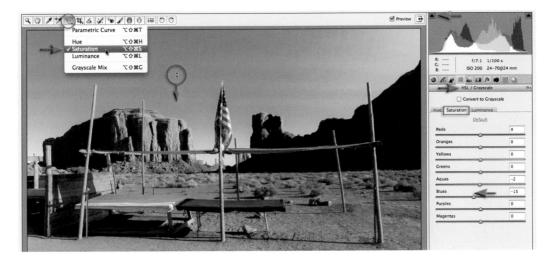

12 It is possible to retain the Vibrancy slider at +50 and reduce the saturation of only the problematic colors. Select Saturation from the targeted adjustment tool drop-down menu and then click and drag down (targeting the sky) until the Shadow clipping warning triangle turns black (indicating the colors have been brought back into gamut).

Note > It is not always possible, or desirable, to bring every color back into gamut (especially when using the smaller sRGB color space). Reducing or eliminating gamut clipping is only important when you need to maximize detail and texture within the color.

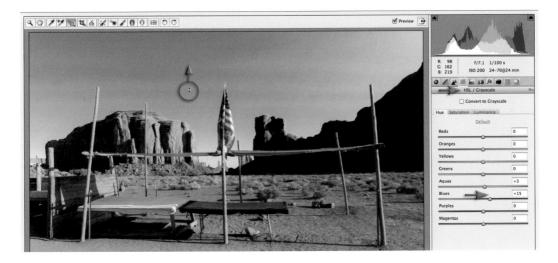

13 The final targeted adjustment can be made to the hue of the sky. As you may have noticed, the Cyan slider in the Luminance and Saturation tabs has been moving as well as the Blues slider. We can reduce the amount of Cyan in the sky by selecting the Hue option in the Targeted Adjustment tool drop-down menu and then dragging up until the Blues slider has a value of +15. This will create a stronger complementary color to orange sand, wood and rocks within the image.

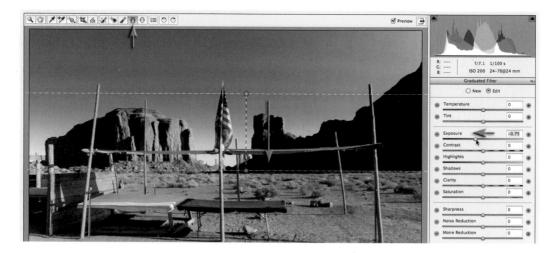

14 As well as the Basic Adjustments and the Targeted Adjustments, it is possible to make Localized Adjustments via the Graduated Filter and the Adjustment Brush. Click on the Graduated Filter icon in the Tools panel in the ACR dialog. Click on the negative icon next to the Exposure slider. This will zero all other sliders and set a negative value for the Exposure. Drag the slider to -0.75 and then click near the top of the flag and drag down to the horizon line. Holding down the Shift key as you drag will constrain the Graduated Filter to a perfect horizontal or vertical. This filter will significantly darken the sky. You can fine-tune the effect by adjusting the Exposure slider after the Graduated Filter has been added.

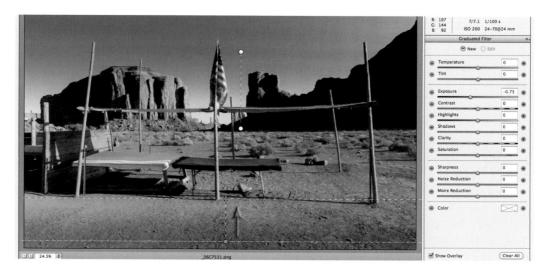

15 Click and drag from the bottom of the image preview to the base of the flag pole to add a new Graduated Filter. This new Graduated Filter will use the same settings as the previous one but can be adjusted to have different settings by adjusting the sliders. Click on the circles associated with either graduated filter to activate it and then fine-tune the settings. Press the Backspace key (PC) or Delete key (Mac) to delete a Graduated Filter. Experiment with dragging shorter or longer graduated filters to see the effects.

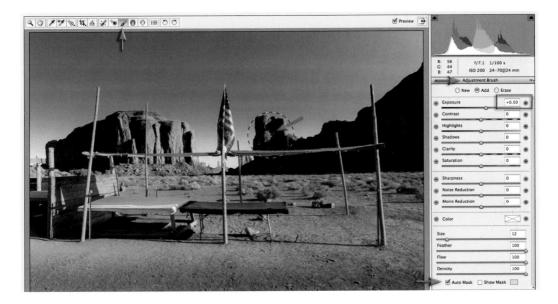

16 Click on the Zoom or Hand tool in the Tools panel to exit the Graduated Filter dialog. Click on the Adjustment Brush icon in the Tools panel (just to the left of the Graduated Filter icon) and click on the plus icon next to the Exposure slider. Set the Feather and Flow sliders to 100% and select the Auto Mask checkbox at the base of the panel. Adjust the size of the brush if required and move your mouse cursor into the image preview. The outer circle denotes the extent of the feather and the inner circle denotes the extent of the adjustment at full strength. Proceed to paint on the dark rocks to lighten them. So long as the cross-hair of the inner circle of the brush does not touch the blue sky the painting will be confined to the rocks only.

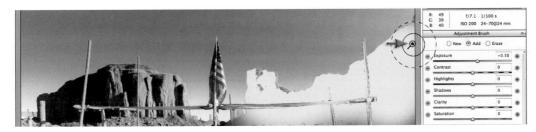

17 The painting action will add a pin where you first click on the image preview. You will have to click the 'New' radio button to add a localized adjustment with different settings. It is possible to add multiple settings to a single pin, e.g. you could add noise reduction when making dark shadows lighter (not required in this project because of the increased exposure in-camera). If you move your mouse cursor over the pin you will observe a colored mask indicating where the adjustment has been applied. If you need to remove any of the adjustments, hold down the Alt key (PC) or Option key (Mac) and erase the adjustment. You can apply different brush settings for adding and subtracting the adjustment. Lower the Flow slider if you want to build up the adjustment with repeated strokes of the brush. Lowering the Density slider will limit the extent of the adjustment and you will not be able to increase the adjustment strength with additional strokes. You can change the color of the mask by clicking on the swatch.

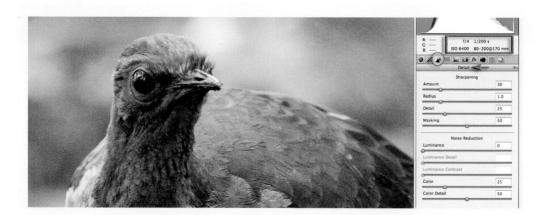

NOISE REDUCTION IN ACR

This image had to be captured at 6400 ISO in order to achieve a subject that was sharp with no motion blur. Raising the ISO has created significant noise that can be reduced by using the Noise Reduction sliders in the Detail panel.

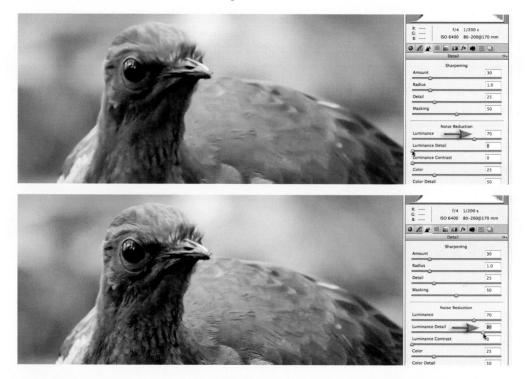

Raising the Luminance slider can drastically reduce or eliminate the noise but can leave tones looking a little plastic. Raising the Luminance Detail slider can restore the fine detail and texture without reintroducing the noise. Occasionally the Luminance Detail cannot be used at a very high setting as it may introduce image artifacts present in the image. In these instances the Luminance slider can be lowered slightly and the Luminance Contrast slider raised to help break up overly smooth tones.

Retouching projects

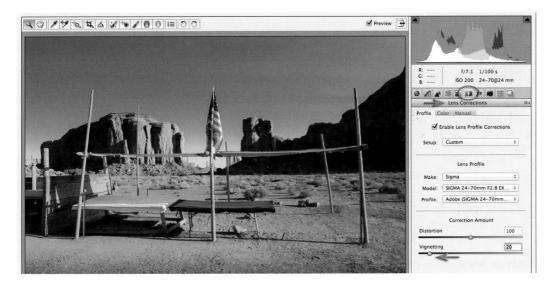

18 Another form of localized editing is to add a vignette to the image to darken the outer edges. This is a very common technique that many photographers use on a large percentage of their images. Many camera lenses darken the outer edges of the image and the Lens Profile Correction that was applied at the beginning of this edit may have lightened the corners of the image to compensate for this effect. By going to the Lens Corrections panel you can reintroduce the darkening effect by dragging the Vignetting slider to the left.

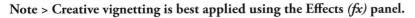

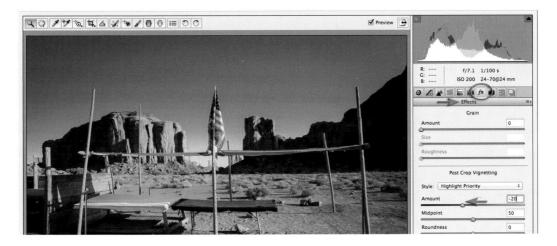

19 If you have cropped your image and you would like to add a vignette you should click on the Effects tab. Choose either Highlight Priority or Color Priority from the Style drop-down menu and then drag the Amount slider to the left. If you encounter a shift in hue or excessive tonal clipping you should switch to the Color Priority style. Adding a vignette may require the overall image to be made a little lighter to compensate. If this is the case, go to the Basic panel and drag the Exposure slider to the right until the correct overall tone is achieved.

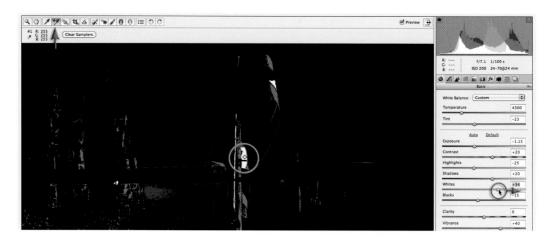

20 Targeted and Localized Adjustments can upset the white and black points set in the Basic panel. If the tonal editing is complete, we are now ready to set precise values for these important tones. Locate the brightest area within the image. This should be a bright surface but not a light source or a reflection of the light source (called a specular highlight). To locate the brightest highlight hold down the Alt/Option key and drag the Whites slider to the right until white areas begin to appear in Threshold view. Reset the Whites slider to the previous setting by using the 'Undo' keyboard shortcut (Ctrl + Z on a PC or Command + Z on a Mac). Zoom in to 100% (double-click the Zoom tool in the Tools panel). Click the Color Sampler tool in the Tools panel and then click in one of the bright areas you have identified to set a color sample. Do not set a sample point that is too close to an edge (when edges are sharpened clipping can occur and these pixel values do not reflect the average tonality of the adjacent surface area). After setting a Color Sampler you will see RGB values appear in a bar below the tools.

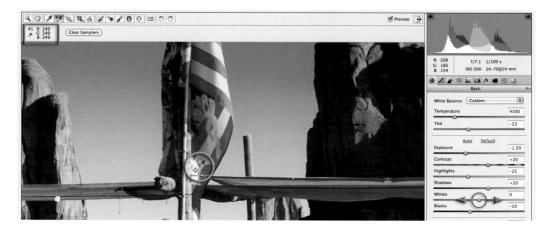

21 Move the Whites slider to set the optimum white point for the intended output device. For this project I am setting the white point to a value of between 245 and 250 which should render a bright tone in the final print that is not quite paper white. If this value cannot be achieved using the Whites slider it is advisable to check the Contrast and/or Highlights sliders are not set too high.

Retouching projects

22 Repeat the process to set the optimum black point for this image. If you are still zoomed in to 100% use the Spacebar and drag the image in the image window to locate the tablecloth. Dragging the Blacks slider to -55 should identify an area on the front of the green tablecloth that is one of the darkest areas within the image. Setting a second Sampler point and resetting the Blacks slider to the previous -20 setting should indicate that the shadow values for this image are not too problematic (double-digit numbers in the RGB readout).

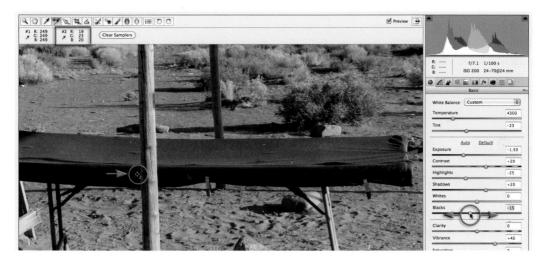

23 To render visible detail in the shadows, the Shadows and Blacks sliders should be set to an 'appropriate' setting. The appropriate setting is where the RGB values are set high enough so that the shadow details are discernible from absolute black when the image is printed. This may vary depending on the quality of the output device and paper used in the printing process. For this project I have aimed to set the values to an average of 20 (an appropriate setting for an average quality inkjet print or high quality commercial printing press using good quality paper). When placing the Color Samplers you may find one of the RGB figures reads significantly higher or lower than the other two. If this occurs take an average from all three RGB figures.

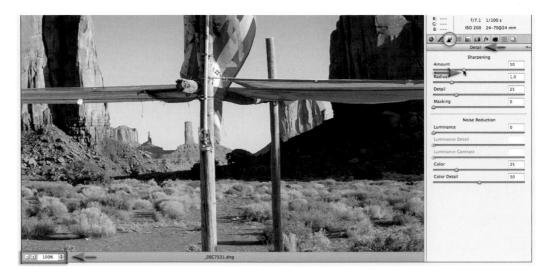

24 All digital images will require sharpening to some extent (even images captured in-focus using professional quality lenses). There are options to sharpen images in the main editing space of Photoshop, on opening or export from ACR (check out the Workflow Panel) or in the Detail panel of ACR. The Detail panel offers sophisticated options and by default a small amount of sharpening is applied already. To increase the amount of sharpening you are advised to zoom in to 100% (at some magnifications the effects of these slides are not visible). In this project I have raised the Amount slider to 50 and left the Radius and Detail sliders at their default settings. Raising the Radius slider higher than 1.0 runs the risk of making the sharpening obvious when images are viewed at close range.

25 The effects of the sharpening process can be limited to only the edges, and not the smooth areas of continuous tone, by raising the Masking slider. Hold down the Alt key (PC) or Option key (Mac) and raise the slider until you can see the areas of smooth tone masked to black. This action will reduce the visibility of noise or artifacts in these areas.

SHARPENING IN ACR

To fully understand what is happening when we sharpen an image it is worth zooming in to 400% and observing the effects of sharpening on the high contrast edges and the areas of smooth tone. Raise the Amount and Radius sliders to 150 and 3.0. You can now see how the pixels either side of an edge are made darker (on the dark side of the edge) and lighter (on the light side of the edge). You can also observe that the areas of smooth tone start to reveal texture. This texture can be increased by raising the Detail slider or suppressed by raising the Masking slider.

The Amount slider controls how much darker and lighter the pixels are rendered at the edge. Sharpening is effectively a localized contrast control. The Radius slider controls the width either side of the edge that the increase in contrast is applied. If the Radius is set too high the viewer is aware of the sharpening effect at normal viewing distance. Higher Radius settings can be employed if the viewing distance is increased. By lowering the Radius slider to 1.0 and raising the Masking slider (as carried out in Step 25 of this project), high amounts of sharpening can be applied.

CLARITY IN ACR

In the Basics tab, the Clarity slider in ACR can be used to effectively increase localized contrast and give images more apparent depth (and sometimes make them appear sharper). Notice how contrast in both the areas of fine detail and the broader areas of continuous tone are increased. When dragged to the right, the Clarity slider is working in a similar way to the Amount slider in the Detail panel that is used to sharpen images (making tones darker or lighter either side of an edge). Clarity, however, is working in much broader areas of adjustment and not just confining its work to a narrow area either side of an edge.

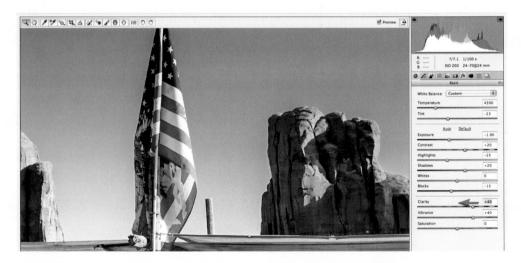

The Clarity slider is capable of expanding contrast or decreasing contrast to such a degree that haloes may appear along edges of high contrast when the slider is used excessively. In the project image the Clarity slider cannot be used globally at settings higher than 40 without these haloes becoming apparent. If higher values are required it is recommended to apply Clarity via the Adjustment Brush (covered later in this project) and use the Auto Mask option to prevent haloes from occurring.

Retouching projects

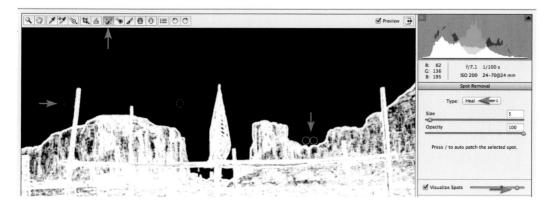

26 As the sky was darkened you may have noticed that a few small darker colored spots appeared in the sky. These are specks of dust on the sensor that become visible when the aperture of the lens is stopped down (sometimes referred to as dust bunnies!). They can be removed using the Spot Removal tool. Raise the Radius to 5 so that the brush is fractionally larger than the spot you wish to remove and set the Type to Heal. Click on the Visualize Spots checkbox and raise the slider until you can see the spots more easily. Each time you click on the spot you will see a red and a green circle appear in the image preview. The red circle indicates where the spot has been removed from and the green circle indicates where Photoshop is drawing its information to repair or heal the area. When working up against edges of contrast or color you may need to switch the Type to Clone and reposition the green circle to repair the area efficiently.

27 When you open an image from ACR or hit the Done button at the base of the ACR dialog Photoshop will store the image settings (in either the xmp sidecar file or in the header of the DNG file). You also have the option of creating a record of the settings you have used in the Snapshots panel. This is useful if you intend to edit the file in different ways, e.g. create an alternative black and white version or edit the image for a different color space such as sRGB. Simply click on the document icon at the base of the panel to create a New Snapshot. If you want to return to a saved setting just click on the name of any snapshot you may have created.

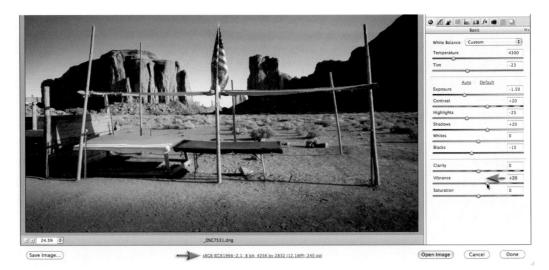

28 It is possible to change the color space of a file in the main editing space of Photoshop (Edit > Convert to Profile or File > Save for Web & Devices). It is also possible to convert the profile by clicking on the Workflow Options at the base of the ACR dialog. The advantage of changing the color profile in ACR is that we can preview or 'soft proof' how the tone and color will change before we commit to the change. Switching to the sRGB color space and closing the Workflow Options dialog you will notice the histogram change shape. Remapping the colors from a larger color space to a smaller color space may result in gamut or luminance clipping. This can be managed in ACR by lowering the vibrance or saturation globally or by targeting any problematic colors. When working with sRGB you may have to let some colors stay out of gamut rather than trying to desaturate them excessively in order to bring them back into gamut.

29 If you re-edit the file you can save an additional Snapshot in the Snapshots panel. This will give you the option of restoring the optimum settings for either screen or print.

SYNCHRONIZE SETTINGS IN ACR

After optimizing the settings for one image it is possible to synchronize the settings across multiple images taken at the same location in the same lighting conditions. If you have opened multiple images into the ACR dialog, click the Select All button and then press the Synchronize button to open the Synchronize dialog. Typically you want to Choose Everything from the Synchronize drop-down menu and then deselect Local Adjustments and Crop if you have been re-framing images using the Crop tool.

After synchronizing the settings across multiple images it is usually only a small task to click on each thumbnail in turn, and then 'tweak' one or two sliders in the Basic panel to optimize the settings for each image. Local adjustments (Graduated Filter and the Adjustment Brush) can be applied if required. If multiple images are not open, but the user wants to apply the settings they have created to other images in their library, then they can record a Preset in ACR (use the Presets tab) or copy and paste the settings using Adobe Bridge.

CROPPING IN ACR

It is possible to crop an image in ACR non-destructively (pixels are hidden from view rather than deleted). When you click and hold on the Crop tool in the Tools panel of the ACR dialog you are shown options to crop to an aspect ratio (shape) that may be different to that of the camera's sensor. In the illustration above I have chosen to crop the image to a 9 to 16 aspect ratio which is suitable for an HD television screen. If you want to crop to a specific size as well as a shape then you can scroll to the Custom option. In the Custom dialog you can choose to crop in 'Inches' or 'cm' (for printing purposes) or Pixels for screen viewing. In the illustration I have set the Custom Crop to 1080 x 1920 for full HD screen viewing.

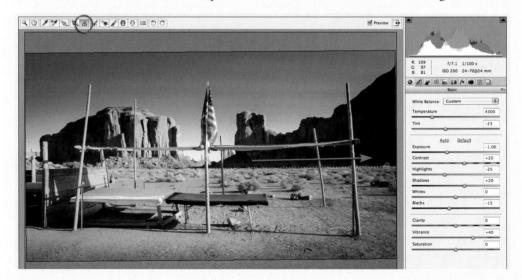

The Straighten tool is used to adjust both horizontal or vertical lines by dragging along an edge in the image. You can also move your cursor to the corner of the crop bounding box and manually rotate the image.

19/14/2/11			Preview
	Save Options		
	Destination: Save in New Location		Save Cancel
	File Naming Example: Monument-Valley-01.jpg Monument-Valley- + 2 Digit Serial Number + Begin Numbering: 01 File Extension: jpg :	•	
	Format: JPEC Metadata: All Remove Location Info Quality: 10 Maximum (10-12)		
24.1%	_05(7531.drg		

SAVING IMAGES IN ACR

If the editing process of the image has been completed in ACR (and there is no reason to open the image in the full editing space of Photoshop) it is possible to save the image or images that you have been editing in a file format that other applications can read, e.g. TIFF or JPEG. Click on the Save Image button in the bottom left-hand corner of the ACR dialog and then fill in the information in the dialog. The information you enter in this dialog is 'sticky', so it is most likely you will only have to change a few of the options the next time you visit this dialog. You will need to choose a location, file naming protocol (if you want to change the name of the original Raw files), format (file type) and quality setting. You are also able to control how much information from the metadata is written into the files you write and is subsequently visible when the file is distributed.

Note > Since ACR 7 and Lightroom 4 it has been possible to save a compressed DNG file as well as a lossless DNG file from this dialog (DNG stands for Digital Negative which is Adobe's Raw file format). If you opened a propriety file format in ACR (CR2, NEF, ORF etc.), choosing to save the Raw file as a DNG will ensure the metadata is embedded in the DNG Raw file rather than being written as a separate xmp sidecar file. This is useful when moving files from folders to ensure the processing data never becomes separated from the Raw file. If this happens, the image preview of the Raw file will revert to the Camera Raw Defaults the next time the Raw file is opened.

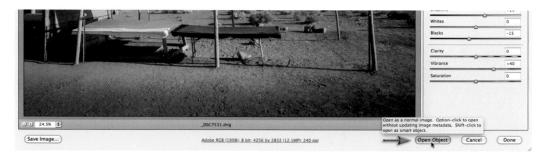

30 If you hold down the Shift key, the Open button at the bottom right-hand corner of the ACR dialog will change to an Open Object button. If you click on the Open Object button in ACR it will open the image as a Smart Object in the main editing space of Photoshop. The layer in the Layers panel will appear with the name of the file and the thumbnail will have a Smart Object icon in the bottom right-hand corner. Double-clicking the thumbnail will open the Raw file that has been embedded in the layer back into ACR. This ensures the connection between the Raw data and any subsequent processing is not broken. This offers a completely non-destructive approach to image editing.

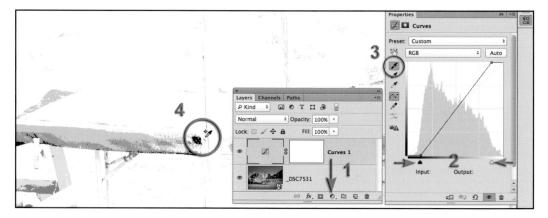

31 If you continue to edit the image in the main editing space of Photoshop you will need to keep an eye on the black and white points that were established in ACR. This can be achieved through the use of a Curves adjustment layer. From the Adjustments panel select a Curves adjustment layer. We can place color samplers in the image to monitor the darkest and lightest tones in the image. To help locate these tones we will temporarily increase the contrast of the image using this Curves adjustment layer. In the Curves dialog move the black Input Levels slider under the bottom left-hand corner of the histogram to the right, and the white Input Levels slider under the bottom right-hand corner of the histogram to the left. This will clip both the highlights and shadows to help you locate the darkest and lightest tones within the image. Select the black eyedropper in the Curves dialog and then move your mouse cursor into the image preview and hold down both the Alt/Option key and the Shift key to see a threshold view of your image. An eyedropper icon will appear with a + icon and a target icon. When you click your mouse over one of the darkest shadows you will record a color sample.

Retouching projects

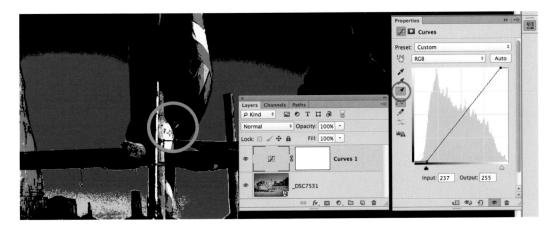

32 Select the white eyedropper, hold down the Alt/Option and Shift keys, move into the image preview and take a color sample from one of the brightest highlights (you are probably getting a good idea where these tones in this image live now). In the bottom right-hand corner of the Curves dialog click on the Reset to Adjustment Defaults icon so that your shadows and highlights are no longer clipped. We are now ready to set appropriate output values to the tones we have targeted.

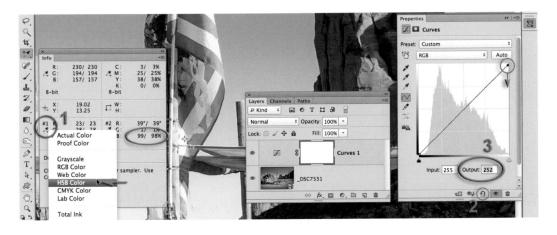

33 Drag the Info panel out of the panels dock and expand it. Locate the two color samples '#1' and '#2'. Right-click on the tiny eyedropper icon underneath each of the # symbols and in the context menu change the RGB readout to HSB (Hue, Saturation and Brightness). It is sometimes easier to work out whether a shadow or highlight will print if we can see a brightness value rather than trying to average out three separate RGB values. To adjust the Brightness values to appropriate levels (I am adjusting to 8% and 98% brightness) you may need to select either the black point or the white point on the curve and adjust the Output higher or lower (highlight the Output field and use the up and down arrow keys on your keyboard to alter the Output value). Monitor the changing Brightness values in the Info panel. This step completes a comprehensive workflow for editing a standard image file non-destructively to achieve maximum quality.

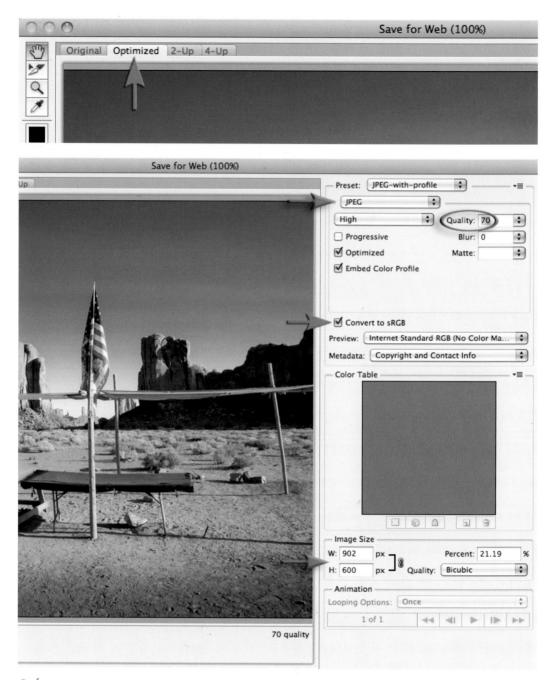

34 If you are working in Photoshop and you wish to create a quick copy to upload to the web (and you don't want to back-track by opening the file in ACR) just go to File > Save for Web. Select the file format (usually JPEG) and a compression setting (usually High). Check the Convert to sRGB checkbox and enter in the new size in the Image Size section. Set the Quality setting to Bicubic or Bicubic Sharper and preview the image in the Optimized tab (top left-hand corner of the dialog). Select 'Save' to export a web version of your master file and be sure to save the master file as a Photoshop (PSD) file.

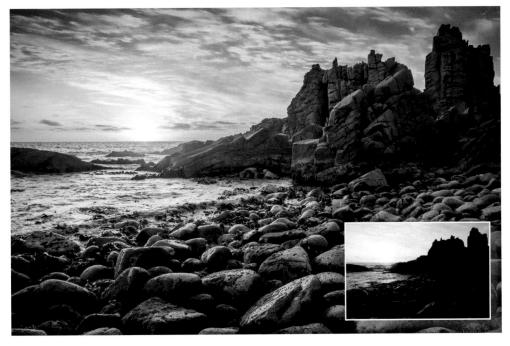

Extreme contrast edits in ACR - Project 2

In many instances the lighting conditions on location have led to the capture of Raw files that are problematic to process. This is typically due to the inherent contrast of the subject. The 2012 Process version found in Adobe Camera Raw 8 (part of CC), however, is much more likely to provide the photographer with a starting point that offers minimal clipping in either the highlight or shadow tones but occasionally the contrast is so extreme that we need to adopt a non-typical approach to the Raw processing.

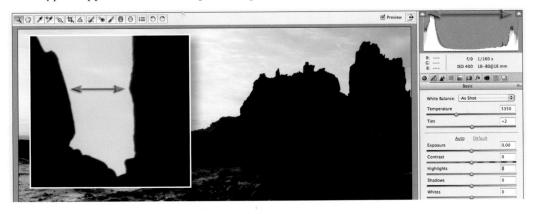

1 Open the project image and observe the extreme clipping, as indicated by the shadow and highlight clipping warnings above the histogram. Start the processing of this file by going to the Lens Corrections panel (see Step 2 in Project 1 of this chapter). The correct lens profile for this image is a Sony DT16-80 F3.5-4.5 ZA. If this cannot be selected just select the Remove Chromatic Aberration option (a lens profile is no longer required to fix chromatic aberration since CS6).

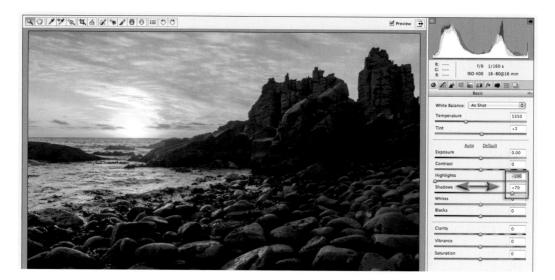

2 Standard Raw processing workflows using the 2012 Process would begin by adjusting the Exposure slider, but as the majority of this file is either underexposed or overexposed it makes sense to start with the Highlights and Shadows sliders first. At -100 for the Highlights and +70 for the Shadows the majority of tones are no longer clipping.

Note > The ease with which the tonality of both highlights and shadows in this tutorial image have been successfully restored is an example of the power of the 2012 Process when compared to previous process versions.

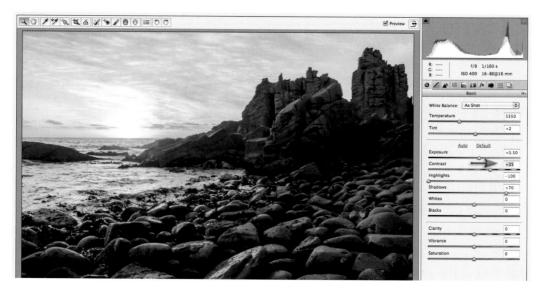

3 Only when the Highlights and Shadows are adjusted can we set appropriate values for the Exposure and Contrast sliders. Adding contrast may seem a little strange, given that the previous step was all about reducing it, but contrast is required for the midtone values to add depth and drama to the rocks in this image.

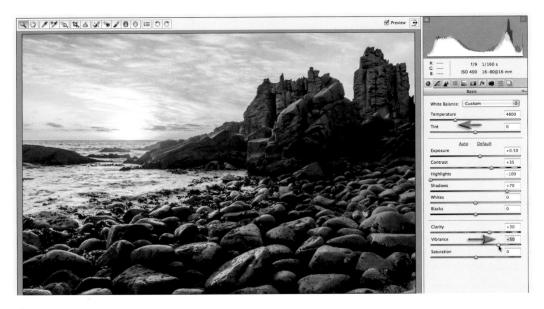

4 Once the overall luminance is adjusted I feel comfortable to fine-tune the white balance for this file by lowering the Temperature slider to 4800°K and the Tint slider to 0. With the White Balance set to a more neutral value I am now able to complete the basic editing by raising the Clarity slider to +30 and the Vibrance slider to +50.

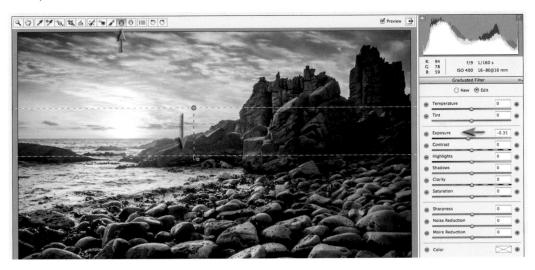

5 To add drama to the sky I have chosen to lower the Luminance values using the Targeted Adjustment tool set to Luminance (see Steps 10 to 12 of Project 1 in this chapter) and then added a Graduated filter set to a negative -0.35 Exposure. If you were to complete the same editing workflow using a previous process version you would notice serious edge artifacts at the edges where the restored detail in the highlights (sky) meets the restored detail in the shadows (rocks). This would be immediately apparent by zooming in to 100%. So long as the Chromatic Aberration has been removed the transition is now excellent.

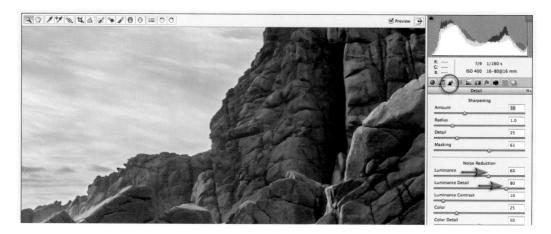

6 After zooming in to 100% to admire the excellent performance of the 2012 Process in rescuing an extremely high-contrast file, you will be immediately aware of the noise present in the recovered shadow detail. Even though the file was captured with the ISO set reasonably low (only 400 ISO) the noise has been rendered more visible due to the fact that these midtones where the noise is most visible were once very dark shadows. This noise can be managed or reduced by going to the Detail tab and raising the Luminance and Luminance Detail sliders to 60 and 80 respectively (see Noise Reduction in ACR in Project 1). Any additional Sharpening for this image should use the Masking slider to prevent artifacts and noise being overly sharpened (see Sharpening in ACR in Project 1 of this chapter).

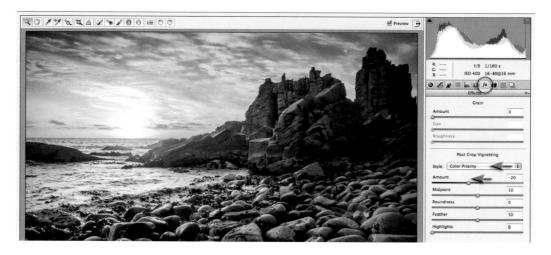

7 To complete this project I have added a Vignette from the Effects panel (see Steps 18 and 19 of Project 1 in this chapter) and switched the Highlight Priority to Color Priority to preserve the integrity of the color values being darkened and reduce the possibilities of clipping the shadow tones in the foreground. Once this has all been achieved it is important to check the black and white point of the image using the Blacks and Whites sliders in the Basic panel. It is advisable not to try to restore full detail in the setting sun as this should be allowed to clip (it is the light source for this image).

Retouching projects

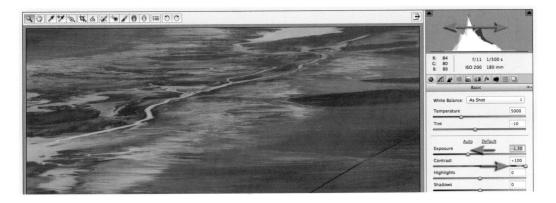

8 Capturing images with a telephoto lens where the air quality is dusty or humid will result in Raw files that are very low in contrast. Opening up the second of the two resource images for this Project will show a histogram that uses less than a half of the dynamic range of the sensor (even when the Contrast slider is set to +100). It is usually possible to correct files that are slightly low in contrast by just adding Contrast via the Contrast slider and setting the Whites and Blacks sliders.

Note > This level of tonal expansion is not possible with an 8-bit JPEG image that has been assigned just 256 levels per channel. Raw files edited at the native bit depth of the sensor in ACR (12, 14 or 16 bits per channel) have thousands of levels assigned to each channel even though many readouts still refer to levels between 0 and 255.

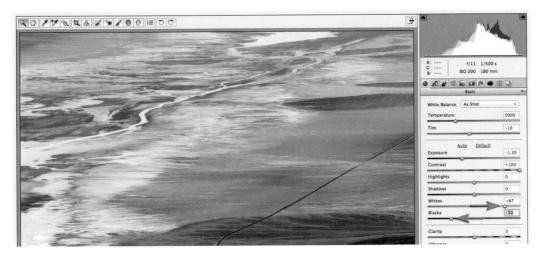

9 With the Contrast slider set to +100 and the Exposure slider set to -1.30, slide the Whites slider to the right until the clipping warning triangle above the histogram indicates clipping (it is no longer black) and then back off slightly. Adjust the Blacks slider to the left until the Shadow clipping triangle indicates clipping and then back off slightly until the clipping triangle is black. This effectively remaps the luminance values of the file across the complete tonal range – from black to white.

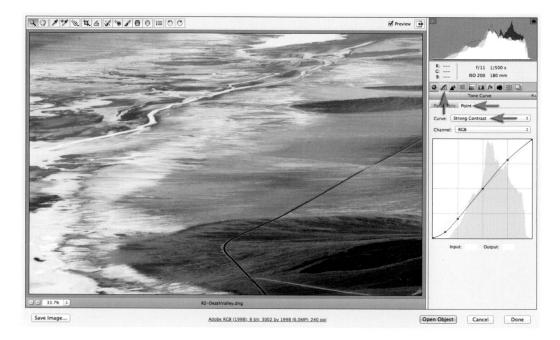

10 Proceed to the Tone Curve panel to increase contrast further. Select the Point tab in the Tone Curve panel and then select the Strong Contrast preset from the Curve pull-down menu. Adjust any of the points on the curve to fine-tune the contrast.

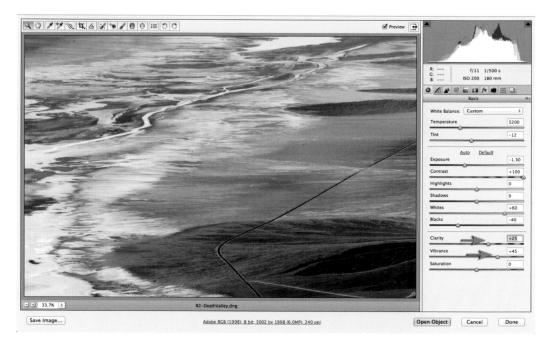

11 We can then return to the Basic panel and complete the processing of this file. I have adjusted the White Balance and then added Clarity and Vibrance.

Lens corrections - Project 3

Many photographers prematurely jump to the conclusion that Photoshop is solely a tool for distorting reality or fabricating an alternative reality (the expression 'it's been Photoshopped' still has negative connotations for some photographers). Although this may be the case in some instances, Photoshop can be used as a tool to correct the distortions introduced by the camera and lens. These corrections can return an image back to how we remember the original subject or location, rather than how the camera interpreted it.

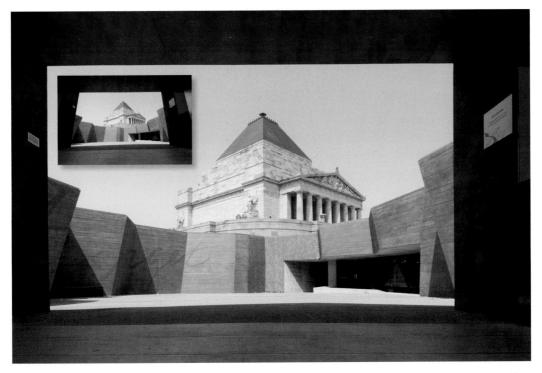

The Shrine of Remembrance, Melbourne – Nikkor 12–24 mm 1:4 G ED @ 12 mm.

Wide-angle lenses are an essential tool for the commercial photographer but they can introduce an unnatural and unnerving sense of perspective. In the natural landscape this exaggerated perspective may go unnoticed but when the photographer is in the urban environment and the photographer has to tilt the camera up in order to frame the shot, the verticals will lean inwards – sometimes to an alarming extent. Architectural photographers may go into this environment equipped with specialized equipment such as tilt-shift lenses and large-format cameras (some even take their own ladders). This specialized equipment allows the photographer to frame the view they need without tilting the camera from the horizontal axis. There is, however, a postproduction answer that allows the photographer to create a more natural sense of perspective. This project focuses its attention on correcting rather than distorting images and will look at perspective correction and chromatic aberration (the misalignment of colors commonly found in the corners of an image). Since Version CS5, Photoshop is capable of using specific lens profiles to correct lens distortions but sometimes we still need to perfect images using the custom adjustments inside the Lens Corrections panel of Adobe Camera Raw (ACR).

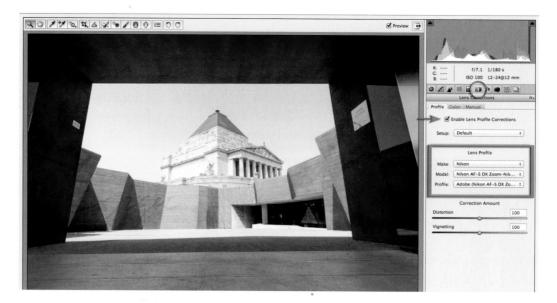

Part 1 – Standard Approach

1 Go to the Lens Corrections panel and click on the Enable the Lens Profile Corrections checkbox. If your lens is not supported (ACR does not have a lens profile to refer to) you could use the Adobe Lens Profile Downloader (go to www.labs.adobe.com) to search for available profiles online.

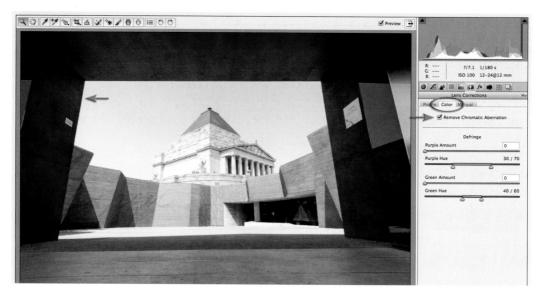

2 Click on the Color tab and click on the Remove Chromatic Aberration checkbox. Chromatic Aberration is present with most wide angle lenses and the color fringing this creates is clearly visible on the high contrast edges in the corners of the image. You may need to Zoom in to 100% to see the color fringing that occurs when this is left uncorrected.

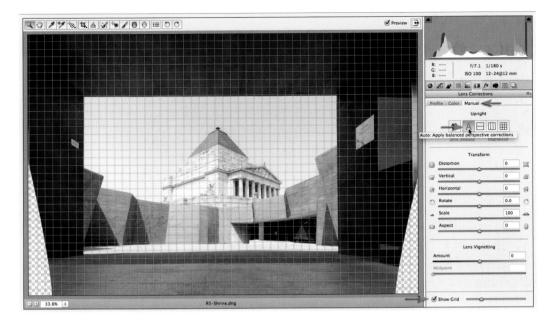

3 Go to the Manual tab in the Lens Corrections panel. The Upright feature is new to Adobe Camera Raw 8. You can choose to correct levels, vertical perspective or the level, vertical and horizontal perspective option. Alternatively you can click on the Auto button that will make an automated correction. In some instances it may choose not to fully correct converging verticals as this option does not replicate the adjustment that levels and corrects vertical and horizontal perspective. Check the Show Grid option to see how the Auto button has corrected your image.

Note > There is a limit to the amount of correction that can be undertaken in some images before shapes at the edges appear excessively distorted. In some images where the verticals of a building are fully corrected, so that they run parallel to the edges of the frame, there is an optical illusion where the building appears to be growing wider. In these instances Upright may adjust the converging verticals so that they are not absolutely vertical.

4 After making perspective corrections it will usually be necessary to scale or crop the image. Click on the Crop Tool and check the Constrain to Image option. The Constrain to Image option will ensure that we do not select any of the transparent areas that may have appeared around the image. You may need to choose Clear Crop to remove any previous cropping specifications otherwise you may crop to a size or shape that is not appropriate for this image.

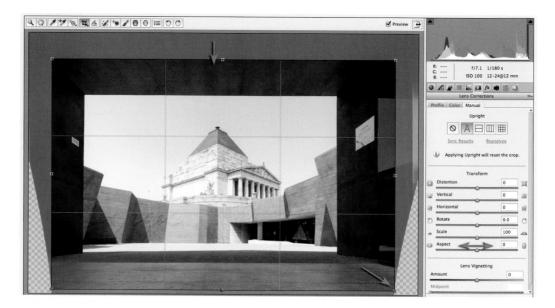

5 Click and drag with the Crop tool to frame your corrected image. Even if you drag the crop marquee into the transparent areas Photoshop will snap back to the image area if you have selected the Constrain to Image option. After performing the initial crop you can click and drag on any of the bounding box handles to perfect the crop. Another new feature to appear in ACR 8 is the option to change the shape of the image using the Aspect slider in the Transform controls. This is often required when objects look taller or shorter that their natural appearance after the perspective has been corrected.

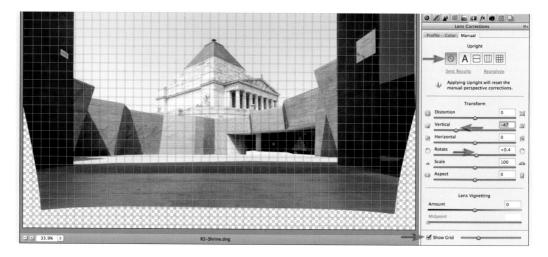

6 In some instances the Upright feature will not be able to correct the perspective of some images to a desired outcome. In these instances it is possible to fine-tune the automated correction using the sliders in the Transform section of the Manual tab or cancel the Upright feature and make a fully manual correction of the level, vertical and horizontal perspective.

Retouching projects

Part 2 – Alternative Approach

7 An alternative approach to correcting the distortions introduced by wide-angle lenses is the Adaptive Wide Angle filter. It is best suited to correcting the distortions introduced by extreme wide-angle and fish-eye lenses and panoramic images. This project image, however, is an excellent example of how any image can be corrected using the manual controls found in the Adaptive Wide Angle dialog. The adjustments can be applied to a Smart Object as a Smart Filter. Open the project image as an Object and then click on the Adaptive Wide Angle option in the Filter menu. When the image opens in the dialog it will appear more distorted prior to making the corrections required. Click on the Constraint tool in the top left-hand corner of the Adaptive Wide Angle dialog and then click and drag a horizontal line across the top of the entrance to the courtyard. Use the magnified view in the Detail panel to ensure accurate alignment.

8 Click and drag a second line at the base of the entrance and then hold down the Shift key and extend the original lines you have drawn to the edges of the image.

9 Hold down the Shift key and click and drag vertical lines either side of the entrance to render these edges straight. Extend the lines to the edges of the image. You may need to drag the scale slider to the left to see the edges of the image. Notice how all the edges inside of the four lines you have drawn have now been corrected but distortion is visible outside of the lines. You can add more lines to correct any distortion closer to the edges of the file.

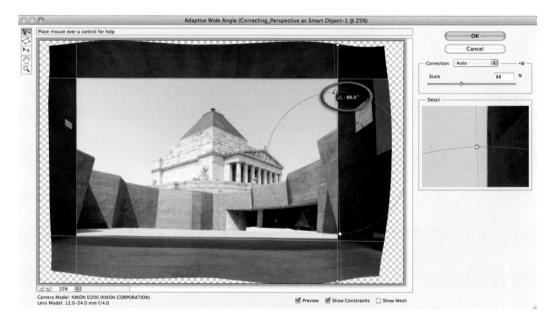

10 Clicking on any of the lines you have drawn will reveal control points. Move your mouse cursor over one of these control points (where the large circle intersects with the line) and this will allow you to rotate the line to create the perfect perspective for your image. In this example I could lean in the two vertical lines by 2° so that the converging verticals are not fully corrected.

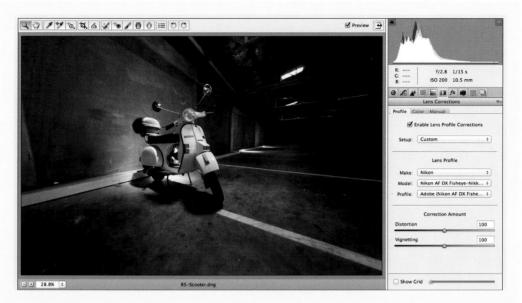

ADAPTIVE WIDE ANGLE COMPARISON TEST

In the illustration above, an image captured with a 10.5 mm wide-angle lens is corrected using the lens profile in the Lens Corrections panel of Adobe Camera Raw. Although mostly corrected you will notice significant distortion is apparent on the extreme left-hand side of the image (the vertical concrete pillar is far from vertical).

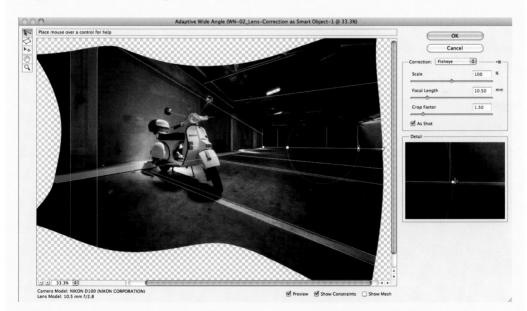

When this image is corrected using the Adaptive Wide Angle filter you can fully correct the perspective in this image. The resulting crop would place the concrete pillar on the left side of the image into the frame.

Raw expression - Project 4

It is possible to unleash an incredible amount of drama from a Raw image without leaving Adobe Camera Raw. These simple and fast techniques will help you to express what you saw, rather than what your camera recorded (the difference can often be considerable).

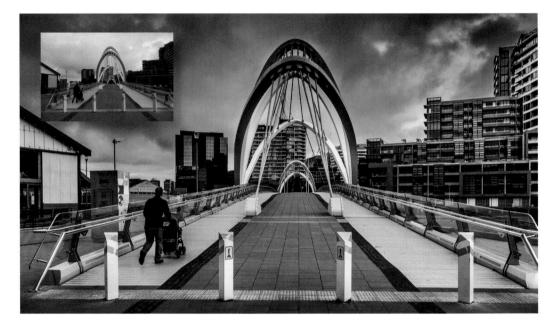

Seafarers Bridge, Melbourne.

Transl	form 0	
Vertical	<u> </u>	
Horizontal	0	1.0
O Rotate	0.0	0
⇒ Scale	100	-
(i) Aspect	0	9

1 Go to the Lens Corrections panel, check the Enable Lens Profile Corrections in the Profile tab, the Chromatic Aberration checkbox in the Color tab and the Auto button in the Upright tab. The image should now appear geometrically straight and without the color fringing on the high contrast edges that often appear when using wide angle lenses. Drag the Vertical slider in the transform section to -4 to fine-tune the perspective corrections.

Retouching projects

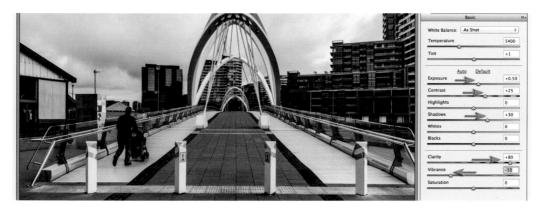

2 Raise the Exposure slider to + 0.5, the Contrast slider to +25, the Shadows slider to +30, the Clarity slider to +80 and lower the Vibrance slider to a value of -50. These tonal adjustments will give the image the dramatic lift it needs and rectify the dull, low contrast appearance of the original Raw file that I did not experience at the time of capture. With the exception of the sky these tonal adjustments restore the image to how I perceived the original scene.

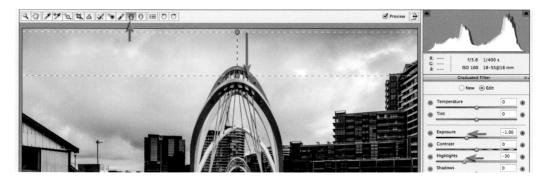

We will draw the viewers eye away from the edges and into the image by darkening the top and bottom edges (unless I am looking through a window or the viewfinder of my camera my vision has no edges or borders). Click on the Graduated Filter tool in the Tools bar and then drag the Exposure slider to a value of -1.00 and the Highlights to -30. Click on the top edge of the image and drag a gradient to a position just below the top of the bridge (hold down the shift key as you drag to ensure the gradient is straight). Add a second gradient from the bottom edge of the image to a position half way up the white bollards.

Note > After you have added a second gradient you will notice there is a white circle or 'pin' for each gradient that you add. If you click on a pin with your mouse cursor you make this gradient active. You can then fine-tune the settings for this gradient by adjusting the sliders. You can also adjust the position or length of each gradient by dragging either the pin or the top and bottom lines that are associated with each gradient. The area between the centre line and the end line denotes the feather radius for the gradient, i.e. the area where the gradient settings fade from 100% opacity to 0% opacity. Be careful when dragging short gradients with large adjustments, as these will be immediately obvious to the viewer of an image.

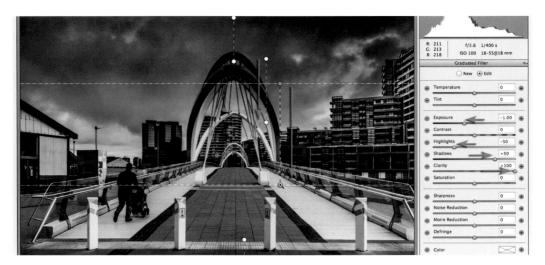

4 Although the camera often records accurate tones within a scene, the resulting image is usually not faithful to how an individual may perceive the scene at the time of capture. I have chosen to add two additional gradients to increase the drama and impact of the bridge by darkening the sky further so that the image communicates the strength and beauty of the structure. Click on 'New' at the top of the Graduated Filter panel and drag the Highlights slider to a new value of -50 and the Shadows slider to a value of +50 (The Exposure slider remains at -1.00 stop). To create more definition and depth in the clouds drag the Clarity slider to +100. In the Image preview, click and drag one gradient from just above the top of the bridge to just above the horizon line and a second from below the top of the bridge to a position just below the horizon line (use the illustration as a guide if you want to replicate the results shown here).

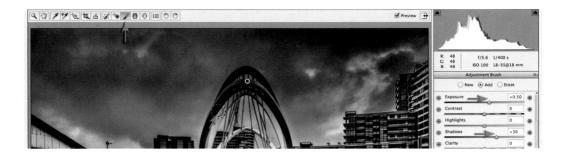

5 The graduated filters darken the sky but also darken the top of the Bridge. To correct this we can click on the Adjustment Brush icon in the Tools bar. Raise the Exposure slider to +0.50 and the Shadows to +30. Deselect the Auto Mask option as when working with an exposure adjustment it can lead to unsightly artefacts appearing along the edges. Set the Size of the brush to 5 with a Feather radius of 65 and then proceed to paint the top part of the bridge structure. Zoom in if you need to work more closely. Hold down the Alt/Option key if you need to remove some of the adjustment.

Note > To get a clearer idea of where you are painting check the Show Mask option.

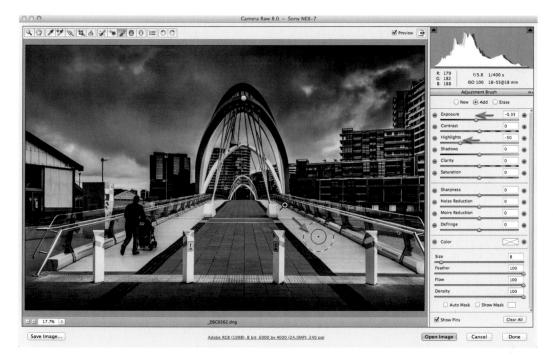

6 Adjusting localized exposure in an image is an extremely powerful tool for a photographer to guide the viewer's eye around an image. The viewer's eye is subconsciously drawn to lighter and sharper areas within the image and this is how the photographers have historically been able to tell their story and express their emotions rather than leave the uncritical eye of the camera to render its impassionate version of reality. The master photographer Ansel Adams often likened the negative to the music score and his work with controlling light in the darkroom to a performance that would enable him to express his ideas and aesthetic sensibilities. The work in ACR is no different. There is no right or wrong when making localized tonal adjustments. I would recommend taking a few minutes to look at the placement of tone and to establish if any of the highlights or colors could be distracting the viewer from viewing the main focal point in the image (which you have chosen to highlight). With this in mind, I have chosen to darken some highlights below the main arch of the structure.

Note > It is often possible to work with one generous exposure setting for Burning (making darker) and another for Dodging (making lighter) and then adjust either the Density or Flow settings in the Adjustment Brush panel as you work. Flow allows you to build up the adjustment using multiple strokes over the same area while Density allows you to brush at a single set value, i.e. painting again in the same area does not add to the initial value. Flow is perhaps the more common of the two sliders to use for this type of work, but lowering Density can be very useful when you need to brush over an area that has an excessive adjustment. Lowering the Flow and painting over the same area, in this instance, would just carry on increasing the adjustment.

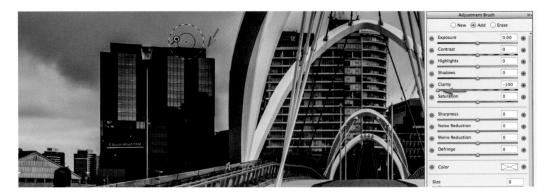

7 If you look at some of the high contrast edges (where the buildings meet the sky) you will see dark or light haloes that are a result of the very generous Clarity settings used in this project. These haloes can be partially or fully removed by brushing with a negative Clarity setting. Click on 'New' at the top of the Adjustment Brush panel and lower the Clarity slider to a value of -100. Using a small brush set to 100% Flow and Density, paint over the edge to suppress or remove any haloes you may find.

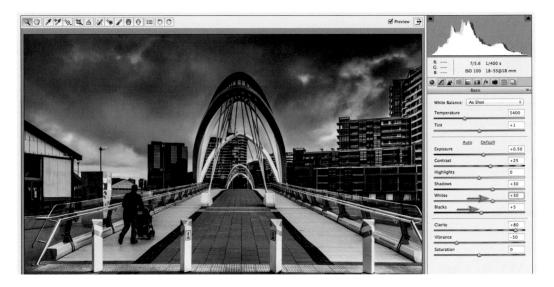

Some photographers believe that they can only render a dramatic image if they clip the darkest tones to absolute black. I personally follow the Ansel Adams approach to tonality (The Zone System) and prefer to leave the darkest shadows with a small amount of visual weight (leaving a hint of tone or texture in these areas). Click on the Zoom Tool to return to the Basic panel. I usually conclude an editing project by establishing black and white points for the image. Adjust the Blacks and Whites sliders until the clipping warnings light up above the histogram and then move them back slightly so that no clipping is occurring. Exceptions are made for shadows that do not, or should not, have a surface, e.g. the entrance to a cave, black studio backdrop etc., or specular highlights, e.g. the light source itself or its reflection off a shiny surface.

Retouching projects

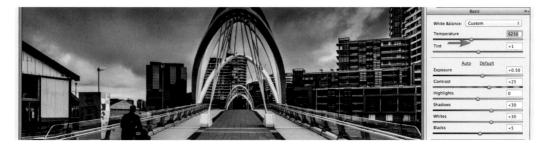

9 Photographers can often obsess unnecessarily over the correct white balance for an image (white balance references and screen calibrators etc.). Although setting the correct white balance may be critical for some projects, if we always adhere to correcting neutral tones so they appear neutral in the final image, we may overlook the potential of using color for emotional expression. Making an image cooler or warmer can be an invaluable tool to communicating how we 'feel' about the content in the image we are portraying. By raising or lowering the 'Temperature' slider in the Basic Panel of the Develop module we can render neutral tones warm or cool. They will not be read as wrong by the viewer (observe how often Hollywood uses color temperature to carry an emotion that is required by the narrative of the script).

10 The final step is to sharpen the image using the sliders in the Detail panel. With images that have been heavily post-produced, or were captured with a raised ISO setting, you may have to be careful not to make any image artefacts such as noise more prominent than they need to be. With this in mind I have raised the Masking slider to +70 to mask the smoother areas of the image from the sharpening process. You can gauge the correct setting for this slider by holding down the Alt key (PC) or Option key (Mac) as you drag the slider (the areas rendered black in the image preview will not be subjected to the sharpening process). The combination of a low 100 ISO setting and the large image sensor of the Sony NEX-7, together with the graphic nature of the subject matter enable a generous Amount setting of 80 to be used in this project.

And the moral of the story? Great photography is often a marriage of technical expertise (mastery of the craft) with emotional expression (storytelling). I strongly feel that photographers need to remind themselves that their work in Photoshop does not always have to be considered as unethical manipulation, cheating, the fixing of errors and distorting reality. It can also be a program that allows photographic artists to express themselves and tell the truth of what they saw, and how they felt about what they saw, rather than what the camera captured. Go forth and change your pixels without fear – express yourself.

Editing for drama – Project 5

When photographers are drawn, first and foremost, to working with the light, color can become an obtrusive element to the editing process. This has led many photographers to chuck out the color and work entirely in Black and White. It is possible, however, to use selected colors in moderation and still create very dramatic images where the light takes center stage.

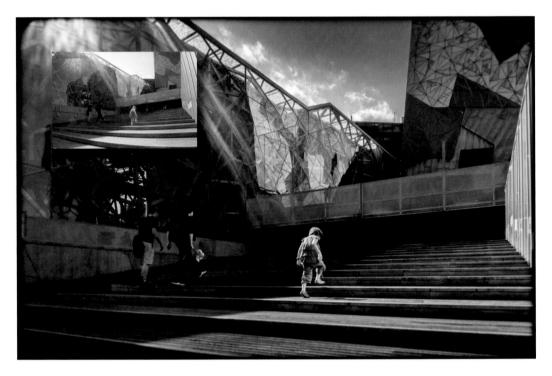

The Girl in the Red Dress, Federation Square, Melbourne

1 This image was captured at a wide 16 mm focal length, so will require some lens corrections to bring the image back into shape (correct the barrel distortion and vignetting). Go to the Lens Corrections panel and in the Profile tab click on the 'Enable Profile Corrections' checkbox. From the Color tab in the Lens Corrections panel, click on the Remove Chromatic Aberration checkbox and then in the Manual Tab click on the Auto button in the Upright section (see Step 1 in the previous tutorial).

Note > When working with your own wide angle lens, it is worth clicking on the flyout menu beneath the histogram and choosing Save New Camera Raw Defaults (so long as these are the only adjustments that have been applied to the image). This action will ensure all images now opened in ACR from the same camera and lens combination will automatically be corrected. If you now choose Camera Raw defaults all adjustments will be reset but the Lens corrections will remain. You can, however, click on the Reset Camera Raw Defaults so that Photoshop will no longer automatically apply the Lens Profile and Chromatic Aberration corrections.

Retouching projects

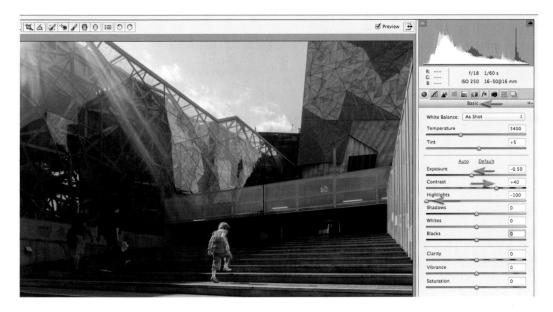

2 There is small amount of highlight clipping in this image and the detail in the sky is nearly blown out (the subject brightness range is very high). To balance the exposure so that it is closer to how we remember the scene, rather than how the camera recorded it, we need to go to the Basic panel. Move the Exposure slider to a value of -0.50, the Highlights to -100 and raise the Contrast slider to +40 to restore the drama to the tonality.

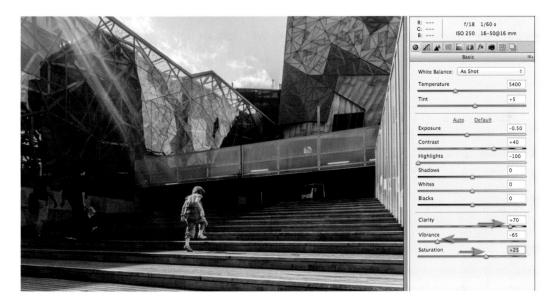

3 In this step we will balance the detail with the color. Raise the Clarity slider to +70 and lower the Vibrance slider to -65 to desaturate all colors except the most vibrant ones, i.e. the reds. These reds become the key colors in the image. Raising the Saturation slider to +25 will increase the saturation of these key colors in the image.

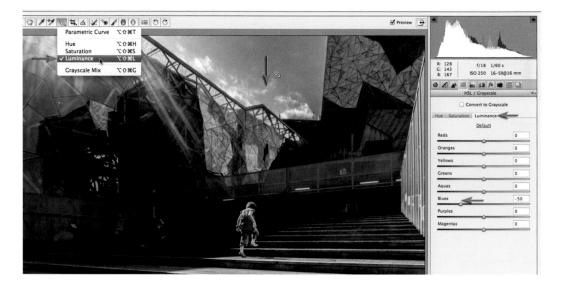

4 We can further enhance the balance of tone and color in the image in the HSL panel (Hue, Saturation and Luminance). Select Saturation from the Targeted Adjustment Tool options in the Tools panel. Click and drag down on the blue sky in the image preview to darken the Blue and Aqua colors. Note the Blue and Aqua sliders move to the left as you drag down. Stop when the sliders are around -50. This click-and-drag adjustment feature is often referred to as the TAT. This action with the TAT will render the sky darker but keep the clouds bright.

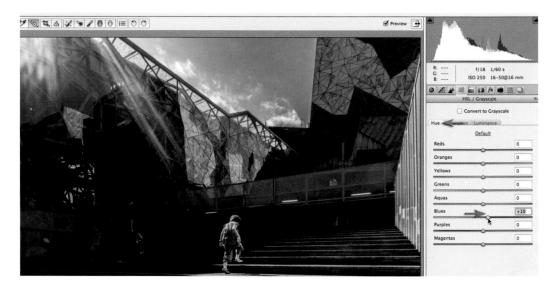

5 In the Hue tab of the HSL panel, adjust the Blue slider to a value of +10. This will change the hue of the sky from a cyan blue to a more royal blue. If you observe any colors in the image that you don't want to be so vibrant go to the Saturation tab in the HSL panel and then click and drag down to desaturate, e.g. you may decide that the few Green and Aqua tones could stand to be less vibrant if you feel they are too distracting.

Retouching projects

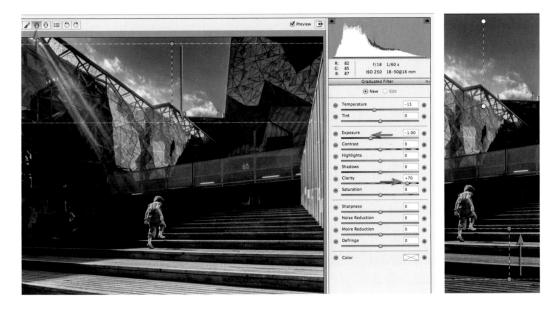

6 To draw our attention towards the girl, we can darken both the upper and lower edges of the image. Click on the Graduated Filter icon in the Tools panel. Set the Temp slider to -15, set the Exposure at -1.00 and raise the Clarity slider to a value of +70. Click and drag from a position high in the sky to where the sky ends (hold down the Shift key as you drag to so the filter is straight). Click on New, reset all sliders and then set the Exposure slider to -1.50. Drag a second graduated filter from the bottom edge of the image to the bottom of the girl's feet.

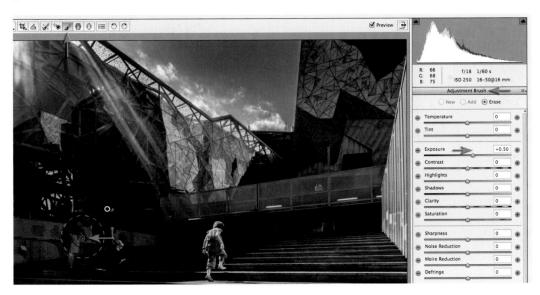

7 The Girl's parents are getting a little lost in the shadows so we can alter the tone in this area. Click on the Adjustment Brush icon and set the Exposure slider to a value of +0.50. Choose a large brush size with the Feather and Flow set to 100%. Deselect the Auto Mask option and then paint broadly over the area of the Parents (no accuracy required).

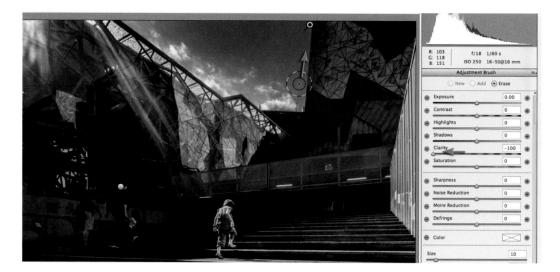

8 The +70 Clarity setting added to the Graduated Filter has created a halo in the sky (adjacent to the edge of the building). Clicking on New, resetting the sliders, and then setting the Clarity to a setting of -100 can start the process to correct this. Check the Auto Mask option and paint over the halo in the blue sky (keep the centre circle of the brush from going over the edge of the building). The Auto Mask option will restrict adjustment to the sky only. Click on the Adjustment Brush icon to close the panel.

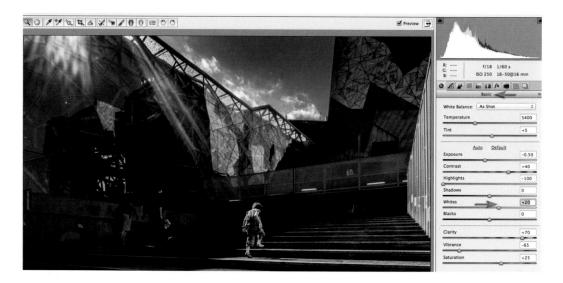

9 If you look at the histogram you will notice, that with all of the tonal adjustments, we no longer have a white point for the image (there is a gap between the end of the histogram and the right side. Go to the Basic panel and raise the slider to a value of approximately +30. If the Highlight Clipping Warning above the histogram turns white reduce the value until the warning is no longer visible. The Blacks may need fine-tuning also.

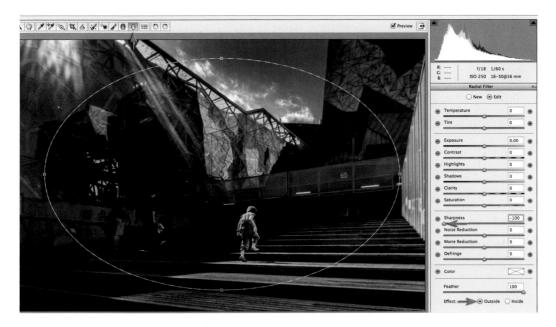

10 This image was captured with sharp focus throughout the image. It is possible, however, to defocus the edges of the image using the Radial Filter to draw the viewers eye towards the center of the image. Select the Radial Filter from the Tools bar and then set the sharpness slider to -100 and select the Outside radio button at the base of the Radial Filter panel. Drag a radial gradient from the center of the image towards the lower right-hand side of the image.

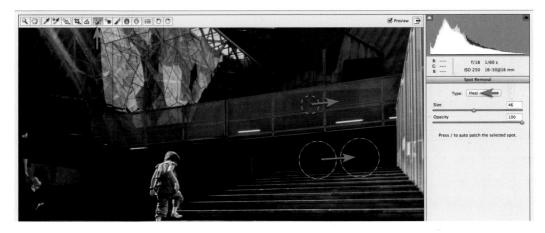

11 There are a couple of distractions in the background surrounding the little girl that can be removed to create a more graphic interpretation of the scene. Select the Spot Removal tool in the Tools panel and set the Type to Heal. On the walkway above the top of the stairs a man appears looking down. Adjust the brush size so that it is a little larger than the man and then click once. Drag the source circle (colored green) to an appropriate position to heal the area. With a slightly larger brush repeat the process to remove the small vehicle.

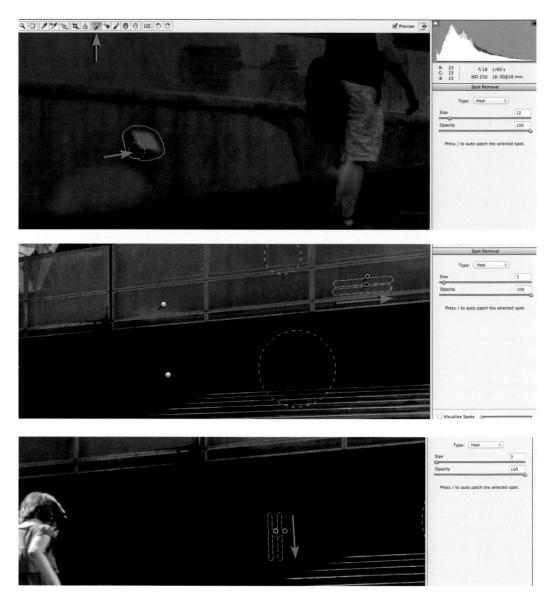

12 The Spot Removal Tool in ACR was greatly improved with the release Photoshop CC. It is now possible to paint in irregular shapes or remove distracting lines. To heal a perfectly straight line, click once at the start of a distracting line, then position the cursor at the end of the line, hold down the shift key and click a second time. Photoshop will complete the healing action by connecting the first and last clicks.

Note > Replacing the vehicle at the top of the stairs will use detail to the right of the vehicle that is currently being blurred by the Radial Filter. This detail will then be placed in an area of sharp focus. When this blurred detail is moved out of the region of the Radial Filter it once again appears sharp. The non-linear nature of editing in ACR means this is entirely possible, and offers a significant advantage over this type of editing in the main working space.

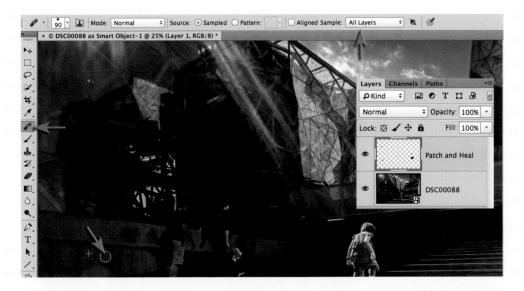

PATCH AND HEAL USING LAYERS

If you need to patch or heal an image in the main editing space of Photoshop you will first need to create an empty new layer. When working with the Patch Tool set the Patch option to Content Aware and check the Sample All Layers checkbox. When working with the Healing Brush or Clone Stamp Tools set the Sample option in the Options bar to All Layers.

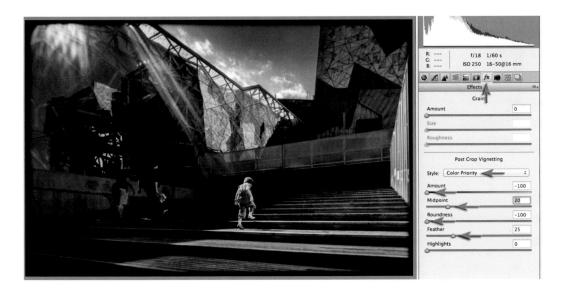

13 To add a border to the image go to the Effects panel and set the style to Color Priority. Set the Amount and Roundness sliders to -100. Adjust the Midpoint and Feather sliders to set the width and softness and your border is complete. Go to the Snapshots panel and click on the New Snapshot icon to save these edits. This will give you the option to edit alternative versions, safe in the knowledge that this version has been saved.

CLONE OR HEAL

When cleaning an image of superfluous detail the question often arises as to which is the best tool for the job. When working to remove small blemishes in broad areas of texture the Spot Healing Brush tool is hard to beat for speed and ease of use. As the areas requiring removal get larger, switching to the Healing Brush and selecting a source point, avoids the errors that occur when using the Spot Healing Brush for this task. The limitations of the Healing Brush (and Spot Healing Brush) become apparent when working up against tones or colors that are markedly different to the area being cleaned. The Healing process draws luminance and color values from the surrounding area and when these colors are very different they contaminate the area to be healed. Problems can often be avoided in these instances by either using a harder brush or making a selection that excludes the neighboring tones that are different. When working up against a sharp edge even these actions may not be enough to avoid contamination – this is the time to switch to the Clone Stamp tool. A selection will help to align edges so that the repair is seamless.

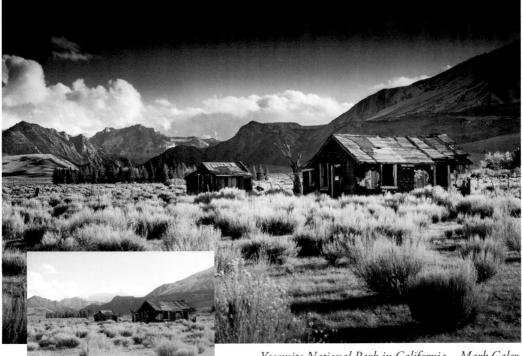

Yosemite National Park in California – Mark Galer.

Black and White in ACR - Project 6

When color film arrived over half a century ago the pundits who presumed that black and white film would die a quick death were surprisingly mistaken. Color is all very nice but sometimes the rich tonal qualities that we can see in the work of the photographic artists are something to be savored. Can you imagine an Ansel Adams masterpiece in color? If you can – read no further. Creating fabulous black and white photographs from your color images is a little more complicated than hitting the 'Convert to Grayscale' or 'Desaturate' buttons in your image editing software (or worse still, your camera). Ask any professional photographer who has been raised on the film medium and you will discover that crafting tonally rich images requires both a carefully chosen color filter during the capture stage and some dodging and burning in the darkroom. Color filters for black and white? Now there is an interesting concept! Well, as strange as it may seem, screwing on a color filter for capturing images on black and white film has traditionally been an essential ingredient in the recipe for success.

We can also control how each color is translated into a darker or lighter tone in Adobe Camera Raw (ACR). The result is an image with considerable tonal differences compared to an image that is desaturated. Adobe Camera Raw offers all of the editing features and flexibility we need to create a high quality black and white image. The drama of the location, however, has not been recorded by the camera – only the Raw data. The tones in their Raw state do not accurately reflect the emotion felt by the photographer. The challenge with the project image is to balance each and every visual element (sky, mountains, buildings and foreground) to tell a different and more dramatic visual story for the viewer.

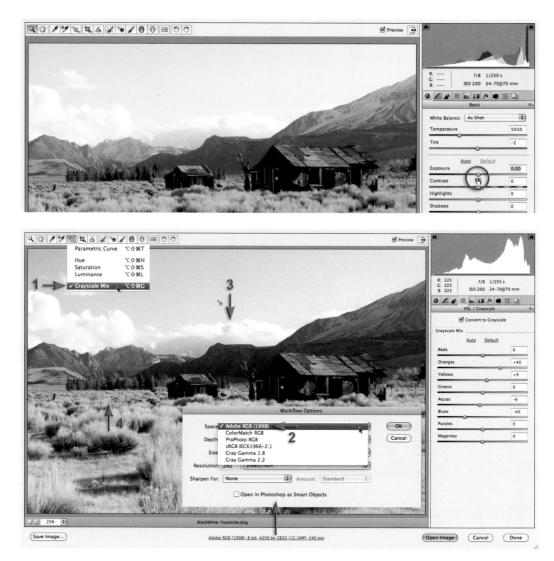

1 The exposure for the project image was set high in-camera to increase the quality of the shadows ('Exposing Right'). Lowering the Exposure in ACR, however, does not improve the overall appearance of the image. Before making any tonal adjustments I have selected the Grayscale Mix option from the Targeted Adjustment tool drop-down menu and dragged the gray tones of the sky darker and the foreground tones lighter. Notice how the associated color sliders move in the HSL/Grayscale panel. These adjustments emulate the use of an Orange filter by photographers using film. Pulling the Blues darker than -50 can introduce image artifacts. We can, however, render the sky darker by using Graduated Filters.

Note > When switching to Grayscale you may notice that your image switches to a Gray Gamma working space. Although this may be approprioate for commercial printing (books and magazines) it is not considered a useful space for inkjet printers. As I am preparing this image for my desktop inkjet printer I have chosen the same RGB workspace as my working space in Photoshop (Adobe RGB).

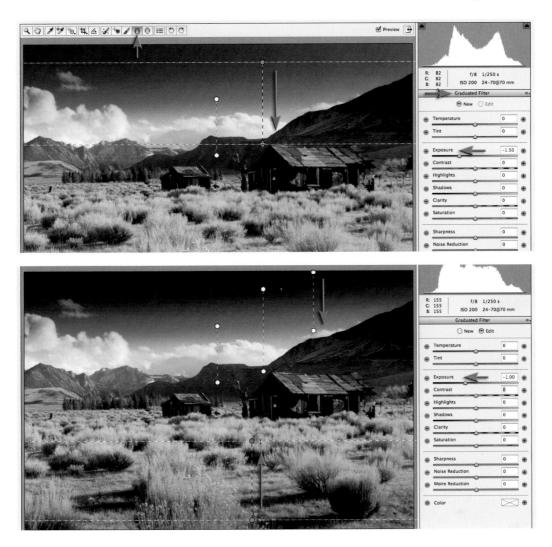

2 Landscape photographers have traditionally used 'neutral density' filters to reduce the exposure to the sky at the time of capture and prevent skies recording unnaturally light. We can emulate this technique with a greater degree of control in post production using the Graduated Filters in ACR. I have selected the Graduated Filter from the Tools panel and then clicked on the negative icon next to the Exposure slider three times to set a value of -1.50 stops. I have then dragged one filter from just above the clouds to a position just above the horizon line and a second filter that starts higher in the sky but ends just above the distant mountains. I have then clicked on the New radio button and adjusted the Exposure to -1.00. I have added a third gradient in the sky (higher than the other two) and another from the base of the image to a position just below the buildings. Click on the any of the circles associated with any of the graduated filters and adjust the exposure settings to fine-tune the appearance. You can also add or subtract contrast associated with any of these filters by adjusting the Contrast slider. If this action is taken you must drag on the control point on the slider rather than click on the negative or plus icons as this will zero the exposure adjustment.

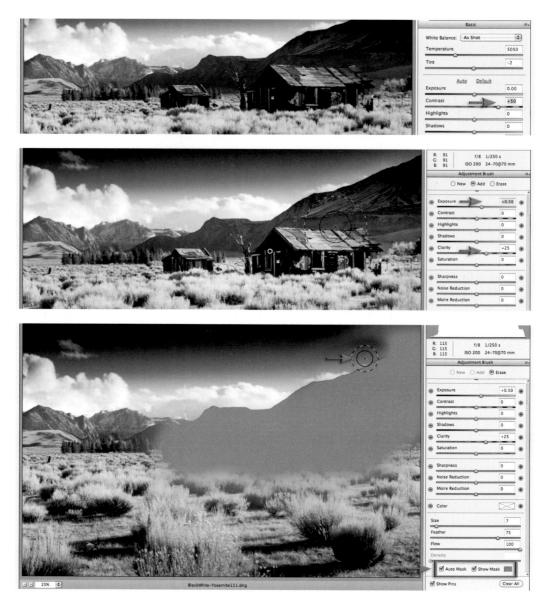

3 Adjust the Contrast slider in the Basic panel if you want to increase the contrast of the entire image (a global rather than a localized adjustment). I have raised the Contrast slider to +50 as I did not add any contrast to the Graduated Filters. A localized adjustment is required to highlight the buildings and render the mountains on the right a little lighter. I have clicked on the Adjustment Brush tool and raised the Exposure and Clarity sliders (+0.5 and +25). I have then painted over this area to throw more light on the focal point of our image. It is quicker to paint with the Auto Mask option switched off but if a light halo is created in the sky above the mountains this can be removed quite easily. To remove this halo I have switched the Auto Mask and Show Mask options on and then, holding down the Alt key (PC) or Option key (Mac), I have carefully painted above the top of the mountain to remove the adjustment that is not required.

Retouching projects

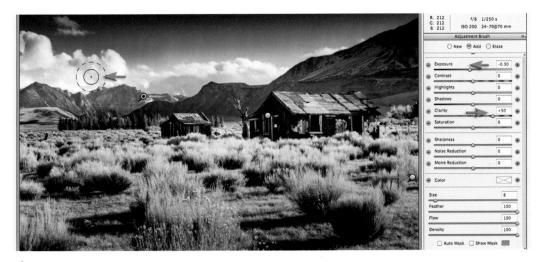

4 I have added two more localized adjustments to complete the 'dodging and burning' process (lightening and darkening). The first is to add a negative Exposure and positive Clarity adjustment to the mountains on the left side of the image and another to darken the foreground bushes (-0.50 Exposure). Burning and dodging is not an exact science – you simply make decisions to assign detail to the shadows and/or bring it to the viewer's attention by giving it more light. This is the way black and white photographers tell the story about the scene they have photographed. It is sometimes valuable to create a snapshot in the Snapshots panel, clear all of the pins and start again to create alternative renderings of the scene. You can then cycle between different snapshots to discover how you respond to each rendering before making your final decision.

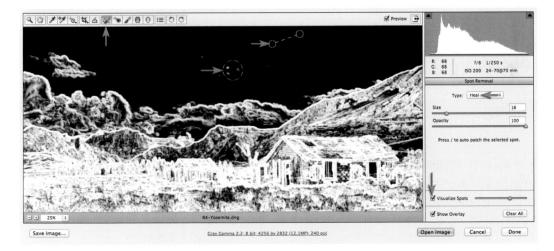

5 In darkening the sky I have noticed a few tiny distracting clouds in the centre of the sky. These can quickly be removed using the Spot Removal tool. Set the Radius to 16 and click once on the distracting clouds to zap them into virtual oblivion! If you are having difficulty seeing the offending cloud, click on the Visualize Spots checkbox and adjust the slider to the right. You will also see an additional sensor spot towards the top of the frame.

Photoshop CC: Essential Skills

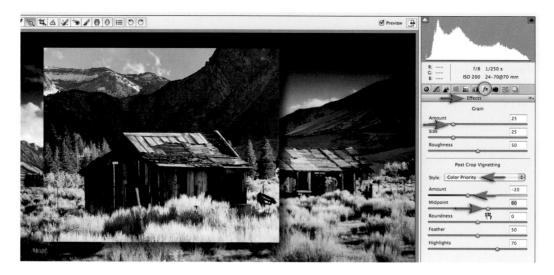

6 To complete the edit I have added a Vignette from the Effects panel. I have used the Color Priority style to protect the darker tones from clipping, raised the Midpoint slider to +60 so that the vignette does not encroach on the building on the right of the image and raised the Highlights slider to +70 so that the clouds on the left of the image are not darkened excessively. I have also decided to add a small amount of Grain to the image to emulate film. This is also applied from the Effects panel by raising the Amount slider to +25. I have decided to keep the Size and Roughness sliders at their default setting so that the grain appears to be from large-format, rather than small-format film.

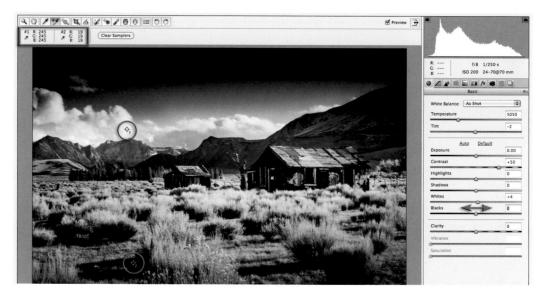

/ Before saving the file, or opening the file in the main editing space of Photoshop I have assigned black and white points (+4 and 0) while monitoring the darkest and lightest values in the image (see Steps 20 to 23 of Project 1 in this chapter). This will ensure the print has the full tonal range that Ansel Adams would have been proud of!

Working spaces – Project 7

Modern DLSR and mirrorless interchangeable lens cameras have large sensors that are capable of recording information over a broad subject brightness range, from deep shadows to bright highlights. In some instances, however, it is not possible to process the file to extract the best highlight and the best shadow information from the file with one set of adjustments. There is a solution that ensures you can have the best of both worlds (highlights and shadows).

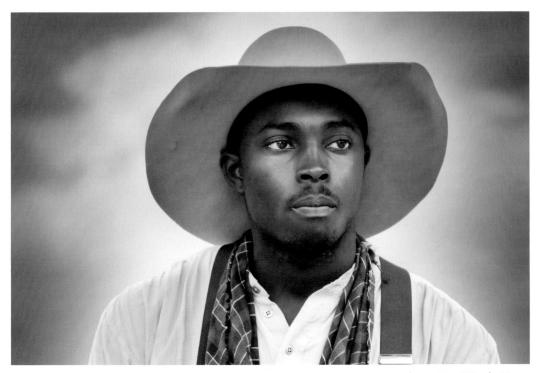

Cowboy – Fort Worth, Texas.

The unedited Raw file leaves a lot to be desired in terms of exposure and framing. This project corrects the exposure for both the highlights and the shadows and combines the edited information using layers in the main editing space of Photoshop.

The project will show how we can edit a single file in both working spaces (ACR and the main editing space). The completely non-destructive workflow outlined will give you the flexibility to return to ACR to tweak some of those initial settings – providing additional flexibility for those photographers (or art directors) who can never make up their mind.

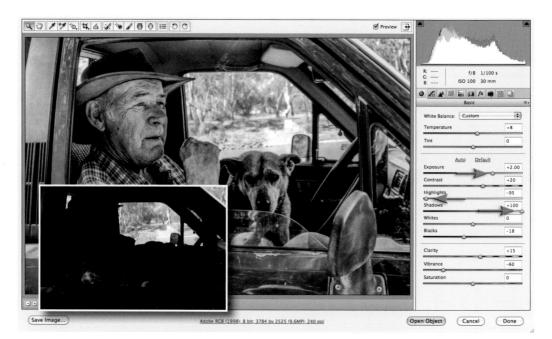

Quick adjustments using Adobe Camera Raw

Adobe Camera Raw can offer fast and convenient control over tones that need adjustment, without the need for extended editing procedures in the main editing space. Using the Exposure, Highlights and Shadows sliders in Adobe Camera Raw (ACR) the user can lighten the deep shadows and recover the bright highlight tones in this image. Localized contrast can be increased using the Contrast and Clarity sliders and finally the excessive saturation that results from these adjustments is put back in check by lowering the Vibrance slider. Not all images with extreme contrast, however, can be rescued entirely in ACR.

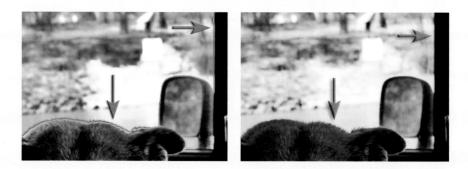

RECOVERING HIGHLIGHTS

The improvements in the 2012 Process version in recovering highlight and shadow detail can be seen in the examples above (Process Version 2010 on the left and Process Version 2012 on the right). These improvements drastically increase the number of images that can be successfully edited using only the controls found in Adobe Camera Raw and reduce the need to create composite images using different exposures.

Retouching projects

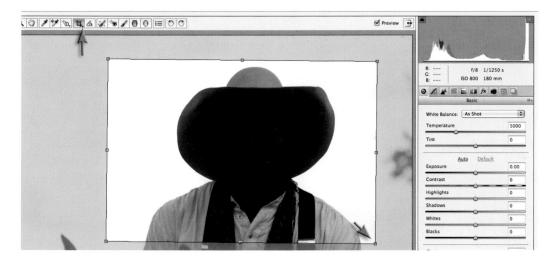

1 Open the project image into Adobe Camera Raw (ACR). Select the Crop tool, set the Crop Tool to 'Normal' and then proceed to create a tighter composition by dragging the tool over the head and shoulders of the cowboy. If required, move your cursor to a position just outside one of the corner handles to rotate the crop marquee. Select the Hand tool or Zoom tool to apply this crop. It is important to remember that pixels are not discarded in the cropping process in ACR – just hidden from view.

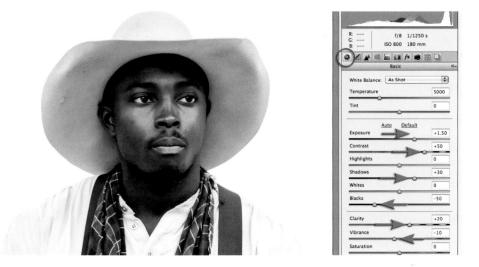

2 No fill-flash reached the subject in any usable strength and the exposure compensation used in-camera was insufficient to lighten the dark shadows. Overall luminance can be increased by raising the Exposure slider to +1.50 and the Shadows slider to +30 and the Blacks slider to -50. Contrast can also be increased by raising the Contrast slider to +50 and the Clarity slider to +20. As contrast increases so does saturation, so this needs to be controlled by reducing the Vibrance slider to -10. The Blacks slider also needs to be lowered to -50 so that the image retains a black point.

Photoshop CC: Essential Skills

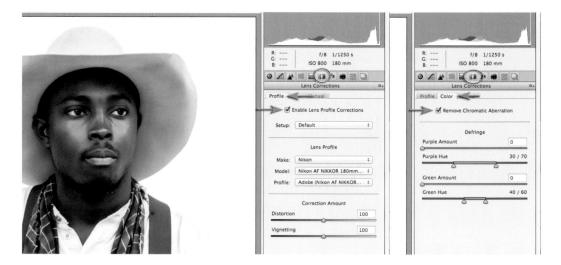

3 To ensure maximum quality at the edges between the highlights and the shadows it is important to select the Enable Lens Profile Corrections and Remove Chromatic Aberration options in the Lens Corrections panel. This will remove any lens distortions that were introduced into the image and any possible color aberrations.

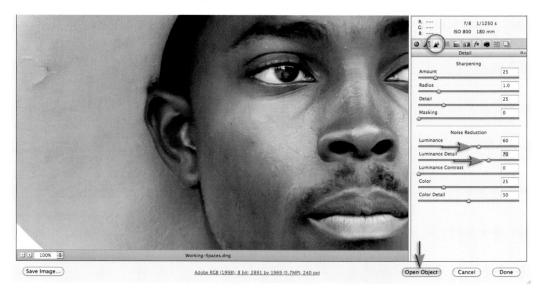

4 With such an underexposed file the noise levels are starting to become a little aggressive. In ACR we have some very sophisticated Noise Reduction controls that will be able to create much smoother tones. These adjustments are best carried out with the file zoomed to 100%. Go to the Detail tab and raise the Luminance slider in the Noise Reduction section to 60. Raising the Luminance Detail slider to 70 will help restore some of the fine detail in this image. Select Open Image as a Smart Object (set this option in the Workflow Options, accessed from the base of the ACR dialog, or hold down the Shift key to access the Open Object button).

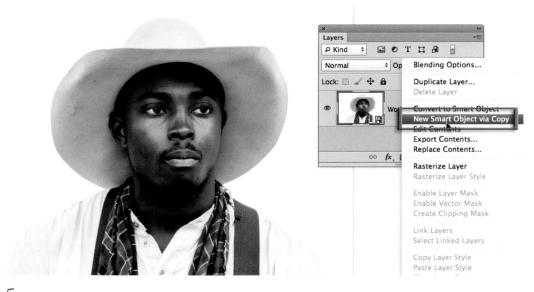

5 When the file opens in the main editing space of Photoshop go to the Layers panel and right-click on the Smart Object to access the context menu (be sure to right-click on the layer rather than the image thumbnail). Choose the New Smart Object via Copy command. This is not the same as dragging the Smart Object to the Create a new layer icon in the Layers panel or using the duplicate layer shortcut. The New Smart Object via Copy command ensures that we can open the embedded Raw file back into Adobe Camera Raw (ACR) and adjust the settings without affecting the settings embedded in the original smart object.

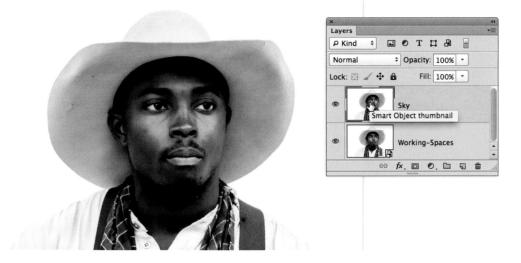

6 Double-click on the name of the layer and type 'Sky'. We can now use this Sky layer to optimize the Raw file for the overexposed sky so that it does not appear clipped or 'blown out' in the final version. Double-click on the Smart Object thumbnail to open the embedded Raw file in ACR. When the Raw file opens for the second time it will appear with all of the settings you used to optimize the shadow tones of this image.

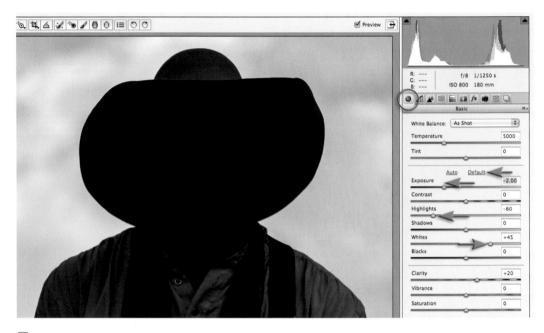

Click on the Default button to reset all of the sliders except for Clarity and Vibrance (reset the Vibrance slider to zero manually) and then lower the exposure slider to -2.00 stops and the Highlight slider to -60 and raise the Whites slider to +45 to darken the sky but retain its white point. The ability to recover such overexposed highlights demonstrates the advantage of working with the extended dynamic range of the Raw format.

Go to the Effects panel and add a Post Crop Vignette to darken the edges of the sky even further. Select OK in the bottom right-hand corner of the ACR dialog to update the settings of the Sky layer.

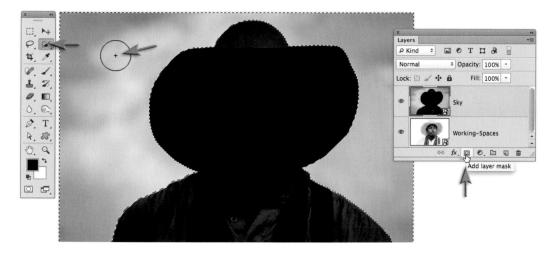

9 We now need to create a mask so that we can balance the two exposures. Select the Quick Selection tool from the Tools panel and then click and drag over the left side of the sky to make a selection. Make an additional selection to add the right side of the sky. If the selection invades the subject just hold down the Alt key (PC) or Option key (Mac) and drag over these areas to exclude them from the initial selection. Click on the Add Layer Mask icon from the base of the Layers panel.

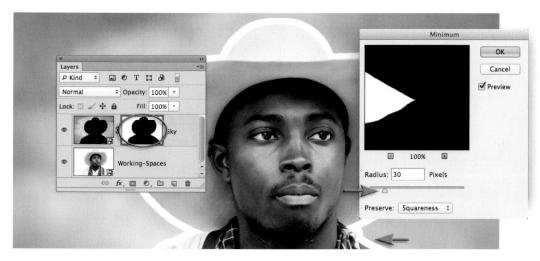

10 The layer mask on the Sky layer will now mask the dark cowboy to reveal the lighter cowboy on the background layer. The extreme exposure variation between the two layers will, however, create an unsightly hard edge around the subject. By softening the layer mask we will create a more gradual transition between the two exposures. Check that the layer mask is the active component of the layer (you should see additional lines around the layer mask thumbnail). Click on the layer mask thumbnail to make it the active component if it is not already selected. Go to Filter > Other > Minimum and raise the Radius slider to 30 pixels and select OK. This will expand the mask. Don't worry about the white band, we will take care of that in the next step.

Photoshop CC: Essential Skills

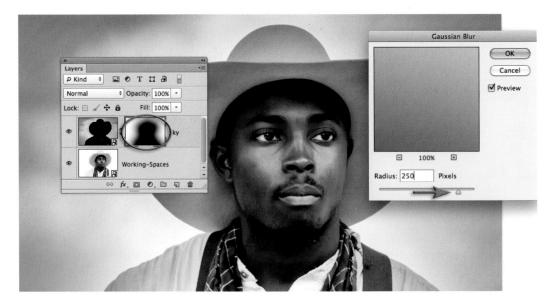

Go to Filter > Blur > Gaussian Blur and apply a 250-pixel Gaussian Blur to the layer mask to soften the edge of the mask. Select OK to apply the adjustment.

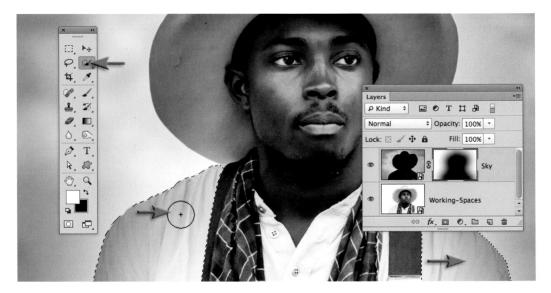

The blur will create a gradual transition between the two layers that is effective over much of the image. Some of the dark tones from the top layer are, however, bleeding over the shoulders of the cowboy so we need to clean this area. Select the Quick Selection tool from the Tools panel and check the Auto-Enhance and the Sample All Layers checkboxes in the Options bar. Select the cowboy's white shirt (both the left and right sides) and then from the Edit menu choose Fill. In the Fill dialog choose Black in the Contents section and then select OK.

Retouching projects

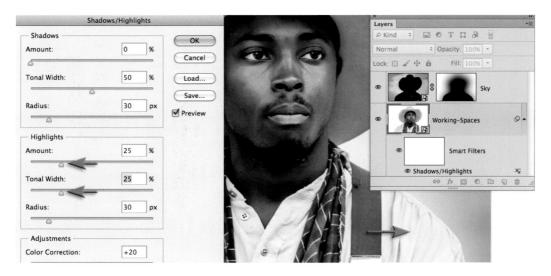

13 The white shirt is now too light against the dark sky so we will now do some localized tonal control of just the highlights on this layer. Select the bottom layer in the Layers panel and then go to Image > Adjustments > Shadows/Highlights. Check the Show More Options checkbox. Set the Amount slider in the Shadows section to 0% and raise the Amount slider in the Highlights section to 25%. Reduce the Tonal Width slider in the Highlights section to 25% to limit the darkening effect to just the white shirt. Select OK to apply the adjustment.

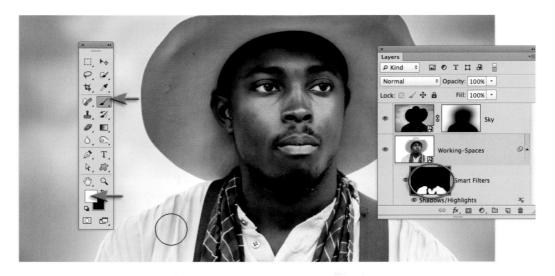

14 To ensure the adjustment only affects the white shirt, and no other highlights in the image, select the Smart Filters mask and then click the Invert button in the Masks panel or use the keyboard shortcut Ctrl + I (PC) or Command + I (Mac). The mask should now appear black instead of white and the effects of the smart filter will be removed. Select the Brush tool from the Tools panel and set White as the foreground color. Use a soft-edged brush (Brush Hardness set to 0%) to paint in this adjustment over the shirt.

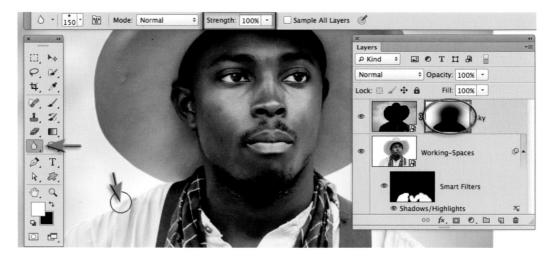

15 If some of the edges appear a little too hard select the Blur tool from the Tools panel, set the strength to 100% in the Options bar and paint over any edges in the Sky mask that require softening.

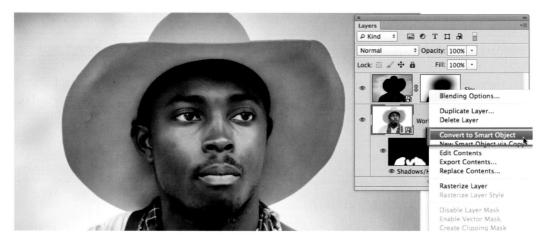

16 The problem with the mask that accompanies a Smart Filter is that there is only one. If you wanted to apply a second Smart Filter it would have to share the same mask that has already been optimized for the Shadows/Highlights adjustment. It is possible, however, to obtain a clean mask that is dedicated to a new Smart Filter by embedding the Smart Object into another Smart Object. To try this out, right-click on the layer and choose Convert to Smart Object. This may sound a little strange as the layer is already a Smart Object but this action will give us the option to apply a new Smart Filter with a new layer mask. If we needed to edit the original Smart Filter at any time we would need to double-click the Smart Object thumbnail to reveal the original Smart Object (render to pixels), which in turn applies the Shadows/Highlights adjustment settings to the pixels and breaks the link with the Raw file and original data. This would, however, be a destructive edit as it would 'bake in' the changes to the pixels.

Retouching projects

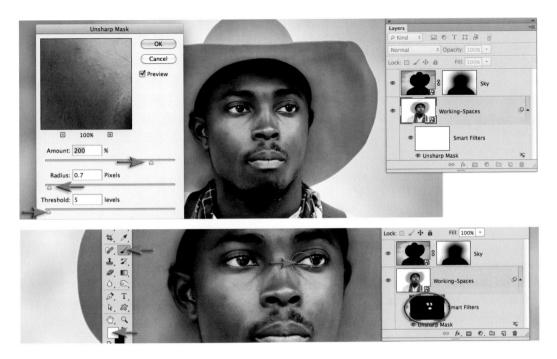

17 After embedding the original Smart Object in a new Smart Object we are now able to apply a new filter to the entire image, i.e. it is not limited by the original layer mask. Sharpen the image by going to Filter > Sharpen > Unsharp Mask. I have chosen settings of 200, 0.7 and 5. By inverting the mask (Ctrl + I or Command + I) you can then paint with white to reveal the sharpening on the eyes, mouth and nose.

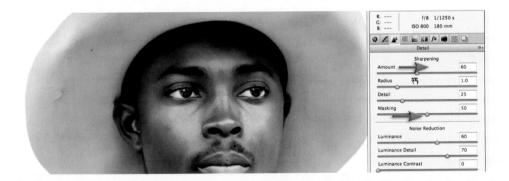

SHARPENING IN ACR

An alternative way of sharpening the image would be to double-click the Smart Object thumbnail to open the Raw file back into ACR and use the Sharpening controls in the Detail panel. Although this workflow may seem unduly complex to basic Photoshop users it does offer the advanced user a completely non-destructive workflow that allows full control over every element of editing. No changes are baked into any of the pixels and therefore every element can either be deleted or modified.

Photoshop CC: Essential Skills

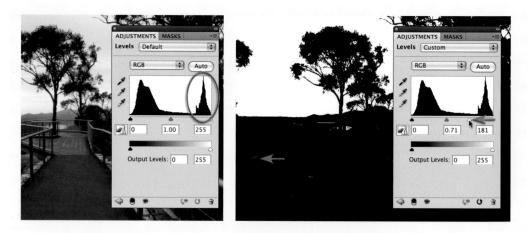

LOCALIZED LEVELS WITH LAYER MASKS

Sometimes when the levels are optimized for the entire image a portion of the image still appears flat. A close examination of the image used in this illustration will reveal that the range of levels on the right of the histogram belong only to the sky. None of the highlights in the foreground have been rendered higher than level 200, even after the white Input Levels slider has been adjusted. Greater contrast can be achieved if the user ignores the sky when setting the white Input Levels slider and then masks the sky later by painting into the layer mask to restore the tonality to this area of the image (preventing the highlights in the sky from becoming clipped by the adjustment). In this example a black/white gradient has been applied to the upper portion of the layer mask. The mode of the Levels adjustment has been set to Luminosity to prevent the color saturation rising.

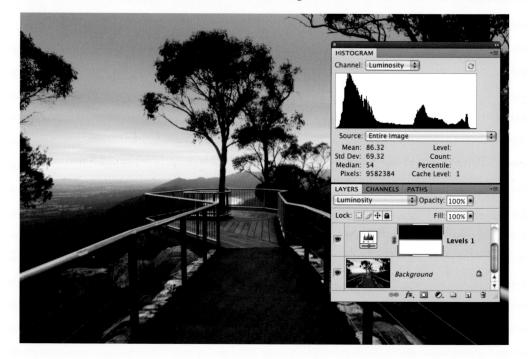

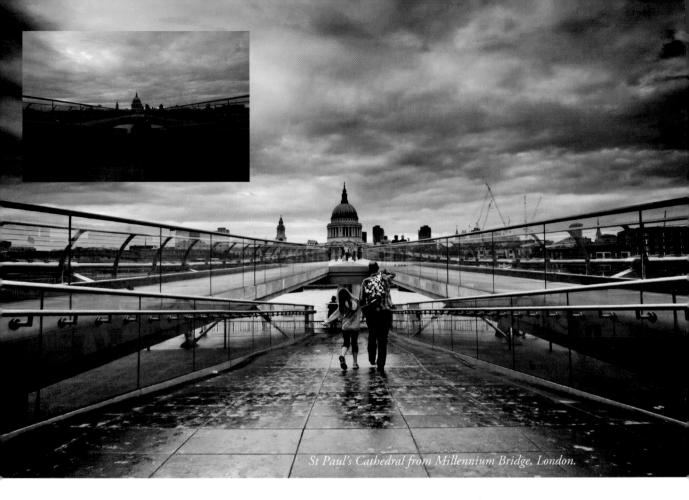

Double processing – Project 8

As we have seen in the previous projects gradients and vignettes can breathe drama into seemingly lifeless images. With a combination of gradients, vignettes and double processing techniques from the previous projects we can extract the maximum impact from this Raw image. The project will also utilize a colored gradient applied to two new layers that, in turn, have been set to two different blend modes. The idea is to extract every ounce of life from this underexposed image captured on a gray and wet day in London (nothing new here).

Note > With the Working Spaces (cowboy) project in this chapter we could not complete the final edit without moving into the main editing space of Photoshop to merge the different exposures for the highlights and shadows. The final treatment for this image, however, can be accomplished using just the Tools in Adobe Camera Raw (ACR). The Raw file contains a snapshot that uses just the ACR editing features. The final appearance, however, is easier for most users to achieve by adopting the compositing workflow that was introduced with the previous 'Double processing' project. It also gives us an opportunity to explore how we can create gradients and vignettes in the main editing space.

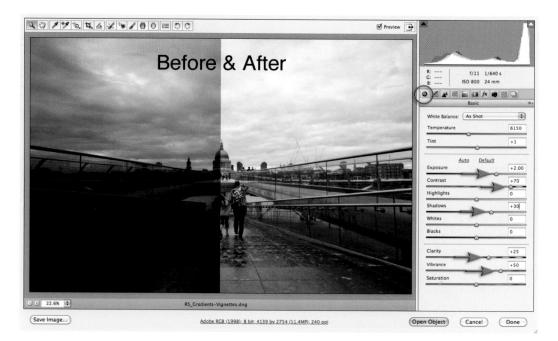

1 Open the Raw file in Adobe Camera Raw (ACR) and then optimize the image for the foreground content. Raise the Exposure Slider to +2.00, the Contrast slider to +70, the Shadows slider to +30, the Clarity slider to +25 and the Vibrance slider to +50.

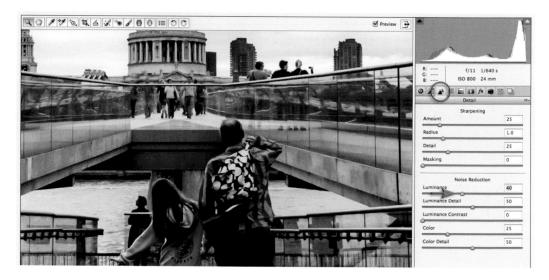

2 Select the Detail tab and raise the Luminance slider in the Noise Reduction section to +40. This will ensure the image is free from excessive noise. Then hit the Open Object button (hold down the Shift key if the button reads Open Image) to open this file into the main editing space of Photoshop (got to love ACR for fast editing!).

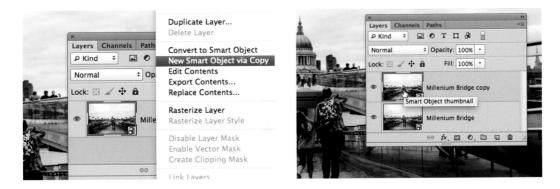

3 When we choose the Open Object button in ACR the Raw file is embedded in the layer. In the Layers panel right-click on the Millennium Bridge Smart Object (not the layer thumbnail) and choose the command 'New Smart Object via Copy'. This allows us to open the Raw file embedded in the copy layer into ACR and change its settings without affecting the appearance of the original Smart Object. Now double-click on the Millennium Bridge copy layer thumbnail to open the Raw image into ACR.

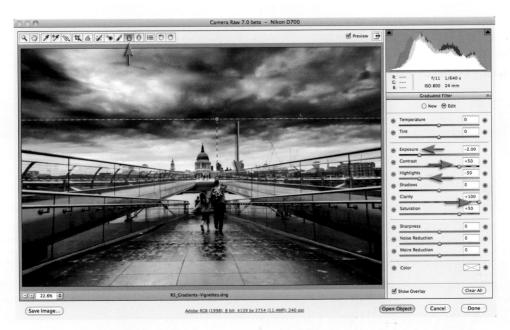

GRADUATED FILTERS

The Graduated Filter can be used to lower the exposure and increase the contrast and saturation of the sky. Although there is a lot of control over how the sky appears we have a few more options in the main editing space to fine-tune the appearance of the final image.

Note > There is no need to add the Graduated Filter in Adobe Camera Raw in this project as this will be completed in the main editing space.

Photoshop CC: Essential Skills

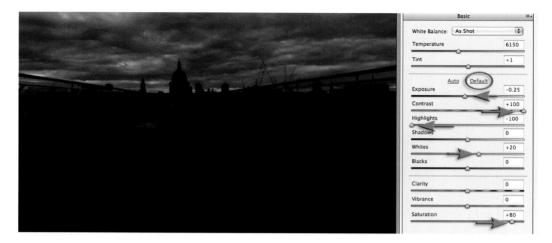

4 When the Raw file opens for the second time you will see all of the settings you used to optimize the image for the foreground. To clear all of these settings click the blue word 'Default'. This will clear all of the settings except for the Clarity, Vibrance and Saturation sliders. Optimize the image for the sky by reducing the Exposure slider to -0.25 stops, raising the Contrast slider to +100, the Whites to +20 and the Saturation slider to +80. Click OK at the base of the ACR dialog to return to Photoshop.

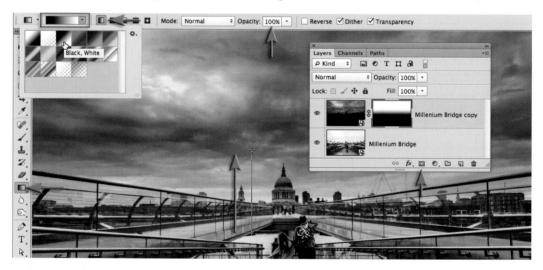

5 Add a layer mask to the Millennium Bridge copy Smart Object by clicking the Add Layer Mask icon at the base of the Layers panel. Select the Gradient tool from the Tools panel. In the Options bar click on the little triangle next to the Gradient ramp to open the gradient picker. Select the third gradient (the Black, White gradient). Select the Linear Gradient option, set the Opacity to 100% and make sure the Reverse option is not checked. Click on the layer mask to make this the active component of the copy layer. Then click and drag a gradient from the people in the center of the image to a position just above the top of the spire on St Paul's Cathedral. If you hold down the Shift key as you drag a gradient it will constrain it so that it is perfectly vertical.

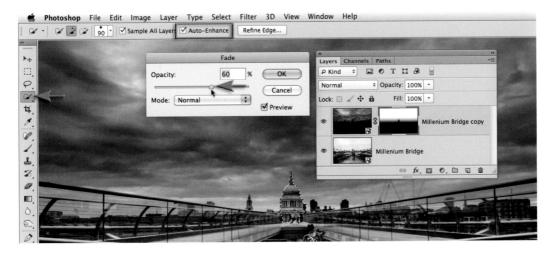

6 To restore some of the brightness to the cathedral we can select the Quick Selection tool from the Tools panel and check the Auto Enhance option in the Options bar. Adjust the brush size so that it is smaller than the cathedral and then click and drag to make a selection. Choose Fill from the Edit menu and select Black as the contents. If the Cathedral is too bright you can fade the last action by going to the Edit menu and choosing Fade Fill. Deselect the cathedral by going to Select > Deselect.

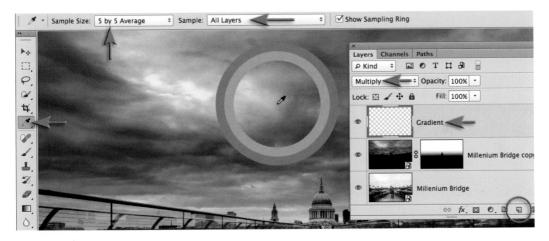

7 We will now increase the intensity of the warm colors in the sky. Click on the Create a New Layer icon at the base of the Layers panel to add an empty new layer. Set the mode of the new layer to Multiply (one of the darkening blend modes) and name the layer Gradient. Select the Eyedropper tool from the Tools panel and in the Options bar select '5 by 5 Average' from the Sample Size drop-down menu, and the All Layers option. This will ensure we can sample a color within the image when either the Gradient tool or Brush tool is selected. This setting is 'sticky' so you will not have to do this action again unless you choose Reset tool or Reset All Tools. Select the Gradient tool and then hold down the Alt key (PC) or Option key (Mac) and click on the orange color in the sky to load this as the foreground color (otherwise known as 'sampling'). Make sure the Transparency option in the Options bar is checked.

Photoshop CC: Essential Skills

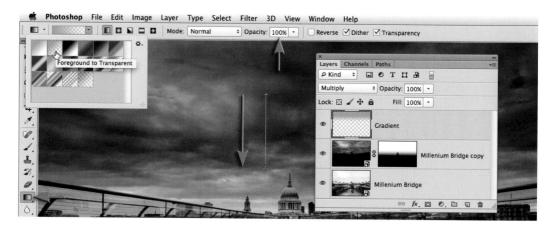

8 Select the second gradient (the Foreground to Transparent gradient) from the gradient presets. While holding down the Shift key, drag a gradient from the top of the image window to a position just below the top of the spire on St Paul's Cathedral. This will enhance the warm colors that are already an important aspect in this dramatic sky. Experiment with dragging longer or shorter gradients and adjusting the opacity of the layer if the effect is too strong.

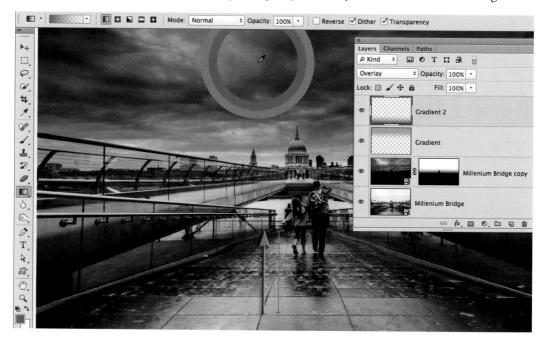

9 Add another new layer (click on the Create a New Layer icon in the Layers panel), name the layer 'Gradient 2' and set the mode to Overlay (one of the contrast blend modes). Hold down the Alt key (PC) or Option key (Mac) and take a sample of the darker orange color that has appeared in the sky after applying the first gradient. While holding down the Shift key drag a gradient from the base of the image window to a position just higher than the feet of the people in the center of the image. This will mirror the warm colors that are in the sky in the wet path.

Retouching projects

10 It is possible to fine-tune the effects of a gradient using the Hue/Saturation adjustment feature. Use the keyboard shortcut Ctrl + U (PC) or Command + U (Mac) to open the Hue/Saturation dialog. Adjust the Saturation and/or Lightness sliders to adjust the impact of this gradient on the composite view.

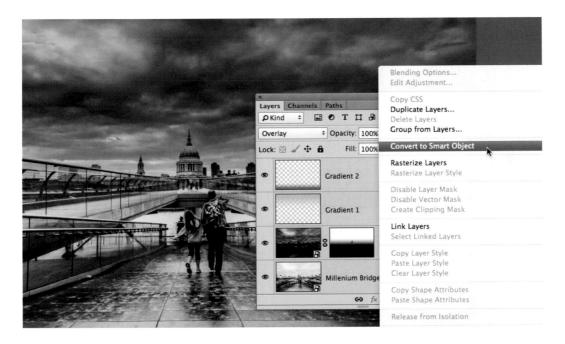

11 We can make the image more dramatic by adding a contrast vignette. Click on the top layer to select it and then hold down the Shift key and click on the base layer in the Layers panel. When all the layers are selected, right click and choose Convert to Smart Object from the context menu. Go the Filter menu and choose Camera Raw Filter.

Photoshop CC: Essential Skills

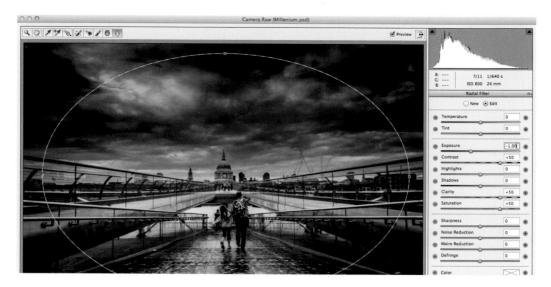

12 Click on the Radial Filter in the Tools bar in ACR and then proceed to drag the Exposure slider to a value of -1.00 and the Contrast, Clarity and Saturation sliders to a value of +50. Select the 'Outside' radio button and then click and drag from the middle of the image to the left or right edge. Select OK in the bottom right-hand corner of the ACR dialog to apply the vignette.

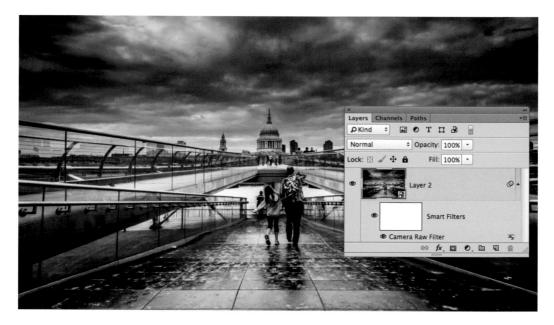

13 As the Vignette is applied as a Smart Filter these settings can be modified by doubleclicking on 'Camera Raw Filter' below the image thumbnail in the Layers panel. If you need to modify an individual layer in the file double-click the image thumbnail in the Layers panel to open the multilayered file inside the Smart Object.

Two seconds in suburbia - Mark Galer

HOW MUCH IS ENOUGH?

Sometimes when we make tone and color adjustments, just a small adjustment with one of the sliders can have a significant impact on the image we are editing. At other times we need to learn to be bold with our adjustments, in order to discover what may be lying dormant in the image. In this example the two-second exposure through a train window has led to an image that is low in contrast and in color saturation. With generous and bold adjustments the color and tone can be made to come alive. My advice is to move sliders boldly and back off if the adjustments become detrimental to the outcome.

Exposure	+0.20
Contrast	+100
Highlights	-100
Shadows	+100
Whites	+30
Blacks	-80
Clarity	+100
Vibrance	0
Saturation	+10

op photoshop photos

Mark Galer

essentíal skílls

• Use Refine Edge, channel masking and a blend mode for a perfect hair transplant.

bhoto:

- Replace the background behind a model while preserving the fine hair detail and the original shadow.
- Use the Pen tool to create a smooth-edged mask.
- Create a simple composite image using layer blend modes.
- Merge or blend a graphic with a three-dimensional form using a displacement map.
- Replace a sky and manipulate the tonality and color for a seamless result.
- Create a composite image while preserving the subject's original shadow.

Refine Edge – Project 1

One of the most challenging montage or masking jobs in the profession of post-production editing used to be the hair lift. When the model had long flowing hair and the subject needed to change location many post-production artists would call in sick. If you got it wrong, just like a bad wig, it showed. Extract filters, Magic Erasers and Tragic Wands didn't get us close but now the new and improved Refine Edge feature has eased the burden of this task. The first step to ensure guaranteed success should be completed before you even press the shutter on the camera. Your number one priority is to shoot your model against a featureless background that is sufficiently different in color or tone to the model's hair. This important aspect of the initial image capture ensures that the resulting hair transplant is seamless and undetectable. The post-production is now the easy bit – simply apply the correct sequence of editing steps for a perfect result. This is not brain surgery and there are no lengthy selection procedures required (the Decontaminate option in the Refine Edge dialog holds the secret to this success).

Composite projects

1 Open the background image and place (drag) the image of the model onto it. The model for this project has been placed on a layer above the new background. Make a rough selection of your subject using the Quick Selection tool from the Tools panel. Select the Auto-Enhance checkbox in the Options bar. Try to select only those areas that are solid subject, i.e. try not to select any regions of hair where the background appears in amongst the strands. The pockets of background in amongst the fine detail can present problems for the Refine Edge feature if they are included in the initial selection. Remove these pockets using the subtract option of the Quick Selection tool.

2 You may like to improve the quality of any hard edges using the Pen tool. I have temporarily hidden the Selection Edges from view (View > Show > Selection Edges) and then proceed to make a Path around the shoulder and arm. I can then right-click to choose the Make selection command and in the Make Selection dialog choose a 1 pixel Feather Radius and the Add to Selection option. The combined selection will come into view when you select OK.

A Martin	Refine Edge
	View Mode View: Show Radius () View: Show Original (P)
12 10	Edge Detection
	Radius: 0.0 px
	Adjust Edge
	Smooth: 0
	Feather: 0.0 px
	Contrast: 0 %
	Shift Edge: 0%
	Output
	Decontaminate Colors
	Amount: %
	Output To: Selection

3 From the Option bar or Select menu (if a selection tool is not active) choose Refine Edge. From the View drop-down menu choose the On Layers option. All sliders should be set to zero and then select the Refine Radius tool on the left side of the dialog. Paint in the image preview to add all of the hair that was not part of the initial selection, taking great care not to move the brush into any solid areas of your subject, but at the same time not leaving a gap. Reduce the size of the brush when painting alongside any edges (such as the arm and ear).

	Adjust Edge
10 3/	Feather: 0.5 px
	Contrast: 0 %
	Output
	Amount: 85 % Output To: New Layer with Layer Mask
	Remember Settings
	Cancel OK

4 Any hard edges can be refined in the Adjust Edge section of the dialog. I do not need to use the Smooth or Contrast sliders as the arm was added to the selection from a Path, but I have added a small amount of feather (0.5). The hair can be refined by checking the Decontaminate checkbox in the Output section and raising the amount much higher. If you move the slider too high you may increase the chances of acquiring some decontamination errors (areas of the background that take on the colors of the subject). You can also increase the amount of fine detail visible by moving the Shift Edge slider to the right. Moving this slider will, however, create problems with the harder edges of your subject so the final settings are a balance between edge quality, fine detail and decontamination errors. Before selecting OK to apply the refinements make sure New Layer with Layer Mask is selected from the Output To drop-down menu.

Composite projects

and the second s	Levels	- Layers Channels Paths +=
	Preset: Custom	PKind : DTIB
1	Channel: Alyssia copy Mask Cancel	Normal
; ;		Lock: 🖾 🖌 💠 👸 🛛 Fill: 100% -
	Input Levels: Auto Options)	Alyssia copy
	A A A	Alyssia
	0 0.67 255	© Sky
	Output Levels:	60 fx. 🔟 0. 🗔 🖶 🚊
	0 255	

5 The decontamination procedure requires a new layer where the color and tonal values of the pixels around the fine detail are modified. The visibility of the original layer has been switched off by default. If one or more of the harder edges of your subject were compromised using the Refine Edge dialog, click on the layer mask to make this the active component of the layer. Select the Lasso tool from the Tools panel and enter a small amount of feather in the Options bar. Make a selection around the edge you wish to refine and then use the keyboard shortcut Ctrl + L (PC) or Command + L (Mac) to open the Levels dialog. Adjust the central gamma slider underneath the histogram to the left or right to adjust the alignment of the mask and adjust the white and black input sliders to either increase the contrast of the edge or move the leading or trailing edge of the mask.

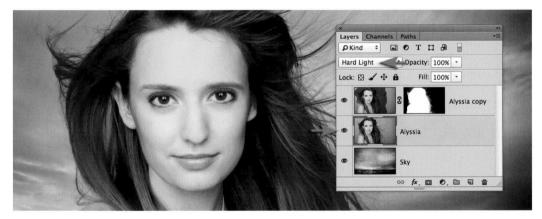

6 Because the image containing the fine detail has been captured on a gray background we can switch on the visibility of this layer and set the blend mode to Hard Light. This action will improve the amount of fine detail visible. If the gray tone is significantly lighter or darker than level 128 this action will lighten or darken the background. This can, however be remedied by placing a Brightness/Contrast adjustment layer above the background.

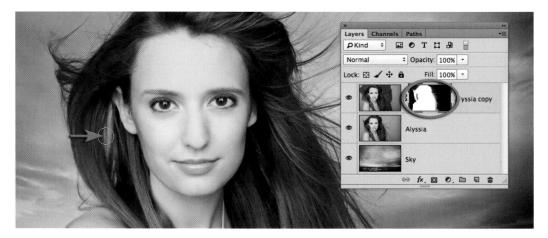

6 The decontamination process in Step 4 may create some color errors, e.g. the sky may take on the color of the hair. This can be corrected by painting with black into the layer mask, on the top layer, with a soft edged brush set to 50% opacity.

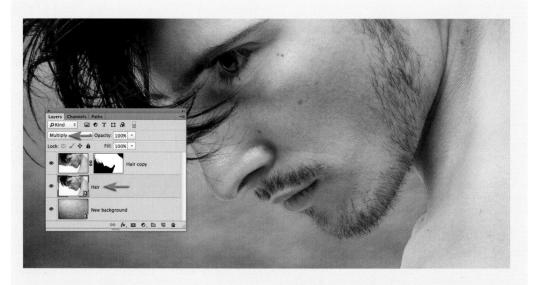

ALTERNATE APPROACH WHEN USING A WHITE BACKGROUND When using a white background instead of a gray background set the original subject layer to the Multiply blend mode instead of Hard Light. The workflow is otherwise the same as the rest of this tutorial.

Note > When lighting a white background in the studio it is important not to over light the background that will lead to 'clipping' in the image file as this will lead to a loss of fine detail around the edge of the subject. Over illuminating a white background may also turn the background into a backlight, which may lead to lighting inconsistencies when the subject is placed in a new background.

Composite projects

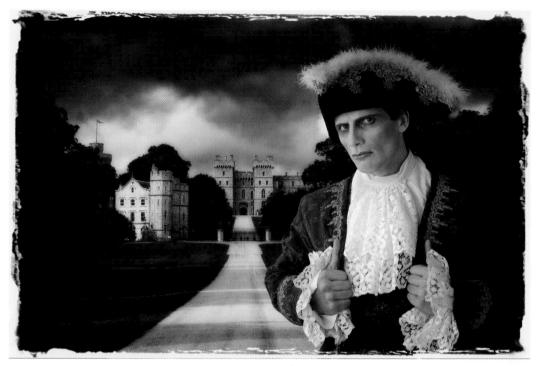

Concept and photography by Shane Monopoli of Exclusive Photography.

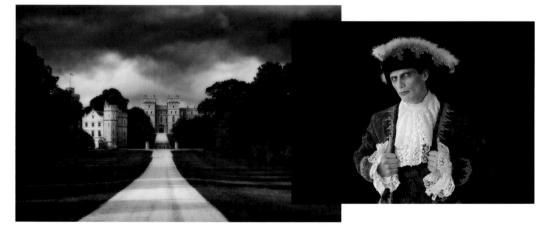

Refine Edge (Take Two) - Project 2

A common task in professional digital image editing is to strip out the subject and place it against a new background – the simplest form of composite image. The effectiveness of such a composite image is often determined by whether the image looks authentic and not manipulated. In order to achieve this the digital photographer often needs to modify the edge of any selection so that it is seamless against the new background. A crude or inappropriate selection technique will make the subject appear as if it has been cut out with garden shears and is floating above the new background. A few essential masking skills can turn the proverbial sow's ear into the silk purse.

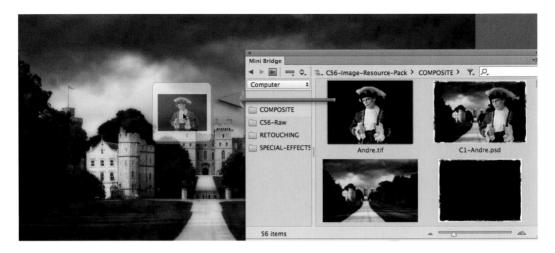

1 In a non-destructive professional workflow it is preferable to hide or mask the background pixels rather than delete them. In this project we are going to learn how to make an accurate selection in order to create a layer mask. We will then need to modify and refine the edge of the mask so that is suited to its new location. To start the project I have opened my background image and then dragged the subject file onto the image preview (this can be from your Desktop, a folder of images or directly from Mini Bridge). Hold down the Shift key as you drag the image to center the image in the host file.

2 Your subject will appear as a Smart Object and you have the option to scale or move the image at this point. You can temporarily lower the opacity of the layer if you need to see how the subject interacts with the background layer. Hit the Commit transform icon in the Options bar when you have resized and positioned your subject. The final position of the subject is to move it to the right slightly so that the center of the castle is visible.

Note > A Smart Object is a non-destructive container for an image file that allows the file to be re-scaled multiple times without progressive loss of quality. The downside to using Smart Objects is that the pixels cannot be directly adjusted.

Composite projects

3 Select the Quick Selection tool in the Tools panel and a 125 pixel hard-edged brush. Deselect the Auto-Enhance option in the Options bar and select the Sample All Layers option. The Auto Enhance option is best left off in this step if you intend to use the Pen tool or Magic Wand to complete this selection. Make an initial selection of the background rather than the subject by dragging the tool over an area of the background (it is easier to select areas with fewer differences in tone and color).

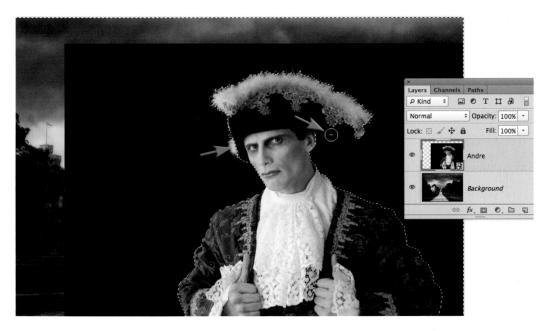

4 Continue to stroke all the areas of the black background behind the subject and any areas of the background layer that may be visible either side of the subject layer. Due to the small differences in tone at the subject edge (on the right side of the image) the initial selection is likely to take in parts of the subject as well. Hold down the Alt key (PC) or Option key (Mac) and stroke any areas that you want to remove from the selection until only the black background is selected. When the background selection is complete, go to Select > Inverse so that the subject is selected rather than the background.

Useful shortcuts for masking work

1 Brush size and hardness

Using the square bracket keys to the right of the letter P on the keyboard will increase or decrease the size of the brush. Holding down the Shift key while depressing these keys will increase or decrease the hardness of the brush.

2 Foreground and background colors

Pressing the letter D on the keyboard will return the foreground and background colors to their default settings (black and white). Pressing the letter X will switch the foreground and background colors.

3 Zoom and Hand tools

Use the keyboard shortcut Ctrl + Spacebar (PC) or Command + Spacebar (Mac) to access the Zoom tool, and the Spacebar by itself to drag the image around in its window.

Fill with foreground or background color

Use the keyboard shortcut Command + Delete (Mac) or Ctrl + Backspace (PC) to fill a selection with the background color. Use the keyboard shortcut Alt + Backspace (PC) or Option + Delete (Mac) to fill a selection with the foreground color.

Inverting the mask

Use the keyboard shortcut Ctrl + I (PC) or Command + I (Mac) to invert the mask if the mask is concealing the edge you are working on.

The use of these shortcuts will make shorter work of creating accurate selections.

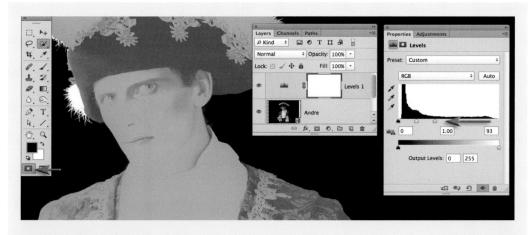

QUICK MASK

You can perfect a selection using the Quick Mask feature. Set the foreground and background colors to their default setting in the Tools panel (press the D key). Double-click on the Edit in Quick Mask Mode icon to open the Quick Mask Options. If needed, you can click the color swatch to open the Color Picker and select a color that contrasts with those found in the image you are working on. If you cannot easily see some of the dark edges of your subject you can add a temporary Levels adjustment layer and drag the White input slider to the left so that it reveals the edge.

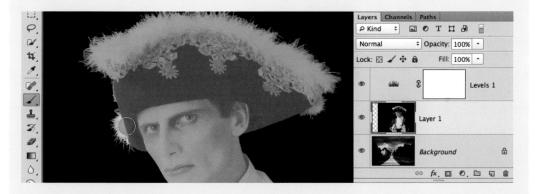

You can modify a Quick Mask by painting directly into the mask or by making a selection and then filling the selection with either the foreground or background color. Zoom in on areas of fine detail and reduce the size of the brush when accuracy is called for. Editing the mask will change the resulting selection when you exit the Quick Mask feature. If the initial selection was made using the Magic Wand or the Quick Selection tool (with the Auto Enhance option switched off) it is important to paint into the Quick Mask with the Brush set to maximum hardness and/or make selections with the Feather radius set to 0 in the Options bar (this will ensure these modifications match the current edge quality). Painting or filling with black will add to the colored mask, while painting/filling with white will remove the mask color.

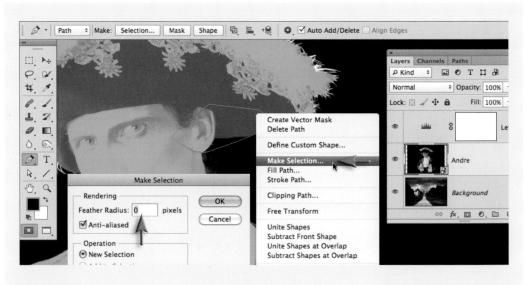

MODIFYING A MASK USING THE PEN TOOL

Making a path and then turning the path into a selection will create the smoothest edges and is often the easiest method for modifying the curved edges of a mask. Right-click after creating a path to access the Make Selection option from the context menu. Choose a Feather Radius of 0 pixels and then select OK. Fill the selection with Black to add to the mask or with White to remove a section of the mask (Edit > Fill).

Note > See 'Selections from paths' in the Selections chapter to get more information on using the Pen tool.

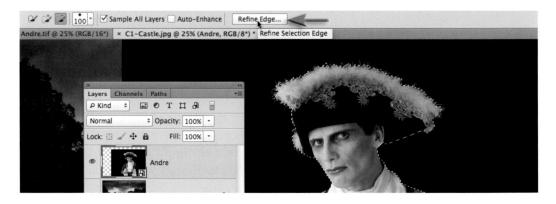

5 When the mask is complete press the letter Q on the keyboard or click on the Quick Mask icon again in the Tools panel. The selection is now ready to be refined or enhanced so that it is a comfortable fit with the new background. If you have used a temporary Levels adjustment layer you can now delete this layer by dragging it to the trash can in the Layers panel. If you have a Selection tool selected, click on the Refine Edge button in the Options bar. If you have another tool selected you can access this feature from the Select menu.

Composite projects

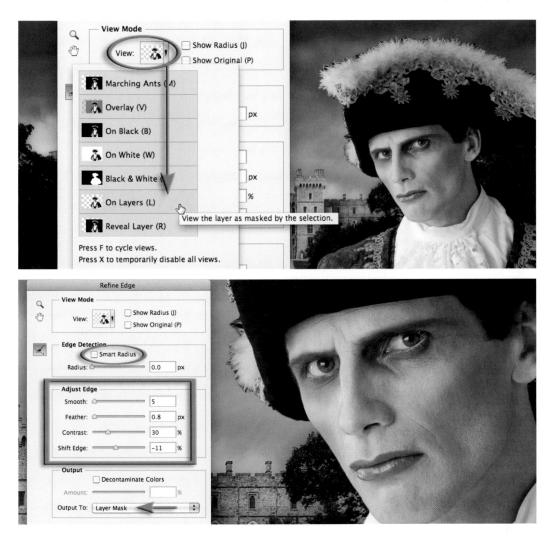

6 In the Refine Edge dialog select the On Layers option from the View menu. This subject has a mixture of sharp edges (the face) and soft edges (the feathers on the hat). To optimize the sharp edge quality I have raised the Smooth slider to +5 (usually required when working with selections created by the Magic Wand or Quick Selection tool) to smooth out the ragged edge quality. I have raised the Feather slider to 0.5 to soften the edge (essential when using either the Magic Wand, Pen tool or Quick Selection tool with Auto Enhance switched off). Contrast can be added if some edges appear semi-opaque and move the Shift Edge slider to the left to hide any remnants of the old background.

Note > When using Refine Edge with very different edge qualities the outcome is often a compromise between achieving fine detail in the softer edges and high quality sharp edges. The Refine Edge dialog box works globally (on the entire edge) so compromises are often necessary if you want to refine a complex edge in a single step. It is possible, however, to process images that have edges that are both soft and sharp twice, and avoid the compromise.

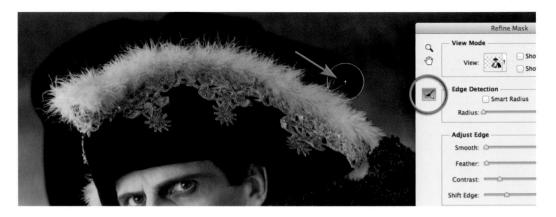

7 Select the Refine Radius tool and paint over the feathers. When using the Refine Radius tool it is important to paint into the areas of transition (where you can see the new background) but not extend into areas of the subject that should be 100% opaque. Any remaining evidence of the old black background can be removed by checking the Decontaminate Colors option, in the Output section of the dialog, and then by raising the Amount slider (approximately 75% for this project image). The Decontaminate Colors option requires Photoshop to adjust the color of the pixels as well as refining the edge of the selection. Select OK to create a new layer and refined layer mask.

Note > When using the Decontaminate option the subject should be in approximately the final location as Photoshop will be using the background information to calculate the changes to the pixels required to hide the old background colors.

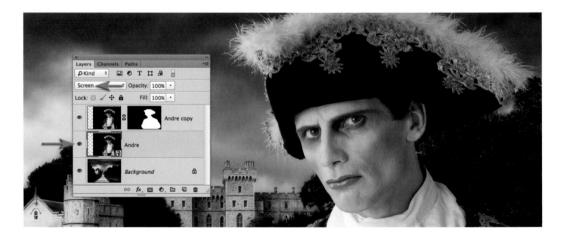

8 Select the original Andre layer in the Layers panel, switch on the visibility of the layer and set the mode of the layer to Screen. This action will provide the maximum detail in the feathers and will avoid the need to refine the edge of the mask a second time in order to optimize them.

Note > If the black background is not absolutely black you will need to clip a Levels adjustment layer to this Screen layer and raise the Black Input Levels slider until no evidence of the old background is visible in the composite file.

Composite projects

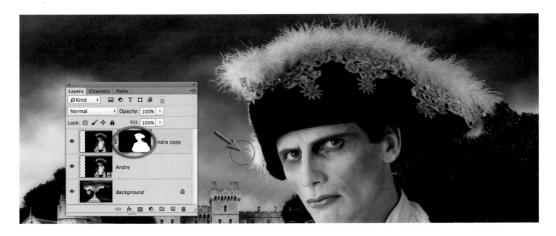

9 Where the brightest feathers on the side of the hat have been placed over a bright area of the sky, the decontaminate option in the Refine Mask dialog has not been successful. This is where the Screen layer below is useful. Select the layer mask on the Andre copy layer and then select the Brush tool from the Tools panel and set black as the foreground color (hit the D key to set the Defaults and then the X key to switch the Foreground and Background colors). Paint into the mask with a small soft edged brush to hide the feathers on this layer so that the feathers on the screen layer are visible. Although the Decontaminate feature is very good at hiding the old background it cannot work with extreme differences, e.g. although the feathers on the top of the hat are OK, the feathers on the side of the hat still show remnants of the old background.

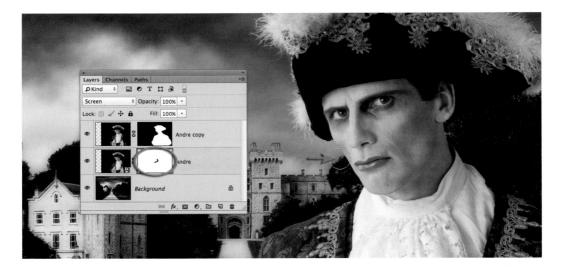

10 Although the Screen layer improves the fine detail in the feathers, it also compromises some of the harder edges that were previously refined. We can mask these problematic edges to create the perfect composite. Select the original Andre layer and click on the Add layer mask icon at the base of the Layers panel. Select the Brush tool and paint over any hard edges to mask them on this screen layer.

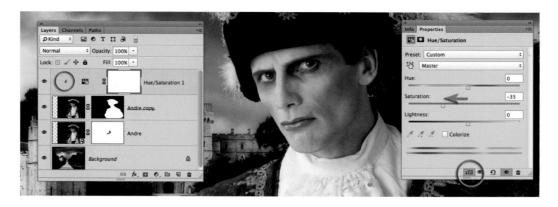

1 Add a Hue/Saturation adjustment layer from the Adjustments panel and clip this adjustment layer to the layer below, using the clipping icon at the base of the Properties panel. Lower the saturation until the subject and its background sit comfortably together. The white point and contrast of the subject matches the background image, so no further adjustments are required. In other compositing projects it may be necessary to make further color and/or tonal corrections to achieve a good match.

ADJUSTING A SECTION OF A LAYER MASK AFTER REFINE EDGE

There are a number of ways we can modify the position or quality of the edge of a mask in localized areas if required (remember the Refine Edge is a global adjustment). Click on the layer mask that you want to edit to make it active. Make a selection of the edge you wish to modify. When a selection crosses an edge of a mask be sure to use a small amount of Feather (in the Options bar) so the changes to the edge do not result in a step. You can now modify the selected edge by applying a Levels adjustment. Go to Image > Adjustments > Levels and then in the Levels dialog box move the central Gamma slider to the right or left to expand or contract the mask edge. The edge of the mask can be made harder by moving the white and black Input Levels sliders in from the edges of the histogram.

Note > You can also use the Minimum and Maximum filters to adjust the position of the edge of the mask. Go to Filter > Other > Minimum to expand the mask (the Maximum filter contracts the edge of the mask by moving it in the opposite direction).

12 To complete this project we can add a creative border. Select the top layer in the Layers panel and then drag a creative border onto the composite project preview. This will add the file as a Smart Object above the group that can then be scaled to suit the composite image. After dragging the handles of the Transform bounding box out to cover the composite image you can then proceed to hit the Commit transform icon in the Options bar. When the blend mode of the layer is changed to Screen only the white border remains visible. If you would prefer a black border you could rasterize this new smart object, invert the layer (Ctrl + I [PC] or Command + I [Mac]) and set the mode to Multiply instead of screen.

Paths, masks and blend modes - Project 3

With the basic drawing skills covered in the Selections chapter we are ready to create a path that can be converted into a selection and then used as a layer mask. This project will see if you can create a path worthy of a Path Master (for the pen is sometimes mightier than the light sabre or magic wand). The resulting edge will be much smoother than an edge created with any of the selection tools. After an accurate path has been created we can use this to modify the subject and background separately.

Body builder by Abhijit Chattaraj.

In the composite image above, the image of the body has been blended with an image of raindrops on a car body. The blended texture takes on the shadows and highlights of the underlying form but does not wrap itself around the contours or shape of the three-dimensional form.

D - Path	+ Make:	Selection	Mask	Shape		+	Aut	to Add/Delete	Align Edges
							Rubber Band)	

1 Select the Pen tool in the Tools panel and the Path option in the Options bar (rather than the Shape option). Select the Rubber Band option if you are new to the Pen tool.

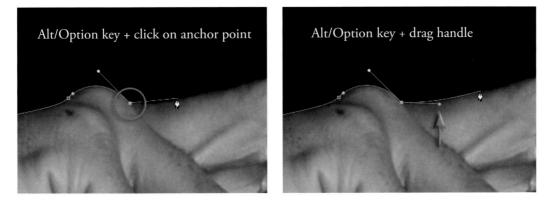

2 Over the next four steps you will create a path to define the edge of the entire body. Zoom in using the keyboard shortcut Ctrl + Spacebar (PC) or Command + Spacebar (Mac) and work close. Drag the image around in the image window using the Spacebar key to access the Hand tool. Make a path by clicking on the edge of the subject and dragging to modify the curves. If you encounter edges that are not well defined, work on the inside edge rather than the outer edge of the subject. Try to use as few anchor points as possible (see Selections, pages 182–185). Remember you can choose to cancel or move a direction line by holding down the Alt/Option key and clicking on either the last anchor point or its direction point before creating a new segment of the path.

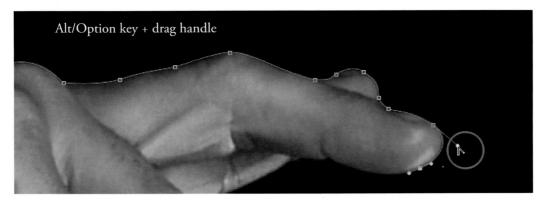

³ You can backtrack at any time and Ctrl + click (PC) or Command + click (Mac) to select an anchor point to make it active again. Then hold down the Alt/Option key to adjust one of the direction lines or hold down the Control key (PC) or Command key (Mac) and click and drag an anchor point to reposition it. Moving the Pen tool over a segment of the path already completed will give you the option to click and add an anchor point to the path. Moving the Pen tool over a previous anchor point will enable you to click to delete the anchor points or drag out from the anchor point to add two new direction lines.

Note > Check that you have the Auto Add/Delete option checked in the Options bar if the above is not happening for you. If you accidentally remove a direction line from an anchor point hold down the Alt/Option key and click and drag out from the anchor point to add new direction lines.

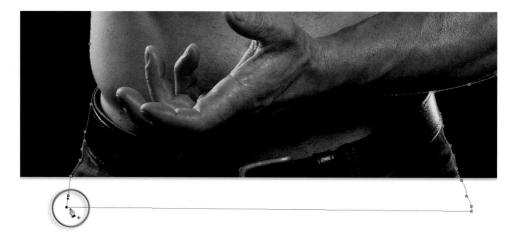

4 Where the blue jeans extend beyond the edge of the frame (at the bottom of the image window) place your anchor points outside of the image window rather than alongside the edge. Continue creating anchor points until you reach the point where you started drawing. When you click on the first anchor point you will close the path. Hold down the Alt/Option key as you click on the first point if the direction line on the first anchor points changes your last drawn curve.

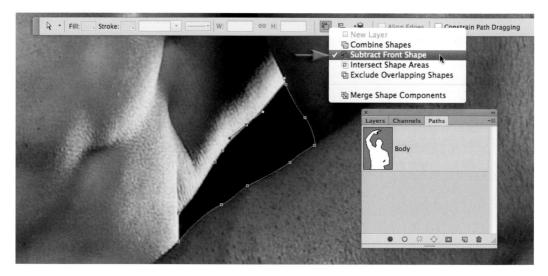

5 In the Paths panel double-click the Work Path. This will bring up the option to save the Work Path and ensure that it cannot be deleted accidentally. Name the path 'Body' and click OK to save it. A saved path can be modified by first clicking on the path in the Paths panel, selecting the Pen tool in the Tools panel and then selecting the 'Add to' or 'Subtract from path area' icon in the Options bar. Select the 'Subtract from path area' icon and proceed to remove the area of background under the man's arm using the same pen techniques as before.

Composite projects

×		Refine Edge
Layers Channel	Is Paths → Duplicate Path Delete Path	View Mode Show Radius (J) Show Original (P)
	Make Selection	Edge Detection
	Fill Subpath Stroke Subpath	Radius: 0.0 px
	New 3D Extrusion from Selected Path	Adjust Edge
• 0		Smooth: 0 0 Feather: 0.5 px
	Make Selection	Contrast: 0 %
Rend	ering	Shift Edge: -25 %
	r Radius: 0 pixels i-aliased Cancel	Contract or expand selection edg
	v Selection	Amount: % Output To: Selection *
O Sub	I to Selection tract from Selection prect with Selection	Remember Settings Cancel OK

6 Right-click on the path and select Make Selection. Choose a Feather Radius of 0 and select OK. Go to Select > Refine Edge and set the Radius, Contrast and Smooth sliders to zero. Apply a 1 pixel Feather. To test the effectiveness of the path it is best to preview the selection over a white background (from the View menu in the Refine Edge dialog). In order to remove the old black background that may just be visible against the edge of the body you will need to move the Shift Edge slider to -25. Select OK to apply the changes.

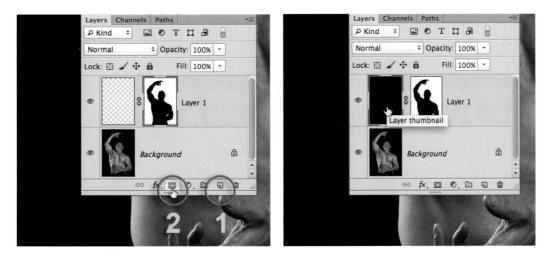

7 Click on the Create a New Layer icon in the Layers panel to create an empty new layer. Hold down the Alt/Option key and click on the Add Layer Mask icon in the Layers panel. Then select the layer image and go to Edit > Fill and choose black as the contents and select OK.

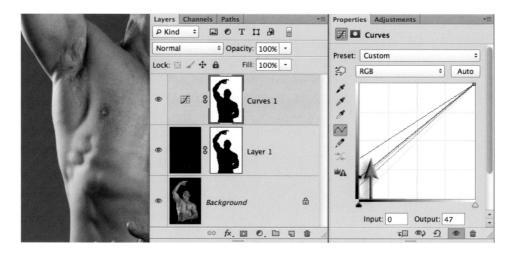

8 This step will create the effect of a backlight behind the subject that slowly fades to black in the corners of the image. Control-click (PC) or Command-click (Mac) on the layer mask to load the mask as a selection, click on the Create New Fill or Adjustment Layer icon in the Layers panel and choose a Curves adjustment layer. Select the Blue channel and click and drag the adjustment point sitting in the bottom left-hand corner of the diagonal line until the output value reads 90 or more. Repeat this process with the Red and Green channels but raise these only a little in order to desaturate the blue. In the master RGB channel raise the black point to raise the overall brightness of the color you have created.

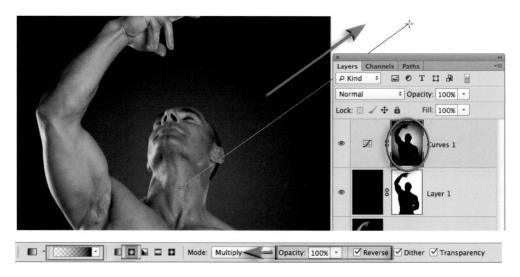

9 Select the Gradient tool in the Tools panel. Select the Foreground to Transparent and Radial Gradient options with black selected as the Foreground color, set the opacity to 100% and select the Reverse, Dither and Transparency options. Click and drag from a position in the center of the man's body out past the top right-hand edge of the image window to create the backlight effect. You can fine-tune the effect by using the Undo command (Ctrl/Command + Z) and dragging a longer or shorter gradient.

Blending the texture

Blending two images in the computer is similar to creating a double exposure in the camera or sandwiching negatives in the darkroom. Photoshop, however, allows a greater degree of control over the final outcome. This is achieved by controlling the specific blend mode, position and opacity of each layer. The use of **layer masks** can shield any area of the image that needs to be protected from the blend mode. The blending technique enables the texture or pattern from one image to be merged with the form of a selected subject in another image.

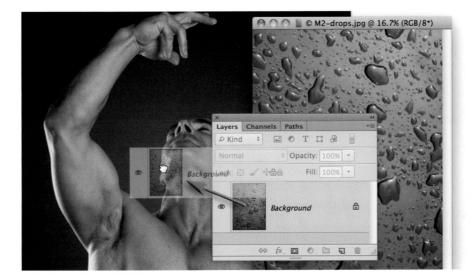

10 Open the 'Drops' image from the project files. Go to Window > Float in Window if you cannot see both images. Click and drag the layer thumbnail of this image into the body image. Hold down the Shift key as you let go of the Drops thumbnail to center the image in the new window. Use the Move tool to reposition the texture if required. Use the Free Transform command (Edit > Free Transform) if required to resize the texture image so that it covers the figure in the image.

SELECTING APPROPRIATE IMAGES TO BLEND

Select or create one image where a three-dimensional subject is modeled by light. Try photographing a part of the human body using a large or diffused light source at right angles to the camera. The image should ideally contain bright highlights, midtones and dark shadows. Select or create another image where the subject has an interesting texture or pattern. Try using a bold texture with an irregular pattern. The texture should ideally have a full tonal range with good contrast. A subtle or low-contrast texture may not be obvious when blended. Alt/Option-click the document sizes in the bottom left-hand corner of each image window to check that the image pixel dimensions (width and height) are similar. It is possible to blend a colored texture with a grayscale image. If the color of the texture is to be retained when it is moved into the grayscale image containing the form, the grayscale image must first be converted to RGB by going to Image > Mode > RGB.

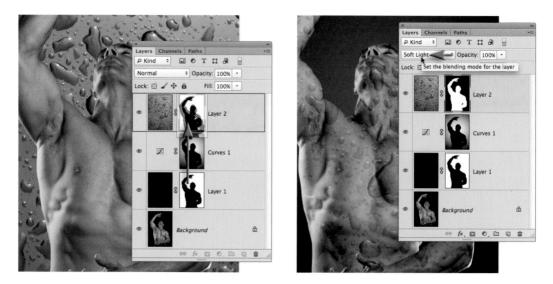

1 Hold down the Alt/Option key and drag the layer mask from Layer 1 to Layer 2 to copy it. Invert the mask using the keyboard shortcut 'Ctrl + I' PC or 'Command + I' Mac. Set the blend mode of the drops layer (Layer 2) to Soft Light or Overlay. Experiment with adjusting the opacity of the layer using the Opacity control in the Layers panel.

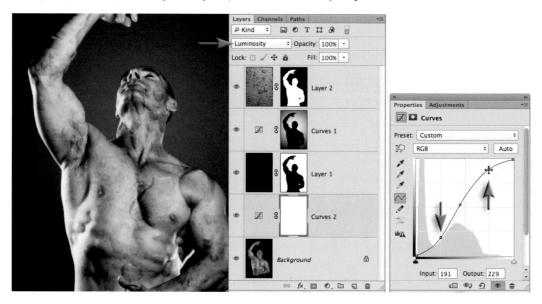

12 After experimenting with the opacity and blend mode of the top layer you can adjust the tonality of the underlying background layer to suit the blend. Select the background layer and select a Curves adjustment from the Adjustments panel. Expand the contrast of the underlying layer by creating an S-curve and set the mode of the adjustment layer to Luminosity if you do not want to increase the saturation levels.

Note > Save your work as a Photoshop Document (PSD) as this will be the start of the work carried out in the next section of the project.

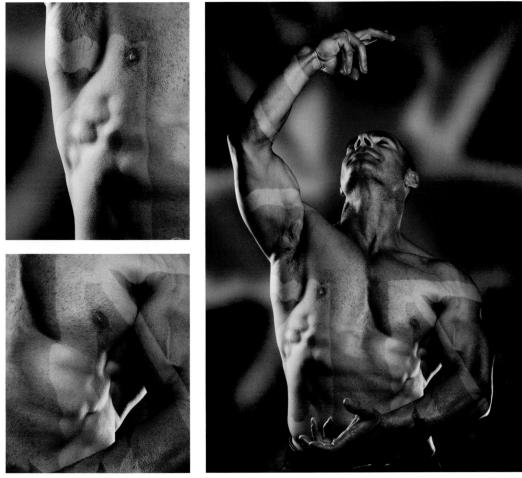

Photography by Abhijit Chattaraj.

Creating a displacement map

The layer **blend** modes are an effective, but limited, way of merging or blending a pattern or graphic with a three-dimensional form. By using the blend modes the pattern or graphic can be modified to respect the color and tonality of the 3D form beneath it. The highlights and shadows that give the 3D form its shape can, however, be further utilized to wrap or bend the pattern or graphic so that it obeys the form's perspective and sense of volume. This can be achieved by using the Displace filter in conjunction with a 'displacement map'. The 'map' defines the contours to which the graphic or pattern must conform. The final effect can be likened to 'shrink-wrapping' the graphic or pattern to the 3D form. Displacement requires the use of a PSD image file or displacement map created from the layer containing the 3D form. This is used as the contour map to displace pixels of another layer (the pattern or graphic). The brightness level of each pixel in the map directs the filter to shift the corresponding pixel of the selected layer in a horizontal or vertical plane. The principle on which this technique works is that of 'mountains and valleys'. Dark pixels in the map raise the graphic pixels down into the shaded valleys of the 3D form. The alternative to using a displacement map is to use the Liquify filter.

The limitation of the displacement technique is that the filter reads dark pixels in the image as being shaded and light pixels as being illuminated. This of course is not always the case. With this in mind the range of images that lend themselves to this technique is limited. A zebra would be a poor choice on which to wrap a flag, while a nude illuminated with soft directional lighting would be a good choice. The image chosen for this project lends itself to the displacement technique. Directional light models the face. Tonal differences due to hue are limited. Note how the straight lines of the flag are distorted after the Displace filter has been applied. The first image looks as though the flag has been projected onto the fabric, while the second image shows the effect of the displacement filter – it appears as though it has been woven or printed onto the surface of the fabric.

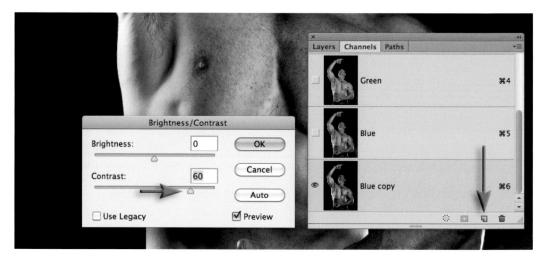

13 Switch off the visibility of the top two layers (the drops and the backlight effect). In order to apply the Displace filter you must first create a grayscale image to become the displacement map. In the Channels panel locate the channel with the best tonal contrast between the shadows and the highlights (in this case the Blue layer). Duplicate this channel by dragging it to the New Layer icon at the base of the panel. Increase the contrast of this channel using the Brightness/ Contrast adjustment (Image > Adjustments > Brightness/Contrast). You can further enhance the hills and valleys by selecting the Dodge or Burn tools from the Tools panel. Set the Exposure to 20% or lower when using these tools and then proceed to either lighten the hills or darken the valleys as you see fit. Remember this is a displacement map not a photograph.

15		
Green	#4	Y
Blue	#5 Duplicate C	Channel
Blue copy	Duplicate: Blue copy As: Blue copy Destination	ОК
HEER	Document: New Name: map	

14 Export this channel to become the displacement map by choosing Duplicate Channel from the Channels menu and then Document > New from the Destination menu. When you select OK in the Duplicate Channel dialog box, a file with a single channel will open in Photoshop.

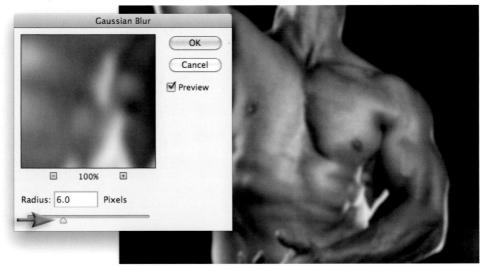

15 Apply Gaussian Blur (Filter > Blur > Gaussian Blur) to the new file. Applying a higher Radius of Gaussian Blur (closer to a Radius of 10 pixels) will create a mask that produces a smooth-edged displacement (minor flaws in the skin will be ignored). Using a lower Radius of Gaussian Blur (1–4 pixels) will create a mask that produces a ragged-edge displacement (every minor flaw in the skin will lead to displaced pixels). Save this file as a Photoshop file (your displacement map) to the same location on your computer as the file you are working on. You will need to access this 'map' several times in order to optimize the displacement.

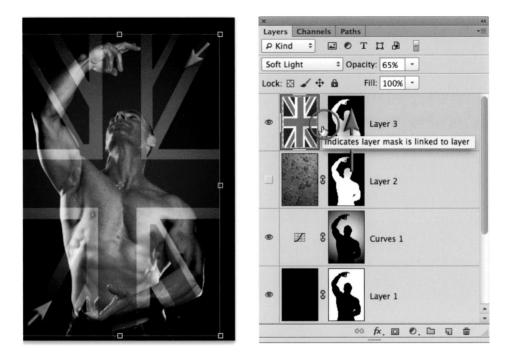

16 In the Channels panel select the RGB master channel (the visibility of the Blue copy channel should now be hidden). Return to the Layers panel. Open the flag image and drag the background layer thumbnail into the portrait image. Apply the Free Transform from the Edit menu and choose Fit on Screen from the View menu. Drag the handles of the bounding box to achieve a 'good fit'. Hit the Return/Enter key to apply the transformation and then set the Opacity of the layer to 65% and the mode to Soft Light. Hold down the Alt/Option key and drag the layer mask on the layer below to this new layer. Click on the link between the image thumbnail and the mask thumbnail to remove it (this will ensure the mask is not distorted in the next step) and click on the image thumbnail to make sure it is the active component of the layer.

17 Choose Filter > Distort > Displace and enter 20–30 in the Horizontal and Vertical Scale fields of the Displace dialog box. Select OK and then browse to the displacement map you created earlier. The displacement is then applied to the layer. The Displace filter shifts the pixels on the selected layer using a pixel value from the displacement map. Grayscale levels 0 and 255 are the maximum negative and positive shifts while level 128 (middle gray) produces no displacement.

Composite projects

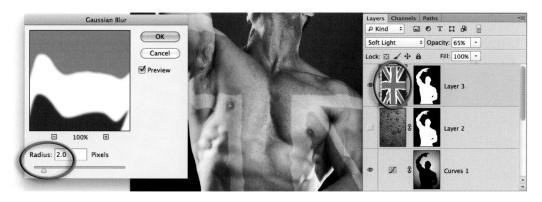

18 Apply 2-pixel Gaussian Blur to the flag layer. Fine-tune the opacity of the flag layer if you feel you need to strike a good balance between the graphic and the tonality of the body.

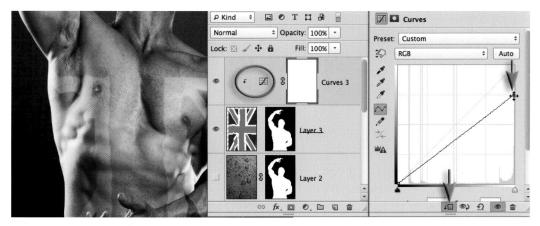

19 The tonality of the flag can be further optimized using an adjustment layer that is clipped to the flag layer (click on the clipping icon at the base of the Curves dialog). In this project a Curves adjustment was used to lower the brightness of the white tones in the flag and the saturation was reduced by lowering the white point.

20 If you don't want the flag to appear on certain parts of the body you can paint with black into the layer mask. Use a soft brush at a reduced opacity if you want to fade the graphic in certain areas.

LAYER COMPS

An alternative version of the composite image has been created by switching off the visibility of the Curves 1 layer that was creating the backlight effect. A new flag background (created using the same displacement technique) is pasted into the host image. A mask is copied from one of the underlying layers and inverted so that it only appears behind the subject. With so many alternative versions that are possible with just one layer mask (used many times) it is possible to keep track of them using the Layer Comp panel.

Each time you create a version you like you can keep a record of the layers that were contributing to the overall effect. The New Layer Comp dialog will keep track of not only which layers are visible but also their opacity and position. If any layer styles are applied it will also keep track of these. After the comps have been created it is then easy to switch between the versions.

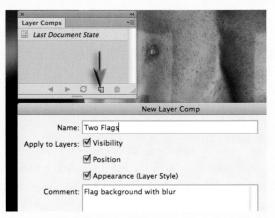

Alternative approach using the Liquify filter

An alternative approach to distorting the flag using the Displacement filter in Project 2 would be to use the Liquify filter. Instead of using the Blue copy channel to create a displacement map it can be used to Freeze an area of the image prior to selectively displacing the unfrozen pixels using the Warp tool. This alternative method of displacing pixels on one layer, to reflect the contours of another layer, is made possible in the Liquify filter due to the option to see the visibility of additional layers other than the one you are working on.

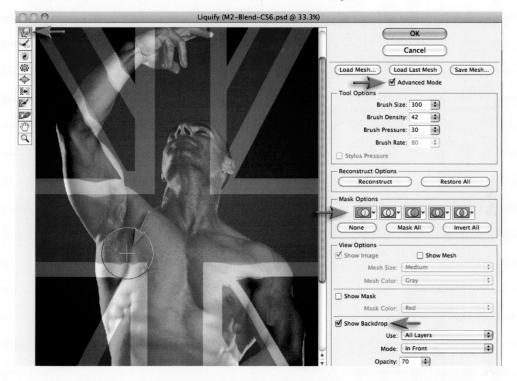

To try this alternative approach just proceed as normal until you reach Step 17. Then, instead of using a displacement map, click on the flag layer and make sure the image, rather than the mask, is the active component of the layer and then go to Filter > Liquify. Check the Show Backdrop option in the dialog box and select Background Layer from the menu. Adjust the opacity to create the optimum environment for displacing the pixels. To selectively freeze the darker pixels in the image load the Blue copy channel in the Mask Options. Select a brush size and pressure and then stroke the flag while observing the contours of the body to displace the lighter pixels. Select Invert All in the Mask Options so that you can displace the darker pixels.

Note > The Liquify filter cannot be applied to a Smart Object but the technique, although labor intensive, does offer the user a little more control over the displacement process. It is possible to save the distortions carried out in the Liquify filter as a 'Mesh'. This Mesh is like a topographic landscape and can be loaded to distort subsequent graphics to the same topography to create a similar distortion.

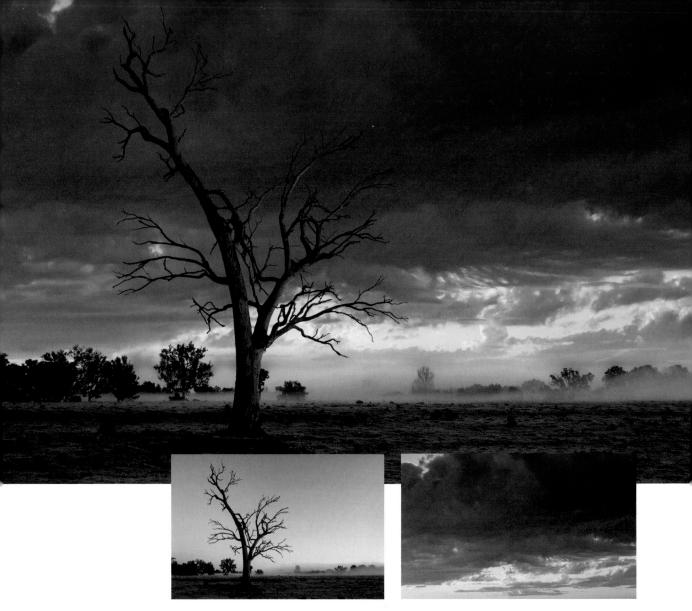

Original image of Tree by Liam Lavery, sky by Mark Galer.

Replacing a sky - Project 4

The sky is an essential ingredient of any memorable landscape image. Unfortunately it is not something the photographer can control unless we have limitless time and patience. The commercial photographer is often required to deliver the goods on a day that suits the client rather than the photographer and weather forecast. In these instances it is worth building a personal stock library of impressive skies that can be utilized to turn ordinary images with bland skies into impressive ones. A digital compact camera set to a low ISO is ideal for capturing these fleeting moments. The most useful skies to collect are the ones that include detail close to the horizon line, i.e. captured without interference from busy urban skylines, such as can be found at the beach or in the desert. In this project we explore how a sky can be adapted to fit the landscape so the montage is not immediately obvious.

Composite projects

1 Drag the replacement Sky image onto the project image. This will add the image as a Smart Object. You can now position the sky by dragging inside the bounding box or resize the sky by dragging the handles to fit the host image. You can drop the opacity of the Smart Object layer in the Layers panel, if required, in order to help you place the new sky in the optimum location.

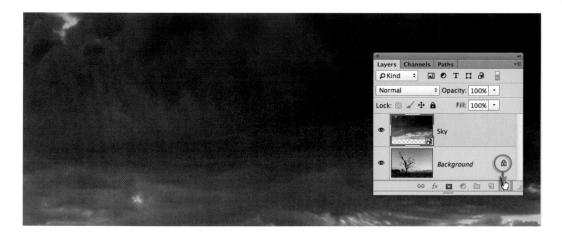

2 In this project we will be using the 'decontaminate' option found in the Refine Mask dialog to ensure maximum quality in the fine detail of the tree branches is achieved. The layer mask to be refined must, however, be placed on the layer that contains the fine detail for the technique to be successful. In the current layer order, the mask cannot be applied to the background layer so the layer sequence must be changed so that the tree layer appears on the top of the layer stack. Drag the lock icon on the bckground layer to the mini trash can at the base of the Layers panel and then click and drag the unlocked layer to the top of the Layers stack. Alternatively you can use the keyboard shortcut (Ctrl +] on a PC or Command +] on a Mac).

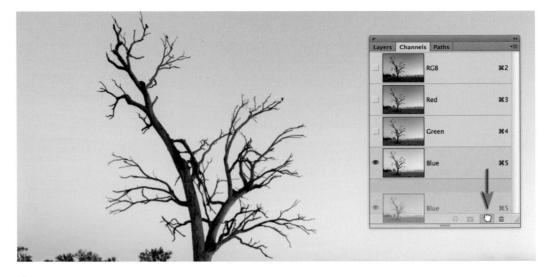

3 In this step we will create an alpha channel mask to preserve the fine detail of the tree. Go to the Channels panel and click on each channel in turn to see which channel has the best contrast between the tree and the sky. The Blue channel has the best contrast so drag this to the New Channel icon to duplicate it. This new channel will form the basis for our mask.

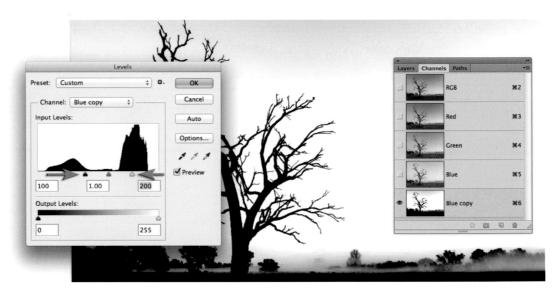

4 Go to Image > Adjustments and choose the Levels adjustment. By clipping both the darkest and lightest tones within the channel we will raise the contrast and take one step closer to creating a channel that can act as our mask. In the Levels dialog raise the Black Input Levels slider to 100 and the White Input Levels slider to 200 to clip some of the lighter tones to white. If we clip all of the lighter tones to white in this step we may lose some of the brighter highlights on the tree branches so we will apply an alternative technique to optimize the channel.

Composite projects

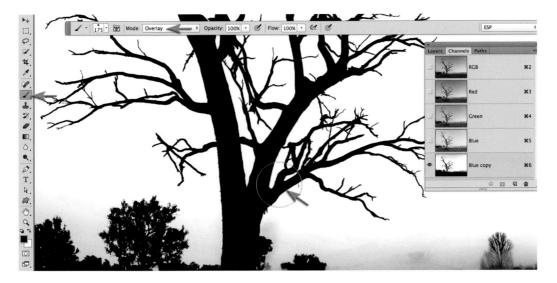

5 Select the Brush tool from the Tools panel and set the Mode to Overlay in the Options bar. Set the Foreground and Background colors to their default (press the D key) and set the Brush Opacity to 100%. Zoom in to the image so you can see any details in the tree branches that have not been rendered black in the previous step. Press the X key to make black the foreground color and then paint over these highlights on the branches to render them black. The Overlay mode will protect the bright highlights in the surrounding sky. In some instances a second or third stroke of the brush may be required to render the branches completely black.

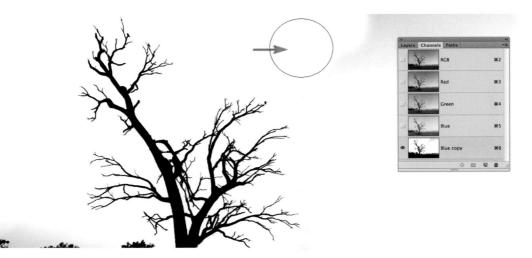

6 Press the X key to switch the Foreground color to White and then proceed to paint over any areas of Sky that are slightly gray. You can use a larger soft-edged brush for this step although you may need to reduce the size if you need to work between the branches to clean any sky that is slightly gray in these areas. The branches that were rendered black in the previous step will be protected by the Overlay mode. Continue painting in Overlay mode until all areas of gray, including the morning mist, have been rendered either black or white.

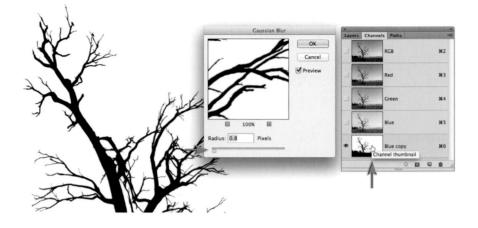

To soften the edges of this alpha channel mask go to Filter > Blur > Gaussian Blur and apply a 0.8 pixel blur. To load the channel as a selection hold down the Ctrl key (PC) or Command key (Mac) and click on the Blue Copy channel. Click on the RGB channel before returning to the Layers panel.

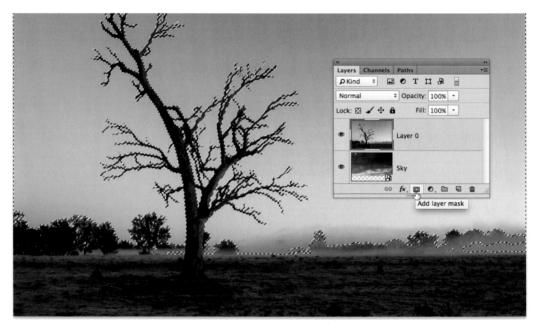

In this step we will convert the selection into a Layer mask that hides the old sky. Hold down the Alt key (PC) or Option key (Mac) and click on the Add layer mask icon at the base of the layers panel. The action of holding down the Alt or Option key will invert the mask as it is created. If you forget to hold down the Alt or Option key as you add the layer mask you can use the keyboard shortcut Ctrl + I on a PC or Command + I for a Mac to invert the layer mask.

Composite projects

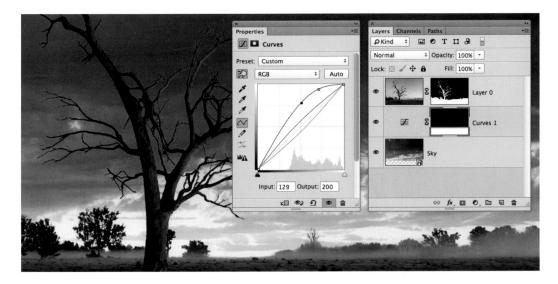

9 To create a more subtle transition at the horizon line we need to add an Adjustment layer above the sky layer. Add a Curves adjustment layer and increase the brightness until the sky at the horizon line is much brighter. Raise the Blue curve slightly and decrease the Red curve to modify the white balance of the sky. Select the layer mask and the Gradient tool from the Tools panel. Choose the Black/White option from Gradient Picker (right-click to access the Gradient Options). Choose the Linear gradient and set the Opacity to 100% in the Options bar. Click and drag a short gradient towards the horizon line. Hold down the Shift key to constrain this gradient to a vertical.

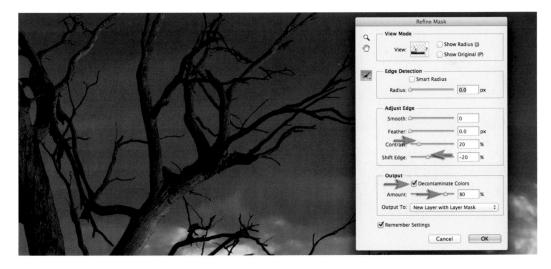

10 Go to Select > Refine Mask and proceed to perfect the edges of the mask around the tree branches. I have added +20 Contrast and moved the Shift Edge slider to -20 to perfect the quality and position of the mask edge. I have also checked the Decontaminate Colors checkbox and raised the Amount slider to +80. Do not click OK at this stage as there is still some fine detail that needs our attention.

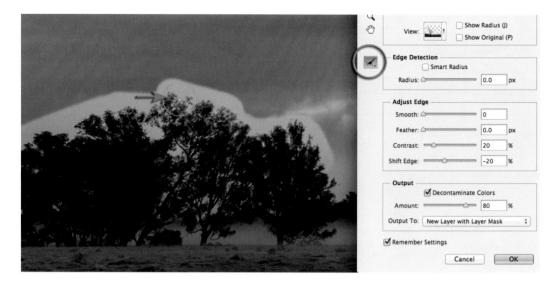

11 Click on the Refine Radius Tool in the Refine Mask dialog and then proceed to paint over the leaves on the distant trees on the horizon line. The Decontaminate Colors option will work to create a more satisfactory transition in this area of the composite file. You can now click OK to process a new layer with a new layer mask.

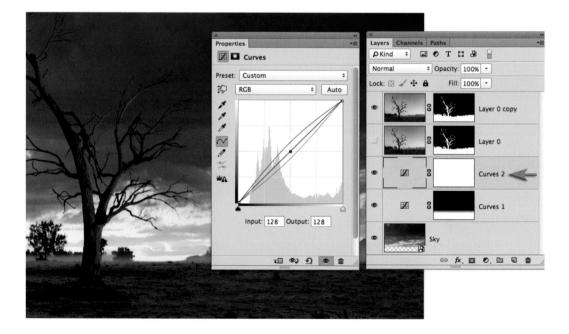

12 Additional adjustments can be made to the composite file by adding an adjustment layer either at the top of the layers stack, clipped to the Tree layer or above the Sky layer. Each of these options will enable you to edit different aspects of the composite file to create a happy blend between the two files.

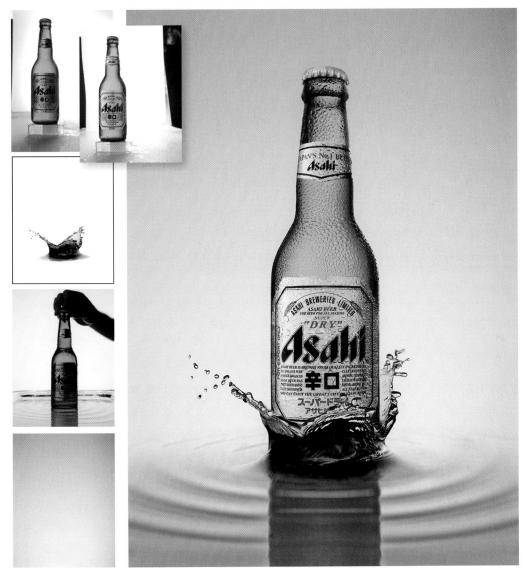

Rory Gardiner – rorygardiner.com.au

Composite studio lighting and action - Project 5

The lighting of a studio set is often compromised by either limitations of time or the complexity of the lighting that is required for the creative outcome. Take the example above, where the ideal lighting required for the liquid and the label is different. Perfect the lighting for one and the quality of the other is compromised. The solution is remarkably simple of course. Perfect the lighting for one at a time and then create a composite image in post-production. The drama is further enhanced by adding a splash, ripples and the perfect background. Prior to CS3, pinregistering each exposure in-camera using a sturdy tripod was an essential requirement for the success of this technique. Small differences in camera position (as a result of knocking the tripod between exposures, for example) can now be corrected using the Auto-Align Layers command.

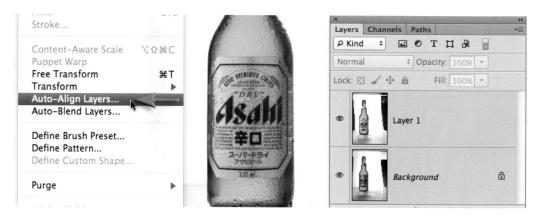

1 Open the two bottle images and make a composite image by dragging the background thumbnail (in the Layers panel) from the label image into the beer image. Shift-click both layers to select them. Select Auto-Align Layers from the Edit menu and, in the dialog box, select the Reposition option before selecting OK. Hold down the Ctrl key (PC) or Command key (Mac) and then click on the 'Create a new layer' icon at the base of the Layers panel to create an empty new layer below Layer 0. Fill this new layer with white (Edit > Fill).

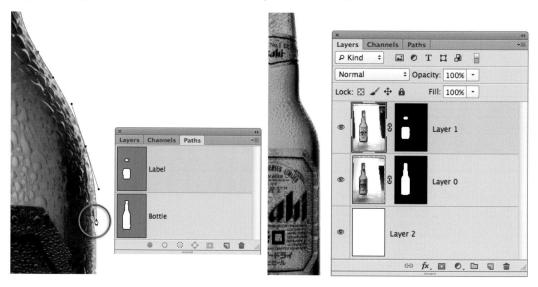

2 Make one path around the bottle and another path around the labels using the Pen tool (see the Selections chapter). The paths are included in the project files if you want to skip this process. Right-click on a Path thumbnail and choose Make Selection from the context menu. Choose a 0.5 pixel Feather Radius and select OK. In the Layers panel select the corresponding layer, e.g. the label path for the label layer, and then click on the 'Add layer mask' icon at the base of the Layers panel. The white layer allows you to check that you have a clean edge. Select the layers and use the keyboard shortcut to load them into a group (Command or Ctrl + G) and name the group 'Bottle'. Switch off the visibility of the white layer as we will not need this when we transfer the bottle to the new background. Save the work you have completed so far.

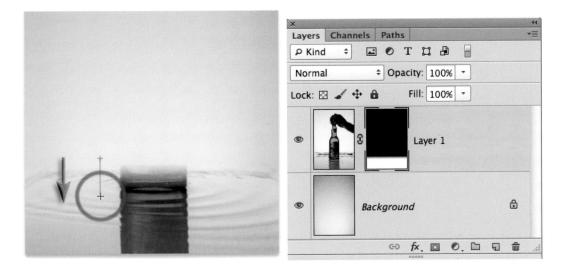

3 Open the 'Blue Backdrop' file and then add the 'Ripples' file to it. Close the Ripples file when this is done. Click on the 'Add layer mask' icon at the base of the Layers panel to add a layer mask to the Ripples layer. Select the Gradient tool and choose the Black, White and Linear options and set the Opacity to 100% (make sure the Reverse option is deselected). Select the layer mask and drag a short gradient to hide the top of the tray containing the ripples and create a smooth transition between the new background below.

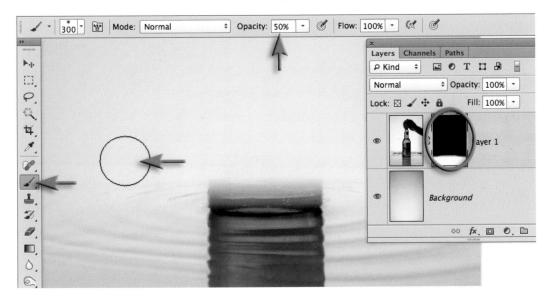

4 Select the Brush tool from the Tools panel and set Black as the foreground color (press D on the keyboard to set the foreground and background colors to their default setting and then X to switch the colors). Choose a large soft-edged brush (0% hardness) and lower the Opacity to around 50%. Paint over any remaining signs of the top of the tray to remove them from view. Several strokes of the brush may be required to complete this task.

Distort Perspective Warp Content-Aware Scale Puppet Warp Rotate 80° CW Rotate 90° CCW Flip Horizontal Flip Vertical	Free Transform Scale Rotate	× Layers Channels Paths P Kind こ 国 の T 口 み
Rotate 180° Rotate 90° CW Rotate 90° CCW	Perspective Warp Content-Aware Scale	
Flip Horizontal	Rotate 180° Rotate 90° CW	
HUNTER 1		Layer -

5 If you would like to make the ripples more symmetrical, duplicate the ripples layer and then go to Edit > Transform > Flip Horizontal. Select the Layer mask and then select the Gradient tool again, choose Multiply as the mode and drag a gradient from the right side of the bottle to the left side of the bottle. From the flyout menu in the Layers panel choose Merge Down. In the dialog that opens choose Preserve and then select OK.

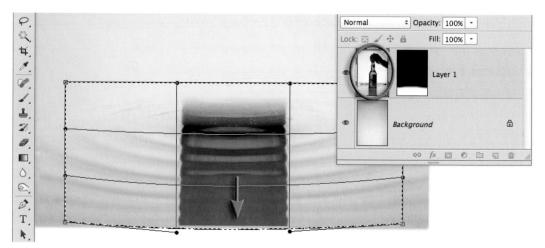

6 This composite layer will enable you to warp the ripples into better shape. Click on the link between the Image thumbnail and the layer mask (we don't want to warp the mask). Select the Image thumbnail on the layer. Select the Rectangular Marquee tool and set the Feather Radius to 0 in the Options bar. Make a selection of the ripples in the water and then go to Edit > Transform > Warp. Drag down on the base of the bounding box to create a better shape for the ripples before committing the transformation (press the Enter/Return key). The background should now be ready to accept the bottle that we prepared earlier. Unlock the background layer (double-click the background layer and accept the Layer 0 default name). Hold down the Shift key and select the top and bottom layers in the Layers panel and then use the keyboard shortcut Ctrl or Command + G to load the layers into a group. Name the group 'Background'.

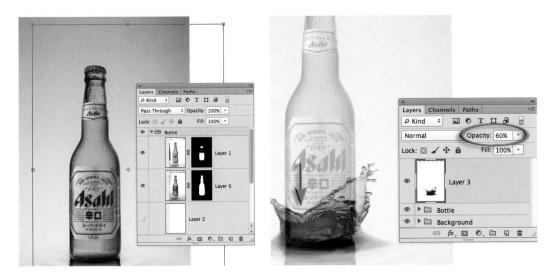

7 Drag the bottle group into the background image and apply the Free Transform (Edit > Free Transform) so that you can move the bottle into position and scale if required. Zoom in and check the edge of the bottle against the new background at 100%. If required, refine the edge of the bottle mask in Layer 0 of the bottle group (Select > Refine Edge). Add the splash image to the composite file, lower the opacity of the layer and use the Free Transform process to position and scale the splash. Return the layer to 100% Opacity when finished.

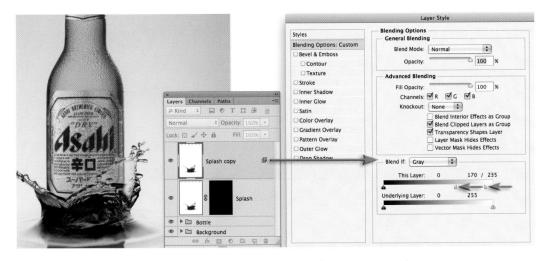

8 To mask the white background behind the splash we first need to duplicate the splash layer and add a black layer mask to the first splash layer (hold down the Alt/Option key as you click the 'Add a layer mask' icon in the Layers panel). Double-click the top splash layer (to one side of the layer name) so that the Layer Style dialog opens (if you double-click near the name of the layer you will be given the option to rename the layer instead). In the Blending Options section of the dialog drag the white slider on the This Layer slider to 235. Hold down the Alt/Option key and drag the left side of the slider again to split the slider. Drag this left side of the slider to 170 to create a smooth transition that will render the white background mostly transparent.

* P 1 Layers Chan Is Pati P Kind \$ -0 ТП -1 Normal + Opacity: 100% -Fill: 100% -Lock: 🖾 🖌 💠 🖨 0 ¥ .000 Solash U BEER HAS E Splash 👁 🕨 🛅 Bottle Background 9 5 60 fx. 🖸 O. 🗅 🕤 🏦 \Box D.

9 Select OK to apply the Advanced Blending options and then add a layer mask to this layer. Select the Brush tool and black as the foreground color. Lower the Opacity in the Options bar to 50% and start to mask any traces of the white background that may still be visible. On the right side of the image mask the splash so that it appears to be going around the bottle rather than in front of the bottle. Adjust the size and hardness of the brush as required.

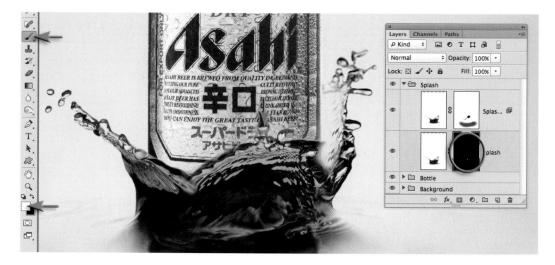

10 The previous two steps will have hidden the white background but also rendered the brightest highlights on the water droplets transparent as well. If you want to replace these bright highlights select the layer mask on the layer below and choose white as the foreground color. Select a small soft-edged brush and 100% Opacity and paint in the image to reveal these bright highlights. Add adjustment layers to any of the groups to fine-tune the color and tonality of the composite image. Setting the blend mode of a group to Normal will ensure the adjustments are confined to the layers in that group.

Composite projects

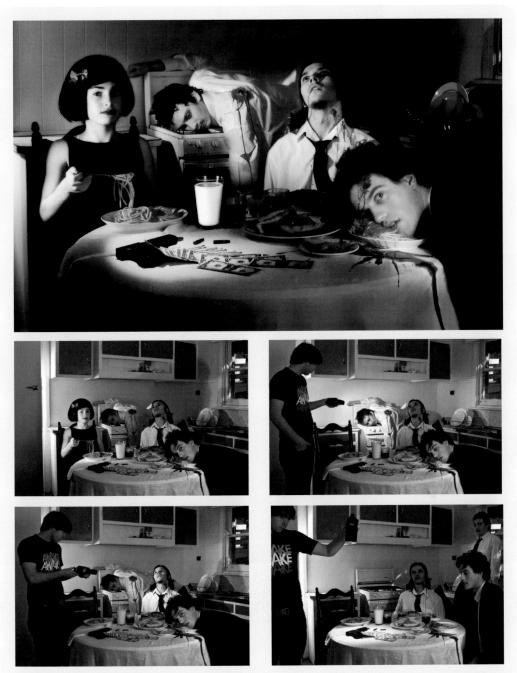

FIXED POSITION COMPOSITE

Haydn Cattach

The composite lighting technique used for the beer bottle does not have to be confined to the studio. Working with the camera in a fixed position the photographer is free to light aspects of a large or complex scene with a single light source – one piece or frame at a time. Masking is relatively simple when most of the subject matter is not moving.

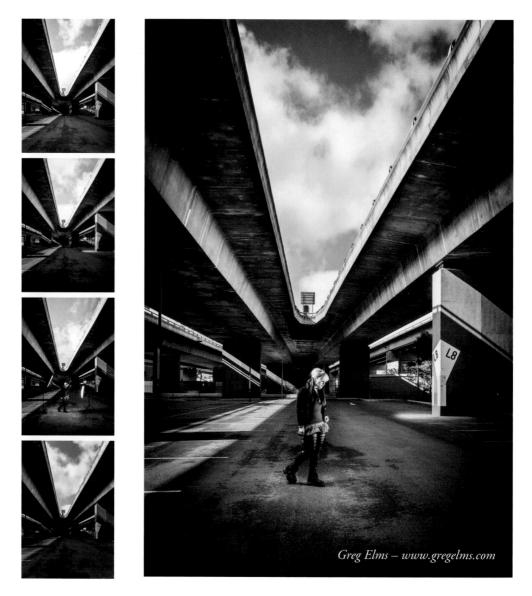

Smart fixed position composite - Project 6

The technique of creating a fixed position composite image gives the photographer the freedom to solve difficult lighting or staging problems, e.g. if you don't have more than two lights but need to light a large location, you can simply light each component of the location separately and combine the elements in post production. If the model needs to be floating in mid air then all you need to do is capture one image without the model and then another with the model balanced on a chair, then simply mask out the chair in post production. As all of the elements are being captured in the same location with the camera's position fixed using a tripod, this gives the photographer the ability to simply mask with a large soft-edged brush instead of making complex selections and using the Refine Edge or Refine Mask techniques. In this project we will preserve the Raw files in the Smart Objects so that the final outcome is completely non-destructive.

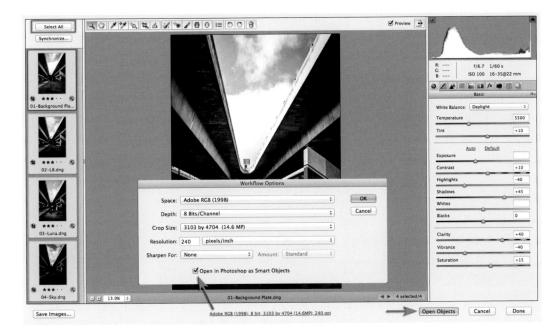

1 Select all the four project files and open in ACR. The four Raw (DNG) files for this project have already been optimized so you can choose the Select All and then click on the Open Object button in the bottom right-hand corner of the ACR dialog (either check the Open in Photoshop as Smart Objects option in the Workflow Options dialog or hold down the Shift key to change the Open Image button into a Open Object button).

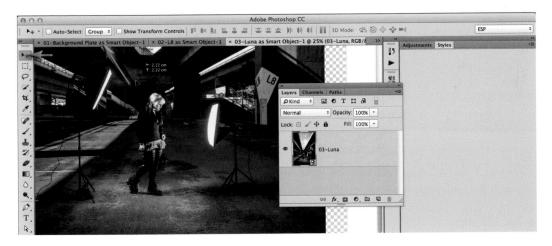

2 Select the Move tool from the Tools panel and click and drag each layer from the 'Luna', 'Sky' and 'L8' images onto the Background Plate image tab below the Options bar. Hold down the Shift key as you let go of the mouse click to ensure all layers are aligned.

Note > If you are working on a Mac computer, choose Application Frame from the bottom of the Window menu to see the files as a series of tabs.

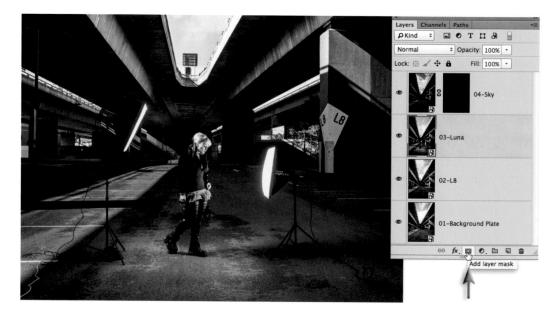

3 We can now proceed to add 'Hide All' layer masks to the top three layers. Select each layer in turn, Hold down the Shift key and click on the Add layer mask button at the base of the Layers panel. The Background Plate layer does not need a mask.

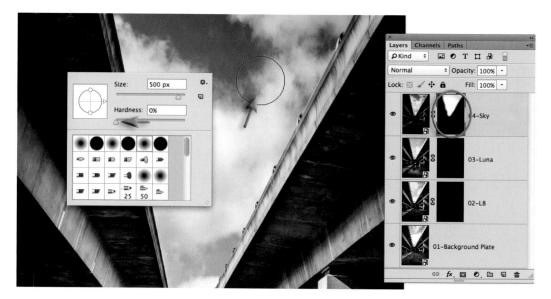

4 We can now start the process of merging selected areas from each of the four layers. Select the Brush Tool from the Tools panel and select a large soft-edged brush (set the Hardness to 0%). Set the Opacity of the brush to 100% in the Options bar. Select the layer mask on the Sky layer and then paint over the sky in the image to reveal the darker exposure in this area. There is no need for accuracy when painting, and it is OK to extend into the edges of the Freeways to darken these areas as well.

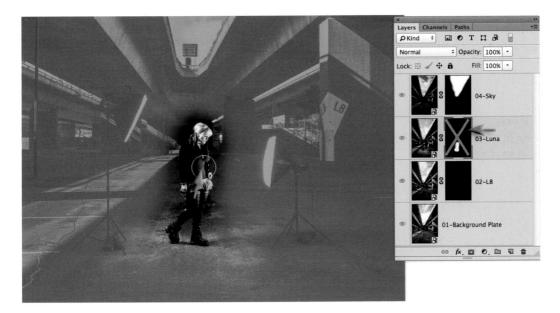

5 We will now reveal Luna (the model) on the layer below. It is easier to reveal Luna if we view the layer mask as an overlay and then disable the layer mask before we start painting. We can show the mask as an overlay by holding down the Shift + Alt keys (PC) or Option + Shift keys (Mac) and clicking on the layer mask. Now disable the layer mask by holding down the Shift key as we click on the mask a second time. With white as the Foreground color, paint over Luna and her shadow, taking care not to paint over either of the light stands. When this action is complete click on the Image thumbnail in the Layers panel to hide the mask overlay and then shift-click the mask to enable the layer mask.

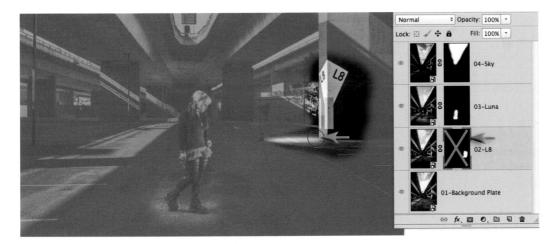

6 Repeat the process outlined in the previous step on the L8 layer to reveal the additional lighting on the L8 sign on the right side of the image. As you paint over the pool of light on the ground take care not to include the electric cable trailing across the ground.

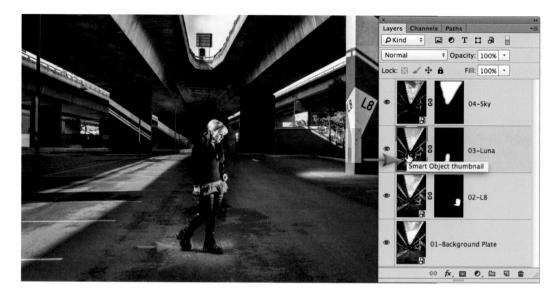

7 As the four Smart Objects all contain the Raw files it is an easy matter to modify the color or tone of any of them by simply double-clicking on the Smart Object thumbnail to open the embedded file in ACR. In this project I would like to fine-tune the tone and color of the ground surrounding Luna's feet to make the white balance and tone closer to the surrounding pavement. Double-click the Image thumbnail to open Luna in ACR.

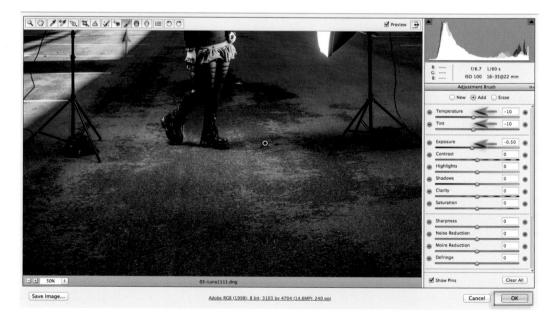

8 In ACR, select the Adjustment Brush and lower the Temperature and Tint sliders to -10 and lower the Exposure slider by half of a stop (approximately -0.50). Paint over the area around Luna's feet and then select OK in the bottom right-hand corner of the ACR dialog to update the composite image.

Composite projects

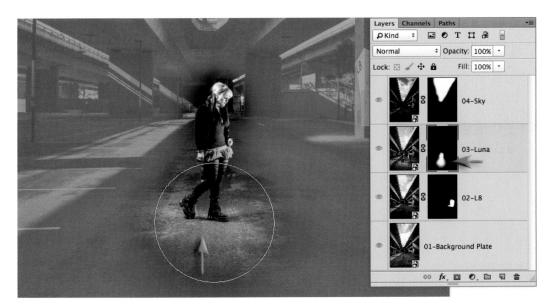

9 Now that we have updated the color and tone of the ground surrounding Luna's feet we can extend the painting in this area. It is again important to keep clear of the light stands when adding this information to the composite view.

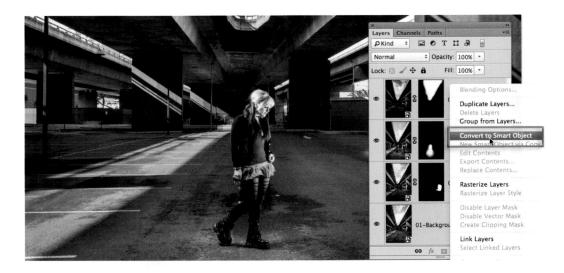

10 Now that we have the best information from the four files in this fixed position composite we can continue to grade the completed file as if it was a single layer. To maintain the non-destructive workflow we will neither flatten the file nor create a merged layer. We will, instead, select all four layers (hold down the Shift key as you click the top and bottom layers to select them all) and convert them into a single Smart Object (right-click to access the context menu).

Note > If at any time we need to modify one of the four component images we simply need to double-click the Smart Object thumbnail to open the multilayered file inside.

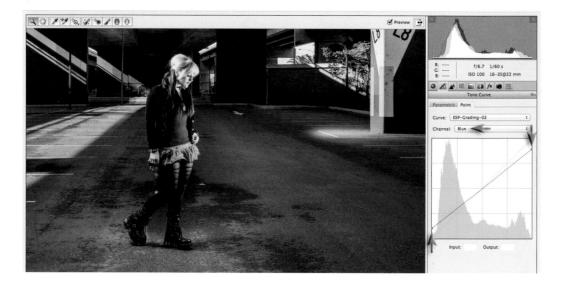

1 1 To open the composite file into ACR go to Filter > Camera Raw Filter. When the file opens in ACR we can now continue to grade the image using the tone and color controls inside of ACR. I have added Contrast and Clarity to the file and a Tone Curve adjustment to add blues to the shadow and yellows to the highlights (see the Special Effects chapter for more information) and then a Post-Crop Vignette from the Effects panel before selecting OK.

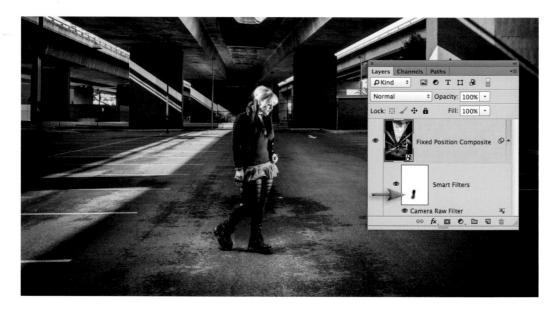

12 As these adjustments are applied as a Smart Filter to the Smart Object we have managed to work in a completely non-destructive way at every stage of the process, i.e. we can still access the Raw data of every component image and modify any of the settings of the final grading treatment. As the Smart Filter has a mask we can conceal any of the grading if required by painting directly into the mask.

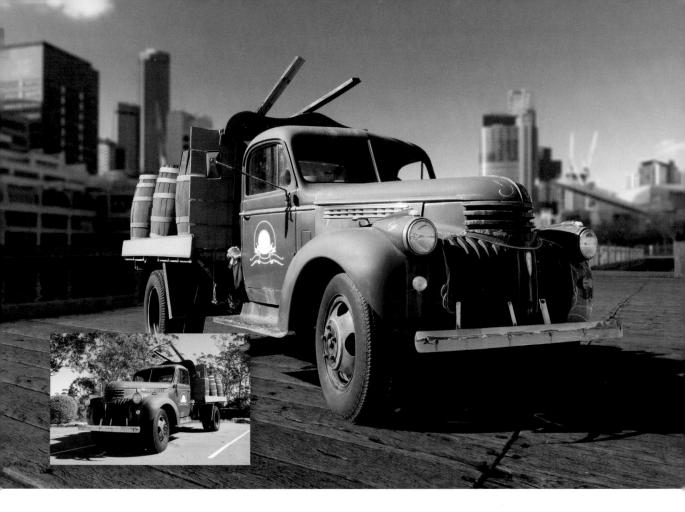

Preserving shadows – Project 7

The techniques outlined in this project will enable the shadow from the original location to be retained when the subject is placed in a new location (saving the need to create an artificial one). When a subject is relocated there will usually be some additional work that needs to be carried out in order to create a realistic end-result. Sometimes a subject cannot be introduced into a particular location because of inconsistencies in the capture technique or lighting quality. It usually makes sense to capture the subject to match the location rather than having to scour the environment to find a location with the appropriate lighting to match your subject.

Critical factors in the creation of a realistic montage are:

- Continuity of vantage point the camera angle to the subject and the background should be the same unless you are scaling a subject so that it appears smaller or larger than normal.
- Continuity of depth of field if in doubt shoot both the subject and the background at a small aperture and reduce depth of field in post-production.
- Continuity of perspective keep the same relative distance from your subjects (zoom in rather than moving close to small objects).
- Continuity of lighting the angle of light source to the subject and background and the quality of lighting (harsh or diffuse) should be the same.

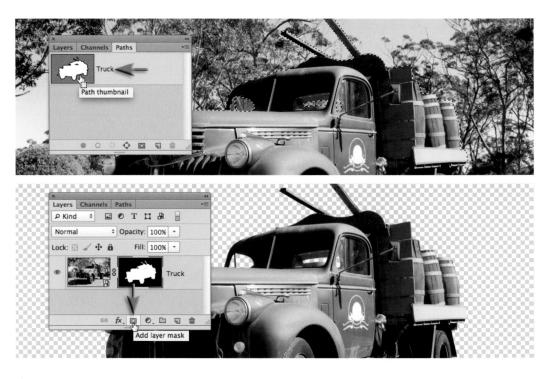

1 Open the project image and go Filter > Convert for Smart Objects. Then go to the Paths panel to locate the saved path. This path was created using the Pen tool and can now be loaded as a selection by holding down the Ctrl key (PC) or Command key (Mac) and clicking on the thumbnail. Go to the Layers panel and click on the 'Add layer mask' icon at the base of the Layers panel to hide the background pixels.

	Refine Mask	
đ	View Mode View: Show Radius () Show Original (P)	
Y	Edge Detection	
	Adjust Edge 0	
	Feather: 0.8 px Contrast: 0 0 %	
	Shift Edge:	
	Decontaminate Colors	
	Output To: Layer Mask	

2 As the selection was created from a Path we will need to refine the edge for the composite to appear believable. From the Selection menu choose Refine Mask. Select the On Black option from the View drop-down menu and then create a slightly softer edge by raising the Feather Radius to 0.8 pixels and drag the Shift Edge slider to -15 to hide any of the old background pixels that may remain. Select OK to apply these adjustments to the layer mask.

Composite projects

3 In this step we will isolate the shadow from the surrounding detail. Hold down the Ctrl key (PC) or Command key (Mac) and click on the layer mask thumbnail in the Layers panel to load a selection from the mask. Hold down the Shift key and then click on the layer mask on the truck layer to hide its visibility. Choose a Levels adjustment layer from the Adjustments panel and from the Masks panel choose Invert or use the keyboard shortcut Ctrl + I (PC) or Command I (Mac). Drag the white Input Levels slider to the left until it clips the tones around the shadow to white. You can hold down the Alt key (PC) or Option key (Mac) to access the Threshold view so that you see when the tones clip to white. Setting the mode of the Levels adjustment layer to Luminosity will prevent the color of the shadow from becoming more saturated.

4 We will now render all the tones that are not the truck, or its shadow, as white. Ctrl click (PC) or Command click (Mac) the Levels layer mask to load it as a selection and then choose the Solid Color adjustment layer option from the 'Create new fill or adjustment layer' icon at the base of the Layers panel. Select the Only Web Colors options and then click on the white color in the top left-hand corner of the color picker. Select OK to create a Color Fill layer.

ALTERNATIVE TECHNIQUE TO CREATE A FILL LAYER

A fast way of creating a white or black fill layer would be to use the keyboard shortcut D to set the Default foreground and background color swatches followed by Ctrl + Alt + Shift + N (PC) or Command + Option + Shift + N (Mac) to create a new empty layer and then use the keyboard shortcut Alt + Backspace (PC) or Option + Delete (Mac) to Fill with Foreground Color, or Ctrl + Backspace (PC) or Command + Delete (Mac) to Fill with Background Color. The layer mask could then be duplicated from the layer below by holding down the Alt/Option key as you drag it to the fill layer. Although this is a little faster, if we need to resize the subject smaller in its new location we will have to be careful to refill this layer to prevent edge artifacts appearing in the final composite image.

5 Drop the Opacity of the layer to around 70% so that you can see the underlying shadow below and then select the Brush tool from the Tools panel. Set the foreground color to black and set the Opacity to 100% and select the layer mask to be the active component of the fill layer. I am using a large brush, with the Brush Hardness set high, to paint over the shadow I can see. The accuracy of this painting action is not important as the Levels layer is clipping the surrounding tones to white. Be careful not to paint over any detail you can see that is not part of the truck's shadow. Return the layer to 100% Opacity when done.

Composite projects

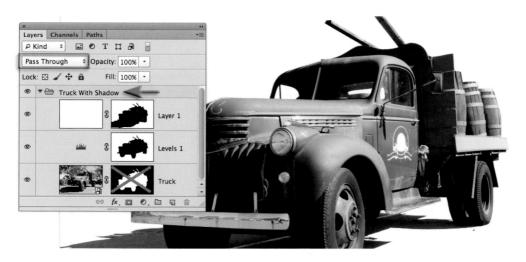

6 Hold down the Shift key and click on the Truck layer to select all three layers. Then use the keyboard shortcut Ctrl + G (PC) or Command + G (Mac) to group the layers. You name a group in the same way that you name layers. The layers can now easily be transferred to the new location in one action. Save this file as a Photoshop document (PSD).

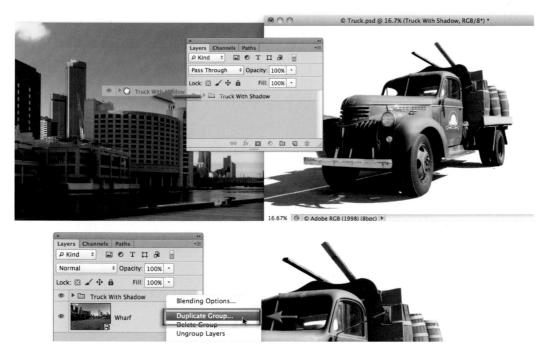

7 Open the new background image and drag the group from the Layers panel onto the new image. Hold down the Shift key before you let go of the mouse button to center the image. If you cannot see both images at the same time you can use one of the Tile or Float options by going to Window > Arrange. After the group has been placed in the new image right-click the group and choose Duplicate Group from the context menu

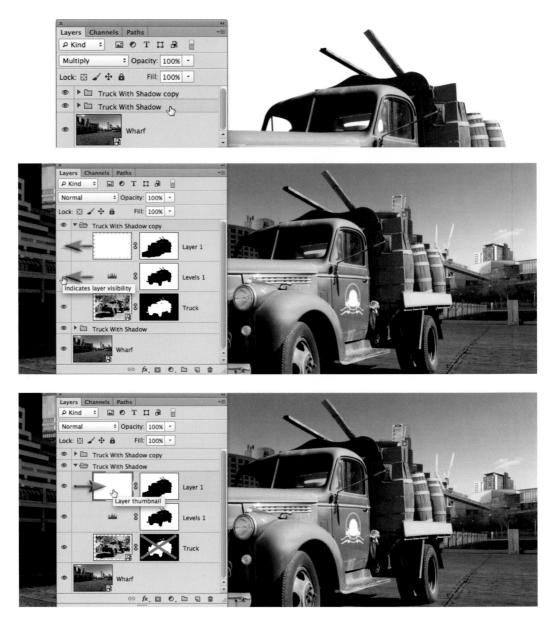

8 Set the mode of the bottom group to Multiply and click on the top group to select it. Expand the group by clicking on the small folder icon. Switch off the visibility of the Levels adjustment layer and Fill layer in this group and Shift-click to turn the truck mask back on. Your subject and its shadow should now appear without the background in the new location. If you have used a regular Fill layer, rather than one from the 'Create new fill or adjustment layer' menu you may need to expand the bottom group and refill the Fill layer to remove any edge artifacts that may have appeared. The light source lighting the location and the truck are coming from different directions so we will have to correct this if the composite image is to look believable.

9 Collapse each group and Shift-click both layer groups to select them and then click on the link icon at the base of the Layers panel. This will ensure that the truck and its shadow stay in perfect alignment when they are moved and scaled. Use the keyboard shortcut Ctrl + T (PC) or Command + T (Mac) to access the Free Transform command and then right-click inside the Transform bounding box and choose Flip Horizontal from the context menu.

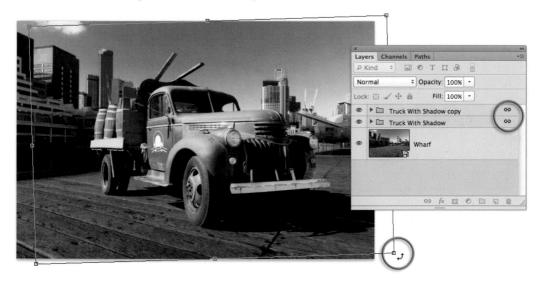

10 We can also scale and rotate the image by moving the mouse cursor to one of the corner handles. Hold down the Shift key and drag a corner handle to scale the image and move the cursor to just outside the corner handle to access the Rotate icon. As you move, rotate and scale the image you need to ensure the shadow extends beyond the edge of the canvas. You can scale the truck and its shadow as many times as you like without any loss of quality as the image layers inside of the groups are Smart Objects (the Smart Objects retain their original resolution even when scaled smaller).

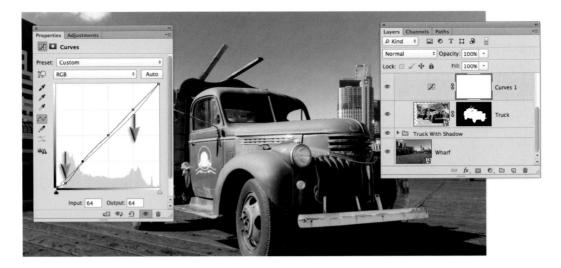

11 Adjustments will be required to ensure the tonal and color quality of the truck and the new background are consistent. Expand the top layer group and click on the truck to make it the active layer. Choose a Curves adjustment from the Adjustments panel. To ensure any adjustment we make to the truck does not affect the background, we need to change the mode of this top group from Pass Through to Normal. In the Curves dialog I have created a curve that darkens the shadow tones of the truck so they match the darker tones of the host image. I have also lowered the Curve in the Blue channel so that the two images appear to share the same white point.

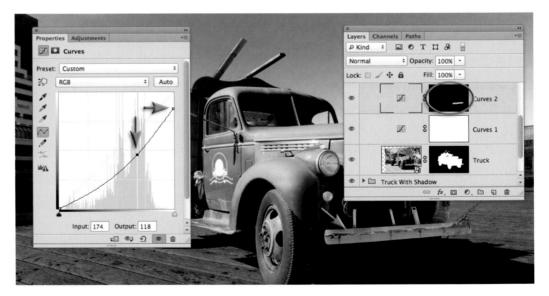

 $12\,$ I have created an additional Curves layer that darkens the highlights significantly and then filled the layer mask with black to conceal this adjustment (alternatively you can click Invert in the Masks panel). I can then paint with the Brush tool with the Foreground Color set to white to darken the chrome fender of the truck.

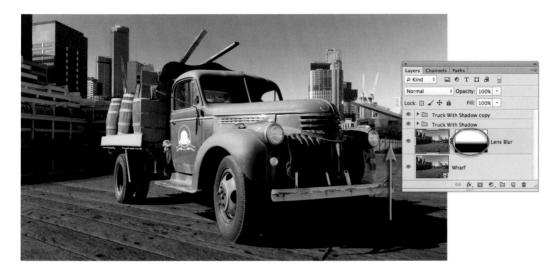

13 To decrease the depth of field for the background image we must first duplicate the layer (right-click and choose Duplicate from the context menu). If you have opened the new background from Adobe Camera Raw as a Smart Object, right-click a second time and choose Rasterize Layer (Lens Blur cannot be applied to a Smart Object). Click on the 'Add layer mask' icon at the base of the Layers panel and then drag a short Black, White gradient from a short distance behind the truck to a position just short of the horizon line.

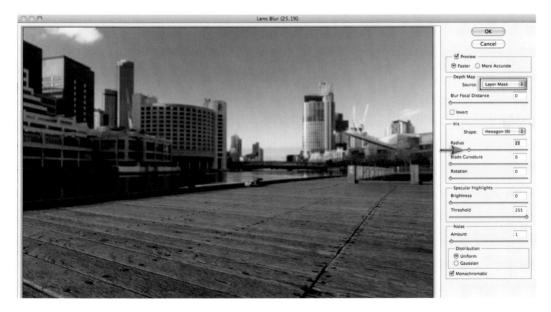

14 Click on the Image thumbnail to make this the active component of the layer and then go to Filter > Blur > Lens Blur. From the Depth Map section choose Layer Mask from the Source drop-down menu. Drag the Radius slider to the right to decrease the focus of the background. Raise the Amount slider in the Noise section to 1% and then select OK.

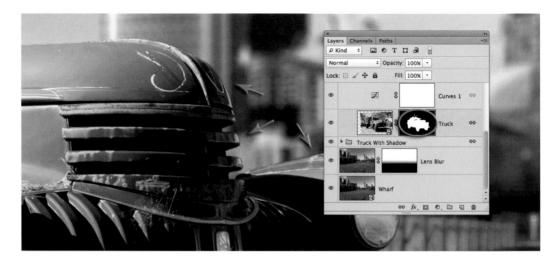

15 Zoom in to 100% Actual Pixels and check the edge of the truck for any areas of the mask that may need further refinement. Global adjustments can be carried out by choosing the Refine Mask option in the Select menu. Localized adjustments to just one section of the mask can be carried out by using the techniques covered in earlier projects of this chapter (selecting a section of the mask and then using a Levels adjustment or the Minimum and Maximum filters).

ADJUSTING SHADOW DETAIL

Use the Healing Brush tool or Clone Stamp tool to remove unwanted detail from the shadow. When using a Smart Object this will have to be applied by adding an empty new layer and setting the tool to All Layers in the Options bar. To ensure a clean repair you may find it easier to temporarily switch the visibility of the other layers Off and the mode of the layer group back to Normal. Unwanted texture can be removed from a shadow by applying a Smart Blur or Gaussian Blur filter as a Smart Filter.

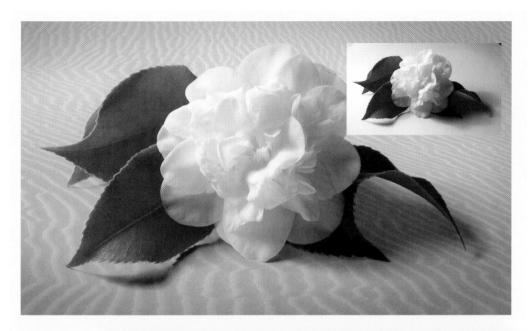

THE BEST TECHNIQUE FOR SUBTLE SHADOWS

This technique of preserving shadows provides those photographers burdened with a meticulous eye a useful way of retaining and transplanting subtle and complex shadows. Observe the subtle shadow cast by the leaf above that would be virtually impossible to recreate using any other means. The primary reasons for not being able to use this technique are when the shadow falls over a surface with a different texture to the one in the new location, or the surface over which the shadow falls is particularly uneven or moves from a horizontal to a vertical plane over the length of the shadow.

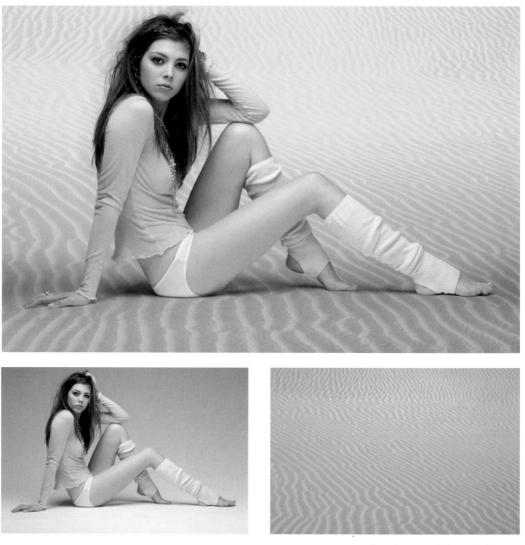

Studio photograph by Rahel Weiss.

Replacing a studio background – Project 8

This project combines the skills learned from both the Refine Edge project (Project 1) and the Preserving shadows project (Project 6). The purpose of this project is to demonstrate how the model's fine hair and the original shadows from the studio backdrop (cyclorama or 'cyc') can be preserved when creating a composite image using a new location image. When photographing a subject in a studio that is destined to be used in a composite project the primary considerations will be to match the lighting conditions of the new location and to ensure that there is sufficient edge contrast for the Refine Edge to extract the fine detail easily. This may require additional lighting for the background or the use of an overly illuminated green or blue screen or white backdrop can cause color fringes on the edge of your subject that will create significant problems.

Composite projects

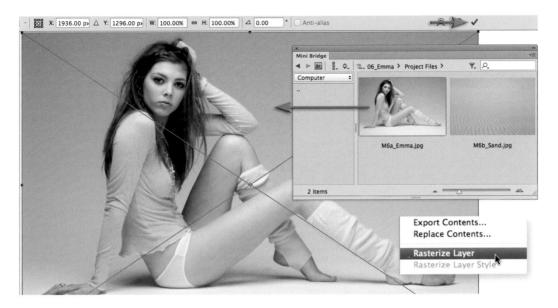

1 Drag the file of the model onto the preview of the Sand project image (this can be directly from the folder of images or from Mini Bridge). Hit the Commit icon in the Options bar and right-click on the layer of the model in the Layers panel and choose Rasterize Layer as we are not intending to re-scale this layer.

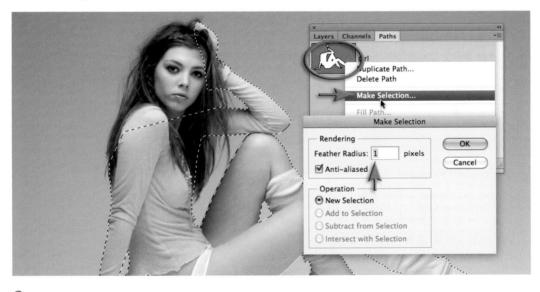

2 Make a selection of the model. A path has been created around all of the harder edges for this model. You can load this as a selection by going to the Paths panel and then right-clicking on the path titled 'Girl'. Enter a value of 1 pixel in the Feather Radius field and then select OK.

Note > You can Ctrl + Click (PC) or Command + Click (Mac) the path thumbnail and override the Make Selection dialog but Photoshop will apply the setting last used in this dialog.

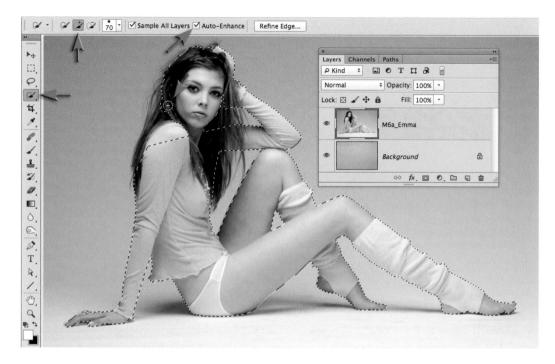

3 Complete the selection using the Quick Selection tool from the Tools panel with the Auto Enhance option checked in the Options bar. Try to avoid selecting any areas of hair where you can see background through the strands.

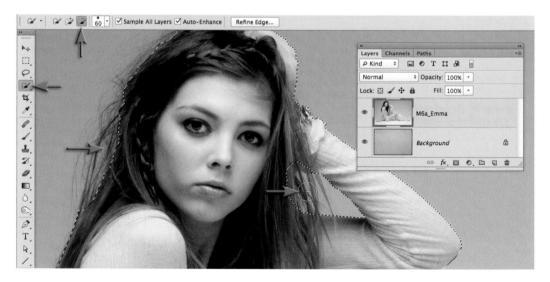

4 You can remove any areas of hair that do have background showing by reducing the size of the brush and selecting the 'Subtract from selection' icon in the Options bar (or by holding down the Alt or Option key) and then dragging the Quick Selection tool over these areas. Take your time to address each area in turn – one click at a time – to create a good selection that includes none of the background.

Com	nooit		ojects
	ipositi	s pr	JECIS

	Refine Edge
	View Mode Image: Show Radius (j) View: Show Original (P)
	Edge Detection Smart Radius Radius:
The state	Adjust Edge Smooth: 0 0.0 px
	Contrast: 0 % Shift Edge: 0 %
E A d	Decontaminate Colors Amount: S Output To: Selection
	Cancel OK

5 When the selection is complete click on the Refine Edge button in the Options bar and select the On layers option from the View drop-down menu in the Refine Edge dialog. Paint over any areas of hair that are missing from view, taking great care not to paint into any of the areas that contain solid subject. Zoom in and work close when working up against the hand at the top of the image and the hair falling in the center of the image.

	Refine Edge
	View Mode Image: Show Radius (j) Image: View: Image: Show Original (P)
10 - and a second	Edge Detection Smart Radius Radius: 0.0 px
	Adjust Edge Smooth: 0
	Feather: 0.0 px Contrast: 0 % Shift Edge: +20 %
	Output
A MARINA	Amount: 80 % Output To: New Layer with Layer Mask
	Remember Settings Cancel OK

6 Check the Decontaminate Colors checkbox and raise the Amount slider to 80%. Drag the Shift Edge slider in the Adjust Edge section to a value of 20%. You do not need to make any adjustments to any of the other sliders as the path was accurate and feathered during the process of creating a selection. Select OK to apply the refinements.

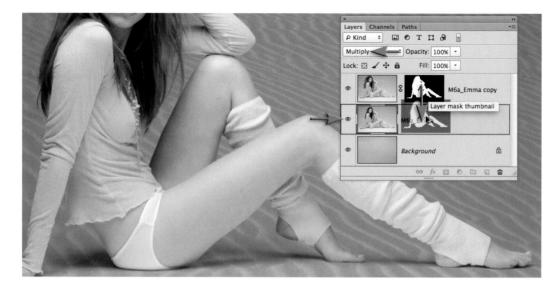

7 Choosing the Decontaminate Colors option in the Refine Edge dialog will lead to the creation of a new layer and layer mask. Switch the visibility of the original layer below this new layer back on and set the mode to Multiply. Hold down the Alt/Option key and drag the layer mask from the copy layer to the layer below.

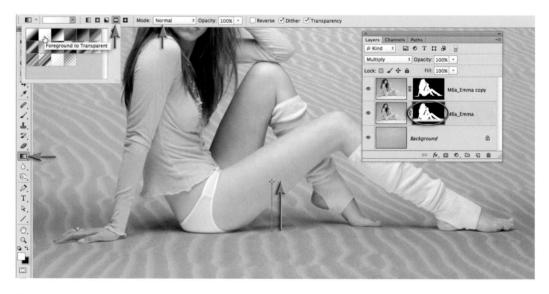

8 Click on the layer mask you have just copied to make sure it is the active component of the layer. Select the Gradient tool from the Tools panel and set the Foreground Color to white (press D on the keyboard to restore the Default Colors). Choose the Foreground to Transparent gradient preset and the Reflected Gradient option in the Options bar and set the Mode to Normal. Click in the image preview and drag a short gradient starting from a position where the model touches the floor. This action will restore the shadow that is on this layer courtesy of the Multiply blend mode.

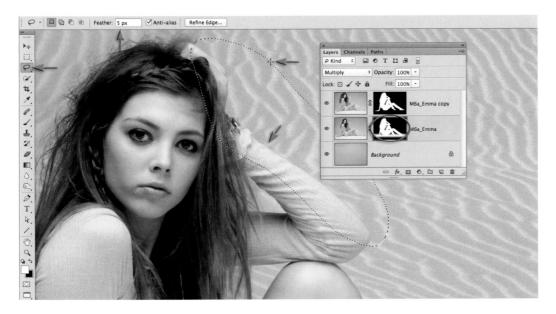

9 Switching the original layer back on may introduce dark edges around some areas of the subject. If this occurs select the Lasso tool and enter a 5-pixel value in the Feather Radius field in the Options bar. Select the layer mask on the original subject layer (the one set to Multiply) and make a selection around any edge that requires refinement.

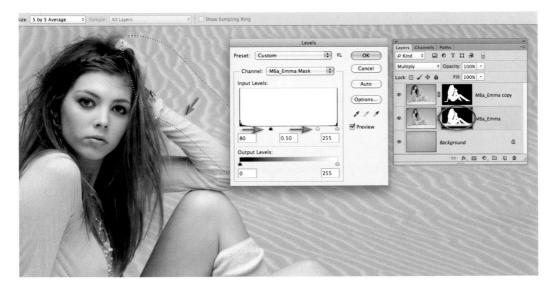

10 Use the keyboard shortcut Ctrl + L (PC) or Command + L (Mac) to open the Levels dialog and then drag the central Gamma slider and the black Input Levels slider to the right to expand the mask and hide the problematic dark edge. You can repeat this process quickly on any other area that requires the same treatment by making a Lasso selection and then using the keyboard shortcut Ctrl + Alt + L (PC) or Command + Option + L to open a Levels dialog with the settings last used.

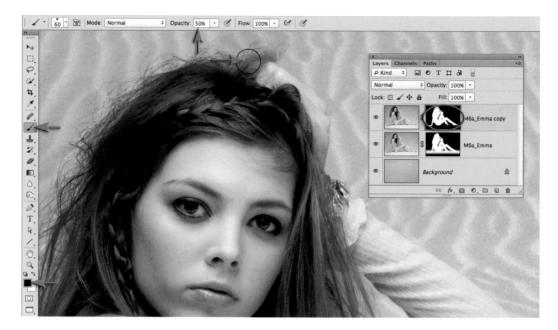

 $1\,1\,$ The Decontaminate Colors options used in the Refine Edge dialog may have created some contamination errors. This can be resolved by painting with the Brush tool in the layer mask of the top layer with the Foreground Color set to black and the Opacity set to 50%, or less, in the Options bar.

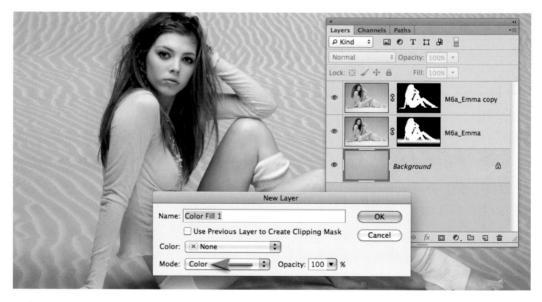

12 In the following two steps we will match the color of the new location to the garment the model is wearing. Select the Background layer and hold down the Alt/Option key while clicking the Solid Color fill option from the 'Create new fill or adjustment layer' menu at the base of the Layers panel. Set the Mode to Color and select OK.

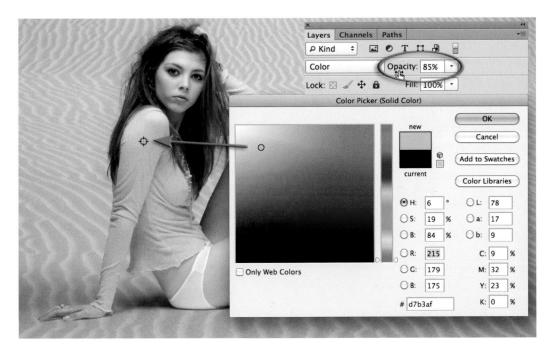

13 When the Color Picker opens move your mouse cursor into the image and click on the garment before selecting OK. You can lower the Opacity of this color fill (solid color) layer to partially restore some of the original color values.

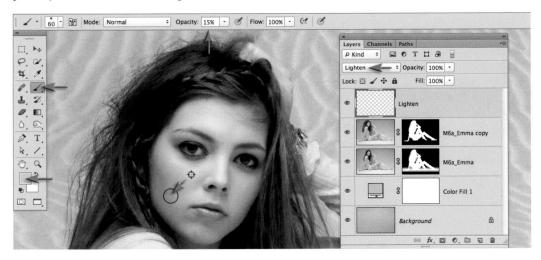

14 To complete this composite image we can modify a slight shadow on the model's face. Create a new layer and set the mode of the layer to Lighten. I have renamed the layer by double-clicking the name of the layer. Select the Brush tool in the Tools panel and hold down the Alt/Option key to sample a color from the brighter portion of the cheek. If the color does not appear in the Foreground Color swatch make sure you have the Eyedropper tool Sample option set to All Layers. Set the Opacity of the Brush to 15% and paint over the darker shadows of the face in order to even out the lighting.

High Dynamic Range (HDR) - Project 9

Contrary to popular opinion, what you see is not what you always get. You may be able to see the detail in those dark shadows and bright highlights when the sun is shining – but can your CCD or CMOS sensor? Contrast in a scene is often a photographer's worst enemy. Contrast is a sneak thief that steals away the detail in the highlights or shadows (sometimes both). A wedding photographer will deal with the problem by using fill flash to lower the subject contrast; commercial photographers diffuse their own light source or use additional fill lighting and check for missing detail using the 'Histogram'.

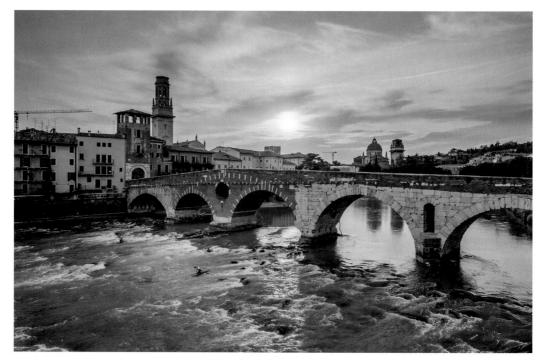

Bridge over the Adige River, Verona, Italy by Mark Galer

Landscape photographers, however, have drawn the short straw when it comes to solving the contrast problem. For the landscape photographer there is no 'quick fix'. A reflector that can fill the shadows of the Grand Canyon has yet to be made and diffusing the sun's light is only going to happen if the clouds are prepared to play ball.

Note > The dynamic range of camera sensors and film cannot compete with the dynamic range of human vision so high contrast has always been a problem for photographers. When the Subject Brightness Range (SBR) exceeds the Dynamic Range (DR) of the sensor, the excessive contrast can result in a loss of detail in the highlights and/or shadows. HDR photography uses techniques to resolve this problem and/or enhance detail throughout the contrast range of the image.

Ansel Adams (the famous landscape photographer) developed the 'Zone System' to deal with the high-contrast scenes. By careful exposure and processing he found he could record highcontrast landscapes and create a black and white print with full detail. Unlike film, however, the latitude of a digital imaging sensor (its ability to record a subject brightness range) is fixed. In this respect the sensor is a straitjacket for our aims to create tonally rich images when the sun is shining – or is it? Here is a post-production 'tone system' that will enrich you and your images.

Note > To exploit the full dynamic range that your image sensor is capable of, it is recommended that you capture in Raw mode. JPEG processing in-camera may clip the shadow and highlight detail (see Adobe Camera Raw).

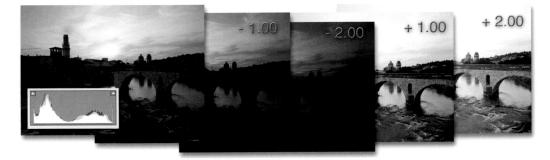

If we can't fit all the goodies in one exposure, then we'll just have to take two or more. The idea is to montage, or merge, the best of both worlds (the light and dark side of the camera's not quite all-seeing eye). To make the post-production easier we need to take a little care in the pre-production. We need to 'bracket' five exposures. Capture an image using the meter-indicated exposure (MIE) from the camera and then take two shots underexposing by first one stop, then two stops and repeat the process overexposing by one stop and then two stops from the MIE. Two stops either side of the meter-indicated exposure should cover most high-contrast situations. Using a tripod helps the process but is not essential.

Note > If you intend to use the 'Automate > Merge to HDR Pro' feature, Adobe recommends that you use the shutter speed rather than the aperture to bracket the exposures. This will ensure the depth of field is consistent between the exposures.

BRACKETING EXPOSURES

If you use a tripod (because you do not want to trust to Auto Aligning the images) you have the option of setting your camera to 'auto bracket exposure mode'. This means that you don't have to touch the camera between exposures, thereby ensuring the exposures can be exactly aligned with the minimum of fuss. Use a cable release or the camera's timer to allow any camera vibration to settle. The only other movement to be aware of is something beyond your control. If there is a gale blowing (or even a moderate gust) you are not going to get the leaves on the trees to align perfectly in post-production. This also goes for fast-moving clouds, leaves, animals and anything else that is likely to be zooming around in the fraction of a second between the first and second exposures. There is a Remove Ghosts option in the Merge to HDR Pro feature that may work in some instances to reduce or eliminate 'ghosts' from moving people or objects.

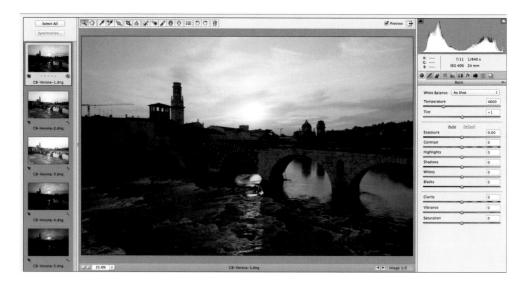

1 Select and open the five Raw project files into Adobe Camera Raw by holding down the Shift key as you select the range of images. The first image was captured using the Meter Indicated Exposure using the Aperture Priority exposure mode. A further four exposures were captured during the bracketing burst. The images for this project were all captured hand-held. The aim of opening these files in ACR is so that we can optimize the images prior to merging the exposures.

🕑 Preview 🕒	• 1	Ð	•		•	1		6
	5	- Ner		~	7/		10	
	R: f/11 1/640 s G: ISO 400 24 mm		R: f/11 1/64 G: ISO 400 24 m		R: G: B:	1/11 1/04		Herord 20
	Lens Corrections				0 1	Lens Corrections		18.4
-	Profile Color Manual	tion	Profile Color Manual	erration	Profile	Color Manual		
	Defringe Purple Amount	0	Defringe Purple Amount	0		Sync. Results Rea	nabize	
	Purple Hue	30 / 70	Purple Hue	30 / 70	Dist	Transform ortion	0	
	Green Amount	0	Green Amount	0	Vert	ical	0	-
	Green Hue	40 / 60	Green Hue	40 / 60	Hori	zontal	0	1
	00		0 0		O Rota	ite	0.0	0
					Scal		100	-
					Asp	act	0	0
					Amour	Lens Vignetting	0	
					Midpol	nt		
H P Image 1/5	Show Grid		Show Grid		Show	v Grid		

2 Go to the Lens Corrections panel and check the Enable Lens Profile Corrections in the Profile tab. Check the Remove Chromatic Aberration checkbox and Click on the A in the Upright section of the Manual tab. This will optimize the lens corrections for this image.

Composite projects

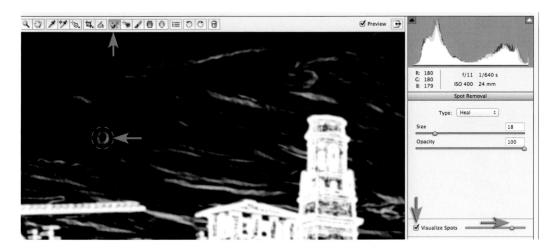

3 Select the Spot Removal tool in the Tools panel and check the Visualize Spots option. Raise the slider until you can see the dust spot to the left of the bell tower. Raise the Radius slider to a size just larger than the spot and then click on it to heal the spot. Click on the Hand tool to exit the Spot Removal panel.

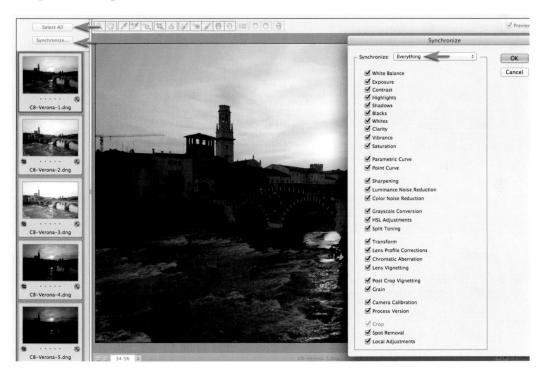

4 Click the Select All button in the top left-hand corner of the ACR dialog and then click the Synchronize button. In the Synchronize dialog choose Everything before selecting OK. Click the Done button in the bottom right-hand corner of the ACR dialog to commit these settings to the Raw files and close the ACR dialog.

5 Go to File > Automate > Merge to HDR Pro. From the dialog that opens click the Browse button and locate the same five files that you just finished optimizing in ACR. Make sure the Attempt to Automatically Align Source Images is checked and then select OK to start the HDR processing. The process may take some time, so be prepared to wait a while.

	e Files se two or more files from a	set of e	xposures	OK
	erge and create a High Dyna			Cancel
Use:	Files	•		
	C8-Verona-1.dng C8-Verona-2.dng		Browse	
	C8-Verona-3.dng C8-Verona-4.dng		Remove	
	C8-Verona-5.dng		Add Open Files	
L				

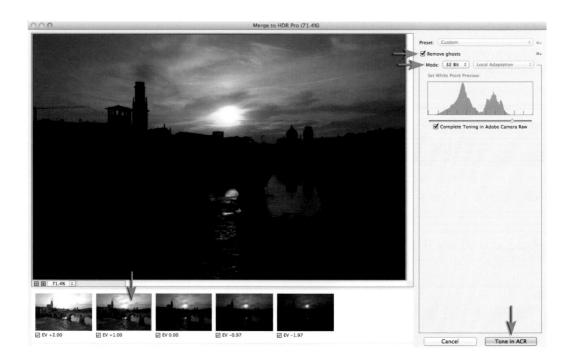

6 The five files will appear in the Merge to HDR Pro dialog along with a large preview of the merged version. This preview will appear very flat until it is optimized. Check the Remove Ghosts option so that the ghosts are removed from the canoeists on the river and click on one of the image thumbnails below the preview to select the optimum detail in the water. Set the Mode to 32 Bit and click on the Tone in ACR button in the bottom right-hand corner of the Merge to HDR dialog.

Note > The Tone in ACR feature is new to the CC version of Photoshop and can offer improved toning to the controls that appear in 16 Bit mode in the Merge to HDR dialog. The advantage of using the Tone in ACR feature is that the toning will be applied to the 32 bit image as a non-destructive smart filter.

Composite projects

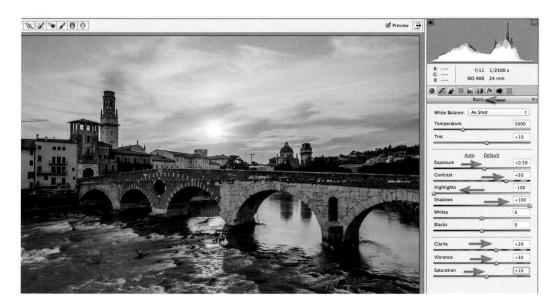

/ When the 32 bit image opens in Adobe Camera Raw the image will still appear flat (low in contrast with little detail in the highlights or shadows). Move the Exposure slider to +0.50, the Highlights slider to -100 and the Shadows slider to +100 to balance the highlight and shadow exposures and then raise the contrast by increasing the contrast to +50 and the Clarity to +30. After raising the Vibrance slider to +30 and the Saturation slider to +10 the image should now look a lot more dramatic than when the image first opened.

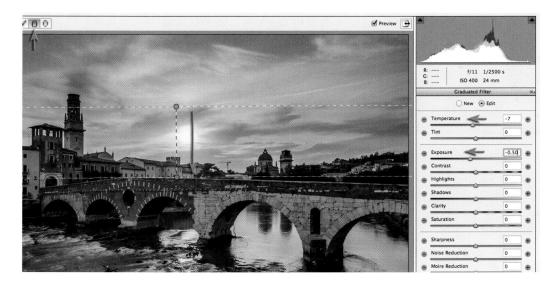

8 The exposure can be further balanced by adding a Graduated Filter. In this image a value of -0.50 has been used and the Temperature slider moved to a value of -7 to ensure we have a clean blue sky in the image.

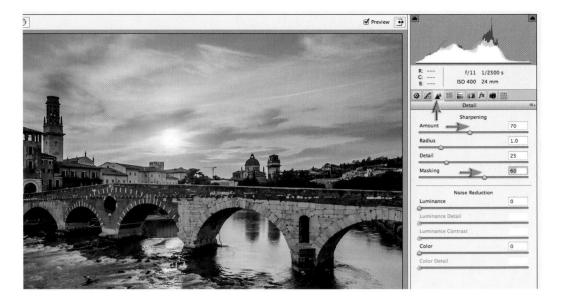

Go to the Detail panel and add sharpening to taste. I have raised the Amount slider to +70 and the Masking slider to +60 to ensure the smooth areas of tone stay noise free.

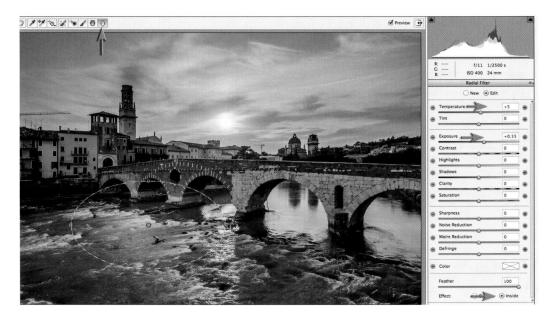

Go to the Radial filter and set the temperature slider to +5 and raise the Exposure slider to +0.55. Click on the Inside radio button at the base of the panel. Hold down the Ctrl + Alt keys (PC) or Command + Option keys (Mac) and drag an ellipse around the canoeists on the river. This should give the effect of bathing them in a little warm sunshine.

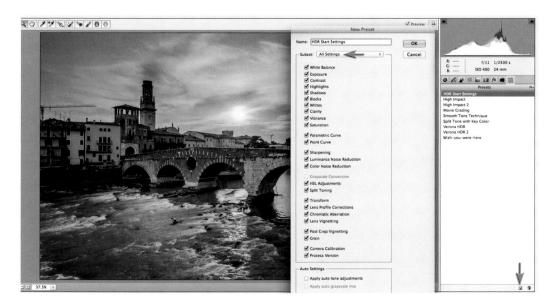

11 As most HDR images require a similar starting point when they arrive in Adobe Camera Raw, it is worth going to the Presets panel and saving a new preset. In the example above I have selected All Settings, as the localized settings (Graduated and Radial filters) are not saved with a Preset. Although this preset is unlikely to be the precise settings required for your next HDR project, it will provide you with a starting point that is a lot closer than ACR's default settings.

			X	Description of the second s	
			Layers		*=
			₽Kind ‡		
	-		Normal	+ Opacity: 100% +]
			Lock: 🖾 🖌]
			•	Layer 0	· •
	A de	MIRIN		Smart Filters	
	Toning	- MAN	the second	Smart Filters	
HDR			the second	Camera Raw Filter	- 5
HDR	Toning	OK	the second		and the second second
HDR Preset: Custom	¢ \$.	OK Cancel	the second	Camera Raw Filter	and the second second
HDR	¢ ¢.	Cancel	the second	Camera Raw Filter	and the second second
HDR Preset: Custom Method: Exposure and Gamm	; Ø.		the second	Camera Raw Filter	and the second second
HDR Preset: Custom	¢ ¢.	Cancel	the second	Camera Raw Filter	and the second second

12 When you select OK in the ACR dialog the settings will be applied as a non-destructive Camera Raw filter to the 32 Bit file which has been placed in a Smart Object. Although we have had HDR capability in Photoshop for quite some time, the ability to tone images in ACR is a giant leap forward for fans of this style of photography.

Note > When you come to save the image for printing you will need to drop the bit depth of the file to 16 or 8 Bits/Channel (Image > Mode). In the HDR Toning box that opens, select Exposure and Gamma from the Method menu and then select OK.

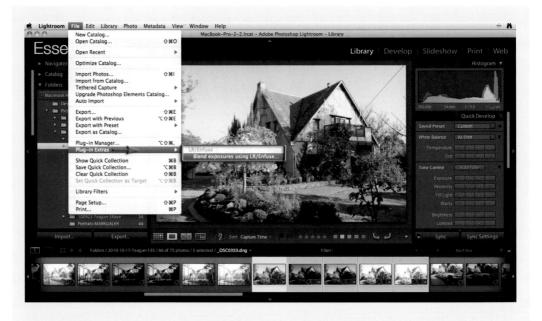

LR/ENFUSE

A fast and efficient alternative to Merge to HDR Pro (although not strictly HDR software) is LR/Enfuse. It is available as a plug-in for Adobe Photoshop Lightroom and aligns and blends or 'enfuses' bracketed exposures to create a realistic end-result without too much fuss (the default options get you there 90% of the time).

<u>o o</u> Lightroom Plu	g-in Manager
Canon Tether Plug	► User Registration
Installed and running	▶ Self Update
ColorChecker Pass Installed and running	Ort Debugging
Facebook Installed and running	V Status
Flickr Installed and running	Path: /Library/Application Support/Adobe/Lightroom/Modules/LREnfuse.Irplugin Show in Finder
Imagenomic Portra Installed and running	Web Site: http://www.photographers-toolbox.com/products/irenfuse.php
Leica Tether Plugin Installed and running	Version: 4.07 Status: This plug-in is enabled.
O LR/Enfuse	Enable Disable
	Plug-in Author Tools No diagnostic messages
MobileMe Gallery Installed and running	Acknowledgements
Nikon Tether Plug Installed and running	

Perhaps the best feature of the LR/Enfuse plug-in is that it only requires a donation to unlock the trial version. The plug-in uses an open source code called 'Enfuse' which is showcased in the next tutorial. Perhaps the only drawback of Enfuse is that it has no 'deghosting' feature.

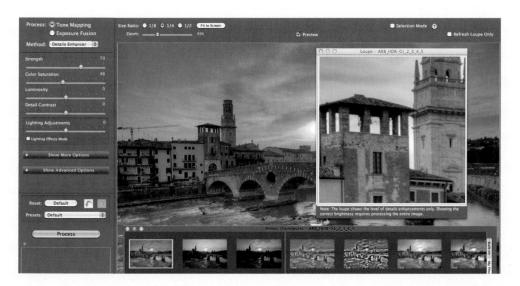

HDR EFFECT

Photomatix Pro is a standalone application with a plug-in for Lightroom. With a little effort you can create natural-looking images or you can enhance/exaggerate detail and localized contrast. This graphic 'illustrative' look has become very popular as a stylized treatment and can be replicated in Photoshop's Merge to HDR Pro by raising the Detail slider.

Note > The deghosting feature found in version 4 is a big improvement over version 3 but sometimes the removal of chromatic aberration is not as efficient as in Adobe Camera Raw.

A 'Faux HDR' look (where exaggerated tonal mapping is applied to single exposure) can be created by going to Image > Adjustments > HDR Toning. The look can also be created in Adobe Camera Raw by raising the Contrast and Clarity sliders very aggressively.

HDR – problems and solutions – Project 10

There is additional HDR software that has been popular in recent times such as Photomatix Pro and EnfuseGUI. EnfuseGUI uses the Enfuse technology developed by sourceforge.net that produces very realistic results with good localized contrast. The downside to EnfuseGUI is that it does not have an auto align option. Photomatix Pro has an Alignment option and an Attempt to Reduce Ghosting Artifacts option but these are generally not as effective as the Remove Ghosting feature in Adobe's Merge to HDR Pro.

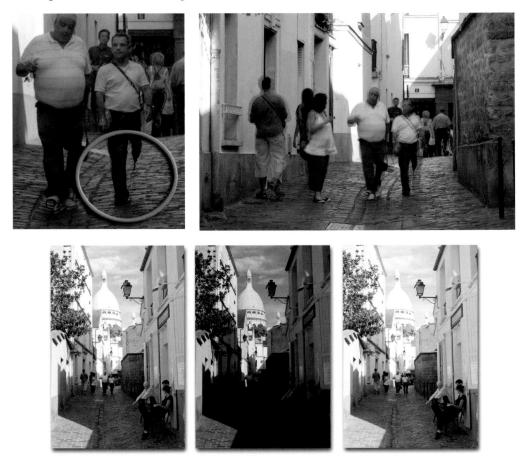

In some images where the movement is coming towards the camera, even Photoshop may not be able to remove ghosting completely (there is no single image in the bracket set where the contours of the moving shape or object are separated from the other images). In the illustration above we can see how, with or without the Remove Ghosting option selected, the outcome is less than perfect. In this project we will look how we can use the Auto-Align feature in Photoshop to align bracketed images (shot hand-held), merge the exposures using EnfuseGUI and then fix the ghosting and minor exposure errors in Photoshop using the Auto-Blend Layers option.

Note > EnfuseGUI is available for Windows and Mac operating systems and in return for a donation (the website suggests a \$10 donation!).

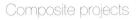

For enthusiasts of HDR imaging EnfuseGUI is an excellent alternative to Photoshop for merging bracketed images. The Enfuse technology from sourceforge.net is also available in a Mac-only GUI called Bracketeer that also has an alignment option (although very slow). Unfortunately the cost-effective EnfuseGUI software has no alignment option and cannot process Raw files. These shortcomings are, however, easily overcome.

Image Processor	Load Layers				
Delete All Empty Layers	Source Files Choose two or more files to load into an image stack.				ОК
Flatten All Layer Effects Flatten All Masks Simplify Layers for FXG	Use:	Files	oad into an	image stack.	Cancel
Layer Comps to Files Layer Comps to WPG		HDR-Paris1.tif HDR-Paris2.tif		Browse	
Export Layers to Files		HDR-Paris3.tif		Remove	
Script Events Manager				Add Open Files	
Load Files into Stack Load Multiple DICOM Files Statistics	Att	tempt to Automatically A	Align Source	e Images 🗲 🗕	
Browse		eate Smart Object after I	Loading Lay	vers	

1 Although this project uses EnfuseGUI to merge the exposures, the processing starts in Photoshop. Process and export the bracketed Raw files from Adobe Camera Raw as 16 Bit TIFF files (see Raw Processing). The images can then be aligned in Photoshop by going to File > Scripts > Load Files into Stack. Check the Attempt to Automatically Align Source Images checkbox and then select OK in the Load Layers dialog.

Destination:				1 33.5	Layers Chan	nels Paths
/Users/E09283/Deskto; Browse	R	in and a second s		r . ma	₽ Kind ‡	EOTI
File Name Prefix:	Car	icel		1. 1. 9 . 8	Normal	Opacity: 100
Paris-Aligned				A Det De se	Lock: 🖾 🖌	🕂 🙆 🛛 Fill: 100
Visible Layers Only			i i		10.1	
File Type:		@ 1.		CONTRACT.		HDR-Paris1.tif
TIFF 👻			3			
✓ Include ICC Profile			2 2 A		Boy (
TIFF Options:	-		E VIE			HDR-Paris2.tif
Image Compression: None -						
Quality: 8		51668				
						HDR-Paris3.tif
					Art A	HUK-Pariss.of
Please specify the format and location for saving e	ach layer as a					ee fx [
file.						IEDuret
L						

2 Crop the multi-layered file that opens in Photoshop so that there is no transparency at the edges. The file will contain all of the bracketed images that have now been aligned. Go to File > Scripts > Export Layers as Files. Select the destination using the Browse button and TIFF as the File Type and then hit the Run button.

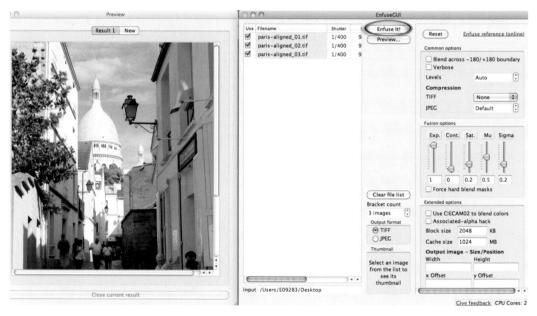

3 The nice thing about Enfuse technology is that it gets it nearly right just about every time without the need to adjust any sliders or tone curves. Localized contrast is very good and alignment is not an issue if Photoshop has handled this part of the process first. The three files exported from Photoshop have been dragged over the EnfuseGUI window to load them and then the 'Enfuse It!' button has been clicked.

Composite projects

4 If you check the histogram after Merge to HDR Pro or EnfuseGUI has 'done its stuff' you may notice that minor clipping of highlights has occurred. Although this is not ideal for a process which is designed to maximize tonality, the error can be fixed quite easily using the following technique.

5 In this scenario, the brightest highlight tones have become blown out or 'clipped'. If we drag the background layer thumbnail from the Layers panel in the underexposed file (from the bracketed images) into the 'Enfused' version we can use the highlights from this file to restore detail in the background layer.

6 If you have used Merge to HDR Pro you will first need to select both layers and run the Auto-Align Layers feature from the Edit menu. If you have used EnfuseGUI the layers will already be aligned. Double-click the top layer to open the Layer Style dialog. In the Blend If section drag the black slider under the bottom left-hand side of the Underlying Layer ramp to a position where the readout is 200. This will effectively render all levels darker than level 200 on this layer transparent. Hold down the Alt key (PC) or Command key (Mac) and separate the two sides of the black triangle and drag the right-hand side to a position of level 245. This will ensure that the transparency on this layer fades in gradually between levels 200 and 245.

This will resolve the issue of the blown out highlights, but not the problem of the mismatched detail due to the subject movement in the image. Even the Remove Ghosting option in Merge to HDR Pro may not be able to resolve all ghosting problems (the example above was merged using EnfuseGUI). Choose Flatten Image from the Layers menu.

Composite projects

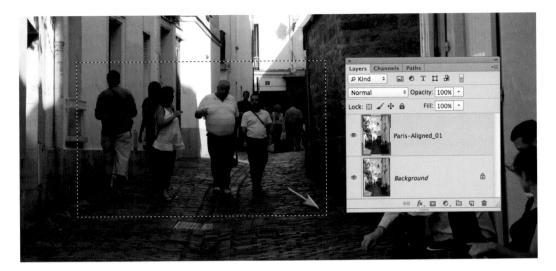

7 Add the image that is closest in exposure to the mismatched detail (in this case it is the image with the middle exposure) to the 'Enfused' project file. Select the Rectangular Marquee tool from the Tools panel and set a Feather value of 0 in the Options bar. Make a selection around the area where ghosting occurs. It is important to make a selection that is generous enough so that the selection edge is set back from the mismatched detail. Click on the 'Add layer mask' icon at the base of the Layers panel.

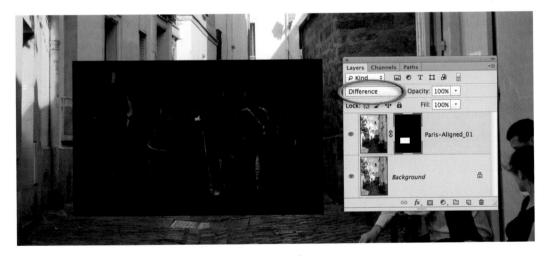

8 To check the alignment before blending the layers set the mode to Difference in the Layers panel. Use the arrow keys on the keyboard to move this layer into alignment if required. Only the moving subject matter should be now visible in the black area. Once alignment has been achieved set the mode of the layer back to Normal.

Note > If you have used Merge to HDR Pro to align and merge the exposures you will once again have to use the Auto-Align Layers option to create alignment between these two layers.

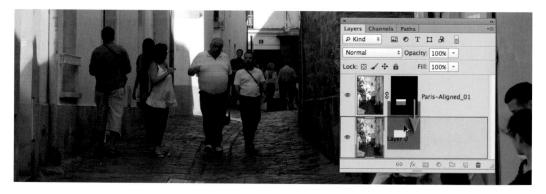

9. Hold down the Alt key (PC) or Option key (Mac) and drag the layer mask from the top to the bottom layer. Use the keyboard shortcut Ctrl + I or Command + I to invert the layer mask.

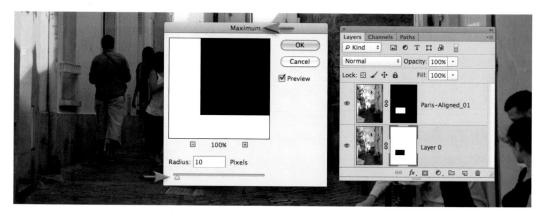

10. A thin transparent line may be visible between the two masks. To create an overlap of content before blending the layers select the layer thumbnail on the bottom layer and then go to Filter > Other > Maximum and raise the Radius slider to 10 pixels and select OK.

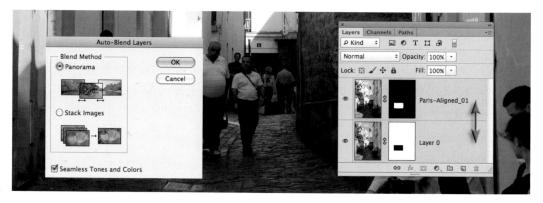

11. Select both layers and then from the File menu choose Auto Blend Layers. As you can see from the merged version (now complete with highlight detail and no ghosting) the EnfuseGUI software offers an alternative to Merge to HDR Pro. Each workflow offers slightly different management of localized contrast, color and tonality.

Composite projects

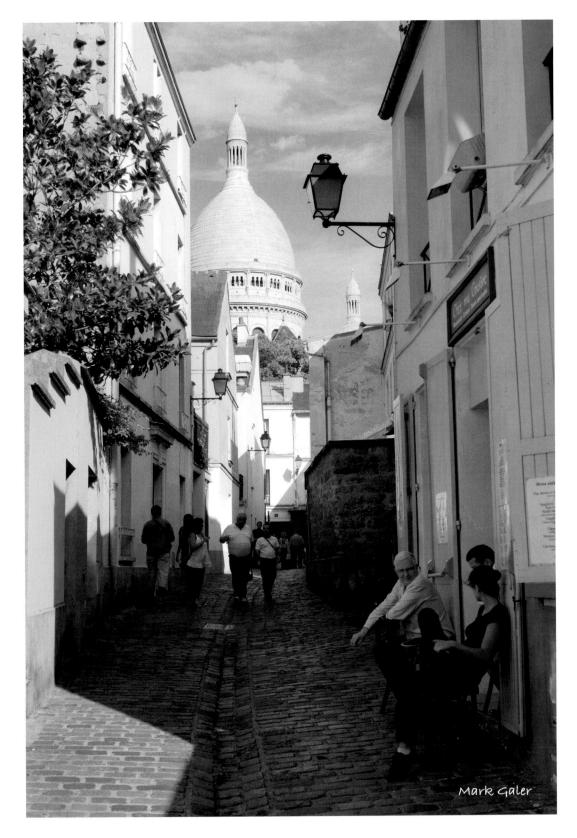

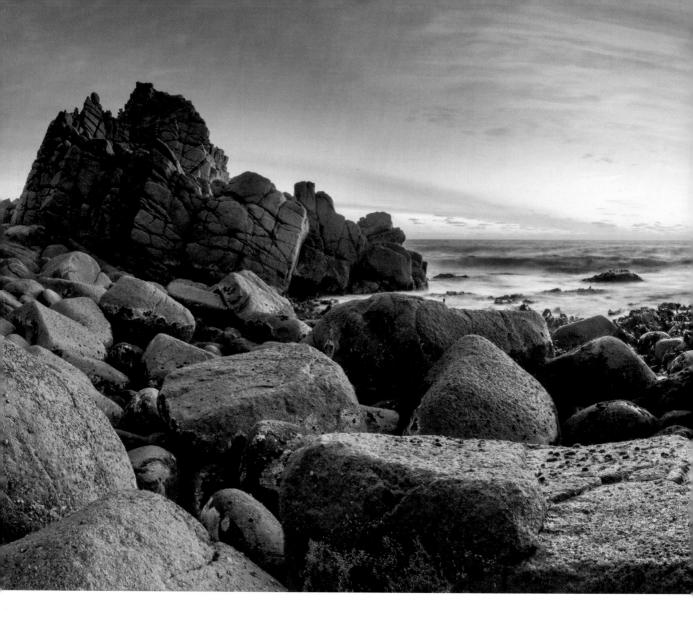

Photomerge - Project 11

Photomerge is capable of aligning and blending images without any signs of banding in smooth areas of transition. The new and improved Photomerge first made its appearance back in Photoshop CS3 and the stitching is usually seamless. This project, however, takes a look at how we can correct minor errors when things don't quite match up. This is usually a result of using a wide-angle lens that includes a lot of foreground subject matter but without using a specialized tripod head to eliminate parallax error. The ease with which Photoshop can stitch these panoramas will be improved if you capture vertical images with a 50% overlap using manual exposure, manual focus and a manual White Balance setting (or process the images identically in Camera Raw). With a little know-how, Photomerge is an excellent way of widening your horizons or competing with your best friend's 60 Megapixel Hasselblad H4D.

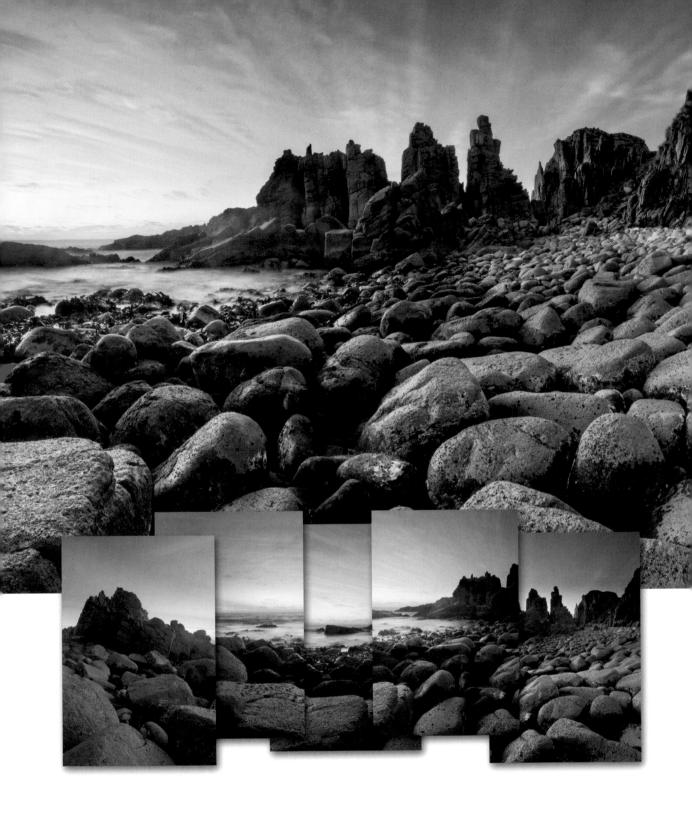

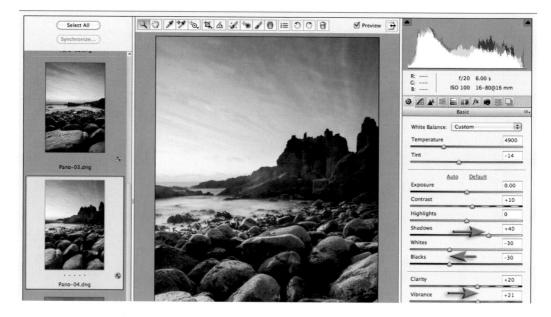

Note > The Raw files on the DVD have already been optimized for the reader for use in this project. No additional processing in Adobe Camera Raw is required. The information on this page highlights the work already carried out.

Raising the Shadows slider has recovered the shadow detail. If the subject brightness range or contrast of the scene had been any higher it may have been necessary to bracket the exposure for each of the component shots and then use Merge to HDR Pro to create an image with full detail for each of the five component images (see High Dynamic Range).

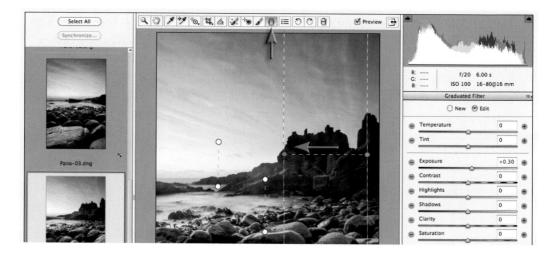

To balance the exposure of the highlights and the exposure of the shadows the Raw files were further optimized using the Graduated Filter in ACR. The sky was darkened using one graduated filter and the Foreground was lightened using another. In some instances a third Graduated Filter was added to even the exposure from left to right.

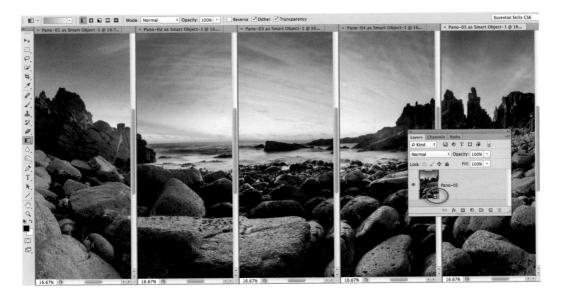

1 To check that the adjustments in ACR have been appropriate you can open the five Raw files as Smart Objects and then, by going to Window > Arrange > Tile All Vertically, you can view the files as if they were a panorama. As the Raw file is embedded in each Smart Object file you can reopen any of the Raw images in ACR (double-click the Smart Object thumbnail in the Layers panel) and modify the color or tonality if required. The preview will then be updated in the Tile view. Save each Smart Object by going to File > Save As and choose TIFF as the format. Uncheck the Layers option in the Save As dialog (if you don't do this the Photomerge rejects it as a Smart Object). It is OK to save as a copy (in fact you must). After saving all files close the Smart Objects. Go to File > Automate and choose Photomerge.

Note > The files for this project were captured on a 12 Megapixel DSLR. If you have less than 2 Gigabytes of RAM on your computer you would be advised to reduce the size of each component image prior to stitching the panorama or be prepared to be patient.

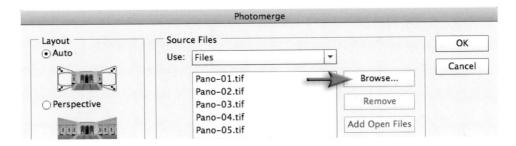

2 In the Photomerge dialog box click on the Browse button and browse to the files you saved in Step 1. Select the Auto radio button in the Layout options. Select the Blend Images Together checkbox and leave the Vignette Removal and the Geometric Distortion checkboxes unchecked (the work in ACR has completed these tasks). Select OK and now let Photoshop do all of the work – and what a lot of work it has to do, aligning and blending all of these images.

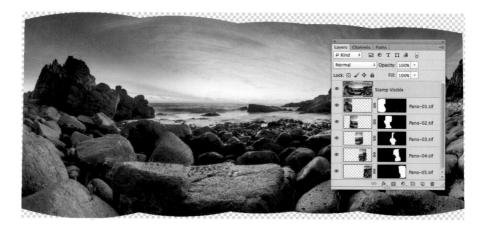

3 Prior to Photoshop CS3 many more steps of manual techniques were required to circumnavigate the shortcomings of Photomerge – but as you can see from the results in this project we just about have perfection handed to us on a plate. Fantabulous! (I know that's not in the dictionary but neither is Photomerge – yet.) If you have used the full-resolution images with insufficient RAM you probably had to go and make a cup of coffee while Photoshop put this one together (all 60 megapixels of it) and will now be considering downsampling your file – but wait, we have a couple of small glitches in this result.

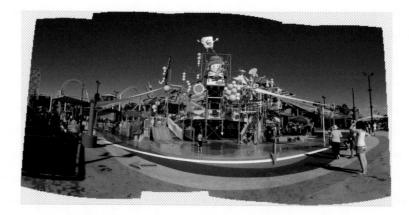

PERFORMANCE TIP 1

Now the only limitation you may run up against when hand-holding the camera, or placing the camera on a standard tripod head, is Photoshop's ability to align and blend strong geometric lines that come close to the camera lens. If you have not used a specialized tripod head designed for professional panoramic stitching work, then the problem of aligning both foreground and distant subject matter is a big problem for any software (Photoshop handles it better than most). The camera should ideally be rotated around the nodal point of the lens to avoid something called parallax error. You will probably not encounter any problems with the new Photomerge feature unless you are working with strong lines in the immediate foreground.

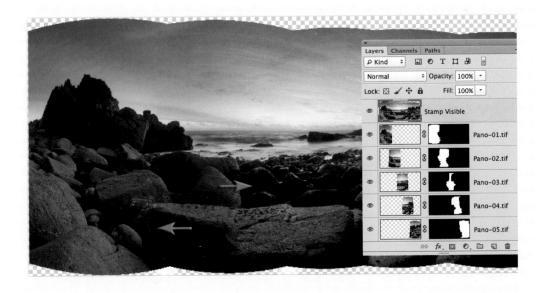

PERFORMANCE TIP 2

If you downsample before you flatten your file you will probably encounter hairline cracks after reducing the image size. The solution to this problem is to either flatten the file or stamp the visible content to a new layer (Ctrl/Command + Shift + Alt/Option and then type the letter E) before you reduce the size of the image.

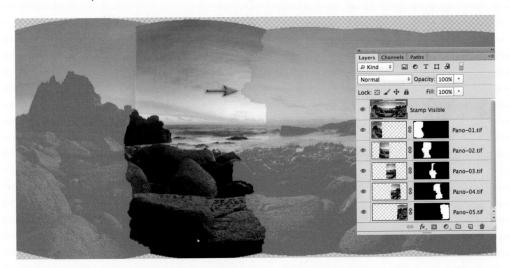

If you hold down the Alt/Option key and click on each layer mask in turn you will notice that Photoshop uses hard-edged layer masks to hide or reveal the piece of the jigsaw puzzle that makes up the final panorama. The panorama has seamless joins because Photoshop has adjusted or 'blended' the color and tonality of the pixels on each layer. Any pixels concealed by the layer masks have not been subjected to these color and tonal adjustments. This, in effect, means that the user cannot override which bit of each layer is visible as the hidden pixels have not been color-matched.

Fill	
Contents Use: Content-Aware Custom Pattern:	ande de la seren
Blending Mode: Normal Opacity: 100 % Preserve Transparency	
No.	
	Same C. Commen

4 Merge the visible elements to a new layer (Ctrl + Shift + Alt and then type the letter E on a PC or Command + Shift + Option and then type the letter E on a Mac). It is usual to crop away the transparent areas of the image or try to extend the image into the transparent areas using Content-Aware Fill. Make a selection of the transparent areas using the Magic Wand tool and then go to Select > Modify > Expand. Choose 20 pixels in the Expand dialog and then choose Content-Aware in the Fill dialog (Edit > Fill). The results are a bit of a hit and miss affair so you may end up with some cloning work or cropping away the errors. If we shoot vertical images for horizontal panoramas we can often crop to the best composition and avoid having to fill in the missing bits.

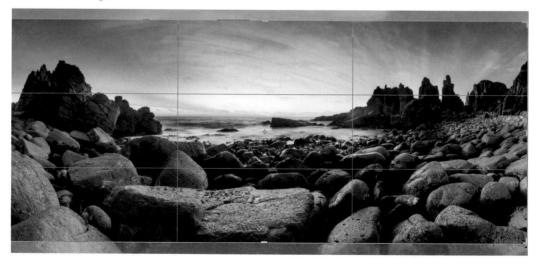

5 Crop away any transparency or errors created by the Content-Aware Fill (be sure to select the Unconstrained option and leave the Width and Height fields blank in the Options bar).

Note > The layers sitting below the Stamp Visible layer can be deleted if the file becomes too large for the processing power of your computer (remember you cannot modify the masks on these layers so these layers do not offer many editing options).

Composite projects

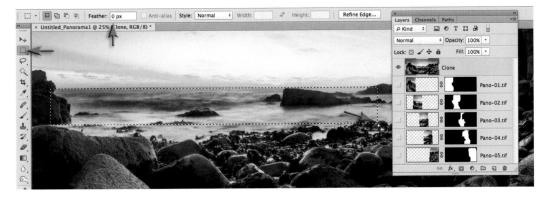

6 When stitching just two or three images Photomerge Panorama gets it right pretty much all of the time. When stitching much wider panoramas, where there is a good deal of foreground detail, you may find a couple of alignment errors. These images were captured using a wide-angle lens and the foreground rocks are just in front of the tripod. If I had used a specialized panorama tripod head the effects of parallax error would not be a problem. Photomerge in this instance, however, has met its match. The foreground rocks all match perfectly but that horizon line has a small break and is undulating. We can fix this. Zoom in to the horizon line, select the Rectangular Marquee tool and make a selection that just touches the horizon line at the lowest point. Make sure the Feather option in the Options bar is set to 0. From the Select menu choose Inverse.

Note > The stitching errors may change depending on the resolution (pixel dimensions) of the files you choose for Photomerge to align and blend.

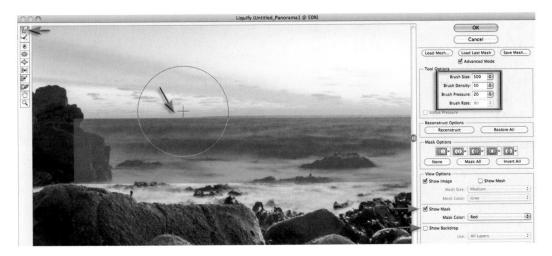

7 Go to Filter > Liquify. Choose the Forward Warp tool to nudge the horizon line down towards the red frozen area that is visible when you select the Show Mask option. The frozen area is created from the selection you made in the last step. Increase the size of the brush to 500 pixels and decrease the Brush Pressure to a lowly 20 pixels. When using the Warp tool just click and drag to push the pixels into alignment. When the horizon line is sitting on top of the red rectangle click OK to apply the changes to the image (this may take a number of passes).

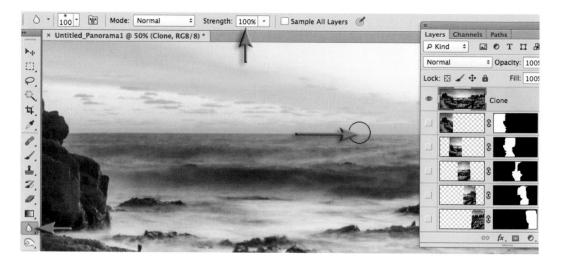

8 Pushing the pixels down onto the selection in Liquify will create an unnaturally hard edge to the horizon. This can be fixed by selecting the Blur tool in the Tools panel and a Strength setting of 100% in the Options bar. Zoom in so you can see the effects of your blurring and then click on one side of the horizon and then shift-click on the other side of the horizon to soften the entire edge.

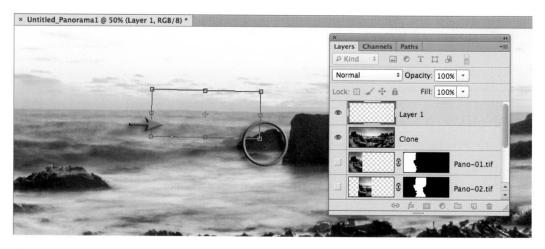

9 If you find a physical break in the horizon line, or on the rocks either side of it, you can create a patch to hide the awkward break. Use the Rectangular Marquee tool with a Feather Radius of 10 pixels and make a small selection just next to the break. Choose Copy and then Paste from the Edit menu to put the patch onto its own layer. Then go to Edit > Free Transform. You can now slide and rotate the patch into position. Hold down the Ctrl key (PC) or Command key (Mac) and pull any of the bounding box handles to distort the shape of the patch so that you can achieve a seamless fix. Don't worry if the sky or sea spills into a rock area because it will be addressed in the next step

Note > An alternative to this technique would be to use the Clone Stamp tool and clone to an empty new layer (see Project 7 from the Retouching chapter).

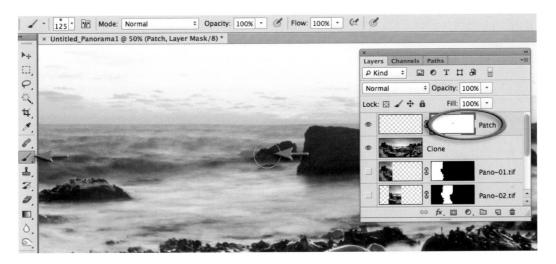

10 Click on the 'Add layer mask' icon at the base of the Layers panel. Select the Brush tool from the Tools panel and set the foreground color to black. Set the Brush hardness low and then mask any areas of the patch that may be affecting the rocks. You may need to zoom in to check that your work does not leave any brush strokes.

1 I If the patch does not match the color of the tones then you can create an empty new layer and set the mode of this layer to Color. Select the Brush tool in the Tools panel, hold down the Alt or Option key and click on a more appropriate color to load this into the Foreground Color Swatch in the Tools panel. Then paint over the area that needs adjusting to further perfect the patched area.

Note > If the Foreground Color does not change when you hold down the Alt/Option key, click in the image window and make sure the Eyedropper tool options are set to All Layers from the Sample pull-down menu in the Options bar.

12 To create a Faux HDR (High Dynamic Range) effect that enhances localized contrast, go to Image > Duplicate and check the Duplicate Merged Layers Only option in the Duplicate Image dialog. It is not possible to apply the HDR Toning Adjustment to a multi-layered file so we will apply the toning to a flattened duplicate version of this file and then re-import the layer.

▶.	HDR Toning		
Ξ,	Preset: Custom	OK	
P.		Cancel	and the second se
Q.	Method: Local Adaptation		
4	• Edge Glow	Preview	the second se
¥.	Radius: 200 px		
50.	Strength: 0.70		Alusta fitte
1.	Smooth Edges		A13
₹.	· Tone and Detail		1993
Z,	Gamma: 1.00		
0.	Exposure:		Comments of the second s
0,	Detail: +122 %		and the second sec
6	· Advanced		
Ø.	Shadow: 0 %		San Per 1 to 16.
Τ.	Highlight: 0 %		
N.	Vibrance: +30 %		Company and a second
- m	Saturation: -15 %		A AND AN
d	Toning Curve and Histogram		SPAN A STORES
5.6			

13 In order to apply the HDR Toning in the image duplicate, Photoshop has to temporarily convert the image into a 32 bits per channel file (hence the reason we have a single layer). Go to Image > Adjustments and select HDR Toning. When the HDR Toning dialog opens expand the Edge Glow and Tone and Detail sections. Raise the Radius slider in the Edge Glow section to 200 px to make a smoother transition between the rocks and sky, lower the Exposure slider to -0.50 and raise the Detail slider to +120. Adjust the Vibrance and Saturation sliders to taste and select OK.

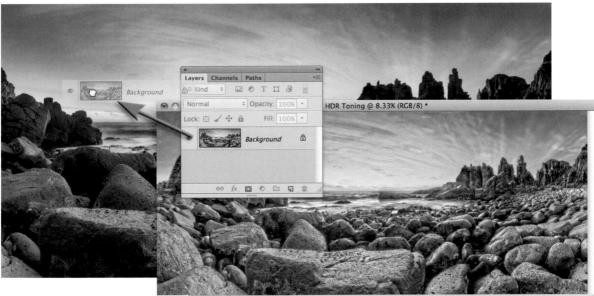

8.33% 🕒 Adobe RGB (1998) (8bpc) 🕨

14 This Faux HDR effect may look a little bit too edgy for most photographers. We can, however, dial in just the right amount of the effect after we have placed this file as a layer above the multi-layered file. Hold down the Shift key and drag the layer thumbnail from the duplicate image (the HDR toned image) into the panorama image.

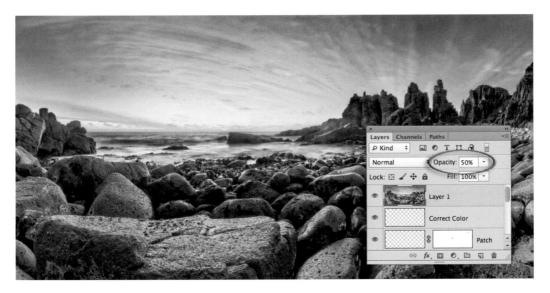

15 Lower the Opacity of this new layer until you achieve a good balance between the panorama image and the HDR toned image. At 50% the effect is still quite pronounced but becomes much more subtle when the Opacity is below 30%.

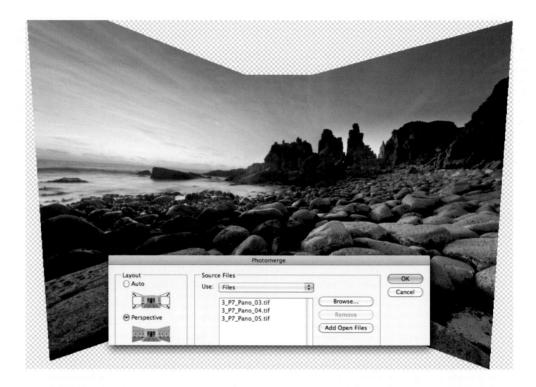

PERSPECTIVE OR CYLINDRICAL

When we selected Auto in the Layout section of the Photomerge dialog, Photoshop elected to use the Cylindrical option. This option is usually preferable and is usually selected by Auto when you are stitching wide panoramas. When stitching two or three images together you may find that Photoshop decides to use the Perspective option or you can choose this option to override the Cylindrical option if it is chosen by Auto. The Perspective option creates a bow-tie effect when stitching three images and is useful for creating a realistic perspective with straight horizon lines. When this option is used for more than three images, however, the distortion required to create the effect tends to be extreme for the images on the edge of the panorama and cannot, therefore, be considered as a usable option.

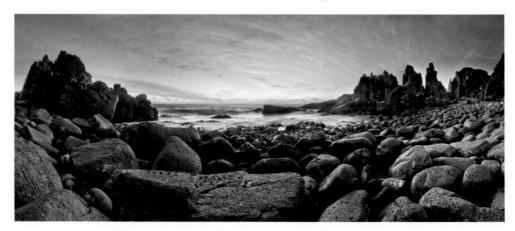

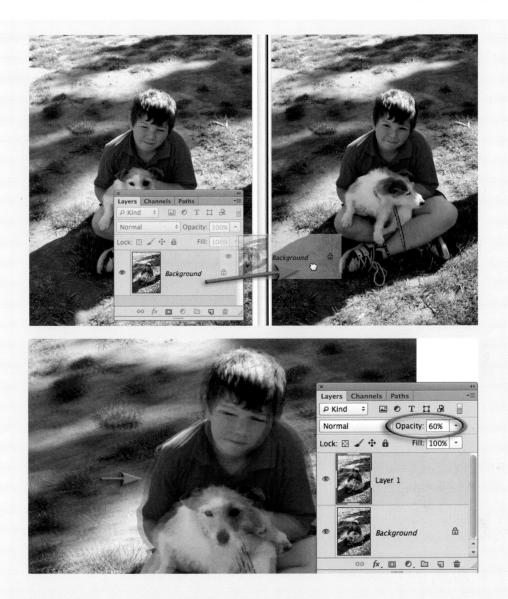

AUTO-ALIGN FOR PIN-REGISTERING IMAGES

The Auto Align feature is an invaluable tool for photographers who need to be able to pinregister images that have been captured hand-held. This is, however, only recommended when you have synchronized the white balance in Adobe Camera Raw or selected a custom white balance in-camera. In the illustration above the boy is blinking in one image and the dog is looking away in the second. The images were captured a split second apart but the best elements of each image can be combined to create one image even though the camera was hand-held. The two images have been combined by dragging the background layer from one file onto the image window of the other (hold down the Shift key as you

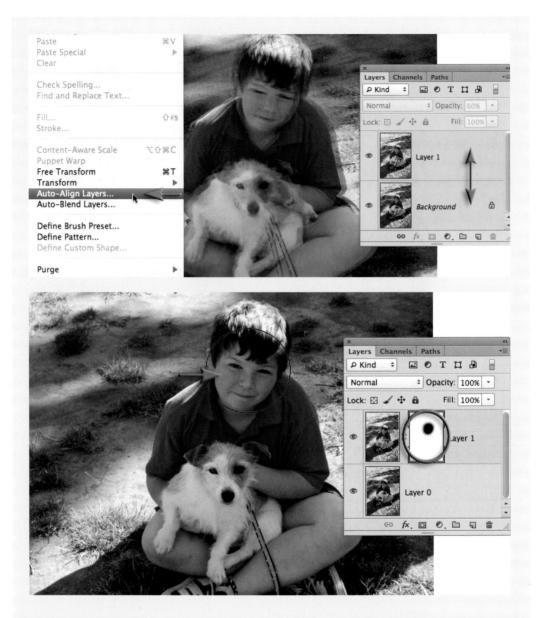

let go of the mouse button). Dropping the Opacity of the top layer reveals the misalignment even though the boy was still. Select both layers in the Layers panel. From the Edit menu choose Auto-Align Layers. Now select only the top layer and click on the 'Add a layer mask' icon in the Layers panel. Choose the Brush tool in the Tools panel and paint with black into the mask to shield any of the pixels you do not want to see on this layer. Painting over the boy's head will reveal the head with the open eyes on the layer below. You will need to crop the image to finish your project. If you can see the value of this technique then you will quickly realize that taking multiple shots the next time you are presented with a group (or even just one man and his best friend) ensures 'the decisive moment' is history (sorry, Henri).

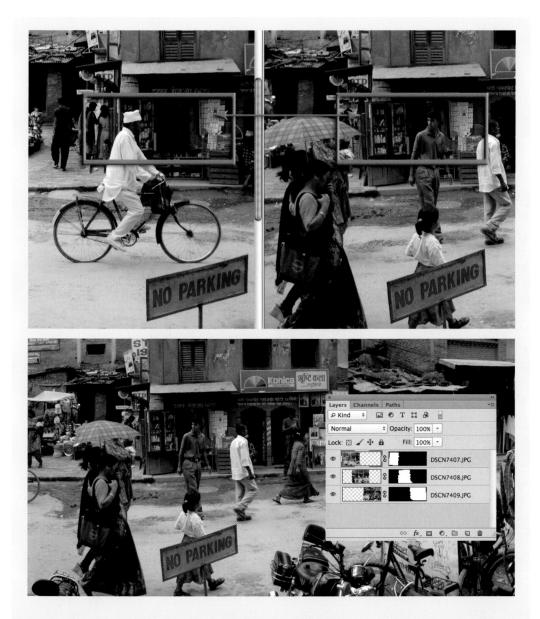

ALIGNING IMAGES WITH MOVING CONTENT

When creating a panorama with moving subject matter the information in the images may change in the region of the 50% overlap as subjects move out of, or into, the frame. The difference in content forces Photoshop to mask around the moving subject matter during the blending process (to avoid cutting subjects in two). This is not always successful as Photoshop finds it difficult to distinguish between different subjects when they overlap. In the illustration above Photoshop has successfully blended images where the subject matter is very different in the region of the overlap. Photoshop has completely ignored the moving bicycle in the resulting blend.

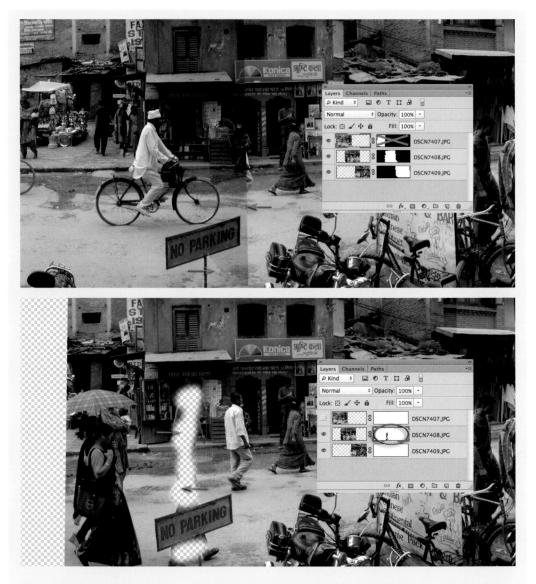

We cannot paint into the layer masks of these layers to adjust visible content after the blend is complete as the differences in tone and color between these two images are significant due to the auto exposure and auto white balance used. In the illustration above (top image) I have switched off the layer mask to illustrate how the colors that have been blended do not extend beyond the hard-edged layer mask (the mask is only used to define visible content). To prevent Photoshop from using content in a blend we need to hide it by adding a layer mask and painting into this mask prior to blending (there is no need to be too precise about the painting). Painting in both layers in the area of transition, however, could result in transparency when the layers are blended.

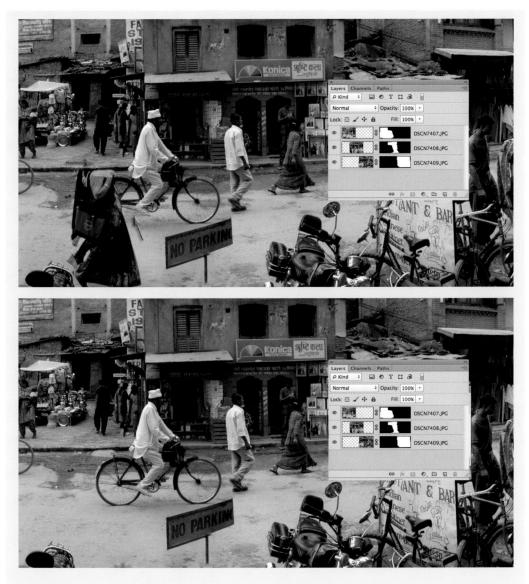

After repeating the blending process we can see that we have now prioritized the bicycle instead of the pedestrians in the region of the overlap. We have, however, created new problems as Photoshop cannot distinguish between the rear end of the bicycle and a nearby pedestrian as the objects overlap. If we undo and add a little more paint into that mask before blending again we can finally resolve the problem in this region. If we turn our attention to the No Parking sign and parked bicycle in front of the restaurant sign we will see that all is not yet fixed. Going backwards and forwards like this can be time-consuming if we have a large number of high-resolution files to be blended each time. Avoid problems with editing by shooting in manual white balance and manual exposure (color and tone on the individual layers will be consistent). This allow us to fix up minor errors by painting into the mask, safe in the knowledge that the color and tone will not change.

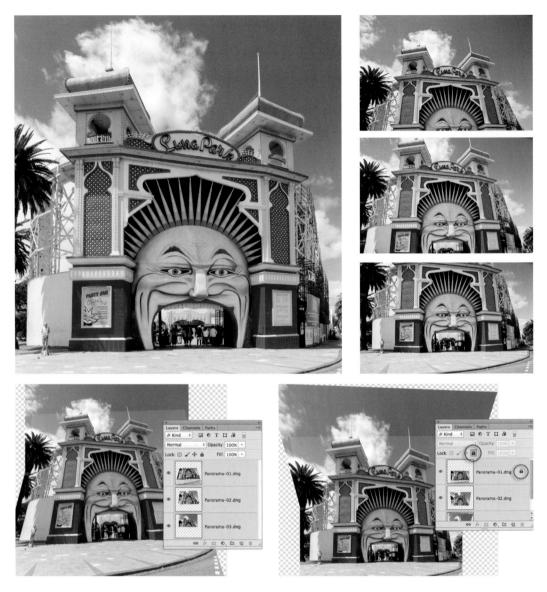

Vertical panoramas – Project 12

In taking the image above, if I had moved any further back there would have been power lines, telephone lines and tram lines between me and the front of this old theme park. Capturing a building so close will inevitably lead to aggressive converging verticals due to a combination of the wide-angle lens and the angle of view required to capture the top of the structure. If you allow Photomerge to take control of the stitching you will end up with the result bottom left. Capture images using the horizontal (landscape) format for a vertical panorama. You can then achieve a more professional result by intercepting the automated process, aligning and blending the images as separate tasks, rather than using the Photomerge feature.

Note > This project makes use of the new Adaptive Wide Angle filter and the ESP-Luminance preset from the supporting DVD or www.markgaler.com

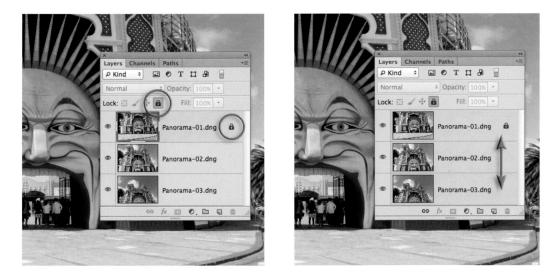

1 Optimize the color and tonality of the Raw files in Adobe Camera Raw and then choose Select All and Synchronize before opening (alternatively you can use the project JPEGs). Go to File > Scripts > Load Files into Stack. Select the Open files but do not select the Attempt to Automatically Align Source Images option in the dialog. When the files have been loaded into one image select the layer with the subject matter that is closest to the ground (the one with the least amount of converging verticals). Go to the Lock options in the Layers panel and click on the 'Lock all' icon to lock this layer. This action will force Photoshop to respect the perspective of this layer (the other layers will be forced to adopt the perspective of this layer when we align the images). Select all three layers in the Layers panel (Shift-click the top and bottom layers).

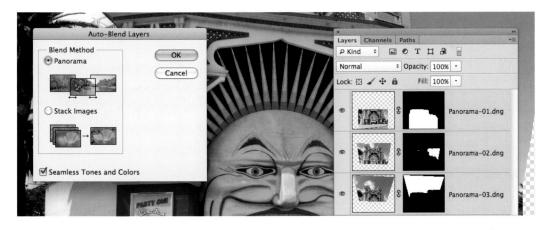

2 Go to Edit > Auto-Align Layers. In the dialog select the Perspective option and also select the Lens Correction options (both Vignette and Geometric Distortion). Select OK to process the layers. After the images have been Auto-Aligned make sure all three layers are still selected and then go to Edit > Auto-Blend Layers. Select the Panorama and Seamless Tones and Colors options and select OK to process the layers. In the Layers panel select only the top layer and unlock this layer before proceeding with the next step.

3 Select all three layers in the Layers panel again and then go to Filter > Convert for Smart Filters. Select the Crop tool and crop the image to remove the transparency that surrounds this composite image. Although we locked the layer with the appropriate perspective (prior to aligning the layers) and selected the Lens Corrections options in the Auto-Align Layers dialog there will still be distortion present in the image. This can be corrected using the Adaptive Wide Angle filter.

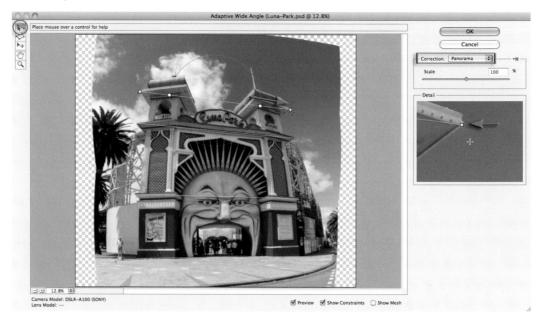

4 Go to Filter > Adaptive Wide Angle and select the Panorama option from the Correction menu. Click and drag four horizontal lines across the front of the building, using the Detail window to check for precise alignment. This will remove the barrel distortion in the horizontal plane of the building.

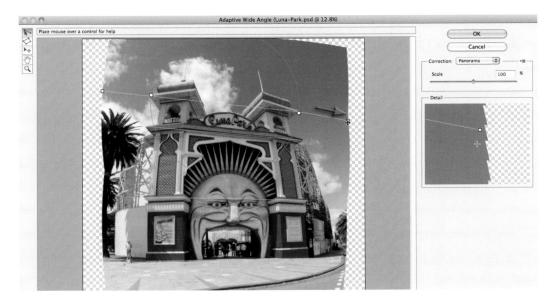

5 Hold down the Shift key and extend the four horizontal lines to the edge of the image area. You may need to click and drag more than once on the adjustment points to coax the lines to the edge of the image. This action will ensure the horizontal distortion is corrected to the edge of the image.

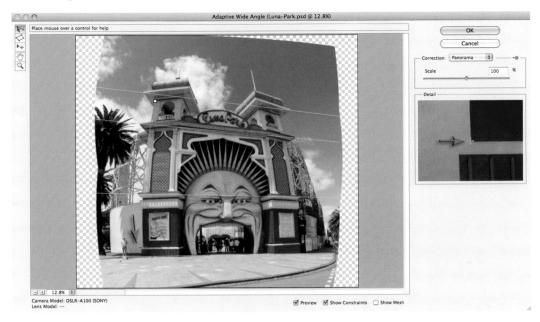

6 Hold down the Shift key and click and drag to add vertical lines across the front of the building. The vertical lines will appear as a different color to the horizontal lines. Add a center line and a line either side of the building to ensure the correction extends to the edge of the image. Hold down the Shift key and then click and drag the lines to extend them to the edge of the image area.

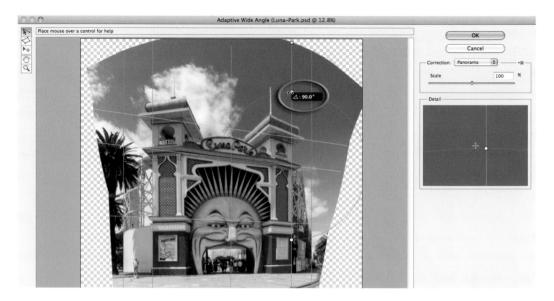

7 The vertical lines will fully correct the perspective of the building but, in many instances, the perspective will look unnatural. There may be an optical illusion that the building is leaning out towards the top of the image. In these instances it would be appropriate to return a small amount of converging perspective to the image. When you click on a correction line you will see a circle appear. Moving your mouse cursor to the adjustment point on the circle will enable you to tilt the line. You will need to replicate the tilt on all of the vertical lines except the center line.

8 After selecting OK in the Adaptive Wide Angle dialog the corrections will be applied to the Smart Object as a Smart Filter. This non-destructive approach to the perspective correction allows you to fine-tune any of the filter settings. After the perspective correction there may be an opportunity to fine-tune the crop.

Composite projects

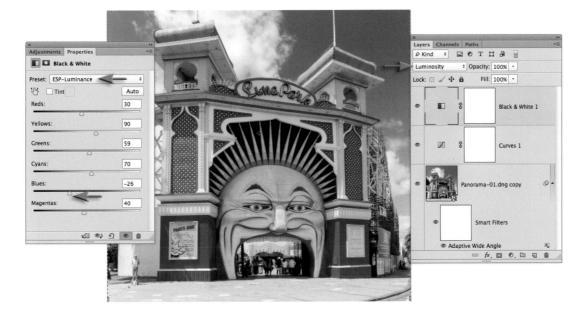

9 I have completed the edit by adding a Curves layer to brighten the image and a Black & White adjustment layer set to Luminosity mode to adjust the luminance values of the blues. The default setting in the Black & White adjustment layer upsets the standard color values so I am using the ESP-Luminance preset that is available from the DVD or the www.markgaler.com website.

The most useful way to target color or tonality in Adobe Camera Raw is with the HSL sliders. The Luminance slider cannot be found, however, in the main editing space of Photoshop. If the Lightness slider is used to control the brightness values of a targeted color, the colors will always be desaturated in the process.

LUMINANCE PRESET

The ESP-Luminance preset enables the type of luminance control over the colors that we enjoy in Adobe Camera Raw (the Lightness control in the Hue/Saturation adjustment feature in the main editing space always desaturates colors when adjusting their brightness).

RECENT POSTS

- FREE Tutorial Maximising Sharpness
- > Tutorial Bundle: Photoshop Elements
- > Photoshop Lightroom 4 Beta: Review
- > Adobe Photoshop Lightroom 4 Beta
- PHOTO WORKSHOP: Creative Processing: SUNSHINE COAST (Australia) – April 13/14/15

EXPORTED GRIDS

Grids exported from Vanishing Point can help the photographer capture additional elements that must conform to the perspective of the first image. The layer containing the grid can be dragged onto subsequent images to ensure 100% accuracy.

'Safety' by Gíles Crook Abus 'Unlocked' competition winner

op photoshop Special effects photoshop phot

essentíal skílls

Mark Galer

- Create a smooth tone effect to suppress detail and texture.
- Enhance detail and depth to create a dramatic effect.
- Color grade and split tone images to create a signature style.
- Create an image with reduced depth of field.
- Create a Tilt-Shift effect.
- Create a 'Faux' style by manipulating focus and color.
- Create a Toy Camera look in Adobe Camera Raw.
- Create a Lens Flare effect.
- Add a creative border and texture.

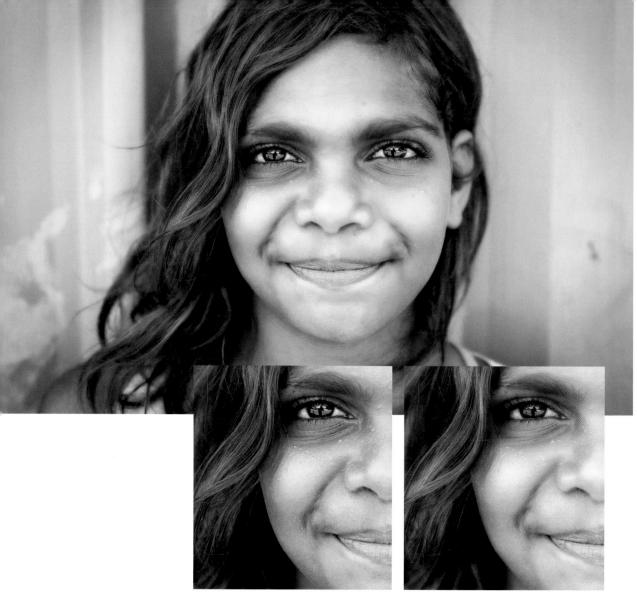

Tia by Mark Galer

Smooth Tone technique - Project 1

Sometimes a digital camera can capture too much surface texture and detail. The resulting image can prove to be an unflattering record of your subject, whether it be a portrait or a landscape image. Sometimes a photographer is looking to create smoother surfaces of continuous tone, but without sacrificing the sharp detail where it counts. This smooth tone technique makes use of the Gaussian Blur filter to create surfaces that appear to be modelled with a softer and gentler light source, while retaining the important edge detail. The secret to this success lies in the blend mode applied to the blur filter and adjustment layers to recover color and tone. This technique can be recorded as an action for playing back on a variety of special effects projects or can be downloaded from www.markgaler.com.

Special effects

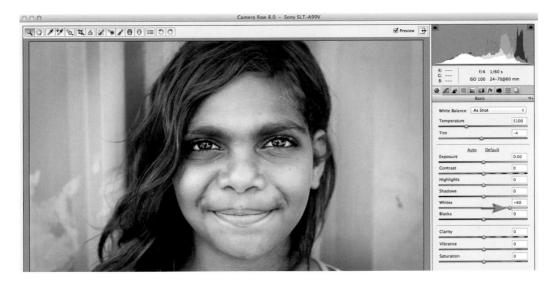

1 Open the project image into Adobe Camera Raw. Some Basic adjustments have already been applied to this image. These include raising the Whites slider to +60 and managing the Greens and Yellows in the HSL tab (resolving some problems presented by the highly illuminated green grass Tia is facing).

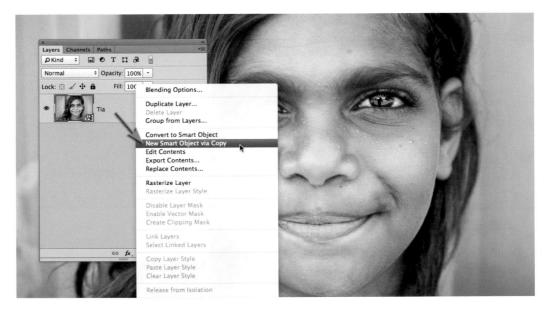

2 As this technique will render all surfaces in the image smoother, it is worth creating a copy of the layer so that we can mask back to the original appearance if required (you may like it crunchy or more detailed in places). It is important to NOT use the keyboard shortcut for duplicating a layer and NOT to drag the layer to the New layer icon to duplicate it. We need to right-click on the Smart Object and choose New Smart Object via Copy instead. This will allow us to edit the contents of each Smart Object independently.

	STH.	1	10
I avers Channels Paths - P Kind € Image: Channels T Image: Channels P Kind € Image: Channels Fill Normal € Opacity 100% Lock: E Image: Channels Fill: Tia copy Image: Channels Fill: Image: Channels Fill: <th></th><th>r OK Cancel Ø Preview</th><th>And F</th>		r OK Cancel Ø Preview	And F
A		1	21

3 Select the copy Smart Object in the Layers panel and then go to Filter > Blur > Gaussian Blur and choose an amount that renders your subject matter clear of all detail. Avoid using an amount that is so high that you lose the basic shapes of your subject. The Amount will rise as your subject matter is closer to the camera or the resolution of the file is higher. For this project file you can choose an Amount of between 10 and 20 pixels. This could be raised even higher if your subject fills the frame and the camera you are using has a high-resolution sensor.

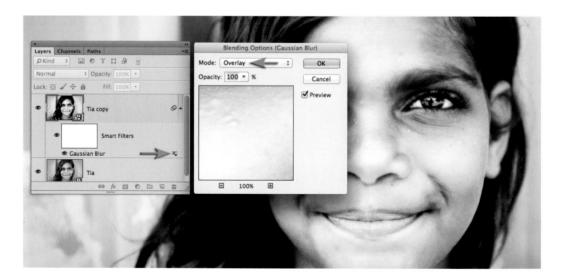

4 To blend the blur into the crunchy pixels, double-click on the Blending Options icon on the Smart Filter in the Layers panel and set the Mode to Overlay. This will create the smoother tones but significantly increase the contrast and saturation of the file. We will restore the color and tonality in the steps that follow.

Special effects

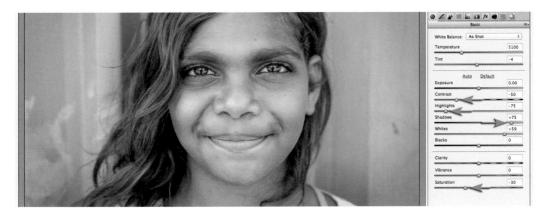

5 Double-click the Smart Object thumbnail to open the raw file in ACR. Lower the Contrast to -50, the Highlights to -75 and raise the Shadows to +75. The contrast can be fixed by lowering the Saturation slider to -30. These adjustments are relative to the raw file you are working on, i.e. if the Contrast of the image you are working on is set to +25 then you should lower it to -25 (a relative adjustment of -50 from its current setting).

Note > The image preview will appear very flat and desaturated until these modified settings are blended with the Gaussian Blur smart filter in the main editing space.

	Shadows/Highlights
	Amount: 25 % Cancel
	Tonal Width: 15 % Load
Layers Channels Paths -=	Save
Normal * Opacity: 100% *	Radius: 30 px
Lock: 🖾 🖌 🕂 🛍 🛛 Filt: 100% -	
101	Amount: 0 %
• Tia copy @-	Amount: 0 %
Smart Filters	Tonal Width: 50 %
Shadows/Highlights	Radius: 30 px
© Gaussian Blur Te	
• Ta	- Adjustments
	Color Correction: +20
	Midtone Contrast: 0
	Black Clip: 0.01 %
	White Clip: 0.01 %
	Reset Defaults
	Show More Options

6 You may have noticed that the shadow values, although not clipped, are now a little darker. You can choose to restore full detail to the darkest shadows by applying a Shadows/Highlights adjustment as a smart filter (Image > Adjustments > Shadows/Highlights). Check the Show More Options box to expand the dialog. Set the Shadow Amount slider to 25%, the Tonal Width to 15% and the Radius slider to 30 pixels. Select OK to apply these settings. You can also adjust the Highlights sliders in this dialog if you prefer them to be a little darker.

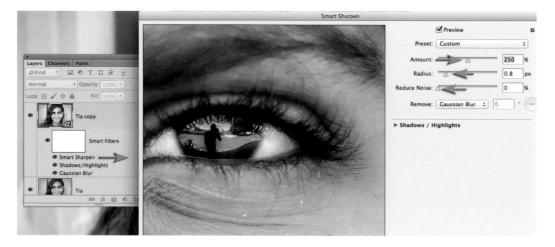

7 To sharpen the fine detail that remains go to Filter > Sharpen > Smart Sharpen. This dialog can be resized if required. I have set the Amount slider to +250, lowered the Radius slider to 0.8 and set the Reduce Noise slider to 0% as this is a low ISO image. You will observe that although we have rendered the surfaces smoother we are still able to sharpen the fine detail around the eyes.

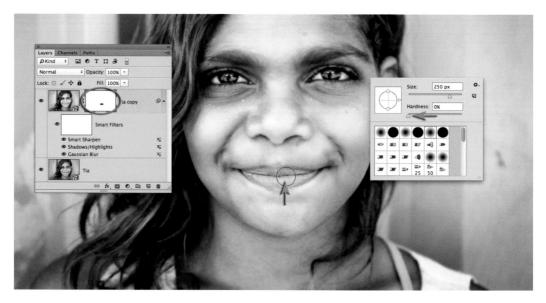

8 If we need to mask back to any of the detail on the layer below we need to add a layer mask to the Smart Object. Click on the Add layer mask icon at the base of the Layers panel. Select the Brush Tool from the Tools panel, 100% in the Options bar and set the Brush Hardness to 0%. With the Foreground color set to Black paint over the lips to reveal better color and detail on the layer below.

Note > If we were to paint into the Smart Filters mask we would not only hide the smoother tones but also reveal the low contrast settings we applied in ACR.

PLUG-IN FILTERS FOR PHOTOSHOP

Many companies make plug-in filters for Photoshop. Once installed these filters can usually be accessed directly from the Filters menu inside Photoshop. Portraiture 2 is a plug-in filter created by Imagenomic that renders smooth skin tones without losing sharp detail. Although Portraiture 2 is a sophisticated plug-in with lots of options for finetuning the effect it is possible to get remarkable results from some of the presets included.

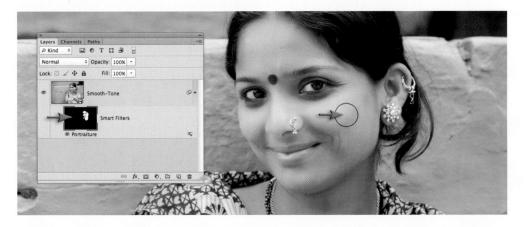

Portraiture 2 also has the advantage of being able to be applied as a non-destructive Smart Filter. This allows the user to adjust the settings after the filter has been applied and also mask areas of the image you do not want to apply the filter to. In this image the Smart Filter mask has been inverted and then the Brush tool, with white set as the Foreground Color, is used to paint in the effect where it is needed. In this instance it is required because the wall has been picked up in the narrow range of skin tones that Portraiture 2 focusses its attention on and has been softened along with the skin.

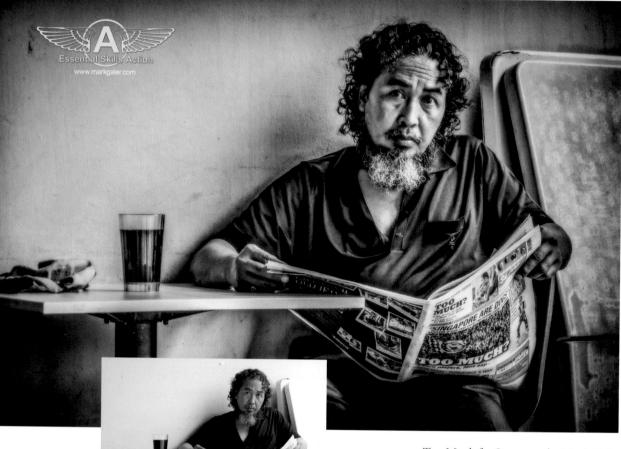

Too Much for Singapore by Mark Galer The 'High Impact CC' automated action is available from www.markgaler.com

High Impact – Project 2

Images captured in flat light can often lack detail, depth and drama. It is possible to unleash hidden potential using post-production techniques. The secret to success lies in features, such as the Clarity slider in Adobe Camera Raw, that can detect and enhance edge contrast. This depth charge technique is designed to inject the drama that the start image lacks. The extended technique follows on from the 'Smooth Tone technique' covered in Project 1 in this chapter to smooth the broader areas of tone while the fine detail is preserved, enhanced and then sharpened. The application of a blur filter in a project where the fine detail is enhanced may, at first, sound strange, but if it is applied in conjunction with a blend mode, the sharp detail within the subject can be made to interact favorably with the smoother tones. The enhanced localized contrast and detail combined with the smooth contours create the drama that is required.

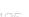

Special effects

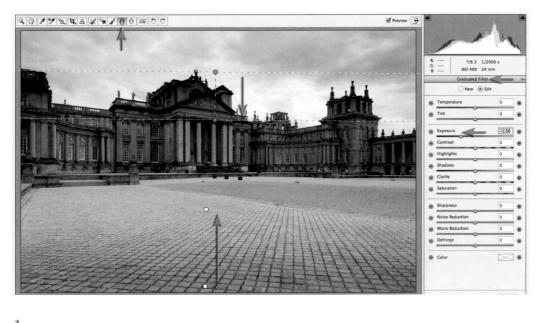

1 It is possible to increase the drama of an image significantly in Adobe Camera Raw using the Clarity, Contrast, Highlights and Shadows sliders in the Basic panel. Before applying these 'Basic' adjustments I have clicked on the Graduated Filter icon in the Tools bar and then added a -1.50 Graduated Filter in the sky to lower the exposure in the brightest tones. I have also added a -1.00 Graduated Filter in the foreground to darken the lower edge of the image.

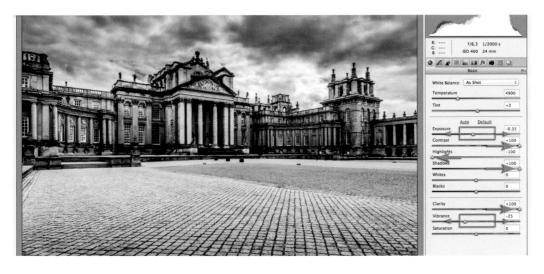

2 The Contrast and Clarity sliders in the Basic panel are then raised to +100, the Highlights slider decrease to -100 and the Shadows slider raised to +100. The Exposure and Vibrance sliders are adjusted last, as the previous action may have rendered the image too bright, too dark or too saturated. In the example above I have decreased the Exposure to -0.35 and the Vibrance slider to -25 to compensate. If the effect is too extreme, back off on all sliders until the required effect is achieved.

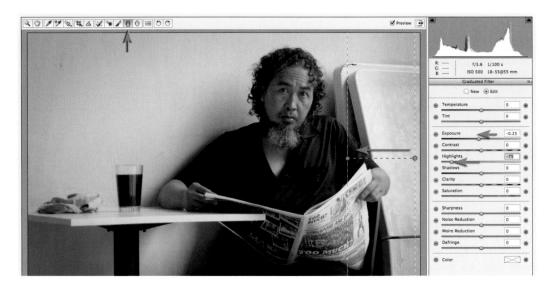

3 In this extended version of the technique we will apply the same two initial actions and then take the image into the main editing space of Photoshop to complete the process. The aim with this extended version is to soften some of the areas of continuous tone while leaving all of the extra detail and drama. We will start the process by clicking on the Graduated Filter icon in the Tools bar of ACR and then add a graduated filter to darken the right side of the image. I have used an Exposure value of -0.25 and set the Highlights slider to -75.

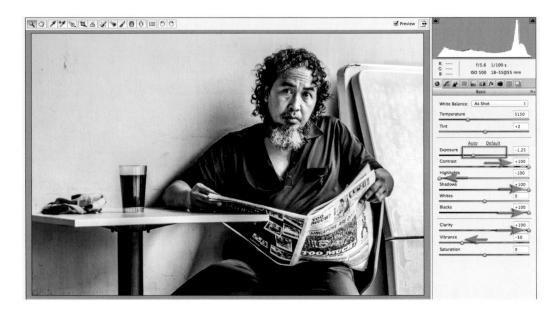

4 The next step is to repeat the actions we took in Step 2 (Contrast and Clarity sliders raised to +100, Highlights lowered to -100 and Shadows raised to +100). To compensate for moving these four sliders I have lowered the Exposure to -1.25 and lowered the Vibrance to -50.

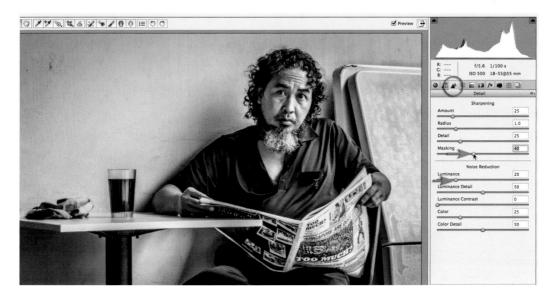

5 The process of expanding the detail also leads to image artefacts such as noise also becoming more visible. We can suppress much of this unwanted detail by going to the Detail tab in ACR and raising the Masking and Luminance sliders. Raising the Masking slider to +40 will prevent the sharpening of detail in the smoother areas of tone and raising the Luminance slider to +20 will suppress any noise present in the image. Moving either of these sliders too much will start to erode the detail we are seeking to highlight.

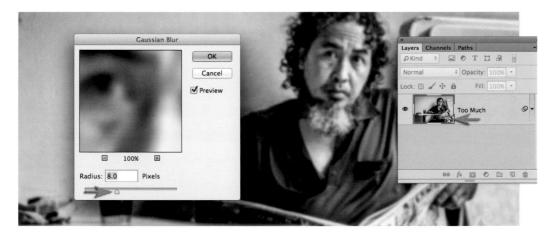

6 Open the Image into the main editing space of Photoshop as a Smart Object. If the blue 'Open' button reads Open Image then hold down the Shift key to change the button to an Open Object button. When the image appears as a Smart Object in the main editing space go to Filter > Blur > Gaussian Blur and choose a value that removes all fine detail from the surfaces but retains the basic shapes of the subject. In this image I have chosen a value of 8.0 pixels, but if you are working with a higher resolution image or the subject is closer to the camera choose a higher value. Select OK to apply the filter as a Smart Filter.

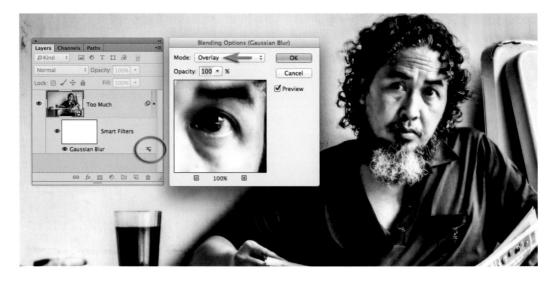

7 Double-click on the blending options icon on the right side of the Smart Filter in the Layers panel to open the Blending Options dialog. When the Blending Options dialog opens change the Mode to Overlay and then select OK. The blur will now be blended with the rich detail in the image. The blend mode does, however, two unfortunate side effects - increased contrast and increased saturation. These will be managed in the following step.

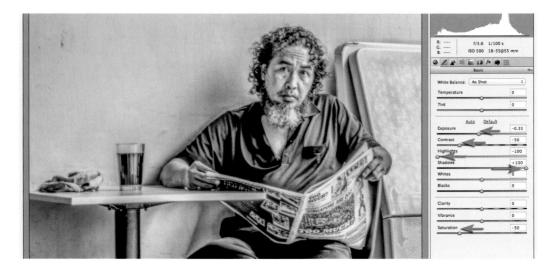

8 Go to Filter > Camera Raw Filter. This opens the processed image into ACR (a version of the image where the blur has been blended with the original Raw image). We can reduce the Contrast by lowering the Contrast slider to -50 and correct the Saturation by lowering the Saturation slider to -50. Lowering the Highlights slider to -100 and raising the Shadows slider to +100 will also serve to reduce the contrast and further highlight the detail. A further Exposure correction may be required to compensate for these actions. In this project image I have lowered the Exposure slider to -0.35.

Special effects

9 To add extra drama to the image we will add a vignette. Go to the Effects panel and reduce the Amount slider to -50. I have left the additional sliders at their default values (Midpoint 50, Roundness 0, Feather 50 and Highlights 0). Out work in ACR is now done but it is worth saving these settings as a Preset so we can fast-track this for future projects.

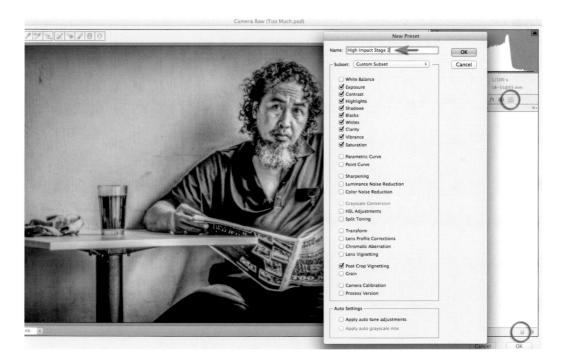

10 Go to the Presets panel in ACR. Click on the New Preset icon at the base of the panel and when the New Preset panel opens choose Basic from the Subset drop-down menu. You may customise these settings slightly by choosing to click on the Post Crop Vignetting option to add this to the Preset. When this step is complete click on the OK button in the bottom right-hand corner of ACR.

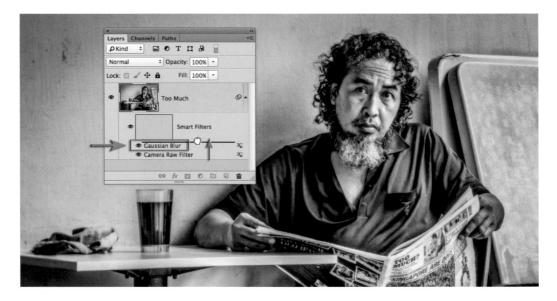

11 The effect is greatly improved if the Gaussian Blur layer is positioned above the Camera Raw filter in the Layers panel. Click and drag the Gaussian Blur filter higher in the filters stack. A dark line will appear to guide you to its new position. Let go of the mouse button when the dark line appears above the Camera Raw Filter.

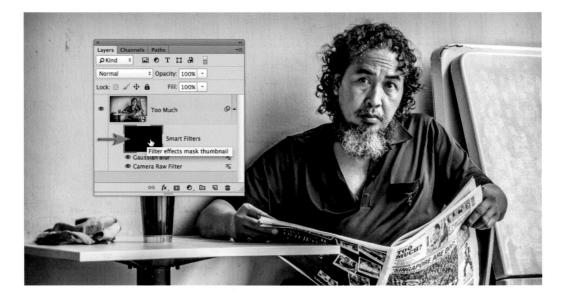

12 If you feel that the secondary treatment (the Gaussian Blur and Camera Raw Filter) is too strong then we can reduce their effects gradually and together. Click on the Smart Filters mask thumbnail in the Layers panel and use the keyboard shortcut Ctrl + I on a PC or Command + I on a Mac. This will render the mask black and hide all of the effects. Double click on the mask to open the Properties panel.

Special effects

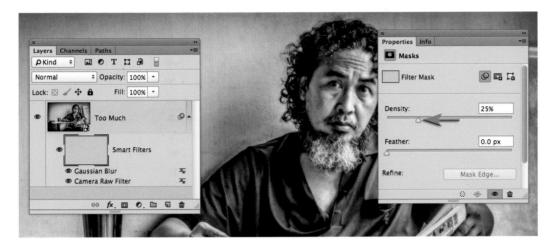

13 In the Properties panel reduce the Density slider to 50% and then to 25% to evaluate whether you like the effect a little more subtle than was originally achieved. As this is a dynamic adjustment you can continue to play with the precise opacity at any stage in the future.

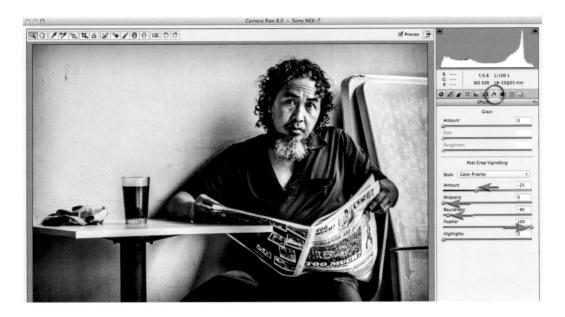

14 We can further modify the effect by double-clicking on the Smart Object thumbnail to open the original image back into ACR (note how the effects of the Camera Raw filter are not visible when this version of the image opens). In this project I have decided to use the sliders in the Effects panel to burn the edges of the image to add to the original vignette added in the Camera Raw Filter. For the edge-burn effect I have set the Amount slider to -25, Midpoint slider to 0, Roundness slider to -90 and Feather slider to +100. The full effects of this work will not be apparent until we select OK and merge this image with the effects of the Gaussian Blur and Camera Raw smart filters

Photograph by Dorothy Connop

HDR TONING

The HDR Toning adjustment only works on a flattened or single layer image file. It is recommended that you first duplicate your file (Image > Duplicate) given that you cannot duplicate the layer. This will allow you to make a composite file of the before and after versions after the adjustment has been applied, so that you can apply the treatment to localized areas of the image to 'tone down' the treatment by dropping the opacity of the treated layer.

The second second	HDR Toning		
· · · · · · · · · · · · · · · · · · ·	Preset: Custom	ОК	
	Method: Local Adaptation	Cancel	
BOARD AND AND AND AND AND AND AND AND AND AN	+ Edge Glow	Preview	
	Radius 105 px		
The state of the s	Strength: 0.52	N N	
and the show the second	Tone and Detail	1	
	Gamma: 1.00		
·	Exposure: 0.00	1a	
and a second second	Detail: +105 %	1. F	
	* Advanced	100 M	
N. T. S.	Shadow: 0%		
the state of the s	Highlight: 0%		
N N N N	Vibrance: 0 %		
	Saturation: -30 %		
2	- • Toning Curve and Histogram		

Go to Image > Adjustments > HDR Toning. The dialog that opens is very similar to the one that is used by the Merge to HDR Pro dialog. Most of the sliders in this dialog are designed for merging multiple exposures, so don't have to be moved. Drag the Detail slider to the right to increase surface texture and then adjust the Radius slider to give the image more 'volume'. As the detail is raised the saturation of the colors will also increase, so you may need to lower the Vibrance or Saturation before selecting OK.

After applying the HDR Toning you can combine the before and after versions to create a composite file. In the Layer panel drag the background thumbnail into the image preview of your duplicate file.

Adjust the Opacity of the treated layer to decrease the overall effect if required. Click the 'Add layer mask' icon at the base of the Layers panel, select the Brush from the Tools panel and set the Foreground Color to black. Set the brush hardness to 0% and lower the opacity of the brush in the Options bar to 20%. Paint over any areas where you need to tone down the effect further and then add an adjustment layer to fine-tune the overall effect.

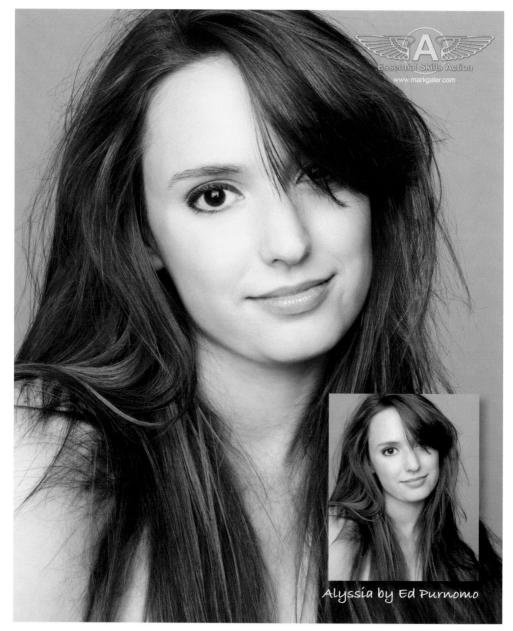

These 'Color Grading' and 'Color Toning' actions are available from www.markgaler.com

Color Grading - Project 3

By carefully controlling the color palette of an image, or series of images, you can help to convey a particular mood or feeling to your viewer. Many of the color grading techniques emulate old film or film intentionally processed in the wrong chemicals (cross-processed). Some of the techniques, however, are purely digital and seek to limit or restrict the color palette to create a signature style for your images. In this project we will explore just a few of the many techniques that can be utilized to grade your images.

Color grading can be applied using the Curves adjustment feature inside of Adobe Camera Raw (ACR) or the main editing space of Photoshop. The Curve can be saved as a Preset in the Curves flyout menu and then applied to other images. In ACR you can choose Save Settings from the Panels flyout menu (below the histogram) and then apply the preset from this same menu or from the Presets panel. Curve presets applied to Raw images in ACR, however, tend to be less predictable than if they are applied to processed images in the main editing space of Photoshop. If you have opened the resource file (as used in the illustration above) and created a Curves Preset) you are advised to save your work as we will use this file again.

Note > Applying a color grading preset is usually a good starting point for a grading project but they usually need fine-tuning to suit the specific image being edited.

When looking for a suitable color treatment for an image I often use a 'Toning' action I have created that provides me with a single-click approach to viewing a variety of treatments. I can then choose the individual action that suits the needs of the project and then fine-tune the settings. These Toning and Grading actions are available to download from www.markgaler.com

Color grading using multiple adjustment layers

Although color grading can often be achieved using a single Curves layer, many users find it difficult to fine-tune results when a single adjustment layer is responsible for every aspect of the color, tone and saturation of the treatment. In these instances it is recommended that you separate the grading over multiple adjustment layers.

1 Start this project by opening the project image into the main editing space of Photoshop (as an Image or as an Object). Create a Levels adjustment layer and select the Red channel from the drop-down menu above the histogram. Move the central Gamma slider underneath the histogram to a value of 0.75 with the aim to remove the warm tones in the image.

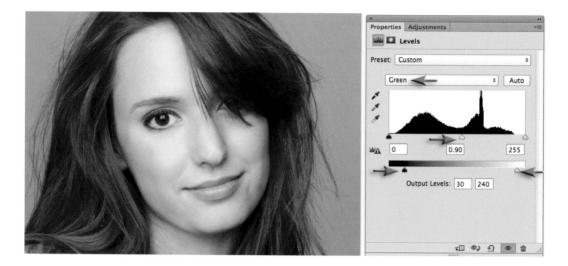

2 Select the Green channel and move the Gamma slider to 0.9 to complete the process of removing the warm tones and then drag the black Output Levels slider to 30 and the white Output Levels slider to 240. The adjustment of the Output Levels sliders is the first step to creating characteristic color casts that are synonymous with stylized color grading.

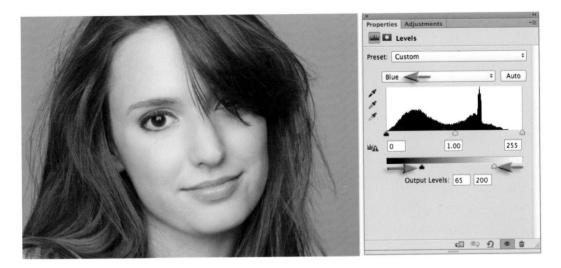

3 Select the Blue channel and drag the black Output Levels slider to a value of 65 and the white Output Levels slider to a value of 200. The shadows should now take on a strong blue/ cyan appearance while the highlights take on a warm color cast. The precise tones can be adjusted by experimenting with the Gamma and Output Levels sliders. These adjustments can be completed using a Curves adjustment layer, but are just that little bit easier to fine-tune using the Output Levels sliders in the Levels adjustment dialog.

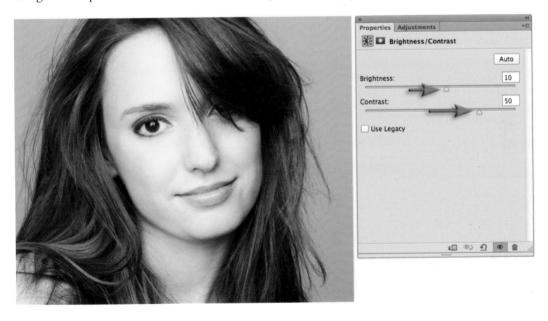

4 By raising the Output Levels sliders we have also lowered the contrast of the image. This can be corrected by adding a simple Brightness/Contrast adjustment layer. To restore the tonal impact of the file I have raised the Brightness slider to 10 and the Contrast slider to 50.

	× et Properties Adjustments et al.
	Hue/Saturation
	Preset: Custom +
	Reds 🔶 🗧
	Hue: 0
0	Saturation: +25
	Lightness:
	# # Colorize 315*/345* 15*\45*
	新 1 1 1 1 1 1 1 1 1 1 1 1 1

5 A third adjustment layer is added to control the hue and saturation of specific colors. This final adjustment layer is also recommended for users who have created a treatment using a single Curves adjustment layer. In the Hue/Saturation dialog I have selected the Red channel and raised the Saturation slider to +25. You may also choose to control the saturation values of the Cyans and Blues using this adjustment dialog. Raising global saturation values can create color banding in some instances. To avoid banding you can try using a Vibrance adjustment instead of a Saturation adjustment and try using a 16 Bits/Channel file instead of an 8 Bits/ Channel file.

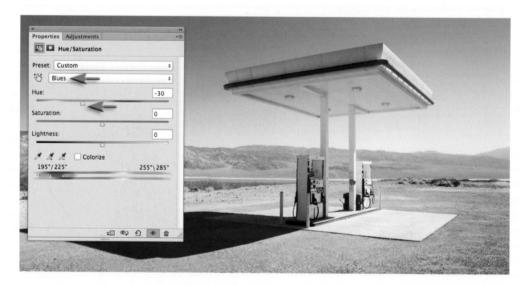

RESTRICTING THE COLOR PALETTE

In color grading projects it is usual either to desaturate colors that do not fit into the color palette you have chosen or to adjust the hue of some colors so that they do fit. In the example above the hue of the blues in the file is moved to cyan.

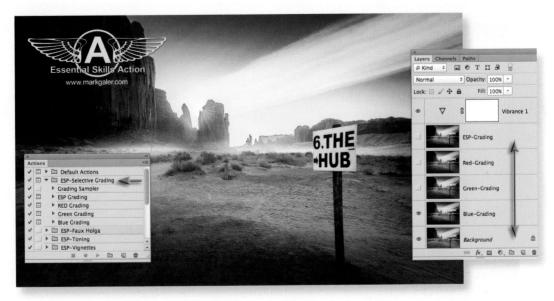

SELECTIVE COLOR GRADING

In some projects you may choose to apply the color grading to the image while protecting the central subject matter from the full effects of the treatment. I have created an action that allows me to sample a range of grading treatments and then apply my favorite after viewing my options in the Layers panel.

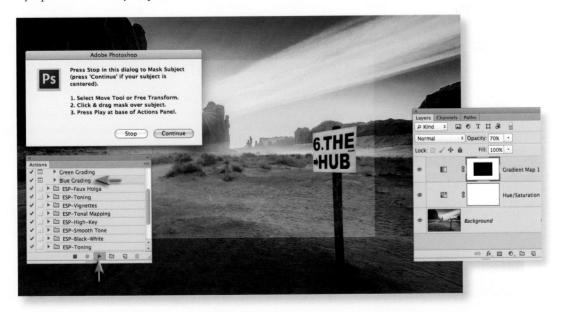

I have programmed the action to pause during the masking process. This allows me to reposition and resize the mask to the project image I am working on before the mask is softened. This 'Selective Grading' action is available from www.markgaler.com

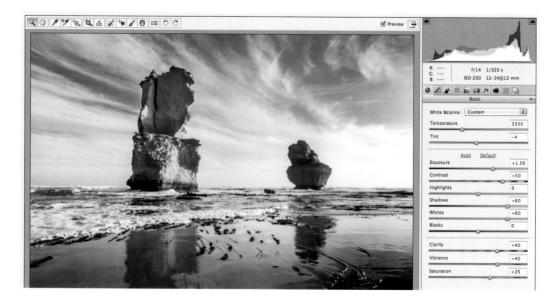

Color grading using the Split Toning panel in ACR

It is possible to create more predictable color grading presets in Adobe Camera Raw using the Split Toning panel.

1 I have first optimized the color and tone of this image using the Tone sliders in the Basic panel and then created a record of this edit in the Snapshots panel (this is already recorded in the project file as the Color-2012-Process snapshot). We can return to this version of the file after first applying the treatment to a black and white version.

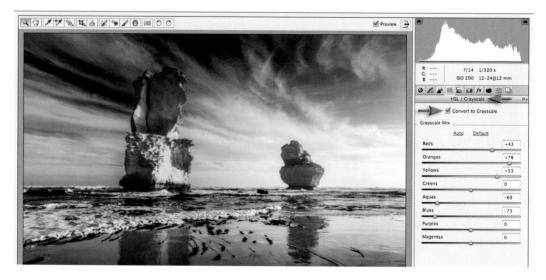

2 In the HSL/Grayscale panel I have checked the Convert to Grayscale option and then raised the Red, Orange and Yellow sliders while lowering the Aquas and Blues sliders. I have then create a second snapshot for the black and white version of the file.

Special effects

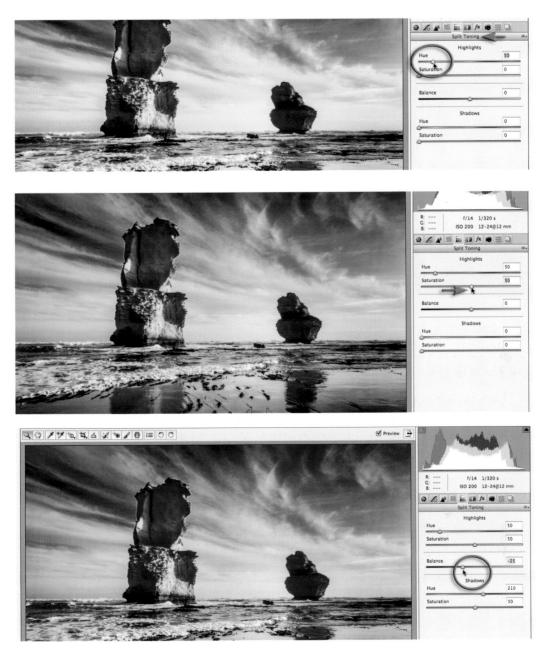

3 In the Split Toning panel I can choose a color for the Highlights by holding down the Alt key (PC) or Option key (Mac) and dragging the Hue slider in the Highlights section to the right (holding down the Alt/Option key will temporarily display the color at 100% saturation). I have chosen a Hue value of 50 for the highlights before letting go of the Alt/Option key and adjusting the Saturation slider to a value of 50. I have then repeated this process to select a Hue value of 210 and Saturation value of 50 for the Shadows. The final step to the split toning process is to adjust the Balance slider. This allows you to decide whether you want the midtones to take on the warm or cool color tones you have created.

4 When you are happy with the Split Toning effect you have created you can save it as a Preset. Click on the fly-out menu on the right-hand edge of the panels and choose Save Settings. A further dialog will open asking you which settings you want to save. Only save the settings associated with the Split Toning panel and deselect all of other settings as the tone and color settings you initially used to optimize this file will most likely be inappropriate for any other file.

5 To apply this preset to a color version of the file simply go to the Snapshots panel and click on the saved color snapshot, or from the fly-out menu choose Apply Preset. You can then fine-tune the Hue or Saturation sliders in the Split Toning panel to suit the color version of the image.

Reduced Depth of Field – Project 4

Compact cameras and camera phones achieve greater depth of field at the same aperture compared to digital cameras using Full Frame or APS-C sensors due to the comparatively small sensor size of small cameras. Greater depth of field is great in some instances but introduces unwelcome detail and distractions when the attention needs to be firmly fixed on the subject.

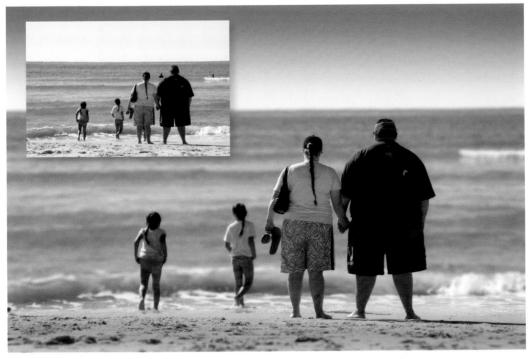

Photography by Dorothy Connop

Sometimes when capturing a decisive moment with a camera the most appropriate aperture or shutter speed for the best visual outcome often gets overlooked. Photoshop can, however, come to the rescue and turn a distracting background into smooth out-of-focus colors. A careful selection to isolate the subject from the background and the application of a blur filter usually does the trick. Problems with this technique arise when the resulting image looks manipulated rather than realistic. The Gaussian Blur filter often requires some additional work if the post-production technique is not to become too obvious. A more realistic shallow depth of field effect, however, is created by using the Lens Blur filter.

Lens Blur or Gaussian Blur?

The Gaussian Blur filter has a tendency to 'bleed' strong tonal differences and saturated colors from around your subject into the background fog, making the background in the image look more like a watercolor painting than a photographic image. The Lens Blur filter (when used with a depth mask) introduces none of the bleed that is associated with the Gaussian Blur technique. The filter is extremely sophisticated, allowing you to choose different styles of aperture and control the specular highlights to create a more realistic camera effect.

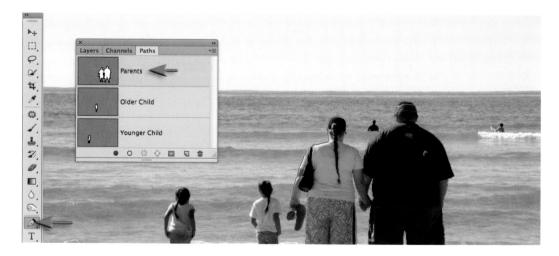

1 The first step in the process is to isolate the subjects that you would like to keep in sharp focus. The people in this project file cannot be selected quickly using any of the selection tools or channel masking techniques. The Pen tool was used to create paths around each of the children and the two parents holding hands. The three paths have been retained in the project file to fast-track the process of adjusting the focus. Hold down the Ctrl key (PC) or the Command key (Mac) and click on the Parents path in the Paths panel to load it as a selection.

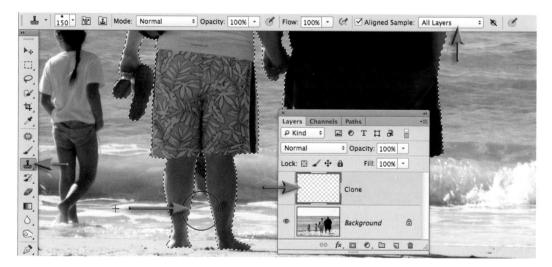

2 In this step we will clear the background of some distracting elements before we move on to adjusting the focus. Go to the Layers panel and click on the 'Create a new layer' icon to create an empty new layer. Double-click on the layer name and name the layer 'Clone'. From the Select menu choose Inverse so that the background is selected instead of the people. Go to Select > Modify > Feather and choose 1 pixel. From the Tools panel choose the Clone Stamp tool and in the Options bar choose a soft-edged brush and select the All Layers option. Hold down the Option/Alt key and set the clone source point in the sea to the left of the woman's legs. Proceed to clone out the legs of the child playing in front of the mother.

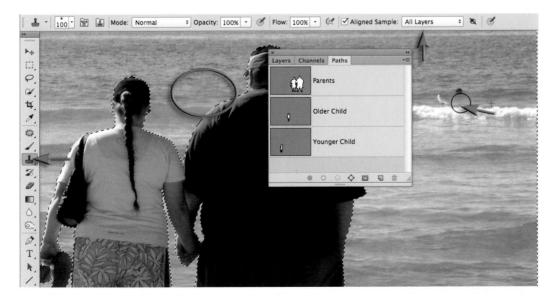

3 With the Clone Stamp tool still selected proceed to clone out the man in the ocean just above the father's shoulder and boy on the body board just above the breaking wave on the right side of the image. The preview inside the clone stamp cursor allows you to line up the waves and the soft edge of the brush makes the cloning seamless.

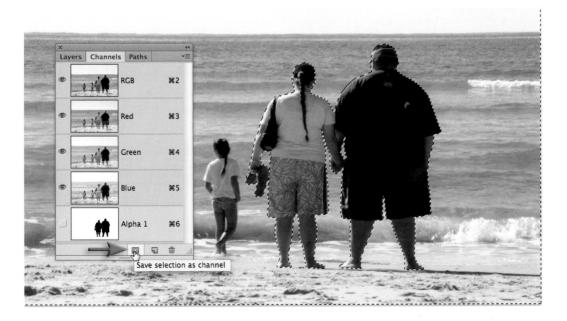

4 When you have finished cleaning up the background go to the Channels panel and click on the 'Save selection as channel' icon at the base of the panel. Go to Select > Deselect and you will now have an Alpha 1 channel which will act as a saved selection and allow us to create a depth map that can be used by the Lens Blur filter. Click on the Alpha channel to select it. This should hide the visibility of the RGB channels.

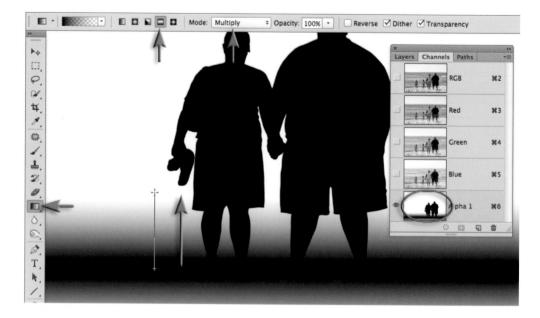

5 The mask will require further work to create an area of sharp focus for positioning or anchoring the subject realistically in its environment. The subject will need to be planted firmly on an area of ground that is not blurred to prevent the subject from floating above the background. A simple gradient will allow us to anchor the subject and allow the background to fade gradually from focus to out-of-focus. Set the Foreground Color to black and then select the Gradient tool from the Tools panel. Choose the Foreground to Transparent, Reflected Gradient and Opacity: 100% options in the Options bar. Drag the Gradient Tool (while holding down the Shift key to constrain the gradient vertically) from the base of the feet to just above the bottom of the shorts. Drag the Gradient tool a second time in the same position to darken this area. The darker areas of this Alpha channel will help retain the focus in this part of the image.

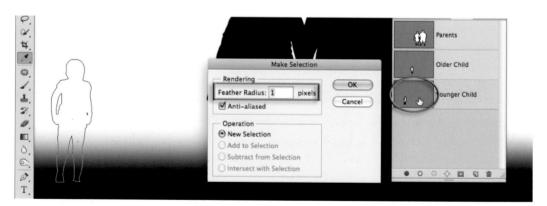

6 We will now add the children to this depth map but as they are a little further away from the camera they will not be as sharp as the parents. Go to the Paths panel and right-click the Younger Child path and select the Make Selection option from the context menu. Choose a Feather Radius of 1 pixel in the Make Selection dialog and select OK.

	Fill		Layers Channels	Paths +m
	Use: Foreground Color Ca	DK	Pare Pare	nts
1	Custom Pattern:		ې Olde	r Child
	Mode: Multiply 🛟		Your	nger Child
The	Preserve Transparency		• • • •	• 🖸 🕤 🍵 者

7 Sample the tone next to the child's feet using the Eyedropper tool. This tone will become the Foreground color in the Tools panel. Go to Edit > Fill. In the Use menu in the Contents section of the Fill dialog box choose Foreground Color and select OK. The child should be slightly lighter than the parents and match the tone of the gradient at the feet. Go to Select > Deselect to clear the selection.

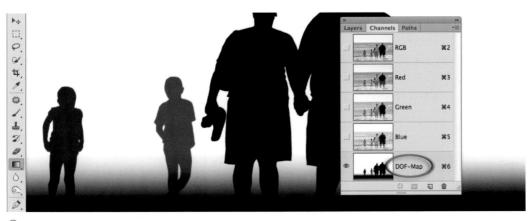

8 Repeat Steps 6 and 7 using the path of the older child. When filled with the Foreground Color the older child will be a slightly lighter gray than the younger child. The depth map is now complete and the channel is renamed DOF-Map (by double-clicking on the name) so that it can be easily identified later. Click on the RGB channel in the Channels panel to return to the color view.

Note > This depth map simulates the depth of field that would have been created if the image had been captured using an extremely wide aperture. Using a longer initial gradient would give you a greater depth of field in the final result. The plane of focus is falling away from the camera towards the horizon. A subject that stands vertically from this horizontal plane of focus must adopt the focus at that point in the gradient for the depth of field to appear realistic.

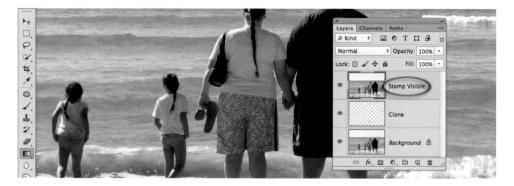

9 In the Layers panel stamp the visible elements from the two layers into a new layer. Hold down the Ctrl, Alt and Shift keys on a PC or Command, Option and Shift keys on a Mac and type the letter E. Rename the layer 'Stamp Visible'. Go to Filter > Blur > Lens Blur to open the Lens Blur dialog box.

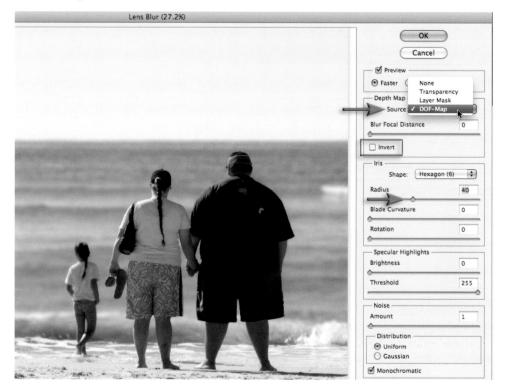

10 From the Depth Map section of this dialog box choose the DOF-Map. Choose the depth of field required by moving the Radius slider (ensure the Invert box is not checked). The Blade Curvature, Rotation, Brightness and Threshold sliders fine-tune the effect. Zoom in to 100% before applying a small amount of Noise (1% or 2% Gaussian Monochromatic is usually sufficient) to replicate the noise of the rest of the image. Select OK to apply the Lens Blur and return to the main workspace. Toggle the visibility of the Stamp Visible layer on and off to see a before and after.

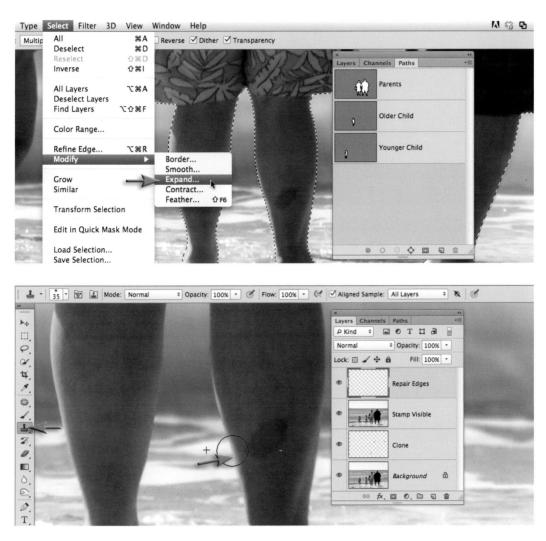

1 I fpart of the background along the edge of the subject is sharp when it should be blurred then this can be corrected using the Clone Stamp tool. Create a new layer and name it Repair Edges. Load an appropriate path as a selection. From the Select menu choose Inverse and feather the selection by 1 pixel (Select > Modify > Feather). Expand the selection by 1 pixel also (Select > Modify > Expand). Select the Clone Stamp tool from the Tools panel and choose the All Layers option from the Sample menu. Hide the selection edges by going to the View > Extras. Hold down the Alt/Option key and take a source point for the Clone Stamp tool just next to the area to be corrected. Cloning away sharp pixels with blurred pixels will correct any minor errors that may exist. Remember to go to Select > Deselect to remove the hidden active selection before proceeding.

Note > Zoom in to 100% (Actual Pixels) and navigate around the edges. If part of the image that should have been sharp has accidentally been blurred (due to an inaccuracy with the original depth map) then add a layer mask to the Stamp Visible layer and paint with black to reveal the sharp image below.

 $12\,$ To complete this project we need to correct one minor flaw and add some finishing touches. There is a small amount of pin-cushion distortion in the image that needs correcting. Stamp the Visible layers to another new layer (see Step 9) and name it 'Stamp & Warp'. Go to View > Rulers (Command or Ctrl + R). Drag a guide from the rule onto the horizon line. You will notice the horizon line curls up at each side of the image.

13 Make sure the Stamp & Warp layer is selected. Go to Edit > Transform > Warp. Move your mouse cursor onto one end of the horizon line in the image window and click and drag down slowly until the horizon aligns with the guide. Move your mouse cursor to the other end of the horizon line and repeat the process until the horizon line is straight. Hit the Enter key when you are done to commit the changes.

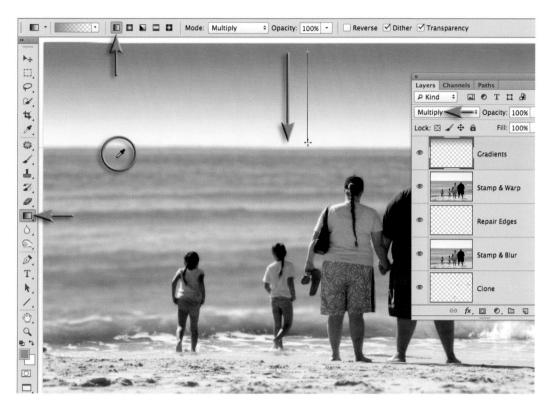

14 To breathe a little more life into that washed-out sky we can add a simple gradient. Click on the 'Create a new layer' icon in the Layers panel to add a new layer named 'Gradients'. Set the layer mode to Multiply. Select the Gradient tool from the Tools panel. Hold down the Alt/ Option key and sample some of the dark blue water just below the horizon line. Select the Foreground to Transparent gradient, set to Linear gradient and drag a gradient from the top of the image down to the horizon line (hold down the Shift key to constrain the line to a vertical).

15 Hold down the Alt/Option key again and this time sample a color from the sand. Using a Reflected gradient drag a short gradient from a position just below the feet to the edge of the water. Drag a second gradient in the same position if the sand needs darkening further.

MOTION BLUR AND RADIAL BLUR (SPIN)

We have looked at both Gaussian Blur and Lens Blur in the preceding projects. The Motion Blur and Radial Blur filters help to extend the creative possibilities even further. The Motion Blur rather than the Radial Blur filter dominates the effect in the image above. The Radial Blur filter is, however, used to spin the wheels. When the wheels appear as an ellipse the following technique must be used to ensure a quality result.

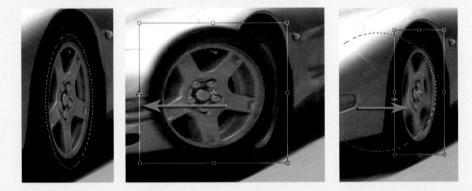

To get the best result from the Radial Blur filter we must present the wheel on the same plane as the one in which the filter works, i.e. front on. Make a selection with the Circular Marquee tool using a small amount of feather. Copy the wheel and paste it into a new layer. Use the Free Transform command and drag the side handle of the bounding box until the wheel appears as a circle instead of an ellipse. From the Blur group of filters choose the Radial Blur filter. When you have applied the filter choose the Transform command again and return the wheel to its original elliptical shape. You can then leave this as a separate layer or merge down.

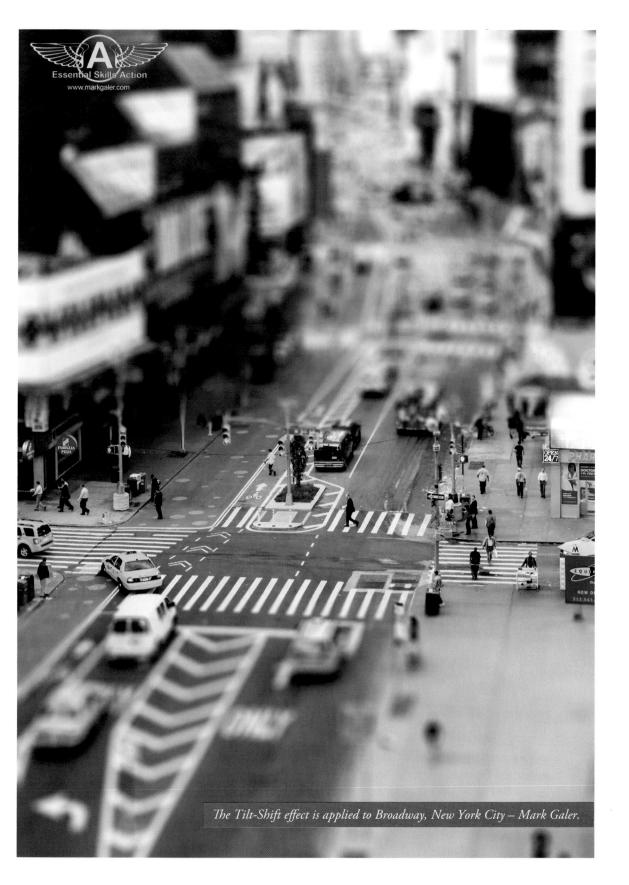

Tilt-Shift Effect – Project 5

The tilt-shift effect is a popular technique that originated from the use of 'tilt-shift' lenses. Architectural photographers use these specialized lenses to correct the converging verticals of the buildings they are photographing, but they can also be used creatively to shift the plane of focus so that areas of the image are thrown dramatically out of focus. One of the most popular effects is to create a 'toy town' look where figures and cars look like they have been placed in a model village. This effect can be created easily in post-production and the advantage is the cost-saving (tilt-shift lenses are extraordinarily expensive) and the fact that the point of focus can be changed at any time, when and if you change your mind.

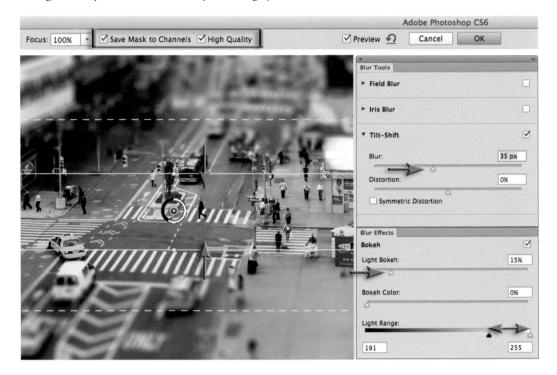

1 The tilt-shift effect can be created using the Lens Blur filter in conjunction with a reflected gradient depth map (see previous Depth of Field project). The effect can, however, be achieved more quickly by applying the Tilt-Shift Blur filter from the Blur Gallery (Filter > Blur > Tilt-Shift). Before selecting the filter you should duplicate your background layer as the blur is applied directly to the pixels (it is not available as a Smart Filter). By default, the tilt shift effect will be applied with a horizontal mask protecting the central portion of the image. Drag the pin to the appropriate position within the image (I have chosen a position close to the man on the pedestrian crossing) and then drag the transition either side of the pin to create a narrower or broader band of focus. The on-image controls also allow you to increase or decrease the blur amount. The Bokeh control in the main panel allows you to change the brightness and color of a selected range of highlights within the image. Select the Save Mask to Channels and High Quality options in the top Options bar so that you can apply further adjustments to the modified areas in the next two steps and then select OK.

Special effects

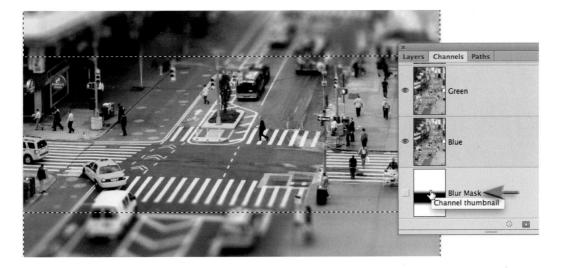

2 After the blur has been applied go to the Channels panel. Below the Blue channel you will find the mask that was saved when the Tilt-Shift Blur was applied. Hold down the Ctrl key (PC) or Command key (Mac) and click on the Blur Mask channel thumbnail to load it as a selection. Alternatively you can drag the channel to the 'Load channel as selection' icon at the base of the Channels panel.

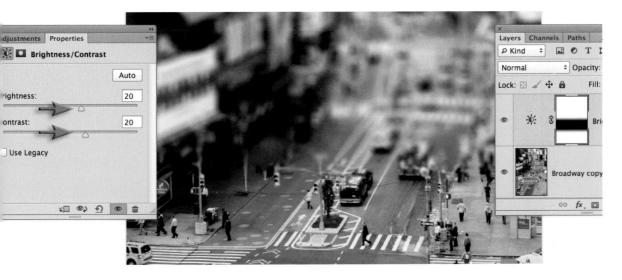

3 In the Layers panel I have chosen to add a Brightness/Contrast adjustment layer. The active selection will create an adjustment mask that will serve to protect the area of sharp focus from any subsequent adjustment. I have raised both the Brightness and Contrast sliders to +20 with the aim of creating the tonality I would expect to see if I was viewing a model village of Manhattan rather than the full scale version. You can also add a Vibrance adjustment layer (no need to mask this adjustment) to raise the richness of the colors further (adjust to taste).

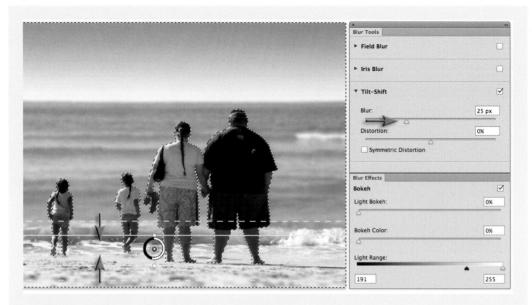

CREATING A QUICK DEPTH OF FIELD EFFECT

If you create and load a selection of the subject matter that you would like to blur, before applying the Tilt-Shift filter, you can create a quick shallow depth of field effect. This approach, however, does not give you the control and flexibility of the approach outlined in the previous Lens Blur project.

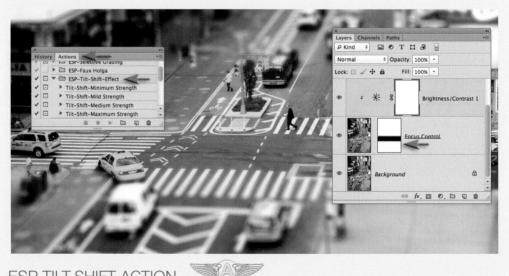

ESP TILT-SHIFT ACTION

A quick and non-destructive approach to applying the tilt-shift effect is to download the action from www.markgaler.com. The action utilizes the high blur quality from the Lens Blur filter and allows the user to control the shape and position of the focus area. The action also allows the user to modify the shape and focus area after the action has been applied. The user simply uses the Move tool or Transform command to change the position or size of the mask which, in turn, changes the focus zone.

				IT Tools	
				Field Blur	
				Iris Blur	
	THE .			Blur:	19 px
				0	
	A	00		Tilt-Shift	
		197	n.		
		1 de	1		
			1		
	1	+ 0		ir Effects	
	1	* 0		ir Effects keh	Z
		¥ Ó	Во		⊠ 15%
		t o	Во	keh	
5			Bo	keh ght Bokeh:	

IRIS BLUR

Iris Blur can be used to create pools of focus and can also be used in conjunction with the Tilt-Shift Blur. In this example the couple reading their timetable have been protected by applying a pin and then adjusting the size of the iris. Each of the four white control points inside of the iris can be adjusted individually by holding down the Alt/Option key as they are moved into position.

	Blur Tools	••
	► Field Blur	
	▼ Iris Blur	
	Blur:	18 px
	0	
	► Tilt-Shift	
The section of the se	Blur Effects	
UNER MAR - Strategies	Bokeh	
A 1 1 101 101 1 1 1 1 1 1 1 1 1 1 1 1 1	Light Bokeh:	15%
144	-	
A RATE A REAL	Bokeh Color:	0%
1 1 1 1 1 1 1 1 1 1 1 1 1 1 1 1 1 1 1	6	and the second se

The point on the upper right-hand side of the iris circle will control the shape of the iris. Additional pins can be added to protect focus in other areas. If these pins are applied in conjunction with the Tilt-Shift Blur, however, they will only restore focus to the secondary blur being applied by the Iris Blur.

Faux Holga - Project 6

Getting tired of pin-sharp, noise-free, character-free images from your 24 Megapixel Pro DSLR? Try this grunge effect to give your images the toy camera aesthetic – think WEIRD, think GRUNGE, think ART!

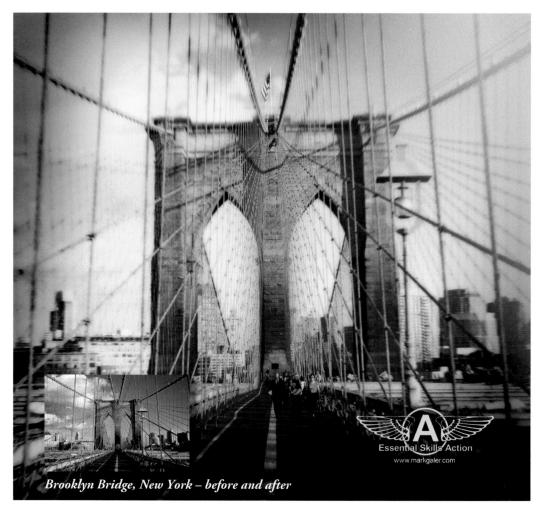

The 'Faux Holga' action is available from www.markgaler.com

The Holga is a cheap (US \$30) plastic medium-format film camera mass-produced in China. Originally manufactured in the early 80s for home use, it has now gained cult status among bohemian western photographers who are drawn to the grunge 'art' aesthetic. The camera represents the antithesis of everything that the modern digital camera manufacturers are striving to achieve. If you are looking for edge-to-edge sharpness and color-fidelity then give the Holga a very wide berth. If, however, you are looking to create images that are full of 'character', but without the hassle of going back to film, then you may like to look into the wonderful, and weird world of Holga-style imagery and give this Photoshop workflow a spin (no Holga required).

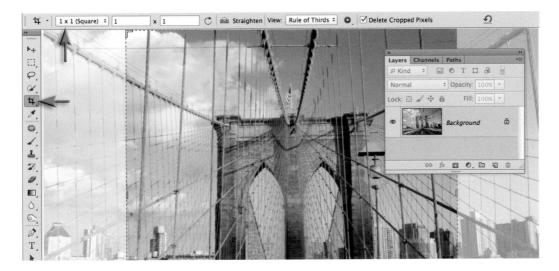

1 Open the project image from the supporting DVD. Images produced by the Holga camera are square so select the Crop tool from the Tools panel and the 1 x 1 (Square) option in the Options bar and drag over the central portion of the start image. Hit the Commit icon or Return/Enter key to get rid of the unwanted pixels. Select the Move tool to exit the crop view.

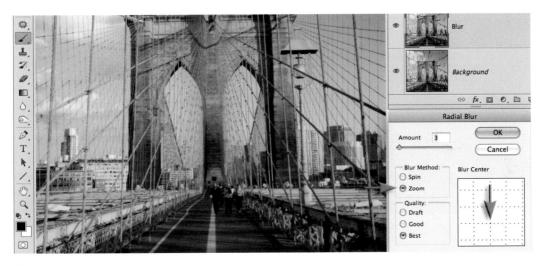

2 Duplicate the background layer using the keyboard shortcut Ctrl + J (PC) or Command + J (Mac) and name the layer 'Blur'. The background layer will serve as a resource to tone down the final effect in localized areas (if required). The next few steps will start to degrade the sharpness of your image (the Holga camera has a simple single-lens element). With the Blur layer selected in the Layers panel go to Filter > Blur > Radial Blur. In the Radial Blur dialog box set the Amount to 3 and then select the Zoom and Best options. Click where you would like to preserve maximum sharpness in the Blur Center control box (to the right of the Zoom and Best options). There is an element of guesswork in this step but sharpness can be restored later in the process. I have selected the region in the lower center (where I estimate the pedestrians to be crossing the bridge in the actual image). Select OK to apply the blur.

3 Go to Filter > Blur > Gaussian Blur. Select a Radius of 1.0 pixel and then select OK to apply the blur filter to the Blur layer. Set the Foreground and Background colors to their Default setting (either click on the small Black and White box icon in the Tools panel or press the D key on the keyboard). This will ensure the next blur filter will have a diffuse glow that is white and not any other color.

Diff	fuse Glow (25%)		
41.1.1	Artistic Brush Strokes Distort	OK Cancel	
	Diffuse Glow Glass Ocean Ripple Glass Ocean Ripple Glass Ocean Ripple Called Content of the second se	Cliffuse Glow Graininess Glow Arnount Clear Amount	¢ 0 4 17
		H Diffuse Clow	

4 Duplicate the Blur layer (Ctrl/Command + J). Name this layer 'Glow'. The Diffuse Glow filter can be found by going to Filter > Filter Gallery. Click on the Distort folder and click on the Diffuse Glow icon. Try setting the Graininess and Glow Amount to 4 and the Clear Amount to 17 as a starting point. You can increase the Graininess to simulate a high ISO film. For this project we will use a separate layer to control the grain look, so set the Diffuse Glow Graininess to 0. Select OK to apply the Diffuse Glow.

Special effects

	1111	Lock: 🖸 🖌 💠 🔒 🛛 Fill: 100% •	
and the second second	Comment of the	● ▶ 🗅 \$	Blur
R	New Layer Name: Grain Use Previous Layer to Create Clipping Mas	OK sk Cancel	ckground D
	Color: None Mode: Overlay Fill with Overlay-neutral color (50% gray)		∞ fx. ⊡ 0. ⊡ 0 â

5 Hold down the Shift key as you select the Glow and Blur layers in the Layers panel and then use the keyboard shortcut Ctrl + G (PC) or Command + G (Mac) to create a layer group and then name it 'Blur'. Click on the 'Add layer mask' icon at the base of the Layers panel (this can be used later to reduce blur in key areas of the image). To create a Grain layer, hold down the Alt key (PC) or Option key (Mac) and click on the 'Create a new layer' icon at the base of the Layers panel. Holding down the Alt/Option key while clicking on the icon will open the New Layer dialog. Name the layer 'Grain', set the mode to Overlay and check the 'Fill with Overlay-Neutral color (50% gray)' checkbox. Select OK to create the Layer. The effects of the layer will be invisible at this point in time (courtesy of the blend mode) until the grain is added in the next step.

6 Go to Filter > Noise > Add Noise. In the Add Noise dialog set the Amount to 7% for a 12-Megapixel image (adjust it higher or lower if you are using a higher- or lower-resolution image). Choose the Gaussian option and select the Monochromatic checkbox before selecting OK to apply the Noise to the Grain layer. Adjust the Opacity of the layer to 50% and adjust even lower if the noise is too prominent (zoom in to 100% to get an accurate view).

/ We will now replicate the dark vignette that is a characteristic of Holga images. Select the Rectangular Marquee tool and set the Feather to 250 pixels (adjust this higher or lower if you are using a higher- or lower-resolution image). Drag a selection so that the central portion of the image is selected (this will leave a border around the edge of the image that is not selected). Hold down the Spacebar as you are making the selection if you need to reposition the selection. From the Select menu choose Inverse and from the Edit menu choose Copy Merged to copy the edge pixels to the clipboard. From the Edit menu choose Paste.

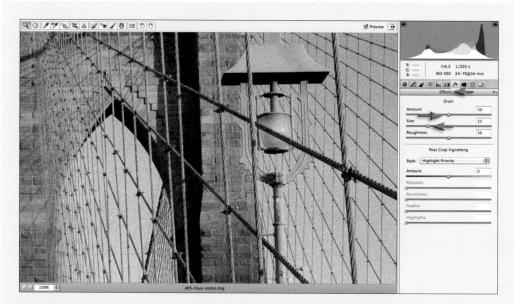

ADDING MORE REALISTIC GRAIN

More realistic grain can be found in the Adobe Camera Raw dialog. If you need to add grain mid-project then you can use the Noise filter or one of the Grain files that are downloaded with the Borders and Textures action from www.markgaler.com.

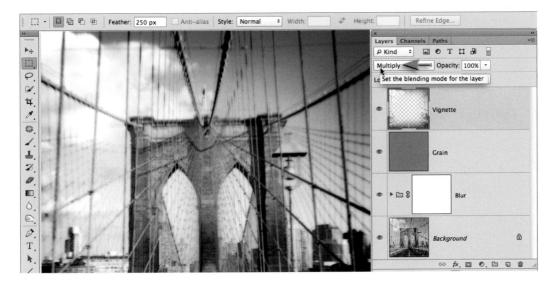

8 The pixels will be pasted to a new layer. I have renamed this layer 'Vignette'. At the moment they are identical to the pixels on the Background layer but when we select the Multiply mode from the Layers panel they can be used to darken down the edges of the image.

9 Another characteristic of the Holga image is the surreal color palette that is present in many (but not all) Holga images. This is a result of either poor processing or cross-processing of the film (cross-processing intentionally uses the wrong chemicals for the film stock used). We can replicate this look with just a few adjustment layers. From the Adjustments panel choose a Levels adjustment layer.

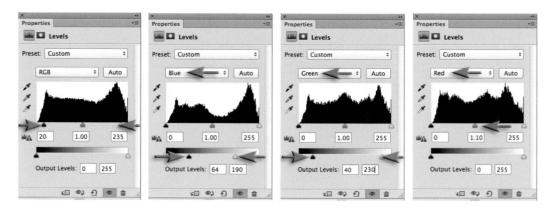

10 Clip the shadow and highlight tones by setting the Black input slider to 20 and the White input slider to 235 (these sliders are located directly underneath the histogram). Select the Blue channel from the drop-down menu in the Levels dialog and then drag the Output Levels sliders to 64 and 190. The Output Levels sliders are located directly underneath the Input sliders. This action will weaken the blacks, render the whites slightly dull and introduce a color cast in both. Select the Green channel and set the Output sliders to 40 and 230 to increase this effect. Finally, select the Red channel and drag the central Gamma slider (directly underneath the histogram) to the left so that it reads 1.10.

1 1 We will fine-tune the color and tonality using additional adjustment layers. Add a Hue/ Saturation layer, select the Reds and drag the Hue slider to -10 and the Saturation slider to +15. Add a Vibrance layer and raise the Vibrance slider to +50 and the Saturation slider to +10 (the Vibrance slider is a little more friendly to the strong colors in this image than using only saturation sliders). Add a Brightness/Contrast adjustment layer and raise the Contrast slider to +50.

Note > Use these target values as a starting point only. When applying this technique to your own images you may like to try experimenting by raising the saturation levels of key colors within a specific image.

12 Add all of the adjustment layers to a group and name the group 'Color Grading'. If you need to reduce any of the effects of the color grading you can add a layer mask to the layer group and paint with a black at a reduced opacity. Save your work this far as a Photoshop file (PSD).

13 Many aspects of the final result can be fine-tuned by going back to the individual layers and adjusting either the settings or the opacity. Paint with black as the foreground color into any of the adjustment layer masks to reduce the effects in a localized region of the image. Add a layer mask to the Blur and Glow layer set and paint with black to restore small amounts of detail for important parts of the subject matter.

14 Some Holga images 'suffer' from (or are 'blessed with' – depending how you look at it) serious edge clipping and/or light leaks. The corner clipping can be unevenly distributed and more severe than your typical vignette. The corner clipping can be replicated by first making another edge selection using the Rectangular Marquee tool with a 150-pixel feather. Choose Inverse from the Select menu.

 $15\,$ Go to Select > Transform Selection. Zoom out so that you can see the corner handles of the Transform bounding box. Hold down the Ctrl key (PC) or Command key (Mac) and drag two of the four corner handles out in a diagonal direction. Commit the transformation by hitting the Return/Enter key.

Special effects

······································	Fill	;
PTA.	Contents Use: Black Custom Pattern:	OK Cancel
	Blending Mode: Normal 🗘 Opacity: 100 % Preserve Transparency	

16 Click on the 'Create a new layer' icon in the Layers panel and then go to Edit > Fill and choose Black as the contents before selecting OK. Lower the Opacity of the layer depending on how severe or subtle you want the effect to appear. Go to Select > Deselect.

17 Light leaks in Holga cameras appear as light orange patches on some frames (some Holga camera owners use black tape around the film-loading area of the camera in an attempt to minimize this problem). These light leaks can easily be simulated. Add a new empty layer and set the mode to Screen. Click on the Foreground color swatch in the Tools panel to open the Color Picker and then select an orange color (or sample one from the image) and then select OK. Select the Gradient tool in the Tools panel, choose the Foreground to Transparent gradient and the Linear Gradient options in the Options bar and then drag a diagonal gradient across one of the corners of the image. Lower the Opacity of the layer to 80%, or lower if you need more subtlety – although to be honest, subtlety is not the name of the game here.

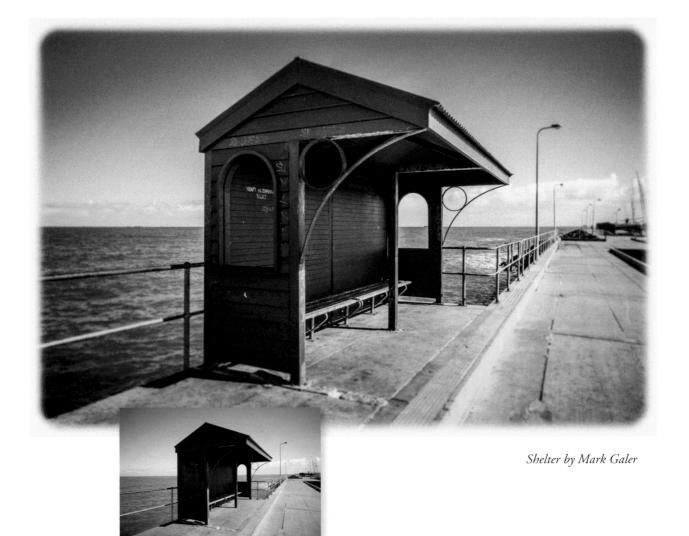

Toy Camera Effect in ACR – Project 7

Adobe Camera Raw or ACR is quickly becoming a one-stop shop for completely changing the mood and style of an image. When 'the look' has been saved as a Preset it can be applied quickly to multiple images to achieve the 'grunge' or 'old film' look that we often see created by the popular smart phone apps. The advantage to using ACR over your smart phone, however, is that we can adopt a non-destructive approach and create a custom made (rather than off-the-shelf) stylized look to our images. The Preset created in this project is suitable for applying to a broad range of Raw images (whatever their resolution). It could technically be applied to JPEG images as well, but the fact that a JPEG image has already been processed once (by the camera), the aggressive treatment used in this workflow may result in excessive banding of tone. Let the grunge begin!

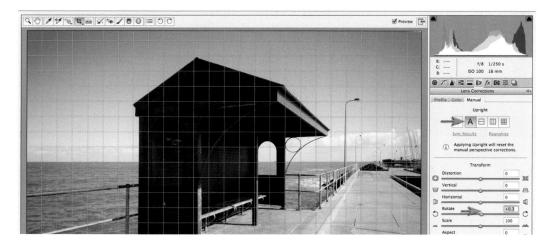

1 Before we start on the Basic tone and color adjustments we will take care of a little bit of housekeeping. Open the Lens Corrections panel and check the Enable Profile Corrections checkbox in the Profile tab and check the Remove Chromatic Aberration checkbox in the Color tab. These actions will correct the small amount of barrel distortion present in the file that was captured with a 16mm wide-angle lens and remove the chromatic aberration present. In the Manual tab apply the Uptight correction by clicking on the A button. If you check the Show Grid box at the base of this panel you will see an additional +0.3 degree rotation is required to level the horizon.

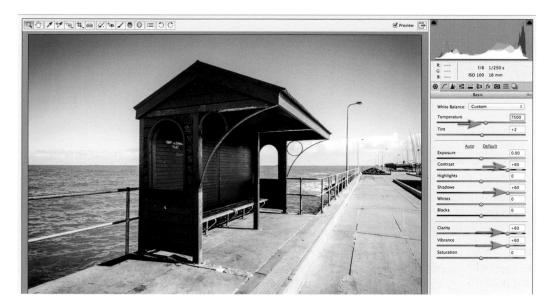

2 Open the Basic panel and adjust the Temperature slider to a value of approximately 7,500°K to warm things up. Move all the Contrast, Shadows, Clarity and Vibrance sliders to a value of +60 to provide drama in the image.

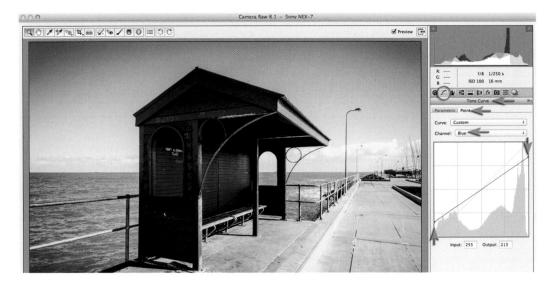

3 To provide the image with a 'faded film' look we will open the Tone Curve panel and choose the 'Point Curve' tab. Select the Blue Channel from the Channels drop-down menu and click on the point in the upper right-hand corner of the curve and drag the point down until it is around 40 levels lower than 255. Now move the point in the lower left-hand side of the curve and move it by approximately the same amount (you will see the Output value change from 0 to 40).

4 Now change from the Blue curve to the Red curve and create a small s-curve, i.e. click in the highlight region of the curve (three quarters of the way to the top) and drag the point slightly higher (you should see the Output value change by approximately 10 levels). Click again in the shadow region of the curve (a quarter of the way from the bottom of the curve) and drag the point slightly lower (another 10 level adjustment). Feel free to experiment with different values to create interesting grading effects (any values are OK so long as there is a disturbance to the reality of the scene).

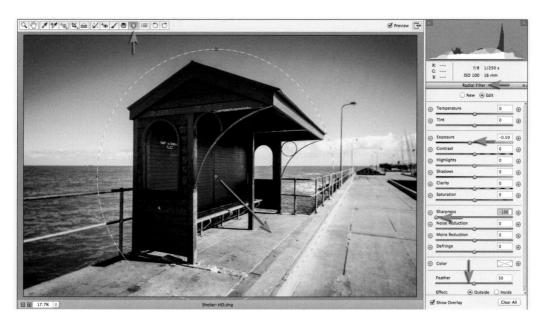

5 In this step we will defocus the edges of the image to create the visual acuity of an image captured with a lens containing just a single element. Click on the Radial Filter icon in the Tools bar. Click on the - icon on the left side of the Exposure slider to set a -0.50 Exposure adjustment and zero all other sliders. Now drag the Sharpness slider to -100. Set the Feather to 50 and check the Outside radio button. Click and drag a radial gradient from the center of the shelter until a circle just surrounds the shelter.

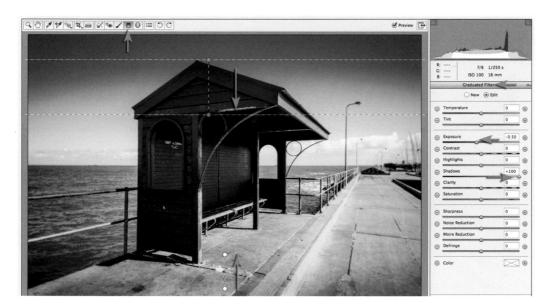

6 Select the Graduated Filter from the Tools bar and add a -0.50 Exposure graduated filter at the top and bottom of the image. Adjusting the Shadows slider to +100 will ensure the top of the shelter does not darken along with the sky.

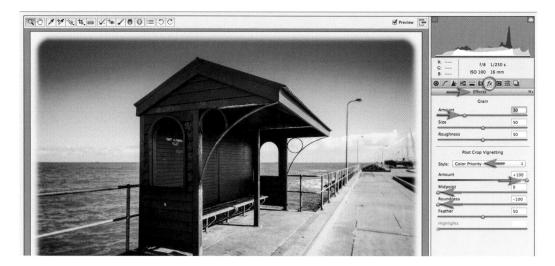

7 Click on the 'fx' icon to access the Effects panel. Raise the Amount slider to 30 to simulate film grain. We can also simulate a faded paper border in the Post Crop Vignetting section of the Effects panel. Raise the Amount slider to +100 and set the Midpoint and Roundness sliders to -100. The border will take on the faded yellow color that we introduced in the Curves panel.

8 To save these steps as a New Preset go to the Presets panel and click on the New preset icon at the base of the panel. The adjustments you decide to include in the preset deserves some thought. Not every image will require the same Exposure and White Balance settings so you may decide to uncheck these boxes. You will also notice that Graduated Filters, Radial Filters and Adjustment Brushes are not included in the preset so these will have to be applied manually.

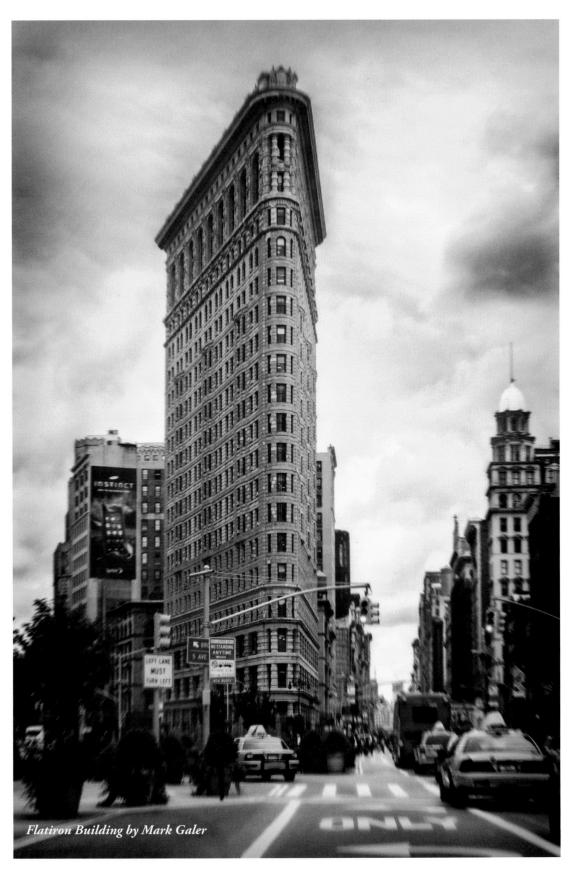

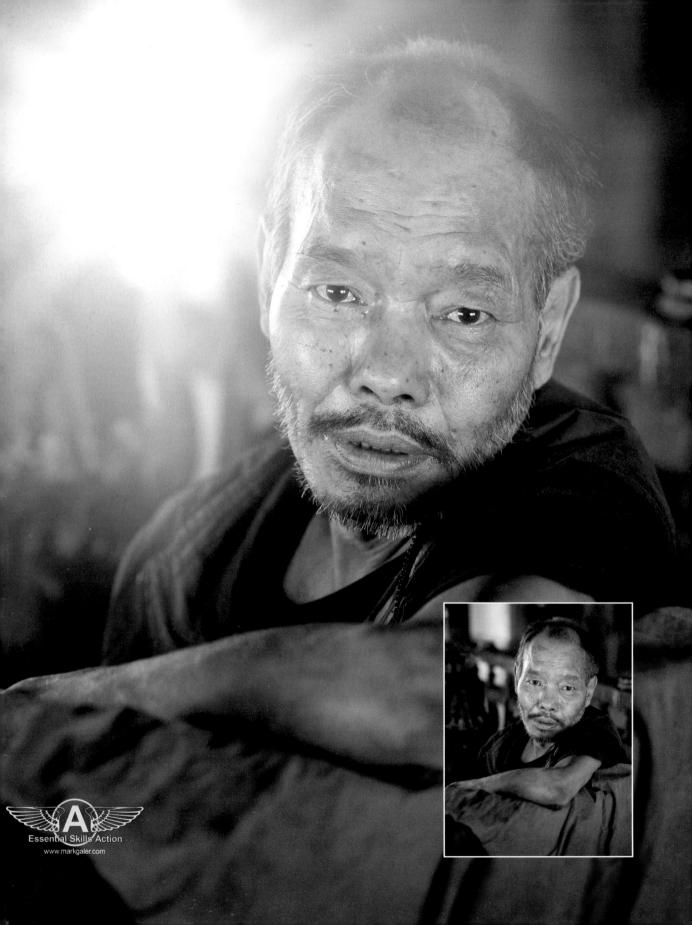

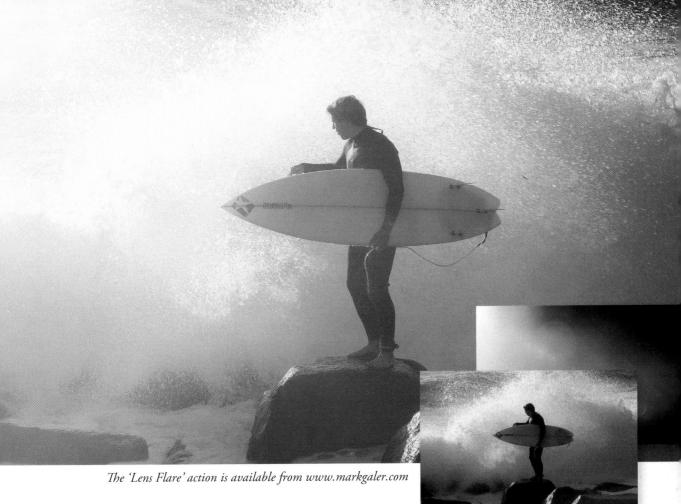

Lens Flare effect - Project 8

Lens flare can occur when a very bright light shines directly into the camera lens. The internal reflections and scattering of light can result in a significant lowering of subject contrast and cause image artifacts to appear (these are created from the numerous lens elements and the shape of the aperture). Photographers mostly try to avoid lens flare by ensuring the camera is not pointed directly at a bright light source or by using a lens hood or 'barn doors' on the lights to ensure the front element of the lens is shaded. Ever since the Hollywood film Easy Rider was released in 1969, however, cinematographers and photographers have been inspired to use lens flare creatively to add drama to a scene. The process of controlling lens flare in-camera can, however, be very challenging and some lenses are a little too good at suppressing it. This project demonstrates how lens flare can be added in post-production with a great deal more control than at the time of capture.

Note > Photoshop has a Lens Flare filter (Filter > Render > Lens Flare) and this can be applied to a separate layer if you are trying to follow a non-destructive workflow (add it to a gray layer in Overlay mode or a black layer in Screen Blend mode). The Lens Flare filter has various options that simulate the effect created by real lenses but the best effects are created by adding a layer, or layers, from image files of real lens flare (ones that were captured with the aim of recording the flare not the subject).

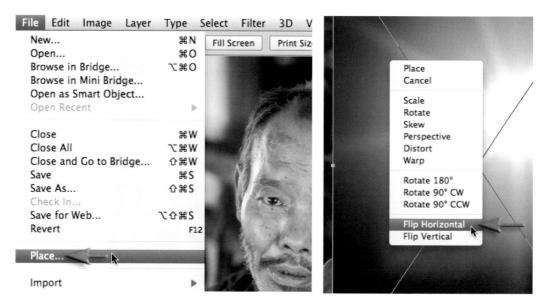

1 In the first of these two lens flare tutorials I will add flare emanating from the window behind the man in the portrait image. Open the project image (LensFlare1.jpg). Go to File > Place and choose the vertical flare file (Flare-17) from the project resources. When it appears you will notice the flare needs to be moved to the upper left side to tie in with the project image. Right-click inside the Transform bounding box and choose Flip Horizontal from the context menu.

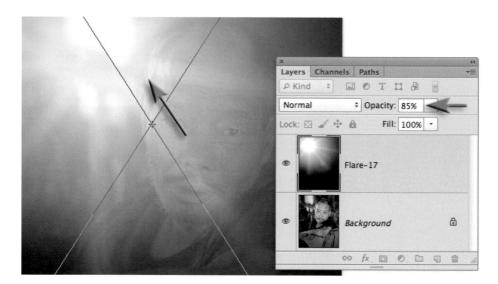

2 Lower the Opacity of the Flare layer in the Layers panel so that we can see the light coming through the window in the background layer. Resize the layer to fit the background image and then scale the layer by dragging the top-left corner handle of the bounding box, up and to the left, until the flare aligns with the window light. You may need to zoom out to complete this step (Command/Ctrl + -).

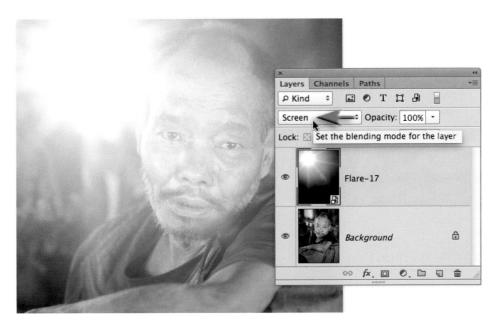

3 Commit the transformation when you have achieved alignment by hitting the Backspace key (PC) or Return key (Mac). Raise the Opacity of the Flare layer to 100% and set the mode of this layer to Screen. The project could be complete here but you may like to proceed to optimize, enhance or protect the tones of the subject.

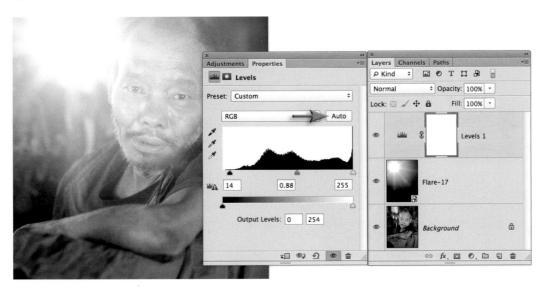

4 Create either a Levels or Curves adjustment layer and hit the Auto button. There are multiple variations of Auto and you can explore these by Alt/Option + clicking the Auto button. Any of the options you choose will attempt to restore a black point to the image (creating richer shadow tones) but will still leave the drama of the flare intact.

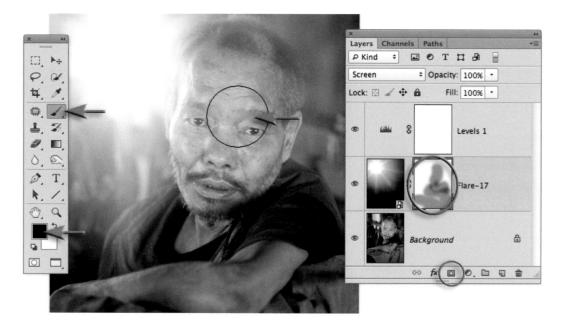

5 Although lighter tones with reduced contrast are a signature characteristic of lens flare, you do have the option of restoring localized contrast and depth of tone. Select the Flare layer in the Layers panel and then click on the 'Add layer mask' icon at the base of the panel. Select the Brush tool from the Tools panel and black as the Foreground Color. Lower the Opacity and the Hardness of the brush in the Options bar and then paint to restore tone in the subject.

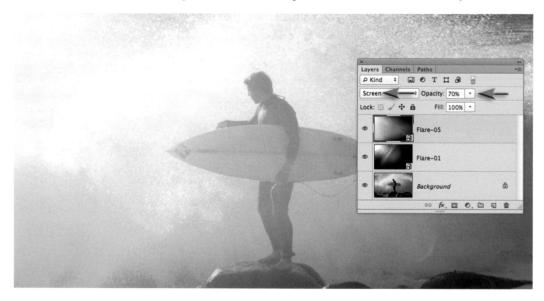

6 It is possible to mix and match more than one flare file. In this example I have opened the surfer file and placed two different flare files above the background layer and set the mode of each layer to Screen and the Opacity of each to 70%.

Special effects

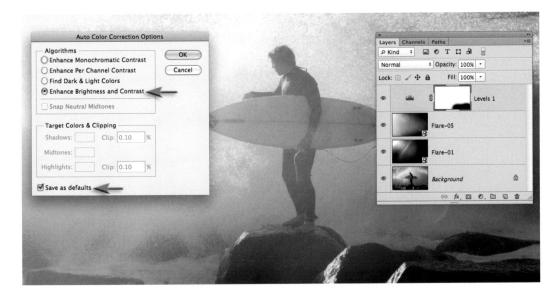

7 I have repeated the process of adding a Levels adjustment layer and have chosen the Enhance Brightness and Contrast option from the Auto options (Alt/Option + Click on Auto). If you would like this option to be the default Auto option then check the Save as Defaults checkbox before selecting OK. Instead of restoring depth to the file by painting into a layer mask added to the flare layers, I have opted to paint into the Adjustment layer mask as I do not want to restore depth of tone to the foreground rocks.

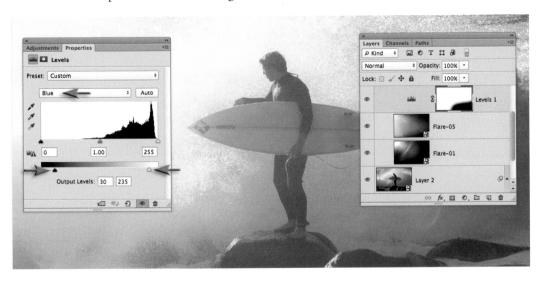

8 Treat the Auto option in the Levels or Curves dialog as a starting point for the color and tonal corrections. In the example above I have created a faded 1970s look by adjusting the Output sliders in the Green and Blue channels (see the Color Grading project in this chapter).

Note > This Flare effect is available as an Action from the www.markgaler.com website. The action comes with a resource pack of 40 flare files.

Borders and Textures - Project 9

In the old days, photographers taking their films to a lab to be processed would often have the choice of several different photo edges. You could get your photos printed edge-to-edge or with a white border. Rough edges were popular for a while, as was printing with the negative edge showing. In this tutorial I'll show you how to replicate some of those effects, as well as the popular 'Polaroid transfer' look. The edges are easy to apply digitally and the results can be stunning. The border for this project is inspired by the Polaroid transfer technique. The edge emulates the fluid and organic transition between image and paper that the historic analog process is known for. The edge also introduces a hint of texture from the original film emulsion and paper backing.

Note > The Action, complete with a project resource pack, makes light work of applying this technique. The Action pack includes a collection of 10 different paper textures, 4 edge effects and 4 assorted grain files from small to extra large.

Special effects

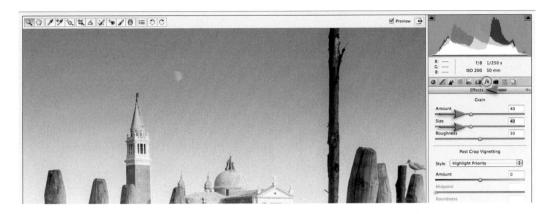

1 The best place to add film-grain texture in Photoshop is in Adobe Camera Raw. If you are using a JPEG image, open the image into ACR from Bridge (File > Open in Camera Raw). Go to the Effects panel and start by raising the Amount and Size sliders to 40. Zoom in to assess the quality of the grain you are adding. Open the image into the main editing space as an Object (this will allow you to readjust the grain by simply double-clicking the Smart Object thumbnail in the Layers panel).

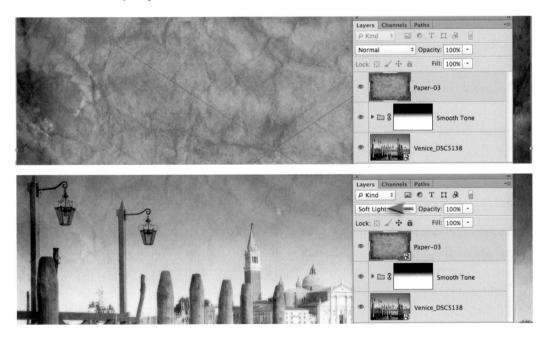

2 Before adding the texture and border to this file I have applied the Smooth Tone technique from Project 1 in this chapter (optional). I have then added a gradient in the layer mask to shield the sky from this adjustment. To add a paper texture go to File > Place and then browse to the project paper texture file. Resize the file if necessary to fit the project image and then hit the Enter key (PC) or Return key (Mac). Set the mode of the layer to Soft Light to blend the texture. You can increase the texture further by switching from the Soft Light to the Overlay blend mode.

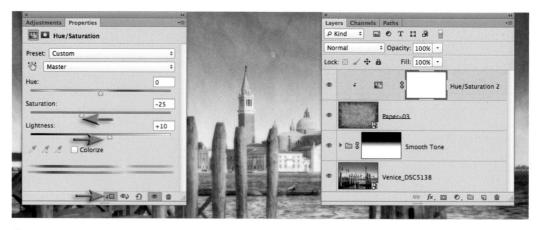

3 The color of the paper, as well as its texture, will have an impact on the underlying image. To reduce the impact of the paper color add a Hue/Saturation adjustment layer. Clip the adjustment layer to the paper layer below by clicking on the clipping icon at the base of the Hue/Saturation dialog. Drag the Saturation slider to the left (-25). Restore the lightness of the project by dragging the Lightness slider to +10.

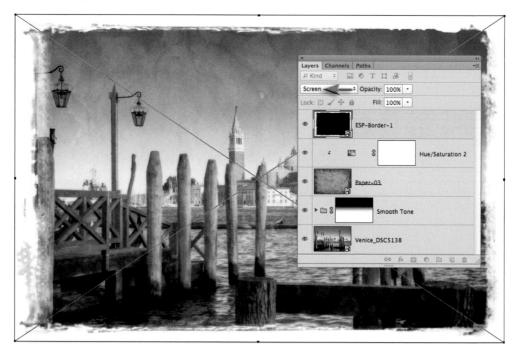

4 To add a border go to File > Place and then browse to the project border file. Set the mode of the layer to Screen and resize if required before hitting the Enter/Return key. Black is neutral in the Screen blend mode so only the white border is now visible.

Note > The Action pack, with its range of 44 resource files, enables you to vary grain texture and edge effects so that you don't have a series of images with exactly the same styling (common with some mobile apps).

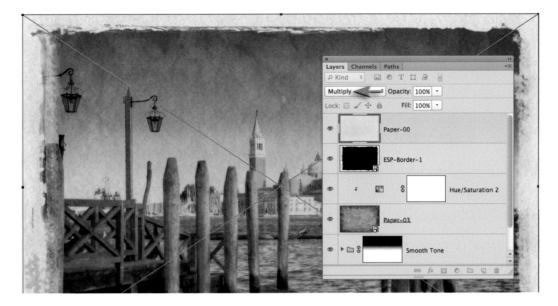

5 You can add a second paper texture to color the white border by going to File > Place and browsing to the second paper texture file. Resize if necessary and set the mode this time to Multiply. The Multiply mode will darken the image but we can mask this in the next two steps.

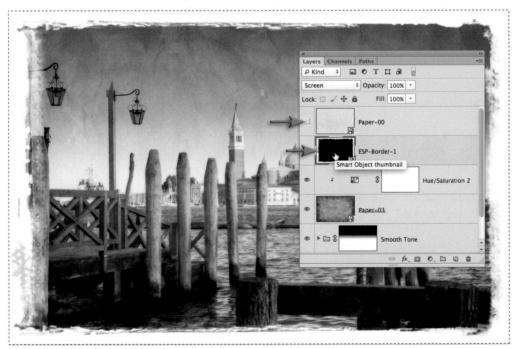

6 Switch off the visibility of the new paper texture layer and click on the border layer to select it. Go to Select > All and then Edit > Copy. The contents of the border layer have now been copied to the clipboard.

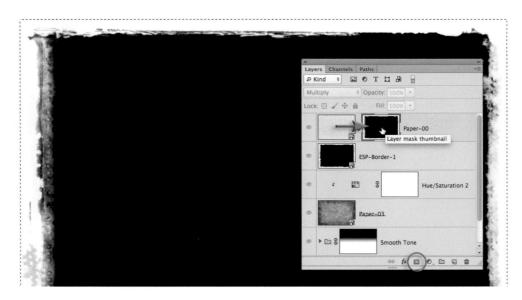

7 Switch the visibility of the new paper layer back on and then click on the 'Add layer mask' icon at the base of the Layers panel. Hold down the Alt key (PC) or Option key (Mac) and then click on the layer mask to view the contents. The preview will turn completely white as the mask is currently empty. From the Edit menu choose Paste.

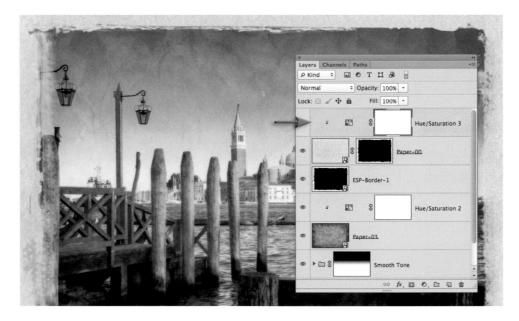

8 Click on the image thumbnail to return to the normal view and then clip a Hue/ Saturation adjustment layer to modify the Saturation or Lightness of the paper that now surrounds your image (-30 Saturation in the project image). The downloadable Action from the www.markgaler.com website can be played in conjunction with other actions to create highly stylized treatments and effects.

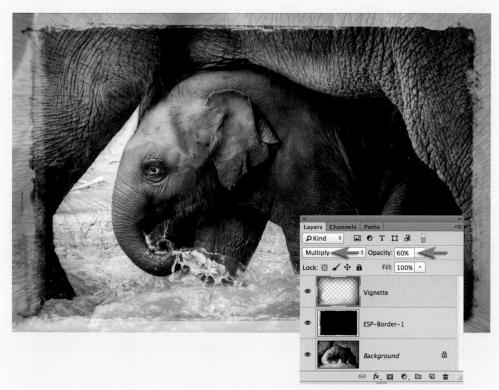

CHANGING PLACES

Another way of using the border creatively is to change its position in the layer stack. In the example above the edges of the image have been pasted into a new layer. The layer opacity is then reduced and the Mode set to Multiply. In order to achieve this effect switch off the visibility of the border layer. Select the Rectangular Marquee tool and set the Feather to approximately 250 pixels. Click and drag to select the central portion of the image. From the Select menu choose Inverse and from the Edit menu choose Copy Merged to copy the edge pixels to the clipboard. From the Edit menu choose Paste. This new layer should be positioned above the Border layer. Now switch on the visibility of the Border layer and adjust its opacity and blend mode (Screen to hide black or Multiply to hide white).

Creative Border and Lens Flare actions applied.

Glossary

Adobe Camera Raw. ACR A color system where the primaries of red, green and blue mix to Additive color form the other colors. Adjustment layer Image adjustment placed on a layer. Adobe Camera Raw Adobe's own Raw conversion utility. Adobe Gamma A calibration and profiling utility supplied with Photoshop. Adobe's download utility used for transferring photos from card or Adobe Photo Downloader camera to computer. The utility ships with Bridge. A sequence of mathematical operations. Algorithm The display of a digital image where a curved line appears jagged Aliasing due to the square pixels. Alpha channel Additional channel used for storing masks and selections. Analyze To examine in detail. The process of smoothing the appearance of a curved line in a Anti-aliasing digital image. APD Adobe Photo Downloader. Aperture A circular opening in the camera lens that controls light reaching the film. Area array A rectangular pattern of light-sensitive sensors alternately receptive Artifacts to red, green or blue light. Pixels that are significantly incorrect in their brightness or color values. The ratio of height to width. Usually in reference to the light-Aspect ratio sensitive area or format of the camera. Short for binary digit, the basic unit of the binary language. Bit Bit depth Number of bits (memory) assigned to recording color or tonal information. A one-bit image, i.e. black and white (no shades of gray). Bitmap Black and White A color to grayscale adjustment feature. As well as customized mapping of colors to gray the feature can tint monochromes. The formula used for defining the mixing of a layer with those Blend mode beneath it. Bracket Capture multiple images using different exposures. Adobe's sophisticated file-browsing and organization program that Bridge ships with Photoshop. The value assigned to a pixel in the HSB model to define its Brightness relative lightness. To make darker. Burn Eight bits. The standard unit of binary data storage containing a Byte value between 0 and 255.

Captured	A record of an image.
CCD	Charge Coupled Device. A solid-state image pick-up device used in
	digital image capture.
Channels	The divisions of color data within a digital image. Data is separated
	into primary or secondary colors.
Charge Coupled Device	See <i>CCD</i> .
CIS	Contact Image Sensor. A single row of sensors used in scanner
	mechanisms.
Clipboard	The temporary storage of something that has been cut or copied.
Clipping mask	Two or more layers that have been linked. The base layer acts as a
11 0	mask, limiting the effect or visibility of those layers clipped to it.
Cloning tool	A tool used for replicating pixels in digital photography.
CMOS	Complementary Metal Oxide Semiconductor. A chip used widely
	within the computer industry, now also frequently used as an image
	sensor in digital cameras.
СМҮК	Cyan, Magenta, Yellow and Black (K). The inks used in four-color
	printing.
Color fringes	Bands of color on the edges of lines within an image.
Color fringing	See Color fringes.
Color gamut	The range of colors provided by a hardware device, or a set of
0	pigments.
Color Picker	Dialog box used for the selection of colors.
Color space	An accurately defined set of colors that can be translated for use as
1	a profile.
ColorSync	System level software developed by Apple, designed to work
,	together with hardware devices to facilitate predictable color.
Complementary metal	See CMOS.
oxide semiconductor	
Composite	Create a single image from multiple images.
Composition	The arrangement of shape, tone, line and color within the
1	boundaries of the image area.
Compression	A method for reducing the file size of a digital image.
Constrain Proportions	Retains the proportional dimensions of an image when changing
1	the image size.
Contact Image Sensor	See <i>CIS</i> .
Context	The circumstances relevant to something under consideration.
Continuous tone	An image containing the illusion of smooth gradations between
	highlights and shadows.
Contrast	The difference in brightness between the darkest and lightest areas
	of the image or subject.
CPU	Central Processing Unit, used to compute exposure.
Crash	The sudden operational failure of a computer.
Crop	Reduce image size to enhance composition or limit information.
Curves	Control for adjusting tonality and color in a digital image.

Glossary

DAT	Digital Audio Tape. Tape format used to store computer data.
Default	The settings of a device as chosen by the manufacturer.
Defringe	The action of removing the edge pixels of a selection.
Density	The measure of opacity of tone on a negative.
Depth of field	The zone of sharpness variable by aperture, focal length or subject
•	distance.
Descreen	The removal of half-tone lines or patterns during scanning.
Device	An item of computer hardware.
Device-dependent	Dependent on a particular item of hardware. For example,
	referring to a color result unique to a particular printer.
Device-independent	Not dependent on a particular item of hardware. For example, a
Device macpenaent	color result that can be replicated on any hardware device.
Digital audio tape	See DAT.
Digital image	A computer-generated photograph composed of pixels (picture
Digital image	elements) rather than film grain.
Digital Negative format	Adobe's open source Raw file format.
Digital Regative Ionnat	Adobe's Digital Negative format.
Dodge	To make lighter.
Douge Download	To copy digital files (usually from the internet).
	Dots per inch. A measurement of resolution.
Dpi Dummy file	To go through the motions of creating a new file in Photoshop
Dummy me	for the purpose of determining the file size required during the
	scanning process.
Dye sublimation print	A high-quality print created using thermal dyes.
	Types of pigment.
Dyes	
Edit	Select images from a collection to form a sequence or theme.
Editable text	Text that has not been rendered into pixels.
Eight-bit image	A single-channel image storing 256 different colors or levels.
Evaluate	Assess the value or quality of a piece of work.
Exposure	Combined effect of intensity and duration of light on a light-
	sensitive material or device.
Exposure compensation	To increase or decrease the exposure from a meter-indicated
	exposure to obtain an appropriate exposure.
Feather	The action of softening the edge of a digital selection.
File format	The code used to store digital data, e.g. TIFF or JPEG.
File size	The memory required to store digital data in a file.
Film grain	See <i>Grain</i> .
Film speed	A precise number or ISO rating given to a film or device
Thin speed	indicating its degree of light sensitivity.
F-numbers (f-stops)	A sequence of numbers given to the relative sizes of lens aperture
1 - numbers (1-stops)	opening. F-numbers are standard on all lenses. The largest
	number corresponds to the smallest aperture and vice versa.
Format	The size of the camera or the orientation/shape of the image.
i omiai	the size of the camera of the orentation shape of the image.

Frame Freeze FTP software	The act of composing an image. See <i>Composition</i> . Failure of software to interact with new information. File Transfer Protocol software is used for uploading and
	downloading files over the internet.
Galleries	A managed collection of images displayed in a conveniently accessible form.
Gaussian Blur	A filter used for defocusing a digital image.
GIF	Graphics Interchange Format. An 8-bit format (256 colors) that supports animation and partial transparency.
Gigabyte	A unit of measurement for digital files, 1024 megabytes.
Grain	Tiny particles of silver metal or dye that make up the final image. Fast films give larger grain than slow films. Focus finders are used to magnify the projected image so that the grain can be seen and an accurate focus obtained.
Gray card	Card that reflects 18% of incident light. The resulting tone is used by light meters as a standardized midtone.
Grayscale	An 8-bit image with a single channel used to describe monochrome (black and white) images.
Half-tone	A system of reproducing the continuous tone of a photographic print by a pattern of dots printed by offset litho.
Hard copy	A print.
Hard drive	Memory facility that is capable of retaining information after the computer is switched off.
HDR	High Dynamic Range image.
High Dynamic Range	A picture type that is capable of storing 32-bits per color channel. This produces a photo with a much bigger possible brightness range than found in 16- or 8-bit per channel photos. Photoshop creates HDR images with the Merge to HDR Pro feature.
Highlight	Area of subject receiving highest exposure value.
Histogram	A graphical representation of a digital image indicating the pixels allocated to each level.
Histories	The memory of previous image states in Photoshop.
History Brush	A tool in Photoshop with which a previous state or history can be painted.
HTML	HyperText Markup Language. The code that is used to describe the contents and appearance of a web page.
Hue	The name of a color, e.g. red, green or blue.
Hyperlink	A link that allows the viewer of a page to navigate or 'jump' to another location on the same page or on a different page.
ICC	International Color Consortium. A collection of manufacturers including Adobe, Microsoft, Agfa, Kodak, SGI, Fogra, Sun and Taligent who came together to create an open, cross-platform standard for color management.

ICM	Image Color Management. Windows-based software designed to work together with hardware devices to facilitate predictable color.
Image Color Management	See ICM.
Image setter	A device used to print CMYK film separations used in the
inlage setter	printing industry.
Image size	The pixel dimensions, output dimensions and resolution used to define a digital image.
Infrared film	A film that is sensitive to the wavelengths of light longer than 720 nm, which are invisible to the human eye.
Instant capture	An exposure that is fast enough to result in a relatively sharp image free of significant blur.
International Color Consortium	See ICC.
	Final resolution of an image arrived at by means of interpolation.
Interpolated resolution Interpolation	Increasing the pixel dimensions of an image by inserting new pixels between existing pixels within the image.
ISO	International Standards Organization. A numerical system for rating the speed or relative light sensitivity of a film or device.
ISP	Internet Service Provider, allows individuals access to a web server.
Jaz	Storage disks capable of storing 1 or 2 GB, manufactured by Iomega.
JPEG (.jpg)	Joint Photographic Experts Group. Popular image compression file format.
Jump	To open a file in another application.
Juxtapose	Placing objects or subjects within a frame to allow comparison.
Juxtapose	
Kilobyte	1024 bytes.
LAB mode	A device-independent color model created in 1931 as an international standard for measuring color.
Lasso tool	Selection tool used in digital editing.
Latent image	An image created by exposure onto light-sensitive silver halide ions, which until amplified by chemical development is invisible to the eye.
Latitude	Ability of the film or device to record the brightness range of the subject.
Layer	A feature in digital editing software that allows a composite digital image where each element is on a separate layer or level.
Layer mask	A mask attached to a layer that is used to define the visibility of pixels on that layer.
Layer Stacks	A group of Photoshop layers that have to be converted into a Smart Object for the purposes of performing image analysis on
	the differences between the picture content of each layer.

LCD	Liquid Crystal Display.
LED	Light-Emitting Diode. Used in the viewfinder to inform the
	photographer of exposure settings.
Lens	An optical device usually made from glass that focuses light rays
Levels	to form an image on a surface.
	Shades of lightness or brightness assigned to pixels.
Light cyan	A pale shade of the subtractive color cyan.
Light magenta	A pale shade of the subtractive color magenta.
LiOn	Lithium ion. Rechargeable battery type.
Lithium ion	See LiOn.
LZW compression	A lossless form of image compression used in the TIFF format.
Magic Wand tool	Selection tool used in digital editing.
Magnesium lithium	See MnLi.
Marching ants	A moving broken line indicating a digital selection of pixels.
Marquee tool	Selection tool used in digital editing.
Maximum aperture	Largest lens opening.
Megabyte	A unit of measurement for digital files, 1024 kilobytes.
Megapixels	A million pixels.
Memory card	A removable storage device about the size of a small card. Many
,	technologies available result in various sizes and formats. Often
	found in digital cameras.
Merge to HDR	Photoshop's feature for creating HDR images from a series of
0	photos with bracketed exposures.
Metallic silver	Metal created during the development of film, giving rise to the
	appearance of grain. See <i>Grain</i> .
Minimum aperture	Smallest lens opening.
MnLi	Magnesium lithium. Rechargeable battery type.
Mode (digital image)	RGB, CMYK, etc. The mode describes the tonal and color range
mode (digital image)	of the captured or scanned image.
Moiré	- 0
Wone	A repetitive pattern usually caused by interference of overlapping
Motherboard	symmetrical dots or lines.
Wiotherboard	An electronic board containing the main functional elements of a
Multiple expective	computer upon which other components can be connected.
Multiple exposure	Several exposures made onto the same frame of film or piece of
	paper.
Negative	An image on film or paper where the tones are reversed, e.g. dark
	tones are recorded as light tones and vice versa.
NiCd	Nickel cadmium. Rechargeable battery type.
Nickel cadmium	See NiCd.
Nickel metal hydride	See NiMH.
NiMH	Nickel metal hydride. Rechargeable battery type.
Noise	Electronic interference producing white speckles in the image.

Non-destructive editing	An editing approach that doesn't alter the original pixels in a photo throughout the enhancement process. Typically used in Raw processing or in techniques that make use of Smart Object technology.
Non-imaging	Not assisting in the formation of an image. When related to light it is often known as flare.
ODR	Output Device Resolution. The number of ink dots per inch of paper produced by the printer.
Opacity	The degree of non-transparency.
Opaque	Not transmitting light.
Optimize	The process of fine-tuning the file size and display quality of an image.
Out of gamut Output device resolution	Beyond the scope of colors that a particular device can create. See <i>ODR</i> .
Path	The outline of a vector shape.
PDF	Portable Document Format. Data format created using Adobe software.
Pegging	The action of fixing tonal or color values to prevent them from being altered when using Curves image adjustment.
Photomerge	Adobe's own panoramic stitching utility.
Photo multiplier tube	See <i>PMT</i> .
Photoshop document	The native file format used by Photoshop.
Piezoelectric	Crystal that will accurately change dimension with a change of applied voltage. Often used in inkjet printers to supply microscopic dots of ink.
Pixel	The smallest square picture element in a digital image.
Pixelated	An image where the pixels are visible to the human eye and curved lines appear jagged or stepped.
Place	A command that adds a file as a Smart Object to the open file.
PMT	Photo Multiplier Tube. Light-sensing device generally used in drum scanners.
Portable Document Format	See PDF.
Pre-press	Stage where digital information is translated into output suitable for the printing process.
Primary colors	The three colors of light (red, green and blue) from which all other colors can be created.
Processor speed	The capability of the computer's CPU measured in megahertz.
PSD	Photoshop Document format.
Quick Mask mode	Temporary Alpha channel used for refining or making selections.

Quick Selection Tool	A selection tool added to Photoshop in version CS3 that tries to predict the shape of the selection as you draw. The feature takes into account tone, color, texture and shape of the underlying photo as it creates the selection.
RAID	Redundant Array of Independent Disks. A type of hard disk assembly that allows data to be simultaneously written.
RAM	Random Access Memory. The computer's short-term or working memory.
Rasterize	Convert vector layers or Smart Objects into pixel layers.
Reflector	A surface used to reflect light in order to fill shadows.
Refraction	The change in direction of light as it passes through a transparent surface at an angle.
Resample	To alter the total number of pixels describing a digital image.
Resolution	A measure of the degree of definition, also called sharpness.
RGB	Red, Green and Blue. The three primary colors used to display images on a color monitor.
Rollover	A web effect in which a different image state appears when the viewer performs a mouse action.
Rubber Stamp tool	A tool used for replicating pixels in digital imaging. Also called Clone Stamp tool.
Sample	To select a color value for analysis or use.
Saturation (color)	Intensity or richness of color hue.
Save a Copy	An option that allows the user to create a digital replica of an image file but without layers or additional channels.
Save As	An option that allows the user to create a duplicate of a digital file but with an alternative name, thereby protecting the original document from any changes that have been made since it was opened.
Scale	A ratio of size.
Scratch disk memory	Portion of hard disk allocated to software such as Photoshop to be used as a working space.
Screen real estate	Area of monitor available for image display that is not taken up by palettes and toolbars.
Screen redraws	Time taken to render information being depicted on the monitor as changes are being made through the application software.
Secondary colors	The colors cyan, magenta and yellow, created when two primary colors are mixed.
Sharp	In focus. Not blurred.
Single lens reflex	See SLR camera.
Slice	Divides an image into rectangular areas for selective optimization
	or to create functional areas for a web page.
Slider	A sliding control in digital editing software used to adjust color, tone, opacity, etc.

SLR camera	Single Lens Reflex camera. The image in the viewfinder is
SER camera	essentially the same image that the film will see. This image, prior
	to taking the shot, is viewed via a mirror that moves out of the
	way when the shutter release is pressed.
Smart Filter	An extension of the Smart Object technology that allows the non-
Sinart Titter	destructive application of Photoshop filters to an image.
Smart Object	Technology first introduced in Photoshop CS2 that maintains
Sillart Object	the original form of an embedded image but stills allows it to
	be edited and enhanced. Smart Objects are used in many non-
	destructive editing or enhancement techniques.
Snapshot	A record of a history state.
Soft proof	The depiction of a digital image on a computer monitor used to
0000 11000	check output accuracy.
Software	A computer program.
Stack	Several photos grouped together in the Bridge workspace.
Subjective analysis	Personal opinions or views concerning the perceived
	communication and aesthetic value of an image.
Subtractive color	A color system where the subtractive primary colors yellow,
	magenta and cyan mix to form all other colors.
System software	Computer operating program, e.g. Windows or Mac OS.
Tagging	System whereby a profile is included within the image data of
00 0	a file for the purpose of helping describe its particular color
	characteristics.
Terabyte	1024 Gigabytes
Thematic images	A set of images with a unifying idea or concept.
TIFF	Tagged Image File Format. Popular image file format for desktop
	publishing applications.
Tone	A tint of color or shade of gray.
Transparent	Allowing light to pass through.
Tri-color	A filter taking the hue of one of the additive primaries, red, green
	or blue.
True resolution	The resolution of an image file created by the hardware device,
	either camera or scanner, without any interpolation.
TTL meter	Through-the-Lens reflective light meter. This is a convenient way
	to measure the brightness of a scene as the meter is behind the
	camera lens.
Tweening	Derived from the words in betweening – an automated process of creating additional frames between two existing frames in an
	animation.
UCR	Under Color Removal. A method of replacing a portion of the
	yellow, magenta and cyan ink, within the shadows and neutral
	areas of an image, with black ink.
Under color removal	See UCR.

Unsharp Mask Unsharp Mask filter URL	See <i>USM</i> . A filter for increasing the apparent sharpness of a digital image. Uniform Resource Locator. The unique web address given to every web page.
USM	Unsharp Mask. A process used to sharpen images.
Vanishing Point	A Photoshop feature designed to allow the manipulation of photos within a three-dimensional space.
Vector graphic	A resolution-independent image described by its geometric characteristics rather than by pixels.
Video card	A circuit board containing the hardware required to drive the monitor of a computer.
Video memory	Memory required for the monitor to be able to render an image.
Virtual memory	Hard-drive memory allocated to function as RAM.
Visualize	To imagine how something will look once it has been completed.
Workflow	Series of repeatable steps required to achieve a particular result within a digital imaging environment.
ZIP	A file format that supports lossless data compression. A .ZIP file may contain files or folders that may have been compressed.
Zoom tool	A tool used for magnifying a digital image on the monitor.

Keyboard Shortcuts

Action

 \mathbb{T} = Option \triangle = Shift \Re = Command \oslash = Delete/Backspace

Keyboard Shortcut

Navigate and view	
Fit image on screen	Double-click Hand tool or ೫/Ctrl + 0 (zero)
View image at 100%	Double-click Zoom tool or $\mathbf{N}/\mathrm{Alt} + \mathbf{H}/\mathrm{Ctrl} + 0$
Zoom tool (magnify)	₩/Ctrl + Spacebar + click image
Zoom tool (reduce)	\mathbf{N} /Alt + $\mathbf{\mathfrak{B}}$ /Ctrl + click image
Full/Standard/Maximized screen mode	F
Show/hide rulers	₩/Ctrl + R
Show/hide guides	₩/Ctrl + ;
Hide panels	Tab key
File commands	

Open	₩/Ctrl + O
Close	₩/Ctrl + W
Save	₩/Ctrl + S
Save As	☆ + ₩/Ctrl + S
Undo/Redo	₩/Ctrl + Z
Step backward	λ /Alt + H/Ctr
Step forward	೫ /Ctrl + ☎ + 2

Selections

Add to selection Subtract from selection Copy Cut Paste Paste Into Free Transform Distort image in Free Transform Feather Select All Deselect Reselect Inverse selection Edit in Quick Mask mode

S rl + Z Ζ

Hold Δ key and select again Hold Σ /Alt key and select again ₩/Ctrl + C **೫**/Ctrl + X **\%**/Ctrl + V ₩/Ctrl む + V **೫**/Ctrl + T Hold # key + move handle $\mathcal{H}/Ctrl + \mathcal{N}/Alt + D$ ₩/Ctrl + A **\%**/Ctrl + D �+\#/Ctrl + D **ૠ**/Ctrl + I Q

Painting

0	
Set default foreground and background colors	D
Switch between foreground and background color	Х
Enlarge brush size (with Paint tool selected)]
Reduce brush size (with Paint tool selected)	[
Make brush softer	[+ Shift
Make brush harder] + Shift
Change opacity of brush in 10% increments	Press number keys 0–9
(with Brush tool selected)	
Fill with foreground color	λ /Alt 🛛
Fill with background color	₩/Ctrl 🔕

Adjustments

Levels	₩/Ctrl + L
Curves	₩/Ctrl + M
Hue/Saturation	\\\\Ctrl + U

Layers and masks

Crop

Enter crop Cancel crop Constrain proportions of crop marquee Straighten tool ♪ 第/Ctrl + N 第/Ctrl + click thumbnail Press number keys 0−9

∑/Alt + click 'Add layer mask' icon ೫/Ctrl + [or]

 $\mathcal{H}/Ctrl + \mathcal{N}/Alt + \Delta$ then type E $\mathcal{H}/Ctrl + G$

 $\begin{aligned} & \texttt{B}/\mathsf{Ctrl} + \mathbf{V}/\mathsf{Alt} + \mathsf{G} \\ & \mathbf{\Phi} + \mathsf{click} \text{ layer mask thumbnail} \\ & \mathbf{V}/\mathsf{Alt} + \mathsf{click} \text{ layer mask thumbnail} \\ & \mathbf{V}/\mathsf{Alt} + \mathbf{\Phi} + \mathsf{click} \text{ layer mask thumbnail} \\ & \texttt{B}/\mathsf{Ctrl} + \mathsf{G} \end{aligned}$

 ∇ /Alt + Δ + (N, K, M, G, S, O, F, Y, C)

Return key Esc key Hold 🏠 key ೫/Ctrl + Shift

Web Links

Online contents

Online resources Website is password protected: http://www.focalpress.com/cw/Galer Please use PCCES13 to access content

Information and blogs

Mark Galer The Luminous Landscape Digital Photography Review Digital Dog John Nack

Actions & Tutorials

Mark Galer Adobe Russell Brown Planet Photoshop Julieanne Kost Deke McClelland

Illustrators

iStockphoto Samantha Everton Rory Gardiner Chis Mollison Shane Monopoli Chris Neylon Serap Osman Ed Purnomo Victoria Verdon Roe http://www.markgaler.com http://www.luminous-landscape.com http://www.dpreview.com http://www.digitaldog.net http://blogs.adobe.com/jnack

http://www.markgaler.com http://www.adobe.com/designcenter/ http://www.russellbrown.com http://www.planetphotoshop.com http://www.jkost.com http://www.deke.com

www.iStockphoto.com www.samanthaeverton.com www.rorygardiner.com.au www.chrismollison.com.au www.exclusivephotography.com.au www.chrisneylon.com.au www.seraposman.com.au www.edpurnomo.com www.victoriaverdonroe.com

Index

3D content 18, 21 adaptive wide angle 198 adjustments how much is enough 309 localized levels with layer masks 300 quick 290-300 recovering highlights 290 sharpening 299 Adobe Camera Raw (ACR) 10, 14 black and white 283-8 clarity 246 color grading using Split Toning panel 450-2 cropping 250 extreme contrast edits 255-60 noise reduction 240 quick adjustments 290-300 saving images 251 sharpening in 245, 299 standard edit in 230-54 synchronize settings 249 toy camera effect 478-82 Adobe Digital Negative (DNG) 38, 51 Adobe Photo Downloader (APD) 38 alpha channel 155, 172 anti-alias 171 archiving 51 Raw files as digital negatives 127 auto-align for pin-registering images 413–14 Behance.net 9 bit depth 94 8-bit editing 94-5 16-bit advantages/disadvantages 54 black and white 283-8 blend modes 214, 328-41 creating displacement map 335-9 selecting appropriate images 333 texture 333-4 Blur Gallery 18, 20, 200 Field Blur 201 Iris Blur 200 tilt-shift blur 201 borders 490-4 changing position 495 bracketing exposures 383 Bridge 24 adding keywords 39 asset management 24 auto stacking options 35 CC version 25-6 custom panel display 30 downloading pictures 38 filtering displayed files 34 labelling pictures 38 locating files 34 Loupe tool 28 Mini Bridge 40-3 multi-image preview 28 Path bar 36 processing in Photoshop 45 processing Raw files 45 **Review Mode 30**

setting up 26-32 slideshow 28 Smart Collections 37 speedy thumbnail/preview generation 31-2 stacking alike photos 34-5 Standard Collections 36–7 tools 43-4 transferring with Adobe Photo Downloader 32-3 using 32-45 viewing options 26, 28 brush workflow 103-4 camera shake 16, 197 capture, options for 48 channels 154, 156 changing 156 **CMYK 157** definition 148 grayscale 157 LAB 157 masking 175-6 **RGB 157** viewing 156 clarity 246 clone or heal 282 color 225 adjustment 65–7 burn 218 dodge 221 range 174-5 color grading 444-5 multiple adjustment layers 446 restricting palette 448 selective 449 Split Toning panel in ACR 450-2 color space 93 Adobe RGB (1998) 94 ProPhoto RGB 94 sRGB 94 composite projects adjusting section of layer mask after Refine Edge 326 aligning images with moving content 415-17 alternative approach to Liquify filter 341 auto-align for pin-registering images 413-14 blending the texture 333 creating displacement map 335-9 exported arids 424 fixed position 355 High Dynamic Range (HDR) 382-98 layer comps 340 LR/Enfuse 390 luminance preset 423 modifying a mask using pen tool 322 paths, masks, blend modes 328-41 perspective or cylindrical 412 photomerge 400-17 preserving shadows 363-73 quick mask 321 Refine Edge 312-27 replacing a sky 342-8 replacing studio background 374-81 selecting appropriate images to blend 333 shortcuts for masking work 320 smart fixed position 356-62 studio lighting and action 349-55

vertical panoramas 418-24 white background 316 Creative Cloud 3-4 saving files 7–8 sharing work 8-9 cropping 63-5, 92-3 in ACR 250 special effects 111-12 Cylindrical 412 darken 216 color burn 218 darker color 218 linear burn 218 multiply 216-18 Defringe 172 depth of field 466 reduced 453-62 difference 224 digital exposure 121 displacement map 335-9 dissolve 215 double processing 301-8 drawing skills 182-5 dust 126 editing 49 adjustments 159 advantages/disadvantages of 16-bit 54 for drama 274-82 extreme contrast in ACR 255-60 non-destructive 158 standard edit in ACR 230-54 enhancing 49, 53 preliminary 118 exclusion 224 exposure 123-4 adjustment in ACR 122 multiple 125 Feather 171 Field Blur 201 file download 60-1 filtering 34 location 34 saving, duplicating, resizing 83-5 filters 34, 151, 188 adaptive wide angle 198 Blur gallery 200-5 DIY 211 fade command 192 Gallery feature 191 graduated 119 improve performance 192 installing/using third party 192-3 lighting effects gallery 199 liquify 194-5 minimum and maximum 17 noise 206-8 plug-in 433 Radial Gradient 11 reclaim detail 120 roundup 193 shape, text, vector layer 193 sharpen 208-9

sharpening with High Pass 210 Smart 189–90 smart object support 20 special effects 112–13 ten commandments for usage 211 texture 210 vanishing point 195–7

graduated filter add 119 adjust 119 Grain effect 111, 120, 472 grayscale 157 conversion 106–9 grids, exported 424

hard light 223 High Dynamic Range (HDR) 382–93 bracketing exposures 383 effect 391 LR/Enfuse 390 problems and solutions 392–8 toning 442–3 high impact effect 434–43 highlights, recovering 290 Holga 468–77 hue 225

image

aligning with moving content 415-17 auto-align for pin-registering 413-14 cleaning 76-7 cropping 92-3 management 62-3 non-destructive editing 158 quality 53 rotating/cropping 63-5 saving in ACR 251 sharpening 77-8 size 15, 92-3 straightening 92-3 image capture digital camera 56 Pro's tips 55-6 tethered 56-60 image stacks reducing noise 207-8 removing noise in Photoshop Extended 208 Iris blur 200, 467

JPEG

format options 83–4 Raw vs JPEG corrections 105–6

Lasso 163 Layer Comp 340 layers 148, 214 3D 153 adding 149 adjustment 153, 158, 159 background 154 blending modes 151–2 darken group 216–18 definition 148 difference and exclusion 224 filtering display 151

hue, saturation, color 225-6 image 152 lighten group 219-21 luminosity 227 major groupings 214 manipulating 151 masks 152, 159 non-destructive image editing 158 opacity 151 opacity and dissolve 215 overlay group 222-3 overview 149 patch and heal 281 quick masks, selections 154 retaining quality 158 saving an image 154 saving selections 155 smart object 153 styles 151 switching between mask/selection modes 154 text 152 vector 153 viewing 150 working with 150-1 lens correction 90, 202-4, 261 alternative approach 265-7 auto 13 batch processing 204-5 full 13 level 13 manual 91-2 profile-based 91 standard approach 262-4 vertical 13 lens flare effect 485-8 lighten 219 color 221 color dodge 221 linear dodge 221 screen 219 lighting effects 199 linear burn 218 linear dodge 221 Liquify 18, 20, 194-5, 341 localized correction 101-3 adding, subtracting, creating new corrections 104-5 adjustment brush workflow 103-4 LR/Enfuse plug-ins 390 luminance 423 luminosity 177-8, 227 Magic Wand 164 moving a selection 165 quicker selections 164-5 tolerance 164 manual corrections 91 chromatic aberration 92 fringing 92 lens vignetting 92

shadow 178-9 shortcuts 320 Matting 172 Mercury Graphics Engine 18 midtone contrast boost 179-80 Mini Bridge 40-3 motion blur 462 multiple files 79 fine tune 81 multi-select 80 quality vs quantity 79 synchronized processing 80 noise filters 206 with image stacks 207-8 per channel mode (advanced section) 207 reduction 206 noise reduction 113-14 in ACR 240 in Photoshop Extended 208 opacity 215 output options 115-17 output processed files 81-2 overlay 222-3 patch and heal 281 paths 328-41 Pen tool 322 Perspective 412 photomerae 400-17 align and blend strong geometric lines 404 hairline cracks 405 perspective or cylindrical 412 Photoshop CC (new/improved features) add non-centered vignettes with Radial Gradient filter 11 Adobe Camera Raw 10, 14 camera shake reduction 16 color-swatch import from HTML, CSS, SVG files 21 conditional actions 20 copy CSS attributes from layers 19 correct crooked pictures 13 creative cloud integration 3 editable rounded rectangles/other shapes 18 immediate updates 3 improved 3D effects 21 improved 3D scene panel 18 improved minimum and maximum filters 17 improved type styles 19 multiple shape/path selection 19 new and improved features 10 new workflow time savers 21 paint-on retouching 12 performance upgrade for Blur Gallery and Liguify 18 retina display support (high res Mac only) 21 setting up settings sync 7-8 sharing work 8-9 showcase images on Behance.net 9 smart object support for more filters 20 smart sharpen 17 smarter upscaling 15 subscriptions 2-3 support for read/write of larger JPEGs 21 synchronise settings 3-6 system-wide type anti-aliasing 18 pixel, control of edges 171

transform 91

localized levels 300

luminosity 177-8

Quick 173, 321

masks 154, 155, 159, 173, 328-41

modifying using the pen tool 322

Marquee 162

printing 130 adjust settings 138 assess test print accuracy 141 create/install custom profile 139 from Photoshop 137 make presets 140 obtain profile target 136 prepare inkjet printer 134-5 prepare monitor 133 prepare workshop 132 preserve shadow detail 142 print target using Adobe® Color Print Utility 136 problem and solution 131 select appropriate color setting 135 soft proofing 143 tag images with Adobe RGB profile 139 test color-managed workflow 140 using professional lab 144-5 processing 48 producing pictures 49

Quick Mask 173, 321

radial blur 462 Radial Gradient filter 11 Raw files 50, 88 add film-like Grain effect 120 add graduated filter effect 119 adding special effects 111–13 adjusting exposure in ACR 122 archiving as digital negatives 127 choosing bit depth 94-5 color space 93-4 controlling saturation/vibrance 100-1 digital exposure 121 dust on the sensor/batch removal 126-7 expose right 125 express what you see 268-73 global tonal adjustments 99-100 grayscale conversion/toning 106-10 lens corrections 90-2 localized correction 101-6 multiple exposures 125 noise reduction/sharpening 113-18 preliminary enhancements 118 preparing system for 51-2 processing 89-90 reclaim filtered detail 120 reprocessing older files 98-9 setting white balance 95-9 straighten, crop, size 92-3 reduced depth of field 453-62 Refine Edge 168-70, 173, 312-27 retouching 127 black and white in ACR 283-8 clarity in ACR 246 clone or heal 282 cropping in ACR 250 double processing 301-8 editing for drama 274-82 extreme contrast edits in ACR 255-60 lens corrections 261-7 localized levels with layer masks 300 quick adjustments in ACR 290 raw expression 268-73 recovering highlights 290

saving images in ACR 251 sharpening in ACR 245, 299 standard edit in ACR 230-54 synchronizing settings in ACR 249 working spaces 289–300 saturation 100-1, 226 selection 155, 162 add to 166 anti-aliasing 171 channel masking 175-6 Color Range 174–5 customizing 165-6 defringe/matting 172 drawing skills 182-5 drawn selections with Lasso tools 163 feather 171 from paths 181-5 intersection 166 inversing 166 Magic Wand 164-5 mode buttons 165 overview 162 Quick Mask/Refine Edge 173 refine edge in action 168-70 refining 167-8 saving as alpha-channel 172 saving/loading 170 shape-based with Marquee tools 162 subtract from 166 tone-based 177-80 shadow adjusting detail 372 alternative technique to create fill layer 366 management 121 preserving shadows 363–72 subtle 373 sharing imagery 49 sharpening 114, 208-9 in ACR 245, 299 capture 114 controls 209 customizing 209 with High Pass filter 210 localized 115 output 115 sky, replacing 342-8 smooth tone technique 428-33 soft light 223 special effects adding more realistic grain 472 borders and textures 490-5 color grading 444-52 depth of field 466 Faux Holga 468-77 Grain 111 HDR toning 442 high impact 434-43 lens flare 485-9 motion blur/radial spin 462-3 new Radial Filter 112-13 post crop vignetting 111-12 reduce depth of field 453-63 smooth tone 428-33 tilt-shift 464-7, 466 toy camera effect in ACR 478-82

split toning 110 Spot Removal 12 studio background, replacing 374–81 studio lighting 349–55 synchronize settings 3–7 in ACR 249

tethered image capture 56-60

texture 210, 333-4, 490-4 tilt-shift 464-5 ESP action 466 tonal adjustment 67–76 global 99-100 toning, split 110 toy camera effect 478-82 Vanishing Point 195-6 exported arids 424 vertical panoramas 418-24 exported s 424 luminance preset 423 vibrance 100-1 Visualize Spots 12 Web, saving, duplicating, resizing 83-5 white background 316 white balance 95 advanced fine-tuning 96-7 automating profile settings 97 custom profile creation 97 workflow 48-9 capture an image 55-60 clean the image 75-7 color adjustment 65-7 download/transfer files 60-1 multiple files 79-81 output processed files 81-2 rate and add keywords to files 62-3 resize and crop 63–5 saving, duplicating, resizing for web 83-5 set options 78-9 sharpen the image 77-8 tonal adjustment 67-75 workflow concepts advantages/disadvantages 16-bit editing 54 choosing bit depth 54 difference between Raw and other formats 50 **DNG 51** enhancement 53 optimizing image quality 53 preparing Raw files 51-2 Raw files 50 saving frequently 53 step back 53 synchronizing development settings 51 working spaces 289 quick adjustments using ACR 290-300